Consumer Behavior
In Fashion

Second Edition

Michael R. Solomon
Nancy J. Rabolt

PEARSON

Prentice
Hall

Upper Saddle River, New Jersey
Columbus, Ohio

Library of Congress Cataloging-in-Publication Data

Solomon, Michael R.
 Consumer behavior : in fashion / Michael R. Solomon, Nancy J. Rabolt.
 p. cm.
 Includes bibliographical references and index.
 ISBN-13: 978-0-13-171474-8 (alk. paper)
 ISBN-10: 0-13-171474-0 (alk. paper)
 1. Fashion merchandising. 2. Clothing and dress—Marketing. 3. Consumer behavior. 4. Consumers'
 preferences. 5. Consumers—Psychology. 6. Consumer protection. I. Rabolt, Nancy J. II. Title.
 HD9940.A2S624 2009
 687.068'8—dc22 2008024353

Editor in Chief: Vernon Anthony
Acquisitions Editor: Jill Jones-Renger
Editorial Assistant: Doug Greive
Project Manager: Alicia Ritchey
Operations Specialist: Deidra Schwartz
Art Director: Michael Fruhbeis
Cover Designer: Michael Fruhbeis
Cover art/image/photo[s]: PhotoAlto Agency RF Collections/Frederic Cirou
Director, Image Resource Center: Melinda Patelli
Manager, Rights and Permissions: Zina Arabia
Manager, Cover Visual Research and Permissions: Karen Sanatar
Image Permission Coordinator: Kathy Gavilanes
Director of Marketing: David Gesell
Marketing Manager: Leigh Ann Sims
Marketing Assistant: Les Roberts
Copyeditor: Donna Mulder

This book was set in ACaslon Regular by Aptara®, Inc., and was printed and bound by Hamilton
Printing Co. The cover was printed by Phoenix Color Corp.

Pearson Education Ltd., London
Pearson Education Singapore, Pte. Ltd
Pearson Education Canada, Inc.
Pearson Education—Japan

Pearson Education Australia Pty, Limited
Pearson Education North Asia Ltd., Hong Kong
Pearson Educación de Mexico, S.A. de C.V.
Pearson Education Malaysia, Pte. Ltd.

10 9 8 7 6 5 4 3 2 1
ISBN-13: 978-0-13-171474–8
ISBN-10: 0-13-171474-0

Brief Contents

Contents

Preface

Our fascination with the everyday activities of people inspired us to write this book. The field of consumer behavior is the study of how our world is influenced by the actions of marketers and, at the same time, how marketers are influenced by us. At times fashion is created and dictated to consumers by retailers and influentials: consider the "What's In and What's Out" sections of fashion magazines! On the other hand, we see retailers and manufacturers struggling to predict what we will want to buy six months from now. Fashion forecasting is, in a sense, a science; but it's more of an art, and many successful marketing gurus have missed the boat on more than one fashion phenomenon.

Fashion is a driving force that shapes the way we live—it influences our apparel, hairstyles, art, food, cosmetics, cars, music, toys, furniture, and many other aspects of our daily lives that we often take for granted. It is a major component of popular culture and one that is ever changing. Fashion touches most of us on a continual basis. We may be unaware of the introduction of a new fashion, but all of a sudden our eyeglasses, clothes, shoes, and even kitchen appliances start to look dated and old-fashioned. Looking back through old pictures and watching old TV shows, by sharp contrast, brings current fashion into view. Like a fish immersed in water, we are often unaware of our ever-changing environment. The fashion industry has always been dynamic and fast moving, but it faces an even greater rate of change in the twenty-first century.

In many classes, students are passive observers learning about topics that affect them indirectly. But fashion concepts affect us directly, especially our students who work in retail and who sell fashion. They are the experts on what's in and what's out, and they are keenly aware of changes that occur on a continual basis—the lifeblood of the fashion industry. We've added new examples in this second edition, but students should have no trouble supplying their own up-to-the-minute examples to support many of the concepts they will read about in this book.

A Research and Consumer Focus

Results of many research studies are used throughout this text to illustrate marketing and consumer behavior theories and concepts as applied to fashion and to further the reader's understanding of how fashion shapes the everyday world of consumers. A marketing perspective is used, with the goal of understanding why consumers behave as they do and how to identify their needs, with the ultimate goal of maximizing company profits. However, it is also important not to forget the impact the marketplace has on the consumer. Therefore, a perspective of the consumer's well-being is also presented

throughout this book. We believe that students going into retailing and marketing need to enter the field with a humanitarian perspective. Who looks out for the consumer's well-being and for that of the environment today? Laws are established to protect consumers—maybe more than they want sometimes, and maybe more than business wants also. Chapter 14, "Ethics, Social Responsibility, and Environmental Issues," and Chapter 15, "The Role of Government and Business in Consumer Protection," especially address the effects of marketing on the consumer. They review laws and practices that watch out for the consumer, that help prevent abuse by businesses, and that provide information and help to the consumer.

Many research opportunities for students are listed in the discussion section at the end of each chapter. Some former student project results are given in this book; we hope to have more in the future!

Acknowledgments

Many colleagues have made significant contributions to this book. We are grateful for the many helpful comments provided by the peer reviewers: Melody Lehew, Kansas State University; Patricia Rigia, University of Bridgeport; Jaeil Lee, Seattle Pacific University; Hanna Hall, Kent State University; Linda Welters, University of Rhode Island; Margaret Rucker, University of California, Davis; Tammy Kinley, University of North Texas; and Kimberly Miller, University of Kentucky.

Thanks go to the professional editors at Prentice Hall for all their help in procuring permissions for the artwork and handling the myriad details involved in turning a manuscript into a book.

Also, thanks to our students, who have been a prime source of inspiration, examples, and feedback. The satisfaction derived from teaching was a prime motivation for the writing of this book.

About the Authors

Michael R. Solomon, Ph.D., is Professor of Marketing and Director of the Center for Consumer Research, Saint Joseph's University, Philadelphia and Professor of Consumer Behavior, The University of Manchester, UK. Prior to joining Auburn University in 1995, he was Chairman of the Department of Marketing in the School of Business at Rutgers University, New Brunswick, NJ. Professor Solomon began his academic career at the Graduate School of Business Administration at New York University, where he also served as Associate Director of NYU's Institute of Retail Management. He earned B.A. degrees in Psychology and Sociology, *magna cum laude,* at Brandeis University in 1977, and a Ph.D. in Social Psychology at The University of North Carolina at Chapel Hill in 1981.

Professor Solomon's primary research interests include consumer behavior and lifestyle issues; the symbolic aspects of products; the psychology of fashion, decoration, and image; and services marketing. He has published numerous articles on these and related topics in academic journals, and he has delivered invited lectures on these subjects in the United Kingdom, Scandinavia, Australia, and Latin America. He currently sits on the editorial boards of the *Journal of Consumer Behavior* and the *Journal of Retailing,* and he serves on the Board of Governors of the Academy of Marketing Science. In addition to his academic activities, Professor Solomon is a frequent contributor to mass media. His feature articles have appeared in such magazines as *Psychology Today, Gentleman's Quarterly,* and *Savvy.* He has been a guest on *The Today Show, Good Morning America,* CNBC, Channel One, *Inside Edition, Newsweek on the Air,* and National Public Radio.

Among the awards that Dr. Solomon has received are the Cutty Sark Men's Fashion Award for his research on the psychological aspects of clothing. He is editor of *The Psychology of Fashion* and co-editor of *The Service Encounter: Managing Employee/Customer Interaction in Services Businesses* (Lexington Books). His textbook *Consumer Behavior: Buying, Having, and Being* (Prentice Hall), now in its eighth edition, is widely used in universities throughout North America, Europe, and Australia, and has been translated into several languages. The fifth edition of *Marketing: Real People, Real Choices* (Prentice Hall) was published in 2006.

Professor Solomon lives in Philadelphia, Pennsylvania, with his wife Gail, and their three children, Amanda, Zachary, and Alexandra.

Nancy J. Rabolt, Ph.D., is Professor of Apparel Design and Merchandising at San Francisco State University, where she is also Chair of the Department of Consumer and Family Studies/Dietetics. Dr. Rabolt also taught fashion consumer behavior and fashion merchandising for over thirty years at Southern Illinois University, Marygrove College, and San Francisco

State. She holds a B.S. degree in Education from State University of New York, Oneonta; an M.S. in Clothing and Textiles from Southern Illinois University; and an interdisciplinary Ph.D. in Textiles/Merchandising/Design, Social Psychology, and Consumer Behavior from the University of Tennessee, Knoxville.

Professor Rabolt's primary research interests include cross-cultural consumer behavior and global aspects of the apparel industry. She has made numerous presentations at marketing, consumer, apparel, and family and consumer sciences conferences. She has published in several international journals: *Clothing and Textiles Research Journal, Journal of Fashion Marketing & Management, International Journal of Human Ecology, Journal of Saitama University, International Journal of Costume Culture, Journal of Korean Society of Costume, Japanese Journal of Clothing Research, Journal of Consumer Studies & Home Economic, and International Textiles and Apparel Association Special Publications.* She is also the primary author of the second edition of *Concepts and Cases in Retail and Merchandise Management* (Fairchild Publications).

Dr. Rabolt lives near the Pacific Ocean in Montara, California.

INTRODUCTION

This section covers basic concepts related to consumer behavior in fashion to set the stage for subsequent chapters. The first chapter introduces you to fashion terminology, concepts, and theories in addition to the basics of the field of consumer behavior. Chapter 2 focuses on cultural influences on our behaviors in the marketplace. Chapter 3 provides an overview of how consumer culture is created, adopted, and diffused throughout society.

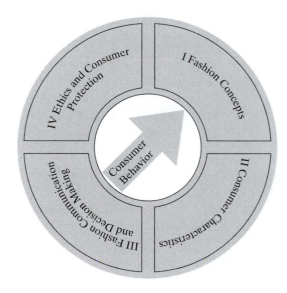

1

Introduction to Fashion Concepts, Theories, and Consumer Behavior

Gail is killing time before her math class by browsing in the college bookstore. Between studying for her marketing and psychology exams, she realizes she hasn't looked through a magazine in weeks. Enough of the serious stuff, she decides. It's time for some *really* educational reading.

The magazine section is filled with what looks like a hundred different selections, from *Motor Trend* to *Mother Jones.*

And so many celebrity magazines! In high school Gail was a dedicated *Seventeen* reader, but as she scans the many titles, she is struck by the glamorous models featured on the covers of other women's magazines. She still looks at *Seventeen* but thinks it's time to expand her horizons a bit. After all, she's a college junior now—time to listen to her sorority sisters and remake her somewhat innocent image.

Looking over the many choices, Gail considers buying a copy of *Vogue* or *Harper's Bazaar.* No, they seem a bit too sophisticated for her. *Elle, Glamour,* and *Cosmopolitan* all look about the same. *Allure* and *McCall's* look like magazines her mother (a stylish "mature" woman) would read, and she can look at *Family Circle* and *Ladies' Home Journal* anytime she visits her Aunt Margie and the kids in the suburbs—as if she'd want to read about endless diets and home decorating ideas.

Finally, Gail is intrigued by *In Style* and *Marie Claire*—they both seem very hot.[1] She heard that *Marie Claire* even has a French version but she better stick to the American version in English. As Gail flips through the pages, her attention is caught by the many ads and editorials showing great fashions. She remembers

coming across *Maire Claire*'s site when surfing the Web last night and see-ing similar fashions. The wine, chocolate and cheese diet, and the "speak your mind" sections sounded interesting. Also the section called "Beauty Road Show: What I Love About Me" might make her feel better about herself. Real, everyday people are pictured. The editor says beauty is no longer dic-tated by this year's model or last year's Oscar winner; hmmmm, she wonders about that. She catches a whiff of that new perfume her friend Monica just bought as she looks at the article on Sarah Jessica Parker about her new role as perfume mogul and $60 million in annual sales from her new scent. Yeah, this magazine is just what the doctor ordered to help create the New Gail. Monica and the other sisters will be proud of her . . .

CONSUMER BEHAVIOR: PEOPLE IN THE MARKETPLACE

This book is about people like Gail. It concerns the products and services they buy and use and the ways these fit into their lives. This introductory chapter describes important aspects of the field of consumer behavior, espe-cially as they relate to the world of fashion, and explains why it's essential to understand how people interact with the marketing system. This chapter also provides basic fashion concepts that should help you understand how con-sumers make decisions about new fashion products. Although many exam-ples in this book revolve around apparel, because we see fashion in many types of products and services, examples of such items as home furnishings, music, food, and art are also included.

For now, though, let's return to one "typical" consumer: Gail, the college student. This brief story allows us to highlight some aspects of consumer behavior that will be covered in this book.

- As a consumer, Gail can be described and compared to other individ-uals in a number of ways. For some purposes, marketers might find it useful to categorize Gail in terms of her age, sex, income, or occupation. These are some examples of descriptive characteristics of a population, or *demographics*. In other cases, marketers would rather know some-thing about Gail's interests in clothing or music, or the way she spends her leisure time. This sort of information comes under the category of *psychographics* and refers to aspects of a person's lifestyle and personal-ity. Knowledge of consumer characteristics plays an extremely impor-tant role in many marketing applications, such as defining the market for a product or deciding on the appropriate techniques to employ when targeting a certain group of consumers.

- Gail's purchase decisions are heavily influenced by the opinions and behaviors of her friends. A lot of product information, as well as rec-ommendations to use or avoid particular brands, is transmitted by conversations among real people rather than by way of television commercials, magazines, billboards, or Web sites. The bonds among Gail's group are cemented by the common products they use. There is also pressure on each group member to buy things that will meet

with the group's approval, and a consumer often pays a price in the form of group rejection or embarrassment when he or she does not conform to others' conceptions of what is fashionable and what is "in" or "out."

- As a member of a large society, such as the United States, people share certain *cultural values*, or strongly held beliefs about the way the world should be structured. Members of *subcultures*, or smaller groups within the culture, also share values; these groups include Hispanics, teens, Midwesterners, or even Paris Hilton fan clubs and "Hell's Angels." The people who matter to Gail—her *reference group*—value the idea that women in their early twenties should be innovative, fashion-conscious, independent, and daring (at least a little).

- When examining magazines, Gail was exposed to many competing brands. Numerous magazines did not capture her attention at all, while others were noticed and rejected because they did not fit the image with which she identifies or to which she aspires. The use of *market segmentation strategies* means targeting a brand only to specific groups of consumers rather than to everybody—even if it means that other consumers who don't belong to this *target market* aren't attracted to that product.

- Brands often have clearly defined images or "personalities" created by product advertising, packaging, branding, and other marketing strategies that focus on positioning a product in a certain way. The purchase of a magazine in particular is very much a lifestyle statement: It says a lot about what a person is interested in, as well as something about the type of person he or she would like to be. People often choose a product because they like its image or because they feel its "personality" somehow corresponds to their own. Moreover, consumers may believe that by buying and using the product or service, its desirable qualities will magically "rub off" onto them. Gail hopes to become more fashionable or "with it" by changing her plain-Jane image of herself.

- When a product succeeds in satisfying a consumer's specific needs or desires, as *Marie Claire* did for Gail, it may be rewarded with many years of *brand loyalty*, a bond between product and consumer that is very difficult for competitors to break. Often a change in one's life situation or self-concept is required to weaken this bond. Brand loyalty can also be affected when a brand's image is altered or repositioned.

- Consumers' evaluations of products are affected by the products' appearance, taste, texture, or smell. We may be swayed by the shape and color of a package as well as by more subtle factors, such as the symbolism used in a brand name, in an advertisement, or even in the choice of a cover model for a magazine. These judgments are affected by—and often reflect—how a society feels that people should define themselves at a certain point in time. For example, Gail's choice of fashions says something about the type of image women like her want to project today. If asked, Gail might not even be able to say exactly why she considered some magazines and rejected others. Many product meanings are hidden below the surface of the packaging and

advertising, and this book will discuss some of the methods used by marketers and social scientists to discover or apply these meanings.

- *Marie Claire* has an international image that appealed to Gail. A product's image often is influenced by its *country of origin*, which helps to determine its brand personality. In addition, our opinions and desires increasingly are shaped by input from around the world, which is fast becoming a much smaller place due to rapid advancements in communications and transportation systems. In today's global culture, consumers often prize products and services that "transport" them to different places and allow them to experience the diversity of other cultures.

Fashion is not limited to apparel. SURFACE is a lifestyle publication that reports on trend leaders in the fashion, interiors, architecture, graphics, film, and music industries.

THE NATURE AND MEANING OF FASHION

Fashion is a billion-dollar industry employing millions of people around the world and affects almost all consumers today more than ever before as our economy becomes more global. Fashion reflects our society and our culture; as a symbolic innovation, it reflects how people define themselves. It is responsible for consumers changing their wardrobes, music systems, furniture, and the cars they drive. Although people tend to equate fashion with clothing and accessories, it is important to keep in mind that fashion processes affect *all* types of cultural phenomena, including other products such as toys, games, electronics, cars, and kitchen appliances in addition to music, food, diets, art, architecture, TV shows, and even science (that is, certain research topics and scientists are "hot" at any point in time). Business practices are also subject to the fashion process; they evolve and change depending on which management techniques are in vogue, such as quality management, theory Z, paradigm shifts, fire-walking, or business process reengineering, among others. In addition academia goes through fashion cycles. Have you heard about distance learning, service learning, zero-based budgeting, and the demographic bulge?[2] (That bulge may be you!) And words come and go in fashion, such as "cool," "meme," "truthiness," and "Wikiality." *Truthiness,* defined as truth unencumbered by the facts, and *Wikiality,* derived from the user-compiled Wikipedia information Web site and defined as reality as determined by majority vote, are two words popularized by political satirist Stephen Colbert on his TV show *The Colbert Report.* They were named the top television buzzwords recently. Indeed, new words (and their definitions) continually enter our language. Wikipedia is an online encyclopedia that can help you understand the newest, coolest word. Or are these word fads? (We'll discuss later in this chapter.)

Fashion can be thought of as a *code*, or language, that helps us to decipher these meanings.[4] Unlike a language, however, fashion is *context dependent.* The same item can be interpreted differently by different consumers and in different situations.[5] In **semiotic** terms (how we interpret the meanings of symbols) the meaning of fashion products often is *undercoded*—that is, there is no one precise meaning but rather plenty of room for interpretation among perceivers.

Apparel Industry Structure Affects Consumers

What's behind that new dress or T-shirt you just bought? The answer is: More people, companies and levels of development than you probably realize.

FASHION IN TOYS

Although there has not been a must-have holiday toy craze lately, that has not been the case in some years past. Visions come to mind of long lines at Christmas waiting for Cabbage Patch dolls, the latest Pokemon trading cards, Teenage Mutant Ninja Turtles, the limited edition Beanie Babies, or more recently the latest version of Xbox. What will the next big toy craze be: a miniature high-tech pony that responds to touch, a Barbie doll that follows the child's dance moves, or a robot made from a LEGO set that can be programmed?[6] Kids seem to grow out of toys at a younger age and become more interested in trendy gadgets. However, some in the industry see that no matter how sophisticated the toys become, most innovative and successful toys embody the principles of classic play—one, of course, is "having fun."[7] While some toys and games come and go, others become classics. The Toy Industry Association reports the following toys still on the market with their year of introduction:

1903 Crayola Crayons	1959 Barbie
1914 Tinkertoys	1963 G.I. Joe
1930 LEGO building sets	1971 Mastermind
1948 Scrabble	1983 Cabbage Patch Kids
1950 Silly Putty	1988 Teenage Mutant Ninja Turtles

According to data compiled by NPD Group, the Toy Industry Association reports that $22 billion was spent on toys in 2005 with another $10.5 billion spent on video games.[8]

Following are a few examples of industry components that ultimately affect what you buy at Macy's or Wal-Mart:

- *Fiber research* on natural and synthetic fibers; fiber marketing. New fibers such as Tencel® take a great deal of technology to perfect and much marketing to introduce to fabric companies, designers, and consumers. It takes years to bring a new product to the consumer. Generally fibers and fabrics are promoted to the next industry level, the apparel manufacturer, but some fiber companies are going directly to consumers. TV and magazine ads for Lycra® are an example of this.

- *Color and fashion forecasting.* Forecasting houses (such as Promostyl and Doneger Group), trade associations (such as Cotton Incorporated), and individual fabric companies (such as DuPont) do extensive research to predict what consumers will want approximately eighteen to twenty months before they buy a new product.

- *Fabric mills,* knitting and weaving. Most U.S. fabric production utilizes high technology and quality control. U.S. textiles are produced in large quantities for cost-effectiveness and to accommodate mass fashion styles. Many designers feel they need to go to Europe or Japan for distinctive, high-quality fabrics in smaller lots.

- *Converters* who finish the fabric with dyes, prints, and finishes.

- *Designers and manufacturers of apparel* and contractors who sew it. U.S. companies continue to design much of the apparel we buy. However, more and more is assembled in developing countries and imported to the United States. Some consumers are reacting to this in the form of boycotts of global companies that are seen as less than socially responsible (see Chapter 14 for discussion).

- *Support services,* including publications such as *Women's Wear Daily,* advertising agencies, retail and economics analysts, trade associations, import specialists, and brokers.

- *Representatives* for the manufacturers and designers who sell to retail buyers. Reps show their lines at market weeks (a specified time for

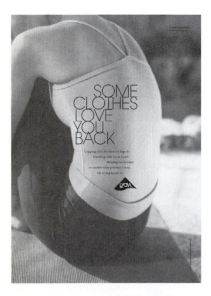

Lycra advertises directly to consumers.

The Doneger Group is a leading source of global market trends. Its trend and color forecasting division covers the apparel, accessories, and lifestyle markets in the Women's, Men's, and Youth categories and develops printed publications, online content, and live presentations. This division addresses the needs of retailers, manufacturers, and other style-related businesses.

HEBRIDES HEATHERS

buyers and sellers to get together) at hotels and apparel marts all across the country and at huge trade shows like the International Fashion Boutique Show, which takes place at the Javits Convention Center in New York City. At the end of the selling season, reps sometimes have sample sales (at wholesale prices or less) directed at consumers who live in apparel market centers such as New York, Los Angeles, Dallas, Chicago, and Atlanta. There are also several other smaller regional centers.

- *Consumer magazines,* such as those Gail looked at, that advertise and editorialize the fashions.
- *Retailers* of all types that sell the merchandise to the ultimate consumer.

To maintain competitiveness in an overcrowded fashion industry, the trend is toward vertical integration of the industry, whereby different levels merge. For example, high-end designers and large manufacturers offer their product for sale in their own retail outlets as a way of controlling the image of the brand, which they can't necessarily do at retail stores, and of offering a full line of their merchandise to consumers. Another trend is for retailers to

become manufacturers as they produce their own private labels. Both scenarios help maintain customer loyalty and also give more credibility to the brand.

Fashion Terminology

It may be helpful to distinguish among some confusing terms before further discussing consumer behavior in the fashion industry. This section looks at what we mean by the terms *style, fashion, high fashion, mass fashion, fad, classic, taste*, and others, many of which are used by consumers slightly differently than by researchers and the industry. The **fashion process** is characterized by social diffusion by which a new style is adopted by a group or groups of consumers. This spread of fashion is discussed in Chapter 12.

Levels of Fashion

In contrast to the concept of fashion as a process, a **fashion** refers to a style that is accepted by a large group of people at a given time. Many people use the terms *fashion* and *style* interchangeably although there is a difference in meaning.[9] People have different personalities and their own "style" in their manner of living, speaking, and dressing. Certain celebrities who have distinctive styles come to mind: Elvis Presley, Madonna, Dennis Rodman. We also think about hairstyles and furniture styles. There certainly are styles also in apparel, art, music, and politics.

In apparel, a **style** is a particular combination of attributes that distinguishes it from others in its category. For example, there are many styles of skirts: mini, midi, long, dirndl or gathered, pleated, A-line, circle, bell, and so on. Think about a style as having a characteristic that does not change; however, new styles are created and styles can be adapted. From time to time a style can become a fashion if it is accepted by enough consumers. For example, tailored jackets became fashionable (that is, accepted by many) in the 1980s with the trend of more women entering professional careers. They are not as fashionable for mainstream consumers today.

High fashion or haute couture, which is literally defined as "fine sewing," means very high-quality, custom-made, or made-to-measure clothing. It originated in France where designers made couture for their private clients. True couture or haute couture comes with a high price of $10,000 or more, a limited market to be sure. High fashion generally refers to new styles that are very expensive and often exaggerated or extreme in style from European designers or design houses (such as Yves St. Laurent, Chanel, Dior, Margiela, Armani, Versace, Gucci, Dolce & Gabbana, Prada, Alexander McQueen, Vivienne Westwood, and so on). These items are accepted by a limited number of fashion leaders who want to be first to have the new items and who can afford them. European designers also produce ready-to-wear lines, called **prêt-à-porter** (or **prêt** for short). These lines are still expensive by average consumer standards and can be quite influential to American fashion, which is much more affordable and casual in style.

We do not do couture in the United States, but the term *conture* is sometimes used to mean designer collections or designer ready-to-wear (off-the-rack) clothing. Many of these items (but not all) become fashion as they are "knocked off" (modified and made into cheaper copies) and sold to

the mass market. The line between American designer fashion and mass fashion is fuzzy at best. American designers (such as Donna Karan, Calvin Klein, Ralph Lauren, and Anna Sui) show their collections twice a year to the public generally in the form of runway shows, but they also offer secondary lines and licensed goods that are mass marketed.

A current trend of American designers working for European design houses makes the American/European designer distinction less clear. And the runway concept may not be a distinguishing feature of higher-end designers anymore. In 2000 Geoffrey Beene announced he would no longer show his new lines in the normal runway manner, as he felt it was too predictable and boring, and experimented with showing his lines, until his death in 2004, through different modes of presentation.[10]

Some designers develop secondary lines, or **bridge lines**, which carry their names. These are often interpretations of their primary lines in a less expensive execution, perhaps made of lesser-quality fabric or licensed to another manufacturer for production. Examples of bridge lines are Emporio Armani and A/X Armani (Georgio Armani's couture line or black label is "Milano Borgonuovo 21"), CK (Calvin Klein), and DKNY (Donna Karan). These secondary lines may be of better or moderate quality and prices.

Bridge lines also can include better quality goods from companies other than high-profile designers, such as Ellen Tracy, Tahari, and Dana Buchman.[11]

Designers offer several levels of innovative styling and price ranges. Their collections are generally the most daring and pricey, whereas their bridge lines are more conservative and less expensive.

FIGURE 1-1
Apparel Price Lines

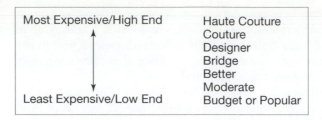

Better goods generally carry a lower price than bridge lines (it may only be due to the lesser-known name) and are of good quality but less than high-end designer collections.

Moderate goods are lower in price and quality than better goods and are sold at many department and specialty stores. **Budget goods** or popular goods are even lower priced and offered at discount stores and mass merchandisers such as Target and Wal-Mart.

Mass fashion accounts for the majority of fashion sales in the United States. These are styles produced in large quantities and sold at Gap, Forever 21, and in department and discount stores throughout the country (and the world). Similar copies are produced by many competing companies. Much of mass fashion today is made in developing countries using low-cost labor. Elaine Stone calls mass fashion "the bread and butter of the fashion banquet."[12] As indicated earlier in this section, there is a fuzzy line between designer and mass fashion. Some may draw the dividing line between exclusive and mass fashion just below couture (see Figure 1-1).

Sizing and Pricing

Women often find shopping for clothes a struggle due to the complexity and mystery of sizing. Men's clothes use basic measurements of neck, sleeve, waist, and inseam to determine size, which is a pretty straightforward system. How many men do you know who try on three sizes in the same style to see which fits best? Several factors in women's sizing relate to confusion in what size will best fit them.

Terminology used by manufacturers and retailers, perplexing for some consumers, relates to size ranges, age, figure type, and price in the women's ready-to-wear industry. Following are labels and general guidelines used by manufacturers:[13]

- *Designer:* unique styling, normally the highest price range; fits a misses figure (mature and slim) age 25 and up, size misses 4–12.
- *Bridge:* same as designer but lower price.
- *Misses:* adaptations of fashion looks; age 25 and up, size misses 4–14, misses mature figure up to 5'7", better to budget price.
- *Petites:* styling is same as misses; age 25 and up, size petite 0–14, misses figure under 5'4", better to budget price.
- *Women's or large sizes:* styling same as misses with some junior looks; age 18 and up, size 16–26W or 16–26WP, misses figure large size and some petite, better to budget price.

- *Contemporary:* trendy styling; age 20–40, size misses 4–12, misses figure slim, better to budget price.
- *Junior:* youthful, trendy, figure-conscious; age 13–25, size juniors 3–15, figure not fully developed, better to budget price.

Fashion for petite and large-sized women was virtually ignored until the late 1970s. Statistics now show that 54 percent of the total female American population wears either petite or large sizes.[14] These are pretty important markets that the industry has catered to for only the past three decades, and at times criticism reccurs that the industry caters to only the junior market and youth.

Many mass-market styles are produced in "letter" sizes, such as S, M, L (small, medium, large) rather than "number" sizes, and even one-size-fits-all with less structured styling that does not necessitate careful fitting. These are less expensive to produce, another way of keeping consumer costs down in a very competitive business. Some companies, such as Chico's, use their own system, for example, 0, 1, and 2. What does that mean? Consumers have to refer to a size chart to figure out what size they are in clothes from these companies. A new concept, matching clothes to one's shape rather than size, is found on MyShape.com. Customers enter their personal preferences and their measurements that are then matched to one of seven shapes. The system creates a choice of clothes that are supposed to fit your body and lifestyle. Try it out.

Another mystery in fashion sizing is what some call "psychological sizing" or "vanity sizing," or skewing sizes down to make the customer feel better. It seems there often is a reverse correlation between size and price; that is, as the price goes up, the size goes down. Remember the statement from the book and movie *The Devil Wears Prada:* "6 is the new 14." So we see many high-end apparel items sized such that women "fit" into a smaller labeled size. How do you think that makes them feel? You're right—great! And they may be more inclined to pay that hefty price. Budget goods often "run" larger in sizing. Thus, in a designer item a woman might wear a 6, but in a similar style from Sears, she wears a 12. Consider the following measurements for size 6:[15]

	Bust	Waist	Hips
Diane Von Furstenberg	34	26.5	37
DKNY	36	28.5	38.5
Target*	36.5	29	39

*Applies to Isaac Mizrahi, Mossimo black, Merona, Cherokee, Pro Spirit, Linden Hill, and C9 by Champion brands.

On the other hand, for some European sizing there appears to be an opposite trend lately. Cambio jean, for example, offers consumers a smaller product with a larger size after conversion to American sizing. Designers and manufacturers have their own proprietary sizing and measurements. For example, a size 10 model might vary by several inches in bust, waist, or hip measurements among different companies. Many women have painstakingly discovered the brand that fits their particular figure the best. This discussion points to the fact that there is no industry standard for particular female

LARGE VERSUS SMALL FASHION COMPANIES

Large companies that try to stay on top of hot fashion trends face a disturbing paradox: Young consumers are drawn to happening street fashions like those produced by small entrepreneurs. For example, when Dina Mohajer was a student at USC, she needed blue nail polish to go with her blue platform shoes and mixed up her own batch. Her friends loved the idea, and she started Hard Candy with a loan from her parents. Soon Drew Barrymore, Cher, and even Antonio Banderas were wearing such Hard Candy colors such as Trailer Trash, Jail Bait, and Fiend.[17]

But, as soon as these styles are "discovered" and mass-produced, they are no longer cool. In the old days, couture houses and major retailers set the styles, but with the advent of the Web and numerous small zines (small-circulation publications) produced by individuals or small companies, the big guys no longer have the final say on what is cool, and big brand names are distrusted. One way around this dilemma is to spin off a separate division and try to distance it from the parent company, as Levi Strauss did with its Silver Tab boutique label.

Sometimes this strategy backfires, as when a watered-down version of a product gets foisted on the market—for instance, jeans that have an underwear-like band of cloth sewn into them to simulate the look of real underwear sticking out of slouchy pants[18] (these styles were considered tacky by young people). Furthermore, there is a fine line between using upstart companies' ideas as "inspiration" and blatant imitation. Another small company called Urban Decay found this out when it was forced to sue Revlon over a line of nail polishes. Its colors included Oil Slick, Rust, and Pallor, and shortly thereafter Revlon introduced Tar, Blood, Rusty, Gun Metal, and other selections.[19] After only five years in business, the "defiant attitude" of this hot new start-up company put it in the same league as the big companies. In 2000 Urban Decay was sold to LVMH Moet Hennessy Louis Vuitton for an undisclosed but estimated $20 million, right after it bought Hard Candy in 1999 for $14 million![20]

sizes. And to make things more confusing, over the years these nonstandard "standards" have changed: One study found that over a ten-year period the measurements for a "standard" industry size 10 got significantly larger.[16]

Taste

Taste is another term bandied about in everyday conversation with somewhat ambiguous meaning. It refers to the prevailing opinion of what is attractive and appropriate for a given occasion or person. We speak of people having *good taste* or *bad taste* in clothes or how they decorate their homes. An avant-garde fashion worn to a conservative event might be considered poor taste. We also may say a young woman wearing a micro-miniskirt to church or an elderly person wearing a "junior" look is in bad taste. Therefore, we think of good taste as being sensitive not only to what is artistically pleasing but also to what is appropriate for a certain situation and a specific individual.[21] This is definitely a value-laden concept, the meaning of which changes from one culture to another and from one time period to another. A good example of the evaluation of an item changing over time is James Laver's theory of what is beautiful. He said a style is considered to be[22]

Indecent	10 years before its time
Shameless	5 years before its time
Daring	1 year before its time

Smart (in fashion)	Now
Dowdy	1 year after its time
Hideous	10 years after its time
Ridiculous	20 years after its time
Amusing	50 years after its time
Charming	70 years after its time
Romantic	100 years after its time
Beautiful	150 years after its time

Look at pictures of your parents in their teenage or young adult years. What do you think of their fashions? You may hate them, validating Laver's theory, or they may have even returned to fashion, something called "recurring fashion." Some feel if you keep your clothes long enough, they will come back in fashion. Consider those hippie clothes your parents wore; they're now called "hippie chic," and we've seen them at a variety of stores from Saks to Target.[23]

Cycles of Fashion Adoption

Although the longevity of a particular style can range from a month to a century, fashions tend to flow in a predictable sequence. The **fashion cycle**, or

LUANN *BY GREG EVANS*

Fashion recurs over time

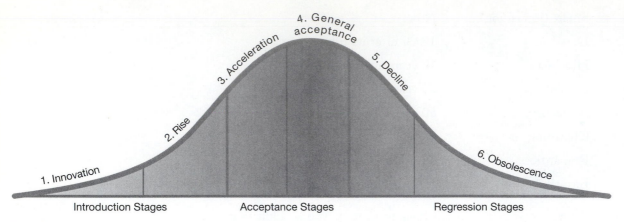

FIGURE 1-2
A Normal Fashion Cycle
Source: Reprinted with the permission of Macmillan College Publishing Company from *The Social Psychology of Clothing* by Susan Kaiser. Copyright © 1985 by Macmillan College Publishing Company, Inc.

fashion life cycle, comprises the introduction, acceptance, culmination, and decline of the acceptance of a certain style as shown in Figure 1-2.

To illustrate how this process works and to show the similarities between other fashion products and apparel, consider how the **fashion acceptance cycle** works in the popular music business (or *has* worked before the advent of MP3 files and the Internet, which in the future will change music distribution methods and no doubt speed up the process). In the *introduction stage*, a small number of music innovators hear a song. It may be played in clubs or on cutting-edge college radio stations, which is how grunge rock groups like Nirvana got their start. During the *acceptance stage*, the song enjoys increased social visibility and acceptance by large segments of the population. A record may get wide airplay on Top 40 stations, steadily rising up the charts "like a bullet."

In the *regression stage*, the song reaches a state of social saturation as it becomes overplayed, and eventually it sinks into decline and obsolescence as new songs rise to take its place. A hit record may be played once an hour on a Top 40 station for several weeks. At some point, though, people tend to get sick of it and focus their attention on newer releases. The former hit record eventually winds up in the discount rack at the local record store.

Apparel fashions go through essentially the same process. Designer goods described earlier may be the source of an innovation that is slowly adopted by fashion-forward, often young, people and found only at pricey boutiques. The look catches on and, unlike the music industry, is produced in lower-priced copies perhaps with lower-quality fabrication and is found in mainstream department stores like Macy's. After the style saturates the market, and people tire of looking at it and wearing it, the style is found only at discount stores and, finally, as it disappears is only found at thrift stores. This is not, however, the only way a style goes through the fashion cycle. The bottom-up theory of fashion leadership (discussed later in this chapter) explains how an item found at a thrift store might be worn by a young, hip group and the look works its way up to pricey boutiques.

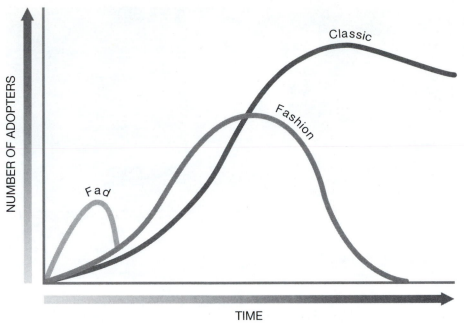

FIGURE 1-3
Comparison of the Acceptance Cycles of Fads, Fashions, and Classics
Source: Reprinted with the permission of Macmillan College Publishing Company from *The Social Psychology of Clothing* by Susan Kaiser. Copyright © 1985 by Macmillan College Publishing Company, Inc.

Figure 1-3 illustrates that fashions are characterized by slow acceptance at the beginning, which rapidly accelerates, peaks, and then tapers off. Many retailers today feel that the fashion cycle is moving faster than ever before going from one year or more down to five months. They see this change as being powered by the Internet and other technological innovations, the globalization of fashion, and savvy chains that produce instant knockoffs. The biggest task for retailers is figuring out which trends become fashion basics, which are flashes in the pan, and which looks will evolve.[24] Although many fashions exhibit a moderate cycle, others are longer-lived or shorter-lived. Classics and fads can be compared to fashions by considering the relative length of the acceptance cycle (see Figure 1-3).

Some styles become **classics**, those that seem to be acceptable or in good taste anytime, any place. They remain in general fashion for an extended period of time. It is in a sense "antifashion," since it guarantees stability and low risk to the purchaser for a long period of time. A classic is generally characterized by simplicity of design that keeps it from being dated.[25] The "Little Black Dress" exhibit at the Victoria and Albert Museum in London in the 1980s exemplified the concept of classic. Many of the dress designs throughout the decades looked as appropriate for today as in their time.

Keds sneakers, introduced in 1917, have been successful because they appeal to those who are turned off by the trendy fashion appeal of Nike or Reebok. When consumers in focus groups were asked to project what kind of building Keds would be, a common response was a country house with a white picket fence. In other words, the shoes are seen as a stable, classic product. In contrast, Nikes were often described as steel-and-glass skyscrapers, reflecting their more modernistic image.[26] Blue jeans have become a classic. Other examples include the Chanel suit, shirtwaist dress, turtleneck

Classics are items that are acceptable over a long period of time.

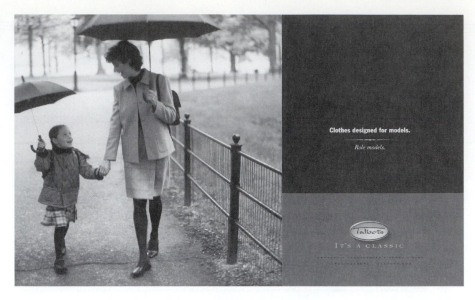

sweater, oxford shirt, blazer, trenchcoat, a skirt length just below the knee, the pearl necklace, penny loafers, and pumps. Often classics are conservative and acceptable business dress. Can you think of others? How many of these items do you have in your wardrobe? You may have more fashions or fads than classics.

A **fad** is a short-lived fashion that suddenly becomes popular and quickly disappears. It generally affects only a specific group in the population. Adopters may all belong to a common subculture, and the fad "trickles across" members but rarely breaks out of that specific group. It may have an extreme design that does not appeal to the general population. Fads can be accompanied by a craze or mania by consumers resulting in retailers finding it difficult to keep the item in stock. Power bracelets, elastic bracelets made with semiprecious stones, was a recent New Age fad with young and not-so-young adults. They are modeled after Buddhist prayer beads and thought to have special powers such as increasing love (rose quartz), intelligence (amethyst), health (turquoise), and self-control (onyx).[27]

There are many examples of fads over the years that you may or may not remember, including hula hoops and pet rocks. Check out www.badfads.com for an amusing look at past fads: Afro haircuts, bell-bottoms, Bermuda shorts, bouffant hairdo, body tattoos, conk hairdo, coonskin caps, DA haircut, Farrah Fawcett hair, glassless glasses, go-go boots, granny glasses, hot pants, hair irons, jazzed-up jeans, leisure suits, Mickey Mouse items, miniskirts, Nehru jackets, pillbox hats, platform shoes, poodle skirts, short shorts, sideburns, tank top, taps on shoes, tie-dye T-shirts, turtleneck sweaters, Twiggy look, wraparound glasses, zoot suits. Some of these have come back into fashion, such as the miniskirt, and some have been labeled classics, such as the turtleneck. What do you think? Figure 1-4 illustrates that some types of fads have longer life spans than others.

Streaking—students running naked through classrooms, cafeterias, and dorms—was a fad that hit college campuses in the mid-1970s. Although the practice quickly spread across many campuses, it was primarily restricted to

FIGURE 1-4
The Behavior of Fads

Source: Michael R. Solomon, *Consumer Behavior*, 8/e, © 2009. Reprinted by permission of Prentice Hall, Inc. Upper Saddle River, NJ.

college settings (with the exception of one Academy Awards show). Streaking highlights several important characteristics of fads.[28]

- The fad is nonutilitarian—that is, it does not perform any meaningful function.
- The fad is often adopted on impulse; people do not undergo stages of rational decision making before joining in.
- The fad diffuses rapidly, gains quick acceptance, and is short-lived.

Is It a Fad, a Trend, or a Fashion?

The term *trend* often is also confused with *fashion*. A **trend** is a general direction or movement. As a style begins to be accepted we think of it as a trend. If several designers are showing similar "looks," perhaps retro or a new skirt length, and fashion-forward consumers (known as opinion leaders, discussed in Chapter 12) are adopting it, then this style might be labeled a trend. Consumers and the industry use the term **trendy** often to mean *new* or *fashion-forward*, but it also is used sometimes to mean *faddish*.

Knowing if a style is a fad, trend, or fashion is difficult and comes only with time. If it quickly disappears, it was a fad. We might think something is a fad, but if its acceptance continues, it may be a trend. And if it lasts and has widespread acceptance, it becomes a fashion. When it peaks and begins to decline, it obviously ceases to be a trend and becomes an *outdated* fashion,

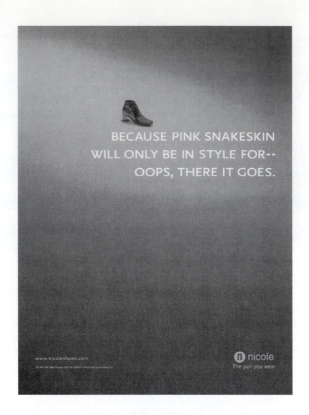

BECAUSE PINK SNAKESKIN
WILL ONLY BE IN STYLE FOR--
OOPS, THERE IT GOES.

www.nicoleshoes.com

nicole
The pair you wear

This ad for Nicole shoes reminds us how quickly fads come and go.

or one that is over. Fashions, trends, and fads are like the stock market. You don't know when they've reached their peak until they're over, and only then can they be fully analyzed.

The trick for companies is to be the first to identify a trend (the other obvious trick is to know when it's over and not get stuck with merchandise no one wants). Companies that act on a new trend have an advantage, whether the firm is Starbucks (gourmet coffee), Nabisco (SnackWell's low-fat cookies and crackers), Chrysler (retro cars), or a popular apparel designer. While nothing is certain, some guidelines help to predict if the idea or item will endure as a long-term trend or fashion or if it will go the way of the hula hoop and pet rock:[29]

- Does it fit with basic lifestyle changes? If a new hairstyle is hard to care for, it will not be consistent with women's increasing time demands. On the other hand, the movement to shorter-term vacations is more likely to last since they make trip planning easier for harried consumers.

- What are the benefits? The switch to poultry and fish from beef came about because these meats are healthier, so a real benefit is evident.

- Can it be personalized? Enduring trends tend to accommodate a desire for individuality, whereas styles like Mohawk haircuts or the grunge look are inflexible and don't allow people to express themselves.

- Is it a trend or a side effect? An interest in exercise is part of a basic trend toward health consciousness, whereas the specific form of exercise that is "in" at any given time will vary (for example, low-impact aerobics versus Pilates).

The Japanese have a weakness for gadgets, and local companies produce toys for adults that may strike others as somewhat, well, bizarre. One recent fad is a hit series of Japanese software called "Princess Maker." Targeted to adult men, the player controls the activities, hobbies, and clothing of a girl character he "raises" from childhood. The game probably would be frowned upon in the West, since this virtual daughter can be programmed to dress in lingerie or sunbathe naked. The player names her, picks her birthday, and even chooses her blood type, which some Japanese believe determines character traits. His choice of activities for her affects her future success in life (and his score). For example, choosing painting lessons increases the score, whereas dressing her in provocative clothing reduces her moral standing and lowers the score. If a player winds up with a really low score, the daughter may face a future as a bar hostess—when this happens, she giggles while holding up a slinky dress.[30]

Another Japanese fad invaded American shores several years ago. It's a handheld chicken video game—a *tamagotch*, or "cute little egg." The keychain computer game unfolds as an egg hatches on the display screen. The owner uses three tiny buttons to feed the baby chick, play with it, clean up after it, and discipline it. The game can go on for several days if the chick is cared for properly, but if the owner forgets to feed it, he or she hears a loud "peep, peep, peep" and eventually the chick grows sickly and dies. Nearly 2,000 people showed up at the store when word leaked out a new shipment had been received, with many sleeping outside in the cold.[31] In late 1997, the concept invaded the United States with about 6 million units of American versions such as Microchimp and Compu Kitty preordered in anticipation of the next craze for these "giga pets."[32] Indeed, Bandai Co. sold 40 million Tamagotchis worldwide in the first two years. Recently, a revamped version, the Tamagotchi Plus, has been released. This time the egg-shaped portable electronic pets can befriend each other, even mate, thanks to an infrared link. Cell phone tie-ins are next for the cute little egg.[33]

- What other changes have occurred in the market? Sometimes the popularity of products is influenced by *carryover effects*. The miniskirt fad in the 1960s brought about a major change in the hosiery market: the development of pantyhose.
- Who has adopted the change? If the innovation is not adopted by working mothers, baby boomers, or some other important market segment, it is not likely to become a trend.

Apparel Brands: National versus Private

The terms *national brand, private brand,* and *store brand* have specific industry meanings, but they are starting to all blend together due to the dynamics of the fashion industry. **National brands** include manufacturer or designer names that are well advertised, such as Revlon, Lee, Guess, Nine West, Donna Karan, and Ralph Lauren. The concept of vertical integration with manufacturers opening their own retail outlets is also seen in reverse at department and specialty stores as they become manufacturers. They offer **private brands** (those sold only by one company, such as Charter Club at Macy's and Arizona jeans at JC Penney) and **store brands** (those sold only in one store that carry the store name, such as Gap). They are an alternative to national brands. *Brand-loyal* people will leave a store and go to another if they can't find their brand. *Store-loyal* customers don't do that. Private brands are generally cheaper for the consumer and the retailer since there is little or no advertising for them compared with national brands. Because there is

generally a higher markup on these products, they often are good candidates for promotions and still provide the retailer with a good margin (or profit). These brands compete with national brands, and interestingly, many are becoming known as legitimate brands sought out by consumers. Among the labels listed as a "brand" in a Kurt Salmon Associates study were Hanes, Lee, Jaclyn Smith, Arizona, Gap, Lands' End, Macy's, and Ellen Tracy (representing traditional national brands, store brands, and private brands).[34]

What are the most popular brands? Several apparel brands were mentioned in a survey by Teenage Research Unlimited that asked 2,000 young men and women to name the three "coolest" brands of any type of product. The following were the top five listed, with Nike by far the most cited brand by 44 percent of the respondents: (1) Nike, (2) Levis, (3) Calvin Klein, (4) Sony, and (5) Pepsi. Fashion and footwear brands mentioned by 3 to 8 percent of respondents included Tommy Hilfiger, Adidas, Gap, Airwalk, Guess, Reebok, and Fila.[35]

Women's Wear Daily commissions annual surveys of top brands (based on familiarity with the brand). The latest was an online survey of over 2,000 consumers, ages 18 to 64. Results include the following categories (with the top brand in parentheses):[36]

designers (Calvin Klein)	dresses (Liz Claiborne)
activewear (Nike)	accessories (Liz Claiborne)
denim (Levi Strauss)	watches/jewelry (Timex)
swimwear (Speedo)	innerwear (Hanes)
young contemporary (Guess)	outerwear (London Fog)
sportswear (Old Navy)	legwear (Hanes)

TECHNOLOGY AS FASHION

iPods, iTunes, cell phones, ringtones . . . technology that are fashion accessories today. And most have their own accessories to make them hot. Apple sells an iPod every second (32 million sold in one year) and add-ons are a billion-dollar business. For every $3 spent on an iPod, at least $1 is spent on an accessory, according to the NPD Group research firm.[37] That works out to three or four additional purchases per iPod. With over 2,000 different add-on options, the message sent to consumers is that the iPod is by far cooler than a Creative or Toshiba player. Accessories range from low-impact colorful sleeves, or socks, to a Coach python case, an iHome clock radio, and a Logitech accessory that turns an iPod into a home media center. Fashion houses such as Gucci group, Chanel, Burberry, Kate Spade, Dior, and Louis Vuitton have entered the iPod accessory field. Jewelry is another iPod accessory market. iPodjewelry.com sells freshwater pearls that can be attached to the Shuffle with a lanyard-like band that users can put around their necks. This is where the iPod becomes the accessory. The Web site states: "Stop accessorizing your iPod. Start accessorizing with it."

And, of course, cell phones, ubiquitous in society, are both a fashion accessory and have their own accessories. Anna Sui's special-edition phone for Samsung looks like her makeup line. The carrying case, the butterfly charm accessory, and six choices of Sui-style wallpaper make it uniquely Sui. Similar to Diane von Furstenberg's limited-edition phone based on her Andy Warhol portrait, such partnerships reach fashion fans. Nokio has entered the upper-end market with $300 to $700 fashion phones with leather trim and mirrored surfaces.[38] Ringtones, another fashion accessory and statement of one's personal identity, have consumers spending hundreds of millions of dollars. The industry is expected to grow to over a billion dollars. Ringtones can be Top 40 songs, dialogues from movies, or your own production. Some songs make it to ringtones before even reaching the airwaves![39]

Surveys also create several Top 10 lists:

- *Top 10 Designers:* (1) Calvin Klein, (2) Tommy Hilfiger, (3) Ralph Lauren, (4) Gucci, (5) Giorgio Armani, (6) Chanel, (7) Anne Klein, (8) Christian Dior, (9) Oscar de la Renta, (10) Louis Vuitton
- *Top 10 Sportswear Brands:* (1) Old Navy, (2) Gap, (3) Tommy Hilfiger, (4) Dockers, (5) Calvin Klein, (6) Eddie Bauer, (7) Liz Claiborne, (8) Ralph Lauren, (9) L.L. Bean, (10) Banana Republic
- *Top 10 Denim:* (1) Levi Strauss, (2) Lee, (3) Old Navy, (4) Wrangler, (5) Gap, (6) Guess, (7) Levi Strauss Signature, (8) Arizona, (9) Tommy Jeans, (10) Mudd

FASHION LEADERSHIP THEORIES

Fashions are accepted by a small group of consumers before they are purchased by the majority, or mass market. Fashions have roots in a variety of phenomena, and theories have been proposed for different explanations of how styles become fashion using sociological, psychological, and economic models. It is important for those attempting to forecast the next big fashion trend to be aware that all fashion does not start with upper-end designers but actually comes from a variety of sources and in different ways.

Fashion is a complex process that operates on many levels. At one extreme, it is a macro, societal phenomenon affecting many people simultaneously. At the other, it exerts very personal effects on individual behavior. A consumer's purchase decisions are often motivated by his or her desire to be in fashion. Fashion products also are aesthetic objects, and their origins are rooted in art and history. For this reason, there are many perspectives and theories on the origin and diffusion of fashion. Theories are attempts to explain phenomena and to help predict the future. Although these cannot be described in detail here, some major approaches and theories are briefly summarized.[40]

Collective Selection

Fashions tend to "sweep" the country; it seems that all of a sudden "everyone" is doing the same thing or wearing the same styles or colors. Some sociologists view fashion as a form of *collective behavior*, or a wave of social conformity. How do so many people get "tuned in" to the same phenomenon at once, as happened with miniskirts or hip-hop styles?

Creative subsystems (for example, apparel designers) within the fashion production system (further discussed in Chapter 2) attempt to anticipate the tastes of the buying public. Despite their unique talents, members of this subsystem are also members of mass culture. Cultural gatekeepers are drawing from a common set of ideas and symbols and are influenced by the same cultural phenomena as the eventual consumers of their products. The process by which certain symbolic alternatives (for example, apparel styles) are chosen over others has been termed **collective selection**.[41]

Fashion buyers from retail stores visit showrooms of designers and apparel manufacturers and choose the styles they feel their customers will want to buy. As with the creative subsystem, members of the managerial (for example, retail buyers) and communications subsystems (for example, *Women's Wear Daily*, the apparel industry trade paper) also seem to develop a common frame of mind. The styles selected must be in step with the **zeitgeist**, or spirit of the times. Although products within each category must compete for acceptance in the marketplace, they can usually be characterized by their adherence to a dominant theme or *motif*—be it "Denim," "The Western Look," "New Wave," "Danish Modern," or "Nouvelle Cuisine."

Trickle-Down Theory

The relationship between product adoption and class structure was first proposed in 1904 by Georg Simmel. The **trickle-down theory** has been an approach used to understand fashion, especially as it applies to fashion history. It states that there are two conflicting forces that drive fashion change. First, subordinate groups try to adopt the status symbols of the groups above them as they attempt to climb up the ladder of social mobility. Dominant styles thus originate with the upper classes and *trickle down* to those below. This is where the second force kicks in: People in the superordinate groups are constantly looking below them on the ladder to ensure that they are not imitated. They respond to the attempts of lower classes to "impersonate" them by abandoning the fashion and adopting even newer fashions. These two processes create a self-perpetuating cycle of change—the machine that drives fashion.[42] We might think of the influence of celebrities as trickling down to the masses; one only has to think of the Academy Awards parade of designer clothes that soon after get reinterpreted for department store racks.

Trickle-Across Theory

The trickle-down theory was quite useful for understanding the process of fashion changes when applied to a society with a stable class structure that permitted the easy identification of lower- versus upper-class consumers. This task is not so easy in modern times. In contemporary Western society, then, this approach must be modified to account for new developments in mass culture; thus, the **trickle-across theory** was developed.[43]

A perspective based on class structure cannot account for the wide range of styles that are simultaneously made available in our society. Modern consumers have a much greater degree of individualized choice than in the past because of advances in technology and distribution. All classes generally have access to the same information at the same time. Thus, we see many of the same styles in a variety of types of retail venues at all different prices. Due to faxes, e-mail, and the Internet, "knockoff artists" (those who copy designer styles) can produce their versions of what they see on the runway very fast and can actually deliver their goods to the stores before the original designer can. Thus, the upper classes are not necessarily getting new style information first. Just as a young adult like Gail is almost instantly aware of the latest style

trends by watching MTV, high fashion has been largely replaced by mass fashion. Also, discounters today are not satisfied with waiting for fashion to trickle down to them. Sears, Kohl's, Wal-Mart, and Kmart have recently opened design studios in New York City and struck deals with high-end designers.[44]

Consumers tend to be influenced more by opinion leaders who are similar to them. As a result each social group has its own fashion innovators who determine fashion trends. It is probably more accurate to speak of this trickle-across effect today, where fashions diffuse horizontally among members of the same social group, than the trickle-down effect.

Subcultural or Trickle-Up Theory

Current fashions often originate with subcultural groups or the lower classes and *trickle up* to higher classes. Grassroots innovators typically are people who lack prestige in the dominant culture (for example, urban youth). Since they are less concerned with maintaining the status quo, they are freer to innovate and take risks.[45] As the theory implies, the flow of information is the opposite of trickle down, which starts with the upper class. The **trickle-up theory** postulates that information starts at the bottom and flows upward. Jeans are a classic example. Jeans were first worn by miners during the gold rush and by farmers and blue-collar workers who needed sturdy, functional clothes. With the addition of a logo or designer initials on the back pocket, designer jeans were born, along with a high price tag, and marketed to those with plenty of discretionary money, not to farmers and laborers. Leg warmers borrowed from dancers: corn rows and the Afro hairstyle borrowed from the African American culture; the hippy look borrowed from the 1960s: bib overalls, prairie looks, and peasant blouses all had similar subcultural origins. The integration of Goth into the mainstream is yet another example. This fashion started as a mode of expressing rebellion by young outcasts who admired nineteenth-century romantics and who defied conventional styles with their black clothing (often including over-the-top fashion statements like Count Dracula capes, studded collars, and black lipstick) and punk music from bands like Siouxsie & the Banshees. Today Virgin Megastores sell vampire-girl lunchboxes and at the Hot Topic Web site, teens can buy a "Multi-Ring Choker." Hard-core Goths are not amused, but hey, that's fashion for you.[46]

The trickle-up phenomenon appears to just happen. If too contrived, however, attempts by upper-end designers to borrow lower-end looks, such as grunge in the 1990s, are not successful. After all, who wants to spend $500 to look like you are wearing thrift store castoffs?

Figure 1-5 illustrates one author's concept of fashion change that incorporates both trickle-up and trickle-down theories relative to age and economic health. In a society that has youth as the dominant role model, Behling postulates that fashion change comes from the bottom—that is, it trickles up from young people who start trends. When the major role model is an affluent upper class (normally older people), fashion filters down from the top—that is, it trickles down. The model also considers the economic health of the country: When times are good, fashion change is accelerated; when the economy is in a depression, change is slow.[47]

FIGURE 1-5
A Fashion Change Model Incorporating Trickle-Up and Trickle-Down Theories

Source: Dorothy Behling, "Fashion Change and Demographics: A Model," *Clothing and Textiles Research Journal,* 4, No. 1 (1985–1986): 18–24. Published by permission of the International Textile Apparel Association, Inc.

Psychological Models of Fashion

Many psychological factors help to explain why people are motivated to be in fashion. These include conformity, variety seeking, personal creativity, and sexual attraction. For example, many consumers seem to have a "need for uniqueness": They want to be different, but not too different.[48] For this reason, people often conform to the basic outlines of a fashion but try to improvise and make a personal statement within these general guidelines.

One of the earliest theories of fashion proposed that **shifting erogenous zones** (sexually arousing areas of the body) accounted for fashion changes and that different zones become the object of interest because they reflect societal trends. J. C. Flugel, a disciple of Freud, proposed in the 1920s that sexually charged areas wax and wane in order to maintain interest and that clothing styles change to highlight or hide these parts. Interest in the female leg in the 1920s and 1930s coincided with women's new mobility and independence, whereas the exposure of breasts in the 1970s signaled a renewed interest in breastfeeding. Breasts were deemphasized in the 1980s as women concentrated on careers, but some analysts have theorized that a larger bust size is now more popular as women try to combine professional activity with child rearing. Some contemporary fashion theorists suggest that the current prevalence of the exposed midriff reflects the premium our society places on fitness.[49]

Economic Models of Fashion

Economists approach fashion in terms of a model of supply and demand. Items that are in limited supply have high value, while those readily available are less desirable. Rare items command respect, prestige, and generally high prices. Thus, we see high fashion in limited supplies at very expensive prices. One exception to this theory, related to price, is the craze of Beanie Babies

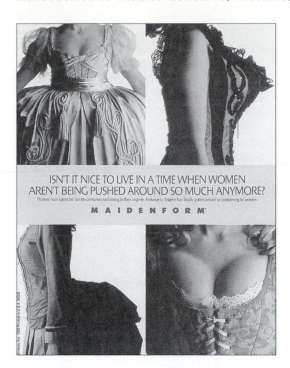

This ad for Maidenform illustrates that fashions have accentuated different parts of the female anatomy throughout history.

in the late 1990s whereby the company limited the number of a particular style that was sent to retailers, but they were supposed to sell at regular prices (normally something in limited supplies can fetch high prices). However, after-market sellers raised prices through the roof. Limiting the supply kept the demand high, such that collectors called stores daily and even sent a list of those styles they wanted to buy. The concept of collectibles is discussed in Chapter 2.

Thorstein Veblen's notion of conspicuous consumption proposed that the wealthy consume to display their prosperity, for example, by wearing expensive (and at times impractical) clothing. As noted in Chapter 7, this approach is somewhat outdated, since upscale consumers often engage in *parody display*, where they deliberately adopt formerly low-status or inexpensive products, such as Jeeps or jeans or shop at cheap-chic stores such as Target. Other social factors also influence the demand curve for fashion-related products. These include a *prestige-exclusivity effect*, called the *Veblin effect*, where high prices create high demand (for exclusive groups high prices actually increase the demand, as they can show off their wealth through expensive purchases), and a *snob effect*, where lower prices reduce demand ("If it's that cheap, it can't be any good").[50]

Meme Theory of Fashion

For years the lowly Hush Puppy was a shoe for nerds. Suddenly—almost overnight—the shoe became a chic fashion statement even though the company did nothing to promote this image. Why did this style diffuse through the population so quickly? Meme theory can explain this. The term **meme**, coined by Richard Dawkins in 1976, refers to a unit of cultural information

transferable from one mind to another. According to Dawkins, examples of memes are tunes, catchphrases ("You're fired!"), or clothing (or shoe) fashions. A meme propagates itself as a unit of cultural evolution analogous in many ways to the gene, the unit of genetic information. Memes spread among consumers in a geometric pattern just as a virus starts off small and steadily infects increasing numbers of people until it becomes an epidemic. The diffusion of many products and fashions seems to follow a similar path. A few people initially use the product, but change happens in a hurry when the process reaches the moment of critical mass—what one author calls the *tipping point*.[51] Cell phones followed such a path: a few early adopters, then all of a sudden everyone had one.

Proponents of memes suggest that memes evolve via natural selection—in a way very similar to Charles Darwin's ideas concerning biological evolution. The memes that survive tend to be distinctive and memorable.[52]

WHAT IS CONSUMER BEHAVIOR?

Let's turn back to the general field of **consumer behavior**, which covers a lot of ground: It is the study of the processes involved when individuals or groups select, purchase, use, or dispose of products, services, ideas, or experiences to satisfy needs and desires. Consumers take many forms, ranging from an 8-year-old child begging her mother for Yu-Gi-Oh! cards to an executive in a large corporation deciding on a multimillion-dollar computer system. The items that are consumed can include anything from Gucci handbags, a massage, democracy, rap music, or a celebrity like Usher. Needs and desires to be satisfied range from hunger and thirst to love, status, or even spiritual fulfillment.

Consumer Behavior Is a Process

In its early stages of development, the field was often referred to as *buyer behavior*, reflecting an emphasis on the interaction between consumers and producers at the time of purchase. Most marketers now recognize that consumer behavior is an ongoing process, not merely what happens at the moment a consumer hands over money or a credit card and in turn receives some good or service.

The **exchange**, in which two or more organizations or people give and receive something of value, is an integral part of marketing.[53] Although exchange remains an important part of consumer behavior, the expanded view emphasizes the entire consumption process, which includes the issues that influence the consumer before, during, and after a purchase. Figure 1-6 illustrates some of the issues that are addressed during each stage of the consumption process.

Consumers Are Actors on the Marketplace Stage

The perspective of **role theory** takes the view that much of consumer behavior resembles actions in a play.[54] As in a play, each consumer has lines, props, and costumes that are necessary to put in a good performance. Since people act out many different roles, they sometimes alter their consumption

FIGURE 1-6
Stages in the Consumption Process
Source: Michael R. Solomon, *Consumer Behavior* 8e. © 2009. Reprinted by permission of Prentice Hall, Inc., Upper Saddle River, NJ.

decisions depending on the particular "play" they are in at the time. The criteria that they use to evaluate products and services in one of their roles may be quite different from those used in another role.

Consumer Behavior Involves Many Different Actors

A consumer is generally thought of as a person who identifies a need or desire, makes a purchase, and then disposes of the product during the three stages in the consumption process (prepurchase, purchase, postpurchase). In many cases, however, different people may be involved in this sequence of events. The *purchaser* and *user* of a product might not be the same person, as when a parent picks out clothes for a teenager (and makes selections that can result in "fashion suicide" in the view of the teen). In other cases, another person may act as an *influencer*, providing recommendations for or against certain products without actually buying or using them. For example, a friend's grimace when one tries on a new pair of pants may be more influential than anything a mother or father might do.

CONSUMERS' IMPACT ON MARKETING

Talking about buying magazines or fashion can be a lot of fun (almost as much fun as actually making the purchases!). But, on the more serious side, why should managers, advertisers, and other marketing professionals bother to learn about this field?

Very simply, understanding consumer behavior is good business. A basic marketing concept states that firms exist to satisfy consumers' needs. These needs can be satisfied only to the extent that marketers understand the people or organizations that will use the products and services they are trying to sell and that they do so *better* than their competitors.

Consumer response is the ultimate test of whether or not a marketing strategy will succeed. Thus, knowledge about consumers should be incorporated into virtually every facet of a successful marketing plan. Data about consumers help organizations to define the market and to identify threats and opportunities in their own and different countries that will affect consumers' receptivity to the product. In every chapter, we'll see how developments in consumer behavior can be used as input to marketing strategies.

Relationship Marketing: Building Bonds with Consumers

Marketers are carefully defining customer segments and listening to people in their markets as never before. Many of them have realized that a key to success is building relationships between brands and customers that will last a lifetime. Marketers who believe in this philosophy, called **relationship marketing**, interact with customers on a regular basis and give them reasons to maintain a bond with the company over time.

Some companies build these ties by returning value to the community. The Hanna Andersson company, which sells children's clothing, ran a program called Hannadowns, which gave a 20 percent credit toward new purchases when customers returned used clothes bought from the company previously. The returned clothing was then distributed to charities. The company's Web site, www.hannaandersson.com, now lists nonprofit organizations to which the company provides grants or gifts. The original returned clothing program appears to have been a bit too popular with customers; however, the company continues the tradition of giving to the community with a strong "Hanna Helps" program. This return of value to the community cements the relationship by giving customers an additional reason to continue buying the company's products year after year. (See Chapter 14 for further examples of socially responsible apparel companies.)

Loyalty programs, first started by the airlines with frequent flyer programs, are another example of relationship marketing. This concept has been borrowed by retailers such as Neiman Marcus, which has a program that rewards repeat shoppers with gifts, discounts, and other prizes.[55] With points equaling $1 of purchases, customers achieve InCircle rewards membership (5,000 points) to Chairman's Circle (1,500,000 points) on their InCircle program, which offers perks ranging from spa experiences to memberships in exclusive travel clubs. Details are given at www.neimanmarcus.com. Nordstrom has a similar loyalty points-based reward program in which points bring you gift certificates.[56]

Another revolution in relationship building is being brought to us courtesy of the computer. **Database marketing** involves tracking consumers' buying habits very closely and crafting products and messages tailored

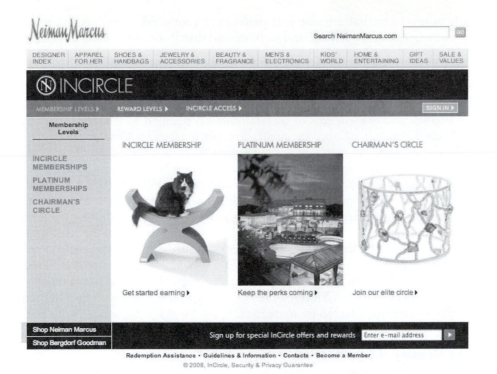

InCircle, the loyalty program for Neiman Marcus, encourages customers to continue to shop its store.

precisely to people's wants and needs based on this information. For example, Wal-Mart gathers massive amounts of information on the 100 million people who visit its stores each week, and the company uses these data to fine-tune its offerings.[57]

MARKETING'S IMPACT ON CONSUMERS

For better or for worse, we all live in a world that is significantly influenced by the actions of marketers. We are surrounded by marketing stimuli in the form of advertisements, stores, and products competing for our attention and our dollars. Much of what we learn about the world is filtered by marketers, whether through the affluence depicted in glamorous magazine advertising or via the roles played by family members in commercials. Ads show us what we should wear, how we should act with regard to recycling, alcohol consumption, the types of houses and cars we wish to own—and even how to evaluate others based on the products they buy or don't buy. In many ways we are also at the mercy of marketers, since we rely on them to

sell us products that are safe and perform as promised, to tell us the truth about what they are selling, and to price and distribute these products fairly.

Marketing and Culture

Popular culture, consisting of the clothes, music, movies, sports, books, celebrities, and other forms of entertainment consumed by the mass market, is both a product of and an inspiration for marketers. Our lives are also affected in more far-reaching ways, ranging from how we acknowledge cultural events, such as marriage, death, or holidays, to how we view social issues such as air pollution, labor abuses, and addictions. Whether it's the Super Bowl, holiday shopping, presidential elections, newspaper recycling, body piercing, in-line skating, or Barbie dolls, marketers play a significant role in our daily lives.

This cultural influence is hard to overlook, although many people do not seem to realize how much their views of the world around them—the latest fashions in clothing, food, and home furnishings, their movie and musical heroes, and even the physical features that they find attractive or ugly in men and women—are affected by marketers.

The Meaning of Consumption

One of the fundamental premises of the modern field of consumer behavior is that *people often buy products not for what they do but for what they mean.* This principle does not imply that a product's basic function is unimportant, but rather that the roles products play in our lives extend well beyond the tasks they perform. The deeper meanings of a product may help it to stand out from other similar goods and services—all things being equal, people will choose the brand that has an image (or even a personality!) consistent with their underlying needs.

For example, while most people probably couldn't run faster or jump higher if they are wearing Nikes instead of Reeboks, many die-hard loyalists swear by their favorite brand. These archrivals are largely marketed in terms of their images—meanings that have been carefully crafted with the help of legions of rock stars, athletes, and slickly produced commercials—and many millions of dollars. So, when you buy a Nike "swoosh" you may be doing more than choosing footwear to wear to the mall—you may also be making a lifestyle statement about the type of person you are or wish you were. For a relatively simple item made of leather and laces, that's quite an accomplishment!

Our allegiances to sneakers, musicians, or even soft drinks help us to define our place in modern society, and these choices also help each of us to form bonds with others who share similar preferences. This comment by a participant in a focus group captures the curious bonding that can be caused by consumption choices: "I was at a Super Bowl party, and I picked up an obscure drink. Somebody else across the room went 'yo!' because he had the same thing. People feel a connection when you're drinking the same thing."[58]

As we have already seen, a trademark of recent marketing strategies is an emphasis on building relationships with customers. The nature of these relationships can vary, and these bonds help us to understand some of the

possible meanings products have to us. Here are some of the types of relationships a person may have with a product:

- *Self-concept attachment*—the product helps to establish the user's identity.
- *Nostalgic attachment*—the product serves as a link with a past self.
- *Interdependence*—the product is a part of the user's daily routine.
- *Love*—the product elicits emotional bonds of warmth, passion, or other strong emotion.[59]

The Global Consumer

The majority of people on Earth will live in urban centers—analysts predict that the number of megacities, defined as urban centers of 10 million or more, is projected to grow to twenty-six in 2015.[60] Already, China boasts four shopping centers that are larger than the massive Mall of America in Minnesota, and within five years it will be home to seven of the world's largest malls.[61] One highly visible by-product of sophisticated marketing strategies is the movement toward a *global consumer culture*, one in which people around the world are united by their common devotion to brand-name consumer goods, movie stars, and celebrities and leisure activities.[62] Many multinational firms are household names, widely recognized (though not necessarily liked) by literally billions of people. McDonald's and Microsoft are the most visible corporate brands on the planet.[63] Some products in particular are associated with a coveted American lifestyle. Levi's jeans, for example, are a status symbol among upwardly mobile Asian and European consumers. The company sells its jeans in such far-flung places as India, Hungary, Poland, Korea, and Turkey.[64] This book will pay special attention to the good and bad aspects of this cultural homogenization. Throughout the chapters is featured a box called "Multicultural Dimensions" that spotlights some international aspect of consumer behavior.

Virtual Consumption

There's little doubt that the digital revolution is one of the most significant influences on consumer behavior, and the impact of the Internet will continue to expand as more and more people around the world log on.[65] Many of us are avid Web surfers, and it's hard to imagine a time when e-mail, MP3 files, and Blackberries were not an accepted part of daily life. Online shopping lets consumers locate hard-to-find products and creates opportunities for smaller, specialized businesses to thrive. Think about start-up companies like Bigfoot, which sells nothing but enormous shoes up to size 25 EEEE! The company was started by two brothers who both wear size 16 shoes. Their Web site, www.oddballshoe.com, features testimonials including this one: "I used to have to wear basketball shoes to church. All the other 'normal' boys and girls would circle around me, laugh and point. Thanks to you guys I got a girlfriend, have been accepted in the corporate workplace and my dog came back!"[66] Satisfying consumers like that is quite a "feat" (no pun intended!).

Electronic marketing has increased convenience by breaking down many of the barriers caused by time and location. You can shop 24/7 without leaving home, you can read today's newspaper without getting drenched picking up a

hard copy in the rain, and you don't have to wait for the 6:00 P.M. news to find out what the weather will be like tomorrow—at home or around the globe.

And it's not all about businesses selling to consumers (*B2C commerce*). In addition, the cyberspace explosion has created a revolution in consumer-to-consumer activity (*C2C commerce*). Just as e-consumers are not limited to local retail outlets in their shopping, they are not limited to their local communities when looking for friends. The explosion of MySpace.com testifies to that. Dating sites such as Match.com and Lava Life have millions of people visiting online. Also the popularity of chat rooms where people can go to discuss various topics with like-minded "Netizens" around the world grows every day. For example, people who are united by a shared passion for sports memorabilia, Barbie dolls, or Harley-Davidson motorcycles talk online. The Internet provides an easy way for consumers around the world to exchange information about their experiences with products, services, music, movies, and restaurants.

Will the Web bring people closer together or drive each of us into our own private virtual worlds? Wired Americans are spending less time with friends and family, less time shopping in stores and watching TV, and more time working at home after hours. On the other hand, a study by the Pew Internet and American Life Project reported that more than half of users surveyed feel that e-mail actually strengthens family ties.[67]

All is not perfect in the virtual world. Many e-companies born overnight also liquidate overnight. Some netheads take bets on which will be the next hot site that goes under. Indeed, e-commerce does have its limitations. One relates to the actual shopping experience. Although it may be satisfactory to buy a computer or a book on the Internet, buying clothing or furniture when trying it on or touching the item is essential may be less attractive. Even though most companies have very liberal return policies, consumers can still get stuck with large delivery and return shipping charges for items that don't fit or simply aren't the right color. Some apparel companies are approaching the Internet slowly by starting an information site rather than a commerce site due to these limitations. Another major concern for consumers is security. We hear horror stories of consumers whose credit cards and other identity information have been stolen.

Despite these drawbacks, some futurists believe that we'll soon reach a point where each of us is wired and online all the time. We'll each be issued a username and password at birth and a computer device will be implanted in our bodies. That hasn't quite happened yet, but consider the service now offered by a Swiss company called www.skim.com: Each user is issued a six-digit number that he or she wears on jackets and backpacks sold by the company. When you see someone on the street or in a club you'd like to get to know better, you go to www.skim.com, type in the person's number, and send him or her a message. And, if you're lucky enough to receive one of these messages, you can decide whether to respond.[68]

Interdisciplinary Influences on the Study of Consumer Behavior

Consumer behavior is a very young field, especially the connection between fashion and consumer behavior. Elaine Stone writes: "As important as fashion is to the individual consumer and to fashion businesses, probably less is commonly known about fashion than about most other human activity.

Although reams of material have been written about fashion, relatively little explains why and how a fashion begins, becomes popular and declines."[69] Many different perspectives shape the field of consumer behavior. Indeed, it is hard to think of a field that is more interdisciplinary. People with training in a very wide range of fields—from psychophysiology to literature—are doing consumer research. Consumer researchers are employed by universities, manufacturers, museums, advertising agencies, and governments.

To gain an idea of the diversity of interests of people who do consumer research, consider the list of professional associations that sponsor the field's major journal, *Journal of Consumer Research:* American Association of Family & Consumer Sciences, American Statistical Association, Association for Consumer Research, Society for Consumer Psychology, International Communication Association, American Sociological Association, Institute of Management Sciences, American Anthropological Association, American Marketing Association, Society for Personality and Social Psychology, American Association for Public Opinion Research, and American Economic Association.

With all of these researchers from diverse backgrounds interested in consumer behavior, which is the "correct" discipline to look into these issues? You might remember a children's story about the blind men and the elephant. The gist of the story is that each man touched a different part of the animal, and as a result, the descriptions each gave of the elephant were quite different. This analogy applies to consumer research as well. A given consumer phenomenon can be studied in different ways and at different levels depending on the training and interests of the researchers studying it. Table 1-1 illustrates how a "simple" topic like magazine usage can be approached in many different ways.

The Issue of Two Perspectives on Consumer Research

One general way to classify consumer research is in terms of the fundamental assumptions researchers make about what they are studying and how to study it. This set of beliefs is known as a **paradigm**. As in other fields of study, consumer behavior is dominated by a paradigm, but some believe it is in the middle of a *paradigm shift*, which occurs when a competing paradigm challenges the dominant set of assumptions.

The basic set of assumptions underlying the dominant paradigm at this point in time is called **positivism** (or sometimes *modernism).* This perspective has significantly influenced Western art and science since the late sixteenth century. It emphasizes that human reason is supreme and that there is a single, objective truth that can be discovered by science. Positivism encourages us to stress the function of objects, to celebrate technology, and to regard the world as a rational, ordered place with a clearly defined past, present, and future.

The emerging paradigm of **interpretivism** (or postmodernism) questions these assumptions.[70] Proponents of this perspective argue that there is too much emphasis on science and technology in our society and that this ordered, rational view of consumers denies the complex social and cultural world in which we live. Others feel that positivism puts too much emphasis on material well-being and that its logical outlook is dominated by an ideology that stresses the homogeneous views of a culture dominated by white males.

Interpretivists instead stress the importance of symbolic, subjective experience and the idea that meaning is in the mind of the person—that is, we

Table 1-1 Interdisciplinary Research Issue in Consumer Behavior

Disciplinary Focus	Magazine Usage Sample Research Issues
Experimental Psychology: product role in perception, learning, and memory processes	How specific aspects of magazines, such as their design or layout, are recognized and interpreted; which parts of a magazine are most likely to be read
Clinical Psychology: product role in psychological adjustment	How magazines affect readers' body images (for example, do thin models make the average woman feel overweight?)
Microeconomics/Human Ecology: product role in allocation of individual or family resources	Factors influencing the amount of money spent on magazines in a household
Social Psychology: product role in the behavior of individuals as members of social groups	Ways that ads in a magazine affect readers' attitudes toward the products depicted: how peer pressure influences a person's readership decisions
Sociology: product role in social institutions and group relationships	Pattern by which magazine preferences spread through a social group (for example, a sorority)
Macroeconomics: product role in consumers' relations with the marketplace	Effects of the price of fashion magazines and expense of items advertised during period of high unemployment
Semiotics/Literary Criticism: product role in the verbal and visual communication of meaning	Ways in which underlying messages communicated by models and ads in a magazine are interpreted
Demography: product role in the measurable characteristics of a population	Effects of age, income, and marital status of a magazine's readers
History: product role in societal changes over time	Ways in which our culture's depictions of "femininity" in magazines have changed over time
Cultural Anthropology: product role in a society's beliefs and practices	Ways in which fashions and models in a magazine affect readers' definitions of masculine versus feminine behavior (for example, the role of working women, sexual taboos)

Source: Michael R. Solomon, *Consumer Behavior* 8e. © 2009. Reprinted by permission of Prentice Hall, Inc., Upper Saddle River, NJ.

each construct our own meanings based on our unique and shared cultural experiences, so there are no single right or wrong answers. In this view, the world in which we live is composed of a *pastiche*, or mixture of images.[71] An interpretive perspective replaces the value we assign to products because they help us to create order with an appreciation of consumption as offering a set of diverse experiences. The major differences between these two perspectives on consumer research are summarized in Table 1-2.

Table 1-2 Positivist versus Interpretivist Approaches to Consumer Behavior

Assumptions	Positivist Approach	Interpretivist Approach
Nature of reality	Objective, tangible Single	Socially constructed Multiple
Goal	Prediction	Understanding
Knowledge generated	Time free Context independent	Time bound Context dependent
View of causality	Existence of real causes	Multiple, simultaneous shaping events
Research relationship	Separation between researcher and subject	Interactive, cooperative with researcher being part of phenomenon under study

Source: Adapted from Laurel A. Hudson and Julie L. Ozanne, "Alternative Ways of Seeking Knowledge in Consumer Research," *Journal of Consumer Research* 14 (March 1988): 508–521. Reprinted with the permission of The University of Chicago Press.

TAKING IT FROM HERE: THE PLAN OF THE BOOK

This book covers many facets of consumer behavior, and many of the research perspectives briefly described in this chapter will be highlighted in later chapters. Chapter 1 has given you basic fashion terminology to use in the succeeding chapters and an introduction to the concept of consumer behavior. The rest of Part I deals with issues related to culture in general as a setting for consumers and their behavior. Part II looks at individual consumer characteristics that affect decisions. These include our motivations and values, self-concept, age, race and ethnicity, income and social class, personality, attitudes and lifestyle, and perceptions of the world around us. Part III focuses on communications and decision making at the individual and household levels, the effects that groups have on consumers, and the ultimate buying situation. Also we briefly discuss how to get rid of some of the merchandise that we buy after it has no further value to us. Part IV explores the ethics and social responsibility of both consumers and the businesses they encounter. Finally, we review the role that government and the private sector take in consumer protection.

CHAPTER SUMMARY

- Consumer behavior is the study of the processes involved when individuals or groups select, purchase, use, or dispose of products, services, ideas, or experiences to satisfy needs and desires.

- A consumer may purchase, use, and/or dispose of a product, but these functions may be performed by different people. In addition, consumers may be thought of as role players who need different products to help them play their various parts.

- Fashion terminology is often used by consumers in overlapping ways. A style of apparel is defined by distinctive attributes that distinguish it from others in its category, such as different types of skirts; a fashion is a style that has been accepted by many people; high fashion consists of new, expensive styles offered by upper-end designers. A trend is a general direction that may lead to a fashion. Merchandise classifications include designer, bridge, better, moderate, and popular prices.

- Fashions tend to follow cycles. The two extremes of fashion adoption, classics and fads, can be distinguished in terms of the length of the cycle.

- Fashions tend to be adopted by many people simultaneously in a process known as collective selection. Perspectives on motivations for adopting new styles include psychological, economic, and sociological models of fashion.

- Marketing activities exert an enormous impact on individuals. Consumer behavior is relevant to our understanding of the dynamics of popular culture.

- The Internet is transforming the way consumers interact with companies and with each other. Online commerce allows us to locate obscure products from around the world, and consumption communities provide forums for people to share opinions and product recommendations. The

benefits are accompanied by potential problems, including the loss of privacy.

- The field of consumer behavior is interdisciplinary; it is composed of researchers from many different fields who share an interest in how people interact with the marketplace.

- There are many perspectives on consumer behavior, but research orientations can roughly be divided into two approaches. The positivist perspective emphasizes the objectivity of science and the consumer as a rational decision maker. The interpretivist perspective, in contrast, stresses the subjective meaning of the consumer's individual experience and the idea that any behavior is subject to multiple interpretations rather than to one single explanation.

KEY TERMS

semiotic	fashion cycle	trickle-up theory
fashion process	fashion acceptance cycle	shifting erogenous zones
fashion	classics	meme
style	fad	consumer behavior
high fashion	trend	exchange
prêt-à-porter	trendy	role theory
prêt	national brands	relationship marketing
bridge lines	private brands	database marketing
better goods	store brands	popular culture
moderate goods	collective selection	paradigm
budget goods	zeitgeist	positivism
mass fashion	trickle-down theory	interpretivism
taste	trickle-across theory	

DISCUSSION QUESTIONS

1. Some consumers complain that they are "at the mercy" of designers: They are forced to buy whatever styles are in fashion because nothing else is available. Do you agree that there is such a thing as a "designer conspiracy"?

2. What is the basic difference between a fad, a fashion, a classic, and a trend? Provide examples of each.

3. Identify a new fashion. Which leadership theory do you think best explains its origins?

4. Apply Behling's model of fashion change to several new and old fashion trends and fads. Does it work as a model to explain these changes?

5. Identify new fashions in areas other than apparel, such as electronics, toys, furniture, cars, music and other entertainment, living arrangements, and other areas of popular culture. What stages of the fashion cycle do you think they are in?

6. What apparel brands are most popular with you and your peers?

7. Describe efforts of companies that you are familiar with that try to keep your loyalty and business.

8. Discuss your experiences of buying online.

9. This chapter states that people play different roles and that their consumption behaviors may differ depending on the particular role they are playing. State whether you agree or disagree with this perspective, giving examples from your personal life. Try to construct a "stage set" for a role—specify the props, costumes, and script that you use to play a role (such as a job interviewee, conscientious student, or party animal).

10. Some researchers believe that the field of consumer behavior should be a pure rather than an applied science. That is, research issues should be framed in terms of their scientific interest rather than their applicability to immediate marketing problems. Give your views on this issue.

11. State the differences between the positivist and interpretivist approaches to consumer research. For each type of inquiry, give examples of product dimensions that would be more usefully explored using that type of research over the other.

ENDNOTES

1. "Media-o-Meter: In Style vs. Marie Claire," *Women's Wear Daily* (September 9, 2005): 20.
2. Joel Best, *Flavor of the Month: Why Smart People Fall for Fads* (Berkeley, CA: University of California Press, 2006).
3. "Survey Names 'Truthiness', 'Wikiality' as Top TV Buzzwords," *San Francisco Chronicle* (August 28, 2006): E5.
4. Umberto Eco, *A Theory of Semiotics* (Bloomington: Indiana University Press, 1979).
5. Fred Davis, "Clothing and Fashion as Communication," in Michael R. Solomon ed., *The Psychology of Fashion* (Lexington, Mass.: Lexington Books, 1985): 15–28.
6. Anne D'Innocenzio, "Robotic Wizardry Producing Ever More Lifelike Playthings," *San Francisco Chronicle* (February 9, 2006): C3.
7. Josslynne Lingard and Marni Goldbery, "Toy Industry Responds to a Changing Market—and Changing Kids," *Toy Wishes,* retrieved from www.toy-tia.org (October 2, 2006).
8. "2004 vs 2005 State of the Industry," retrieved from www.toy-tia.org (October 2, 2006).
9. Paul H. Nystrom, *Economics of Fashion* (New York: The Ronald Press, 1928).
10. Eric Wilson, "No More Runways for Beene," *Women's Wear Daily* (February 15, 2000): 2, 8.
11. Miles Socha, "From New Designers to Exploring the Net, Bridge Tries to Cope," *Women's Wear Daily* (October 20, 1999): 1, 8–9.
12. Elaine Stone, *The Dynamics of Fashion,* 2nd ed. (New York: Fairchild Publications, 2004).
13. Gini Frings, *Fashion From Concept to Consumer* (Upper Saddle River, N.J.: Prentice Hall, 2008).
14. As quoted in Frings, *Fashion From Concept to Consumer.*
15. Joceyln Noveck, "A Size 2 Might Not Be a Size True, Bit It Sells," *San Francisco Chronicle* (September 17, 2005): F4.
16. Jane E. Workman, "Body Measurement Specifications for Fit Models as a Factor in Clothing Size Variation," *Clothing and Textiles Research Journal* 10, no. 1 (1991): 31–36.
17. Gregory Beals and Leslie Kaufman, "The Kids Know Cool," *Newsweek* (March 31, 1997): 48–49.
18. Marc Spiegler, "Marketing Street Culture: Bringing Hip-Hop Style to the Mainstream," *American Demographics* (November 1996): 29–34.
19. Beals and Kaufman, "The Kids Know Cool."
20. Kerry Diamond, "Urban Decay: A New Wild Child for Arnault's LVMH," *Women's Wear Daily* (February 25, 2000): 1, 12; Nola Sarkisian-Miller, "Hard Candy Founder Enters T-Shirt Arena," *Women's Wear Daily* (January 14, 2005): 13.
21. Mary Wolfe, *The World of Fashion Merchandising* (Tinley Park, Ill. Goodheart-Wilcox, 1998).
22. James Laver, *Taste and Fashion from the French Revolution to Today* (London: Harrap, 1937).
23. Anne D'Innocenzio and Georgia Lee, "Hippie Chic Fashions Cast a Wide Net," *Women's Wear Daily* (May 11, 2000): 6.
24. Anne D'Innocenzio, "Fashion's Fast Cycle," *Women's Wear Daily* (June 15, 2000): 6.
25. Stone, *The Dynamics of Fashion.*
26. Anthony Ramirez, "The Pedestrian Sneaker Makes a Comeback," *New York Times* (October 14, 1990): F17.

27. Rachel Beck, "A Wristful of Happiness," *San Francisco Chronicle* (October 8, 1999): B2.

28. B. E. Aguirre, E. L. Quarantelli, and Jorge L. Mendoza, "The Collective Behavior of Fads: The Characteristics, Effects, and Career of Streaking," *American Sociological Review* (August 1989): 569.

29. Martin G. Letscher, "How to Tell Fads from Trends," *American Demographics* (December 1994): 38–45.

30. The Associated Press, "Hit Japanese Software Lets Players Raise 'Daughter,'" *Montgomery Advertiser* (April 7, 1996): 14A.

31. "Japanese Flock to Stores for Virtual Chicken Game," *Montgomery Advertiser* (January 27, 1997): 6A.

32. Joseph Pereira, "Retailers Bet Virtual Pets Will Be the Next Toy Craze," *The Wall Street Journal Interactive Edition* (May 2, 1997).

33. Yuri Kageyama, "Virtual Pets Hatched Anew," *San Francisco Chronicle* (April 12, 2004): D5.

34. "Stagnant Industry Escalates PL Chase," *WWD Infotracs* (supplement to *Women's Wear Daily*) (November, 1995): 6–10.

35. K. Parr, "Fashion's Next Wave: Who, What and 'Y'," *Women's Wear Daily* (February 27, 1997): 8–9.

36. "The WWD 100," *A WWD Special Report* (July 2006).

37. Damon Darlin, "The iPod Ecosystem," *New York Times* (February 3, 2006); Meredith Derby, "IPods Dress for Success," *Women's Wear Daily* (January 24, 2005): 15.

38. "Nokia's Passion for Style," *Women's Wear Daily* (November 9, 2005): 8.

39. Peter Hartlaub, "Ring Tones Make Cell Phones Personalized Fashion Accessories," *San Francisco Chronicle* (June 26, 2005): A1, A4; Alex Veiga, "Turning Cell Phones into Audible Fashion Accessory," *San Francisco Chronicle* (September 26, 2005): F5.

40. For more details, see Susan Kaiser, *The Social Psychology of Clothing* (New York: Macmillan, 1985); George B. Sproles, "Behavioral Science Theories of Fashion," in *The Psychology of Fashion*, ed. Michael R. Solomon (Lexington, Mas: Lexington Books, 1985): 55–70.

41. Herbert Blumer, *Symbolic Interactionism: Perspective and Method* (Englewood Cliffs, N.J.: Prentice Hall, 1969); Howard S. Becker, "Art as Collective Action," *American Sociological Review* 39 (December 1973); Richard A. Peterson, "Revitalizing the Culture Concept," *Annual Review of Sociology* 5 (1979): 137–166.

42. Georg Simmel, "Fashion," *International Quarterly* 10 (1904): 130–155.

43. Charles W. King, "Fashion Adoption: A Rebuttal to the 'Trickle-Down' Theory," in *Toward Scientific Marketing*, ed. Stephen A. Greyser (Chicago: American Marketing Association, 1963), 108–125; Grant D. McCracken, "The Trickle-Down Theory Rehabilitated," in *The Psychology of Fashion*, ed. Michael R. Solomon (Lexington, Mass. Lexington Books, 1985): 39–54.

44. Michael Barbaro, "Discounters Go on Road to Find New York Style," *New York Times online* (October 12, 2006).

45. Alf H. Walle, "Grassroots Innovation," *Marketing Insights* (Summer 1990): 44–51.

46. Nara Schoenberg, "Goth Culture Moves into Mainstream," *Montgomery Advertiser* (January 19, 2003): 1G.

47. Dorothy Behling, "Fashion Change and Demographics: A Model," *Clothing and Textiles Research Journal* 4, no. 1 (1985–1986): 18–24.

48. C. R. Snyder and Howard L. Fromkin, *Uniqueness: The Human Pursuit of Difference* (New York: Plenum Press, 1980).

49. Linda Dyett, "Desperately Seeking Skin," *Psychology Today* (May/June 1996): 14; Alison Lurie, *The Language of Clothes* (New York: Random House, 1981).

50. Harvey Leibenstein, *Beyond Economic Man: A New Foundation for Microeconomics* (Cambridge, Mass.: Harvard University Press, 1976).

51. Malcome Gladwell, *The Tipping Point* (New York: Little, Brown and Co., 2000).

52. See Geoffrey Cowley, "Viruses of the Mind: How Odd Ideas Survive," *Newsweek* (April 14, 1997): 14; www.wikipedia.com.

53. Michael R. Solomon and Elnora W. Stuart, *Marketing: Real People Real Choices* (Englewood Cliffs, N.J.: Prentice Hall, 2005).

54. Erving Goffman, *The Presentation of Self in Everyday Life* (Garden City, N.Y.: Doubleday, 1959); George H. Mead, *Mind, Self, and Society* (Chicago: University of Chicago Press, 1934); Michael R. Solomon, "The Role of Products as Social Stimuli: A Symbolic Interactionism Perspective," *Journal of Consumer Research* 10 (December 1983): 319–329.

55. Kim Ann Zimmermann, "Neiman Marcus Seeking Expanded Loyalty Program," *Women's Wear Daily* (July 2, 1997): 11; www.neimanmarcus.com.

56. Denise Power, "Nordstrom Banks on Credit Options," *Women's Wear Daily* (May 31, 2000): 12.

57. Constance L. Hays, "What Wal-Mart Knows About Customers' Habits," *New York Times on the Web* (November 14, 2004).

58. Quoted in "Bringing Meaning to Brands," *American Demographics* (June 1997): 34.

59. Susan Fournier, "Consumers and Their Brands. Developing Relationship Theory in Consumer Research," *Journal of Consumer Research* 24 (March 1998): 343–373.

60. Brad Edmondson, "The Dawn of the Megacity," *Marketing Tools* (March 1999): 64.

61. David Barbosa, "China, New Land of Shoppers, Builds Malls on Gigantic Scale," *New York Times Online* (May 25, 2005).

62. For a discussion of this trend, see Russell W. Belk, "Hyperreality and Globalization: Culture in the Age of Ronald McDonald," *Journal of International Consumer Marketing* 8, no. 3/4 (1995): 23–38.

63. Ronald Alsop, "Best Known Companies Aren't Always Best Liked," *Wall Street Journal* (November 14, 2004): B4.

64. Nina Munk, "The Levi Straddle," *Forbes* (January 17, 1994): 44.

65. Some material in this section was adapted from Michael R. Solomon and Elnora W. Stuart, *Welcome to Marketing.Com: The Brave New World of E-Commerce* (Upper Saddle River, N.J.: Prentice Hall, 2000).

66. Susan G. Hauser, "These Guys, Their Big Feet and Her," *Wall Street Journal Interactive Edition* (January 24, 2000).

67. Rebecca Fairley Raney, "Study Finds Internet of Social Benefit to Users," *New York Times on the Web* (May 11, 2000).

68. Tiffany Lee Brown, "Got Skim?" *Wired* (March 2000): 262.
69. Stone, *The Dynamics of Fashion.*
70. For an overview, see Eric J. Arnould and Craig J. Thompson, "Consumer Culture Theory (CCT): Twenty Years of Research," *Journal of Consumer Research* 31 (March 2005): 868–882.
71. Alladi Venkatesh, "Postmodernism, Poststructuralism and Marketing," paper presented at the American Marketing Association Winter Theory Conference, San Antonio, February 1992; see also A. Fuat Firat, "Postmodern Culture, Marketing and the Consumer," in *Marketing Theory and Application,* eds. T. Childers et al. (Chicago: American Marketing Association, 1991): 237–242; A. Fuat Firat and Alladi Venkatesh, "The Making of Postmodern Consumption," in *Consumption and Marketing: Macro Dimensions,* eds. Russell W. Belk and Nikhilesh Dholakia (Boston: PWS-Kent, 1993).

2
Cultural Influences on Consumer Behavior

Whitney is at her wits' end. It's bad enough that she has a deadline looming on that new Christmas promotion for her gift shop. Now there's trouble on the home front as well: Her son Stephen had to go and flunk his driver's license road test, and now he's just about suicidal because he feels he can't be a "real man" without successfully obtaining his license. To top things off, her much-anticipated vacation to Disney World with her younger stepchildren will have to be postponed because she just can't find the time to get away.

When Whitney meets up with her buddy Gabrielle at their local Starbucks for their daily

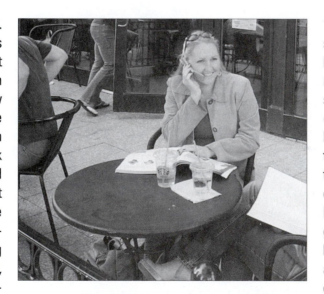

"retreat," though, her mood starts to brighten. Somehow the calm of the cafe rubs off on her as she savors her grande cappuccino. Gab consoles her with her usual assurances, and then her friend prescribes the ultimate remedy to defeat the blues: Stop at Macy's for one of those great sweaters on sale, go home, take a nice long bath, and then consume a quart of Espresso Swirl ice cream. Yes, that's the ticket. It's amazing how the little things in life can make such a big difference. As she strolls out the door, Whitney makes a mental note to get Gab a really nice Christmas gift this year—she's earned it.

UNDERSTANDING CULTURE

Whitney's daily coffee "fix" is mimicked in various forms around the globe, as people participate in activities that allow them to take a break and affirm their relationships with others. Of course, the products that are consumed in the process can range from black Turkish coffee to Indian tea or from lager beer to hashish.

Starbucks has experienced phenomenal success by turning the coffee break into a cultural event that for many has assumed almost cultlike status. The average Starbucks customer visits eighteen times a month, and 10 percent of the clientele stop by twice a day. The company has outlets all around the world and continues to open new outlets every day.[1] Starbucks chairman says the ultimate projected growth of Starbucks is 30,000 stores worldwide (compared with about 15,000 today).[2] And the chain is innovating to create different kinds of coffee break experiences. It decorates with vintage furniture for a comfortable feel but also equips stores with high-speed Internet connections for techies and music downloading. Part of the appeal for many is that the retail outlets provide an oasis from the hectic world. Indeed, one of the advertising themes the firm has considered underscores the idea that a visit to a Starbucks is like a visit to a sacred, magical island of calm: "A little sanity, conveniently located."[3] Americans are discovering a secret that Europeans have known for years: Life is too short to spend the *whole* day behind a desk.

We can think of culture as a society's personality. It includes both abstract ideas, such as values and ethics, and material objects and services, such as automobiles, clothing, food, art, and sports, which are produced or valued by a society. Put another way, **culture** is the accumulation of shared meanings, rituals, norms, and traditions among the members of an organization or society.

Fashion and other consumption choices simply cannot be understood without considering the cultural context in which they are made: Culture is the "lens" through which people view products. Ironically, the effects of culture on consumer behavior are so powerful and far-reaching that this importance is sometimes difficult to grasp. Like a fish immersed in water, we do not always appreciate this power until we encounter a different culture. Suddenly many of the assumptions we had taken for granted about the clothes we wear, the food we eat, or the way we address others no longer seem to apply. The effect of encountering such differences can be so great that the term *culture shock* is not an exaggeration. For example, we don't think twice about women wearing skirts and men wearing pants until we see Prince Charles in a kilt.

The analysis of dress or fashion in a cultural context is complex in a society such as the United States since it is composed of so many subcultures (discussed in later chapters). And as groups of people migrate from one part of the world to another, they bring their culture with them to a new society. Many exhibit allegiance to their cultural heritage and claim a cultural identity that is visibly shown through their dress. Muslim women cover their face and hair with a veil when in public (in their home country and in other countries) since their culture defines their idea of modesty in

These students are in traditional Persian dress.

dress. In contrast, American women can appear quite immodest in current fashion, which may show considerable skin. Some cultural and ethnic groups become assimilated into American society and leave behind ways of their cultural heritage. These groups may wear their cultural dress only during holidays and special occasions, while others wear it every day no matter where they live in the world.

The importance of cultural expectations often is only discovered when they are violated. For example, while on tour in New Zealand, The Spice Girls (remember them?) created a stir among New Zealand's indigenous Maoris by performing a war dance supposed to be done by men only. A tribal official indignantly stated, "It is not acceptable in our culture, and especially by girlie pop stars from another culture."[4] Sensitivity to cultural issues, whether by rock stars or by brand managers, can only come by understanding these underlying dimensions—which is one of the goals of this chapter. We also look at how consumer culture is becoming global culture.

Consumer Behavior and Culture: A Two-Way Street

A consumer's culture determines the overall priorities he or she attaches to different activities and products. It also mandates the success or failure of specific products and services. A product that provides benefits consistent with what those members of a culture desire at any point in time has a much better chance of attaining acceptance in the marketplace. For example, American culture started to emphasize the concept of a fit, trim body as an ideal of appearance in the mid-1970s. The premium consumers placed on this goal, which stemmed from underlying values like mobility, wealth, and a focus on the self, greatly contributed to the success of products related to exercise and fewer calories.

The relationship between consumer behavior and culture is a two-way street. On the one hand, products and services that resonate with the priorities of a culture at any given time have a much better chance of being accepted by consumers. On the other hand, the study of new products and innovations in product design successfully produced by a culture at any point in time provides a window onto the dominant cultural ideals of that period. Consider, for example, some American products that reflect underlying cultural processes at the time they were introduced:

- Cosmetics made of natural materials and not animal-tested, which reflected consumers' apprehensions about pollution, waste, and animal rights.
- The TV dinner, which hinted at changes in family structure and the onset of a new informality in American home life.
- Condoms marketed in pastel carrying cases for female buyers, which signaled changes in attitudes toward sexual responsibility and frankness.

Cultural Categories

The meaning that is imparted to products reflects underlying **cultural categories**, which correspond to the basic ways we characterize the world.[5] Our culture makes distinctions between different times, between leisure and work, between genders, and so on. The fashion system provides us with products that signify these categories. For example, the apparel industry gives us clothing to denote certain times (for example, evening wear or resort wear), it differentiates between leisure clothes and work clothes, and it promotes masculine and feminine styles.

These cultural categories affect many different products and styles. As a result, it is common to find that dominant aspects of a culture at any point in time tend to be reflected in the design and marketing of very different products. This concept is a bit hard to grasp, since on the surface, a clothing style, say, has little in common with a piece of furniture or with a car. However, an overriding concern with a value such as achievement or environmentalism can determine the types of products likely to be accepted by consumers at any point in time. These underlying or latent themes then surface in various aspects of design. A few examples of this interdependence will help to demonstrate how a dominant fashion theme reverberates across industries.

- After the terrorist attacks on September 11, 2001, designers, advertisers, and retailers were more sensitive to the feelings and mood of the

buying public. Previous fashions flirting with military themes such as uniforms, camouflage prints, and even PLO headscarves generally became fashion taboo. The aftermath of September 11 created a strong patriotic movement across the United States. We saw U.S. flags everywhere, flying from homes, commercial buildings, cars, businesses, and retail stores. People found solace and solidarity in making such a statement. It was not unusual to find American flag pins and T-shirts along with other fashion items. Some felt that it was a way to show that everyone was thinking about each other and everyone felt pain and sorrow. Many retailers donated a portion of proceeds from patriotic items to varied disaster funds for victims' families.[6] Similar outpourings of sentiments occurred after Hurricane Katrina hit New Orleans in 2005.

- Clothing worn by political figures or movie and rock stars can affect the fortunes of the apparel and accessory industries. A movie appearance by actor Clark Gable without a T-shirt (unusual at that time) dealt a severe setback to the men's apparel industry, while Jackie Kennedy's famous "pillbox hat" prompted a rush for similar hats by women in the 1960s. Other cross-category effects include the craze for ripped sweatshirts instigated by the movie *Flashdance*, a boost for cowboy boots from the movie *Urban Cowboy*, and singer Madonna's legitimation of lingerie as an acceptable outerwear clothing style.

- Major sports events such as the Olympics and the World Cup, as well as extreme sports, have influenced fashion and retail sales of specific merchandise. From Turkey to Paris the recent World Cup spurred worldwide sales of Adidas, Fila, Puma, and Nike jerseys.[7]

- The Louvre in Paris was remodeled to include a controversial glass pyramid at the entrance designed by the architect I. M. Pei. Shortly thereafter, several designers unveiled pyramid-shaped clothing at Paris fashion shows.[8]

- In the 1950s and 1960s, much of America was preoccupied with science and technology. This concern with "space-age" mastery was fueled by the Russians' launching of the *Sputnik* satellite, which prompted fears that America was falling behind in the technology race. The theme of technical mastery of nature and of futuristic design became a *motif* that cropped up in many aspects of American popular culture—from car designs with prominent tail fins to high-tech kitchen styles.

- At the turn of the millennium, fifty years later, technology continues to influence fashion design with utility features such as the gadget-specific details of cell-phone holders and pouches and new electronic paraphernalia. Many designers have entered the market for such organizer bags, and cell phone and iPod cases.

Aspects of Culture

Culture is not static. It is continually evolving, synthesizing old ideas with new ones. There are several ways to describe the components of culture. One includes three functional areas of ecology, social structure, and ideology.[9]

1. *Ecology:* the way in which a system is adapted to its habitat. Japanese consumers, for example, greatly value products that are designed for

A cultural emphasis on science in the 1950s and 1960s affected product designs, as seen in the design of automobiles with large tail fins (to resemble rockets).

efficient use of space because of the cramped conditions in that island nation.[10]

2. *Social structure:* the way in which orderly social life is maintained. This structure includes the domestic and political groups that are dominant within the culture (for example, the nuclear family versus the extended family).

3. *Ideology:* the mental characteristics of a people and the way in which they relate to their environment and social groups. This concept revolves around the belief that members of a society possess a common *worldview*. They share certain ideas about principles of order and fairness. They also share an *ethos*, or a set of moral and aesthetic principles.

Another typology in which to understand culture is through material and nonmaterial culture.

1. *Material culture:* includes handmade material items such as clothing, tools, and furniture. We find these artifacts in museums; they are used to study how people lived. Anthropologists interpret material culture to examine how ideas and beliefs of a group of people (nonmaterial culture) are imbedded in material things. Therefore, we see material and nonmaterial aspects of culture very much intertwined. Consider the concept of modest clothing representing the values of a person or group.

2. *Nonmaterial culture:* includes patterns of thought, feeling, and behavior shared by members of a group who regularly interact with each other. These include learned behavior patterns, religious beliefs, values, standards, symbolic meanings, and expectations that are shared as people in a society develop a heritage of common experiences. Culture

changes as current members interpret ideas, beliefs, and values in light of new experiences.[11]

Although every culture is different, four dimensions appear to account for much of the variability among cultures.[12]

1. *Power distance:* the way in which interpersonal relationships form when differences in power are perceived. Some cultures emphasize strict, vertical relationships (such as Japan), whereas others (such as the United States), stress a greater degree of equality and informality. Look at the dress of your college professors today. Sometimes they dress formally (perhaps they have a meeting with the university president that day), but often they dress in a way similar to their students.

2. *Uncertainty avoidance:* the degree to which people feel threatened by ambiguous situations and have beliefs and institutions that help them to avoid this uncertainty (for example, organized religion).

3. *Masculinity/femininity:* the degree to which sex roles are clearly delineated (see Chapter 5). Traditional societies are more likely to possess very explicit rules about the acceptable behaviors of men and women, such as what is acceptable dress and who is responsible for certain tasks within the family unit.

4. *Individualism:* the extent to which the welfare of the individual versus that of the group is valued. Cultures differ in their emphasis on individualism versus collectivism. In **collectivist cultures**, people subordinate their personal goals to those of a stable in-group. In contrast, consumers in **individualist cultures** attach more importance to personal goals. These concepts are certainly expressed in the clothes we choose to wear. Some strongly individualistic cultures include the United States, Australia, Great Britain, Canada, and the Netherlands. Venezuela, Pakistan, Taiwan, Thailand, Turkey, Greece, and Portugal are some examples of strongly collectivist cultures.[13]

Values are very general standards about what is good and bad (see Chapter 4). From these flow **norms**, or rules dictating what is right or wrong, acceptable or unacceptable. Some norms, called **enacted norms**, are explicitly decided upon, such as the rule that a green traffic light means "go" and a red one means "stop." Many norms, however, are much more subtle. These **crescive norms** are embedded in a culture and are only discovered through interaction with other members of that culture. Crescive norms include customs, mores, and conventions.[14]

• A **custom** is a norm or practice handed down from the past that is slow to change, especially if it has strong emotional or spiritual content, such as the white wedding dress.

• A **more** (MOR-ay) is a custom with a strong moral overtone. These customs are elevated to a higher level of concern for the welfare of society. A more often involves a taboo, or forbidden behavior, mostly relating to the regulation of sexual activity essential to the functioning of the kinship system. Incest, for example, is considered a taboo in most cultures. Such violations meet with strong punishment from members of a society. The length of skirts or amount of cleavage relates

to dress mores. In Islamic countries like Saudi Arabia, it's considered sacrilege to display underwear on store mannequins or to feature a woman's body in advertising, so retailers have to tread lightly—one lingerie store designed special headless and legless mannequins with only the slightest hint of curves in order to display its merchandise.[15]

• **Conventions** are norms regarding the conduct of everyday life. These rules deal with the subtleties of consumer behavior, including the "correct" way to furnish one's house or wear one's clothes. The direction of shirt openings with men's shirts buttoning left over right and women's buttoning right over left is a convention in dress. We hardly notice this until we put on the opposite-gender shirt and realize how awkward it is!

All three types of crescive norms may operate to define a culturally appropriate behavior. For example, a more may tell us how much skin can show in our dress. Of course, mores vary across cultures, as in the example of Muslim women covering their faces, while young American women wear shorts and camisoles in public. An American custom dictates that the bride wears white to her wedding, and friends and family wear black to funerals. (This also varies across cultures.) Conventions even tell us the appropriate clothes to wear to a restaurant.

We often take these norms for granted, assuming that they are the "right" things to do (again, until we travel to a foreign country!). It is good

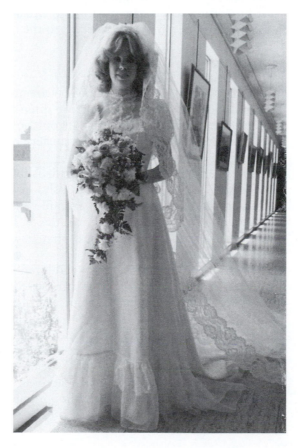

The bride wears a white gown, a custom in American culture.

to remember that much of what we know about these norms is learned *vicariously*, as we observe the behaviors of actors and actresses in television commercials, sitcoms, print ads, and other popular-culture media.

MYTHS AND RITUALS

Every culture develops stories and practices that help its members to make sense of the world. When we examine these activities in other cultures, they often seem strange or even unfathomable. Yet, our *own* cultural practices appear quite normal—even though a visitor may find them equally strange!

To appreciate how "primitive" belief systems that some may consider bizarre, irrational, or superstitious continue to influence our supposedly "modern" rational society, consider the avid interest of many American consumers in magic. Marketers of antiaging cosmetics, health foods, and exercise programs often imply that their offerings have "magical" properties that will ward off sickness, old age, poverty, or just plain bad luck. People by the millions play their "lucky numbers" in the lottery, carry rabbits' feet and other amulets to ward off "the evil eye," and many have "lucky" clothing or other products that they believe will bring them good fortune. Software developers even supply "wizards" that help to guide the uninitiated through the arcane layers of their programs!

This section will discuss myths and rituals, two aspects of culture common to all societies, from the ancients to the modern world.

Myths

A **myth** is a story containing symbolic elements that express the shared emotions and ideals of a culture. The story often features some kind of conflict between two opposing forces, and its outcome serves as a moral guide for people. In this way, a myth reduces anxiety because it provides consumers with guidelines about their world.

An understanding of cultural myths is important to marketers, who in some cases (most likely unconsciously) pattern their strategy along a mythic structure. Consider, for example, the way that a company like McDonald's takes on "mythical" qualities.[16] The "golden arches" are a universally recognized symbol, one that is virtually synonymous with American culture.

Corporations often have myths and legends as a part of their history, and some make a deliberate effort to be sure newcomers to the organization learn these stories. Nike designates senior executives as "corporate storytellers" who explain the company's heritage to other employees, including the hourly workers at Nike stores. They tell stories about the founders of Nike, including the coach of the Oregon track team who poured rubber into his family waffle iron to make better shoes for his team—the origin of the Nike waffle sole. The stories emphasize the dedication of runners and coaches involved with the company to reinforce the importance of teamwork. Rookies even visit the track where the coach worked to be sure they grasp the importance of the Nike legends.[17]

The Functions and Structure of Myths

Myths serve four interrelated functions in a culture.[18]

1. *Metaphysical:* Myths help to explain the origins of existence.
2. *Cosmological:* Myths emphasize that all components of the universe are part of a single picture.
3. *Sociological:* Myths maintain social order by authorizing a social code.
4. *Psychological:* Myths provide models for personal conduct.

Myths can be analyzed by examining their underlying structures, a technique pioneered by the French anthropologist Claude Lévi-Strauss (no relation to the blue jeans company). Lévi-Strauss noted that many stories involve **binary opposition**, where two opposing ends of some dimension are represented (such as good versus evil, or nature versus technology). Characters, and in some cases, products, are often defined by what they are *not* rather than what they *are* (for example, "This is *not* your father's Oldsmobile"). The conflict between mythical opposing forces is sometimes resolved by a *mediating figure* who can link the opposites by sharing characteristics of each. For example, many myths contain animals that have human abilities (such as a talking snake) to bridge the gap between humanity and nature, just as cars (technology) are often given animal names (nature) like Cougar, Cobra, or Mustang.

Animals are often used in trademarks by apparel companies. One symbolic analysis of animal apparel trademarks viewed animal icons to signify human dominion over the natural world. It also likened Ralph Lauren's Polo trademark with the mounted horseman as an archetypal symbol of power. The Izod Lacoste alligator and the Gloria Vanderbilt swan carry traces of ancient mythology into the present by signifying a romantic attachment to tales that describe the world in terms of magic and mystery. The swan is particularly rich in mythology. Many fairy tales deal with transformation of a swan maiden or swan princess. Remember the Hans Christian Anderson tale dealing with the unexpected transformation of an ugly duckling into a beautiful swan? It is an allegorical reference to the blossoming of gangly adolescence into graceful adulthood. The swan's imagery is certainly a reference to Vanderbilt's personal mythology, a classic poor-little-rich-girl tale of triumph over depression, custody battles, failed marriages, and difficulties of dealing with extraordinary wealth. *Once Upon a Time* is the title of her autobiography.[19]

Myths Abound in Modern Popular Culture

Although we generally equate myths with the ancient Greeks or Romans, modern myths are embodied in many aspects of modern popular culture, including trademarks (as just discussed), movies, comic books, holidays, and yes, even commercials. Commercials and advertisements can be analyzed in terms of the underlying mythic themes they represent. Often fashion ads, especially fragrance ads, use fantasy and mythical themes.

Comic book superheroes demonstrate how myths can be communicated to consumers of all ages. Some of these fictional figures represent a **monomyth**, a myth that is common to many cultures.[20] The most prevalent monomyth involves a hero such as Superman who emerges from the everyday

world with supernatural powers and wins a decisive victory over evil forces. Comic book heroes, familiar to most consumers, may even be more credible and effective than real-life celebrity endorsers.

Many "blockbuster" movies and hit TV shows draw directly on mythic themes. Although dramatic special effects or attractive stars certainly don't hurt, a number of these movies perhaps also owe their success to their presentation of characters and plot structures that follow mythic patterns. Three examples of these mythic blockbusters include the following:

- *Gone with the Wind:* The North (representing technology and democracy) is pitted again the South (representing nature and aristocracy). The movie depicts a lost era in which people and nature existed in harmony.

- *E.T. The Extraterrestrial:* E.T., a messianic visitation of a gentle creature from another world, visits Earth and performs miracles. His "disciples" are neighborhood children, who help him combat the forces of modern technology and an unbelieving secular society.

- *Star Trek:* The television series and movies documenting the adventures of the starship *Enterprise* represent stories similar to the New England Puritans exploring and conquering a new continent—"the final frontier." Klingons mirror Native Americans. The quest for Paradise was a theme employed in at least thirteen out of the original seventy-nine episodes filmed.[21]

Rituals

A **ritual** is a set of multiple, symbolic behaviors that occurs in a fixed sequence and that tends to be repeated periodically.[22] Although bizarre tribal ceremonies, perhaps involving animal or virgin sacrifice, may come to mind when people think of rituals, in reality many contemporary consumer activities are ritualistic. How many of us take regular "mental health" trips to Starbucks or the local department store like Whitney in the chapter-opening story?

Rituals can occur at various levels. Some affirm broad cultural or religious values, whereas others occur in small groups or even in isolation. Rituals can even be invented or modified to bring about changes in consumer behavior. Rituals are not always set in stone; they can be modified to change with the times. The custom of throwing rice to symbolize fertility at weddings is evolving. In recent years many newlyweds have substituted soap bubbles or jingling bells because of the tendency of birds to eat the rice, which can then expand inside their bodies and cause injury or death. Some enterprising businesses are springing up to work around this problem. The Hole-in-Hand Butterfly Farm in Pennsylvania ships newly hatched butterflies at $100 a dozen. They arrive in dark, cool envelopes that keep them in a resting stage until the package is opened, when they fly out in a crescendo of wagging wings. Another company sells a product called Bio Wedding Rice; this reconstituted rice dissolves in water and doesn't harm birds.[23]

Ritual dress includes items we wear during transitional and important times in our lives. These include white gowns worn by debutantes at cotillion balls, prom dresses and tuxedos, graduation gowns, wedding gowns, and

baptismal gowns. These often are the types of items we save for years, sometimes such that daughters wear their mother's wedding dress for their own wedding. In addition, rituals are involved with items worn for special functions, such as judicial robes, religious garb, and royal regalia. Jewelry such as sorority pins, wedding bands, and engagement rings also have deep personal meaning for the owner.

Many businesses owe their livelihoods to their ability to supply **ritual artifacts**, or items used in the performance of rituals, to consumers. Special clothing, as just discussed, birthday candles, diplomas, specialized foods and beverages (such as wedding cakes and champagne), greeting cards, retirement watches, and so on, all are used in consumer rituals as noted in Table 2-1. In addition, consumers often employ a ritual script, which identifies the artifacts, the sequence in which they are used, and who uses them. Examples include graduation programs, fraternity manuals, and etiquette books.

A recent study by the BBDO Worldwide advertising agency illustrates just how crucial rituals are to many brands. It labels brands that we closely link to our rituals as **fortress brands** because once they become embedded in our rituals (whether brushing our teeth or drinking a beer) we're unlikely to replace them. The study ran in twenty-six countries, and the researchers found that overall people worldwide practice roughly the same consumer rituals. The study found 89 percent of people use the same brands for these

Table 2-1 Selected Rituals and Associated Artifacts

Selected Rituals	Typical Artifacts
Wedding	White gown, something old, something new, something borrowed, something blue
Birth of a child	U.S. savings bond, silver baby spoon
Baptism	White gown
Birthday	Card, present, cake with candles
Fiftieth wedding anniversary	Catered party, card and gift, display of photos of the couple's life together
Graduation	Pen, U.S. savings bond, card, wristwatch, graduation gown
Valentine's Day	Candy, card, flowers, lingerie
New Year's Eve	Champagne, party, fancy dress
Thanksgiving	Preparing a turkey meal for family and friends
Going to the gym	Towel, exercise clothes, water, portable tape player
Fraternity initiation	Hazing, sweatshirts and pins with Greek symbols
Prom	Tuxedos and gowns
Grooming	Brushing hair, cleansing face, applying clarifying lotion
Sunday football	Beer, potato chips, pretzels
Super Bowl party	Same as Sunday football (only more)
Starting a new job	Getting a haircut, buying new clothes
Job promotion	Going out to lunch with co-workers, receiving token gift
Retirement	Company party, watch, plaque
Death	Sending a card, giving to charity in the name of the deceased

Source: Adapted from Leon G. Schiffman and Leslie Lazar Kanuk, *Consumer Behavior* (Upper Saddle River, N.J.: Prentice Hall, 2000), p. 329.

sequenced rituals, and three out of four are disappointed or irritated when something disrupts their ritual or their brand choice isn't available.[24]

Grooming Rituals

Whether brushing one's hair a hundred strokes a day or talking to oneself in the mirror, virtually all consumers undergo private grooming rituals. These are sequences of behaviors that aid in the transition from the private self to the public self or back again. These rituals serve various purposes, ranging from inspiring confidence before confronting the world to cleansing the body of dirt and other impure materials. When consumers talk about their grooming rituals, some of the dominant themes that emerge from these stories reflect the almost mystical qualities attributed to grooming products and behaviors. Many people emphasize a before-and-after phenomenon, where the person feels magically transformed after using certain products (similar to the Cinderella myth).[25]

Two sets of binary oppositions that are expressed in personal rituals are *private/public* and *work/leisure*. Many beauty rituals, for instance, reflect a transformation from a natural state to the social world (as when a woman "puts on her face") or vice versa. In these daily rituals, women reaffirm the

Nivea is well known for its numerous skin care products. Research conducted for the company as it sought to develop a more consistent brand image of all its lines confirmed the important, yet intangible, functions played by these items for women as they conduct their private grooming rituals. Consumers associated the Nivea image with scenes depicting moisture, freshness, and relaxation.[28]

value placed by their culture on personal beauty and the quest for eternal youth.[26] This focus is obvious in ads for Oil of Olay Beauty Cleanser, which proclaim ". . . and so your day begins. The Ritual of Oil of Olay." Similarly, the bath is viewed as a sacred, cleansing time, a way to wash away the sins of the profane world.[27]

Gift-Giving Rituals

The promotion of appropriate gifts for every conceivable holiday and occasion provides an excellent example of the influence consumer rituals can exert on marketing phenomena. In the **gift-giving ritual**, consumers procure the perfect object, meticulously remove the price tag, carefully wrap it (symbolically changing the item from a commodity to a unique good), and deliver it to the recipient.[29]

Gift giving is primarily viewed by researchers as a form of *economic exchange*, in which the giver transfers an item of value to a recipient, who in turn is somehow obligated to reciprocate. However, gift giving also can involve *symbolic exchange*, whereby a giver is motivated by unselfish factors, such as love or admiration, and does not expect anything in return, such as Whitney wanting to acknowledge her friend Gabrielle's intangible support and companionship. Some research indicates that gift giving evolves as a form of social expression; it is more exchange oriented (instrumental) in the early stages of a relationship but becomes more altruistic as the relationship develops.[30] In addition, third parties can exert strong influences on gift giving as people are influenced by others in their social network when selecting gifts.[31] One set of researchers identified multiple ways in which giving a gift can affect a relationship. These are listed in Table 2-2.[32]

Surveys spanning twenty-five years and several countries indicate clothing persists as a frequently given gift for birthdays and holidays. Retail ads for Mother's Day, Father's Day and, of course, Christmas encourage the purchase of clothing as gifts, attesting to the economic importance of clothing and fashion as gifts. Giving clothing as gifts involves more than one might think. It not only involves the giver selecting the right combination of attributes (such as style, color, fit, quality, fashionability) but also, and more important, it involves the meaning of the gift for the recipient. What does a gift of lingerie mean to a woman? What if it's from a man she just met? We infer intentions of others by their actions. Since clothing conveys nonverbal messages about its wearer, miscommunication can occur in decoding meanings. "Why did he give me this gift?" The recipient may see a gift as a means of manipulation. The ultimate success of a clothing gift may depend on the receiver's understanding of the intentions of the giver.[33] Lingerie was used in a study of Asian and White subjects who perceived differences in gift recipients' characteristics, indicating that selecting a clothing gift that successfully matches the recipient's self-concept is not easy.[34] Since clothing is such a personal, symbolic item, perhaps only the wearer knows the real meaning of the clothes he or she likes to wear; therefore, giving the "perfect" gift to someone can be difficult.

The occasion affects the acceptability of clothing gifts. Lingerie was listed as an unacceptable wedding gift in one study; in fact, clothing (except the wedding dress) was never listed as a best wedding gift and was listed several times as a worst gift. Guess what? Money was found to be the most popular wedding

Table 2-2 Effects of Gift Giving on Social Relationships

Relational Effect	Description	Example
Strengthening	Gift giving improves the quality of a relationship	An unexpected gift such as one given in a romantic situation
Affirmation	Gift giving validates the positive quality of a relationship	Usually occurs on ritualized occasions such as birthdays
Negligible effect	Gift giving has a minimal effect on perceptions of relationship quality	Nonformal gift occasions and those where the gift may be perceived as charity or too good for the current state of the relationship
Negative confirmation	Gift giving validates a negative quality of a relationship between the gift giver and receiver	The selection of gift is inappropriate, indicating a lack of knowledge of the receiver The gift is viewed as a method of controlling the receiver
Weakening	Gift giving harms the quality of the relationship between giver and receiver	When there are "strings attached" or the gift is perceived as a bribe, a sign of disrespect, or offensive
Severing	Gift giving harms the relationship between the giver and the receiver to the extent that the relationship is dissolved	When the gift forms part of a larger problem, such as when a relationship is threatened When a relationship is severed through the receipt of a "parting" gift

Source: Adapted from Julie A. Ruth, Cele C. Otnes, and Frederic F. Brunel, "Gift Receipt and the Reformulation of Interpersonal Relationships," *Journal of Consumer Research* 25 (March 1999): 385–402, Table 1, p. 389.

gift! And money was found to be a good gift for other life stages such as graduation, but not for occasions such as Christmas or Valentine's Day, where clothing was rated as more appropriate. Money was seen as too impersonal for those occasions.[35] A study on Father's Day gifts found that the largest percentage of the population (28 percent) will purchase apparel as a gift, split between sports (such as Nike) and fashion brands (such as Ralph Lauren).[36]

One study on clothing as gifts found that men and women have similarities but also assume somewhat different roles as givers of gifts. For example, men felt that clothing should be given only to very close friends and family, and men stressed the importance of the recipient's liking and wearing their gift.[37] See Table 2-3 for factors involved with giving and receiving clothing gifts.

A conceptual analysis of research areas related to clothing as gifts includes the following:[38]

- *Prepurchase:* occasions that result in purchase, symbolic meanings of gifts chosen, physical characteristics of gifts chosen, importance of information source, degree to which recipient participates in the selection of the gift, price of gift, proportion of clothing gift to total gift expenditures
- *Purchase:* type of retailer and store image favored by purchaser, importance of service

Table 2-3 Examples of Measurement Factors Involved with Giving
and Receiving Gifts of Clothing

Receiving gifts (reflecting attribution, equity, reactance):
My sister or brother gets better clothing gifts than I do. (F & M)
When people give me clothing, they are trying to influence the way I dress. (F & M)
Clothing that people give me just doesn't suit my lifestyle. (F)
When someone gives me a clothing gift, I feel they are limiting my freedom to make my
 own choices. (F & M)
People give me clothing that is hard to care for. (F & M)
You should not let anybody know if something you wear was a gift. (F & M)

Giving gifts (concern for recipient; satisfaction, success of gifts):
When I buy clothing as a gift, I try to purchase it at a store where it can be returned. (F)
I try to choose clothing gifts that reflect the recipient's taste in clothing, not my own
 taste. (F & M)
I avoid clothing fads as gifts because they go out of style too quickly. (F)
It is important to me for the receiver to like my gift. (M)
It is important to me that the recipient wear my clothing gift. (M)

Giving gifts (impressing the recipient):
When I give a clothing gift, I try to find something in my favorite brands. (F & M)
It is important for the receiver of the gift to know I was trying to please him or her. (F)
I want the receiver to know I spent time trying to select the right gift. (M)
I like to buy gift clothing from stores with good images. (F & M)

Giving and receiving gifts (closeness of relationship):
People should give clothing gifts only to close friends and relatives. (F)

Note: M = male recipient; F = female recipient.
Source: Linda Manikowske and Geitel Winakor, "Equity, Attribution, and Reactance in Giving and
Receiving Gifts of Clothing," *Clothing and Textiles Research Journal* 12 (1994): 22–30.

- *Presentation:* importance of surprise, significance of wrapping the gift, evidence of price (tag), ceremony involved with presenting gift
- *Postpresentation:* impact of the gift on the relationship between giver and recipient, ways recipient expresses satisfaction or dissatisfaction, recipient's perception of the meaning of the gift, frequency of use/inactive storage, return of gifts

You might consider any of these areas as a research project related to different types of gifts and comparing clothing gifts to nongift clothing.

One opinion poll found that American consumers plan to spend more on Christmas gifts than in the past, but they plan to give fewer gifts. The average Christmas shopper will purchase 22 gifts (down from 25). Females appear to be a tad more giving (25 gifts) than males (18 gifts). The biggest gift givers are 45–54-year-olds (26 gifts), who are planning to spend the most, a little over $1,000.[39] How does this compare to your budget?

Every culture prescribes certain occasions and ceremonies for giving gifts, whether for personal or professional reasons. The giving of birthday presents alone is a major undertaking. Americans on average buy about six birthday gifts a year—about 1 billion gifts in total.[44] Business gifts are an important component in defining professional relationships. Expenditures on business gifts exceed $1.5 billion per year, and great care is often taken to ensure that the appropriate gifts are purchased (sometimes with the aid of professional gift consultants).

GIFTS ONLINE

For better or worse, the Web is transforming the age-old ritual of buying wedding gifts. Numerous online gift registries take the guesswork out of buying that perfect wedding gift for the new couple. These sites collect a referral fee from a retailer if a guest makes a purchase. Although registries have been around since the early 1930s, they used to be more subtle—Macy's used to publish "Hints on Hinting" to help brides offer gentle suggestions to guests.

Competition for the matrimonial market is fierce, so registry sites are scrambling to offer new incentives that will engage the engaged. At www.theknot.com couples can even subsidize their honeymoon airfare: They earn a frequent-flier mile for every dollar their guests spend on them. At www.weddingchannel.com, the lucky couple creates a personal wedding page where they post directions and pictures, plan toasts and seating arrangements, and tell stories about how they met. Guests pull up updated versions of a gift registry and purchase from retailers directly through the Web site. The Wedding Channel hopes to track its customers (assuming they stay married) and create registries as they celebrate anniversaries and the arrival of babies (uh oh, need another gift!).

The proliferation of these registries is understandable given that this business now takes in $19 billion a year. Revenues for Williams-Sonoma's registry alone were an estimated $120 million in 2001; the chain has registered more brides online than in all of its 200-plus physical stores combined.[40] The average wedding party includes 12 people plus 150 guests. On average, the bride and groom register for more than 50 products and they receive an average of 171 wedding gifts.[41] Wedding registries continue to evolve; some couples have become so brazen they are requesting specific shares of stock, contributions to fund an around-the-world trip, or even mortgage payments on that new dream house (available on a special registry maintained by the U.S. Department of Housing and Urban Development at www.hud.gov).

Of course, there are downsides to this new efficiency: Because the wedding couple specifies exactly what they want in advance, the giver doesn't really have to know very much about the recipients. Part of gift giving is developing or reinforcing a symbolic relationship but now the process is much more automated. As one etiquette expert disdainfully points out, in the old days (pre-Internet) people were supposed to be "zealous with creativity" when selecting a gift. "Now, it's just gimme, gimme, gimme with a dollar amount attached." And in many cases the registry is listed on the invitation itself—a social no-no.[42] Registries also eliminate the likelihood of getting homemade or creative gifts.

In addition, the "surprise factor" is eliminated, since the recipients can see in advance which gifts they will get by checking what has been purchased on their registry.[43] In fact, you can even "snoop" on what other couples (including celebrities) are getting by accessing their registry information.

Sometimes gifts are not appropriate or appreciated by the recipient. Although just about everyone has at one time or another received a ghastly gift, this "dark side" of gift giving was highlighted in a study by an economist, who calculated that of the $40 billion spent yearly on holiday gifts, roughly $4 billion is a "deadweight loss." This refers to the difference between the amount spent on a gift and the value the recipient assigns to it; a gift's "yield" is regarded as its perceived value compared to its true value. For example, if a tie cost $10 but you feel it's worth only $8 to you, its yield is 80 percent. The study computed the average yield of a gift to be 94.1 percent. Based on a survey of students at five universities, these yields were reported (100 percent means the gift has an intrinsic value equal to its actual value):[45]

- CDs, 104.4 percent
- Books, 91 percent
- Socks and underwear, 87.7 percent
- Cosmetics, 85.7 percent

Another recent study found that the deadweight loss resulting from apparel gifts was significantly greater than that from all other types of gifts except perfume.[46] Again, this shows that clothes are personal and, therefore, difficult to buy for others. Supporting this notion is the finding that clothing appears to be the gift most frequently returned.[47] One way to combat returns

The importance of gift-giving rituals is underscored by considering Japanese customs, where the wrapping of a gift is as important (if not more so) than the gift itself. The economic value of a gift is secondary to its symbolic meaning.[49] To the Japanese, gifts are viewed as an important aspect of one's duty to others in one's social group. Giving is a moral imperative (known as *giri*).

Highly ritualized gift giving occurs during the giving of both household/personal gifts and company/professional gifts. Each Japanese has a well-defined set of relatives and friends with which he or she shares reciprocal gift-giving obligations (*kosai*).[50]

Personal gifts are given on social occasions, such as at funerals, to people who are hospitalized, to mark movements from one life stage to another (for example, weddings, birthdays), and as greetings (for example, when one is meeting a visitor). Company gifts are given to commemorate the anniversary of a corporations' founding or the opening of a new building or when new products are announced. In keeping with the Japanese emphasis on saving face, often presents are not opened in front of the giver, so that it will not be necessary to hide one's possible disappointment with the present.

is the prepaid gift card that recently has become the number-one holiday gift choice. However, there is also a downside to gift cards: Some consumers find themselves with gift cards they don't want. This has spurred the new business of swapping cards. On www.swapagift.com you can swap your card for one you can use.[48]

In addition to expressing their feelings toward others through consumption, people commonly find (or devise) reasons to give themselves something as well. It is common for consumers to purchase self-gifts as a way to regulate their behavior. This ritual provides a socially acceptable way to reward ourselves for good deeds, to console ourselves after negative events, or to motivate ourselves to accomplish some goal.[51] Indeed, retailers report that it is becoming increasingly common for people to treat themselves while they are ostensibly searching for goodies for others. As one shopper admitted recently, "It's one for them, one for me, one for them."[52]

Holiday Rituals

On holidays consumers step back from their everyday lives and perform ritualistic behaviors unique to those occasions.[53] Holidays are filled with ritual artifacts and scripts, and increasingly enterprising marketers find ways to encourage consumers to give gifts to commemorate them. The Thanksgiving holiday bursts with rituals for Americans; these scripts include serving (in gluttonous portions) foods such as turkey and cranberry sauce that often are only consumed on that day, and complaints about how much one has eaten (yet rising to the occasion to somehow find room for dessert). On Valentine's Day, standards regarding sex and love are relaxed or altered as people express feelings that may be hidden during the rest of the year. Nearly three-fourths of Americans celebrate Valentine's Day, with men spending significantly more money on gifts than women (much of it being lingerie), according to a Maritz poll.[54]

Most cultural holidays are based on a myth, and often a historical (such as Miles Standish on Thanksgiving) or imaginary (such as Cupid on Valentine's Day) character is at the center of the story. These holidays persist because their basic elements appeal to consumers' deep-seated needs.[55] Christmas and

Halloween are two holidays that are especially rich both in cultural symbolism and in consumption meanings.

- The Christmas holiday is bursting with myths and rituals, from adventures at the North Pole to those that happen under the mistletoe. One of the most important holiday rituals involves Santa Claus, a mythical figure eagerly awaited by children the world over. In opposition to Christ, Santa is a champion of materialism. Perhaps it is no coincidence, then, that he appears in stores and shopping malls—secular temples of consumption. Whatever his origins, the Santa Claus myth serves the purpose of socializing children by teaching them to expect a reward when they are good and that members of society get what they deserve.

- Halloween observances among adults are booming and changing the character of this holiday. Halloween is now the second most popular party night for adults (after New Year's Eve); one in four grown-ups wears a costume.[56] Spending has grown to $3.3 billion for candy, costumes, and decorations, while we have seen a rise in Halloween specialty stores.[57] In contrast to Christmas, it celebrates evil instead of good and death rather than birth, and it encourages revelers to extort treats with veiled threats of "tricks" rather than rewarding only the good. Halloween provides a ritualized and, therefore, socially sanctioned context in which people can act out uncharacteristic behaviors and try on new roles. The holiday is now going global: It's becoming popular in Singapore, Sri Lanka, the Bahamas, Hong Kong, and even France. Critics say it's just another manifestation of creeping U.S. commercialism in an age of globalization.[58] After September 11, costumes changed. It was felt that "no one wants a costume that has anything to do with the real kind of horror . . . witches are OK, ghosts are OK, weapons are not OK."[59]

Halloween is evolving from a children's festival to an opportunity for adults to experiment with fantasy roles—and party.

In addition to established holidays, new occasions are invented to capitalize on the need for cards and other ritual artifacts that will then have to be acquired.[60] These cultural events often originate with the greeting card industry, which conveniently stimulates demand for more of its products. Some recently invented holidays include Administrative Professionals' Day and Grandparents' Day.

Rites of Passage

What does a dance for recently divorced people have in common with a fraternity hell week? Both are examples of modern **rites of passage**, or special times marked by a change in social status. Every society, both primitive and modern, sets aside times when such changes occur, often with special accompanying clothing. Some of these changes may occur as a natural part of consumers' life cycles (such as puberty or death), whereas others are more individual in nature (such as getting divorced and reentering the dating market).

Some marketers attempt to reach consumers on occasions in which their products can enhance a transition from one stage of life to another.[61] For example, a chain of fur stores ran a series of ads positioning a fur coat as a way to celebrate "all of life's moments." Suggested moments included a thirtieth birthday, a raise, a second marriage, and even a "divorce-is-final" fur coat: "Shed the tears and slip into a fur," reads the ad.[62]

Much like the metamorphosis of a caterpillar into a butterfly, consumers' rites of passage consist of three phases.[64]

1. The first stage, *separation*, occurs when the individual is detached from his or her original group or status (such as when the college freshman leaves home).

2. *Liminality* is the middle stage, where the person is literally in-between statuses (for example, the new arrival on campus tries to figure out what is happening during orientation week).

3. The last stage, *aggregation*, takes place when the person reenters society after the rite of passage is complete (for example, when the student returns home for vacation as a college "veteran").

Rites of passage mark many consumer activities, as exemplified by sorority/fraternity pledges, wedding vows, or religious vows. A similar transitional state can be observed when people are prepared for certain occupational

THE PROM—A COSTLY RITE OF PASSAGE

A senior prom can be a costly affair, especially for low-income consumers. But it's a once-in-a-lifetime event that most teenagers do not want to miss. The cost of the four-hour event can add up: There's the dress, stiletto heels, hair and nail appointments, prom tickets, tuxedo rental, a rental car or limousine, flowers, and the after-prom meal out with friends. It can add up to hundreds, if not thousands, of dollars for one couple. Even schools in low-income areas, which are sacrificing field trips and "nonessential" curriculum, are not relinquishing a fancy prom saying it's crucial to celebrate a high school ritual. Some say it's silly to spend so much on one night when college bills are just around the corner. Publishers of the magazine, *The Prom*, estimate total spending on proms in the United States is $4 billion per year and the average prom attendee spends over $600. One young man said, "It makes me nervous, but money comes and goes . . . prom's just one night—you can't get that back."[63]

roles. For examples, fashion models typically undergo a "seasoning" process. They are removed from their normal surroundings (young models often are moved to Paris), indoctrinated into a new subculture, and then returned to the real world in their new roles.

Funeral ceremonies help the living to organize their relationships with the deceased, and action tends to be tightly scripted, down to the costumes (such as the ritual black attire, black ribbons for mourners, the body in its

High school proms are quite an investment nowadays some-times costing several thousand dollars for the prom tickets, dress, accessories, hair, makeup, tuxedo rental, flowers, limousine, dinner, and even breakfast the next morning.

best clothes) and specific behaviors (such as sending condolence cards or holding a wake). Mourners "pay their last respects," and seating during the ceremony is usually dictated by mourners' closeness to the individual. Even the *cortege* (the funeral motorcade) is accorded special status by other motorists, who recognize its separate, sacred nature by not cutting in as it proceeds to the cemetery.[65]

SACRED AND PROFANE CONSUMPTION

As we saw when considering the structure of myths, many types of consumer activity involve the demarcation, or binary opposition, of boundaries, such as good versus bad, male versus female—or even regular versus diet. One of the most important of these sets of boundaries is the distinction between the sacred and the profane. **Sacred consumption** involves objects and events that are "set apart" from normal activities and are treated with some degree of respect or awe. They may or may not be associated with religion, but people tend to regard most religious items and events as sacred. **Profane consumption** involves consumer objects and events that are ordinary, everyday objects and events that do not share the "specialness" of sacred ones. (Note that *profane* does not mean "vulgar" or "obscene" in this context.)

Domains of Sacred Consumption

Sacred consumption events permeate many aspects of consumers' experiences. We find ways to set apart a variety of places, people, and events. In this section, we'll consider some examples of ways that ordinary consumption is sometimes *not* so ordinary after all.

Sacred Places

A society sets apart sacred places because they have religious or mystical significance (such as Bethlehem, Mecca, or Stonehenge) or because they commemorate some aspect of a country's heritage (such as the Kremlin, the Emperor's Palace in Tokyo, the Statue of Liberty, or more recently, Ground Zero in Manhattan). The sacredness of these places is due to the property of *contamination*—that is, something sacred happened on that spot, so the place itself takes on sacred qualities.

Still other places are created from the profane world and imbued with sacred qualities. Graumann's Chinese Theater in Hollywood, where movie stars leave their footprints in concrete for posterity, is one such place. Theme parks are a form of mass-produced fantasy that take on aspects of sacredness. In particular, Disney World and Disneyland (and their outposts in Europe and Japan) are destinations for pilgrimages by consumers around the globe.

In many cultures, the home is a particularly sacred place. It represents a crucial distinction between the harsh, external world and consumers' "inner space." Americans spend more than $50 billion a year on interior decorators and home furnishings, and the home is a central part of consumers' identities.[69] Consumers all over the world go to great lengths to create a special environment that allows them to create the quality of "homeyness." This

Quinceanera is the name of the rite of passage celebrated in almost every Latin culture when girls turn 15. The tradition originated in Aztec Mexico about 500 B.C. Fifteen was the age when boys became warriors and girls were presented to the community because they could marry and bear children. Today, the custom is a rite of religious passage, in which the *quinceanera* celebrant is called upon, during a special mass, to reaffirm the vows she took at first communion. She is surrounded by a court of her friends, called *madrinas,* in white gowns. At the end of the service, there is the traditional bestowing of gifts. Her sister gives her a doll (the last doll she will receive as a child) and her friends give her a Bible and flowers. At the end of this rite of passage, she is considered an adult in the eyes of her culture. Parents spend from $3,500 to $15,000 on a *quinceanera,* according to a San Francisco company that offers everything needed for the ceremony from dresses to video cameras.[66]

Descendants of Pacific Islanders are rediscovering the long-dormant art of tattoos. The modern tattoo originated as a rite of passage hundreds of years ago in places such as Samoa, Tahiti, and Hawaii. Polynesians used tattoos to mark a girl's sexual maturity, a young person's coming of age, or a man's decision to take responsibility for a family or village. Today, these ceremonies serve as reminders of roots.[67]

In the Jewish religion traditions start with the very young, with the 3,000-year-old circumcision ritual that is the Jewish male's first rite of passage, followed by his bar mitzvah at puberty, and later his wedding ceremony. The *mohel,* the individual who conducts the circumcision ceremony, sets the stage, propping up framed photos of deceased family members, arranging the candlesticks, putting the family's Kiddush cups in spots of honor, and preparing the ceremonial empty chair for the Jewish prophet Elijah. During the ceremony he wears appropriate garb, while the baby is wrapped in *tallis,* a Jewish prayer shawl.[68]

effect is created by personalizing the home as much as possible, using such devices as door wreaths or a "memory wall" for family photos.[70] Fashionable retail outlets like Pottery Barn, Restoration Hardware, and Crate and Barrel are becoming increasingly popular and successful. Even public places, like Starbucks cafes, strive for a homelike atmosphere that shelters customers from the harshness of the outside world.

Sacred People

People themselves can be sacred when they are idolized and set apart from the masses. Souvenirs, memorabilia, and even mundane items touched or used by sacred people take on special meanings and acquire value in their own right. For example, Jacqueline Kennedy Onassis led such a private life after President Kennedy was killed that she became an intense interest of the public. And after her death she still holds great interest. A *Town & Country* magazine promo offered the first hundred lucky people who subscribe a free copy of *A Thousand Days of Magic: Dressing Jacqueline Kennedy for the White House,* by Oleg Cassini, her personal couturier during Kennedy's presidency. And in 2001 the Metropolitan Museum of Art's Costume Institute presented a hugely popular exhibit that celebrated her style.[71]

Indeed, many businesses thrive on consumers' desire for products associated with famous people. There is a thriving market for celebrity autographs and objects once owned by celebrities, whether Princess Di's gowns or John Lennon's guitars. Such items often are sold at auction for astronomical prices. A store called A Star Is Worn sells items donated by celebrities—a black bra autographed by Cher went for $575. As one observer commented

Little girls dressed as Disney characters, such as Cinderella and Snow White, parade before a castle for the celebration of Girls' Festival at the Tokyo Disneyland. Disneyland is a sacred place for children the world round.

about the store's patrons, "They want something that belonged to the stars, as if the stars have gone into sainthood and the people want their shrouds."[72]

Sacred Events

Many consumer activities also have taken on a special status. Public events in particular resemble sacred, religious ceremonies, as exemplified by the recitation of the Pledge of Allegiance before a ball game or the reverent show of lighters at the end of a rock concert.[73]

For many people, the world of sports is sacred and almost assumes the status of a religion. The roots of modern sports events can be found in ancient religious rites, such as fertility festivals (for example, the original Olympics).[74] Indeed, it is not uncommon for teams to join in prayer prior to a game. The sports pages are like the Scriptures (and we describe ardent fans as reading them "religiously"). Devotees engage in group activities, such as tailgate parties and the "wave," where (resembling a revival meeting) participants on cue join the wavelike motion as it makes its way around the stadium. They also wear requisite team garb including baseball caps with team logos. Major league baseball and NFL teams do thriving businesses of T-shirts, sweatshirts, and every imaginable item with their teams' logo. Malls in most major sports cities have sports shops to supply these important souvenirs. Fans often come to see athletes as godlike; they are reputed to have almost superhuman powers (especially superstars like Michael Jordan, who is accorded the ability to fly in his Air Nikes).

Tourism is another example of a sacred, nonordinary experience of extreme importance to marketers. When people travel on vacation, they occupy sacred time and space. The tourist is continually in search of "authentic" experiences that differ from his or her normal world (think of Club Med's motto, "The antidote to civilization").[75] This traveling experience involves binary oppositions between work and leisure and being "at home" versus "away." Often we relax everyday (profane) norms regarding appropriate behavior as tourists scramble after adventurous experiences they would not dream of engaging in at home ("What happens in Vegas, stays in Vegas"). The desire of travelers to capture these sacred experiences in objects forms the bedrock of the souvenir industry, which may be said to be in the business of selling sacred memories. Whether a personalized matchbook from a wedding or New York City T-shirt, souvenirs represent a tangible piece of the consumer's sacred experience.[76]

In addition to personal mementos, such as ticket stubs saved from a favorite concert, the following are other types of sacred souvenir icons:[77]

- Local products (such as wine from California)
- Pictorial images (such as postcards)
- "Piece of the rock" (such as seashells, pine cones)
- Symbolic shorthand in the form of literal representations of the site (such as a miniature Statue of Liberty)
- Markers (such as Hard Rock Cafe T-shirts)

From Sacred to Profane, and Back Again

Just to make life interesting, in recent times many consumer activities have moved from one sphere to the other: Some things that were formerly regarded as sacred have moved into the realm of the profane, while other everyday phenomena now are regarded as sacred.[78] Both of these processes are relevant to our understanding of contemporary consumer behavior.

Souvenirs, tacky or otherwise, allow consumers to make tangible sacred (that is, out of the ordinary) experiences accumulated as tourists.

Desacralization

Desacralization occurs when a sacred item or symbol is removed from its special place or is duplicated in mass quantities, becoming profane as a result. For example, souvenir reproductions of sacred monuments such as the Washington Monument or the Eiffel Tower, artworks such as the Mona Lisa, or adaptations of important symbols such as the American flag by clothing designers eliminate their special aspects by turning them into unauthentic commodities, produced mechanically with relatively little value.[79] A similar thing happens when original designer goods are knocked off and mass-marketed. The special fabrication and detail that made it expensive and noteworthy are often lost in cheap copies.

Religion itself has to some extent been desacralized. Religious symbols, such as stylized crosses or New Age crystals, have moved into the mainstream of fashion jewelry.[80] Religious holidays, particularly Christmas, are regarded (and criticized) by many as having been transformed into secular, materialistic occasions devoid of their original sacred significance. A similar process is occurring in relatively Westernized parts of the Islamic Middle East, where the holy month of Ramadan (traditionally observed by fasting and prayer) is starting to look like Christmas: People are buying lights in the shape of an Islamic moon, sending Ramadan cards to one another, and attending lavish fast-breaking feasts at hotels.[81]

Sacralization

Sacralization occurs when ordinary objects, events, and even people take on sacred meaning to a culture or to specific groups within a culture. For example, events such as the Super Bowl and people such as Elvis Presley are sacred for some consumers. Virtually anything can become sacred. Skeptical? Consider that a Web site is thriving by selling unlaundered athletic wear

This Diesel ad borrows "sacred" imagery and applies it in a "profane" context.

worn by members of the Dallas Cowboys football team. Shoes worn by quarterback Troy Aikman sell for $1,999, while an unwashed practice jersey that retains the sweat of an unknown player goes for $99. Used socks are flying out the door at $19.99 a pair. Says the owner, "Fans who have never been able to touch the Cowboys before now have an opportunity."[82]

Objectification occurs when sacred qualities are attributed to mundane items (like smelly socks). One way that this process can occur is through contamination, where objects associated with sacred events or people become sacred in their own right. This reason explains the desire by many fans for items belonging to, or even touched by, famous people. Even the Smithsonian Institution in Washington, D.C., maintains a display featuring such "sacred items" as the inaugural gowns of the First Ladies, the ruby slippers from *The Wizard of Oz*, and a phaser from *Star Trek*—all reverently protected behind sturdy display glass.

In addition to museum exhibits displaying rare objects, even mundane, inexpensive things may be set apart in *collections*, where they are transformed from profane items to sacred ones. An item is sacralized as soon as it enters a collection, and it takes on special significance to the collector that, in some cases, may be hard to comprehend by the outsider. **Collecting** refers to the systematic acquisition of a particular object or set of objects. This widespread activity can be distinguished from hoarding, which is merely unsystematic collecting.[83] Name an item, and the odds are that a group of collectors is lusting after it. The contents of collections range from movie memorabilia, rare books, and autographs to G.I. Joe dolls, Elvis memorabilia, Barbie dolls, and Beanie Babies.[84] Collecting starts young: The average American girl between 3 and 11 owns ten Barbie dolls, according to Mattel.[85]

Collecting typically involves both rational and emotional components. On the one hand, avid collectors carefully organize and exhibit their treasures.[86] On the other hand, they may be ferociously attached to their collections. This passion is exemplified by the comment made in one study by a woman who collects teddy bears: "If my house ever burns down, I won't cry over my furniture. I'll cry over the bears."[87]

Beanie Baby fever infected many people in the late 1990s. The Ty Web site (www.ty.com) features over 250 Beanie Babies. And McDonald's has sold several series of Teanie Beanie Babies to the delight of young and old children. The premature announcement of the "end" of the collection increased sales significantly.

BARBIE, THE FASHION ICON

Developed in 1959, Barbie has been that impossibly curvy doll beloved by millions of little girls and reviled by feminists. Barbie's animated Web site (www.barbie.com) starts off with "be a fashionista, styling Barbie girl." But Barbie keeps up with the times; she has undergone more than eighty career changes in her fifty years. In 1998 she had surgery. Mattel Inc. released a version of Barbie with a new silhouette, developed, according to Mattel, in response to demands from their target market, girls 3 to 11. They wanted Barbie to be "cooler . . . and more reflective of themselves."[89] This Barbie has a gentle closed-mouth smile and straighter hair that has a blend of shades. She has smaller hips and bust and slightly wider waist and flat feet, rather than a high-arched foot that wears a high-heel shoe. Mattel says that the change in Barbie's physique was not a reaction to feminist claims that the doll, whose measurements would be about 38-18-34 in human inches, presents harmful and distorted images. The company is aware of the criticisms, but it is listening to the ones buying Barbie.

Because many young girls have dreamed of looking like Barbie, despite denouncements for giving them an impossible standard to try to achieve in adulthood, Mattel has made that dream come true with its popular Barbie shops in Japan that sell human-size Barbie clothes.[90] Barbie has always been a fashion icon. She has had designers from Bob Mackie and Donatella Versace to Hillary Duff design for her. The phenomenally popular doll produces $1.5 billion worldwide annual sales. And Mattel fights to keep her reputation intact by attempting to bring trademark infringement cases to the U.S. Supreme Court for such parodies as the Barbie Girl song with lyrics of "I'm a blond bimbo girl in a fantasy world" and photos of Barbie in sexualized and dangerous situations (these cases were dismissed based on freedom of expression).[91]

Do you know Barbie's full name? (It's Barbie Millicent Roberts®). Barbie and Ken dolls are named after Mattel founders Ruth and Elliot Handler's son and daughter, Barbara and Ken, another piece of trivia for you.

Some consumer researchers feel that collectors are motivated to acquire their "prizes" in order to gratify a high level of materialism in a socially acceptable manner. By systematically amassing a collection, the collector is allowed to "worship" material objects without feeling guilty or petty. Another perspective is that collecting is actually an aesthetic experience; for many collectors the pleasure emanates from being involved in creating the collection. Whatever the motivation, hard-core collectors often devote a great deal of time and energy to maintaining and expanding their collections, so for many this activity becomes a central component of their extended selves (see Chapter 5).[88]

TRANSFERRING PRODUCT MEANING FROM CULTURE TO CULTURE

In modern times cultural products travel across oceans and deserts with blinding speed. Just as Marco Polo brought silk and spice from China, today multinational firms seeking to expand their markets are constantly working to conquer new markets and convince legions of foreign consumers to desire their offerings.

Just as worldwide consumers want American products, American consumers gobble up new ideas from around the world. As "coolhunters" research new trends in Los Angeles for such companies as MTV and Sprint, they are finding that *fusion* is going to be a term used a lot. "It's really hard to be original these days, so the easiest way to come up with new stuff is to mix things that already exist . . . travel's huge right now—you go to a place and bring stuff back. There's going to be more blending, like Spanish music and punk—things that are so unrelated."[92] Consider a French artist named

These designs at the Rootstain Manneguin Showroom in New York City have a Japanese theme.

Pascal in West Hollywood carefully drawing swirls of henna down the arm of a Hispanic girl to the rhythm of Brazilian samba music . . . a beautiful, temporary, painless Indian tattoo practice called *mehndi*. With increased and low-cost travel, coupled with lots of discretionary income and the Internet, fusion will continue creeping through many cultures throughout the world.

As if understanding the dynamics of one's culture weren't hard enough, consumer research becomes more complex when we take on the daunting—but essential—task of learning about the practices of other cultures. The consequences of ignoring cultural sensitivities can be costly. Muslims objected to a logo designed for Nike athletic shoes since the stylized word "Air," which they felt resembled "Allah" in Arabic script, was disrespectful when used on shoes. Nike apologized, calling the design an innocent mistake, and pulled the shoes from distribution after a threatened boycott of Nike products by the world's 1 billion Muslims.[93] Similarly, after complaints, Levi's withdrew an ad in Turkey showing an out-of-work Father Christmas (suggesting the low prices of the jeans had put the old man out of the gift-giving business). A court petition against Levi's indicated the company mocked the values Father Christmas stands for; St. Nicholas, the fourth-century Christian bishop on whom the well-beloved figure is based, was born in Turkey.[94]

In this section, we'll consider some of the issues confronting consumer researchers seeking to understand the cultural dynamics of other countries. We'll look at criticism of the "Americanization" of global culture, as U.S. marketers (and to some extent Western European marketers) continue to export popular culture to a globe full of increasingly affluent consumers, many of whom are eagerly waiting to replace their traditional products and practices with the likes of McDonald's, Levi's, Nike, and MTV.

Think Globally, Act Locally

As corporations increasingly find themselves competing in many markets around the world, the debate intensifies regarding the necessity of developing separate marketing plans for each culture versus crafting a single plan that can be implemented everywhere. Let's briefly consider each viewpoint.

Adopting a Standardized Strategy

Proponents of a standardized marketing strategy argue that many cultures, especially those of relatively industrialized countries, have become so homogenized that the same approach will work throughout the world. By developing one approach for multiple markets, a company can benefit from economies of scale, since it does not have to incur the substantial time and expense of developing a separate strategy for each culture.[95] This viewpoint represents an **etic perspective**, or global strategy, which focuses on commonalities across cultures. An etic approach is objective and analytical; it reflects impressions of a culture as viewed by outsiders. Benetton, Gap, IKEA, and Starbucks are examples of companies using this global approach. These companies are generally vertically integrated[96] (the company owns different levels in the production and distribution hierarchy, such as factories and retail outlets) and they sell their private label. Critics of the cultural consequences of standardization often

point to Starbucks as an example of a company that succeeds by obliterating local customs and driving small competitors out of business.

Adopting a Localized Strategy

On the other hand, many marketers endorse an **emic perspective**, or multinational strategy, which focuses on variations within a culture. They feel that each culture is unique, with its own norms, value system, conventions, and regulations. This perspective argues that each country has a *national character,* a distinctive set of behavior and personality characteristics.[97] An effective strategy must be tailored to the sensibilities and needs of each specific culture. An emic approach is subjective and experiential; it attempts to explain a culture as it is experienced by insiders.

Sometimes this strategy involves modifying a product or the way it is positioned to make it acceptable to local tastes. Toys "R" Us is an example of a company that carries brands other than its own and adjusts its offerings and prices according to the location it is entering.[98] Similarly in India, Revlon has adapted the color palette and composition of its cosmetics to suit the Indian skin and climate.[99] IKEA finally realized that Americans put a lot of ice in their glasses so they weren't buying smaller European glasses. The company also figured out that Americans sleep in bigger beds, need bigger bookshelves, and like to curl up on sofas rather than sit on them. With China's growing home improvement market, their new Beijing store is their largest store outside of their Stockholm flagship and has a restaurant that seats 700 people.[100]

Some companies change wordings in product names or promotions to become appropriate in certain cultures. Other situations demand more than wordplay. Consumers in some cultures simply do not like some products that are popular elsewhere. American clothing in Japan is not prevalent, with some exceptions, as prices are high, quality is perceived as low, and styles and colors are not always suitable to the Japanese body type. Similarly some global fashion retailers have not been successful in the United States. Galeries Lafayette, a French department store, closed its doors and Shanghai Tang, a Hong Kong retailer, scaled back operations after ventures in Manhattan. Because prices were too high and styles didn't change as often as Americans are used to, the store reinvented itself to offer more lifestyle mainstream apparel that goes from "utterly Chinese to subtly Chinese."[101]

Cultural Differences Relevant to Marketers

Which perspective is correct—the emic or the etic? Perhaps it will be helpful to consider some of the ways that cultures vary in terms of norms regarding what types of products are appropriate or desirable.

Given the sizable variations in tastes within the United States alone, it is hardly surprising that people around the world have developed their own unique preferences—differences that researchers need to uncover. Consumers also are accustomed to different forms of advertising. In general, ads that focus on universal values such as love of family travel fairly well, whereas those with a focus on specific lifestyles do not. In some cases, advertising content and store hours are regulated by the local government. For example, most shops in Paris are closed on Sundays; recently a Paris court

ruled that Louis Vuitton, which had preliminary approval to open, must close on Sunday.[102] Because pricing in Germany is controlled, special sales can be held only for a particular reason, such as going out of business or the end of the season. German advertising also focuses more on the provision of factual information rather than on the aggressive hard sell. Indeed, it is illegal to mention the names of competitors.[103] In contrast, the British and the Japanese regard advertising as a form of entertainment. Compared to the United States, British television commercials contain less information,[104] and Japanese advertising is more likely to feature emotional appeals while avoiding comparative messages that are considered impolite.[105]

Although Wal-Mart is successful in some countries outside the United States, it is not in others. Its formula for success—low prices, zealous inventory control, and a large array of merchandise—doesn't work in Germany, Korea, or Japan. Some non-American consumers prefer daily outings to a variety of local stores that specialize, some like small packages, and some don't want to buy products with unfamiliar names.[106]

Marketers must be aware of a culture's norms regarding sensitive topics. Opals signify bad luck to the British, whereas hunting dog or pig emblems are offensive to Muslims. The Japanese are superstitious about the number four. *Shi*, the word for four, is also the word for death. For this reason, Tiffany sells glassware and china in sets of five in Japan. Cultures also vary sharply in the degree to which reference to sex and bodily functions is permitted. Many American consumers pride themselves on their sophistication. However, some would blush at much European advertising, where sexuality is more explicit. On the other hand, Muslim countries tend to be quite puritanical by Western standards. Similarly a more conservative attire was created on a billboard for Lux soap after Orthodox Jews reportedly complained about the revealing outfit worn by *Sex and the City* star Sarah Jessica Parker.[107]

Economic differences also can be an important factor. Companies with global advertising campaigns in some cases encounter obstacles to acceptance, especially in less-developed countries or areas. And credit is not as widely available in many parts of the world as it is in the United States. Credit is just beginning to be offered by major retailers in China.[108] Thus, consumers have to save enough money to buy most things rather than buy now and pay later.

The language barrier is another obvious problem confronting marketers who wish to break into foreign markets. Travelers abroad commonly encounter signs in tortured English such as a dry cleaner in Majorca who urged passing customers to "drop your pants here for best results." Chapter 6 notes some gaffes made by U.S. marketers when advertising to ethnic groups in their own country. Imagine how these mistakes are compounded outside of the United States! One technique that is used to avoid this problem is *back-translation*, in which a translated ad is retranslated into the original language by a different interpreter to catch errors.[109]

Does Global Marketing Work?

Although the argument for a homogenous world culture is appealing in principle, in practice it has met with mixed results. As the preceding discussion implies, one reason for the failure of global marketing is that consumers in

different countries have different conventions and customs, so they simply do not use products the same way.

So does global marketing work? Perhaps the more appropriate question is, "*When* does it work?" To maximize the chances of success for these multicultural efforts, marketers must locate consumers in different countries who nonetheless share a common worldview. Who is likely to fall into this category? Two consumer segments are particularly good candidates: (1) affluent people who are "global citizens" and who are exposed to ideas from around the world through their travels, business contacts, and media experiences, and (2) young people whose tastes in music and fashion are strongly influenced by MTV and other media that broadcast many of the same images to multiple countries. For example, viewers of MTV Europe in Rome or Zurich can check out the same "buzz clips" as their counterparts in London or Luxembourg.[110] Benetton, the Italian apparel manufacturer, has been at the forefront in creating vivid (and often controversial) messages about AIDS, poverty, racial equality, and more recently victims of war, disease, and world hunger that transcend national boundaries.[111]

A recent large-scale study conducted with consumers in forty-one countries grouped consumers who evaluate global brands in the same way and they identified four major segments:[112]

1. *Global citizens.* The largest segment (55 percent) used the global success of a company as a signal of quality and innovation. At the same time they are concerned whether companies behave responsibly on issues like consumer health, the environment, and worker rights.

2. *Global dreamers.* The second largest segment (23 percent) consisted of consumers who see global brands as quality products. They aren't as concerned with those companies' social responsibility as are the global citizens.

3. *Antiglobals.* Thirteen percent of consumers are skeptical that transnational companies deliver higher-quality goods. These consumers dislike brands that preach American values and don't trust global companies to behave responsibly. Antiglobals try to avoid global brands.

4. *Global agnostics.* The remaining 9 percent of consumers don't base purchase decisions on a brand's global attributes. Instead, they evaluate a global product by the same criteria they use to judge local brands and don't regard its global nature as meriting special consideration.

The Diffusion of Western Consumer Culture

Walk the streets of Lisbon or Buenos Aires and you'll be accosted by the sight of Nike hats, Gap T-shirts, and Levi's jeans at every turn. The National Basketball Association sells $500 million of licensed merchandise every year *outside* of the United States.[113] The allure of consumer culture has spread throughout the world. In a global society, people are quick to borrow from other cultures, especially those they admire. For example, many Koreans are influenced by the cultural scene in Japan, which they view as a very sophisticated country. Japanese rock bands are more popular than Korean bands, and other

exports such as comic books, fashion magazines, and game shows are eagerly snapped up. A Korean researcher explains, "Culture is like water. It flows from stronger nations to weaker ones. People tend to idolize countries that are wealthier, freer, and more advanced, and in Asia that country is Japan."[114]

I'd Like to Buy the World a Coke . . . or a Nike

The West (and especially the United States) is a net exporter of popular culture. Many consumers have learned to equate Western lifestyles in general and the English language in particular with modernization and sophistication.

According to polls a market research firm recently conducted, nearly 10 percent of consumers abroad say they will avoid U.S. companies and products like McDonald's, Starbucks, American Airlines, and Barbie dolls because of America's unilateral foreign policies. And the more American a brand is perceived to be, the more resistance it encounters. However, some products have become so widespread that many people are only vaguely aware of their countries of origin. In surveys consumers routinely guess that Heineken is German (it is really Dutch) and that Nokia is Japanese (it's Finnish). Few people know that Estée Lauder was born in the United States.[117]

American television often inspires knockoffs. For example, *The Apprentice* is being reproduced all over the globe. As local versions spread rapidly across Europe, Latin American, and Asia, the Trump role is being

Despite the increasing popularity of European jeans, American brands such as Levi's and Wrangler, which are associated with the American West and American sportswear, are in demand around the world.

CRAVING FOREIGN PRODUCTS

Although some products have a single global image, it is not the case for all products. For consumers, it seems the grass is always greener. We see American consumers wanting foreign goods and foreign consumers wanting American goods and it's curious how a company's image can be different at home and abroad. In the United States IKEA has long lines and a popular buzz as a place for inexpensive but fashionable home furnishings, quite unlike its image at home. "In Sweden, you don't brag about buying things at IKEA," said one Swedish consultant, while a home owner apologizes saying, "It's only while the children are small, then we'll get a proper one later." Americans see IKEA as a wonder of good design.[115] On the other side of the world, the Chinese crave U.S. products, and older brands such as Lee jeans and Buick cars are enjoying a revival with high prestige in China. Consumers have seen them in Hollywood movies and are eager to own quintessentially American products. Starting with a clean slate, companies can create new images through marketing campaigns. Lee jeans, which sell in U.S. discount stores, have been recently introduced in China as the ultimately cool American wear.[116]

assumed by such disparate taskmasters as a German soccer-team manager, a billionaire Arab entrepreneur, and a Brazilian ad agency CEO. Each local "Apprentice" is tailored to the country's culture; contestants sell flowers in London, hot dogs in Frankfurt, and rolled fish in Finland.[118] Not everyone is treated as harshly as the American losers—in Finland contestants are told, "You're free to leave."

Critics deplore the creeping Americanization of their cultures because of what they view as excessive materialism. The French have been the most outspoken opponents of this influence. They have even tried to ban the use of such "Franglish" terms as *le drugstore, le fast food,* and *le marketing.*[119] Dismayed by Western values that the Barbie doll is thought to promote, Arab parents are buying the modest Fulla doll, covered in the traditional head-to-toe black robe (or hijab). Fulla's main market is parents upset by what they see as Western-inspired changes in views on sexuality and on the role of women. Fulla will always be single and won't have a boyfriend like Barbie's Ken.[120]

Emerging Consumer Cultures in Transitional Economies

Over 60 countries have a gross national product of less than $10 billion, but there are at least 135 transnational companies with revenues greater than that. The dominance of these marketing powerhouses has helped to create a **globalized consumption ethic**.[121] People the world over are increasingly surrounded by tempting images of luxury cars, glamorous rock stars on MTV, and modern appliances that make life easier. They begin to share the ideal of a material lifestyle and value well-known brands that symbolize prosperity. Shopping evolves from a wearying, task-oriented struggle to locate basic necessities to a leisure activity. Possessing these coveted items becomes a mechanism to display one's status (see Chapter 7)—often at great personal sacrifice. After the downfall of communism, Eastern Europeans emerged from a long winter of deprivation into a springtime of abundance. The picture is not all rosy, however, because attaining consumer goods is not easy for many in **transitional economies**. This refers to a country (for example, China, Portugal, or Romania) that is struggling with the difficult adaptation from a controlled, centralized economy to a free-market system. In these situations rapid change is required on social, political, and economic

dimensions as the populace suddenly is exposed to global communications and external market pressures.[122] Some of the consequences of the transition to capitalism include a loss of confidence and pride in the local culture, alienation, frustration, and an increase in stress as leisure time is sacrificed to work ever harder to buy consumer goods. The yearning for the trappings of Western material culture is perhaps most evident in parts of Eastern Europe, where citizens who threw off the shackles of communism now have direct access to coveted consumer goods from the United States and Western Europe—if they can afford them. One analyst observed, ". . . as former subjects of the Soviet empire dream it, the American dream has very little to do with liberty and justice for all and a great deal to do with soap operas and the Sears Catalogue."[123]

As the global consumption ethic spreads, the products wished for in different cultures become homogenized. For example, Christmas is now celebrated among some urbanites in Muslim Turkey. In China, Christmas fever is gripping the newly rising urban middle class as an excuse to shop, eat, and party. They are embracing Christmas because they see it as international and modern, not because it's a traditional Christian celebration.[124] Chinese women demand Western cosmetics costing up to a quarter of their salaries, ignoring domestically produced cosmetics. As one Chinese executive noted, "Some women even buy a cosmetic just because it has foreign words on the package."[125]

This photo of a mother and daughter from India that appeared on the cover of National Geographic *depicts the concept of global culture, the combining of clothing from different parts of the world.*

Creolization

Does this homogenization mean that in time consumers who live in Nairobi, New Guinea, or the Netherlands will all be indistinguishable from those in New York or Nashville? Probably not, because the meanings of consumer goods often mutate to be consistent with local customs and values. For example, in Turkey some urban women use ovens to dry clothes and dishwashers to wash muddy spinach. A traditional clothing style such as a *bilum* worn in Papua New Guinea may be combined with Western items such as Mickey Mouse shirts or baseball caps.[126] These processes make it unlikely that global homogenization will overwhelm local cultures, but rather that there will be multiple consumer cultures, each blending global icons such as Nike's pervasive "swoosh" with indigenous products and meanings.

A process called **creolization** occurs when foreign influences are absorbed and integrated with local meanings. This process sometimes results in bizarre permutations of products and services when they are modified to be compatible with local customs. Consider these creolized adaptations:[127]

- In India, a popular music hybrid called Indipop mixes traditional styles with rock, rap, and reggae.[128]
- In the United States, young Hispanic Americans bounce between hip-hop and Rock en Espanol, blend Mexican rice with spaghetti sauce, and spread peanut butter and jelly on tortillas.[129]
- When a Swazi princess marries a Zulu king, she wears a traditional costume of red touraco wing feathers around her forehead and a cape of windowbird feathers and oxtails and the kindis wrapped in a leopard skin. But the ceremony is recorded on a Kodak movie camera while the band plays "The Sound of Music."
- In highland Papua New Guinea, tribesmen wear Pentel pens instead of nosebones.
- The Japanese use Western words as a shorthand for anything new and exciting, even if they do not understand their meanings. Cars are given names such as Fairlady, Gloria, and Bongo Wagon. Consumers buy *deodoranto (*deodorant) and *appuru pai (*apple pie). Ads urge shoppers to *stoppu rukku* (stop and look), and products are claimed to be *yuniku* (unique).[130] Coca-Cola cans say, "I feel Coke & sound special," and a company called Cream Soda sells products with the slogan, "Too old to die, too young to happy."[131] Other Japanese products with English names include Mouth Pet (breath freshener), Brown Gross Foam (hair-coloring mousse), Virgin Pink Special (skin cream), and Cow Brand (beauty soap).[132]

Fashion in Postmodern Society

The contemporary social and economic conditions that shape the global apparel marketplace and our multiple possibilities for shaping identity and meaning within it are often referred to as "postmodernity." Lyons indicates that a new sort of society is emerging, one structured around consumers and consumption rather than workers and production.[133] As we have discussed, styles and looks from around the world are available to consumers today

through an array of sources, such as instant communications through the Internet, affordable travel, and, of course, television. Along with increased global awareness, traditional cultural categories and boundaries are bending (in some cases collapsing, sometimes spurred by the process of creolization) with such ideas as gender bending, retro looks, and subcultural (and international) fusions.[134]

Kaiser describes today's consumers in a postmodern society as faced with "choice, confusion, and creativity" as they negotiate an image for themselves. The range of fashion choices in the marketplace is tremendous because goods are produced and distributed worldwide; the assortment of styles and colors can become overwhelming. Even buying a basic item such as jeans or sport shoes can offer a plethora of styles each with a different purpose. This complexity and resulting confusion can backfire to a preference for simplicity—hence, the popularity of black and classics in much of fashion. Decision making in such an environment can lead to confusion on one hand but creativity on the other. Image and style seem to be in a constant state of flux with influences such as apparel manufacturers delivering different lines each month (and with no reorders); music videos showing frequent changes of looks, suggesting identity is changeable in a flick of a second (think of Madonna's constant remake of herself); and youth subcultures reinventing themselves with such labels as punk, Goth, boardhead, and so on.

The basis of the postmodern look is the management of styles and component parts in a new way that is perhaps more tolerant of diversity and ambiguity, more exploratory, and more "constructed" of elements from various places around the world. We are commodity consumers and identity producers as we manage appearances and continue to create ourselves.[135]

CHAPTER SUMMARY

- A society's culture includes its values, ethics, and the material objects produced by its people. It is the accumulation of shared meanings and traditions among members of a society. A culture can be described in terms of ecology, social structure, and ideology. The typology of material and nonmaterial culture positions fashion and clothing in our understanding of culture.

- Myths are stories containing symbolic elements that express the shared ideals of a culture. Many myths involve a binary opposition, where values are defined in terms of what they are and what they are not (such as nature versus technology). Modern myths are transmitted through advertising, movies, and other media and even apparel trademarks.

- A ritual is a set of multiple, symbolic behaviors that occurs in a fixed sequence and that tends to be repeated periodically. Rituals are related to many consumption activities that occur in popular culture including clothing for special occasions, holiday observances, gift giving, and grooming.

- A rite of passage is a special kind of ritual that involves the transition from one role to another. These passages typically entail the need to acquire

products and services, called ritual artifacts, which often include clothing, to facilitate the transition. Modern rites of passage include graduations, fraternity initiations, weddings, debutante balls, and funerals.

- Consumer activities can be divided into sacred and profane domains. Sacred phenomena are set apart from everyday activities or products. People, events, or objects can become sacralized. Objectification occurs when sacred qualities are ascribed to products or items owned by sacred people. Sacralization occurs when formerly sacred objects or activities become part of the everyday, as when one-of-a-kind works of art are reproduced in large quantities. Some might place mass fashion that copies original designer goods into this category. Desacralization occurs when objects that previously were considered sacred become commercialized and integrated into popular culture.

- Because a consumer's culture exerts such a big influence on his or her lifestyle choices, marketers must learn as much as possible about differences in cultural norms and preferences when marketing in more than one country. One important issue is the extent to which marketing strategies must be tailored to each culture versus standardized across cultures. Followers of an etic perspective believe that the same universal messages will be appreciated by people in many cultures. Believers in an emic perspective argue that individual cultures are too unique to permit such standardization; marketers must instead adapt their approaches to be consistent with local values and practices. Attempts at global marketing have met with mixed success; in many cases this approach is more likely to work if the messages appeal to basic values and/or if the target markets consist of consumers who are more internationally rather than locally oriented.

- The United States is a net exporter of popular culture. Consumers around the world have eagerly adopted American products. There are many critics of the "Americanization" of world culture. In other cases, consumers are integrating Western products with existing cultural practices in a process known as creolization.

- Fashion in our postmodern society blends looks from around the world and breaks conventional rules.

KEY TERMS

culture	myth	desacralization
cultural categories	binary opposition	sacralization
collectivist cultures	monomyth	collecting
individualist cultures	ritual	etic perspective
norms	fortress brands	emic perspective
enacted norms	ritual artifacts	globalized consumption
crescive norms	gift-giving ritual	ethic
custom	rites of passage	transitional economics
more	sacred consumption	creolization
conventions	profane consumption	

DISCUSSION QUESTIONS

1. Culture can be thought of as a society's personality. If your culture were a person, how would you describe its personality traits?

2. What is the difference between an enacted norm and a crescive norm? Identify the set of crescive norms operating when a man and woman in your culture go out for dinner on a first date. What would they wear?

3. Read the article "Body Ritual Among the Nacirema" by Horace Miner in the *American Anthropologist* (Vol. 58, 1956) and discuss what is going on.

4. Interview some of your classmates who are from other countries to compare holiday customs and usage of products that differ from the United States.

5. How do the consumer decisions involved in gift giving differ from other purchase decisions? What clothing gifts you have received? Did you like them? What are some of the major motivations for the purchase of self-gifts?

6. Compare clothing and nonclothing gifts in terms of the prepurchase, purchase, presentation, and postpresentation stages of gift giving. Compare men and women on some of these factors.

7. Construct a ritual script for a wedding in your culture. How many artifacts can you list that are contained in this script? Carefully describe the clothing involved.

8. Describe the three stages of the rite of passage associated with graduating from college.

9. "Christmas has become just another opportunity to exchange gifts and stimulate the economy." Do you agree? Why or why not?

10. Is there a type of product that you collect? Describe others that you know about.

11. Due to increased competition and market saturation, marketers in industrialized countries increasingly are trying to develop third-world markets by encouraging people in underdeveloped countries to desire Western products. Should this practice be encouraged, even if the products being marketed divert needed money away from the purchase of essentials?

12. Identify creolized products that you see around you. In what type of products do you see this happening? Give examples of clothing and accessories used in different ways than intended.

13. Have you traveled out of the United States lately? If you have, what differences did you notice in advertising and in preferences and usage of products? What U.S. brands did you see most often? Compare ads in magazine from different countries.

ENDNOTES

1. Nelson D. Schwartz, "Starbucks: Still Perking After All These Years," *Fortune* (May 24, 1999): 203; Louise Lee, "Now, Starbucks Uses Its Bean," *Business Week* (February 14, 2000): 92–94; Mark Gimein, "Behind Starbucks' New Venture: Beans, Beatniks, and Booze," *Fortune* (May 15, 2000): 80.
2. G. Pascal Zachary, "Joltin' Joe," *San Francisco Chronicle* (May 15, 2005): C1; "Starbucks Planning to Open 1,500 Stores This Year," *San Francisco Chronicle* (February 10, 2005): C3. www.starbucks.com.
3. Seanna Browder, "Starbucks Does Not Live by Coffee Alone," *Business Week* (August 5, 1996): 76; for a discussion of the act of coffee drinking as ritual, see Susan Fournier and Julie L. Yao, "Reviving Brand Loyalty: A Reconceptualization within the Framework of Consumer-Brand Relationships," Working Paper 96-039, Harvard Business School (1996).
4. "Spice Girls Dance into Culture Clash," *Montgomery Advertiser* (April 29, 1997): 2A.
5. Grant McCracken, "Culture and Consumption: A Theoretical Account of the Structure and Movement of the Cultural Meaning of Consumer Goods," *Journal of Consumer Research* 13 (June 1986): 71–84.
6. "Fashion's New Taboo? Industry Repudiates 'Terrorist Chic' Looks," *Women's Wear Daily* (October 1, 2001): 1, 4, 10; Georgia Lee, "The Sensitive Side of Retail," *Women's Wear Daily* (October 19, 2001): 8, 10; Lisa Lockwood, "In the Age of Peril, a New Mood Prevails in Fashion Advertising," *Women's Wear Daily* (October 19, 2001): 1, 6, 10; "Three Cheers for the Red, White and Blue," *Women's Wear Daily* (November 8, 2001): 2; "The Wave of Patriotic Wear," *San Francisco Chronicle* (November 18, 2002): E7.
7. "World Cup's Fashion Kick," *Women's Wear Daily* (June 27, 2002): 8.
8. "The Eternal Triangle," *Art in America* (February 1989): 23.
9. Clifford Geertz, *The Interpretation of Cultures* (New York: Basic Books, 1973); Marvin Harris, *Culture, People and Nature* (New York: Crowell, 1971); John F. Sherry, Jr., "The Cultural Perspective in Consumer Research," in *Advances in Consumer Research* ed., Richard J. Lutz, 13 (Provo, Utah: Association for Consumer Research, 1985), 573–575.
10. William Lazer, Shoji Murata, and Hiroshi Kosaka, "Japanese Marketing: Towards a Better Understanding," *Journal of Marketing* 49 (Spring 1985): 69–81.
11. Joanne B. Eicher, Sandra Lee Evenson, and Hazel A. Lutz, *The Visible Self* (New York: Fairchild Publications, 2000).
12. Geert Hofstede, *Culture's Consequences* (Beverly Hills, CA: Sage, 1980); see also Laura M. Milner, Dale Fodness, and Mark W. Speece, "Hofstede's Research on Cross-Cultural Work-Related Values: Implications for Consumer Behavior," in *Proceedings of the 1992 ACR Summer Conference* (Amsterdam: Association for Consumer Research, 1992).
13. Daniel Goleman, "The Group and the Self: New Focus on a Cultural Rift," *New York Times* (December 25, 1990): 37; Harry C. Triandis, "The Self and Social Behavior in Differing Cultural Contexts," *Psychological Review* 96 (July 1989): 506; Harry C. Triandis, Robert Bontempo, Marcelo J. Villareal, Masaaki Asai, and Nydia Lucca, "Individualism and Collectivism: Cross-Cultural Perspectives on Self-Ingroup Relationships," *Journal of Personality and Social Psychology* 54 (February 1988): 323.
14. George J. McCall and J. L. Simmons, *Social Psychology: A Sociological Approach* (New York: The Free Press, 1982).
15. Arundhati Parmar, "Out from Under," *Marketing News* (July 21, 2003): 9–10.
16. Conrad Phillip Kottak, "Anthropological Analysis of Mass Enculturation," in *Researching American Culture*, ed. Conrad P. Kottak (Ann Arbor: University of Michigan Press, 1982), 40–74.
17. Eric Ransdell, "The Nike Story? Just Tell It!" *Fast Company* (January–February 2000): 44.
18. Joseph Campbell, *Myths, Dreams, and Religion* (New York: E. P. Dutton, 1970).
19. Marcia A. Morgado, "Animal Trademark Emblems on Fashion Apparel: A Semiotic Interpretation—Part II Applied Semiotics," *Clothing and Textiles Research Journal* 11, no. 3 (1993): 31–38.
20. Jeffrey S. Lang and Patrick Trimble, "Whatever Happened to the Man of Tomorrow? An Examination of the American Monomyth and the Comic Book Superhero," *Journal of Popular Culture* 22 (Winter 1988): 157.
21. See William Blake Tyrrell, "Star Trek as Myth and Television as Mythmaker," in *The Popular Culture Reader*, eds. Jack Nachbar, Deborah Weiser, and John L. Wright (Bowling Green, OH: Bowling Green University Press, 1978), 79–88; Elizabeth C. Hirschman, "Movies as Myths: An Interpretation of Motion Picture Mythology," in *Marketing and Semiotics: New Directions in the Study of Signs for Sale*, ed. Jean Umiker-Sebeok (Berlin: Mouton de Guyter, 1987), 335–374.
22. See Dennis W. Rook, "The Ritual Dimension of Consumer Behavior," *Journal of Consumer Research* 12 (December 1985): 251–264; Mary A. Stansfield Tetreault and Robert E. Kleine III, "Ritual, Ritualized Behavior, and Habit: Refinements and Extensions of the Consumption Ritual Construct," in *Advances in Consumer Research*, eds. Marvin Goldberg, Gerald Gorn, and Richard W. Pollay, 17 (Provo, Utah: Association for Consumer Research, 1990), 31–38.
23. Joyce Cohen, "Here Comes the Bride; Get Ready to Release a Swarm of Live Insects," *Wall Street Journal* (January 22, 1996): B1. For a study on updated wedding rituals in Turkey, see Tuba Ustuner, Guliz Ger, and Douglas B. Holt, "Consuming Ritual: Reframing the Turkish Henna-Night Ceremony," in *Advances in Consumer Research*, eds. Stephen J. Hoch and Robert J. Meyers, 27 (Provo, Utah: Association for Consumer Research, 2000): 209–214.
24. Karl Greenberg, "BBDO: Successful Brands Become Hard Habit for Consumers to Break," *Marketing Daily*, available from www.mediapost.com (May 14, 2007).
25. Dennis W. Rook and Sidney J. Levy, "Psychosocial Themes in Consumer Grooming Rituals," in *Advances in Consumer Research*, eds. Richard P. Bagozzi and Alice M.

Tybout, 10 (Provo, Utah: Association for Consumer Research, 1983), 329–333.

26. Diane Barthel, *Putting on Appearances: Gender and Attractiveness* (Philadelphia: Temple University Press, 1988).

27. Quoted in Barthel, Putting on Appearances: Gender and Advertising.

28. Kevin Keller, *Strategic Marketing Management* (Upper Saddle River, N.J.: Prentice-Hall, 1998).

29. Russell W. Belk, Melanie Wallendorf, and John F. Sherry, Jr., "The Sacred and the Profane in Consumer Behavior: Theodicy on the Odyssey," *Journal of Consumer Research* 16 (June 1989): 1–38.

30. Russell W. Belk and Gregory S. Coon, "Gift Giving as Agapic Love: An Alternative to the Exchange Paradigm Based on Dating Experiences," *Journal of Consumer Research* 20, no. 3 (December 1993): 393–417.

31. Tina M. Lowrey, Cele C. Otnes, and Julie A. Ruth, "Social Influences on Dyadic Giving over Time: A Taxonomy from the Giver's Perspective," *Journal of Consumer Research* 30 (March 2004): 547–558.

32. Julie A. Ruth, Cele C. Otnes, and Frederic F. Brunel, "Gift Receipt and the Reformulation of Interpersonal Relationships," *Journal of Consumer Research* 25 (March 1999): 385–402.

33. Linda Manikowske and Geitel Winakor, "Equity, Attribution, and Reactance in Giving and Receiving Gifts of Clothing," *Clothing and Textiles Research Journal* 12, no. 4 (1994): 22–30.

34. Margaret Rucker, A. Freitas, R. Karp, A. Abraham, S. Kim, S. Lopez, and M. Sim, "Translating the Clothing Code as Gift by Ethnic Identity," *International Textiles and Apparel Association Proceedings* (1994): 122.

35. Kimli Socarras, Margaret Rucker, April Kangas, and Katrina Dolenga, "The Newlyweds' New Clothes: Situational Effects on Acceptability of Apparel and Money as Gifts," *International Textiles and Apparel Association Proceedings* (1996): 88; Margaret Rucker, April Kangas, A. Daw, J. Gee, and A. Snodgrass, "Gift Norms: A Comparison of Clothing, Cash and Gift Certificates Across Three Occasions," *International Textiles and Apparel Association Proceedings* (1997): 58.

36. "American Dads: The DNR List," *Daily News Record* (June 5, 2006): 45.

37. Manikowske and Winakor, "Equity, Attribution, and Reactance in Giving and Receiving Gifts of Clothing."

38. Lena Horne and Geital Winakor, "A Conceptual Framework for the Gift-Giving Process: Implications for Clothing," *Clothing and Textiles Research Journal* 9, no. 4 (1991): 23–33.

39. "Average American Expects to Spend $825 on Christmas Gifts This Year" (November 1999). Available online at http://www.maritz.com/mmri/apoll.

40. "Power of Registries," *Chain Store Age* 77 (October 2001): 41. For a study on how brides use message boards to plan weddings, see Michelle R. Nelson and Cele C. Otnes, "Exploring Cross-Cultural Ambivalence: A Netnography of Intercultural Wedding Message Boards," *Journal of Business Research* 58 (2005): 89–95.

41. Quoted in Cyndee Miller, "Nix the Knick-Knacks; Send Cash," *Marketing News* (May 26, 1997): 1, 13.

42. Quoted in "I Do . . . Take MasterCard," *Wall Street Journal* (June 23, 2000): W1.

43. Deborah Kong, "Web Wish List," *Montgomery Advertiser* (November 8, 1999): 1A.

44. Monica Gonzales, "Before Mourning," *American Demographics* (April 1988): 19.

45. Hubert B. Herring, "Dislike Those Suspenders? Don't Complain, Quantify!" *New York Times* (December 25, 1994): F3.

46. Karen Hyllegard and Johnathan Fox, "The Value of Gifts to College Students: The Impact of Relationship Distance, Gift Occasion, and Gift Type," *Clothing and Textiles Research Journal* 15 (1997): 103–114.

47. M. H. Rucker, L. Leckliter, S. Kivel, M. Dinkel, T. Freitas, M. Wynes, and H. Prato, "When the Thought Counts: Friendship, Love, Gift Exchanges and Gift Returns," in *Advances in Consumer Research*, eds. R. R. Holman and M. R. Solomon, 18 (Provo, Utah: Association for Consumer Research, 1991).

48. Denise Power, "Gift Cards: A Mixed Blessing," *Women's Wear Daily* (December 8, 2004): 16; Betsy Taylor, "Gift Card Swapping Aided by Net Sites," *San Francisco Chronicle* (January 1, 2005): C1.

49. Colin Camerer, "Gifts as Economics Signals and Social Symbols," *American Journal of Sociology* 94 (Supplement 1988): 5, 180–214.

50. Robert T. Green and Dana L. Alden, "Functional Equivalence in Cross-Cultural Consumer Behavior: Gift Giving in Japan and the United States," *Psychology & Marketing* 5 (Summer 1988): 155–168.

51. David Glen Mick and Michelle DeMoss, "Self-Gifts: Phenomenological Insights from Four Contexts," *Journal of Consumer Research* 17 (December 1990): 327; John F. Sherry, Jr., Mary Ann McGrath, and Sidney J. Levy, "Monadic Giving: Anatomy of Gifts Given to the Self," in *Contemporary Marketing and Consumer Behavior: An Anthropological Sourcebook*, ed. John F. Sherry, Jr. (New York: Sage, 1995), 399–432.

52. Quoted in Cynthia Crossen, "Holiday Shoppers' Refrain: 'A Merry Christmas to Me,'" *Wall Street Journal Interactive Edition* (December 11, 1997).

53. See, for example, Russell W. Belk, "Halloween: An Evolving American Consumption Ritual," in *Advances in Consumer Research*, eds. Richard Pollay, Jerry Gorn, and Marvin Goldberg, 17 (Provo, Utah: Association for Consumer Research, 1990), 508–517; Melanie Wallendorf and Eric J. Arnould, "We Gather Together: The Consumption Rituals of Thanksgiving Day," *Journal of Consumer Research* 18 (June 1991): 13–31.

54. "A Many-Splendored Thing: 74% of Americans Celebrate Valentine's Day" (February 1999). Available online at http://www.maritz.com/mmri/apoll.

55. Bruno Bettelheim, *The Uses of Enchantment: The Meaning and Importance of Fairy Tales* (New York: Alfred A. Knopf, 1976).

56. Andrea Adelson, "A New Spirit of Sales of Halloween Merchandise," *New York Times* (October 31, 1994): D1.

57. National Retail Federation; Dan Fost, "Pumpkins Prove Profitable," *San Francisco Chronicle* (October 29, 2005): C1.

58. Steven Gutkin, "U.S.-Style Halloween Going Global," *San Francisco Examiner* (October 29, 2000); A25.

59. Steve Rubenstein, "Events Take the Bite Out of Halloween," *San Francisco Chronicle* (October 21, 2001): A23, A29.

60. Rick Lyte, "Holidays, Ethnic Themes Provide Built-In F&B Festivals," *Hotel & Motel Management* (December 14, 1987): 56; Megan Rowe, "Holidays and Special Occasions: Restaurants Are Fast Replacing 'Grandma's House' as the Site of Choice for Special Meals," *Restaurant Management* (November 1987): 69; Judith Waldrop, "Funny Valentines," *American Demographics* (February 1989): 7.

61. Michael R. Solomon and Punam Anand, "Ritual Costumes and Status Transition: The Female Business Suit as Totemic Emblem," in *Advances in Consumer Research*, eds. Elizabeth C. Hirschman and Morris Holbrook, 12 (Washington, DC: Association for Consumer Research, 1995), 315–318.

62. "Divorce Can Be Furry," *American Demographics* (March 1987): 24.

63. Heather Knight, "Prom—A Costly Rite of Passage," *San Francisco Chronicle* (May 27, 2005): B1, B7.

64. Arnold Van Gennep, *The Rites of Passage*, trans. Maika B. Vizedom and Gabrielle L. Caffee (London: Routledge and Kegan Paul, 1960; orig. published 1908); Solomon and Anand, "Ritual Costumes and Status Transition."

65. Walter W. Whitaker III, "The Contemporary American Funeral Ritual," in *Rites and Ceremonies in Popular Culture*, ed. Ray B. Browne (Bowling Green, Ohio: Bowling Green University Popular Press, 1980), 316–325; for an examination of funeral rituals, see Larry D. Compeau and Carolyn Nicholson, "Funerals: Emotional Rituals or Ritualistic Emotions," Paper presented at the Association of Consumer Research, Boston (October 1994).

66. Jane Ganahl, "From Newborn to Newly Adult, Communities Celebrate Life's Stages Rites of Passage," *San Francisco Chronicle* (December 30, 2001): E4.

67. Peter Hartlaub, "Wearing the Art of Polynesian Culture," *San Francisco Chronicle* (December 30, 2001): E4, E5.

68. Sam McManis, "Jewish Bris Ceremony Shows You're Never Too Young for Tradition," *San Francisco Chronicle* (December 30, 2001): E5.

69. Joan Kron, *Home-Psych: The Social Psychology of Home and Decoration* (New York: Clarkson N. Potter, Inc., 1983); Gerry Pratt, "The House as an Expression of Social Worlds," in *Housing and Identity: Cross-Cultural Perspectives*, ed. James S. Duncan (London: Croom Helm, 1981), 135–179; Michael R. Solomon, "The Role of the Surrogate Consumer in Service Delivery," *The Service Industries Journal* 7 (July 1987): 292–307.

70. Grant McCracken, "'Homeyness': A Cultural Account of One Constellation of Goods and Meanings," in *Interpretive Consumer Research*, ed. Elizabeth C. Hirschman (Provo, Utah: Association for Consumer Research, 1989), 168–184.

71. Richard Lacayo, "First Lady of Fashion: An Exhibit Celebrates Jackie Kennedy's Stylish Years in the White House," *Time* (April 30, 2001): 72–73; Eric Wilson, "The Subtleties of Wear," *Women's Wear Daily* (April 23, 2001): 20.

72. James Hirsch, "Taking Celebrity Worship to New Depths," *New York Times* (November 9, 1988): C1.

73. Emile Durkheim, *The Elementary Forms of the Religious Life* (New York: Free Press, 1915).

74. Susan Birrell, "Sports as Ritual: Interpretations from Durkheim to Goffman," *Social Forces* 60 (1981)2: 354–376; Daniel Q. Voigt, "American Sporting Rituals," in *Rites and Ceremonies* in *Popular Culture*, ed. Ray B. Browne (Bowling Green, Ohio: Bowling Green University Popular Press, 1980), 125–140.

75. Dean MacCannell, *The Tourist: A New Theory of the Leisure Class* (New York: Schocken Books, 1976).

76. Belk et al., "The Sacred and the Profane in Consumer Behavior: Theodicy on the Odyssey."

77. Beverly Gordon, "The Souvenir: Messenger of the Extraordinary," *Journal of Popular Culture* 20 (1986)3: 135–146.

78. Belk et al., "The Sacred and the Profane in Consumer Behavior."

79. Belk et al., "The Sacred and the Profane in Consumer Behavior."

80. Deborah Hofmann, "In Jewelry, Choices Sacred and Profane, Ancient and New," *New York Times* (May 7, 1989): 66.

81. Lee Gomes, "Ramadan, a Month of Prayer, Takes on a Whole New Look," *Wall Street Journal Interactive Edition* (December 4, 2002).

82. J. C. Conklin, "Web Site Caters to Cowboy Fans by Selling Sweaty, Used Socks," *Wall Street Journal Interactive Edition* (April 21, 2000).

83. Dan L. Sherrell, Alvin C. Burns, and Melodie R. Phillips, "Fixed Consumption Behavior: The Case of Enduring Acquisition in a Product Category," in *Developments in Marketing Science*, ed. Robert L. King, 14 (1991): 36–40.

84. For an extensive bibliography on collecting, see Russell W. Belk, Melanie Wallendorf, John F. Sherry, Jr., and Morris B. Holbrook, "Collecting in a Consumer Culture," in *Highways and Buyways*, ed. Russell W. Belk (Provo, Utah: Association for Consumer Research, 1991), 178–215. See also Russell W. Belk, "Acquiring, Possessing, and Collecting: Fundamental Processes in Consumer Behavior," in *Marketing Theory: Philosophy of Science Perspectives*, eds. Ronald F. Bush and Shelby D. Hunt (Chicago: American Marketing Association, 1982), 185–190; Werner Muensterberg, *Collecting: An Unruly Passion* (Princeton, N.J.: Princeton University Press, 1994); Melanie Wallendorf and Eric J. Arnould, "'My Favorite Things': A Cross-Cultural Inquiry into Object Attachment, Possessiveness, and Social Linkage," *Journal of Consumer Research* 14 (March 1988): 531–547.

85. Peter Inton, "Barbie and Friend Help Raise Understanding," *San Francisco Chronicle* (July 26, 2000): D4.

86. Belk, "Acquiring, Possessing, and Collecting: Fundamental Processes in Consumer Behavior."

87. Quoted in Ruth Ann Smith, "Collecting as Consumption: A Grounded Theory of Collecting Behavior," Unpublished manuscript, Virginia Polytechnic Institute and State University (1994): 14.

88. For a discussion of these perspectives, see Smith, "Collecting as Consumption: A Grounded Theory of Collecting Behavior."

89. Teresa Moore, "Barbie Doll to Get More Real," *San Francisco Chronicle* (November 18, 1997): A3.

90. Julee Greenberg, "Barbie's Dream Line Goes Global," *Women's Wear Daily* (February 12, 2004): 18.

91. Bob Egelko, "Supreme Court Spurs Barbie Suit," *San Francisco Chronicle* (January 28, 2003): A2; Bob Egelko, "Court Upholds Artist's Right to Toy with Barbie's Image," *San Francisco Chronicle* (December 10, 2003): A2.

92. Quoted in Erla Zwingle, "Goods Move, People Move, Ideas Move," *National Geographic* (August 1999): 12–33.

93. Joel L. Swerdlow, "The Power of Writing," *National Geographic* (August 1999): 128.

94. "Levi's Pulls Ad in Turkey After Group Complains," *San Francisco Chronicle* (December 24, 1998): D2.

95. Theodore Levitt, *The Marketing Imagination* (New York: The Free Press, 1983).

96. Brenda Sternquist, *International Retailing* (New York: Fairchild, 1998), 36.

97. Terry Clark, "International Marketing and National Character: A Review and Proposal for an Integrative Theory," *Journal of Marketing* 54 (October 1990): 66–79.

98. Sternquist, *International Retailing*.

99. Zwingle, "Goods Move. People Move, Ideas Move."

100. Marc Cobe, *Emotional Branding: The New Paradigm for Connecting Brands to People* (New York: Allworth Press, 2001); Joe McDonald, "IKEA Expands to Cash in on China's Growing Home-Improvement Market," *San Francisco Chronicle* (April 13, 2006): C2.

101. Sharon Edelson, "Shanghai Tang Reinvented," *Women's Wear Daily* (February 25, 2005): 15; Anamaria Wilson, "Shanghai Tang Looks West," *Women's Wear Daily* (June 4, 2002): 15; Sharon Edelson, "Shanghai Tang Closing Reflects Key Dilemma of Prestige vs. Profits," *Women's Wear Daily* (July 7, 1999): 1, 12, 13.

102. Robert Murphy, "Paris Court Keeps Vuitton Shut on Sundays," *Women's Wear Daily* (June 1, 2006): 3.

103. Matthias D. Kindler, Ellen Day, and Mary R. Zimmer, "A Cross-Cultural Comparison of Magazine Advertising in West Germany and the U.S.," Unpublished manuscript, The University of Georgia, Athens (1990).

104. Marc G. Weinberger and Harlan E. Spotts, "A Situational View of Information Content in TV Advertising in the U.S. and U.K.," *Journal of Marketing* 53 (January 1989): 89–94; see also Abhilasha Mehta, "Global Markets and Standardized Advertising: Is It Happening? An Analysis of Common Brands in USA and UK," in *Proceedings of the 1992 Conference of the American Academy of Advertising* (1992): 170.

105. Jae W. Hong, Aydin Muderrisoglu, and George M. Zinkhan, "Cultural Differences and Advertising Expression: A Comparative Content Analysis of Japanese and U.S. Magazine Advertising," *Journal of Advertising* 16 (1987): 68.

106. Mark Landler and Michael Barbaro, "Wal-Mart Finds That Its Formula Doesn't Fit Every Culture," *New York Times online* (August 2, 2006).

107. "Too Sexy for This City?" *San Francisco Chronicle* (November 25, 2004): A15.

108. Sternquist, *International Retailing*.

109. David A. Ricks, "Products That Crashed into the Language Barrier," *Business and Society Review* (Spring 1983): 46–50; "Speaking in Tongues," *@ Issue:* 3, no. 1 (Spring 1997): 20–23.

110. MTV Europe, personal communication (1994); see also Teresa J. Domzal and Jerome B. Kernan, "Mirror, Mirror: Some Postmodern Reflections on Global Advertising," *Journal of Advertising* 22, no. 4 (December 1993): 1–20; Douglas P. Holt, "Consumers' Cultural Differences as Local Systems of Tastes: A Critique of the Personality-Values Approach and an Alternative Framework," *Asia Pacific Advances in Consumer Research* 1 (1994): 1–7.

111. Roberto Grandi, "Benetton's Advertising: A Case History of Postmodern Communication," Unpublished manuscript, Center for Modern Culture & Media, University of Bologna, 1994; David Moin, "Benetton Gets Political Again," *Women's Wear Daily* (February 21, 2003): 13.

112. Douglas B. Holt, John A. Quelch, and Earl L. Taylor, "How Global Brands Compete," *Harvard Business Review* (September 2004): 68–75.

113. "They All Want to Be Like Mike," *Fortune* (July 21, 1997): 51–53.

114. Quoted in Calvin Sims, "Japan Beckons, and East Asia's Youth Fall in Love," *New York Times* (December 5, 1999): 3.

115. Birgita Forsberg, "Trendy IKEA Ho-Hum at Home," *San Francisco Chronicle* (January 22, 2005): C1.

116. Jehangir S. Pocha, "Craving U.S. Products," *San Francisco Chronicle* (July 15, 2005): C1.

117. Special Report, "Brands in an Age of Anti-Americanism," *Business Week* (August 4, 2003): 69–76.

118. Laurel Wentz and Claire Atkinson, "Apprentice Translators Hope for Hits All over Globe," *Advertising Age* (February 14, 2005): 3.

119. John F. Sherry Jr. and Edward G. Camargo, "French Council Eases Language Ban," *New York Times* (July 31, 1994): 12.

120. Craig Nelson, "The Middle East's Answer to Barbie: Demure Fulla," *San Francisco Chronicle* (November 24, 2005): A1.

121. Material in this section adapted from Güliz Ger and Russell W. Belk, "I'd Like to Buy the World a Coke: Consumptionscapes of the 'Less Affluent World,'" *Journal of Consumer Policy* 19, no. 3 (1996): 271–304; Russell W. Belk, "Romanian Consumer Desires and Feelings of Deservingness," in *Romania in Transition*, ed. Lavinia Stan (Hanover, N.H.: Dartmouth Press, 1997), 191–208; see also Güliz Ger, "Human Development and Humane Consumption: Well-Being Beyond the Good Life," *Journal of Public Policy and Marketing* 16 (1997): 110–125.

122. Professor Güliz Ger, Bilkent University, Turkey, personal communication (July 25, 1997).

123. Erazim Kohák, "Ashes, Ashes … Central Europe After Forty Years," *Daedalus* 121 (Spring 1992): 197–215; Belk, "Romanian Consumer Desires and Feelings of Deservingness."

124. David Murphy, "Christmas's Commercial Side Makes Yuletide a Hit in China," *Wall Street Journal Interactive Edition* (December 24, 2002).

125. Quoted in Sheryl WuDunn, "Cosmetics from the West Help to Change the Face of China," *New York Times* (May 6, 1990): 16.

126. This example courtesy of Professor Russell Belk, University of Utah, personal communication (July 25, 1997).

127. Eric J. Arnould and Richard R. Wilk, "Why Do the Natives Wear Adidas: Anthropological Approaches to Consumer

Research," in *Advances in Consumer Research* 12 (Provo, Utah: Association for Consumer Research, 1985), 748–752.

128. Miriam Jordan, "India Decides to Put Its Own Spin on Popular Rock, Rap and Reggae," *Wall Street Journal Interactive Edition* (January 5, 2000); Rasul Bailay, "Coca-Cola Recruits Paraplegics for 'Cola War' in India," *Wall Street Journal Interactive Edition* (June 10, 1997).

129. Rick Wartzman, "When You Translate 'Got Milk' for Latinos, What Do You Get?" *Wall Street Journal Interactive Edition* (June 3, 1999).

130. John F. Sherry Jr. and Eduardo G. Camargo, "'May Your Life be Marvelous': English Language Labeling and the Semiotics of Japanese Promotion," *Journal of Consumer Research* 14 (September 1987): 174–188.

131. Bill Bryson, "A Taste for Scrambled English," *New York Times* (July 22, 1990): 10; Rose A. Horowitz, "California Beach Culture Rides Wave of Popularity in Japan," *Journal of Commerce* (August 3, 1989): 17; Elaine Lafferty, "American Casual Seizes Japan: Teenagers Go for N.F.L. Hats, Batman and the California Look," *Time* (November 13, 1989): 106.

132. Lucy Howard and Gregory Cerio, "Goofy Goods," *Newsweek* (August 15, 1994): 8.

133. David Lyon, *Postmodernity* (Minneapolis, MN: University of Minnesota Press, 1994).

134. Susan Kaiser, "Identity, Postmodernity, and the Global Apparel Marketplace" in *The Meanings of Dress,* eds. Mary Lynn Damhorst, Kimberly A. Miller, and Susan O. Michelman (New York: Fairchild, 1999), 106–115.

135. Susan Kaiser, "Identity, Postmodernity, and the Global Apparel Marketplace," 114.

3
The Creation and Diffusion of Fashion Consumer Culture

As Alexandra is browsing through the racks at her local Abercrombie & Fitch store in Wichita, Kansas, her girlfriend Cloe yells to her, "Alex, check this out! These leopard-skin Capri pants are so tight!" From watching MTV, Alex knows tight means *cool*, and she agrees. As she takes the pants to the cash register, she's looking forward to wearing them to school the next day. All of her girlfriends in junior high compete with

each other to dress just like the women in Destiny's Child and other hot groups—her friends just won't believe their eyes tomorrow. Maybe some of the younger kids in her school might even think she was fresh off the mean streets of New York City! Even though she has never been east of the Mississippi, Alex just knows she would fit right in with all of the Bronx "sistahs" she reads about in her magazines.

THE CREATION OF CULTURE

Even though inner-city teens represent only 8 percent of all people in that age group and have incomes significantly lower than their white suburban counterparts, their influence on young people's musical and fashion tastes is much greater than these numbers would suggest. Turn on MTV, and it won't be long before a rap video fills the screen. Go to the newsstand, and magazines like *Vibe* are waiting for you. Numerous Web sites like www.vibe.com, www.templeofhiphop.org, and www.b-boys.com are devoted to hip-hop culture.

In addition to music, "urban" fashion is spreading into the heartland as major retail chains pick up on the craze and try to lure legions of young middle-class shoppers. Macy's and JCPenney carry FUBU ("for us by us"); although this urban clothing company sells a lot of shiny satin baseball jackets, baggy jeans with loops, and fleece tops in the inner city, 40 percent of its sales are to white customers in the suburbs. Big names like Versace, Tommy Hilfiger, Polo by Ralph Lauren, Nautica, Sean Jean, and Guess have become standard issue for kids who are into the hip-hop nation. Web sites like www.hiphopcapital.com sell grillz and bling bling, emblems of the hip-hop culture. How does this subculture influence the mass market in so many ways? Americans always have been fascinated by outsider heroes—whether John Dillinger, James Dean, or Dr. Dre—who achieve money and fame without being hemmed in by societal constraints. As one executive of a firm that researches urban youth noted, "People resonate with the strong anti-oppression messages of rap, and the alienation of blacks."[1]

Ironically, the only "oppression" Alex has experienced is being grounded by her parents after her mom found a half-smoked cigarette in her room. She lives in a white middle-class area in the Midwest, but she is able to "connect" symbolically with millions of other young consumers by wearing styles that originated far away—even though the original meanings of those styles have little relevance to her. As a privileged member of "white bread" society, her hip-hop clothes have a very different meaning in her suburban world than they would to street kids in New York City or Los Angeles. These cutting-edge types might even interpret the fact that Alex is wearing a style as a sign that this item is no longer in fashion and decide it is time to move on to something else.

Big corporations are working hard to capture the next killer fashion being incubated in black urban culture—what is called "flavor" on the streets. For example, Fila, which started as an Italian underwear maker in 1926, initially broke into sportswear by focusing on "lily-white" activities like skiing and tennis, and first made a splash by signing Swedish tennis sensation Bjorn Borg as an endorser. Ten years later, the tennis fad faded, but company executives noticed that rap stars like Heavy D were wearing Fila sweat suits to symbolize their idealized vision of life in white country clubs. Fila switched gears and went with the flow, and its share of the sneaker market grew dramatically as a result.[2]

How did hip-hop music and fashions, which began as forms of expression in the black urban subculture, make it to mainstream America? Here's a brief chronology:

- *1968:* Bronx DJ Kool Herc invents hip-hop.
- *1973–1978:* Urban block parties feature break dancing and graffiti.

- *1979:* A small record company named Sugar Hill becomes the first rap label.
- *1980:* Manhattan art galleries feature graffiti artists.
- *1981:* Blondie's song "Rapture" hits number one on the charts.
- *1985:* Columbia Records buys the Def Jam label.
- *1988:* MTV begins *Yo! MTV Raps*, featuring Fab 5 Freddy.
- *1990:* Hollywood gets into the act with the hip-hop film *House Party;* Ice-T's rap album is a big hit on college radio stations; amid controversy, white rapper Vanilla Ice hits the big time; NBC launches a new sitcom, *Fresh Prince of Bel Air.*
- *1991:* Mattel introduces its Hammer doll (a likeness of the rap star Hammer, formerly known as M. C. Hammer); designer Karl Lagerfeld shows shiny vinyl raincoats and chain belts in his Chanel collection; designer Charlotte Neuville sells gold vinyl suits with matching baseball caps for $800; Isaac Mizrahi features wide-brimmed caps and takeoffs on African medallions; Bloomingdale's launches Anne Klein's rap-inspired clothing line by featuring a rap performance in its Manhattan store.
- *1992:* Rappers start to abandon this look, turning to low-fitting baggy jeans, sometimes worn backwards; white rapper Marky Mark appears in a national campaign wearing Calvin Klein underwear, exposed above his hip-hugging pants; composer Quincy Jones launches *Vibe* magazine, and it gains a significant white readership.[3]
- *1993:* Hip-hop fashions and slang continue to cross over into mainstream consumer culture. An outdoor ad for Coca-Cola proclaims, "Get Yours 24–7." The company is confident that many viewers in its target market will know that the phrase is urban slang for "always" (24 hours a day, 7 days a week).[4]
- *1994:* The Italian designer Versace, among other upper-end designers, pushes oversized overalls favored by urban kids. One ad asks: "Overalls with an oversize look, something like what rappers and homeboys wear. Why not a sophisticated version?"[5]
- *1996:* Tommy Hilfiger, a designer who was the darling of the preppie set, turns hip-hop. He gives free wardrobes to rap artists like Grand Puba and Chef Raekwon and in return found his name mentioned in rap songs—the ultimate endorsement. The September 1996 issue of *Rolling Stone* features the Fugees, with the Hilfiger logo prominently displayed by several band members. In the same year the designer uses rap stars Method Man and Treach of Naughty by Nature as runway models. Hilfiger's new Tommy Girl perfume plays on his name but also is a reference to the New York hip-hop record label Tommy Boy.[6]
- *1997:* Coca-Cola features rapper LL Cool J in a commercial that debuts in the middle of the sitcom *In the House*, a TV show starring the singer.[7]
- *1998:* In its battle with Dockers for an increased share of the khaki market, Gap launches its first global ad campaign. One of the commercials, "Khakis Groove," includes a hip-hop dance performance set to music by Bill Mason.[8] An urban-oriented trade show for retail

buyers called Vibestyle receives considerable attention when it opens in New York. Shows include music and entertainment and major exhibitors such as FUBU and Tommy Hilfiger. The show clearly identifies with hip-hop.

- *1999:* Rapper turned entrepreneur Sean (Puffy) Combs introduces an upscale line of menswear he calls "urban high fashion." New companies FUBU, Mecca, and Enyce attain financial success in the multibillion-dollar industry.[9] Lauryn Hill and the Fugees sing at a party sponsored by upscale Italian clothier Emporio Armani and proclaim, "We just wanna thank Armani for giving a few kids from the ghetto some great suits."[10]

- *2000:* Hip-hop goes digital when www.360hip-hop.com, a Web-based community dedicated to the hip-hop culture, is launched. Consumers can purchase clothing and music online while watching video interviews with such artists as Will Smith and Busta Rymes.[11] A UC Berkeley class analyzes hip-hop as popular culture using the text *Droppin' Science: Critical Essays on Rap Music and Hip Hop Culture.* The Vibestyle fashion show represents the "new youth" on a basketball court and defines hip-hop in 2000 as a combination of activewear, streetwear, retro, utility, and attitude.[12]

- *2002–2003:* Toy manufacturers mimic the hip-hop practice of using the letter "Z" instead of the letter "S" in names, a trend started with the 1991 film *Boyz N the Hood.* During the 2002 Christmas season, Target created a kids' section called "Kool Toyz," with dolls with names like Bratz (Girlz and Boyz), Diva Starz, and Trophy Tailz.[13]

- *2005–2006:* Successful artists begin to expand their empires into other categories. Jay-Z uses his hip-hop fortune to become part owner of the New Jersey Nets basketball team; Nelly buys into the Charlotte Bobcats and then branches out into the energy drink, and 50 Cent invests in "Vitamin Water." Esquire names Andre 3000 of Outkast the world's best-dressed man. *The Wire* becomes a popular show on HBO.

- *2007–2008:* Hip-hop disengages from its American roots as artists around the world develop their own localized interpretations. An aboriginal Australian hip-hop dancer tells a crowd the FUBU brand shirt he is wearing means "full blond."[14] Home-grown European artists are popular, such as Jokeren and Den Gale Pose in Denmark, Statis and NATill in Germany, and Sway in the United Kingdom.[15]

It's quite common for mainstream culture to modify symbols identified with cutting-edge subcultures and present these to a larger audience. As this occurs, these cultural products undergo a process of **cooptation** in which their original meanings are transformed by outsiders. In this case, rap music was to a large extent divorced from its original connection with the struggles of young African Americans and is now a mainstream entertainment format.[16] One writer sees the white part of the "hip-hop nation" as a series of concentric rings. In the center are those who actually know blacks and understand their culture. The next ring consists of those who have indirect knowledge of this subculture via friends or relatives but who don't actually rap, spray-paint, or break-dance. Then there are those a bit

Hip-hop style is combined with an Asian motif at the Vibestyle trade show in New York.

further out who simply play hip-hop between other types of music. Finally come those who are simply trying to catch on to the next popular craze.[17] The spread of hip-hop fashions and music is just one example of what happens when the marketing system takes meanings created by some members of a culture, reinterprets them, and produces them for mass consumption.

This chapter considers how the culture in which we live creates the meaning of everyday products and how these meanings move through a society to consumers. As Figure 3-1 shows, the advertising and fashion industries help to transfer meaning by associating functional products with symbolic qualities such as sexiness, sophistication, or being just plain "cool." These goods, in turn, impart their meanings to consumers as they use these products to create and express their identities.[18]

FIGURE 3-1
The Movement of Meaning
Source: Adapted from Grant McCracken, "Culture and Consumption: A Theoretical Account of the Structure and Movement to the Cultural Meaning of Consumer Goods," *Journal of Consumer Research* 13 (June 1986): 72. Reprinted with permission of The University of Chicago Press.

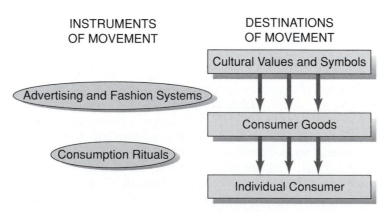

INSTRUMENTS OF MOVEMENT

DESTINATIONS OF MOVEMENT

Cultural Values and Symbols

Advertising and Fashion Systems

Consumer Goods

Consumption Rituals

Individual Consumer

Cultural Selection

Leopard-skin pants. Nipple rings. Platform shoes. Sushi. High-tech furniture. Postmodern architecture. Chat rooms. Double decaf cappuccino with a hint of cinnamon. We inhabit a world brimming with different styles and possibilities. The clothes we wear, the food we eat, the cars we drive, the places we live and work, the music we listen to—all are influenced by the ebb and flow of popular culture and fashion.

Consumers may at times feel overwhelmed by the sheer number of choices in the marketplace. A person trying to decide on something as routine as a necktie has many hundreds of alternatives from which to choose. Despite this seeming abundance, however, the options available to consumers at any point in time actually represent only a small fraction of the total set of possibilities.

The selection of certain alternatives over others—whether dresses, automobiles, computers, recording artists, political candidates, religions, or even scientific methodologies—is the culmination of a complex filtration process resembling a funnel as depicted in Figure 3-2. Many possibilities initially compete for adoption, and these are steadily winnowed out as they make their way down the path from conception to consumption in a process of **cultural selection**.

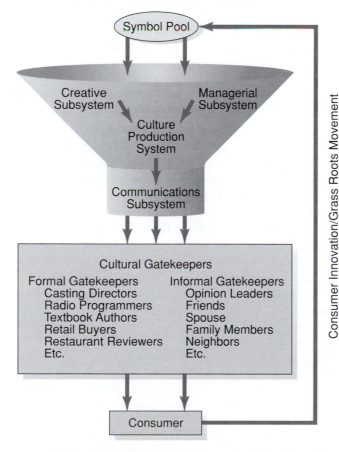

FIGURE 3-2
The Culture Production Process
Source: Adapted from Michael R. Solomon, "Building Up and Breaking Down: The Impact of Cultural Sorting on Symbolic Consumption," in *Research in Consumer Behavior,* ed. J. Sheth and E. C. Hirschman © 1988, pp. 325–351, with permission from Elsevier Science.

We don't form our tastes and product preferences in a vacuum. Our choices are driven by the images presented to us in mass media, by our observations of those around us, and even by our desires to live in the fantasy worlds created by marketers. These options are constantly evolving and changing. A clothing style or type of cuisine that is "hot" one year may be "out" the next.

In the chapter-opening scene, Alex's emulation of hip-hop style illustrates some of the characteristics of fashion and popular culture:

- Fashions often are a reflection of deeper societal trends (e.g., politics and social conditions).

- A fashion often begins as a risky or unique statement by a relatively small group of people and then spreads as others increasingly become aware of it and feel confident about trying it.

- Fashions usually originate as an interplay between the deliberate inventions of designers and businesspeople and spontaneous actions by ordinary consumers who modify the fashion to suit their needs. Designers, manufacturers, and merchandisers who can anticipate what consumers want will succeed in the marketplace. In the process, they also help to fuel the fire by encouraging mass distribution of the item.

- These cultural products can travel widely, often across countries and even continents.

- Influential people in the media play a large role in deciding which fashions will succeed.

- Most fashions eventually wear out, as people continually search for new ways to express themselves and marketers scramble to keep up with these desires.

Culture Production Systems

No single designer, company, or advertising agency is totally responsible for creating popular culture. Every product, whether a new clothing style, a hit record, or a car, requires the input of many different participants. The set of individuals and organizations responsible for creating and marketing a cultural product is a **culture production system**.[19]

The nature of these systems helps to determine the types of products that eventually emerge from them. Factors such as the number and diversity of competing systems and the amount of innovation versus conformity that is encouraged are important. For example, apparel is an industry comprised of many companies with a great deal of competition. Designers and manufacturers strive to create uniqueness as a way to differentiate themselves from others, thus creating a unique image for which they become known. At the same time, however, large mass-market companies such as The Limited and Gap and power brands such as Calvin Klein, Ralph Lauren, Tommy Hilfiger, and Donna Karan tend to dominate retail with increasingly similar looks. With mergers a way of life in the fashion industry, it is more and more difficult for designers to remain independent. But smaller firms are more flexible and many, such as Betsy Johnson, say they can better control company direction and product quality by remaining independent.[20]

The different members of a culture production system may not necessarily be aware of or appreciate the roles played by other members, yet

many diverse agents work together to create popular culture.[21] Each member does his or her best to anticipate which particular images and styles will be most attractive to a consumer market. Of course, those who are able to consistently forecast consumers' tastes most accurately will be successful over time.

Components of a Culture Production System

A culture production system (CPS) has three major subsystems:

1. The *creative subsystem* is responsible for generating new symbols and/or products.
2. The *managerial subsystem* is responsible for selecting, making tangible, mass-producing, and managing the distribution of new symbols and/or products.
3. The *communications subsystem* is responsible for giving meaning to the new product and providing it with a symbolic set of attributes that is communicated to consumers.

An example of the three components of a culture production system for a fashion item would be (1) a designer (e.g., Calvin Klein, a creative subsystem); (2) a company (e.g., a licensing company that manufactures and distributes CK Jeans, a managerial subsystem); and (3) the advertising and publicity agencies (agencies hired to promote the jeans, a communications subsystem). Table 3-1 illustrates some of the many *cultural specialists* who are required to

Table 3-1 Apparel Specialists in the Fashion Industry

Specialist	Function
Designer	Designs the specific items in a line and translates these ideas into finished patterns by draping muslin on a dress form or drafting a flat pattern using a sloper
Merchandiser	Conducts research for future styles and trends, plans, and decides the number of items in a line for each season
Piece-goods/trim buyer	Purchases all raw materials
Costing engineer	Analyzes the cost of manufacturing each item and the final wholesale price to the retailer
Quality control engineer	Develops standards of production, identifies problems, and works with the production staff to correct them
Production patternmaker	Produces the perfect pattern once a sample is accepted for the line
Grader	Sizes the pattern
Marker maker	Lays out the pattern pieces on the fabric for cutting
Sewing contractor	Contracts out the sewing process
Manufacturer's rep	Shows samples of the line to retail buyers
Retail buyer	Researches the market for current trends and buys the best goods in a given category
Planner	Decides on the amount of merchandise to order for each store in a chain; works with buyer
Controller	Manages the retailer's financial plans
Store manager	Oversees merchandise categories, ensures that problems are dealt with, and supervises the entire staff
Merchandise manager	Develops and oversees a division's objectives in merchandise planning, buying, advertising, and promotion
Sales manager	Supervises the receiving of merchandise and updates inventory
Salesperson	Sells; provides information and assistance to customers; maintains displays and balances daily cash receipts
Advertising department	Conceives and develops ideas for campaigns and creates advertisements to promote the merchandise
Public relations department	Deals with the public in areas related to exposure and recognition of the company

create a hot new fashion. About halfway through the fashion CPS is where knockoff companies come into play, as described in Chapter 1, when the designer's work is copied, quickly manufactured, and sold to lower-end retail-ers, discounters, and mass merchandisers. This process is facilitated by com-panies like firstVIEW (www.firstview.com), that help distribute the new designer information instantly.

Cultural Gatekeepers

Many judges or "tastemakers" influence the products that are eventually offered to consumers. These **cultural gatekeepers** are responsible for filtering the overflow of information and materials intended for consumers. Gatekeepers include magazine editors, retail buyers, movie and restaurant reviewers, interior designers, and disc jockeys. Collectively, social scientists call this set of agents the *through-put sector*.[23] One of the most important gatekeepers for apparel designers is *Women's Wear Daily*, which reviews and publicizes the new collec-tions each season. A bad review in this publication can be devastating for designers, new and established alike, as the slogan "you're only as good as your last collection" is pretty much the rule on Seventh Avenue.

High Culture and Popular Culture

Do Beethoven and Puff Daddy have anything in common? Although we associate both the famous composer and rap singer with music, many would argue that the similarity stops there. Culture production systems create many kinds of products, but some basic distinctions can be offered regarding their characteristics.

Arts and Crafts

One distinction is between arts and crafts.[24] An **art product** is viewed prima-rily as an object of aesthetic contemplation without any functional value. A **craft product**, in contrast, is admired because of the beauty with which it per-forms some function (such as a hand-knitted afghan). A piece of art is origi-nal, subtle, and valuable and typically is associated with the elite of society. A craft tends to follow a formula that permits rapid production. According to this framework, elite culture is produced in a purely aesthetic context and is judged by reference to recognized classics. It is high culture—"serious art."[25]

Fashion and Art

Where would you categorize clothing and fashion? Is it an art? Is it a craft? a one of a kind "art-to-wear" hand-painted silk kimono might be classified

as art even though it may be worn as a functional item. Similar items are showcased on the wall as art pieces and never meant to be worn. Some feel haute couture can be considered art because a $30,000 one-of-a-kind creation from a top designer is comparable to a painting hanging in someone's living room or in a museum. On the other hand, fashion by definition is designed and produced with the purpose of selling to a mass market for profit. It is not considered art. Art purists consider anything that is not original and is mass-produced or copied to be *kitsch*, or tacky.

The age-old tension in fashion between art and commerce was highlighted when Jil Sander resigned from the Prada Group in early 2000 over a dispute related to creativity versus cost control. Designers fear losing control over their creative endeavors when joining a mass market group. On the other hand, large design houses (more and more prevalent today with mergers and takeovers) have the capital to offer their top designers the freedom to "live out their fantasies."[26] That appears to be the case with John Galliano, designer for Dior (part of LVMH), and Alexander McQueen for Gucci who both offer edgy to extreme collections. Some say that the big luxury houses like LVMH and Prada Group provide these pricey, edgy looks to build hype so that they can eventually sell logo products at the lower end. Donna Karan, although she has mass merchandised lines such as DKNY, is not ready to "go Gap." She says, "I couldn't live without the artistic hand in fashion . . . for me, fashion is sculpture for the human body."[27] But fashion is a business and the bottom line is selling clothes.

Christian Lacroix and other edgy designers have the financial backing to "live out their fantasies."

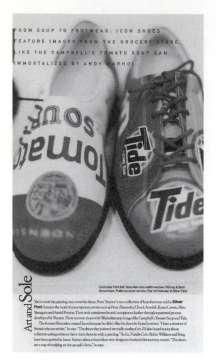

Pop Art footwear by Peter Traynor is reminiscent of Andy Warhol. Traynor says, "The shoes are a way of working art into people's lives."

French designer Lacroix put the concept of fashion and art in this perspective: ". . . a dress which isn't worn doesn't exist for me. If I want to go even further in my fantasies, I turn to the theater so that these kinds of creations can exist on stage . . . or I look toward conceptual art, presenting myself to galleries to present my most radical ideas."[28] Thus, he sees fashion and art as a sort of continuum. Rei Kawakubo said, "Fashion is not art. Art is for museums, galleries or the home. Fashion is living and is to be worn. What I find interesting is the synergy that can occur when different kinds of creation come together. This is the beauty of collaboration and the meaning of the meeting of art and fashion or art within fashion."[29]

The first acknowledged couturier (as opposed to dressmaker) was Charles Worth, whose work for the French imperial court was disseminated throughout Europe in the 1860s and later in America. Designers have been selling their "art" ever since. Some feel the most effective link between art and fashion was during the 1930s when the designer Elsa Schiaparelli joined with surrealists, particularly Salvador Dali. Her designs included surreal decorative detail such as a piece of witty trompe l'oeil beading on a jacket or a hat in the form of a vegetable or item of furniture.[30]

Peter Wollen notes that "the design and making of garments has traditionally been viewed as artisanal (craft) rather than artistic . . . its status, however, has continued to rise during the last 200 years."[31] Not every art critic agrees, as the commercial character of fashion in constant change is the antithesis of what art represents. Inspiration from art such as Yves Saint Laurent's 1965 Mondrian couture dresses, Versace's 1991 Andy Warhol's polychrome portraits of James Dean and Marilyn Monroe, Stephen Sprouse's Pop Art prints, or Karl Lagerfeld's Watteau collections are thought of by some as not just inspiration from history, but cannibalizing. Although many fashion designers are inspired by art, others believe that if you take it too literally you will only sell a piece of it.

Fashion has often been represented as an art form and showcased in art museums and at times is coupled with other art pieces. A good example is the Saks Fifth Avenue's Project Art and Art Collection initiative, which seeks to combine the worlds of fashion, art, and design in an accessible way for the public. The Art Collection includes more than a thousand permanently installed artworks on display in Saks Fifth Avenue stores nationwide. Project Art uses storefront windows as gallery space with works of photographer William Wegman, sculptor Charles Long, and painter-sculptor Kenny Scharf showcased in their store windows. Madison Avenue stores in New York including Ralph Lauren and Versace teamed up with artists for a promotion of the area called "Where Fashion Meets Art." Local gallery art was displayed next to fashion items.[32] Montblanc asked artists to embellish shopping bag sculptures on view at Rockefeller Center; Ferragamo and Hermes opened galleries in or near their flagships. Some question whether a fashion brand can show edgy or controversial art when its first obligation is to the sensibilities of its customers.[33]

There have been many museum exhibitions of fashion and the close connections of fashion with art, such as the following:

- In the 1980s Issey Miyake's was said to be the first popular designer to show his work in a museum (San Francisco Museum of Modern Art)

This Scharf display was in Saks Fifth Avenue's window at Christmas.

Issey Miyake's work shown at the San Francisco Museum of Modern Art in the 1980s was different from his designs sold in department stores, but this was the first time a designer's work was found in both places at the same time.

at the same time as it was being sold in a department store (I. Magnin). Since then we see other examples. Miyake also features new artists' work in his Miyake Design Studio Gallery in Tokyo near his store.[34]

- The Costume Institute of the Metropolitan Museum of Art in New York has presented many noteworthy exhibits including "25 years of Yves St. Laurent" in 1985, a retrospective of Gianni Versace's work in 1998 following his death (over 410,000 people viewing the exhibit, "indicative of how fashion plays a broader cultural role than anyone had imagined," said Richard Martin, curator of the exhibit[35]), Chanel in 2005, and in 2006 "AngloMania: Tradition and Transgression in British Fashion."

- The Fashion Institute of Technology museum for many years has presented exhibits of its collections. While Richard Martin was curator, he created such landmark fashion exhibits as "Three Women" (Claire McCardell, Rei Kawakubo, and Madeleine Vionnet), "Fashion and Surrealism," "Splash!" and "Jocks and Nerds."

- In 1996, the Biennale di Firenze (Florence, Italy) presented an exhibit called Art/Fashion, curated by Franca Sozzani, editor in chief of the Italian *Vogue*. It featured collaborations between artists and fashion designers.

- Fashion designers and retailers sponsor art exhibits. In 1996, Donna Karen sponsored "New York New York: City of Ambition" at the Whitney Museum of American Art. In 1998, Calvin Klein sponsored an exhibition of Man Ray photography in Paris. Banana Republic co-sponsored (with BMW and Lufthansa) "The Art of the Motorcycle," a retrospective at the Guggenheim, and also sponsored an Alexander Calder exhibition at San Francisco's MOMA. Hugo Boss has been a longtime benefactor of the Guggenheim and recently the museum has administered an award named for Hugo Boss for emerging artists. Saks Fifth Avenue has integrated art exhibits into its window displays under the Project Art program with borrowed paintings from the Royal Academy of London.[36]

- In 1999, the Hayward Gallery in London showed "100 Years of Art and Fashion."

- Nike set up a New York gallery art exhibit of its new Air Presto sneakers. "We wanted to push the product toward art. We wanted to present Air Presto in a different light since the product aims to redefine sneakers" (a unisex stretch mesh product in seventeen colors and sizes from extra small to extra large.)[37]

- The much talked about and controversial exhibit at the New York and Bilbao Guggenheim in fall 2000 was a major retrospective of Giorgio Armani's work. The show was sponsored by *In Style* magazine, in which Armani was an advertiser. This advertising money and a sizable donation by Armani to the museum created a controversial perceived conflict of interest.

- In 2002 the Design Museum in London exhibited "John Galliano at Dior," featuring design themes such as "high life and low life." Also in 2002 the Victoria and Albert Museum in London presented "The Art and Craft of Gianni Versace," a retrospective of the late designer's work.[38]

- The International Festival of Fashion Arts awards a prize to an aspiring designer annually. The title of the event implies a melding of fashion and art.[39]
- In 2006 the Los Angeles County Museum of Art presented "Breaking the Mode: Contemporary Fashion From the Permanent Collection" showing inventive shapes and fabric surfaces.[40]

As we can see, the distinction between high and low culture is not as clear as it may first appear. In addition to the possible class bias that drives such a distinction (that is, we assume that the rich have culture while the poor do not), high and low culture is blending together in interesting ways. The relationship between art and fashion has been moving into the realm of marketing as discussed. The reason? Designers have discovered that art can sell apparel.[41] Their target market is involved with art as part of their lifestyle.

Popular culture reflects the world around us; these phenomena touch rich and poor. All cultural products that are transmitted by mass media become a part of popular culture.[42] Classical recordings are marketed in much the same way as Top 40 albums, and museums use mass-marketing techniques to sell their wares. The Metropolitan Museum of Art even runs a satellite gift shop offering copies of artwork at Macy's Herald Square in Manhattan and at the Westfield San Francisco Centre.

Cultural Formulas

Mass culture churns out products specifically for a mass market. These products aim to please the average taste of an undifferentiated audience and are predictable because they follow certain patterns. Many popular art forms,

such as detective stories or science fiction, generally follow a **cultural formula**, in which certain roles and props often occur consistently.[43] Romance novels are an extreme case of a cultural formula. Computer programs even allow users to "write" their own romances by systematically varying certain set elements of the story.

Reliance on these formulas also leads to a recycling of images, as members of the creative subsystem reach back through time for inspiration. Thus, young people watch retro TV shows like *Gilligan's Island*. Apparel designers modify styles from Victorian England, colonial Africa, and other historical periods and use art inspiration as discussed earlier. We also see Gap ads and commercials featuring icons such as Audrey Hepburn dancing in skinny black pants and Humphrey Bogart, Gene Kelly, and Pablo Picasso dressed in khaki pants. And the regeneration of images in the postmodern world (see Chapter 2) is accelerating, as the technology of borrowing becomes more available. With easy access to DVD/VCRs, CD and DVD burners, digital cameras and imaging software, virtually anyone can "remix" the past.[44]

Reality Engineering

Many of the environments in which we find ourselves, whether shopping malls, sports stadiums, or theme parks, are composed at least partly of images and characters drawn from products, marketing campaigns, or the mass media. **Reality engineering** occurs as elements of popular culture are appropriated by marketers and converted to vehicles for promotional strategies.[45] These elements include sensory and spatial aspects of everyday existence, whether in the form of products appearing in movies and TV or odors pumped into offices and stores. It's hard to know what's real anymore; even "used jeans" get created by specialists who apply chemical washes, sandpaper, and other techniques to make a new pair of jeans look like they're ready for retirement. The industry even has a term for this practice that sums up the contradiction: *new vintage*.[46]

REALITY ENGINEERING

One of the most controversial intersections between marketing and society occurs when companies provide "educational materials" to schools. Many firms, including Nike, Hershey, Crayola, Nintendo, and Foot Locker, provide free book covers covered with ads. Twelve thousand secondary schools in the United States start the day with a video feed from Channel One, which exposes 8 million students to commercials in the classroom in exchange for educational programming.[47] The Seattle School Board voted to accept corporate advertising in middle and high schools, and students in Colorado Springs ride in buses adorned with company logos; in San Francisco Bay Area, it's Old Navy. In some schools third graders use reading software that sports logos from Kmart, Coke, and Pepsi. Nike donates to many school sports programs.

Math problems in school textbooks use Nike shoes, M&Ms, Pop Secret, and many other brands popular with chil-

dren. In this case textbook publishers say they take no money for product placement—all they are trying to do is make math more interesting by using real examples. Parents, educators, and lawmakers in California feel children should not be subjected to unnecessary advertising since they are a captive audience.[48]

Corporate involvement with schools is hardly new—in the 1920s Ivory Soap sponsored soap-carving competitions for students. But the level of intrusion is sharply increasing, as companies scramble to compensate for the decrease in children's viewership of television on Saturday mornings and weekday afternoons and find themselves competing with videos and computer games for their attention. Many educators argue that these materials are a godsend for resource-poor schools.[49] What do you think?

Marketing sometimes seems to exert a self-fulfilling prophecy on popular culture. As commercial influences on popular culture increase, marketer-created symbols make their way into our daily lives to a greater degree. Analyses of Broadway plays, best-selling novels, and the lyrics of hit songs, for example, clearly show large increases in the use of brand names over time.[50]

Reality engineering is accelerating due to the current popularity of product placements by marketers. It is quite common to see real brands prominently displayed or to hear them discussed in movies and on television. In many cases, these "plugs" are no accident. **Product placement** refers to the insertion of real products and/or the use of brand names in movies, TV shows, books, plays and video games.

Many types of products play starring (or at least supporting) roles in our culture; in 2007, for example, the most visible brands ranged from Coca-Cola and Nike apparel to the Chicago Bears football team and the Pussycat Dolls band.[51] Consumers respond well to placements when the show's plot makes the product's benefit clear. For example, audiences have a favorable impression of retailers that provide furniture, clothes, appliances, and other staples for struggling families who get help on ABC's *Extreme Makeover: Home Edition*.[52]

Fashion Products in Movies, TV, and Video Games

Some researchers claim that product placement can aid in consumer decision making because the familiarity of these props creates a sense of cultural belonging while generating feelings of emotional security.[53] Costs of such placement vary from just getting the merchandise to the set on time to millions of dollars. Risks of such expenditures include the big close-up of the logo landing on the cutting room floor or the movie being a flop.[54] For better or worse products are popping up everywhere. Here are other examples of placements:

- *The Bachelor* features a department store window filled exclusively with DKNY merchandise and DKNY ads plastered on telephone poles and walls around the city.

- *All My Children* actually launched a new fragrance, "All My Children Fusion," on one episode with a cadres of beauty editors playing themselves. Previously the Enchantment fragrance premiered on *All My Children*, which was sold exclusively and successfully at Wal-Mart.[55]

- In the video game Cool Borders, three characters ride past Butterfinger candy bar banners and wear Levi's jeans while attempting to beat opponents' times as recorded on Swatch watches. A Sony PlayStation game called Psybadek outfits its main characters in shoes and clothing from Vans. A Sony executive comments, "We live in a world of brands. We don't live in a world of generics."[56] Even an updated version of Monopoly is using some branded tokens that march around the board, passing Go. They include a Motorola Razr cell phone, a New Balance running shoe, a cup of Starbucks coffee, and a Toyota Prius, making it a "representation of America in the 21st Century."[57]

- New York designer Anna Sui teamed up with illustrator Billy Tucci so that characters in the comic book "Shi" wear clothes, hosiery, and other Sui accessories.[58]

- Some say it's the stars of television who have not only been selling fashion and creating buzz but also influencing designers and inciting them to attempts at product placement. *Sex and the City, The Sopranos, Judging Amy*, and *Will & Grace* have been influential.[59] Manolo Blahnik became a household name with the huge exposure the company got as Carrie's favorite shoe designer in *Sex in the City*. With the ending of the show, many designers were hoping for another influential show.[60]

- One entire *Friends* episode concentrated on the mass marketing of furnishings from Pottery Barn.

- The CBS show *Survivor* portrays the adventures of sixteen people stranded on a desert island near Borneo for thirty-nine days. They battle for a chance to wear Reeboks, drink Budweiser, and sleep in a Pontiac Aztec sport-utility vehicle.[61] In China, a *Survivor* clone used twelve contestants who hunted for treasure in a Ford Maverick, wore Nike clothing, and cooled off with Nestlé drinks. Ford said it "really built the show around the product."[62]

- Whole episodes of *The Apprentice* can be seen as product placement as contestants market or design new products or promotions for one company. In one episode teams created promotions for Levi's with the winning group creating a jeans pocket-shaped brochure showcasing a range of styles with the participants as models. The brochure done in conjunction with JCPenney was distributed in its stores.

- *Project Runway*, the fashion industry's answer to reality TV, is said to be 80 percent entertainment and 20 percent reality. Vera Wang and other designers who served as judges and Heidi Klum, as host, became known to millions of households, and even college fashion program enrollment has gone up since the show aired on the Bravo network.[63] The winner of a challenge to design a career look that could be sold at Macy's was actually produced under Macy's INC label.[64]

Product placement has become an accepted form of advertising.

Traditionally, networks demanded that brand names be "greeked" or changed before they could appear in a show, as when a Nokia cell phone was changed to Nokio on *Melrose Place*.[65] Nowadays, though, real products are shown. Today most major movie releases are brimming with real products, even though a majority of consumers believe the line between advertising and programming is becoming too fuzzy and distracting.[66] Directors like to incorporate branded props because they contribute to the film's realism. When Stephen Spielberg did the movie *Minority Report,* he used such brands as Gap, Nokia, Reebok, Lexus, Pepsi, and American Express to lend familiarity to the futuristic setting (the year 2054). Lexus even created a new sports car model called the Maglev just for the film.[67]

TV and movie personalities wearing fashion can be extremely influential due to the huge exposure of the style or designer. Costumes from movies are sometimes directly copied or offer "inspiration" to other designers, and brand names get immense promotion. An episode of *Friends* inspired 30,000 calls about where to get Jennifer Aniston's pants; Sarah Jessica Parker wore a large pin-on flower and other accessories in *Sex and the City,* which created a huge demand for them.[68] Some think *Austin Powers, The Spy Who Shagged Me* may have been responsible for bringing back psychedilia and Pucci-inspired dresses.[69] Giorgio Armani suddenly became a leading designer in the United States after Richard Gere modeled his wardrobe in *American Gigolo*.[70] And when Sharon Stone wore a simple black Gap shirt to the Academy Awards, Gap stores were flooded with requests for that item. There is a long list of examples of the influence of film and TV stars on fashion starting with Gloria Swanson, Marlene Dietrich, Katharine Hepburn, Clark Gable, Elizabeth Taylor, and Marlon Brando, among others (see Chapter 12 for "Clothesline: The Leading Ladies"), and movies and TV shows over the years such as *Annie Hall, Urban Cowboy, Out of Africa, Miami Vice, Dynasty, Murphy Brown, Friends,* and *Sex in the City,* among others. Television, perhaps more than any other medium, has an impact on worldwide trends and influences the acceptance of global apparel brands such as Nike, Levi's, and Calvin Klein.

Product placement is becoming so commonplace that it's evolving into a new form of promotion called **branded entertainment**, showcasing products in a longer format. The reality show *Unwrapping Macy's* on WE (the Women's Entertainment network) is the latest entrant to the emerging genre of corporate TV docudramas combining realism with the hucksterism of an infomercial.[71] Not everyone is in favor of this. The Writer's Guild of America West is making fun of the interweaving of product into films and TV shows with a viral video on a union-sponsored Web site where Tyra Banks, the host of the popular reality series *America's Next Top Model* on UPN, is mocked. The video shows an actress portraying Ms. Banks in a mock episode of "America's Next Top Commercial." It relentlessly mocks Procter & Gamble products and even rents out space on Banks's forehead to advertisers like Nike.[72]

THE DIFFUSION OF INNOVATIONS

An **innovation** is any product or service that is perceived to be new by consumers (even if it has long been used by others elsewhere). Innovations may take the form of a new clothing style, a new manufacturing technique (such

as the ability to design your own running shoe at www.nike.com), or a novel way to deliver a service (such as a new way of sharing home videos online).

A **fashion innovation** can be thought of as a style, design, or look perceived as new by consumers. The apparel fashion industry offers the public new styles or variations of former styles with new fabrications and detail on an ongoing basis encouraging us to replace last year's purchases. Seen as wasteful and frivolous by some, this has long been a criticism of the fashion industry. Some companies have developed a more responsible perspective of "updating" and building wardrobes through a system of basics that serve as the backbone of a wardrobe, which can be added to with new coordinating items each season. These companies are more likely to offer conservative, career-oriented apparel rather than young, cool, fashion-forward merchandise. Consumers evaluate new offerings and decide whether to "indulge" in new purchases each season. Thus, adoption of fashion innovations is a continual process.

The fashion innovation may be completely out of the control of the fashion industry, as when young people combine items on their own for a new look that no one company offers. Recall the discussion on trickle-up fashion leadership theory in Chapter 1. Young people searching thrift shops for new ideas and mixing it with other items has been popular for some time. Currently a mixed look is hot in Japan: Young Japanese consumers are combining classic looks from Gap (and Uniqlo, the Japanese equivalent) with an expensive Gucci watch, Louis Vuitton handbag, or Prada accessories. And classic button-down shirts coordinated with jeans, skirts, and sandals are hot.[73]

If an innovation is successful (most real innovations are not), it spreads throughout the population. First, it is bought and/or used by only a few people, and then more and more consumers decide to adopt it until, in some cases, it seems that almost everyone has bought or tried the innovation. **Diffusion of innovations** refers to this process whereby a new product, service, or idea spreads through a population.[75]

MULTICULTURAL DIMENSIONS

Tokyo seems to be bursting with streetwear trends. "A lot of fashion streets exist in Tokyo now," said Tsuyoski Kawata, a fashion trend analyst and fashion editor. Shibuya and Harajuku are well known as fashion areas for young streetwear; but now Daikanyama and Ura-Harajuku are also very popular. Daikanyama, which is both a street and a neighborhood, is a three-minute train ride from Shibuya. It is an emerging shopping area for young people. Hollywood Ranch Market, a store that carries California-inspired styles from the sixties and seventies located in Daikanyama, is getting more teens shopping. Harajuku, the heart of young streetwear in Tokyo, is constantly evolving. Ura-Harajuku (or off-Harajuku) is now one of the hottest areas in town as young independent designers who cannot afford shops on the main strip are finding lower-cost space nearby. This is where fashion-conscious people come to find new looks. Tokyo is becoming a mecca for trendspotting by merchandisers and designers around the world.

Stores are expanding their offerings as they key on a lifestyle concept, one that has been critical for American retailers in recent years. "Only selling clothes is not enough," said a spokesperson for the area. "We sell CDs as well." And the recent invasion by Starbucks has accelerated a custom that is new for many Japanese: relaxing over a cup of coffee. In response, several shops are adding their own cafes. Japanese consumers, like others around the world, get their information instantaneously from local and international sources.[74]

How fast and how far an innovation diffuses are influenced by many factors such as the communication and marketing channels used, the persuasive influence of consumer leaders (see Chapter 12), the mobility and geographic location of consumers, and social norms and mores. Some more daring styles, for example, may not be accepted in Peoria but could be widely accepted in New York and California. With time (and perhaps some modifications of the style), the new style can diffuse throughout the country. Some analysts feel new fashion ideas start on the West and East Coasts of the United States and diffuse inward where consumers are more conservative. Some fashions start in Europe or in other parts of the world and diffuse to the United States, whereas others, such as California sportswear, start in the United States and diffuse around the world, as discussed in Chapter 2.

Adopting Innovations

Diffusion of the innovation focuses on the adoption decisions of many people within and across groups.[76] An individual consumer's adoption of an innovation resembles the decision-making sequence (see Chapter 11) as the person moves through each stage. The relative importance of each stage may differ depending on how much is already known about a product, as well as on cultural factors that may affect people's willingness to try new things.[77] Rogers's model of innovation adoption includes five stages:[78]

1. *Knowledge:* The consumer gains information about the innovation. He or she has awareness but has made no judgment.
2. *Persuasion:* The consumer begins to form a favorable or unfavorable opinion of the innovation. This stage is related to the perceived risk of the new product (or service)—that is, the evaluation of the consequences of using it.
3. *Decision:* The consumer decides to either adopt or reject the innovation.
4. *Implementation:* The consumer actually puts the product (or service) to use.
5. *Confirmation:* The consumer seeks reinforcement for the innovation decision.

Some researchers feel that the key to the diffusion of innovations may be in building consumer knowledge and patterns of experiencing it.[79] Therefore, companies of innovations need to get the word out.

Types of Adopters

Even within the same culture, not all people adopt an innovation at the same rate. Some do so quite rapidly, such as fashion-forward consumers, and others never do at all. Consumers can be placed into approximate categories based on their likelihood of adopting an innovation. The categories of adopters, shown in Figure 3-3, can be related to phases of the product life cycle concept used widely by marketing strategists.

As can be seen in Figure 3-3, roughly one-sixth of the population (**innovators and early adopters**) are very quick to adopt new products, and one-sixth of the people (**laggards**) are very slow. The other two-thirds, so-called

DIFFUSION OF GLOBAL CONSUMER CULTURE

The huge popularity of a humble local product traditionally worn by Brazilian peasants illustrates the diffusion on global consumer culture as consumers hunger for fresh ideas and styles from around the globe. These are simple flip-flops called *Havaianas* (pronounced ah-vai-YAH-nas)—the name is Portuguese for Hawaiians. Brazilians associate the lowly shoes, which sell for $2 a pair, so strongly with poor people that the expression *pe de chinelo*, or "slipper foot," is a popular slang term for the downtrodden. The main buyers in Brazil continue to be blue-collar workers, but now fashionable men and women in cities from Paris to Sydney are wearing the peasant shoes to trendy clubs and in some cases even to work.

How did these flip-flops make the leap to fashion? In an attempt to boost profit margins, a company named Alpargatas introduced new models in colors like lime green and fuchsia that cost twice as much as the original black- or blue-strapped sandal with a cream-colored sole. Then it launched newer styles including a masculine surf model. Middle-class Brazilians started to adopt the shoes and even the country's president was seen wearing them. The fashion spread as a few celebrities, including supermodels Naomi Campbell, Kate Moss, and Brazil's own Gisele Bundchen, discovered the flip-flops. Company representatives helped fuel the fire by giving out free sandals to stars at the Cannes Film Festival. The result: Alpargatas's international sales zoomed from virtually zero to over 5 million sandals sold around the world.[80]

early and late majority, are somewhere in the middle; these adopters represent the mainstream public. They are interested in new things, but they do not want them to be *too* new. In some cases, people deliberately wait to adopt an innovation or new fashion because they assume that its price will fall after it has been on the market awhile or, in the case of technology, that its qualities or features will be improved.[81] Keep in mind that the proportion of consumers falling into each category is an estimate; the actual size of each depends on such factors as the complexity of the product, its cost, and how much risk is associated with trying it.

Even though innovators represent only 2.5 percent of the population, marketers are always interested in identifying them. These are the brave souls who are always on the lookout for novel developments and will be the first to try a new offering. Just as generalized opinion leaders do not appear to

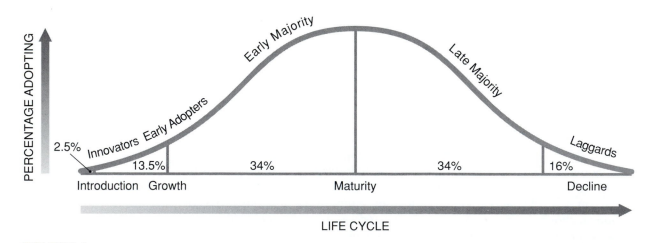

FIGURE 3-3
Types of Adopters
Source: Michael R. Solomon, *Consumer Behavior* 5/e, © 2002. Reprinted by permission of Prentice-Hall, Inc. Upper Saddle River, NJ.

COOLHUNTERS

The race to uncover the preferences of innovators is ongoing. Some companies are even hiring *coolhunters* to scout out the latest trends and report back to headquarters. For example, the Steven Ritkind Co. sends its "street teams," an army of 80 kids in 28 cities, into local clubs, record stores, and other hangouts as part of an urban intelligence network on behalf of Nike, Tommy Hilfiger, Miramax Films, and other corporate clients. These "soldiers of cool" hand out free samples of product prototypes to kids they identify as trendsetters and then get their feedback regarding what's cool and what isn't.[83] Look-Look, a Los Angeles youth-marketing firm, employs over 35,000 coolhunters aged 14 to 35 to investigate youth trends in major markets like New York, Los Angeles, and London. The company sends clients, among other things, lifestyle images produced by amateur shutterbugs. Some say with the explosion of the Internet and blogs, predicting trends has gotten much more complicated. Coolhunters prefer to be called futurists or researchers and are really social scientists with a hipster edge.[84] But lately marketers' long-term trend forecasters are reminding us that market research is a serious business; they spent $18.9 billion worldwide in 2004. Cool or hip ideas and products are only one small part of a more serious business objective. Trend translators, however, do acknowledge coolhunting has its place, and forecasters employ their own networks of "hot" watchers while others check in with independent purveyors of cool such as www.coolhunting.com and www.joshspear.com.[85] Check them out.

exist, innovators tend to be category specific as well. A person who is an innovator in one area may even be a laggard in another. For example, a college woman who prides herself as being on the cutting edge of fashion may have no conception of new developments in recording technology and may still stubbornly cling to old phonograph albums even while she searches for the latest avant-garde clothing styles in trendy boutiques. Despite this qualification, some generalizations can be offered regarding the profile of innovators.[82] Not surprisingly, for example, they tend to have more favorable attitudes toward taking risks. They also are likely to have higher educational and income levels and to be socially active.

Early adopters share many of the same characteristics as innovators, but an important difference is their degree of concern for social acceptance, especially with regard to expressive products, such as clothing, cosmetics, and so on. Generally speaking, an early adopter is receptive to new styles because he or she is involved in the product category and also places high value on being in fashion. What appears on the surface to be a fairly high-risk adoption (for example, wearing a skirt five inches above the knee when most people are wearing them below the knee) is actually not *that* risky if the style change has already been "field-tested" by innovators, who truly take the fashion risk. Early adopters are likely to be found in fashion-forward stores featuring the latest "hot" designers. In contrast, true innovators are more likely to be found in small boutiques featuring as-yet-unknown designers. One study found significantly more females in the innovator and early adopter categories and more males in the late majority and laggard categories.[86] Do you think this is city specific?

Types of Innovations

Innovations can occur in different forms. A **symbolic innovation** communicates a new social meaning (such as a new hairstyle or car design), whereas a

technological innovation involves some functional change (such as a new textile form or central home air-conditioning).[87] Whether symbolic or functional, new products, services, and ideas have characteristics that determine the degree to which they will probably diffuse. As a general rule, innovations that are less novel or different are more likely to diffuse, because things that are fairly similar to what is currently in use require fewer changes in behavior. On the other hand, an innovation that radically alters a person's lifestyle requires the person to modify his or her way of doing things, thus requiring more effort to adapt to the change and, therefore, is less likely to diffuse.

Behavioral Demands of Innovations

Innovations can be categorized in terms of the degree to which they demand changes in behavior from adopters. Three major types of innovations have been identified, though these three categories are not absolutes. They refer, in a relative sense, to the amount of disruption or change they bring to people's lives.

A **continuous innovation** refers to a modification of an existing product, as when Levi's promoted shrink-to-fit jeans or its Original Spin program in which consumers developed their own Levi's version. This type of change may be used to set one brand apart from its competitors. Most product innovations are of this type; that is, they are evolutionary rather than revolutionary. Small changes are made to position the product, add line extensions, or merely to alleviate consumer boredom. Consumers may be lured to the new product, but adoption represents only minor changes in consumption habits, because innovation perhaps adds to the product's convenience or to the range of choices available. Much of fashion falls under this category and diffuses rapidly.

Patterns etched by lasers by Fractal Jean Co. are an example of a continuous innovation. Photo: Courtesy of Fractal Jeans and Communica Inc.

A **dynamically continuous innovation** is a more pronounced change in an existing product, as represented by self-focusing 35-mm cameras or cordless telephones. These innovations have a modest impact on the way people do things, creating some behavioral changes. "Perma-Press" fabrics that required no ironing changed many housewives' ironing regimens.

A **discontinuous innovation** creates major changes in the way we live. Major inventions, such as the car, the airplane, the computer, the television, cell phones, and wireless devices have radically changed our lifestyles. The personal computer replaced the typewriter and created the phenomenon of "telecommuters" by allowing many people to work out of their homes. The Internet and e-mail has changed the way many of us buy things, do business, and communicate with friends and family—even the way you may be taking classes at your university. We said the rates of acceptance of innovations vary. Discontinuous innovations often take the longest compared with other types of innovations. (But rates still vary depending on the receptivity of consumers and many other factors.) For example, within ten years after its introduction, cable TV was used by 40 percent of U.S. households, compact disks by 35 percent, answering machines by 25 percent, and color TVs by 20 percent. It took radio 30 years to reach 60 million users and TV 15 years to reach this number. In contrast, within three years 90 million people were surfing the Web.[88] Can you explain this?

Of course, the cycle continues, as all types of innovations are constantly being developed. The communications and entertainment industries are introducing new discontinuous vehicles that many industry types say will revolutionize our lives. With the closing of record stores and video stores, and the advent of iTunes and YouTube we see major changes in the music and entertainment industries.

Prerequisites for Successful Adoption

Regardless of how much behavioral change is demanded by an innovation, several factors are desirable for a new product to succeed, including compatibility, trialability, complexity, observability, and relative advantage.[89] This model suggested by Rogers was supported by a recent study of the use of the computer to purchase apparel, food, and home furnishings products. Findings indicated users, as compared with nonusers, rated Internet shopping as relatively advantageous, more compatible with their values and needs, more observable, and less complex,[90] a strong argument for marketers to communicate these attributes to their customers.

Compatibility

The innovation should be compatible with consumers' lifestyles. As one illustration, consumers did not accept a major change in skirt lengths in 1970 from the popular miniskirt to the midi as promoted heavily by designers and fashion-forward retailers. This is a classic case of the fashion industry attempting to dictate to consumers, but this time they were not successful. A well-known study that analyzed this failure found that women perceived the midi as old-fashioned and would make them feel older—a feeling incompatible with their lifestyles.[91] Also skirts for men have periodically been introduced

Styles of American designers are often more suitable to American lifestyles than are styles of high-fashion European designers.

with consistent failure as most men do not see this as compatible with their lifestyles and self-concept.

Trialability

Since an unknown is accompanied by high perceived risk, people are more likely to adopt an innovation if they can experiment with it prior to making a commitment. To reduce this risk, some companies choose the expensive strategy of distributing free "trial-size" samples of new products such as a fragrance or makeup. Generally apparel fashion items can be tried on before purchase. But the real trial is when the new fashion is worn in public. Something "too different" may come with high social risk since the wearer may not receive acceptance. Some apparel purchases cannot be tried on, such as those purchased through the Internet (an innovation that has been less successful with apparel than other products) and mail order (which has a high return rate). Assurance that ill-fitting apparel can easily be returned reduces the consumer risk.

Complexity

The product should be low in complexity. A product that is easier to understand and use will be chosen over a competitor. This strategy requires less effort from the consumer, and it also lowers perceived risk. For example, Apple touts iTunes' ease of copying music from the Internet to your iPod to encourage adoption. Some cell phone companies are finding that all the extra

features that should give an advantage over others are just making consumers frustrated. Some want a tough phone that's easy to use, not one with complicated, advanced services. One company rep indicated as they go from early adopter tech-junkies to mainstream customers, cell phone interfaces will have to be simplified.[92] Although apparel fashions are generally not "complex," Issey Miyake's styles have stumped more than one consumer (and salesperson!) when attempting to figure out how to wear them—which hole is for the arm and which one for the head?

Observability

Innovations that are easily observable and communicated are more likely to spread, since this quality makes it more likely that other potential adopters will become aware of its existence. New apparel fashions are inherently visible making them readily known to other consumers. Also, due to the intense competition in the industry, designs that are seen in *Women's Wear Daily* and fashion magazines and that are sold in fashion-forward stores are more likely to become adopted. Remember, however, the example of the midi. No amount of promotion will ensure success of a new style if it is not congruent with what consumers want.

Relative Advantage

Most importantly, the product should offer relative advantage over other alternatives. The consumer must believe that its use will provide a benefit other products cannot offer. One example that demonstrates the importance of possessing a perceived relative advantage vis-à-vis existing products is a new product by Nano-Tex, a California company that has applied the emerging field of nanotechnology to textiles. A thin chemical protection applied to fabric makes it "spill-proof" as spills bead up rather than soaking into the fabric. Another example of potential relative advantage is "green" or environmentally friendly apparel and textiles. They have been promoted as being better for the environment because they do not use processes and materials that are harmful, such as polluting dyes and synthetic, nonrenewable fabrics.

KNOCKOFFS

The issue of what exactly constitutes a "new" product is quite important to many businesses. It is said that "imitation is the sincerest form of flattery," and decisions regarding how much (if at all) one's product should resemble those of competitors are often a centerpiece of marketing strategy (such as packaging of "me-too" or look-alike products). On the other hand, the product cannot be an exact duplicate; patent, copyright, and trademark laws are concerned with the precise definition of what is a new and/or protected product (see Chapter 14).

A **knockoff** is a style that has deliberately been copied and modified, often with the intent to sell to a larger or different market. For example, haute couture clothing styles presented by top designers in Paris and elsewhere are commonly "knocked off" by other designers and sold to the mass market. It is difficult to legally protect a design (as opposed to a technological feature), but pressure is building in some industries to do just that. See Chapter 14 for more on design protection.[93]

CHAPTER SUMMARY

- The styles prevalent in a culture at any point in time often reflect underlying social and political conditions. The set of agents responsible for creating stylistic alternatives is termed a *culture production system*. Factors such as the types of people involved in this system and the amount of competition by alternative product forms influence the choices of styles that eventually make their way to the marketplace for consideration by end consumers.

- An important gatekeeper in the apparel industry is *Women's Wear Daily*, which provides positive or negative reviews of designers' works.

- Culture is often described in terms of high (or elite) forms and low (or popular) forms. One-of-a-kind apparel might be considered an elite form whereas mass-produced fashion is considered low. Products of popular culture tend to follow a cultural formula and contain predictable components. On the other hand, these distinctions are blurring in modern society as imagery from "high art" is increasingly being incorporated into marketing efforts.

- Reality engineering occurs as elements of popular culture are appropriated by marketers and converted to vehicles for promotional strategies. These elements include sensory and spatial aspects of everyday existence, whether in the form of fashions appearing in movies and TV series or odors pumped into offices and stores.

- A new fashion often begins as a risky statement by a few innovators, then spreads as others become aware of it, and eventually dies out as people search for new styles.

- Diffusion of innovations refers to the process whereby a new fashion (product, service, or idea) spreads through a population. Innovators and early adopters are quick to adopt new products, and laggards are very slow. A consumer's decision to adopt a new fashion depends on his or her personal characteristics as well as on characteristics of the innovation itself. Innovations stand a better chance of being adopted if they demand relatively little change in behavior from users, can be tried before purchase, are easy to understand, are visible, and provide a relative advantage compared to existing products.

KEY TERMS

cooptation
cultural selection
culture production system
cultural gatekeepers
art product
craft product
cultural formula
reality engineering

product placement
branded entertainment
innovation
fashion innovation
diffusion of innovations
innovators and early adopters
laggards
early and late majority

symbolic innovation
technological innovation
continuous innovation
dynamically continuous innovation
discontinuous innovation
knockoff

DISCUSSION QUESTIONS

1. Choose another cultural product, such as music or one you are familiar with, and identify the components of the culture production system including the creative subsystem, managerial subsystem, and communications subsystem.

2. List other gatekeepers in fashion besides *Women's Wear Daily*.

3. What is the difference between an art and a craft? Where would you characterize fashion within this framework? What about advertising?

4. Identify art in fashion examples.

5. How do you feel about schoolchildren watching Channel One?

6. The chapter mentions some instances in which market research findings influenced artistic decisions. Certainly this is applied to apparel fashion as mass-market companies keep costs down to create something that will appeal to mass tastes. Also movie endings have actually been reshot to accommodate consumers' preferences. Many people would oppose this practice, claiming that books, movies, records, or other artistic endeavors should not be designed to merely conform to what people want to read, see, or hear. What do you think?

7. Do you think product placement is fair competition? What fashion brand examples do you see in your favorite TV shows and movies?

8. Comment on the growing practices described as reality engineering. Do marketers "own" our culture, and should they?

9. Identify several real innovations that you are aware of. Do they fit the characteristics of innovations as described in this chapter? Ask your parents, grandparents, or other older adults to identify an innovation that has affected their lifestyle. Analyze the characteristics. Which one do you think was most responsible for the product's success? Do you think fashion is an innovation? Why or why not?

10. Are you an early adopter? Explain why or why not.

ENDNOTES

1. Quoted in Marc Spiegler, "Marketing Street Culture: Bringing Hip-Hop Style to the Mainstream," *American Demographics* (November 1996): 29–34.
2. Joshua Levine, "Badass Sells," *Forbes* (April 21, 1997): 142.
3. Nina Darnton, "Where the Homegirls Are," *Newsweek* (June 17, 1991): 60; "The Idea Chain," *Newsweek* (October 5, 1992): 32.
4. Cyndee Miller, "X Marks the Lucrative Spot, But Some Advertisers Can't Hit Target," *Marketing News* (August 2, 1993): 1.
5. Ad appeared in *Elle* (September 1994).
6. Marc Spiegler, "Marketing Street Culture: Bringing Hip-Hop Style to the Mainstream"; Joshua Levine, "Badass Sells."
7. Jeff Jensen, "Hip, Wholesome Image Makes a Marketing Star of Rap's LL Cool J," *Advertising Age* (August 25, 1997): 1.
8. Alice Z. Cuneo, "Gap's 1st Global Ads Confront Dockers on a Khaki Battlefield," *Advertising Age* (April 20, 1998): 3–5.

9. Jancee Dunn, "How Hip-Hop Style Bum-Rushed the Mall," *Rolling Stone* (March 18, 1999): 54–59.

10. Quoted in Teri Agins, "The Rare Art of 'Gilt by Association': How Armani Got Stars to Be Billboards," *Wall Street Journal Interactive Edition* (September 14, 1999).

11. Eryn Brown, "From Rap to Retail: Wiring the Hip-Hop Nation," *Fortune* (April 17, 2000): 530; Leonard McCants, "Urban Gets Wired," *Women's Wear Daily Section II* (April 6, 2000): 4.

12. "VIBESTYLE Clarifies the Hip Hop Form," *NAMSB News* (December 1999/January 2000): 1.

13. Maureen Tkacik, "'Z' Zips into the Zeitgeist, Subbing 'S' in Hot Slang," *Wall Street Interactive Edition* (January 4, 2003); Maureen Tkacik, "Slang from the 'Hood Now Sells Toyz in Target," *Wall Street Interactive Edition* (December 30, 2002).

14. Damien Arthur, "Authenticity and Consumption in the Australian Hip Hop Culture," *Qualitative Market Research* 9, no. 2 (2005): 140.

15. "European Hip Hop," Wikipedia.com, available from http://en.wikipedia.org/wiki/European/hiphop (July 30, 2007).

16. Elizabeth M. Blair, "Commercialization of the Rap Music Youth Subculture," *Journal of Popular Culture* 27 (Winter 1993): 21–34; Basil G. Englis, Michael R. Solomon, and Anna Olofsson, "Consumption Imagery in Music Television: A Bi-Cultural Perspective," *Journal of Advertising* 22 (December 1993): 21–33.

17. Marc Spiegler, "Marketing Street Culture: Bringing Hip-Hop Style to the Mainstream."

18. Grant McCracken, "Culture and Consumption: A Theoretical Account of the Structure and Movement of the Cultural Meaning of Consumer Goods," *Journal of Consumer Research* 13 (June 1986): 71–84.

19. Richard A. Peterson, "The Production of Culture: A Prolegomenon," in *The Production of Culture*, Sage Contemporary Social Science Issues, ed. Richard A. Peterson (Beverly Hills, Calif.: Sage, 1976): 7–22.

20. Samantha Conti, "The Independents: When Standing Alone Beats Mega-Mergers," *Women's Wear Daily* (January 3, 2000): 1, 8–10.

21. Elizabeth C. Hirschman, "Resource Exchange in the Production and Distribution of a Motion Picture," *Empirical Studies of the Arts* 8, no. 1 (1990): 31–51; Michael R. Solomon, "Building Up and Breaking Down: The Impact of Cultural Sorting on Symbolic Consumption," in *Research in Consumer Behavior,* eds. J. Sheth and E. C. Hirschman (Greenwich, Conn.: JAI Press, 1988): 325–351.

22. Robin Givhan, "Designers Caught in a Tangled Web," *The Washington Post* (April 5, 1997): C1.

23. See Paul M. Hirsch, "Processing Fads and Fashions: An Organizational Set Analysis of Cultural Industry Systems," *American Journal of Sociology* 77 (1972)4: 639–659; Russell Lynes, *The Tastemakers* (New York: Harper and Brothers, 1954); Michael R. Solomon, "The Missing Link: Surrogate Consumers in the Marketing Chain," *Journal of Marketing* 50 (October 1986): 208–219.

24. Howard S. Becker, "Arts and Crafts," *American Journal of Sociology* 83 (January 1987): 862–889.

25. Herbert J. Gans, "Popular Culture in America: Social Problem in a Mass Society or Social Asset in a Pluralist Society?" in *Social Problems: A Modern Approach,* ed. Howard S. Becker (New York: Wiley, 1966).

26. Miles Socha, "Art vs. Commerce: Is the Bottom Line What Drives the Line?" *Women's Wear Daily* (February 10, 2000): 1, 10, 11.

27. Quoted in "Art vs. Commerce: Is the Bottom Line What Drives the Line?" p. 10.

28. Quoted in "Art vs. Commerce: Is the Bottom Line What Drives the Line?" p. 10.

29. Sharon Edelson, "Fashion and Culture: An Artful Combination Adds a Marketing Spin," *Women's Wear Daily* (October 5, 1998): 1, 14–15.

30. "Is Fashion Art?" *Irish Times.* (July 8, 1999): 16.

31. Cited in "Is Fashion Art?"

32. "Art in the Street," *Women's Wear Daily* (May 11, 2000): 13.

33. Sharon Edelson, "Art and Fashion as Bedfellows," *Women's Wear Daily* (May 17, 2004): 27.

34. Edelson, "Art and Fashion as Bedfellows."

35. Eric Wilson and Janet Ozzard, "Met Curator Richard Martin Dies," *Women's Wear Daily* (November 9, 1999): 11.

36. Edelson, "Fashion and Culture: An Artful Combination Adds a Marketing Spin."

37. "Nike Takes a Stab at Artistry," *Women's Wear Daily* (May 4, 2000): 9.

38. Miles Socha, "Museum to Exhibit John Galliano," *Women's Wear Daily* (July 30, 2001): 17; Samantha Conti, "Art and Craft of Versace," *Women's Wear Daily* (October 11, 2002): 6.

39. Robert Murphy, "Melding Fashion and Art," *Women's Wear Daily* (June 4, 2002): 10.

40. Marc Karimzadeh, "Museum Takes Close Look at the Shape of Fashion," *Women's Wear Daily* (August 22, 2006): 10.

41. Edelson, "Fashion and Culture: An Artful Combination Adds a Marketing Spin."

42. Michael R. Real, *Mass-Mediated Culture* (Englewood Cliffs, N.J.: Prentice-Hall, 1977).

43. Arthur A. Berger, *Signs in Contemporary Culture: An Introduction to Semiotics* (New York: Longman, 1984).

44. Michiko Kabutani, "Art Is Easier the 2nd Time Around," *New York Times* (October 30, 1994): E4.

45. Michael R. Solomon and Basil G. Englis, "Reality Engineering: Blurring the Boundaries Between Marketing and Popular Culture," *Journal of Current Issues and Research in Advertising*, 16, no. 2 (Fall, 1994): 1–17.

46. Austin Bunn, "Not Fade Away," *New York Times on the Web* (December 2, 2002).

47. Julian Guthrie, "Pitching to Pupils," *San Francisco Examiner* (February 18, 1998): A1, A9.

48. "Gripes Grow Over Rampant Textbook Ads," *San Francisco Chronicle* (June 26, 1999): A1, A14.

49. Suzanne Joeyander Ryan, "Companies Teach All Sorts of Lessons with Educational Tools They Give Away," *Wall Street Journal* (April 19, 1994): B1; Cyndee Miller, "Marketers Find a Seat in the Classroom," *Marketing News* (June 20, 1994): 2.

50. T. Bettina Cornwell and Bruce Keillor, "Contemporary Literature and the Embedded Consumer Culture: The Case of Updike's Rabbit," in *Empirical Approaches to Literature and Aesthetics: Advances in Discourse Processes*, eds. Roger J. Kruez and Mary Sue MacNealy, 52 (Norwood, N.J.: Ablex Publishing Corporation, 1996), 559–572; Monroe Friedman, "The Changing Language of a Consumer Society: Brand Name Usage in Popular American Novels in the Postwar Era," *Journal of Consumer Research* 11 (March 1985): 927–937; Monroe Friedman, "Commercial Influences in the Lyrics of Popular American Music of the Postwar Era," *Journal of Consumer Affairs* 20 (Winter 1986): 193.

51. "Top 10 Product Placements in First Half of '07," *Marketing Daily* (September 26, 2007) www.mediapost.com.

52. Motoko Rich, "Product Placement Deals Make Leap from Film to Books," *New York Times Online* (June 12, 2006).

53. Denise E. DeLorme and Leonard N. Reid, "Moviegoers' Experiences and Interpretations of Brands in Films Revisited," *Journal of Advertising*, 28, no. 2 (1999): 71–90.

54. Lisa Lockwood, "Fashion's Cinematic Moments," *Women's Wear Daily* (May 7, 1999): 13.

55. Faye Brookman, "Fusion Puts New Spin on Reality TV," *Women's Wear Daily* (July 29, 2005): 10.

56. Benny Evangelista, "Advertisers Get into the Video Game," *San Francisco Chronicle* (January 18, 1999). Available online at http://www.sfchron.com.

57. Stuart Elliott, "Monopoly Finds New Balance," *San Francisco Chronicle* (September 14, 2006): C2.

58. Stephanie Kang, "Comics Character Is Fashion Plate 'Shi' Heroine, Others Wear Anna Sui's Collection in Deal with Illustrator," *Wall Street Journal* (May 4, 2004): B2.

59. Merle Ginsberg, "TV Ups the Fashion Quotient," *Women's Wear Daily* (July 28, 2000): 12.

60. "Deconstructing Carrie: Fashion World Hoping There's Life After 'Sex'," *Women's Wear Daily* (February 24, 2004): 1+.

61. Joe Flint, "Sponsors Get a Role in CBS Reality Show," *Wall Street Journal Interactive Edition* (January 13, 2000).

62. Geoffrey A. Fowler, "New Star on Chinese TV: Product Placements," *Wall Street Journal* (June 2, 2004): B1.

63. Julee Greenberg, "'Project Runway': Fantasy TV," *Women's Wear Daily* (August 1, 2006): 8.

64. Eric Wilson, "Blame the Rosettes," *New York Times Online* (August 3, 2006).

65. Fara Warner, "Why It's Getting Harder to Tell the Shows from the Ads," *Wall Street Journal* (June 15, 1995): B1.

66. Claire Atkinson, "Ad Intrusion Up, Say Consumers," *Advertising Age* (January 2003): 1.

67. Wayne Friedman, "'Minority Report' Stars Lexus, Nokia," *Advertising Age* (June 17, 2002): 41; George Raine, "Picture Placement," *San Francisco Chronicle* (July 6, 2002): B1.

68. Merle Ginsberg, "TV Ups the Fashion Quotient"; "Deconstructing Carrie."

69. Anne D'Innocenzio, "Austin Powers: Mod Revival," *Women's Wear Daily* (June 30, 1999): 8.

70. Lockwood, "Fashion's Cinematic Moments."

71. Michael Barbaro, "Media; Macy's Backstage," *New York Times Online* (July 24, 2006).

72. Stuart Elliott, "In Parody Video, Writers Ridicule Placing Products," *New York Times Online* (March 6, 2006).

73. Koji Kirano, "Tokyo's Streets of Dreams," *Women's Wear Daily* (July 27, 2000): 12.

74. Kirano, "Tokyo's Streets of Dreams."

75. The new science of memetics, which tries to explain how beliefs gain acceptance and predict their progress, was spurred by Richard Dawkins, who in the 1970s proposed culture as a Darwinian struggle among "memes" or mind viruses—see Geoffrey Cowley, "Viruses of the Mind: How Odd Ideas Survive," *Newsweek* (April 14, 1997): 14; Everett M. Rogers, *Diffusion of Innovations*, 3d ed. (New York: Free Press, 1983).

76. George B. Sproles and Leslie Davis Burns, *Changing Appearances Understanding Dress in Contemporary Society* (New York: Fairchild, 1994).

77. Eric J. Arnould, "Toward a Broadened Theory of Preference Formation and the Diffusion of Innovations: Cases from Zinder Province, Niger Republic," *Journal of Consumer Research* 16 (September 1989): 239–267; Susan B. Kaiser, *The Social Psychology of Clothing: Symbolic Appearances in Context,* 2nd ed. (New York: Fairchild, 1997); Thomas S. Robertson, *Innovative Behavior and Communication* (New York: Holt, Rinehart and Winston, 1971).

78. Everett M. Rogers, *Communication of Innovations* (New York: Free Press, 1971).

79. H. Gatignon and T. Robertson, "A Propositional Inventory for New Diffusion Research," *Journal of Consumer Research*, 11, no. 4 (1985): 849–867.

80. Mirium Jordan and Teri Agins, "Fashion Flip-Flops: Sandal Leaves the Shower Behind," *Wall Street Journal Interactive Edition* (August 8, 2002).

81. Susan L. Holak, Donald R. Lehmann, and Fareena Sultan, "The Role of Expectations in the Adoption of Innovative Consumer Durables: Some Preliminary Evidence," *Journal of Retailing* 63 (Fall 1987): 243–259.

82. Hubert Gatignon and Thomas S. Robertson, "A Propositional Inventory for New Diffusion Research," *Journal of Consumer Research* 11 (March 1985): 849–867.

83. Joshua Levine, "The Streets Don't Lie," *Forbes* (April 21, 1997): 145.

84. Stephanie Kang, "Trying to Connect with a Hip Crowd," *Wall Street Journal* (October 13, 2005); Gina Piccalo, "Fads Are So Yesterday," *Los Angeles Times* (October 9, 2005): E1; www.look-look.com (October 2006).

85. Beth Snyder Bulik, "Cool Hunting Goes Corporate," *Advertising Age* (Midwest region edition, Chicago) (August 1, 2005): 3–4.

86. Pierre Beaudoin, Marie J. Lachance and Jean Robitaille, "Fashion Innovativeness, Fashion Diffusion, and Brand Sensitivity Among Adolescents," *Journal of Fashion Marketing and Management* 7, no. 1 (2003): 23–30.

87. Elizabeth C. Hirschman, "Symbolism and Technology as Sources of the Generation of Innovations," in *Advances in Consumer Research*, ed. Andrew Mitchell, 9 (Provo, Utah: Association for Consumer Research, 1981): 537–541.

88. Robert Hof, "The Click Here Economy," *Business Week* (June 22, 1998): 122–128.

89. Everett M. Rogers, *Diffusion of Innovations*, 3d ed. (New York: Free Press, 1983).

90. Kim K. P. Johnson, Sharon J. Lennon, Cynthia Jasper, Mary Lynn Damhorst, and Hilda Buckley Lakner, "An Application of Rogers's Innovation Model: Use of the Internet to Purchase Apparel, Food, and Home Furnishings Products by Small Community Consumers," *Clothing and Textiles Research Journal*, 21, no. 4 (2003): 185–196.

91. Fred D. Reynolds and Williams R. Darden, "Why the Midi Failed," *Journal of Advertising Research* 12 (August 1972): 39–44.

92. David Twiddy, "Cell Phone Firms Can't Sell Some Customers on New Features," *San Francisco Chronicle* (May 29, 2006): E3.

93. Edmund L. Andrews, "When Imitation Isn't the Sincerest Form of Flattery," *New York Times* (August 9, 1990): 20.

CONSUMER CHARACTERISTICS AND FASHION IMPLICATIONS

The chapters in this section consider some of the social influences that help to determine who we are with an emphasis on demographic and psychographic subcultures. Chapter 4 discusses our reasons or motivations for absorbing information and how these are influenced by the values to which we subscribe as members of a particular culture. Chapter 5 explores how our views about ourselves—particularly our physical appearance—affect what we do, want, and buy.

Chapters 6 and 7 consider the subcultures that help to define each of our unique identities: age, race, ethnicity, income, and social class. Social class is defined and explores what we want to buy with the money we make. Age cohorts are outlined and the bonds that we share with others who were born at roughly the same time are considered. Our race and ethnicity also help define who we are.

Chapter 8 discusses how our attitudes—our evaluations of products and messages—are formed. It considers how our individual personalities influence our decisions and how the choices we make in terms of products, services, and leisure activities help to define our lifestyles. Chapter 9 describes the process of perception, in which we absorb and interpret information about products and other people from the outside world.

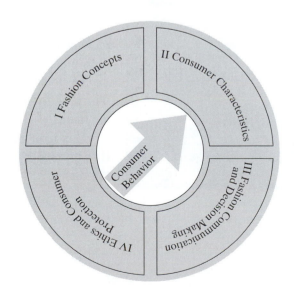

4

Individual Consumer Dynamics: Motivation and Values

It's been two years since Basil gave up smoking, drinking, and eating junk food. He now devotes the same enthusiasm to working out that he used to bring to partying. Basil has become a dedicated triathlete. Participating in this sport, which involves running, swimming, and biking, has become so important to him that he structures his entire schedule around his training regimen. He even passed on an important class he needed for his major because the only open section was at the same time he did his daily five-mile run.

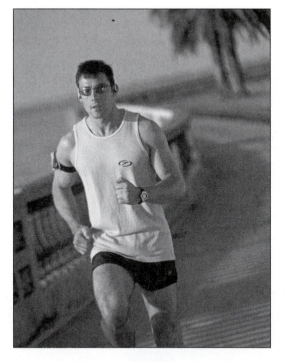

Basil has been so engrossed in the sport—spending most of his free time (when not in training) reading magazines dedicated to the sport, shopping for special equipment like running shoes and Lycra tights for winter training, or traveling to triathlon events all over the country—that his friends hardly see him anymore. His girlfriend, Judy, has even complained that he likes looking at himself in the mirror more than he likes looking at her.

Basil remains committed! He's nothing if not dedicated to the cause. . . .

INTRODUCTION

Some people are so involved in an activity that they can be termed *fanatic consumers*. Whether they are training for a triathlon, watching television, or playing music, these people tend to become totally engrossed in an activity to the point where such involvement has been called a "positive addiction." One survey of triathletes (like Basil), for example, found that intense commitment to the sport resulted in a highly modified daily schedule, unwillingness to stop training even if injured, major dietary changes, and—most relevant to marketers—a substantial financial commitment for travel to races, specialized clothing, and health club memberships.[1]

The forces that drive people to buy and use products are generally straightforward, as when a person chooses a pair of running shoes for everyday wear. As hard-core triathletes demonstrate, however, even the consumption of an everyday product may also be related to wide-ranging beliefs regarding what is appropriate or desirable. In some cases, these emotional responses create a deep commitment to the product. Sometimes people are not even fully aware of the forces that drive them toward some products and away from others. And often these choices are influenced by the person's values—his or her priorities and beliefs about the world.

To understand motivation is to understand *why* consumers do what they do. Why do some people choose to allot a considerable part of their income to expensive designer clothing when others in the same income bracket wear moderately priced ready-to-wear? Likewise, why do people choose to bungee jump off a bridge or go white-water rafting in the Yukon or compete on reality shows, while others spend their leisure time playing chess or gardening? We do everything for a reason, whether to quench a thirst, kill boredom, or to attain some deep spiritual experience. Students of consumer behavior and marketing are taught from day one that the goal of marketing is to satisfy consumers' needs. However, this insight is useless unless we can discover what those needs are and why they exist. A popular beer commercial says, "Why ask why?" In this chapter, we'll find out.

THEORIES OF MOTIVATION FOR WEARING CLOTHES

When considering fashion, let's start by looking at fundamental reasons why people wear clothes. That may seem obvious, but actually there are many reasons. Early theories put forth by anthropologists and psychologists of why people wear clothing are related to the functions of clothing.[2] These have been much discussed and outlined by fashion and apparel researchers.[3] Early theorists met with little agreement as to the motivation for our first beginning to wear clothes, but most agree on the following four main functions, many of which are motivations for buying fashion today: modesty, immodesty, protection, and adornment. (Be aware that some terms such as *functions, needs, drives,* and *motivations* are used inconsistently and in an overlapping way by consumers and researchers alike in the following discussion.)

Modesty Theory

This theory suggests that people wore clothing to conceal the private parts of their bodies. Moralists believe that one's innate feelings of guilt and shame from being naked led to finding ways to clothe the body. This theory, often called the Biblical theory, stems from the story of Adam and Eve and the fig leaf. However, modesty is not universal, that is, the same in all cultures. A part of the body covered in one culture is left exposed in another without shame. Modesty in Muslin cultures is dictated; the *chador*, which envelops the woman in black, and the strictest, face-concealing variation, the *niqab*, protect women's virtue. Also consider little children who love to run around with the freedom of no clothes and feel no shame. The definition of modesty changes over time. For example, the swimsuit of the 1920s is quite different from today's in terms of acceptable exposure. A recent article discusses a group of teens who don't adhere to today's fashion of exposing skin with low-riding jeans and high-riding T-shirts. Some are tired of the "trashy" look and have a name for girls who wear flesh-baring fashion, and it's not exactly flattering: "prostitots."[4] Do you think modesty is an important element in today's fashions? Or is it immodesty?

Immodesty Theory

Indeed, clothes have been worn to draw attention to certain parts of the body. We use the words "decent" or "proper" to refer to the appropriate amount of body exposure through clothing selection. A tight sweater and jeans cover the body, but they also draw attention at the same time. Sex

Some clothing items reveal more than conceal the body.

appeal is not solely what fashion is about, but women's sexuality and dress throughout the ages have been inexplicably intertwined. Davis discusses his concept of erotic-chaste ambivalence as women's fashion both covers and arouses. He quotes Michelle Pfeiffer's wardrobe consultant whose golden rule is "don't show it all."[5]

Protection Theory

Some theorists feel that clothing was first used to protect us from the elements, such as the cold, or from insects and animals. Still others argue that clothing was used as protection against enemies or from the harm of supernatural forces. Clothing functions as a barrier between the body and the environment. We wear clothes to protect our bodies from the sun, wind, rain, and cold by wearing parkas, gloves, hats, and so on. Some wear clothing or accessories as amulets to bring good luck or protection from harmful spiritual powers; this might be called psychological protection as opposed to physical protection. Superstitions, fear of the unseen, belief in evil spirits, and luck have all been responsible for the use of certain garments, jewelry, and other adornment.[6] Following are some interesting examples:

- Cowrie shells protect women from sterility in many Pacific cultures.
- Bridal veils protect the bride from evil spirits.
- Evil-eye beads protect children and animals from unseen powers in Southeast Asia.
- Lucky charms, jewelry, coins, clothing, shoes, and hats bring good luck.

Do you know anyone who has a "lucky shirt"? Although the main purpose of today's fashion is often not functional or protective, there certainly is this element in most clothing.

Adornment Theory

Perhaps the most universal function of clothing and accessories is adornment, personal decoration, or aesthetic expression. Adornment shows status and identity and also raises one's self-esteem.[7] Adornment is achieved through clothing and accessories (external adornment) or through making permanent changes to the body (bodily adornment). One author outlined external adornment as wrapped around the body (shawls), suspended from the body (necklaces), preshaped to fit the body (jackets), clipped to the body (earrings), applied to the body (false eyelashes), and handheld (purses).[8] Bodily adornment includes such things as tatooing, piercing (certainly prevalent today and discussed more in Chapter 5), scarification, or plastic surgery. Temporary bodily adornment that we all do includes changes to our hair, wearing makeup, shaving body hair, or using lotions to change skin texture. Through the ages, women have reshaped their bodies to conform to the current definition of beauty by "paring down" through the use of tight corsets or "adding on" through the use of padding or other means, such as petticoats.[9] This is also discussed more in Chapter 5.

These original functions of clothing may be thought of as intrinsic reasons or motivations for clothing choices. Social-psychological or hedonic

bases, also primary reasons for today's fashion choices, are discussed in the next section.

THE MOTIVATION PROCESS

Motivation refers to the processes that lead people to behave as they do. It occurs when a need (something that is lacking) is aroused that the consumer wishes to satisfy. Once a need has been activated, such as protection, a state of tension exists that drives the consumer to attempt to reduce or eliminate the need. Once the goal is attained, tension is reduced and the motivation recedes (for the time being). Motivation can be described in terms of its *strength*, or the pull it exerts on the consumer, and its *direction*, or the particular way the consumer attempts to reduce motivational tension.

Theories

Early work on motivation ascribed behavior to instinct, the innate patterns of behavior that are universal in a species. This view is now largely discredited. For one thing, the existence of an instinct is difficult to prove or disprove. The instinct is inferred from the behavior it is supposed to explain (this type of circular explanation is called a *tautology*).[11] It is like saying that a consumer buys products that are status symbols because he or she is motivated to attain status, which is hardly a satisfying explanation.

The degree to which a person is willing to expend energy to reach one goal as opposed to another reflects his or her underlying motivation to attain that goal. Many theories have been advanced to explain why people behave the way they do. Most share the basic idea that people have some finite amount of energy that must be directed toward certain goals.

Drive Theory

Drive theory focuses on biological needs that produce unpleasant states of arousal (for example, your stomach grumbles during a morning class). We are motivated to reduce the tension caused by this arousal. Tension reduction has been proposed as a basic mechanism governing human behavior.

In a marketing context, tension refers to the unpleasant state that exists if a person's consumption needs are not fulfilled. A person may be grumpy if he hasn't eaten, or he may be dejected or angry if he cannot afford that new fashion item he wants. This state activates goal-oriented behavior, which attempts to reduce or eliminate this unpleasant state and return to a balanced

NIKES GIVE YOUR MOTIVATION A BOOST

Some of us have more or less motivation to achieve a goal. Nike knows that. A Nike ad shows its Air Zoom Spiridon running shoe and states:

This is not a running shoe. This is your ever-faithful companion to give you and your motivation a gentle tug toward the door. This is the hybrid whelp of super-light and fast, sitting patiently with that certain look in its eye that says: "It's go time. Let's lace up, get outdoors and take it up a notch."[10]

one, called **homeostasis**. Behaviors that are successful in reducing the drive by eliminating the underlying need are strengthened and tend to be repeated.

Drive theory, however, runs into difficulties when it tries to explain some facets of human behavior that run counter to its predictions. People often do things that *increase* a drive state rather than decrease it. For example, people may delay gratification. If you know you are going out for a lavish dinner, you might decide to forgo a snack earlier in the day even though you are hungry at that time.

Expectancy Theory

Most current explanations of motivation focus on cognitive factors rather than biological ones to understand what drives behavior. **Expectancy theory** suggests that behavior is largely pulled by expectations of achieving desirable outcomes—*positive incentives*—rather than pushed from within. We choose one product over another because we expect this choice to have more positive consequences for us. For example, a teenage girl may choose to wear specific clothes in anticipation of acceptance into a coveted group at school. One study found that motivations for shopping for clothing by television

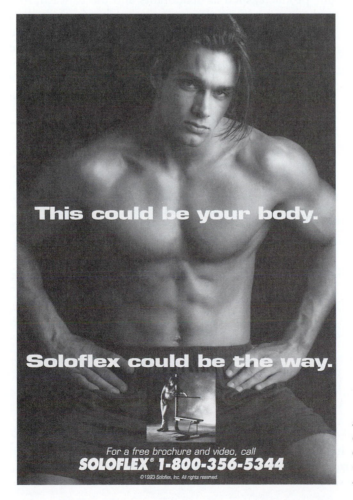

This ad for exercise equipment shows men a desired state (as dictated by contempory Western culture) and suggests a solution (purchase of the equipment) to attain it.

rather than in retail stores included convenience, the amount of information available on the shopping channels, and liberal return policies. These motivations were incentives to shop in this manner because traditional retailers did not meet these needs as well for these consumers.[12]

Motivational Conflicts

A goal has *valence*, which means that it can be positive or negative. A positively valued goal is one toward which consumers direct their behavior; they are motivated to *approach* the goal and will seek out products that will be instrumental in attaining it. However, not all behavior is motivated by the desire to approach a goal. Consumers may instead be motivated to *avoid* a negative outcome. They will structure their purchases or consumption activities to reduce the chances of attaining this end result. For example, many consumers work hard to avoid rejection, a negative outcome. They will stay away from products that they associate with social disapproval. Perhaps last year's fashion is a product for some to stay away from since that would bring on social disapproval from peers. Not everyone, of course, reacts that way, as many consumers feel last season's styles on sale are good bargains. We also buy products, such as deodorants and mouthwash, to avoid negative results such as onerous social consequences of underarm odor or bad breath.

Because a purchase decision may involve more than one source of motivation, consumers often find themselves in situations in which different motives, both positive and negative, conflict with one another. Since marketers are attempting to satisfy consumers' needs, they can also be helpful by providing possible solutions to these dilemmas. As shown in Figure 4-1, three

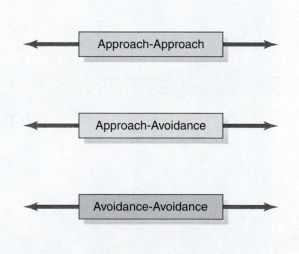

FIGURE 4-1
Three Types of Motivational Conflicts

Source: Michael R. Solomon, *Consumer Behavior* 8e, © 2009. Reprinted by permission of Prentice-Hall, Inc., Upper Saddle River, NJ.

general types of conflicts can occur: approach–approach, approach–avoidance, and avoidance–avoidance.

Approach–Approach Conflict

In an **approach–approach conflict**, a person must choose between two desirable alternatives. A student might be torn by having to choose between two fashion items to wear to a club, or he or she might have to decide between going home for the holidays or going on a skiing trip with friends.

The theory of **cognitive dissonance** is based on the premise that people have a need for order and consistency in their lives and that a state of tension is created when beliefs or behaviors conflict with one another. The conflict that arises when choosing between two alternatives may be resolved through a process of cognitive dissonance reduction, in which people are motivated to reduce this inconsistency (or dissonance) and, thus, eliminate unpleasant tension.[13]

A state of dissonance occurs when there is a psychological inconsistency between two or more beliefs or behaviors. It often occurs when a consumer must make a choice between two products when both alternatives usually possess both good and bad qualities. By choosing one product and not the other, the person gets the bad qualities of the chosen product and loses out on the good qualities of the unchosen one. This loss creates an unpleasant, dissonant state that the person is motivated to reduce. People tend to convince themselves, after the fact, that the choice they made was the smart one by finding additional reasons to support the alternative they chose, or perhaps by "discovering" flaws with the option they did not choose. A marketer can resolve an approach–approach conflict by bundling several benefits together. For example, the latest fashions are on sale.

Approach–Avoidance Conflict

Many of the products and services we desire have negative consequences attached to them as well. We may feel guilty or ostentatious when buying a status-laden product like a fur coat or feel like a glutton when contemplating a tempting package of Twinkies. An **approach–avoidance conflict** exists when we desire a goal but wish to avoid it at the same time.

Some solutions to these conflicts include the proliferation of fake furs, which eliminate guilt about harming animals to create a beautiful fashion item, and the success of diet foods, such as Weight Watchers, that promise good food without the calories (www.weight-watchers.com). Many marketers try to overcome guilt by convincing consumers that they are deserving of luxuries, for example, when the model for L'Oreal cosmetics claims "Because I'm worth it!"

Avoidance–Avoidance Conflict

Sometimes consumers find themselves caught "between a rock and a hard place." They may face a choice with two undesirable alternatives; for instance, the option of either paying a high price for a new fashion item or buying last season's styles, which are on sale and affordable, but will be seen as out of style. Marketers frequently address an **avoidance–avoidance conflict**

Consumer desire has been defined as "a feeling of longing for goods or services not presently enjoyed."[14] Consumers in the former Eastern bloc now are bombarded with images of luxury goods yet may still have trouble obtaining basic necessities. In one study where Romanian students named the products they hoped for, their wish lists included not only the expected items like sports cars and the latest model televisions but also water, soap, furniture, and food.

Their frustration was summed up by one informant, who explained, "Then [before the revolution] there were few goods on the shelves, but we could afford them. Now there are more goods on the shelves, but no one can afford them."[15] Ironically, these consumers appear to be less happy now, because they are given more to desire but still can't attain these products. This frustration is a result of *relative deprivation*, where the gulf between what is available and what one possesses becomes wider.

with messages that stress the unforeseen benefits of choosing one option (for example, 10 percent off if you open a charge account, easing the pain of an expensive new fashion purchase).

NEEDS

A **need** is actually the discrepancy between the consumer's present state and some ideal state. This gulf creates a state of tension. The magnitude of this tension determines the urgency the consumer feels to reduce the tension. Marketers try to create products and services that will provide the desired benefits and permit the consumer to reduce these tensions created by needs.

Needs versus Wants

A basic need can be satisfied in any number of ways, and the specific path a person chooses is influenced both by a person's unique set of experiences and by the values instilled by the culture in which the person has been raised. These personal and cultural factors combine to create a **want**, which is the manifestation of a need. For example, protection and hunger are basic needs that must be satisfied. The lack of protection can be satisfied by a $10 coat from Goodwill that gives adequate coverage and keeps one warm. A $1,000 coat from Neiman Marcus can also satisfy this need for protection. Similarly, hunger creates a tension state that can be reduced by the intake of such foods as cheeseburgers, double fudge Oreo cookies, raw fish, or bean sprouts. Participants on the TV show *Survivor* ate bugs and broiled rats! The specific route to satisfying needs is culturally (or contextually) determined.

Types of Needs

People are born with a need for certain elements necessary to maintain life, such as food, water, air, and shelter. These are called *biogenic needs*. People have many other needs, however, that are not innate. We acquire *psychogenic needs* as we become members of a specific culture. These include the need for status, power, and affiliation. Psychogenic needs reflect the priorities of a culture.

Needs can also be thought of as utilitarian versus hedonic. **Utilitarian needs** are desires to achieve some functional or practical benefit (such as comfort or protection, as discussed earlier). The satisfaction of utilitarian needs implies that consumers will emphasize the objective, tangible attributes of products, such as the durability of a pair of blue jeans, miles per gallon in a car, or the amount of fat, calories, and protein in a cheeseburger. **Hedonic needs** are subjective and experiential involving emotional responses. Consumers may rely on a product to meet their needs for excitement, self-confidence, fantasy—perhaps to escape the routine aspects of life.[16] Of course, we may be motivated to purchase a product because it provides *both* types of benefits. For example, a mink coat may be bought because of the luxurious image it portrays and because it also happens to keep one warm throughout the long cold winter.

Classifying Consumer Needs

Much research has been done on classifying human needs. Some psychologists have tried to define a universal inventory of needs that could be traced systematically to explain virtually all behavior. One such effort, developed by Henry Murray, delineates a set of twenty psychogenic needs that result in specific behaviors. These needs include such dimensions as *autonomy* (being independent), *defendance* (defending the self against criticism), and even *play* (engaging in pleasurable activities).[17]

Specific Needs

Other approaches have focused on specific needs and their ramifications for behavior. Some personal needs that are relevant to consumer behavior include the following.

- *Need for achievement* (personal accomplishment is strongly valued).[18] Those with this need place a premium on products and services that signify success or evidence of their achievement. One study of working women found that those who were high in achievement motivation were more likely to choose clothing they considered businesslike and less likely to be interested in apparel that accentuated their femininity.[19]
- *Need for affiliation* (to be in the company of other people).[20] This need is relevant to products and services that are consumed in groups and alleviate loneliness, such as team sports, shopping malls, and bars. Teenagers often shop for clothing together.
- *Need for power* (to control one's environment).[21] Many products and services allow consumers to feel that they have mastery over their surroundings, ranging from "hopped-up" muscle cars and loud boom boxes imposing one's musical tastes on others) to power clothes. Certainly John Molloy's "dress for success" approach to clothing espoused in the 1980s relates to creating a power look for both men and women in business.[22]
- *Need for uniqueness* (to assert one's individual identity).[23] This need is satisfied by products that pledge to accentuate a consumer's distinctive qualities. For example, Cachet perfume claims to be "as individual as you are."

For information 800 535-4491

© Benetton Group S.p.A. 2002 - www.benetton.com

FABRICA

UNITED COLORS OF BENETTON.

Benetton: This ad appeals to the need for affiliation.

Maslow's Hierarchy of Needs

One influential approach to motivation and needs was proposed by the psychologist Abraham Maslow. Maslow's approach is a general one originally developed to understand personal growth and the attainment of "peak experiences."[24] Maslow formulated a hierarchy of biogenic and psychogenic needs, in which levels of needs are specified. A hierarchical approach implies

Upper-Level Needs

Relevant Products		Example
	SELF-ACTUALIZATION Self-Fulfillment,	
Hobbies, travel, education	Enriching Experiences	U.S. Army—"Be all you can be."
	EGO NEEDS Prestige, Status,	
Cars, designer clothing, credit cards, stores, country clubs, liquors	Accomplishment	Royal Salute Scotch—"What the rich give the wealthy."
	BELONGINGNESS Love, Friendship,	
Fashion, grooming products, clubs, drinks	Acceptance by Others	Gap— "For all generations."
Fire-retardant children's sleep- wear, insurance, investments	**SAFETY** Security, Shelter, Protection	Allstate Insurance—"You're in good hands with Allstate."
Medicines, staple items, food	**PHYSIOLOGICAL** Water, Sleep, Food	Quaker Oat Bran—"It's the right thing to do."

Lower-Level Needs

FIGURE 4-2
Level of Needs in the Maslow Hierarchy

Source: Adapted from Michael R. Solomon, *Consumer Behavior* 8e, © 2009. Reprinted by permission of Prentice-Hall, Inc., Upper Saddle River, NJ.

that the order of development is fixed—that is, a certain level must be attained before the next higher one is activated. This perspective has been adapted by marketers because it (indirectly) specifies certain types of product benefits people might be looking for, depending on the different stages in their development or their environmental conditions.

These levels are summarized in Figure 4-2. At each level, different priorities exist in terms of the product benefits a consumer is looking for. Ideally, an individual progresses up the hierarchy until his or her dominant motivation is a focus on "ultimate" goals, such as justice and beauty. Unfortunately, this state is difficult to achieve (at least on a regular basis); most of us have to be satisfied with occasional glimpses or peak experiences.

The implication of Maslow's hierarchy is that one must first satisfy basic needs before progressing up the ladder (that is, a starving man is not interested in status symbols, friendship, or self-fulfillment). This hierarchy is not set in stone. Its use in marketing has been somewhat simplistic, especially since the same product or activity can satisfy a number of different needs. For example, clothing can satisfy needs at nearly every level of the hierarchy:

- *Physiological:* Clothing covers the body and protects us from the elements.
- *Safety:* Clothing sold in the United States must pass flammability standards so that it won't burst into flames when close to an ignition source; we should feel relatively safe in our clothing.

- *Social:* Fashion is something to share with and be seen in by others.
- *Esteem:* Wearing the latest fashion or an art-to-wear piece makes us feel good about ourselves and gives us a sense of status among our peers.
- *Self-Actualization:* "My clothes are an expression of the total me."

Another problem with taking Maslow's hierarchy too literally is that it is culture-bound. The assumptions of the hierarchy may only apply to Western culture. People in other cultures (or, for that matter, in Western culture) may question the order of the levels as specified. A religious person who has taken a vow of celibacy would not necessarily agree that physiological needs must be satisfied for self-fulfillment to occur.

Similarly, many Asian cultures value the welfare of the group (belongingness needs) more highly than needs of the individual (esteem needs). The point is that this hierarchy, while widely applied in marketing, is helpful to marketers because it reminds us that consumers may have different need priorities in different consumption situations and at different stages in their lives rather than because it *exactly* specifies a consumer's progression up the ladder of needs.

CONSUMER INVOLVEMENT

Do consumers form strong relationships with products and services? If you don't believe so, consider these recent events:

- *Lucky* is a magazine devoted to shopping for shoes and other fashion accessories. The centerfold of the first issue featured rows of makeup sponges. The editor observes, "It's the same way that you might look at a golf magazine and see a spread of nine irons. *Lucky* is addressing one interest in women's lives, in a really obsessive, specific way."[25]
- After being jilted by his girlfriend, a Tennessee man tried to marry his car. His plan was thwarted, however, after he listed his fiance's birthplace as Detroit, her father as Henry Ford, and her blood type as 10W40. Under Tennessee law, a man can't marry his car.[26] So much for that exciting honeymoon at the car wash.

These examples illustrate that people can get pretty attached to products. As we have seen, a consumer's motivation to attain a goal influences his or her desire to expend the effort necessary to attain the products or services believed to be instrumental in satisfying that objective. However, not everyone is motivated to the same extent—one person might be convinced he or she can't live without the latest style or modern convenience, while another is not interested in this item at all.

Involvement is defined as "a person's perceived relevance of an object based on their inherent needs, values, and interests."[27] The word *object* is used in the generic sense and refers to a product (or a brand), an advertisement, or a purchase situation. Consumers can find involvement in all these "objects." Since involvement is a motivational construct, it can be triggered by one or more of the different antecedents as shown in Figure 4-3. The antecedents are something about the person, something about the object, and

INVOLVEMENT = f (Person, Situation, Object)

The level of involvement may be influenced by one or more of these three factors. Interactions among persons, situation, and object factors are likely to occur.

FIGURE 4-3
Conceptualizing Involvement
Source: Judith Lynne Zaichkowsky, "Conceptualizing Involvement," *Journal of Advertising* 15, no. 2 (1986): 4–14.

something about the situation. On the right-hand side of Figure 4-3 are the results or consequences of being involved with the "object."

Involvement can be viewed as the motivation to process information.[28] To the degree that there is a perceived linkage between a consumer's needs, goals, or values and product knowledge, the consumer will be motivated to pay attention to product information. When relevant knowledge is activated in memory, a motivational state is created that drives behavior (such as shopping). As involvement with a product increases, the consumer devotes more attention to ads related to the product, exerts more cognitive effort to understand these ads, and focuses attention on the product-related information in them.[29]

On the other hand, a person may not bother to pay any attention to the same information if it is not seen as relevant to satisfying some need. One person who prides himself on his knowledge of exercise equipment may read anything he can find about the subject, spend his spare time in athletics stores, and so on, while another person may skip over this information without giving it a second thought. So it is with fashion; many young (and older) people are extremely involved with fashion, spending considerable time and money shopping for the latest styles, whereas others (often men qualify for this category) find shopping for clothes a chore.

Levels of Involvement: From Inertia to Passion

The type of information processing that will occur depends on the consumer's level of involvement. It can range from *simple processing*, in which only the basic features of a message are considered, all the way to *elaboration*, in which the incoming information is linked to a person's preexisting knowledge systems.[30]

Inertia

A person's degree of involvement can be conceived as a continuum, ranging from absolute lack of interest in a marketing stimulus at one end to obsession at the other. Consumption at the low end of involvement is characterized by **inertia** when decisions are made out of habit because the consumer lacks the motivation to consider alternatives. At the high end of involvement, we can expect to find the type of passionate intensity reserved for people and objects that carry great meaning to the individual. For example, the passion of some consumers for famous people (living like Michael Jackson or—supposedly—dead like Elvis Presley) demonstrates the high end of the involvement continuum. For the most part, however, a consumer's involvement level with products falls somewhere in the middle, and the marketing strategist must determine the relative level of importance to understand how much elaboration of product information will occur.

Cult Products and Obsession

In June 2007, a momentous event shook the modern world: Apple started selling its iPhone. Thousands of adoring iCultists (including the mayor of Philadelphia) around the country waited in front of Apple stores for days to be one of the first to buy the device—even though they could order the phone online and have it delivered in three days. Somehow that was too long to wait for a cell phone with a touchscreen. As one loyal consumer admitted, "If Apple made sliced bread, yeah, I'd buy it."[31]

Cult products command fierce consumer loyalty, devotion, and maybe even worship by consumers who are very highly involved with a brand. These items take many forms, from Apple iPhones and Harley-Davidson motorcycles to Manolo Blahnik shoes, not to mention devotion to recording artists and sports teams.[32]

SNEAKER OBSESSION

Even though some shoes are too good to wear you'll wait in line for a week to buy a pair. Under rain ponchos and umbrellas, waiting for the right to pay $295 for designer sneakers in a gold box from Niketown in San Francisco, "sneakerheads" waited patiently. Air Jordan VI Retro and Air Jordan XI Retro basketball shoes are reissued versions of earlier models released in the 1990s, and some people didn't mind giving up a week of their life to get their hands on them. "Wearing them would be stupid. Wearing them makes the value go down really fast," said one avid fan and collector. The shoes came with a picture of retired basketball star Michael Jordan, a certificate of authenticity, and a brass tag attached to the laces.[33]

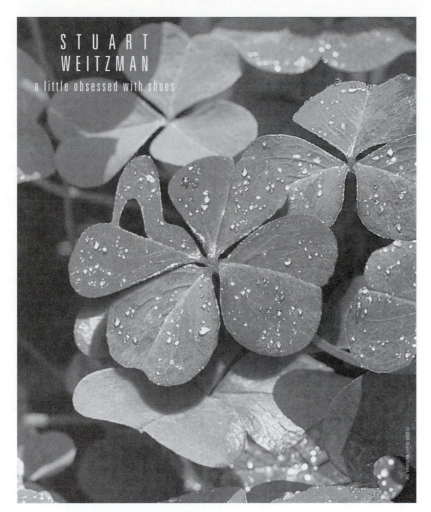

STUART
WEITZMAN
a little obsessed with shoes

This ad illustrates consumer involvement with shoes. Mr. Wietzman, who is a little obsessed with shoes, sees shoes in everything around him, in this case even in a four-leaf clover.

The Many Faces of Involvement

As previously defined, involvement can take many forms. Involvement can be cognitive, as when a "webhead" is motivated to learn all he or she can about the latest specs of a new multimedia PC, or emotional, as when the thought of a new Armani suit gives a clotheshorse goosebumps.[34] And the very act of buying the Armani may be very involving for people who are passionately devoted to shopping. To complicate matters further, advertisements, such as those produced for Nike or Adidas, may themselves be involving for some reason (for example, because they make us laugh, cry, or inspire us to work harder).

It seems that involvement is a fuzzy concept because it overlaps with other things and means different things to different people. Indeed, the consensus is that there are actually several broad types of involvement related to the product, the message, the perceiver, or the process.[35]

Product Involvement

Product involvement is related to a consumer's level of interest in a particular product. The more involved consumers are in a product, the more they are

apt to purchase it or purchase it sooner than others. They also may encourage others to do the same. Many sales promotions are designed to increase product involvement. In a contest sponsored by Dare perfume, for example, women submitted details of their most intimate trysts by letter or by phone to radio talk shows. The winning stories were edited into a romance novel published by Bantam Books. These books, in turn, were given away as a gift with the purchase of the perfume.[36]

Smart marketers know that their most avid fans are a great resource—rather than ignoring their suggestions, they know they need to take them seriously. Perhaps the most powerful way to enhance product involvement is to invite consumers to play a role in designing or personalizing what they buy. *Mass customization* is the personalization of products and services for individual customers at a mass-production price.[37] Improved manufacturing techniques in many industries are allowing companies to produce made-to-order products for many customers at a time. One clothing study found that both men and women were most likely to customize jeans and "fit to shape" was the feature women were most interested in customizing.[38] Customers love the idea of mass customization—today around 40 percent of Lands' End shoppers choose a customized garment over the standard-sized equivalent even though these items cost at least $20 more and take about three to four weeks to arrive. At www.landsend.com you can also view the clothes on a model that you create by choosing measurements and personal coloring that are similar to your own. Then clothes can be "tried on" to view the total effect. At www.nike.com buyers can specify a unique palette of colors or even words that will appear on their shoes whereas www.venturoma.com lets the shopper create her own blend of massage oils, skin creams, or body washes. At www.whatshotnow.com, a consumer-driven Internet store offering a selection of sports entertainment and lifestyle merchandise and apparel, consumers build 4,250 new "stores" a month featuring merchandise requested by them. Each time a user visits the site, she sees only the merchandise she's interested in.[39]

The Nikeid Web site allows consumers to "build their own." After choosing your customized colors for heal, swoosh, swoosh border, lining, lace, midsole, and body, you can even put your personal ID on the tongue (Nike's personalization policy does explain it will only accept appropriate requests).

Message-Response Involvement

Vigilante marketing, where freelancers and fans film their own commercials for favorite products and post them on Web sites, is hot. In one unauthorized spot that got media attention in magazines like *Wired* and in advertising blogs like AdRants, an iPod Mini zips around to the song "Tiny Machine" by the Darling Buds.[40] This devotion is an extreme example of *message-response involvement* (also known as *advertising involvement*), which refers to the consumer's interest in processing marketing communications.[41]

Television is considered a low-involvement medium because it requires a passive viewer who exerts relatively little control (remote control "zipping" notwithstanding) over content. In contrast, print is a high-involvement medium. The reader is actively involved in processing the information and is able to pause and reflect on what he or she has read before moving on.[42] The role of message characteristics in changing attitudes is further discussed in Chapter 10.

The quest to heighten message involvement is fueling the rapid growth of **interactive mobile marketing**, where consumers participate in real-time promotional campaigns via their trusty cell phones, usually by text-messaging entries to on-air TV contests. These strategies are very popular in the United Kingdom, for example, where revenue from phone and text-messaging services for TV programs brings in almost a half billion dollars a year. The United States with several different wireless network technologies and time zones took longer to adopt this strategy. Viewers sent more than 500,000 text-message votes within two days during the reality show *Big Brother*. But *American Idol* reigns supreme in this category with 97 million viewers voting for the final winner in season 7.[43] Similarly, Nike entered the interactive-TV arena for those with dish DVRs. Users can click into 30-and 60-second TV spots starring San Diego Chargers running back LaDanian Tomlinson and other Nike athletes with the option of viewing interviews with the stars, a Nike-branded game to test viewers' remote-control reflexes, or a three-dimensional demo of the Zoom shoe.[44]

Purchase Situation Involvement

Purchase situation involvement refers to differences that may occur when buying the same object for different contexts. Here the person may perceive a great deal of social risk or none at all. What people think when they consume the product for themselves or when others consume the product they buy is not always obvious or intuitive. For example, when you want to impress someone, you may try to buy a brand or a product with a certain image that you think reflects good taste. When you have to buy a gift for someone in an obligatory situation—for example, a wedding gift for a cousin you do not really like—you may not care what image the gift portrays. Or you may actually pick something cheap that reflects your desire to distance yourself from that person.

Measuring Involvement

The measurement of involvement is important for many marketing applications. For example, research evidence indicates that a viewer who is more involved with a television show will also respond more positively to commercials contained in that show and that these spots will have a greater chance of influencing his or her purchase intentions.[45] Therefore, many research

Table 4-1 A Scale to Measure Involvement

	To Me [Object to Be Judged] Is		
1.	important	_:_:_:_:_:_:_	unimportant*
2.	boring	_:_:_:_:_:_:_	interesting
3.	relevant	_:_:_:_:_:_:_	irrelevant*
4.	exciting	_:_:_:_:_:_:_	unexciting*
5.	means nothing	_:_:_:_:_:_:_	means a lot to me
6.	appealing	_:_:_:_:_:_:_	unappealing*
7.	fascinating	_:_:_:_:_:_:_	mundane*
8.	worthless	_:_:_:_:_:_:_	valuable
9.	involving	_:_:_:_:_:_:_	uninvolving*
10.	not needed	_:_:_:_:_:_:_	needed

Note: Totaling the 10 items gives a score from a low of 10 to a high of 70.

*Indicates item is reverse scored. For example, a score of 7 for item no. 1 (important/unimportant) would actually be scored as 1.

Source: Judith Lynne Zaichkowsky, "The Personal Involvement Inventory: Reduction, Revision, and Application to Advertising," *Journal of Advertising* 23, no. 4 (December 1994): 59–70.

companies like Involvement Marketing Inc. measure the level of consumer involvement to make predictions on the success of advertising campaigns. One of the most widely used measures of the state of involvement is the scale shown in Table 4-1. It is the most widely used because it is context free and, therefore, applicable to products, advertisements, and purchase situations.

Teasing Out the Dimensions of Involvement

Apparel and fashion purchasing is generally thought of as a high-involvement activity. The term *fashion involvement* has been found by some researchers to be imprecise and may be composed of many diverse dimensions. Although many researchers agree that consumers consider apparel purchases important to them and many (not all) conduct an active search before purchase, there is a limited amount of research on the concept of fashion involvement.[46] Several instruments have, however, been used. Tigert, Ring, and King's early work found fashion involvement is composed of five fashion-related dimensions:[47]

- Fashion awareness
- Fashion knowledgeabilty
- Fashion interest
- Fashion interpersonal communications
- Fashion innovativeness

A later study found fashion involvement composed of two different types of dimensions: dress to express personality and dress as a signaling device.[48] Items that measured these dimensions include the following:

Dress to Express Personality
- The clothes that somebody wears tells me a lot about that person.
- My clothes help me express who I am.
- You can tell a lot about a person by the clothes he or she wears.

Dress as a Signaling Device
- When I wear one of my favorite outfits, others see me the way I want them to see me.

More recently a study using Korean and U.S. student and adult consumers validated Mittal and Lee's "Enduring Involvement Scale" applied to fashion[49] and has been used by other researchers.[50] This scale includes the following three items:

- I have a strong interest in new fashions.
- New fashions are very important to me.
- For me, new fashions do not matter. (reverse coded)

This last scale has been correlated with other expected constructs. For example, high fashion involved consumers are consistently shown to shop more, spend more, be more innovative, use more product category–related information sources, and be less concerned with price. Researchers also have found high clothing involved consumers are more often impulse buyers.[52] Also, Zaichkowsky's general involvement instrument has been applied to fashion.[51] Thus, we see a variety of scales used in the literature to measure fashion involvement.

Shopping involvement has been measured by such items as the following:

- Shopping is recreation.
- Shopping is enjoyable.
- I like to shop for clothing.
- Shopping wastes my time. (reverse coded)

In studying several types of products, a pair of French researchers devised a scale to measure the antecedents of product involvement. Recognizing that consumers can be involved with a product because it is a risky purchase and/or its use reflects on or affects the self, they advocate the development of an *involvement profile* containing five components:[53]

- The personal interest a consumer has in a product category
- The perceived importance of the potentially negative consequences associated with a poor product choice
- The probability of making a bad purchase
- The pleasure value of the product category
- The sign value (related to self-concept) of the product category

These researchers asked a sample of homemakers to rate a set of fourteen product categories on each of the foregoing facets of involvement. The results are shown in Table 4-2. These data indicate that no single component captures consumer involvement, since this quality can occur for different reasons. For example, the purchase of a durable product such as a vacuum cleaner is seen as risky because one is stuck with a bad choice for many years. However, the vacuum cleaner does not provide pleasure (hedonic value), nor is it high in sign value (that is, its use is not related to the person's self-concept). In contrast, chocolate is high in pleasure value but is not seen as risky or closely related to the self. Dresses, on the other hand, appear to be

Table 4-2 Involvement Profiles for a Set of French Consumer Products

	Importance of Negative Consequences	Subjective Probability of Mispurchase	Pleasure Value	Sign Value
Dresses	121	112	147	181
Bras	117	115	106	130
Washing machines	118	109	106	111
TV sets	112	100	122	95
Vacuum cleaners	110	112	70	78
Irons	103	95	72	76
Champagne	109	120	125	125
Oil	89	97	65	92
Yogurt	86	83	106	78
Chocolate	80	89	123	75
Shampoo	96	103	90	81
Toothpaste	95	95	94	105
Facial soap	82	90	114	118
Detergents	79	82	56	63

Average product score = 100.

Note: The first two antecedents of personal importance and importance of negative consequences are combined in these data.

Source: Giles Laurent and Jean-Noël Kapferer, "Measuring Consumer Involvement Profiles," *Journal of Marketing Research* 22 (February 1985): 45, Table 3. By permission of American Marketing Association.

involving for a combination of reasons: They are socially risky (will this style be accepted by others?), have a high pleasure value, and are very highly related to one's self-concept.

Segmenting by Involvement Levels

A measurement approach of this nature allows consumer researchers to capture the diversity of the involvement construct, and it also provides the potential to use involvement as a basis for market segmentation. For example, bras are shown here to be lowest in pleasure value. This, however, might be quite different for the Wonderbra, the Water Bra, or Victoria's Secret Dream Angels or BioFit® bra which attracts quite a different market than basic bras. Consider the differences in markets for a sports bra and the Water Bra.[54] A manufacturer could adapt its strategy to account for the motivation of different segments to process information about the product. Note also that involvement with a product class may vary across cultures. Although this sample of French consumers rated champagne high in both sign value and personal value, the ability of champagne to provide pleasure or be central to self-definition might not transfer to other countries (such as Islamic cultures).

Brand commitment or involvement (see Chapter 11 for discussion on brands) has been studied to develop a product/brand involvement model to segment the collegiate market for jeans. Four segments were identified based on high and low scores for involvement and brand commitment of four

groups. The high product/strong brand–involved group was found to be the least price conscious, most fashion conscious, most concerned with both image and utilitarian attributes of jeans, and most likely influenced in terms of their opinions of brands of jeans by market and personal information sources.[55] Different marketing approaches would be recommended to target each segment.

Strategies to Increase Involvement

Although consumers differ in their level of involvement with respect to a product message, marketers do not have to just sit back and hope for the best. By being aware of some basic factors that increase or decrease attention, they can take steps to increase the likelihood that product information will get through. A marketer can boost consumers' motivation to process relevant information by using one or more of the following techniques:[56]

- Appeal to the consumers' hedonic needs. For example, ads using sensory appeals generate higher levels of attention.[57]
- Use image interactive technology on Web sites, such as close-up pictures or zoom-in features. Research has shown a high level of interactivity was related to high levels of shopping involvement.[58]
- Use novel stimuli, such as unusual cinematography, sudden silences, or unexpected movements in commercials.
- Use prominent stimuli, such as loud music and fast action, to capture attention in commercials. In print formats, larger ads increase attention. Also viewers look longer at colored pictures as opposed to black-and-white pictures.
- Include celebrity endorsers to generate higher interest in commercials. This strategy will be discussed in Chapter 10.
- Build a bond with consumers by maintaining an ongoing relationship with them. Loyalty programs discussed in Chapter 1 are good examples of a clothing company maintaining ties with customers.
- Personalize the product as discussed earlier. One of the exciting advantages of the Internet is the ability to personalize content so that a Web site offers information or products tailored to individual surfers.[59] According to one study, personalized e-commerce sites increased new customers by 47 percent in the first year.[60]

Consumer-Generated Content

Consumer-generated content, where everyday people voice their opinions about products, brands, and companies on blogs, podcasts, and social networking sites such as Facebook and MySpace, and even film their own commercials that thousands view on sites such as YouTube, probably is the biggest marketing phenomenon of the past few years (even bigger than the iPhone or Paris Hilton's jail stay!). This important trend helps to define the era of so-called **Web 2.0**, the rebirth of the Internet as a social, interactive medium from its original roots as a form of one-way transmission from producers to consumers.

Companies can no longer rely solely on a "push method" to inform their customers about their products; now they need to encourage a vibrant two-way dialogue that allows consumers to contribute their evaluations of products within their respective Web communities. Consumers embrace this trend for several reasons: The technology is readily available and inexpensive to use. Internet access allows any surfer to become somewhat of an expert on anything in a matter of hours, and people trust their peers' opinions more than they do those of big companies.[61] Marketers need to accept this new reality—even when they don't necessarily like what customers have to say about their brands. Here are some of the many consumer-generated campaigns we've seen recently.

- A Converse campaign that allowed customers to send in homemade commercials to www.conversegallery.com attracted about 1,500 submissions. Converse ran several of them on television.

- Pepsi offered consumers a chance to design a new can for the beverage; the winning design will appear on 500 million Pepsi cans.

- California State University, Fresno sponsored a campus competition to create video clips posted on YouTube that appeal to potential applicants as well as stir feelings of pride among students, alumni, and members of the faculty and staff.

- Apple contacted 18-year-old British student Nick Haley about a 30-second spot he made for the new iPod touch on YouTube. At first, it all seemed like a joke, but it was used in a major Apple promotion in the United States, Europe, and Japan. He was inspired to make the commercial by a lyric in the song, "My music is where I'd like you to touch."[62]

- America selected its favorite Dove® Body Wash ad, created by real woman Celeste Wouden of Mantua, Utah, as part of the Dove® Supreme Cream Oil Body Wash Ad Contest. The Dove® Supreme Cream Oil Body Wash ad contest invited real women to share their views on luxury in a 30-second ad. The brand received an overwhelming response with over 3,500 real women submitting entries, more than doubling last year's inaugural contest submissions.[63]

VALUES

Values are fundamental beliefs that direct or motivate our behavior and decision making. They also can be thought of as conditions preferable to their opposite. For example, many avidly pursue products and services that will make them look young, believing that this is preferable to appearing old. A person's set of values plays an important role in consumption activities, since many products and services are purchased because people believe they will help to attain a value-related goal.

Two people can believe in the same behaviors but their underlying belief systems may be quite different. The extent to which people share a belief system is a function of individual, social, and cultural forces. Advocates of a belief system often seek out others with similar beliefs, so that social networks overlap; as a result, believers tend to be exposed to information that supports their beliefs.[64] Research has shown that a person's general values affect specific

clothing decisions. Such research is evident as far back as the 1930s, but there has been a problem defining and measuring values over the years.

Core Values

More than 8.2 million women in fifty countries read versions of *Cosmopolitan* in twenty-eight different languages—even though due to local norms about modesty some of them have to hide the magazine from their husbands! Adapting the *Cosmo* crede of "Fun, Fearless Female" in all these places gets a bit tricky. Different cultures emphasize varying belief systems that define what it means to be female, feminine, or appealing—and what is considered appropriate to see in print on these matters. In India you won't come across any *Cosmo* articles about sex. Publishers of the Chinese version aren't even permitted to mention sex at all, so articles about uplifting cleavage are replaced by uplifting stories about youthful dedication. Ironically there isn't much down-and-dirty material in the Swedish edition either but for the opposite reason: The culture is so open about this topic that it doesn't grab readers' attention the way it would in the United States.[65]

Every culture has a set of values that it imparts to its members.[66] For example, people in one culture might feel that being a unique individual is preferable to subordinating one's identity to the group, whereas another culture may emphasize the virtues of group membership. A study by Wirthlin Worldwide, for example, found that the most important values to Asian executives are hard work, respect for learning, and honesty. In contrast, North American businesspeople emphasize the values of personal freedom, self-reliance, and freedom of expression.[67] These differences in values often explain why marketing efforts that are a big hit in one country can flop in another. For example, a hugely successful advertisement in Japan promoted breast cancer awareness by showing an attractive woman in a sundress drawing stares from men on the street as a voice-over says, "If only women paid as much attention to their breasts as men do." The same ad flopped in France because the use of humor to talk about a serious disease offended the French.[68]

In many cases, however, values are universal. Who does not desire health, wisdom, or world peace? What sets cultures apart is the *relative importance*, or ranking, of these universal values. This set of rankings constitutes a culture's **value system**.[69] For example, one study found that North Americans have more favorable attitudes toward advertising messages that focus on self-reliance, self-improvement, and the achievement of personal goals as opposed to themes stressing family integrity, collective goals, and the feeling of harmony with others. The reverse pattern was found for Korean consumers.[70]

Every culture is characterized by its members' endorsement of a value system. These values may not be equally endorsed by everyone, and in some cases, values may even seem to contradict one another (for example, Americans appear to value both conformity and individuality and seek to find some accommodation between the two). Nonetheless, it is usually possible to identify a general set of *core values* that uniquely defines a culture. These beliefs are taught to us by *socialization agents*, including parents, friends, and teachers.

Core values such as freedom, youthfulness, achievement, materialism, and activity have been claimed to characterize American culture, but even these basic beliefs are subject to change. For example, Americans' emphasis

on youth is eroding as the population ages (see Chapter 6). Also, after September 11, 2001, Americans' value of patriotism increased significantly. A study of the dominant values underlying a set of American print ads representing the period from 1900 to 1980 found the prevalence of practicality and product effectiveness as an underlying advertising theme. Do you think these values are still valid today?

Is sustainability a new American core value? In a 2007 survey, fully eight in ten consumers said they believe it's important to buy green brands and products from green companies and that they'll pay more to do so. The U.S. consumer is focusing on personal health, which is merging with a growing interest in global health. Some analysts call this new value **conscientious consumerism**.[71] Marketers point to a segment of consumers who practice LOHAS—an acronym for "lifestyles of health and sustainability," referring to those who worry about the environment and want products to be produced in a sustainable way. These consumers represent a great market for products such as organic foods and apparel, hybrid cars, and ecotourism. One organization that tracks this group estimates the market for socially conscious products at more than $200 billion.[72] Many apparel companies and designers are creating items made from recycled products and developing lines of organic cotton and other renewable source. The book *Sustainability, Why now?*[73] looks at best practices in the design and production arenas of the apparel industry to reduce harm to the environment. The industry and consumers are using terms such as *eco-chic*, *eco-fashion*, and *environmentally friendly* without really having a good idea of what these terms mean. A recent student/faculty study found that apparel industry professionals were fairly clear about these meanings while many consumers were clearly unclear![73] The concept of reducing our **carbon footprint**, the human impact on the environment, is becoming an important issue in many businesses and consumers' lives today.

Values Related to Clothing Choices

Three major value paradigms have been used over the years to study clothing values:[75] (1) Spranger, (2) Hartmann, and (3) Allport-Vernon-Lindzey (AVL). The latter two are based on Spranger's work that profiled six "ideal" personality types by describing each as possessing one of the six characteristics as dominant. These include theoretical, economic, aesthetic, social, political, and religious. Hartmann developed statements for Spranger's personality types meant to measure clothing values shown in Table 4-3.

Table 4-3 Personal Values and Dress

Value	Emphasis in Clothing
Theoretical	Stresses objective properties of fabrics
Economic	Shrewd purchaser; eliminates waste
Aesthetic	"If it's good looking, nothing else matters"
Social	Conscientious; disturbed by rags versus riches
Political	Requires effects evoking admiration or submission from others
Religious	Follows simplicity as ideal; original Quakerism

Source: Marcia A. Morgado, "Personal Values and Dress: The Spranger, Hartmann, AVL Paradigm in Research and Pedagogy," *Clothing and Textiles Research Journal* 13, no. 2 (1995): 139–148.

Allport-Vernon-Lindzey instruments, faithful to Spranger's typology, have subjects rank order the described behavior representing the values so that values are relative, one against another. These early paradigms have been used heavily by clothing researchers who found relationships between these general values and specified clothing concepts and orientations[76] and cross-cultural differences between clothing values.[77] The typology has been described in books throughout the past three decades by clothing scholars in discussions of relating an individual's general values and his or her specific clothing value orientations.[78] Finding difficulty in supporting this typology some researchers have added the additional values of exploratory, sensory, and a second social category (the need for acceptance). Early work has been criticized as being too limiting and based on questionable assumptions. Clothing researchers have challenged others to go beyond the Spranger typology; however, it has an important place in the history of this research area. Researchers who have departed from this typology have studied more specific values such as fashion, function, aesthetics, and interpersonal values. For example, one study indicates fashion-oriented consumers tend to value quantity over quality and buy from "want rather than need."[79]

One of the criticisms of many of the value typologies (not just clothing frameworks) is that they have a closed-ended rather than open-ended structure. One study using an open-ended structure identified sixteen clothing values: fun, independence or freedom, beauty and attractiveness, freedom from bother and annoyance, safety, accomplishing something, acceptance and inclusion by others, standard of living, self-regard, self-expression, fashion, variety, economy, creativity, functionality, and sexuality. Others have labeled some of these concepts as functions of, or motivations for, purchasing clothing.

Sontag and Schlater developed a two-dimensional theoretical model for measuring values that they used to categorize over fifty studies of clothing values.[80] The two dimensions, named Focus and Subject-Object Inclusion, include names of values, their structure and process, values with and without specific objects, and interactive effects of an individual's action on the object.

Using Values to Explain Consumer Behavior

Despite their importance, values have not been as widely applied to direct examinations of consumer behavior as might be expected. One reason is that such broad-based concepts as freedom, security, or inner harmony (subject-only values) are more likely to affect general purchasing patterns than to differentiate between brands within a product category. For this reason, some researchers have found it convenient to make distinctions among such broad-based *cultural values* as security or happiness, *consumption-specific values* such as convenient shopping or prompt service, and *product-specific values* such as ease of use or durability.[81] For example, people who value group affiliation and approval have been shown to place more importance on style and brand name when evaluating the desirability of clothing products.[82]

Since values drive much of consumer behavior (at least in a very general sense), it could be said that virtually *all* consumer research ultimately is related to the identification and measurement of values. This section describes some specific attempts by researchers to measure cultural values and apply this knowledge to marketing strategy.

Table 4-4 Two Types of Values in the Rokeach
Value Survey

Instrumental Values	Terminal Values
Ambitious	A comfortable life
Broadminded	An exciting life
Capable	A sense of accomplishment
Cheerful	A world at peace
Clean	A world of beauty
Courageous	Equality
Forgiving	Family security
Helpful	Freedom
Honest	Happiness
Imaginative	Inner harmony
Independent	Mature love
Intellectual	National security
Logical	Pleasure
Loving	Salvation
Obedient	Self-respect
Polite	Social recognition
Responsible	True friendship
Self-controlled	Wisdom

Source: Richard W. Pollay. "Measuring the Cultural Values
Manifest in Advertising." *Current Issues and Research in
Advertising* (1983): 71–92. Reprinted by permission of University
of Michigan Division of Research.

The Rokeach Value Survey

Psychologist Milton Rokeach identified a set of **terminal values**, or desired end states, that apply to many different cultures. The Rokeach Value Survey, a scale used to measure these values, also includes a set of **instrumental values**, which are composed of actions needed to achieve these terminal values.[83] These two sets of values appear in Table 4-4. Clearly, the importance of values varies across countries, as stated, but they also vary in different parts of the United States. Researchers have found that people in the Mountain region, for example, are relatively more concerned with environmental mastery, whereas those in the West South Central area focus on personal growth and feeling cheerful and happy; the West North Central area emphasizes feeling calm, peaceful, and satisfied; and people in the East South Central area are more concerned with contributing to others' well-being.[84]

The List of Values (LOV)

Although some evidence indicates that differences on these global values do translate into product-specific preferences and differences in media usage, the Rokeach Value Survey has not been widely used by marketing researchers.[86] As an alternative, the *List of Values (LOV) Scale*, based theoretically on Maslow's and Rokeach's work, was developed to isolate values with

Japanese culture is well known for its emphasis on cleanliness. The Shinto religion requires a ritual washing of hands and mouth before entering shrines, and people always take off their shoes at home to avoid dirtying the floors. When people give money as a wedding gift, they often iron the bills before placing them in the envelope. Some laundromats even allow customers to rinse out the inside of a machine before using it.

This value reached new proportions with a food poisoning epidemic one summer. Demand for products such as antiseptic bicycle grips, karaoke microphones, and gauze masks skyrocketed, and a rash of sterilized products ranging from stationery to telephones and dishwashers invaded the market. Pentel makes a germ-free pen decorated with a medical blue cross; the popular brand is advertised with the slogan: "The pen is mightier than the bacterium." Japan's Sanwa Bank literally "launders money" for its customers in specially designed ATM machines, whereas Tokyo's Mitsubishi Bank opened a "Total Anti-Germ Branch" featuring ATMs with surfaces made of plastics saturated with chemicals that resist bacteria and fungus. A bank spokesperson noted the branch is especially popular with young female customers.[85]

more direct marketing applications. This instrument identifies nine consumer segments based on the values they endorse and relates each to differences in consumption behaviors. These segments include consumers who place a priority on the following values:

- Sense of belonging
- Warm relationships with others
- Security
- Self-respect
- Sense of accomplishment
- Self-fulfillment
- Being well respected
- Fun and enjoyment of life
- Excitement

Researchers subsequently combined some of these values such as "fun and enjoyment of life" with "excitement."[87] One study using this scale found that people who endorse the value of sense of belonging are more likely to read *TV Guide*, drink and entertain more, prefer group activities, and are older than people who do not endorse this value as highly. In contrast, those who endorse the value of excitement are younger and prefer *Rolling Stone* magazine.[88]

Syndicated Surveys

A number of companies track changes in values through large-scale surveys. The results of these studies are sold to marketers, who receive regular updates on changes and trends. This approach originated in the mid-1960s, when Playtex was concerned about declining girdle sales. The company commissioned the market research firm of Yankelovich, Skelly & White to see why sales had dropped. The firm's research determined that sales had been affected by a shift in values regarding appearance and naturalness. Playtex designed lighter, less restrictive garments, while Yankelovich went on to track

the impact of these types of changes in a range of industries. Gradually, the firm developed the idea of one big study to track American attitudes. In 1970, the firm developed the Yankelovich *Monitor*, which is based on two-hour interviews with 4,000 respondents.[89] This survey attempts to track changes in values; for example, it reported a movement among American consumers toward simplification and away from hype as people try to streamline their hectic lives.

Today, many other syndicated surveys also track changes in values; some of these are operated by advertising agencies to allow them to stay on top of important cultural trends and help them to shape the messages they craft on behalf of their clients. These services include VALS 2™ (described in Chapter 8), GlobalScan (operated by the advertising agency Backer Spielvogel Bates), New Wave (the Ogilvy & Mather advertising agency), and the Lifestyles Study conducted by the DDB World Communications Group. The Angus Reid Group in Canada surveys changes in values of specific groups or industry segments. Cotton Incorporated's *Lifestyle Monitor* (www.cottoninc.com) tracks values and attitudes related to fashion. (See Chapter 8 for discussion on this.)

The 1997 Roper Reports Worldwide Global Consumer Survey interviewed people in thirty-five countries who ranked fifty-six values by the importance they held as guiding principles in their lives. The study identified six global values segments: strivers, devouts, altruists, intimates, fun seekers, and creatives. Some interesting differences in core values emerged from this large study. For example, Indonesians rank respecting ancestors as their number one guiding principle. Great Britain leads the world in wanting to protect the family, Brazil has the most fun seekers, the Netherlands is highest in valuing honesty, and Korea is first in valuing health and fitness.[90]

Another recent global study, the New World Teen Study, surveyed 27,000 teenagers in forty-four countries and identified six values segments that characterize young people around the world: thrills and chills, resigned, world savers, quiet achievers, bootstrappers, and upholders. Table 4-5 summarizes some of the findings from this massive study.

Materialism: "He Who Dies with the Most Toys Wins"

During World War II, members of "cargo cults" in the South Pacific literally worshiped cargo that was salvaged from crashed aircraft or washed ashore from ships. These people believed that the ships and planes passing near their islands were piloted by their ancestors, and they tried to attract them to their villages. They went so far as to construct fake planes from straw in hopes of luring the real ones to their islands.[91]

Although most people don't literally worship material goods in quite this way, things do play a central role in many people's lives. **Materialism** refers to the importance people attach to worldly possessions. Americans inhabit a highly materialistic society where people often gauge the worth of themselves and others in terms of how much they own. The popular bumper sticker, "He Who Dies with the Most Toys Wins" is a comment on this philosophy. We sometimes take the existence of an abundance of products and services for granted, until we remember how recent many of these developments are. For example, in 1950 two of five American homes did not have a

Table 4-5 New World Teen Study

Segment	Key Countries	Driving Principles	Overview	Marketing Approach
Thrills and Chills	Germany, England, Lithuania, Greece, Netherlands, South Africa, United States, Belgium, Canada, Turkey, France, Poland, Japan, Italy, Denmark, Argentina, and Norway	Fun, friends, irreverence, and sensation	Stereotype of the devil-may-care, trying-to-become-independent hedonist. For the most part, they come from affluent or middle-class parents, live mainly in developed countries, and have allowance money to spend.	Respond to sensory stimulation. Tend to get bored easily so stale advertising messages will escape their notice. They want action ads with bells and whistles, humor, novelty, color, and sound. Edgier than their peers. Constantly seek out the new. First ones to hear of the newest technology or the hippest Web site. Experimenting is second nature. Wear all sorts of body rings and wear their hair in different shades.
Resigned	Denmark, Sweden, Korea, Japan, Norway, Germany, Belgium, Netherlands, Argentina, Canada, Turkey, England, Spain, France, and Taiwan	Friends, fun, family, and low expectations	Resemble the thrills-and-chills teens, often decorating their bodies with rings and dye. However, they are alienated from society and very pessimistic about their chances for economic success. The punk rockers of the world, who sometimes take drugs and drink to excess. Respond to heavy metal and grunge music that emphasizes the negative and angry side of society.	Do not have as much discretionary income to spend as teens in other segments. Infrequent consumers save for some fast-food, low-ticket clothes items, tobacco, and alcohol. They are drawn to irony and to ads that make fun of the pompousness of society.
World Savers	Hungary, Philippines, Venezuela, Brazil, Spain, Colombia, Belgium, Argentina, Russia, Singapore, France, Poland, Ukraine, Italy, South Africa, Mexico, and England	Environment, humanism, fun, and friends	A long list of do-good global and local causes that spark their interest. The intelligentsia in most countries who do well in school. They are the class and club leaders who join many organizations. They attend the same parties as the thrills-and-chills kids. But they are more into romance, relationships, and strong friendships. Eagerly attend concerts, operas, and plays. They exhibit a *joie de vivre* about life and enjoy dancing or drinking at bars and cafes with friends. They love the outdoors as well, including camping, hiking, and other sports activities.	Attracted by honest and sincere messages that tell the truth. Offended by any ad that puts people down or makes fun of another group. Piggyback a promotion with a worthwhile cause.
Quiet Achievers	Thailand, China, Hong Kong, Ukraine, Korea, Lithuania, Russia, and Peru	Success, anonymity, anti-individualism, and social optimism	Value anonymity and prefer to rest in the shadows. They are the least rebellious of all the groups, avoid the limelight, and do not ever want to stand out in the crowd. These are the bookish and straight kids who study long hours, are fiercely ambitious and highly goal-directed. Their top priority is to make good grades in school and use higher education to further their career advancement. Most of the quiet achievers live in Asia, especially Thailand and China.	Love to purchase stuff. Part of the reward for working diligently is being able to buy products. Their parents will defer to their children's needs when it comes to computers and other technological products that will aid in homework. This group is also keen on music; they are inner directed and adept at creating their own good times. Prefer ads that address the benefits of a product. They are embarrassed by ads that display rampant sexuality. And they *(Continued)*

Table 4-5 New World Teen Study (*Continued*)

Segment	Key Countries	Driving Principles	Overview	Marketing Approach
			But these somewhat stereotypical studious types also exist in the United States, where they are sometimes regarded as being techies or nerds.	do not respond to the sarcastic or the irreverent.
Bootstrappers	Nigeria, Mexico, United States, India, Chile, Puerto Rico, Peru, Venezuela, Colombia, and South Africa	Achievement, individualism, optimism, determination, and power	Most dreamy and childlike of the six segments. They live sheltered and ordered lives that seem bereft of many forms of typical teen fun and wild adult-emulating teen behavior. Spend a lot of time at home, doing homework and helping around the house. Eager for power; they are the politicians in every high school who covet the class offices. They view the use of authority as a means for securing rewards, and they are constantly seeking out recognition. Geographically many of these teens come from emerging nations such as Nigeria and India. In the United States, bootstrappers represent one in every four teens. Moreover, they represent 40% of young African Americans. A major error of U.S. marketers is to misread the size and purchasing power of this ambitious African American segment.	Young yuppies in training. They want premium brands and luxury goods. Bootstrappers are also on the lookout for goods and services that will help them get ahead. They want to dress for success, have access to technology and software, and stay plugged into the world of media and culture to give them a competitive edge. They are attracted by messages that portray aspirations and possibilities for products and their users.
Upholders	Vietnam, Indonesia, Taiwan, China, Italy, Peru, Venezuela, Puerto Rico, India, Philippines, and Singapore	Family, custom, tradition, and respect for individuals	Traditions act as a rigid guideline, and these teens would be hard-pressed to rebel or confront authority. They are content to rest comfortably in the mainstream of life, remaining unnoticed. The girls seek mostly to get married and have families. The boys perceive that they are fated to have jobs similar to their fathers'. Predominate in Asian countries, such as Indonesia and Vietnam that value old traditions and extended family relationships. Teens in these countries are helpful around the home and protective of their siblings. Moreover, many upholders are in Catholic countries where the Church and tradition guide schooling, attitudes, and values.	Advertisers and marketers have had success selling to upholders using youthful, almost childlike communication and fun messages. These are teens that still watch cartoons and are avid media consumers. They are highly involved in both watching and playing sports, particularly basketball and soccer. More than any other group, they plan to live in their country of birth throughout adulthood. Essentially upholders are homebodies. They are deeply rooted in family and community and they like to make purchase decisions that are safe and conform to their parents' values. Brands that take a leadership stance will attract upholders for their risk-free quality value and reliability.

Source: Adapted from "The Six Value Segments of Global Youth," *Brandweek* 11, no. 21 (May 22, 2000) 38, based on data initially presented in *The $100 Billion Allowance: How to Get Your Share of the Global Teen Market* by Elissa Moses (New York: John Wiley & Sons, 2000).

telephone, and in 1940 half of all households still did not possess complete indoor plumbing. Today, though, many Americans now energetically seek "the good life," which abounds in material comforts. Most young people can't imagine a life without cell phones, MP3 players, and other creature comforts. Even with the high price of gas and heating fuel and the size of families decreasing, we see supersize homes (some call them McHouses) and gigantic SUVs as the norm. Some say we are at the peak of the latest American materialistic cycle with the typical new house twice the size of an average home of the 1950s. Who can explain boutiques selling clothing, diet supplements, and confections for our pampered dogs?[92]

Materialists are more likely to value possessions for their status and appearance-related meanings, whereas those who do not emphasize this value tend to prize products that connect them to other people or that provide them with pleasure in using them.[93] As a result, high materialists value products that are more likely to be publicly consumed and to be more expensive. A study that compared specific items valued by low versus high materialists found that people low on the value cherished items like a mother's wedding gown, picture albums, a rocking chair from childhood, or a garden, whereas those who scored high preferred things like jewelry, china, or a vacation home.[94]

Although there still is no shortage of materialistic consumers who relish the race to acquire as much as possible before they die, there are signs that a sizable number of Americans are evolving a different value system. The Brain Waves/Market Facts survey reports that about a quarter of the population is displaying a value system characterized by a rejection of tradition and conformity. Significantly, more than half of this group is under the age of 35. They are still interested in achievement, but they are trying to balance life in the fast lane with an emphasis on developing close personal relationships and having fun.

These changes are not confined to young people. In the past there was often a sharp divide in values between young and old, but it seems these old categories no longer make sense. As one analyst noted, for example, even conservative small towns now often feature "New Age" stores and services that are patronized by consumers of all ages. Retailers that used to be considered "bohemian" now are mainstream; grocers like Fresh Fields sell Mayan Fungus soap and vegetarian dog biscuits to a hodgepodge of consumers. Big corporations like Apple and Gap use countercultural figures like Gandhi and Jack Kerouac in their advertising, and Ben & Jerry's boasts of its unconventional corporate philosophy. It's become hard to separate establishment from antiestablishment as bohemian attitudes of the hippie 1960s have merged with the bourgeois attitudes of the yuppie 1980s to form a new culture that is a synthesis of the two. The people who dominate our culture (this analyst calls them "BoBos," or Bourgeois Bohemians!) now are richer and more worldly than hippies but more spiritual than yuppies.[95]

The disenchantment among some people with a culture dominated by big corporations shows up in events that promote uniqueness and anticorporate statements. Probably the most prominent movement is the annual Burning Man project, a one-week-long antimarket event, where thousands of people gather at Black Rock Desert in Nevada to proclaim their emancipation from corporate America. The highlight of the festival

Participants at the anticorporate Burning Man Festival find novel ways to express their individuality.

involves the burning of a huge figure of a man made out of wood that symbolizes the freedom from market domination. As we noted earlier, even core values do change over time; stay tuned to see how our always evolving culture continues to put a fresh spin on materialism and other values.

CONSUMER BEHAVIOR IN THE AFTERMATH OF 9/11

The need for balance in our lives became a mantra for many after September 11, 2001. Certainly no other event in our recent history has forced such a dramatic and public reexamination of consumer values including safety, security, privacy, and trust. The threats to our safety and security have had a direct impact on businesses ranging from travel and hospitality to home improvement products and take-out foods, as people seek the sanctuary of their homes rather than venturing out as much as they did before. Even television programming has been affected; conventional situation comedies and family-oriented shows have reemerged.[96] Some people are redirecting their focus from luxury goods to community activities and quality family time. Others have reacted differently by purchasing those luxury goods with a "you can't take it with you" mentality.[97] We also see more visual signs of patriotism, such as flags in places of business, outside homes, and even on clothing.

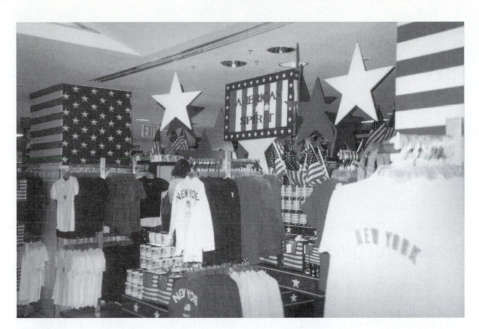

We see more of the flag symbol in retail today, after the September 11, 2001, terrorist attacks.

CHAPTER SUMMARY

- Marketers try to satisfy consumer needs, but the reasons any product is purchased can vary widely. The identification of consumer motives is an important step in ensuring that the appropriate needs will be met by a product.

- Theories of motivations or functions of wearing clothing include modesty, immodesty, protection, and adornment.

- Traditional approaches to consumer behavior have focused on the abilities of products to satisfy rational needs (utilitarian motives), but hedonic motives (e.g., the need for exploration or for fun) also play a role in many purchase decisions.

- As demonstrated by Maslow's hierarchy of needs, the same product can satisfy different needs, depending on the consumer's state at the time. In addition to his or her objective situation (for example, have basic physiological needs already been satisfied?), the consumer's degree of involvement with the product must be considered.

- Consumer motivations often are driven by underlying values. In this context, products take on meaning because they are seen as being instrumental in helping the person to achieve some goal that is linked to a general value, such as individuality or freedom, and to more specific clothing values such as economy or aesthetics. Each culture is characterized by a set of core values to which many of its members adhere.

- Materialism refers to the importance people attach to worldly possessions. Although many Americans can be described as being materialists, there are indications of a value shift among sizable portions of the population.

KEY TERMS

motivation	carbon footprint	materialism
need	conscientious	approach–approach
want	consumerism	conflict
homeostasis	interactive mobile	approach–avoidance
values	marketing	conflict
expectancy theory	consumer-generated	avoidance–avoidance
cognitive dissonance	content	conflict
involvement	value system	utilitarian needs
inertia	terminal values	hedonic needs
cult products	instrumental values	Web 2.0

DISCUSSION QUESTIONS

1. Describe functions of clothing. Do you think these early theories explain why we wear fashion today? If not, what would you add?

2. Describe three types of motivational conflicts, citing an example of each from current marketing campaigns.

3. Devise separate promotional strategies for an article of clothing, each of which stresses one of the levels of Maslow's hierarchy of needs.

4. Collect a sample of fashion ads that appear to appeal to consumer values. What value is being communicated in each, and how is this done? Is this an effective approach to designing a marketing communication?

5. Describe how a man's level of involvement with fashion would affect how he is influenced by different marketing stimuli. How might you design a strategy for a line of suits for a segment of low-involvement consumers, and how would this strategy differ from your attempts to reach a segment of men who are very involved in their appearance in the workplace?

6. "High involvement is just a fancy term for expensive." Do you agree?

7. "College students' concerns about the environment, animal rights, vegetarianism, and health consciousness are just a passing fad, a way to look cool." Do you agree?

8. How do you think consumers have changed since 9/11?

ENDNOTES

1. Ronald Paul Hill and Harold Robinson, "Fanatic Consumer Behavior: Athletics as a Consumption Experience," *Psychology & Marketing* 8 (Summer 1991): 79–100.

2. Knight Dunlap, "The Development and Function of Clothing," *Journal of General Psychology* 1 (1928): 64–78; John Flugel, *The Psychology of Clothes* (London: Hogarth Press, 1930); Elizabeth Hurlock, *The Psychology of Dress* (New York: Ronald Press, 1929); Elizabeth Hurlock, "Motivation in Fashion," *Archives of Psychology* 17, no. 111 (1929).

3. Mary Ellen Roach and Joanne Eicher, *Dress, Adornment and the Social Order* (New York: John Wiley & Sons, 1965); Marilyn Horn and Lois Gurel, *The Second Skin* (Boston: Houghton Mifflin, 1981); Susan Kaiser, *The Social Psychology of Clothing: Symbolic Appearances in Context,* 2nd ed. (New York: Fairchild, 1997); George Sproles and Leslie Davis Burns, *Changing Appearances: Understanding Dress in Contemporary Society* (New York: Fairchild, 1994).

4. "Trashy Clothes on the Way Out," CBS News www.cbsnews.com/sories/2004/07/15/earlyshow/contributors/tracysmith/main6299 (July 16, 2004).

5. Fred Davis, *Fashion, Culture and Identity* (Chicago: The Univeristy of Chicago Press, 1992).

6. Suzanne G. Marshall, Hazel O. Jackson, M. Sue Stanley, Mary Kefgen, and Phyllis Touchie-Specht, *Individuality in Clothing Selection and Personal Appearance*, 5th ed. (Upper Saddle River, N.J.: Prentice Hall, 2000): 36.

7. Victoria Ebin, *The Body Decorated* (New York: Thames and Hudson, 1979).

8. Sproles and Davis Burns, *Changing Appearances: Understanding Dress in Contemporary Society.*

9. Eline Cremers van der Does, *The Agony of Fashion* (Pool, England: Blanford Press, 1980).

10. Nike ad appeared in *Self* magazine (September 2003).

11. Robert A. Baron, *Psychology: The Essential Science* (Needham, Mass.: Allyn & Bacon, 1989).

12. Sharron J. Lennon, Margaret J. Sanik, and Nancy F. Stanforth, "Motivations for Television Shopping: Clothing Purchase Frequency and Personal Characteristics," *Clothing and Textiles Research Journal* 21, no. 2 (2003): 63–74.

13. Leon Festinger, *A Theory of Cognitive Dissonance* (Stanford, Calif.: Stanford University Press, 1957).

14. Quoted in Russell W. Belk, "Romanian Consumer Desires and Feelings of Deservingness," in Lavinia Stan, ed., *Romania in Transition* (Hanover, N.H.: Dartmouth Press, 1997): 191–208, quoted on p. 193.

15. Quoted in Belk, "Romanian Consumer Desires and Feelings of Deservingness," p. 200.

16. Russell W. Belk, Guliz Ger, and Soren Askegaard, "The Fire of Desire: A Multisited Inquiry into Consumer Passion," *Journal of Consumer Research* 30 (2003): 326–351.

17. See Paul T. Costa and Robert R. McCrae, "From Catalog to Classification: Murray's Needs and the Five-Factor Model," *Journal of Personality and Social Psychology* 55, no. 2 (1988): 258–265; Calvin S. Hall and Gardner Lindzey, *Theories of Personality*, 2nd ed. (New York: Wiley, 1970); James U. McNeal and Stephen W. McDaniel, "An Analysis of Need-Appeals in Television Advertising," *Journal of the Academy of Marketing Science* 12 (Spring 1984): 176–190.

18. See David C. McClelland, *Studies in Motivation* (New York: Appleton-Century-Crofts, 1955).

19. Mary Kay Ericksen and M. Joseph Sirgy, "Achievement Motivation and Clothing Preferences of White-Collar Working Women," in *The Psychology of Fashion*, ed. Michael R. Solomon (Lexington, Mass.: Lexington Books, 1985), 357–369.

20. See Stanley Schachter, *The Psychology of Affiliation* (Stanford, Calif.: Stanford University Press, 1959).

21. Eugene M. Fodor and Terry Smith, "The Power Motive as an Influence on Group Decision Making," *Journal of Personality and Social Psychology* 42 (1982): 178–185.

22. John T. Molloy, *Dress for Success* (New York: Warner Books, 1975); John T. Molloy, *The Woman's Dress for Success Women's Book* (Warner Books, 1977).

23. C. R. Snyder and Howard L. Fromkin, *Uniqueness: The Human Pursuit of Difference* (New York: Plenum Press, 1980).

24. Abraham H. Maslow, *Motivation and Personality*, 2nd ed. (New York: Harper & Row, 1970).

25. Quoted in Alex Kuczynski, "A New Magazine Celebrates the Rites of Shopping," *New York Times on the Web* (May 8, 2000).

26. "Man Wants to Marry His Car," *Montgomery Advertiser* (March 7, 1999): 11A.

27. Judith Lynne Zaichkowsky, "Measuring the Involvement Construct in Marketing," *Journal of Consumer Research* 12 (December 1985): 341–352.

28. Andrew Mitchell, "Involvement: A Potentially Important Mediator of Consumer Behavior," in *Advances in Consumer Research*, ed. William L. Wilkie, 6 (Provo, Utah: Association for Consumer Research, 1979): 191–196.

29. Richard L. Celsi and Jerry C. Olson, "The Role of Involvement in Attention and Comprehension Processes," *Journal of Consumer Research* 15 (September 1988): 210–224.

30. Anthony G. Greenwald and Clark Leavitt, "Audience Involvement in Advertising: Four Levels," *Journal of Consumer Research* 11 (June 1984): 581–592.

31. Jeremy W. Peters, "Gave Up Sleep and Maybe a First-Born, but at Least I Have an iPhone," New York Times Online (June 30, 2007).

32. Robert W. Pimentel and Kristy E. Reynolds, "A Model for Consumer Devotion: Affective Commitment with Proactive Sustaining Behaviors," *Academy of Marketing Science Review* (online) 2004 (5). Available http://www.amsreview.org/articles/pimentel05-2004.pdf.

33. Steven Rubenstein, "Sneakerheads Camp Out for Reissued Air Jordans That Won't Be Worn," *San Francisco Chronicle* (Januray 28, 2006): B1.

34. Judith Lynne Zaichkowsky, "The Emotional Side of Product Involvement," in *Advances in Consumer Research*, eds. Paul Anderson and Melanie Wallendorf, 14 (Provo, Utah: Association for Consumer Research): 32–35.

35. For a discussion of interrelationships between situational and enduring involvement, see Marsha L. Richins, Peter H. Bloch, and Edward F. McQuarrie, "How Enduring and Situational Involvement Combine to Create Involvement Responses," *Journal of Consumer Psychology* 1, no. 2 (1992): 143–153; Janice L. Haynes, Allison L. Pipkin, William C. Black, and Rinn M. Cloud, "Application of a Choice Sets Model to Assess Patronage Decision Styles of High Involvement Consumers," *Clothing and Textiles Research Journal* 12, no. 3 (Spring 1994): 22–32.

36. Laurie Freeman, "Fragrance Sniffs Out Daring Adventures," *Advertising Age* (November 6, 1989): 47.

37. Joseph B. Pine II, *Mass Customization* (Boston: Harvard Business School Press, 1993); Joseph B. Pine II and James H. Gilmore, *Markets of One—Creating Customer-Unique Value through Mass Customization* (Boston: Harvard Business School Press, 2000); http://www.managingchange.com/asscust/overview.htm (May 30, 2005).

38. Seung-Eun Lee, Grace I. Kunz, Ann Marie Fiore, and J. R. Campbell, "Acceptance of Mass Customization of Apparel: Merchandising Issues Associated with Preference for

Product, Process, and Place," *Clothing and Textiles Research Journal* 20, no. 3 (2002): 138–146.

39. Stacy Baker, "Wanna Know What's Hot Now . . . ?" *Apparel Industry Magazine* (September 1999): 34–35.

40. Nat Ives, "Advertising: Unauthorized Campaigns Used by Unauthorized Creators Become a Trend," *New York Times on the Web* (December 23, 2004).

41. Rajeev Batra and Michael L. Ray, "Operationalizing Involvement as Depth and Quality of Cognitive Responses," in *Advances in Consumer Research,* eds. Alice Tybout and Richard Bagozzi, 10 (Ann Arbor, Mich.: Association for Consumer Research, 1983): 309–313.

42. Herbert E. Krugman, "The Impact of Television Advertising: Learning without Involvement," *Public Opinion Quarterly* 29 (Fall 1965): 349–356.

43. Li Yuan, "Television's New Joy of Text Shows with Vote by Messaging Are on the Rise as Programmers Try to Make Live TV Matter," *Wall Street Journal* (July 20, 2006): B1. www.americanidol.com (accessed May 25, 2008).

44. Jeremy Mullman and Alice Z. Cuneo, "Nike Setting the Pace in Interactive-TV Race," *AdAge.com* (August 13, 2007).

45. Kevin J. Clancy, "CPMs Must Bow to 'Involvement' Measurement," *Advertising Age* (January 20, 1992): 26.

46. Zaichkowsky, "Measuring the Involvement Construct."

47. Douglas Tigert, Lawrence Ring, and Charles King. "Fashion Involvement and Buying Behavior: A Methodological Study," in *Advances in Consumer Research,* ed. B. B. Anderson, 3 (Chicago: Association for Consumer Research, 1976): 46–52.

48. Jane Boyd Thomas, Nancy Cassill, and Sandra Forsythe, "Underlying Dimensions of Apparel Involvement in Consumers' Purchase Decisions," *Clothing and Textiles Research Journal* 9, no. 3 (Spring 1991): 45–48.

49. Leisa R. Flynn, Ronald E. Goldsmith, and Wan-Min Kim, "A Cross-Cultural Validation of Three New Marketing Scales for Fashion Research: Involvement, Opinion Seeking and Knowledge," *Journal of Fashion Marketing and Management* 4, no. 2 (2000): 110–120; B. Mittal and M. Lee, "A Causal Model of Consumer Involvement," *Journal of Economic Psychology* 10 (1989): 363–389.

50. Ronald E. Goldsmith, Leisa R. Flynn, and M. A. Moore, "The Self-Concept of Fashion Leaders," *Clothing and Textiles Research Journal* 14 (1996)4: 242–248; Leisa R. Flynn, "Fashion Innovators, Early Majority and Late Adopters Implication for Fashion Retailers," in *Enriching Marketing Practice and Education: Proceedings of the Southern Marketing Association,* eds. Stuart and Moore (1977): 20–24.

51. Ann Fairhurst, Linda Good, and James Gentry, "Fashion Involvement: An Instrument Validation Procedure," *Clothing and Textiles Research Journal* 7, no. 3 (Spring 1989): 10–14.

52. Sejin Ha and Sharron J. Lennon, "Apparel Impulse Buying, Self-Monitoring, and Perceived Peers' Clothing Involvement," *Proceedings of the International Textiles and Apparel Association* (2004): 97–98. See also Bonnie Belleau, R. McFatter, Teresa Summers, and Yingjiao Xu, "Fashion Involvment of Affluent Female Consumers, *Proceedings of the International Textiles and Apparel Association* (2005): 34–35.

53. Gilles Laurent and Jean-Noel Kapferer, "Measuring Consumer Involvement Profiles," *Journal of Marketing Research* 22 (February 1985): 41–53; this scale was validated on an American sample as well; see William C. Rodgers and Kenneth C. Schneider, "An Empirical Evaluation of the Kapferer-Laurent Consumer Involvement Profile Scale," *Psychology & Marketing* 10, no. 4 (July/August 1993): 333–345.

54. Karyn Monget, "Wonderbra vs. Water Bra," *Women's Wear Daily* (June 14, 1999): 9.

55. Patricia Warrington and Soyeon Shim, "Segmenting the Collegiate Market for Jeans Using a Product/Brand Involvement Model," *Proceedings of the International Textile and Apparel Association* (November 1998): 82.

56. David W. Stewart and David H. Furse, "Analysis of the Impact of Executional Factors in Advertising Performance," *Journal of Advertising Research* 24, no. 6 (1984): 23–26; Deborah J. MacInnis, Christine Moorman, and Bernard J. Jaworski, "Enhancing and Measuring Consumers' Motivation, Opportunity, and Ability to Process Brand Information from Ads," *Journal of Marketing* 55 (October 1991): 332–353.

57. Morris B. Holbrook and Elizabeth C. Hirschman, "The Experiential Aspects of Consumption: Consumer Fantasies, Feelings, and Fun," *Journal of Consumer Research* 9 (September 1982): 132–140.

58. Jihyun Kim, Ann Marie Fiore, and Hyun-Hwa Lee, "Consumer Online Retailer Patronage Behavior Model: Impact of Image Interactivity Technology on Consumer's Perception of Store Environment," *Proceedings of the International Textiles and Apparel Association* (2005): 291–294.

59. Natalie T. Quilty, Michael R. Solomon, and Basil G. Englis, "Icons and Avatars: Cyber-Models and Hyper-Mediated Visual Persuasion," Paper presented at the Society of Consumer Psychology Conference on Visual Persuasion, Ann Arbor, Michigan (May 2000).

60. Robert D. Hof, "Now It's Your Web," *Business Week* (October 5, 1998): 164.

61. Scott Donaton, "How to Thrive in New World of User-Created Content: Let Go," *Advertising Age* 77, no. 18 (May 2006): 38; "Interactive: User-Generated—Cheap, but Is It Safe to Let Go?" *Marketing Week* (May 2006): 40–41; Todd Wasserman, "Intelligence Gathering," *Brandweek* 47, no. 25 (June 2006): S8–S18.

62. Stuart Elliott, "Student's Ad Gets a Remake, and Makes the Big Time," *New York Times online* (October 26, 2007).

63. "America's Vote Determined New Dove® Real Woman Ad," *PR Newswire* (February 25, 2008).

64. Ajay K. Sirsi, James C. Ward, and Peter H. Reingen, "Microcultural Analysis of Variation in Sharing of Causal Reasoning about Behavior," *Journal of Consumer Research,* 22 (March 1996): 345–372.

65. David Carr, "Romance in Cosmo's World Is Translated in Many Ways," *New York Times on the Web* (May 26, 2002).

66. Richard W. Pollay, "Measuring the Cultural Values Manifest in Advertising," *Current Issues and Research in Advertising* (1983): 71–92.

67. Paul M. Sherer, "North American and Asian Executives Have Contrasting Values, Study Finds," *Wall Street Journal* (March 8, 1996): B12.

68. Sarah Ellison, "Sexy-Ad Reel Shows What Tickles in Tokyo Can Fade Fast in France," *Wall Street Journal Interactive Edition* (March 31, 2000).

69. Milton Rokeach, *The Nature of Human Values* (New York: Free Press, 1973).

70. Sang-Pil Han and Sharon Shavitt, "Persuasion and Culture: Advertising Appeals in Individualistic and Collectivistic Societies," *Journal of Experimental Social Psychology* 30 (1994): 326–350.

71. Emily Burg, "Whole Foods Is Consumers' Favorite Green Brand," *Marketing Daily*, available from www.mediapost. com (May 10, 2007).

72. www.lohas.com/about.htm (June 30, 2007).

73. Janet Hethorn and Connie Ulasewicz, *Sustainability, Why Now? A Conversation about Issues, Practices, and Possibilities* (New York: Fairchild Publications, 2008).

74. Nancy J. Rabolt, Kristina Bagdasarova, and Rachael Pierson, "How Do You Define Eco-Fashion?," submitted to International Apparel & Textiles Association conference (2008).

75. Marcia A. Morgado, "Personal Values and Dress: The Spranger, Hartmann, AVL Paradigm in Research and Pedagogy," *Clothing and Textiles Research Journal* 13, no. 2 (1995): 139–148; Eduard Spranger, *Types of Man*, trans. P. J. W. Pigors (Halle/Salle, Germany: Max Niemeyer orig. published 1914); Gordon Allport, Philip Vernon, and Gardner Lindzey, *A Study of Values* (Boston: Houghton Mifflin, 1960).

76. Anna Creekmore, *Clothing Behaviors and Their Relation in General Values and to the Striving for Basic Needs*, Ph.D. Thesis, Penn State University (1963); Mary Lapitsky, "Clothing Values," in *Methods of Measuring Clothing Variables*, eds. Anna Creekmore et al., Project 783 (Lansing, Michi.: Agricultural Experiment Station, 1966): 59–64.

77. Judith C. Forney and Nancy J. Rabolt, "Clothing Values of Women in Two Middle Eastern Cultures," *Canadian Home Economics Journal* 40, no. 4 (Fall 1990): 187–191; Judith C. Forney, Nancy J. Rabolt, and Lorraine A. Friend, "Clothing Values and Country of Origin of Clothing: A Comparison of United States and New Zealand University Women," *Clothing and Textiles Research Journal* 12, no. 1 (Fall 1993): 36–42.

78. Mary Shaw Ryan, *Clothing: A Study in Human Behavior* (New York: Holt, Rinehart and Winston, Inc., 1966); Mary Kefgan and Phyllis Touchie-Specht, *Individuality in Clothing: Selection and Personal Appearance* (New York: Macmillan, 1986); Susan Kaiser, *Social Psychology of Clothing: Symbolic Appearances in Context*; Sproles and Davis Burns, *Changing Appearances: Understanding Dress in Contemporary Society*; Penny Storm, *Functions of Dress: Tool of Culture and the Individual* (Englewood Cliffs, N.J.: Prentice Hall, 1987).

79. Michelle Morganosky, "Aesthetic, Function, and Fashion Consumer Values: Relationships to Other Values and Demographics," *Clothing and Textiles Research Journal* 6, no. 1 (Fall 1987): 15–19; Rita Purdy, "Clothing Values, Interpersonal Values, and Life Satisfaction in Two Generations of Central Appalachian Women," *ACPTC Proceedings* (Reston, Va.: Association of College Professors of Textiles and Clothing, 1983): 69–70.

80. M. Suzanne Sontag and Jean Schlater, "Clothing and Human Values: A Two-Dimensional Model for Measurement," *Clothing and Textiles Research Journal* 13, no. 1 (1995): 1–10.

81. Donald E. Vinson, Jerome E. Scott, and Lawrence R. Lamont, "The Role of Personal Values in Marketing and Consumer Behavior," *Journal of Marketing* 41 (April 1977): 44–50.

82. Gregory M. Rose, Aviv Shoham, Lynn R. Kahle, and Rajeev Batra, "Social Values, Conformity, and Dress," *Journal of Applied Social Psychology* 24, no. 17 (1994): 1501–1519.

83. Milton Rokeach, *Understanding Human Values* (New York: The Free Press, 1979); see also J. Michael Munson and Edward McQuarrie, "Shortening the Rokeach Value Survey for Use in Consumer Research," in *Advances in Consumer Research*, ed. Michael J. Houston, 15 (Provo, Utah: Association for Consumer Research, 1988): 381–386.

84. Victoria C. Plaut and Hazel Rose Markus, "Place Matters: Consensual Features and Regional Variation in American Well-Being and Self," *Journal of Personality and Social Psychology* 83 (2002): 160–184.

85. Quoted in "New Japanese Fads Blazing Trails in Cleanliness," *Montgomery Advertiser* (September 28, 1996): 10A; see also Andrew Pollack, "Can the Pen Really Be Mightier Than the Germ?" *New York Times* (July 27, 1995): A4.

86. B. W. Becker and P. E. Conner, "Personal Values of the Heavy User of Mass Media," *Journal of Advertising Research* 21 (1981): 37–43; Vinson, Scott, and Lamont, "The Role of Personal Values in Marketing and Consumer Behavior."

87. Lynn R. Kahle, Sharon E. Beatty, and Pamela Homer, "Alternative Measurement Approaches to Consumer Values: The List of Values (LOV) and Values and Life Styles (VALS)," *Journal of Consumer Research* 13, no. 3 (1986): 405–409.

88. Sharon E. Beatty, Lynn R. Kahle, Pamela Homer, and Shekhar Misra, "Alternative Measurement Approaches to Consumer Values: The List of Values and the Rokeach Value Survey," *Psychology & Marketing* 2 (1985): 181–200; Lynn R. Kahle and Patricia Kennedy, "Using the List of Values (LOV) to Understand Consumers," *Journal of Consumer Marketing* 2 (Fall 1988): 49–56; Lynn Kahle, Basil Poulos, and Ajay Sukhdial, "Changes in Social Values in the United States During the Past Decade," *Journal of Advertising Research* 28 (February/March 1988): 35–41; see also Wagner A. Kamakura and Jose Alfonso Mazzon, "Value Segmentation: A Model for the Measurement of Values and Value Systems," *Journal of Consumer Research* 18 (September 1991): 28; Jagdish N. Sheth, Bruce I. Newman, and Babara L. Gross, *Consumption Values and Market Choices: Theory and Applications* (Cincinnati, Ohio: South-Western, 1991).

89. "25 Years of Attitude," *Marketing Tools* (November/December 1995): 38–39.

90. Tom Miller, "Global Segments from 'Strivers' to Creatives,'" *Marketing News* (July 20, 1998): 11.

91. Russell W. Belk, "Possessions and the Extended Self," *Journal of Consumer Research* 15 (September 1988): 139–168; Melanie Wallendorf and Eric J. Arnould, "'My Favorite Things': A Cross-Cultural Inquiry into Object

Attachment, Possessiveness, and Social Linkage," *Journal of Consumer Research* 14 (March 1988): 531–547.

92. Arrol Gellner, "America May Be at the Peak of Latest Materialistic Cycle," *San Francisco Chronicle* (October 8, 2005): F2.

93. Marsha L. Richins, "Special Possessions and the Expression of Material Values," *Journal of Consumer Research* 21 (December 1994): 522–533.

94. Richins, "Special Possessions and the Expression of Material Values."

95. David Brooks, "Why Bobos Rule," *Newsweek* (April 3, 2000): 62–64.

96. Bill Carter, "Mom, Dad and the Kids Reclaim TV Perch," *New York Times on the Web* (October 15, 2002).

97. Julia Cosgrove, "What-the-Hell Consumption," *Business Week* (October 29, 2001): 12.

5

Individual Consumer Dynamics

The Self

Rhoda is trying to concentrate on the report her client is expecting by five o'clock. Rhoda has always worked hard to maintain this important account for the firm, but today she keeps getting distracted thinking about her date last night with Rob. Although things seemed to go okay, why couldn't she shake the feeling that Rob regarded her more as a friend than as a potential romantic partner?

Leafing through *Glamour* and *Cosmopolitan* during her lunch hour, Rhoda is struck by all of the articles about ways to be more attractive by

dieting, exercising, and wearing sexy clothes. Rhoda begins to feel depressed as she looks at the models in the many advertisements for perfumes, apparel, and makeup. Each woman is more glamorous and beautiful than the next. She could swear that some of them must have had breast implants and other assorted "adjustments"—women just don't look that way in real life. Then

again, it's unlikely that Rob could ever be mistaken for Fabio on the street.

In her downcast mood, though, Rhoda actually considers the possibility of cosmetic surgery. She even checks out a live nose job being performed on the Web at www.onlinesurgery.com. Even though she's never considered herself unattractive, who knows—maybe a new nose or larger breasts are what it will take to turn Rob around. At the least, maybe after work she'll pick up one of those new Natural Liquid Miracle Bras at Victoria's Secret with the liquid-filled inner pockets or even order an X-Bra from Lily of France that allows you to increase or decrease cleavage on demand with a center clasp. Or she could go all out and buy the Hollywood Kiss Bra, "a marvel of underwire construction that creates incredible kissing cleavage—'from here to eternity.'"[1] On second thought, though, is Rob even worth it?

PERSPECTIVES ON THE SELF

Rhoda is not alone in feeling that her physical appearance and possessions affect her "value" as a person. Consumers' insecurities about their appearance are rampant: It has been estimated that 72 percent of men and 85 percent of women are unhappy with at least one aspect of their appearance.[2] Many products, from clothing and cologne to cars, are bought because the person is trying to highlight or hide some aspect of the self.

Proximity of Clothing to Self, a measure that links the importance of clothing and the self, was developed by Sontag and Schlater. The measure uses a scale of coded responses to the following question: "What are some of the most important reasons why you feel as you do about your clothing?"[3] Half of the women and about one-third of men in the study identified these reasons with some proximity to self. In this chapter, we'll focus on how such consumers' thoughts and feelings about themselves shape their appearance and fashion consumption practices, particularly as they strive to fulfill their society's expectations about how a man or woman should look and act.

Does the Self Exist?

The 1980s were called the "Me Decade" because for many this time was marked by an absorption with the self. Twenty years later, *Self* magazine designated March 7 as Self Day and encouraged women to spend a minimum of one hour doing something for themselves.[4] Although it seems natural to think about each consumer having a self, this concept is actually a relatively new way of regarding people and their relationship to society and is culture bound. To illustrate cross-cultural differences, a Roper Starch Worldwide survey compared consumers in thirty countries to see which were the most and least vain. Women living in Venezuela were the chart toppers; 65 percent said they thought about their appearance all the time. Other high-scoring countries include Russia and Mexico. The lowest scorers lived in the Philippines and Saudi Arabia (where only 28 percent of consumers surveyed agreed with this statement).[5]

The idea that each single human life is unique, rather than a part of a group, developed in late medieval times (between the eleventh and fifteenth centuries). The notion that the self is an object to be pampered is even more recent. In addition, the emphasis on the unique nature of the self is much greater in Western societies.[6] Many Eastern cultures instead stress the importance of a collective self, where the person's identity is derived in large measure from his or her social group.

For example, a Confucian perspective stresses the importance of "face"—others' perceptions of the self and maintaining one's desired status in their eyes. One dimension of face is *mien-tzu*—reputation achieved through success and ostentation. Some Asian cultures developed explicit rules about the specific garments and even colors that certain social classes and occupations were allowed to display, and adaptations of these live on today in Japanese style manuals that provide very detailed instructions for dressing and addressing people of differing status.[7] That orientation is a bit at odds with such Western conventions as "casual Fridays," which encourage employees to express their unique selves with emphasis on individuality.

Self, Identity, and Clothing

According to Gregory Stone, clothing is instrumental in expressing one's identity:

> One's identity is established when others *place* him as a social object by assigning him the same words of identity that he appropriates for himself or *announces*. It is in the coincidence of placements and announcement that identity becomes a meaning of the self.[8]

Clothing is a method of announcement of one's identity. It can validate and help establish this identity: "Whenever we clothe ourselves, we dress 'toward' or address some audience whose validating responses are essential to the establishment of our self."[9]

SELF-CONCEPT

Self-concept refers to the beliefs a person holds about his or her attributes and how he or she evaluates these qualities. Although one's overall self-concept may be positive, there certainly are parts of the self that are evaluated more positively than others. For example, Rhoda felt better about her professional identity than she did about her feminine identity.

Components of the Self-Concept

The self-concept is a complex construct. It is analyzed by scholars in different ways, using different typologies. Kaiser[10] discusses self-concept in the following ways:

- *Self as structure* or *self-schema:* structured thought processes that organize qualities of self. Clothing can be thought of as "like me" or "not like me"; studies have found that people quickly can decide what clothing falls into each category.[11]
- *Self as process:* a symbolic interactionist view of the development of self through social interactions. Responses to our appearance or to our clothes affect the feelings about the self; social interaction causes us to continually examine and refine our perceptions of self.
- *Self-perception* or *self-image:* based on observations of our own behavior, we make self-attributions. We also receive feedback from others to help us in forming a self-image. We choose clothing to be consistent with how we want to appear to others and how we see ourselves.
- *Social comparison* or *self-evaluation:* our comparison with others in society.[12] Our appearance is so visual that it is natural for people to compare themselves with others.
- *Self-definition* or *symbolic self-completion:* statements about the self; self-definitions can also be thought of as goals or roles, such as career, religious, or gender self-definition, where an individual uses symbols to build and retain these parts of self. After evaluation with a resulting sense of incompleteness, one may take action to reduce this tension by finding a suitable symbol, which might be clothing or fashion, to complete one's self-definition.

- *Self-esteem:* feelings of self-worth; the positivity or negativity of self. Often with social comparison we evaluate ourselves; we evaluate the self as we would any object. Those with high self-esteem think highly of themselves. Sometimes one's self-assessment does, and sometimes it does not, correspond to reality.

As we'll see later in the chapter, consumers' self-assessments can be quite distorted, especially with regard to their physical appearance. Some of the preceding constructs will also be further discussed.

Self-Esteem and Clothing

Self-esteem refers to the degree of positivity of a person's self-concept. People with low self-esteem do not expect that they will perform very well, and they will try to avoid embarrassment, failure, or rejection. In contrast, people with high self-esteem expect to be successful, will take more risks, and are more willing to be the center of attention.[13] Self-esteem often is related to acceptance by others. As you probably remember, high school students who hang out in high-status "crowds" seem to have higher self-esteem than their classmates (even though this may not be deserved!).[14]

Cultural symbols such as fashion and the act of appearance management can function to express one's self-esteem—that is, when people feel good about themselves, they may pay a great deal of attention to their appearance. On the other hand, people who have low self-esteem may ignore their appearance or overcompensate by being obsessive about appearance. Creekmore calls this latter case *adaptive functioning* as people use clothing as a means of social approval.[15] In a study of adolescents, those with higher levels of self-esteem were concerned with a pleasing appearance and were unafraid to draw attention to themselves through their use of clothing. For others, clothing use reflected feelings of insecurity. Thus, clothing may be a means of self-expression or a means of coping with the social milieu.[16] Similar findings were reported in a study of depression and appearance self-concept, which found these concepts positively related—indicating that those who are depressed may use clothing to enhance their self-concept, particularly on days when they are feeling down, in order to counteract this depressed state.[17]

Much of the existing self-concept research is correlational. We know there is a relation between self-concept and clothing/appearance, but not which comes first, the esteem or the appearance. Thus, we don't have a good handle on cause and effect in this case. Also, there is no consensus in the literature. Some studies confirming popular thinking have found relationships between clothing and self-esteem, as discussed earlier; however, several studies have found no such relationships.[18] Therefore, more research is needed to refine relationships between clothing and the many facets of the self-concept construct as outlined earlier.

Self-Esteem Advertising

Nevertheless, it is fairly clear that marketing communications can influence a consumer's level of self-esteem. Exposure to ads like the ones Rhoda was checking out can trigger a process of *social comparison* in which a person tries

to evaluate his or her self by comparing it to the people depicted in these images. This form of comparison appears to be a basic human motive, and many marketers have tapped into this by supplying idealized images of happy, attractive people who just happen to be using their products.

Results of several studies illustrate the social comparison process. One showed that female college students indeed do tend to compare their physical appearance with models who appear in advertising. Furthermore, study participants who were exposed to beautiful women in advertisements afterward expressed lowered satisfaction with their own appearance, as compared to other participants who did not view ads with attractive models.[19] Another study demonstrated that young women's perceptions of their own body shapes and sizes can be altered after being exposed to as little as thirty minutes of television programming.[20] Young men also are affected by this social comparison. Those viewing TV commercials featuring fit, muscular men were more depressed and had more body dissatisfaction than those who watched neutral ads.[21] An analysis revealed that TV commercials used large numbers of models who were inordinately slender.[22] These studies appear to reinforce what media critics lament—that there is a one-dimensional portrayal of women in advertising, characterized by extreme thinness and sensuality. With this emphasis on perfection, such ads can create body dissatisfaction and fuel addictions. The ideal is unattainable, and today even more so, says Jean Kilbourne, with the ability to alter photographs with computers such as elongating the body. The ideal is no longer a real woman![23]

Self-esteem advertising attempts to change product attitudes by stimulating positive feelings about the self. One strategy is to challenge the consumer's self-esteem and then show a linkage to a product that will provide a remedy—for example, "You're not getting older, you're getting better" by Clairol.[24] Another strategy is outright flattery, as when Virginia Slims cigarettes proclaims, "You've come a long way, baby." Many cosmetic and fragrance companies use this type of advertising.

In a twist to self-esteem advertising, in 2006, Dove changed the party atmosphere of the Super Bowl with a serious commercial, one that is part of its *Global Campaign for Real Beauty* program, with a purpose of debunking conventional beauty stereotypes, raising young girls' self-esteem, and provoking debate. One dark-haired girl "wishes she were blond"; a red-haired girl "hates her freckles"; another "thinks she's ugly."[25] The ad was ranked as the most engaging by professionals, professors, and students in a study at Michigan State University.[26]

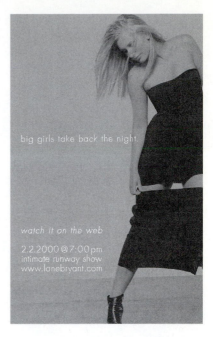

Lane Bryant offers lingerie for large women with the slogan "Big girls take back the night," illustrating large-size women's comfort level with their body.

Real and Ideal Selves

Self-esteem is influenced by a process where the consumer compares his or her actual standing on some attribute to some ideal. A consumer might ask, "Am I as attractive as I would like to be?," "Do I make as much money as I should?," and so on. The **ideal self** is our conception of how we would like to be, while the **actual self** refers to our more realistic appraisal of the qualities we have and don't have.

The ideal self is partly molded by elements of the consumer's culture, such as heroes or people depicted in advertising, who serve as models of achievement or appearance.[27] We may purchase products because we believe

FIGURE 5-1
Model of the Effects of Social Comparison on the Construction and Evaluation of Appearance

Source: Sharron J. Lennon, Nancy A. Rudd, Bridgette Sloan, and Jae Sook Kim, "Attitudes Toward Gender Roles, Self-Esteem, and Body Image: Application of a Model," *Clothing and Textile Research Journal* 17 (1999) 4: 191–202. Published by permission of the International Textile and Apparel Association, Inc.

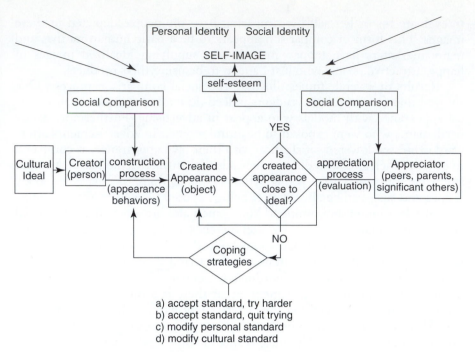

a) accept standard, try harder
b) accept standard, quit trying
c) modify personal standard
d) modify cultural standard

they are instrumental in helping us achieve these goals. We choose some products because we perceive them to be consistent with our actual self, while we use others to help us reach the standard set by the ideal self. Figure 5-1 illustrates one conceptualization of the effects of social comparison to models and heroes and an explanation of the use of products to reach this ideal. When a person's created appearance is not close to the ideal, he or she engages in coping strategies, such as trying harder to achieve the societal standard (among other strategies). Another fashion study found that people select clothing that represents an image that is a compromise between their actual and ideal self-concepts.[28] That could be another method of coping, as described by Figure 5-1.

Public versus Private Self

The ideal and actual selves often do not coincide. Appearance management can be instrumental in one's attempt to achieve, at least visually, one's ideal self. The *public self* is concerned with how others see us. Thus, social expectations of age, gender, occupation, and other roles are considered when one "manages" his or her appearance or *self-presentation* when in public.

The *private self* involves introspection. This may not be communicated with others and may become a "dress rehearsal" for public presentation. Some researchers have broken the private self down one step further to include the *secret self*. Eicher stated that people dress for fun while expressing the private self and for fantasy while expressing their secret self.[29] A measurement of private and secret self-concept, called "Dressing for Fun and Fantasy," includes questions on occupational, athletic, and sexual fantasies, in addition to childhood memories related to dress. Sexual fantasies and childhood memories of dress have been found to relate to secret and private self-expression.[30]

Fantasy: Bridging the Gap between the Selves

While most people experience a discrepancy between their real and ideal selves or between their public and private selves, for some consumers this gap is larger than for others. These people are especially good targets for marketing communications that employ *fantasy appeals*.[31] A **fantasy** or daydream is a self-induced shift in consciousness, which is sometimes a way of compensating for a lack of external stimulation or of escaping from problems in the real world.[32] Many products and services are successful because they appeal to consumers' fantasies. These marketing strategies allow us to extend our vision of ourselves by placing us in unfamiliar, exciting situations or by permitting us to "try on" interesting or provocative roles. Chanel fragrance has blatantly used this theme with the campaign, "Feel the fantasy." With today's technology, such as Cosmopolitan's virtual makeover software and the virtual preview of sunglass styles superimposed on your scanned photo at www.rayban.com, consumers can even experiment with different looks before actually taking the plunge in the real world.[33]

The thousands of personal Web sites people create to make a statement about themselves relate to the motivation to project a version of the self (perhaps an idealized one) into popular culture. A recent study investigated why consumers create personal Web sites and how those Web space strategies compare to the self-presentation strategies of real life. The authors found that many of these personal sites are triggered by such events as graduation or promotion and so on, a desire for personal growth (such as mastering technology or search for a job), or advocacy (such as homage to a favorite artist or product). The creators choose every element of the site carefully, selecting images and text that symbolize something about their self-identity, and many of them digitize their physical selves as part of their self-presentation. Also the sites often reveal intimate aspects of the self that people wouldn't necessarily share in real life.[34] Of course, www.myspace.com, a Web site where you can share pictures of yourself, information about your life, blogs,

CREATING YOUR ALTER EGO—A VIRTUAL IDENTITY

You can create your alter ego, an idealized, animated version of yourself, at www.meez.com and send it to friends' e-mail addresses or cell phones. Choose gender, skin tone, eye color, makeup, clothes, hairstyle, shoes, setting, and activity to become a meezer (a term that plays on the word "me" and is used in lieu of "avatar," tech lingo for manifestation of one's physical presence in the virtual world).[37] This is another way for users to express themselves. The closest analogy is a ringtone, which can quickly identify you as a rap or country music person. In the online world, avatars are a way for people to show what they are passionate about. Some women have been known to refashion their Meez look on a daily basis. The Web site keeps current with trends, and there generally is a lot to choose from every week. Most items are free but some will cost you beenz (Meez currency you put on your credit card). Soon you will be able to trade or sell your Meez clothes. This is a new frontier for avatars being connected and visual.

Other sites are www.secondlife.com and www.there.com where over a million users create avatars to represent their fantasy selves in a fantasy environment where they can experiment with identity. One user said "In SL (Second Life) I am what I've always wanted to be: A sort of marketing/PR/designer. I dress up in business suits with my intelligent yet sexy black-framed glasses, walking around SL in stiletto heels . . . My behavior in SL, however, is the same in RL (Real Life). I am every bit the geek, spiritual and free-spirited person that I am in RL."[38] With companies like Nike, Sony, and American Apparel promoting their products, SL might start looking less like an escape from the real world than an extension of it.

This avatar has been created in www.meez.com and is used by the creator in e-mails, blogs, and so on as an identification symbol. Maybe this is the owner's fantasy look.

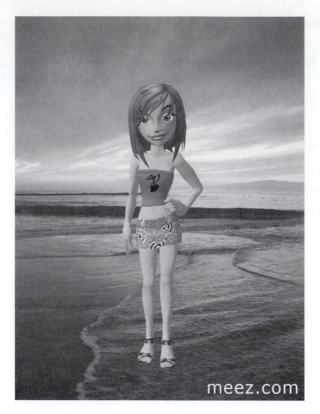

meez.com

and so on, has become one of the most popular sharing sites for young people, drawing almost 80 million unique visitors in one month.[35] It is also gaining popularity with older participants.[36]

Multiple Selves and Identities

In a way, each of us really is a number of different people—your mother probably would not recognize the "you" that emerges at a rave at 2 A.M. with a group of friends! We have as many selves as we do different social roles. Depending on the situation, we act differently, use different products and services, and even vary in terms of how much we like the "me" that is on display at various times. A person may require a different set of products to play a desired role: She may choose a sedate, understated perfume when she is being her professional self, but splash on something more provocative on Saturday night as she becomes her *femme fatale* self. The dramaturgical perspective on consumer behavior views people much like actors who play different roles. We each play many roles, and each has its own script, props, and costumes.[39]

The self can be thought of as having different components, or *role identities*, and only some of these are active at any given time. Some identities (husband, boss, student) are more central to the self than others, but other identities (stamp collector, dancer, advocate for the homeless) may be dominant in specific situations.[40]

Symbolic Interactionism

If each person potentially has many social selves, how does each develop and how do we decide which self to "activate" at any point in time? The sociological tradition of **symbolic interactionism** stresses that relationships with other people play a large part in forming the self.[41] This perspective maintains that people exist in a symbolic environment, and the meaning attached to any situation or object is determined by the interpretation of these symbols. As members of society, we learn to agree on shared meanings. Thus, we know that a red light means stop, the "golden arches" means fast food, and "blondes have more fun."

Each of us interprets our identity, and this assessment is continually evolving as we encounter new situations and people. In symbolic interactionist terms, we *negotiate* these meanings over time. Essentially the consumer poses the question, "Who am I in this situation?" The answer to this question is greatly influenced by those around us: "Who do *other people* think I am?" We tend to pattern our behavior on the perceived expectations of others in a form of *self-fulfilling prophecy*. By acting the way we assume that others expect us to act, we often wind up confirming these perceptions.

The Looking-Glass Self

This process of imagining the reactions of others toward us is known as "taking the role of the other," or the **looking-glass self**."[42] According to this view, our desire to define ourselves operates as a sort of psychological sonar: We take readings of our own identity by "bouncing" signals off others and trying to project what impression they have of us. The looking-glass image we receive will differ depending on whose views we are considering. Like the distorted mirrors in a funhouse, our appraisal of who we are can vary, depending on whose perspective we are taking and how accurately we are able to predict their evaluations of us. A confident career woman like Rhoda may sit morosely at a nightclub, imagining that others see her as an unattractive woman with little sex appeal (whether these perceptions are true or not). A *self-fulfilling prophecy* can operate here, since these "signals" can influence Rhoda's actual behavior. If she doesn't believe she's attractive, she may choose dowdy clothing that actually does make her less attractive. On the other hand, her confidence in herself in a professional setting may cause her to assume that others hold her "executive self" in even higher regard than they actually do (we've all known people like that!).

Self-Consciousness

There are times when people seem to be painfully aware of themselves. If you have ever walked into a class in the middle of a lecture and noticed that all eyes were on you, you can understand this feeling of *self-consciousness*. In contrast, consumers sometimes behave with shockingly little self-consciousness. For example, people may do things in a stadium, a riot, or a fraternity party that they would never do if they were highly conscious of their behavior.[43]

Some people seem in general to be more sensitive to the image they communicate to others. On the other hand, we all know people who act as if they're oblivious to the impression they are making. A heightened concern

about the nature of one's public "image" also results in more concern about the social appropriateness of products and consumption activities.

Several measures have been devised to measure this tendency. Consumers who score high on a scale of *public self-consciousness*, for example, are also more interested in clothing and are heavier users of cosmetics.[44] They may use clothing as a means for reducing social anxiety by "creating an image that is socially desirable."[45] It seems that those who focus attention on themselves are sensitive to the subtle nuances of their own responses to social pressure. One study found that those high in public self-consciousness tended to conform to others' ideas about what will be fashionable in the future.[46] A study on weight satisfaction found a direct relationship with public self-consciousness. The less satisfied women were with their weight, the more likely they were to display public and private self-consciousness.[47]

A similar measure is *self-monitoring*. High self-monitors are more attuned to how they present themselves in their social environments, and their product choices are influenced by their estimates of how these items will be perceived by others.[48] Self-monitoring is assessed by consumers' extent of agreement with such items as "I guess I put on a show to impress or entertain others," or "I would probably make a good actor."[49] High self-monitors are more likely than low self-monitors to evaluate products consumed in public in terms of the impressions they make on others.[50] Similarly, groups such as college football players and fashion models tend to score high on vanity, which includes a fixation on physical appearance or on the achievement of personal goals.[51] High self-monitors have been found to exhibit characteristics of fashion leadership, are more favorable toward image-oriented fashion advertisements, and are willing to pay more for some products—for example, designer jeans—than low self-monitors.[52]

CONSUMPTION AND SELF-CONCEPT

Thus, our self-identities and self-concepts directly affect the marketplace. By extending the dramaturgical perspective, it is easy to see how the consumption of products and services contributes to the definition of the self. For an actor to play a role convincingly, he or she needs the correct props, stage setting, and so on. Consumers learn that different roles are accompanied by *constellations* of products and activities that help define these roles.[53] Some "props" are so important to the roles we play that they can be viewed as a part of the *extended self*, a concept to be discussed shortly.

Products That Shape the Self: You Are What You Consume

Recall that the reflected self helps to shape self-concept, which implies that people see themselves as they imagine others see them. Since what others see includes a person's clothing, jewelry, furniture, car, and so on, it stands to reason that these products also help determine the perceived self. A consumer's products place him or her into a social role, which helps answer the question, "Who am I now?"

People use an individual's consumption behaviors to help them make judgments about that person's social identity. In addition to considering a

person's clothes, grooming habits, and so on, we make inferences about personality based a person's choice of leisure activities (for example, squash versus bowling), food preferences (for example, tofu and beans versus steak and potatoes), cars, home decorating choices, and so on. People who are shown pictures of someone's living room, for example, are able to make surprisingly accurate guesses about his or her personality.[54] In the same way that a consumer's use of products influences others' perceptions, the same products can help determine his or her *own* self-concept and social identity.[55]

A consumer exhibits *attachment* to an object to the extent that it is used by that person to maintain his or her self-concept.[56] Objects can act as a sort of security blanket by reinforcing our identities, especially in unfamiliar situations. For example, students who decorate their dorm rooms with personal items are less likely to drop out of college. This coping process may protect the self from being diluted in a strange environment.[57] Clothing can function in a similar way.

The use of consumption information to define the self is especially important when an identity is yet to be adequately formed, as occurs when a consumer plays a new or unfamiliar role. **Symbolic self-completion theory** suggests that people who have an incomplete self-definition tend to complete this identity by acquiring and displaying symbols associated with it.[58] Women in the early stages of their career were found to use clothing as a strategy for acquiring a sense of success; other career women accepted more information about clothing from others when they were less confident about dressing professionally.[59]

Loss of Self

The contribution of possessions to self-identity is perhaps most apparent when these treasured objects are lost or stolen. One of the first acts performed by institutions that want to repress individuality and encourage group identity, such as prisons or convents, is to confiscate personal possessions.[60] Victims of burglaries and natural disasters commonly report feelings

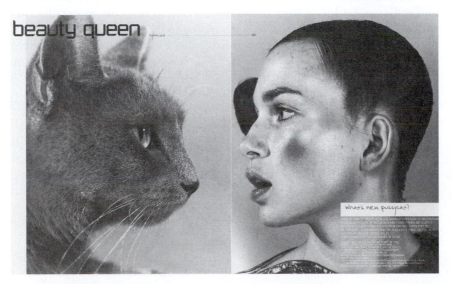

In emphasizing the notion that looking the right way gives one confidence, in this innovative approach to advertising makeup, Nylon magazine uses "Cat-talk" to teach us about looking good. Relating cats and self-confidence, the editors say: Strut your stuff. From Erma Bombeck: "Cats . . . invented self-esteem; there is not an insecure bone in their bodies."

of alienation, depression, or being "violated." One consumer's comment after being robbed is typical: "It's the next worse thing to being bereaved; it's like being raped."[61] Burglary victims exhibit a diminished sense of community, feel that they have less privacy, and take less pride in their houses' appearance than do their neighbors.[62]

The dramatic impact of product loss is highlighted by studying postdisaster conditions when consumers may literally lose almost everything but the clothes on their backs following a fire, hurricane, flood, or earthquake. Some people are reluctant to undergo the process of re-creating their identity by acquiring all new possessions. This happened after Hurricane Katrina; many people did not return to New Orleans after the floods. Interviews with disaster victims reveal that some are reluctant to invest the self in new possessions and so become more detached about what they buy. This comment from a woman in her fifties is representative of this attitude: "I had so much love tied up in my things. I can't go through that kind of loss again. What I'm buying now won't be as important to me."[63]

Self/Product Congruence

Because many consumption activities are related to self-definition, it is not surprising to learn that consumers demonstrate consistency between their values (see Chapter 4) and the things they buy.[64] **Self-image congruence models** suggest that we choose products when their attributes match some aspect of the self.[65] These models assume a process of cognitive matching between these attributes and the consumer's self-image.[66]

Although results are somewhat mixed, the ideal self appears to be more relevant as a comparison standard for highly expressive social products such as perfume and fragrances. In contrast, the actual self is more relevant for everyday, functional products. These standards are also likely to vary by usage situation. For example, students might want functional, comfortable clothing for attending class every day, but more fashionable, fun, and perhaps more daring clothes for going to clubs on the weekend.

Research tends to support the idea of congruence between product usage and self-image. One of the earliest studies to examine this process found that car owners' ratings of themselves tended to match their perceptions of their cars: Pontiac drivers saw themselves as more active and flashier than did Volkswagen drivers.[67] Congruity also has been found between consumers' self-images and their favorite stores.[68] Some specific attributes that have been found to be useful in describing some of the matches between consumers and products include *rugged/delicate, excitable/calm, rational/emotional,* and *formal/informal.*[69]

Although these findings make some intuitive sense, we cannot blithely assume that consumers will always buy products whose characteristics match their own. It is not clear that consumers really see aspects of themselves in down-to-earth, functional products that don't have very complex or humanlike images. It is one thing to consider a brand personality for an expressive, image-oriented product such as perfume and quite another to impute human characteristics to a toaster.

Another problem is the old "chicken-and-egg" question: Do people buy products because they are seen as similar to the self, or do they *assume* that

This Italian ad demonstrates that our favorite products are part of the extended self.

these products must be similar because they have bought them? The similarity between a person's self-image and the images of products purchased does tend to increase with ownership, so this explanation cannot be ruled out.

The Extended Self

As noted earlier, many of the props and settings consumers use to define their social roles in a sense become a part of their selves. Those external

objects that we consider a part of us make up the **extended self**. In some cultures, people literally incorporate objects into the self—they lick new possessions, take the names of conquered enemies (or in some cases eat them), or bury the dead with their possessions.[70]

We don't usually go that far, but some people do cherish possessions as if they were a part of them. Consider shoes, for example: You don't have to be Carrie of *Sex and the City* fame to acknowledge that many people feel a strong bond to their footwear. One study found that people commonly view their shoes as magical emblems of self, Cinderella-like vehicles for self-transformation. One study concluded that women tend to be more attuned to the symbolic implications of shoes than men. A common theme that emerged was that a pair of shoes obtained when younger—whether a first pair of leather shoes, a first pair of high heels, or a first pair of cowboy boots—had a big impact even later in life. These experiences were similar to those that occur in such well-known fairy tales and stories as Dorothy's red shoes in *The Wizard of Oz* and Cinderella's glass slippers.[71]

Many material objects, ranging from personal possessions and pets to national monuments or landmarks, help to form a consumer's identity. Just about everyone can name a valued possession that has a lot of the self "wrapped up" in it, whether it is a beloved photograph, an old shirt, a trophy, a car, or a cat. Indeed, it often is possible to construct a pretty accurate "biography" of someone just by cataloging the items on display in his or her bedroom or office.

In one study on the extended self, people were given a list of items that ranged from favorite clothes, facial tissues, and television programs to parents, body parts, and electronic equipment. They were asked to rate each in terms of its closeness to the self. Objects were more likely to be considered a part of extended self if "psychic energy" was invested in them by expending effort to obtain them or because they were personalized and kept for a long time.[72] The concept of "proximity of clothing to self," as discussed in the opening of this chapter, is an example of this.

Four levels of the extended self have been described, ranging from very personal objects to places and things that allow people to feel as though they are rooted in their larger social environments.[73]

- *Individual level:* Consumers include many of their personal possessions in self-definition. These products can include jewelry, cars, clothing, and so on. The saying "You are what you wear" reflects the belief that one's things are a part of one's identity.

- *Family level:* This part of the extended self includes a consumer's residence and the furnishings in it. The house can be thought of as a symbolic body for the family and often is a central aspect of identity.

- *Community level:* It is common for consumers to describe themselves in terms of the neighborhood, city, or country from which they come. For farm families or other residents with close ties to a community, this sense of belonging is particularly important.

- *Group level:* Our attachments to certain social groups also can be considered a part of the self—we'll consider some of these subcultures in later chapters. A consumer also may feel that landmarks, monuments, or sports teams are a part of the extended self.

SEX ROLES

Sexual identity is a very important component of a consumer's self-concept. The terms *sex* and *gender* are often used interchangeably; however, they do have different meanings. Sex refers to the biological differences between men and women, whereas gender is a social construct—that is, there are certain different social expectations of men and women. People often conform to these expectations about how they should act, dress, and speak. Of course, these guidelines change over time, and they can differ radically across societies.

At a very young age children learn the differences between boys and girls. Often gender differences are reinforced by others with the first baby gift of pink or blue. Society's expectations are often oversimplified—for example, females are supposed to be interested in clothes, fashion, and beauty, while males are not.

Masculinity and femininity are difficult to define, and even more difficult in terms of fashion change.[74] Masculinity has been defined as the lack of femininity.[75] In terms of acceptable appearance, it is easier for men to discuss the looks they do not want to adopt. When men describe their clothes, they do not focus on masculinity, but rather they tend to describe the meanings of clothes in terms of achievement or fond remembrances from the past events, such as good times with friends, and clothing worn ("I wish they still made them").[76] When asked about their least favorite clothing, men seem to be concerned about clothes that even vaguely suggested femininity with such references as "too much" of anything: too trendy, too dressy, and so on.[77]

It's unclear to what extent gender differences are innate versus culturally shaped—but they're certainly evident in many consumption decisions.

Gender Differences in Socialization

A society communicates its assumptions about the proper roles of men and women by stressing ideal behaviors for each sex. Many commercial sources, in addition to parents and friends, provide lessons in gender socialization for both girls and boys:

- Drawing on the success of the American Girl Place, which features in-store activities and entertainment based on American Girl dolls, Disney's flagship store on Fifth Avenue in New York City lets little girls be princesses for a day. Of course, playing this role isn't cheap: There is a $75 admission charge to Cinderella's Princess Court and build-your-own crowns cost $24. Bracelets and necklaces run $6 to $8 each, with attachable charms an additional $4. Other feminine goodies include cashmere sweaters for $360 and scarves for $260.[78]

- ESPN Zone in Chicago is a male preserve that lets boys be boys and men be . . . boys. Researchers report that the venue is perceived as a place where "buddies" can be together, in which men can watch men's sports, establish camaraderie with other men, and where women are largely treated as trophies and forms of entertainment.[79]

Gender roles do change over time—even in traditional societies. The conservative, macho male stereotypes that have long dominated society in countries like Japan and South Korea are falling out of fashion as women gain power and independence. For the first time commercials for beauty

products feature "softer" men. As one Asian executive described it, "A pretty face with big eyes and fair skin, and a moderately masculine body, are what Korean women want in men these days." In a recent Korean commercial, an actor carefully applies lipstick to a woman's lips. A Japanese spot for Vidal Sassoon features eight men who are reduced to tears by a beautiful woman (this ad increased the company's market share by 15 percent, which is nothing to cry over). Korea's largest ad agency labels the new style of man "Mr. Beauty" and cites the desire of his counterpart, "Ms. Strong," to be in control.[80] Still, traditional roles have not disappeared in Asia. A current style for women in Japan known as the "Lolita" look illustrates the yearning of many young women there for a more idyllic feminine expression: The look consists of baby-doll outfits that typically include a puffy pink dress, frilly bloomers, knee socks, and a big white bonnet. A chain called Baby, the Stars Shine Bright sells clothing for aspiring Lolitas all over Japan, and magazines with names like *Lolita Bible* spell out what women need to join the movement. Expressions of gender identity are constantly evolving—indeed, a number of fans are also exploring the "Gothic Lolita" style where women continue to dress in ruffles—but now all in black.[81]

Many societies expect males to pursue **agentic goals**, which stress self-assertion and mastery. On the other hand, they teach females to value **communal goals**, such as affiliation and the fostering of harmonious relations.[82] One study found that even a male voice emanating from a computer is perceived as more accurate and authoritative than the same words with a female voice.[83]

Gender Identity

Gender identity is a state of mind as well as body. A person's biological sex does not totally determine whether he or she will exhibit **sex-typed traits**, characteristics that are stereotypically associated with one sex or the other. A consumer's subjective feelings about his or her sexuality are crucial as well.[84]

Unlike maleness and femaleness, masculinity and femininity are *not* biological characteristics. A behavior considered masculine in one culture may not be viewed as such in another. For example, the norm in the United States is that males should be "strong" ("real men don't eat quiche"), wear classic or tailored rather than soft clothing (Jerry Seinfeld wore a "puffy shirt" in an episode of his sitcom that parodied this concept), and avoid touching each other (except in "safe" situations such as on the football field). In some Latin and European cultures, however, it is common for men to hug one another. Each society determines what "real" men and women should and should not do.

Sex-Typed Products

Many products (in addition to quiche) are *sex typed*; they take on masculine or feminine attributes, and consumers often associate them with one sex or another.[85] Clothing generally is a product that is obviously appropriate for either men or women. On the other hand, the term *unisex* refers to a style of clothing worn by men or women that was popular in the 1970s and continues today with many young people and subcultures.

This ad for Bijan illustrates how sex-role identities are culturally bound by contrasting the expectations of how women should appear in two different countries.

The sex typing of products is often created or perpetuated by marketers (for example, Princess telephones, boys' and girls' toys, and Luvs color-coded diapers). Even brand names appear to be sex-typed: Those containing *alphanumerics* (Formula 409, 10W40, Clorox 2) are assumed to be technical and, hence, masculine.[86] Computers have always been thought as the domain of men and boys, but software makers are attempting to engage young girls. Mattel's Barbie Fashion Designer software, which has proven popular among preteen girls, lets the operator design doll clothes on the computer and print them out on special fabric that fits in a color printer. There have been knockoffs of this concept, as it has been difficult for software makers to figure out what else girls want. One company said, "Figure out what girls like to do and put it on the computer . . . teenage girls like boys, shopping, makeup and dating."[87] Thus, the computer age continues the legacy of sex-typed products.

Androgyny

Androgyny refers to the possession of both masculine and feminine traits.[88] Researchers make a distinction between *sex-typed people*, who are stereotypically masculine or feminine, and *androgynous people*, who possess a mixture of feminine and masculine characteristics that allows them to function well in a variety of social situations. Women's business dress in the 1980s took on masculine elements with tailored, conservative looks. Many felt this was done so that women looked more similar to men, which was necessary to compete in the male-dominated business world. The fashion industry even used the word *androgyny* in its promotion of masculine-looking suits and tailored styles for women. Later, women's business looks were softened with more feminine styling and fabrications. The industry also uses the term to refer to products that are marketed to both sexes.

Recently, researchers developed a scale to identify "nontraditional males" who exhibit stereotypical female tendencies. The scale included items such as "I enjoy looking through fashion magazines," and "I am good at fixing mechanical things." Not too surprisingly, strong differences emerged between men who answered along traditional sex-role lines versus those who had a nontraditional orientation. When asked how they would like to be seen by others, nontraditional males were more likely than traditional males to say that they would like to be seen as sensitive, spiritual, affectionate, organized, and thrifty, but less likely to say they would like to be seen as "outdoorsy."[89]

Female Sex Roles and the Market Place

Sex roles for women are changing rapidly. Younger women's views of themselves today are quite different from those of their mothers who fought the good fight for feminism. To some extent they may take for granted that they have certain rights that their mothers had to fight for. After all, they have grown up with female role models who are strong leaders; they participate to a much greater degree in organized sports; and they spend a lot of time on the Internet where factors such as gender, race, and social status tend to disappear. In one study only 34 percent of girls aged 13 to 20 labeled themselves as feminists—even though they strongly endorse the principles of the feminist movement. Ninety-seven percent of the same respondents believe a woman should receive the same pay for the same work as a man does; 92 percent agree that a woman's lifestyle choices should not be limited by her gender.[90]

Still, it's premature to proclaim the death of traditional sex-role stereotypes. Women continue to be depicted by advertisers and the media as they did years ago as stereotypes and decoration for the products they were selling from cars and beer to laundry detergent. Twenty years ago analysis of ads in such magazines as *Time*, *Newsweek*, *Playboy*, and even *Ms.* showed that the large majority of women included were presented as sex objects (so-called cheesecake ads) or in traditional roles.[91] Similar findings were obtained in the United Kingdom.[92] Ads may also reinforce negative stereotypes. Women often are still portrayed as stupid, submissive, or temperamental. They are shown as cleaning-obsessed women mostly in cars, kitchens, or bathrooms limiting them to four basic stereotypes: mother, partner, career woman, and sex object. One infamous, much-despised campaign was the Herbal Essence shampoo-orgasm spots, which made most women cringe. Although women continue to be depicted this way, the situation is changing as advertisers scramble to catch up with reality, which is that women worldwide are better educated, earn more money than ever before, and spend 80 percent of most household's dollars.[93]

Nike, long known as a progressive company, frequently showcases women in positive and realistic roles. One analyst pointed out two of its most memorable ads: "You Were Born" in 1993, showing women athletes in motion, and "If You Let Me Play" in 1996, featuring teenage and preteen girls explaining how playing sports would help them avoid smoking, drugs, and abusive relationships.[94] But not all Nike ads are beloved by women. In 2005, splashing thunder thighs, tomboy knees, and one prodigious posterior was seen by some women as lacking tack. Although the

intent was to show real women with a message that "my body is OK with me," some felt the tone was hostile to thin women and so was the comment about "kissing another woman's butt."[95] "Campaign for Real Beauty," a recent Dove campaign originating from the United Kingdom, features women of varying body types and aims to celebrate women who are not classically beautiful. This marks a shift in how women are being portrayed in media advertising.

Ironically, it seems that in some cases marketers have overcompensated for their former emphasis on women as homemakers and in stereotypical images by reversing those stereotypes. Brands such as Reebok, Sketchers, and Armani Exchange have shown girls hungrily taking down men in their print campaigns. *Ellegirl* magazine shows one "man-eating" female after another. This has been seen as a trendy marketing tactic called "advancing backwards," where advertisers strive to put an innovative edge into their ads by reversing and recycling old-school gender clichés. Ironically they exhibit the very attitudes and behaviors that girls find frustrating about guys—aggression, the need to dominate, lack of emotion, and egocentricity. A Reebok ad turns a girl into an emotionally detached playboy, representing the strong, independent girl of the future. But some women feel Ms. Reebok isn't trendy; she's messed up. They feel ads depicting women should show sincerity, spontaneity, genuine feelings, caring, family feeling, honesty, and trust. That's not sappy but shows balance, values, and humanity.[96]

Male Sex Roles

Although the traditional concept of the ideal male as a tough, aggressive, muscular man who enjoys "manly" sports and activities is not dead, society's definition of the male role is evolving. Just as for women, the true story tends to be complicated. **Masculinism** is the study of the male image and the complex cultural meanings of masculinity.[97] Men have been allowed to be more compassionate and to have close friendships with other men. In contrast to the depiction of macho men who do not show feelings, some marketers are promoting men's "sensitive" side. An emphasis on male bonding has been the centerpiece of many ad campaigns.[98]

Males' lifestyles are changing to allow greater freedom of expression in clothing choices, hobbies such as cooking, and so on. But enough is enough, say some. Men who are tired of seeing their lives redesigned by the *Queer Eye* crew or who feel that their private sanctuary—aka the bathroom—has turned into a feminine haven can now at least "take back the shower." A Dial commercial shows "real men" frowning at chintz pillows and rabbit food salads and proclaiming that it is time to be a man again by using Dial for Men Wash, in a container that looks like an oil can, while he knocks his wife's plethora of shower products off a shelf.[99]

Men as well as women often are depicted in a negative manner in advertising. They frequently come across as helpless or bumbling. As one advertising executive put it, "The woman's movement raised consciousness in the ad business as to how women can be depicted. The thought now is, if we can't have women in these old-fashioned traditional roles, at least we can have men being dummies."[100] Some ads play on men's doubts and insecurities

by portraying them as fools, and often such commercials play on the stereotypes of both sexes. One credit card commercial shows a man sprawled on a couch watching television all day while his wife rushes about cleaning the house. Finally, exasperated, she sucks him into the vacuum cleaner. We guess the credit card is supposed to solve all of life's problems.[101] Just as advertisers often are criticized for depicting women as sex objects, the same accusations can be made about how males are portrayed—a practice correspondingly known as "beefcake." A Dolce & Gabbana ad for low-rise jeans were so low slung, readers wondered how they stayed on the wearer's hips.

One consequence of the continual evolution of men's sex roles is that men are concerned as never before about their appearance. Men spend $7.7 billion on grooming products globally each year. A wave of male cleansers, moisturizers, sunscreens, and body sprays is washing up on U.S. shores, largely from European marketers. Unilever spent $90 million to launch its Axe body spray after its research showed that a sizable number of American men would put on a spritz or two in addition to their usual deodorant. To encourage young men to start spraying, the company sends women called "Axe Angels" to nightclubs and sports events where they spray potential male converts. Similar products have transformed the market: Men now buy more deodorant than women do.[102]

No doubt one of the biggest marketing buzzwords over the past years is the **metrosexual**, a straight, urban male who exhibits strong interest and knowledge of product categories such as fashion, home design, gourmet cooking, and personal care that run counter to the traditional male sex role. A gay writer named Mark Simpson actually coined the term in a 1994 article when he "outed" British (and now American) soccer star and pop icon David Beckham as a metrosexual.[103] Hype aside, how widespread is the metrosexual phenomenon? Although there is no doubt that "everyday guys" are expanding their horizons, many actively resist this label and in many circles the "M word" has become taboo and other labels (perhaps less threatening) are popping up instead. One such label is the **übersexual**, which is defined as

> In German it means the best, the greatest, super, or above. Ubersexuals are the most attractive, most dynamic, and the most compelling men of their generations. They are confident, masculine, and have depth, subtlety and individuality . . . similar to a metro-sexual but has the traditional manly qualities of confidence, strength, and class.

The current icon of übersexuals is Bono. He is global and socially aware, confident, and compassionate, and he commands a huge base of followers who are fans of his music and humanitarianism. Other notable übersexuals are Bill Clinton, George Clooney, Jon Stewart, and Pierce Brosnan.[104] Marketers also refer to such style-obsessed shoppers as *prosumers* or *urban influentials*—educated customers who are willing and able to focus their attention on their personal appearance and living environment. In the United Kingdom, sales of male grooming products grew 560 percent over the last five years. Gillette India's research found that Indian men now spend an average of 20 minutes in front of the mirror each morning, more than the 18-minute average for Indian women.[105]

THE NEW MALE MARKET

As sex roles for males evolve, formerly "feminine products" such as fragrances and hair coloring have been successfully marketed to men in recent years. Cosmetics companies such as Aramis, Clinique, and Urban Decay are attempting to expand the male market even further. Even nail polish is slowly making its way onto men's shelves—the Hard Candy line offers its Candy Man collection, which includes a metallic gold called Cowboy and a forest green shade named Oedipus.[106]

And, responding to pressures felt by many men to look younger, ads aimed at getting men to remove gray hair have tripled over the past decade. Roper Starch Worldwide reports that 36 percent of men either have tried coloring their hair or were open to it. L'Oréal's new Feria line for men's hair includes new hues such as Camel and Cherry Cola. Other vanity products introduced in recent years include Bodyslimmers underwear, which sucks in the waist, and Super Shaper Briefs that round out the buttocks (for an extra $5 the buyer can get an "endowment pad" that slips into the front).[107]

Gay, Lesbian, Bisexual, and Transgender Consumers

The proportion of the population that is gay and lesbian is difficult to determine, and efforts to measure this group have been controversial.[108] Estimates range from 4 to 8 percent of the total U.S. population, but many sources put the number at roughly 15 million, about 6 percent. The respected research company Yankelovich Partners Inc., which has tracked consumer values and attitudes since 1971, now includes a question about sexual identity in its annual Monitor survey. This study was virtually the first to use a sample that reflects the population as a whole instead of polling only smaller or biased groups (such as readers of gay publications) whose responses may not be as representative of all consumers.

The buying power of the gay, lesbian, bisexual, and transgendered (GLBT) population has been estimated at over $600 billion.[109] However, mainstream companies have been reluctant to market directly to this group. In the mid-1990s, IKEA, a Swedish furniture retailer with stores in major U.S. markets, broke new ground by running a TV spot featuring a gay male couple who purchased a dining room table at the store. And a Nike television spot was the first and only one to focus on HIV by following real-life, openly gay, HIV-positive athlete Ric Munoz of Los Angeles. It aired in Japan and the United Kingdom as part of the *Just Do It* campaign.[110]

As companies become more comfortable with targeting gays, realizing they are not getting backlash, they tend to sponsor GLBT festivals and develop specific creative ads with gay content, such as lesbian couples with children. San Francisco gay pride festivities have two dozen corporate sponsors including conservative financial institutions of Wells Fargo and Bank of America, and other companies such as Travelocity, Delta Airlines, and Bud Light. Companies realize gay consumers are very loyal to supportive companies.[111]

In fashion advertising, gay vague imagery, or ads that are unclear in terms of sexual orientation, continue to dominate—an irony considering the business regularly serves up a sexual appeal in its marketing and the style leadership for which the gay community is known. Fashion and beauty companies with gay-targeted ads are rated with a corporate equality index by the "Human Rights Campaign," the largest U.S. gay lobbying group. Top companies are Nike, Levi Strauss, Gap, The Limited, Nordstrom, Federated Stores, Reebok, Abercrombie & Fitch, Lillian Vernon, The Men's Wearhouse, and

Donna Karan. In the future the "Commercial Closet Association," a nonprofit organization that attempts to influence the advertising industry to understand, respect, and include GLBT references, will open ratings up to the viewers.[112]

For many consumers, gay culture is more familiar largely due to the prominence of gay people in popular television shows like *The L Word, Queer Eye for the Straight Guy,* and *Brothers and Sisters,* and due to the decisions of stars like Ellen DeGeneres and Rosie O'Donnell to openly discuss their sexuality. The Internet will play a major role both in building a gay community and for marketing to this group. Content, community, and commerce site www.gay.com leads the list of gay Web destinations, followed by PlanetOut and Evite.

In addition to gay men, lesbian consumers have recently been in the cultural spotlight. Dior, Charles David, and Sisley fashion ads clearly depict lesbian relationships. Perhaps the trendiness of "lesbian chic" is due in part to such high-profile cultural figures as tennis star Martina Navratilova, singers K D Lang and Melissa Etheridge, and actress Ellen DeGeneres. A readers' survey by a lesbian-oriented magazine called *Girlfriends* found that 54 percent hold professional/managerial jobs, 57 percent have partners, and 22 percent have children. But lesbian women are harder to reach than gay men since they don't tend to concentrate in urban neighborhoods or in bars and don't read as many gay publications. Some marketers have chosen to focus instead on such venues as women's basketball games and women's music festivals.[113]

Kaiser has done considerable research in the area of gender socialization, which has an important influence on appearance management. Gays and lesbians have expressed the desire to challenge some dominant gender norms through their dress. Some do not want to look "mainstream" or like straights.[114]

BODY IMAGE

A person's physical appearance is a large part of his or her self-concept and self-esteem. One recent study found that low self-esteem and negative feelings may result when one's body is discrepant from cultural standards or perceived standards. College women who perceived their body to be discrepant from the ideal had higher body dissatisfaction, overall appearance dissatisfaction, and investment in appearance than those who viewed themselves as less discrepant from the ideal.[115] Conversely, another study found that across several ethnic groups high self-esteem was associated with positive body image.[116] **Body image** refers to a consumer's subjective evaluation of his or her physical self.

As was the case with the overall self-concept, body image is not necessarily accurate. A man may think of himself as being more muscular than he really is, or a woman may feel she appears fatter than is the case. In fact, it is not uncommon to find marketing strategies that exploit consumers' tendencies to distort their body images by preying upon insecurities about appearance, thereby creating a gap between the real and ideal physical self and, consequently, the desire to purchase products and services to narrow that gap. Indeed, the success of the photo chain Glamour Shots, which provides dramatic makeovers to customers (90 percent of them women) and then gives

them a pictorial record of their pinup potential, can be traced to the fantasies of everyday people to be supermodels—at least for an hour or two.[117]

In real life, clothing can be used to extend the body and change its perceived shape. Certain styles of clothing are often chosen to camouflage parts of one's body due to a negative body image. Many consumers (but not all) are skilled at applying principles of design to create illusions of a slimmer or taller body and de-emphasizing certain parts with which they are unhappy.

As shown by people who use either clothing or cosmetics cleverly to disguise a loathsome part of the body, or even cosmetic surgery to permanently change it, body image issues seem to be growing in importance, despite the concerns of feminists and others. From three landmark studies in the 1970s, 1980s and 1990s, *Psychology Today* has described our changing attitudes about body image, indicating there is more discontent about body shape than ever before.

Body Cathexis

A person's feelings about his or her body can be described in terms of **body cathexis**. The word *cathexis* refers to the emotional significance of some object or idea to a person, and some parts of the body are more central to self-concept than are others. The *Psychology Today* studies indicate that almost universally, women are less satisfied with their bodies than are men (height is generally the exception). For women, the largest increase in dissatisfaction over a twenty-five-year period was with overall appearance, while for men it was the abdomen—although in almost every body area studied, both men's and women's dissatisfaction increased over the years, as illustrated in Table 5-1.[118]

Other studies have found female dissatisfaction with the midsection of the body, including the hip and thigh areas.[119] Not surprisingly, this dissatisfaction has been correlated with dissatisfaction of the fit of clothing to this part of the body.[120] Body satisfaction varies by culture. African American students were found to be the most satisfied with their bodies whereas Asian Americans were the least satisfied.[121] When intention to change the body

Table 5-1 Men and Women's Dissatisfaction with Their Bodies

	1972 Survey %		1985 Survey %		1997 Survey %	
	Women	Men	Women	Men	Women	Men
Overall appearance	25	15	38	34	56	43
Weight	48	35	55	41	66	52
Height	13	13	17	20	16	16
Muscle tone	30	25	45	32	57	45
Breasts/chest	26	18	32	28	34	38
Abdomen	50	36	57	50	71	63
Hips or upper thighs	49	12	50	21	61	29

Note: n = 3,452 women, 548 men.

Source: David Garner, "The 1997 Body Image Survey Results," *Psychology Today* (January/February 1997): 30–40.

was investigated, the less satisfied women were with their bodies, the more they wanted to change. Their intention to change was also related to how much significant others wanted them to change.[122]

Another study of young adults' feelings about their bodies found that respondents were the most satisfied with their hair and eyes and had the least positive feelings about their waists. These feelings were related to usage of grooming products. Consumers who were more satisfied with their bodies were more frequent users of such "preening" products as hair conditioner, hair dryers, cologne, facial bronzer, tooth polish, and pumice soap.[123] But several studies have not found similar applications to clothing; that is, clothing interest and body cathexis are not necessarily related. Apparently females in general are socialized to place special importance on clothing and fashion on a regular basis regardless of the satisfaction with their physical body.[124] A case in point is the successful large-size apparel business. More large-size women, who may not be satisfied with their bodies but are tired of endless diets, are willing to pay for good quality and fashionable clothes in their size.

Ideals of Beauty

A person's satisfaction with the physical image he or she presents to others is affected by how closely that image corresponds to the image valued by his or

THE REAL TRUTH ABOUT BEAUTY

Dove conducted a groundbreaking study on how global society defines beauty.[126] Only 2 percent of thousands of women from ten countries around the world considered themselves beautiful. Does this mean we live in a world where women are not beautiful, or does it mean that we are defining beauty in very narrow terms?

Indeed, over half of the respondents strongly agreed that the attributes of female beauty have become very narrowly defined in today's world. And more than two-thirds strongly agreed that the media and advertising set an unrealistic standard of beauty that most women can't ever achieve. Respondents said they felt pressure to try to be that "perfect" picture of beauty. They said that society expects women to enhance their physical attractiveness and they feel that physically attractive women are more valued by men.

Almost all women reported concern with their overall physical appearance. The women of Japan have the highest levels of dissatisfaction with their body weight and shape (59 percent), followed by Brazil (37 percent), United Kingdom (36 percent), and the United States (36 percent).

It's hard to feel beautiful when confronted with the ideals of beauty portrayed in popular culture. Respondents would like to see the media change the way it represents beauty. More than three-fourths of the sample wished female beauty was portrayed as more than just physical attractiveness, and they wished the media did a better job of portraying women of diverse physical attractiveness, ages, shapes, and sizes. They said beauty includes character, passion, presence, and respect. Over 90 percent strongly agreed that a woman can be beautiful at any age and that every woman has something about her that is beautiful.

The study reported that when women are dissatisfied with their self-image they withdraw from normal activities of daily life such as going on a date or doing physical activity. Women are passionate about changing this dynamic for future generations and express strong desires to create a constructive and early discourse for young girls on beauty and body image.

Sparked by results of this study, Dove created a major initiative, *The Campaign for Real Beauty*, designed to provoke discussion and encourage debate about the nature of beauty. The Dove Self-Esteem Fund was established to raise awareness of the link between beauty and body-related self-esteem. In the United Kingdom it supports *BodyTalk*, an educational program for schools created by the Eating Disorders Association. In the United States the fund works in partnership with the Girl Scouts of the USA to promote improved self-esteem among girls in a venture called *uniquely ME!* In Canada a touring photographic exhibition, *Beyond Compare,* has raised money for the National Eating Disorders Information Centre (NEDIC) and in the Netherlands for the Kenniscentrum Eetstoornissen Nederland—a leading charity in the fight against eating disorders. Check out its Web site, www.dove.us.

her culture. In fact, infants as young as two months show a preference for attractive faces.[125] An **ideal of beauty** is a particular model, or exemplar, of appearance. Ideals of beauty for both women and men may include physical features (big breasts or small, bulging muscles or not) as well as clothing styles, cosmetics, hairstyles, skin tone (pale versus tan), and body type (petite, athletic, voluptuous).

Is Beauty Universal?

Recent research indicates that preferences for some physical features over others are "wired in" genetically, and that these reactions tend to be the same among people around the world. Specifically, people appear to favor features associated with good health and youth, attributes linked to reproductive ability and strength. These characteristics include large eyes, high cheekbones, and a narrow jaw. Another cue that apparently is used by people across ethnic and racial groups to signal sexual desirability is whether the person's features are balanced. In one study, men and women with greater facial symmetry started having sex three to four years earlier than lopsided people!

Men also are more likely to use a woman's body shape as a sexual cue, and it has been theorized that this is because feminine curves provide evidence of reproductive potential. During puberty a typical female gains almost 35 pounds of "reproductive fat" around hips and thighs that supply the approximately 80,000 extra calories needed for pregnancy. Most fertile women have waist-hip ratios of .6 to .8, an hourglass shape that also happens to be the one men rank highest. Even though preferences for overall weight change over time waist-hip ratios tend to stay in this range—even the superthin model Twiggy (who pioneered the "waif look" decades before Kate Moss) had a ratio of .73.[133] Figure 5-2 illustrates how body shape changes

FIGURE 5-2
Waist-Hip Ratios

Source: Newsweek (June 3, 1996): 65 (0) 1996 Newsweek, Inc. All rights reserved. Reprinted by permission.

as waist-hip ratios increase or decrease. Other positively valued female characteristics include a higher forehead than average, fuller lips, a shorter jaw, and a smaller chin and nose. Women, on the other hand, favor men who have a heavy lower face (a record of high concentration of androgens that impart strength), are slightly above average height, and have a prominent brow.

Of course, the way these faces are "packaged" still varies enormously, and that's where marketers come in: Advertising and other forms of mass media play a significant role in determining which forms of beauty are considered desirable at any point in time. An ideal of beauty functions as a sort of cultural yardstick. Consumers compare themselves to some standard (often advocated by the fashion media) and are dissatisfied with their appearance to the extent that they don't match up to it.

These cultural ideals often are summed up in a sort of cultural shorthand. We may talk about a "bimbo," a "girl next door," or an "ice queen," or we may refer to specific women who have come to embody an ideal, such as J-Lo, Gwyneth Paltrow, or the late Princess Diana.[134] Similar descriptions for men include "jock," "pretty boy," and "bookworm," or a "Brad Pitt type," a "Wesley Snipes type," and so on.

The Western Ideal

For women the Western ideal of beauty is big round eyes, tiny waists, large breasts, blond hair, and blue eyes; for men, it is a strongly masculine, muscled body. Fashion magazines for both women and men reinforce these ideals. As

LARGE-SIZE FASHION

A third of all U.S. women wear a size 16 or larger, according to the National Institutes of Health. Throw in size 14s and that's half of all women and rising as baby boomers age. A national size survey found that the U.S. population has grown taller and heavier.[127] It is estimated that about 30 percent of American adults are obese and that an additional third are overweight,[128] yet large-size sales are just 25.4 percent of all women's apparel sales, according to market researcher NPD Group.[129] This oversize business has room to grow. Luxury retailers such as Neiman Marcus and Nordstrom are pushing into the women's plus-size market, which used to be dominated by specialty retailers such as Lane Bryant and Forgotten Woman. Torrid has become known as a fashionable store for plus-size young women, and more companies are adding plus sizes in their catalogs and Web sites.

Lane Bryant has turned its focus from comfortable, baggy styles to the body-hugging fashions popular in smaller sizes. It has carefully groomed a hip image, featuring full-figured celebrity spokesmodels such as Anna Nicole Smith and Camryn Manheim. A Lane Bryant executive commented, "If a short-sleeve rib sweater is the hot item this fall it is our challenge to deliver that for our customer, too. But not to do it in a way that makes her look as though she's pushed into a sausage

casing."[130] Not all full-figured women are happy with Lane Bryant's selection. And there is a great deal of general dissatisfaction with the offerings by fashion designers for large sizes. Very few make plus sizes; but some women have given kudos to American designers Donna Karan and Oscar de la Renta for maintaining the same philosophy as when designing their smaller clothing, whereas others can only think of such lines as featuring straight-cut drawstring pants.[131]

Cazak, an elegant plus-size boutique off the Champs-Elysees, has a mushrooming clientele including wives of politicians and businessmen. But Cazak complains that only one famous European designer—Gianfranco Ferre—carries a ready-to-wear brand for larger-size women. Cazak's owner says "[designers] are like ostriches—pretending that the problem doesn't exist so that maybe it will go away." And even with the controversy over the waiflike runway models when Madrid barred five superthin girls from the catwalk in 2006, Johanna Dray, a successful full-figured, size 16 French model, says there is only a handful of designers who have used big women for their shows. But in Germany model agencies are seeing healthier-looking models.[132] Only time will tell if the runways will better resemble real women in the future. What do you think?

Some research indicates that balanced or symmetrical facial features are a cue used by men and women to decide who is attractive. Country Singer Lyle Lovett is an example of a man with asymmetrical features. The left picture is the real Lovett; the right is a computerized image that is really two left sides of his face.

media images of glamorous American (Caucasian) celebrities proliferate around the globe, Western ideals of beauty are being adopted by cultures that have to literally go under the knife to achieve these attributes:

- Many Korean women are lifting their noses, shaving their jaws, and widening their eyes in pursuit of a Western image of beauty. The newest craze is to reduce the size of thick calves as women seek the slender legs of Western supermodels.[135]

- The proportion of African American women who are using plastic surgery to enhance their looks has almost doubled in the last decade. A columnist for *Essence* magazine recently expressed her concerns about black women wanting to exchange their African features for European ones by buying into "a culture that dictates the feminine ideal."[136]

- A model named Cindy Burbridge, who was the local spokeswoman for Lux soap and Omega watches, became the first blue-eyed Miss Thailand. She's one of a generation of racially mixed Thais who now dominate the local fashion and entertainment industries as the public abandons the round face, arched eyebrows, and small mouth of the classical Thai look in favor of Western ideal. Many buy blue contact lenses to enhance their looks.[137]

- Agbani Darego, the 2001 Most Beautiful Girl in Nigeria, went on to win the Miss World title. She was the first African winner in the contest's fifty-one-year history. However, pride was mixed with puzzlement: The new Miss World didn't possess the voluptuous figure prized in African culture. As one African explained, "Plumpness means prosperity." In contrast Ms. Darego is six feet tall and skinny. Older Nigerians did not find the winner especially attractive at all, and some bitingly described her as a white girl in black skin. But younger people

are a different story. For them, thin is in. In Lagos, fashionably thin girls are called *lepa* and there is even a popular song with this title and a movie that celebrates this new look.[138]

Ideals of Beauty over Time

While beauty may be only skin deep, throughout history women in particular have worked very hard to attain it. They have starved themselves; painfully bound their feet; inserted plates into their lips; spent countless hours under hair dryers, in front of mirrors, and beneath tanning lights; and have undergone breast reduction or enlargement operations to alter their appearance and meet their society's expectations of what a beautiful woman should look like.

In retrospect, periods of history tend to be characterized by a specific "look," or ideal of beauty. American history can be described in terms of a succession of dominant ideals. For example, in sharp contrast to today's emphasis on health and vigor, in the early 1800s it was fashionable to appear delicate to the point of looking ill. The poet Keats described the ideal woman of that time as "a milk white lamb that bleats for man's protection."

Other looks have included the voluptuous, lusty woman as epitomized by Lillian Russell, the athletic Gibson Girl of the 1890s, and the small, boyish flapper of the 1920s as exemplified by Clara Bow.[139]

In much of the nineteenth century, the desirable waistline for American women was eighteen inches, a circumference that required the use of corsets pulled so tight that they routinely caused headaches, fainting spells, and possibly even the uterine and spinal disorders common among women of the time. While modern women are not quite as "straightlaced," many still endure such indignities as high heels, body waxing, eye lifts, and liposuction. In addition to the millions spent on cosmetics, clothing, health clubs, and fashion magazines, these practices remind us that—rightly or wrongly—the desire to conform to current standards of beauty is alive and well.

As suggested by this Benetton ad, a global perspective on ideals of beauty is resulting in more ways to be considered attractive.

The ideal body type of Western women has changed radically over time, and these changes have resulted in a realignment of *sexual dimorphic markers*—those aspects of the body that distinguish between the sexes. The first part of the 1990s saw the emergence of the controversial "waif" look, where successful models (most notably Kate Moss) were likely to have bodies resembling those of young boys. Using heights and weights from winners of the Miss America pageant, nutrition experts concluded that many beauty queens are in the undernourished range. In the 1920s, contestants had a body mass index in the range now considered normal—20 to 25. Since then, an increasing number of winners have had indexes under 18.5, which is the World Health Organization's standard for undernutrition.[140] Similarly, a study of almost fifty years of *Playboy* centerfolds shows that the women have become less shapely and more androgynous since Marilyn Monroe graced the first edition with a voluptuous hourglass figure of 37-23-36. However, a magazine spokesman comments, "As time has gone on and women have become more athletic, more in the business world, and more inclined to put themselves through fitness regimes, their bodies have changed, and we reflect that as well."[141]

One factor leading to this change has been the opposition to the use of overly thin models by feminist groups, who charge that these role models encourage starvation diets and eating disorders among women who want to emulate the look.[142] These groups have advocated boycotts against companies such as Calvin Klein and Coca-Cola, which have used wafer-thin models in their advertising. Some protesters have even taken to pasting stickers over these ads that read "Feed this woman" or "Give me a cheeseburger."

We can also distinguish among ideals of beauty for men in terms of facial features, musculature, and facial hair. In fact, one recent national survey that asked both men and women to comment on male aspects of appearance found that the dominant standard of beauty for men is a strongly masculine, muscled body—though women tend to prefer men with less muscle mass than men themselves strive to attain.[143] Advertisers appear to have the males' ideal in mind—a study of men appearing in advertisements found that most sport the strong and muscular physique of the male stereotype.[144]

Betting that men are becoming every bit as body conscious as women, manufacturers including Seven for All Mankind, Miss Sixty, and Diesel are introducing figure-enhancing jeans for men in styles that would have been deemed too risky even a few years ago. The new styles feature many of the same touches that designers have brought to women's jeans: low-rise cuts, stretch fabrics, bleached-out colors. Chip and Pepper lowered the back pockets on one man's style by several inches to make pear-shaped guys look less pearlike, and Diesel's slim-fitting "Bumix" jean features a "sexy undercrotch enforcement."[145]

Working on the Body

Because many consumers are motivated to match up to some ideal of appearance, they often go to great lengths to change aspects of their physical selves. From cosmetics to plastic surgery, tanning salons to diet drinks, a multitude of products and services are directed toward altering or maintaining aspects of the physical self in order to present a desirable appearance. It is difficult to

overstate the importance of the physical self-concept (and consumers' desire to improve their appearance) to many marketing activities.

Fattism

As reflected in the expression, "You can never be too thin or too rich," our society has an obsession with weight. Even elementary school children say they would rather be disabled than be obese.[146] The pressure to be slim is continually reinforced both by advertising and by peers. Americans in particular are preoccupied by what they weigh. We are continually bombarded by images of thin, happy people. In a survey of girls age 12 to 19, 55 percent said they see ads "all the time" that make them want to go on a diet.[147]

Although America's obsession with thinness is legendary worldwide, the weight-loss obsession is spreading—often with help from American media figures. In traditional Figian culture, for example, the body ideal for females is robust. If a Figi woman loses weight there is concern that she is ill. When satellite TV started showing skinny actresses in imported shows like *Melrose Place* and *Beverly Hill 90210*, teenage girls started exhibiting eating disorders. They wanted to look like actresses such as Heather Locklear.[148] And in England, the diet brand Slim-Fast recently tackled a common stereotype: British women are the plump ones on the beaches of Europe. The United Kingdom has the highest obesity rate in Europe; nearly one in five of all 15-year-olds is overweight. The company is running ads that rally British women to lose weight or lose face to their sexier Continental counterparts in France, Spain, and Sweden. In one Slim-Fast ad, a French model says, "I love British women. They make me look great."[149]

How realistic are these appearance standards? The average height and weight of an American woman is 5'4" and 142 pounds, while the average height and weight of a model is 5'9" and 110 pounds.[150] Also, fashion dolls, such as the ubiquitous Barbie, reinforce an unnatural ideal of thinness. The dimensions of these dolls, when extrapolated to average female body sizes, are unnaturally long and thin; Barbie's measurements would be 38-18-34.[151] In 1998, Mattel conducted "plastic surgery" on Barbie to give her a less pronounced bust and slimmer hips.[152] Even newer models feature a body shape that is more athletic and natural, with wider hips and a smaller bust.[153]

Still, many consumers focus on attaining an unrealistic ideal weight, sometimes by relying on height and weight charts compiled by the insurance industry that show what one *should* weigh. These charts often are outdated because they don't take into account today's larger body frames or such factors as muscularity, age, or activity level.[154] In fact, Metropolitan Life changed its height/weight charts due to these inconsistencies with reality. Indeed, only 12 percent of blacks and 21 percent of whites (but 43 percent of Hispanics) weigh within the recommended range.[155] American women believe that the "ideal" body size is a 7, an unrealistic goal for most.[156] Even women who are at their best medical weight want on average to be eight pounds lighter.[157]

A controversy over weight and discrimination spurred much discussion of the concept of fitness vesus slimness. A San Francisco aerobics instructor

made international news when she sued Jazzercise (and won) when she was rejected as an instructor because she did not appear fit. This was the first case settled under San Francisco's "fat and short" law, an ordinance barring discrimination on the basis of weight and height. Studies have shown that one can be fit without being slim.[158]

Yet perceptions of "slim is better" persist, especially as it relates to fashion. One study found that college students would prefer to seek fashion advise from an average-weight, as opposed to overweight, person. An overwhelming 93 percent of the sample indicated that a thin or average-weight individual would be more likely to follow fashion as opposed to an obese person.[159]

Heightism

Similar to the agony of fattism, there is a bias against short men that, according to some, is hurtful and irrational but real. Men under 5'5" are perceived as less successful and less masculine and even judge themselves negatively. The Western ideal for men is about 6'2" and even the relationship between height and status is embedded in our very language: Respected men are "looked up to." Research has found that tall men have an advantage over short men in terms of politics, business, professional status, jobs and income, and even sex.[160] Unlike weight, there is little we can do about our height other than invest in a good pair of elevator shoes.

Body Image Distortions

Although many people perceive a strong link between self-esteem and appearance, some consumers exaggerate this connection even more and sacrifice greatly to attain what they consider to be a desirable body image. Women tend to be taught to a greater degree than men that the quality of their bodies reflects their self-worth, so it is not surprising that most major distortions of body image occur among females.

Men do not tend to differ in ratings of their current figure, their ideal figure, and the figure they think is most attractive to women. In contrast,

MULTICULTURAL DIMENSIONS

One in ten Argentine females between the ages of 14 and 18 suffers from an eating disorder, according to a poll of 90,000 teens by the Argentine Association to Bulimia and Anorexia.[161] This twenty-nation study (the United States was not included) of female high school and university students from Europe, Asia, Latin America, and Africa showed Argentina tied for second place along with India. In these two countries 29 percent suffered from an eating disorder, while only 4 percent suffered in China. Japan, on the other hand, led all nations, with an average of 35 percent.

Health experts agree that a constant publicity barrage by the Argentine diet and cosmetic industries has taken a toll on the psyche of that nation's youth. In addition, the clothing industry is getting more than criticism. A bill was approved by the Argentine Senate to force the clothing industry to manufacture exact numerical measurements rather than the arbitrary small, medium, and large sizes that vary considerably from one store to another and from international sizes. When a medium fits an 8-year-old and adolescents can't fit into a large, they leave the store convinced they are overweight.

―――――――――――――――――――――――― **WHEN IS THIN TOO THIN?** ――――――――――――――――

Recently the public has been horrified by the images of ultrathin fashion runway models with ribs showing, appearing so gaunt and thin that their knees and elbows were larger than their concave thighs and pipe cleaner arms. Many don't think the frail, fragile look is very feminine or attractive and there appears to be a new sense of concern that designers are contributing to unhealthy and potentially life-threatening behavior among models vying to appear in their shows. Yet there remains an ideal among designers who seem to prize an ever thinner frame to display their clothes.[162] If the industry needed a wake-up call, it got one when Luisel Ramos, a Uruguayan model who had been advised to lose weight, died of heart failure after taking her turn on the catwalk. She reportedly had gone days without eating and for months had consumed only lettuce and diet soda. Also with the death of Brazilian model Ana Carolina Reston at age 21 due

to complications from anorexia, Fashion Rio banned models younger than age 16 and now requires proof of good health.[163]

Other fashion industry councils around the world have made changes in their guidelines for models. Madrid's 2006 Fashion Week banned unreasonably thin models from its show; organizers said they wanted to project an image of beauty and health. The Madrid standard is a minimum body mass index (BMI) of at least 18—a measure of body fat based on weight and height. The World Health Organization considers this underweight (18.5 to 25 is considered normal) but is outsized among supermodels, many of whom hover between 14 and 16.[164] The new guidelines of the Council of Fashion Designers of America (CFDA) do not include limitations; they emphasize education about the warning signs for eating disorders and other healthy dietary issues in addition to age and work guidelines.[165]

women rate both the figure they think is most attractive to men and their ideal figure as much thinner than their actual figure.[166] In one survey, two-thirds of college women admitted resorting to unhealthy behavior to control weight. Advertising messages that convey an image of slimness help reinforce these activities by arousing insecurities about weight.[167]

A distorted body image has been linked to the rise of eating disorders, which are particularly prevalent among young women. People with *anorexia* regard themselves as fat, and virtually starve themselves in the quest for thinness. This condition often results in *bulimia*, which involves two stages: First, binge eating occurs (usually in private), where more than five thousand calories may be consumed at one time. The binge is then followed by induced vomiting, abuse of laxatives, fasting, and/or overly strenuous exercise—a "purging" process that reasserts the woman's sense of control.

Eating disorders affect mostly women, but some men as well. They are common among male athletes who must also conform to various weight requirements, such as jockeys, boxers, and male models.[168] In general, though, most men who have distorted body images consider themselves to be too light rather than too heavy: Society has taught them that they must be muscular to be masculine. Men are more likely than women to express their insecurities about their bodies by becoming addicted to exercise. In fact, striking similarities have been found between male compulsive runners and female anorexics.

As with women, perhaps men are influenced by media images and products encouraging an unrealistic physique. Consider, for example, that if the dimensions of the original GI. Joe action figure were projected onto a real 5'10" man, he would have a 32-inch waist, a 44-inch chest, and 12-inch biceps. Or how about the Batman action figure: If the superhero came to life he would boast a 30-inch waist, 57-inch chest and 27-inch biceps.[169] Holy steroids, Robin!

Cosmetic Surgery

Consumers increasingly are electing to have cosmetic surgery to change a poor body image.[170] Highlighting the growing acceptance of such procedures into the mainstream is the popularity of two television shows: *Nip/Tuck*, a drama about two high-flying Miami plastic surgeons, and *Extreme Makeover*, a reality show on ABC that features people getting transformed by a series of radical surgeries. There is no longer much of a psychological stigma (if any) associated with having this type of operation; it is commonplace and accepted among many segments of consumers. Going under the knife is not just for women anymore: Men now account for as much as 20 percent of plastic surgery patients, with liposuction the most common procedure. Popular operations include the implantation of silicon pectoral muscles (for the chest) and even calf implants to fill out "chicken legs."[171] Reasons for cosmetic surgery for men often relate to an investment in their career as opposed to women's pure cosmetic and vanity motivations.[172] This difference has been disputed by some, as men appear to be plagued by similar insecurities that women have related to the discrepanies between body image and society's portrayal of beauty.

Some women feel that larger breasts will increase their allure and undergo breast augmentation procedures. In more traditional areas of the country, such as the Sun Belt, this procedure is more likely to be selected.[173] Although some of these procedures have generated controversy due to possible negative side effects, it is unclear whether potential medical problems will deter large numbers of women from choosing surgical options to enhance their (perceived)

MULTICULTURAL DIMENSIONS

Cosmetic surgeons often try to mold their patients into a standard ideal of beauty, using the features of such Caucasian classic beauties as Grace Kelly and Katharine Hepburn as a guide. The aesthetic standard used by surgeons is called the *classic canon*, which spells out the ideal relationships among facial features. For example, it states that the width of the base of the nose should be the same as the distance between the eyes.

However, this standard applies to the Caucasian ideal and is being revised as people from other ethnic groups are demanding less rigidity in culture's definition of what is beautiful. Some consumers are rebelling against the need to conform to the Western ideal. For example, a rounded face is valued as a sign of beauty by many Asians, but giving cheek implants to an Asian patient would remove much of what makes her face attractive.

Some surgeons who work on African Americans are trying to change the guidelines they use when sculpting features. For example, they argue that an ideal African American nose is shorter and has a more rounded tip than does a Caucasian nose.

Doctors are beginning to diversify their "product lines," offering consumers a broader assortment of features that better reflect the diversity of cultural ideals of beauty in a heterogeneous society.[174]

Racial differences in beauty ideals also surfaced in one study of teenagers. White girls who were asked to describe the "ideal" girl agreed she should be 5'7", weigh between 100 and 110 pounds, and have blue eyes and long flowing hair—in other words, she should look a lot like a Barbie doll. Almost 90 percent of the girls in this study said they were dissatisfied with their weight.

In contrast, 70 percent of the black girls in the study responded that they were *satisfied* with their weight. They were much less likely to use physical characteristics to describe the ideal girl, instead emphasizing someone who has a personal sense of style and who gets along with others. It was only when prodded that they named such features as fuller hips, large thighs, and a small waist, which the authors of the study say are attributes valued by black men.[175]

femininity. The importance of breast size to self-concept has been noted by lingerie companies. In Europe and the United States, both Gossard and Playtex are promoting nonsurgical alterations. They are aggressively marketing specially designed bras offering "cleavage enhancement" that use a combination of wires and internal pads (called "cookies" in the industry) to create the desired effect. Despite some protests by feminists, sales are booming as consumers' preferences for the ideal body type shift once again.

Body Decoration and Mutilation

The body is adorned or altered in some way in every culture. Many U.S. teens and twenty somethings are part of a new daring subculture that is defining itself today by "exploring the line between fashion and mutilation, design and destruction, choice and compulsion. For some, pain is part of the attraction and for many, it is part of self-definition, self-discovery."[176] Decorating the self has served a number of purposes over the years:[177]

- *To separate group members from nonmembers:* Chinook people of North America pressed the head of a newborn between two boards for a year, permanently altering its shape. In our society, teens go out of their way to adopt distinctive hair and clothing styles that will separate them from adults.

- *To place the individual in the social organization:* Many cultures engage in puberty rites, where a boy symbolically becomes a man. Young men in Ghana paint their bodies with white stripes to resemble skeletons to symbolize the death of their child status. In Western culture, this rite may involve some form of mild self-mutilation or engaging in dangerous activities.

- *To place the person in a gender category:* The Tchikrin people of South America insert a string of beads in a boy's lip to enlarge it. Western women wear lipstick to enhance femininity. In the early twentieth century, small lips were fashionable because they represented women's submissive role at that time.[178] Today, big, red lips are provocative and indicate an aggressive sexuality. Some women, including a number of famous actresses and models, receive collagen injections or lip inserts to create large, pouting lips (known in the modeling industry as "liver lips").[179]

- *To enhance sex-role identification:* The modern use of high heels, which podiatrists agree are a prime cause of knee and hip problems, backaches, and fatigue, can be compared with the traditional Chinese practice of foot binding to enhance femininity. As one doctor observed, "When [women] get home, they can't get their high-heeled shoes off fast enough. But every doctor in the world could yell from now until Doomsday, and women would still wear them."[180]

- *To indicate desired social conduct:* The Suya of South America wear ear ornaments to emphasize the importance placed in their culture on listening and obedience. In Western society some gay men may wear an earring in the left or right ear to signal what role (submissive or dominant) they prefer in a relationship.

- *To indicate high status or rank:* The Hidates people of North America wear feather ornaments that indicate how many people they have killed.

Body piercing and tattoos have become a form of expression for young people the world over.

In our society, some people wear glasses with clear lenses, even though they do not have eye problems, to increase their perceived status.

- *To provide a sense of security:* Consumers often wear lucky charms, amulets, rabbits' feet, and so on to protect them from the "evil eye." Some modern women wear a "mugger whistle" around their necks for a similar reason.

Tattoos

Tattoos—both temporary and permanent—are a popular form of body adornment, for both men and women, more recently for women who use it as a fashion statement. This body art can be used to communicate aspects of the self. One recent trend is for middle-aged women to get a tattoo in order to commemorate a milestone like a big birthday, a divorce, or becoming an "empty nester."[181] One health study found that tattooed adolescents overwhelmingly agreed that the purpose of their tattoo was to "be myself; I don't need to impress anyone anymore."[182] Tattoos may also serve some of the same functions that other kinds of body painting do in primitive cultures.

Tattoos (from the Tahitian *ta-tu*) have deep roots in folk art. Until recently, the images were crude and were primarily either death symbols (for example, a skull), animals (especially panthers, eagles, and snakes), pinup women, or military designs. More current influences include science-fiction themes, Japanese symbolism, and tribal designs.

A tattoo, especially temporary tattoos which can easily be removed, may be viewed as a fairly risk-free way of expressing an adventurous side of the self. Tattoos have a long history of association with people who are social outcasts. For example, the faces and arms of criminals in sixth-century Japan were tattooed as a means to identify them, as were Massachusetts prison inmates in the nineteenth century and concentration camp internees in the twentieth century. These emblems are often used by marginal groups, such as bikers or Japanese *yakuze* (gang members), to express group identity and solidarity.

However, recently tattoos and body piercings, which often are linked, have crossed over into popular culture and become accepted by the young. A recent study found about 15 percent of those ages 18 to 29 have both a tattoo and a piercing. The general public perceived this behavior as "rebellious" and "experimental," and the majority find tattoos and body art distasteful.[183] Tattoos and body piercings aren't for everyone.

Body Piercing

Decorating the body with various kinds of metallic inserts also has evolved from a practice associated with some fringe groups to become a popular personal or fashion statement. The initial impetus for the mainstreaming of what had been an underground West Coast fad is credited to Aerosmith's 1993 video "Cryin," where Alicia Silverstone receives both a navel ring and a tattoo.[184] Piercings can range from a hoop protruding from a navel to scalp implants, where metal posts are inserted in the skull (do not try this at home!). Publications like *Piercing Fans International Quarterly* are seeing their circulations soar, and Web sites on body art are attracting numerous followers; however, these sites often come and go quickly. This popularity is not pleasing to hardcore piercing fans, who view the practice as a sensual consciousness-raising ritual and are concerned that now people just do it because it's trendy. As one customer waiting for a nipple piercing remarked, "If your piercing doesn't mean anything, then it's just like buying a pair of platform shoes."[185]

CHAPTER SUMMARY

- Consumers' *self-concepts* are reflections of their attitudes toward themselves. Whether these attitudes are positive or negative, they will help to guide many purchase decisions; products can be used to bolster self-esteem or to "reward" the self.

- Clothing and fashion are used by some to express their positive self-esteem and by others to overcome self feelings of inferiority.

- Many product choices are dictated by the consumer's perceived similarity between his or her personality and attributes of the product. The *symbolic interactionist perspective* on the self implies that each of us actually has many selves, and a different set of products is required as props to play each. Many things other than the body can also be viewed as part of the

self. Valued objects, clothing, cars, homes, and even attachments to sports teams or national monuments are used to define the self, when these are incorporated into the extended self.

- A person's sex-role identity is a major component of self-definition. Conceptions about masculinity and femininity, largely shaped by society, guide the acquisition of "sex-typed" products and services.

- The media play an important role in socializing consumers to be male and female. While traditional women's roles have often been perpetuated in advertising depictions, this situation is changing somewhat, showing women in a variety of roles. The media do not always portray men accurately either.

- A person's conception of his or her body also provides feedback to self-image. A culture communicates certain ideals of beauty, and consumers go to great lengths to attain them. In addition to the consumption of fashion to achieve an ideal, many consumer activities involve manipulating the body, whether through dieting, cosmetic surgery, piercing, or tattooing.

- Sometimes these activities are carried to an extreme, as people try too hard to live up to cultural ideals. One common manifestation is eating disorders, where women in particular become obsessed with thinness.

- Body decoration and/or mutilation may serve such functions as separating group members from nonmembers, marking the individual's status or rank within a social organization or within a gender category (such as homosexual), or even providing a sense of security or good luck.

KEY TERMS

self-concept	self-image congruence	body cathexis
ideal self	models	ideal of beauty
actual self	extended self	masculinism
fantasy	agentic goals	metrosexual
symbolic interactionism	communal goals	übersexual
looking-glass self	sex-typed traits	
symbolic self-	androgyny	
completion theory	body image	

DISCUSSION QUESTIONS

1. How might the creation of a self-conscious state be related to consumers who are trying on clothing in dressing rooms? Does the act of preening in front of a mirror change the dynamics by which people evaluate their product choices? Why?

2. Is it ethical for marketers to encourage infatuation with the self?

3. List six components by which the self-concept can be described.

4. Compare and contrast the real versus the ideal self. List three fashion products for which each type of self is likely to be used as a reference point when a purchase is considered.

5. Watch a set of ads featuring men and women on television. Try to imagine the characters with reversed roles (that is, the male parts

played by women and vice versa). Can you see any differences in assumptions about sex-typed behavior?

6. To date, the bulk of advertising targeted to gay consumers has been placed in exclusively gay media. If it were your decision to make, would you consider using mainstream media as well to reach gays? Or, remembering that members of some targeted segments have serious objections to this practice, should gays be singled out at all by marketers?

7. Do you agree that marketing strategies tend to have a male-oriented bias? If so, what are some possible consequences? How would you change this, if you could?

8. In the past, some marketers have been reluctant to use disabled people in advertising out of fear they would be seen as patronizing or that their ads would be depressing. Should the disabled be viewed as a distinct market segment, or should marketers continue to assume that their wants and needs are the same as the rest of the mainstream market? What companies depict the disabled in their clothing ads?

9. Construct a "consumption biography" of a friend or family member. Make a list and/or photograph his or her most favorite possessions, and see if you or others can describe this person's personality just from the information provided by this catalog.

10. Some consumer advocates have protested the use of superthin models in advertising, claiming that these women encourage others to starve themselves in order to attain the "waif" look. Other critics respond that the media's power to shape behavior has been overestimated, and that it is insulting to people to assume that they are unable to separate fantasy from reality. What do you think?

11. Analyze fashion ads from several fashion magazines and ads from other types of magazines (home, men's, sports, and so on). Count and compare the number of superthin female models versus average female body types, and supermuscular male models versus average male body types.

12. Interview victims of burglaries, or people who have lost personal property (including clothing) in floods, hurricanes, or other natural disasters. How do they go about reconstructing their possessions, and what effect did the loss appear to have on them?

13. Locate additional examples of self-esteem advertising. Evaluate the probable effectiveness of these appeals—is it true that "flattery gets you everywhere"?

ENDNOTES

1. Barbara Nachman, "Manufacturers in Battle of Bras Want to Provide Ultimate Boost," *Montgomery Advertiser* (May 7, 2000): 7G.
2. Daniel Goleman, "When Ugliness Is Only in Patient's Eye, Body Image Can Reflect Mental Disorder," *New York Times* (October 2, 1991): C13.
3. M. Suzanne Sontag and Jean Schlater, "Proximity of Clothing to Self: Evolution of a Concept," *Clothing and Textiles Research Journal* 1 (1982): 1–8; For an updated version of the Proximity of Clothing to Self Scale, see M. Suzanne Sontag and Jongnam Lee, "Proximity of Clothing to Self Scale,"

Clothing and Textiles Research Journal 22, no.4 (2004): 161–177.

4. Ann-Christine P. Diaz, "'Self' Declares Its Own Holiday," *Advertising Age* (January 31, 2000): 20.

5. Lisa M. Keefe, "You're So Vain," *Marketing News* (February 28, 2000): 8.

6. Harry C. Triandis, "The Self and Social Behavior in Differing Cultural Contexts," *Psychological Review* 96, no. 3 (1989): 506–520; H. Markus and S. Kitayama, "Culture and the Self: Implications for Cognition, Emotion, and Motivation," *Psychological Review* 98 (1991): 224–253.

7. Nancy Wong and Aaron Ahuvia, "A Cross-Cultural Approach to Materialism and the Self," in *Cultural Dimensions of International Marketing*, ed. Dominique Bouchet (Denmark: Odense University, 1995), 68–89.

8. Gregory Stone, "Appearance and the Self," in *Human Nature and Social Process*, ed. Arnold M. Rose (Boston: Houghton Mifflin, 1962), 86–118.

9. Stone, "Appearance and the Self," p. 102.

10. Susan Kaiser, *The Social Psychology of Clothing: Symbolic Appearances in Context* (New York: Fairchild, 1997).

11. H. A. Pines, "The Fashion Self-Concept: Structure and Function," paper presented at Eastern Psychological Association meeting, Philadelphia, 1983; H. A. Pines and S. A. Roll, "The Fashion Self-Concept: Clothes That Are Me," paper presented at Eastern Psychological Association meeting, Baltimore, 1984.

12. Leon Festinger, "A Theory of Social Comparison," *Human Relations* 7 (1954): 117–140.

13. Roy F. Baumeister, Dianne M. Tice, and Debra G. Hutton, "Self-Presentational Motivations and Personality Differences in Self-Esteem," *Journal of Personality* 57 (September 1989): 547–575; Ronald J. Faber, "Are Self-Esteem Appeals Appealing?" in *Proceedings of the 1992 Conference of the American Academy of Advertising*, ed. Leonard N. Reid (1992), 230–235.

14. B. Bradford Brown and Mary Jane Lohr, "Peer-Group Affiliation and Adolescent Self-Esteem: An Integration of Ego-Identity and Symbolic-Interaction Theories," *Journal of Personality and Social Psychology* 52, no. 1 (1987): 47–55.

15. Anna Creekmore, "Clothing Related to Body Satisfaction and Perceived Peer Self," *Research Report 239* (Lansing, Mich.: Michigan Agricultural Experiment Station, 1974).

16. Carolyn Humphrey, Mary Klassen, and Anna Creekmore, "Clothing and Self-Concept of Adolescents," *Journal of Home Economics* 63, no. 4 (1971): 246–250.

17. Mary Lynn Johnson Dubler and Lois M. Gurel, "Depression: Relationships to Clothing and Appearance Self-Concept," *Home Economics Research Journal* 13, no. 1 (1984): 21–26.

18. Betty Feather, Betty Martin, and Wilbur Miller, "Attitudes toward Clothing and Self-Concept of Physically Handicapped and Able-Bodied University Men and Women," *Home Economics Research Journal* 7, no. 4 (1979): 234–240; Geitel Winakor, Bernetta Canton, and Leroy Wolins, "Perceived Fashion Risk and Self-Esteem of Males and Females," *Home Economics Research Journal* 9, no. 1 (1980): 45–56; Catherine Daters, "Importance of Clothing and Self-Esteem Among Adolescents," *Clothing and Textiles Research Journal* 8, no. 3 (1990): 45–50; Usha Chowdhary, "Self-Esteem, Age Identification, and Media Exposure of the Elderly and their Relationship to Fashionability," *Clothing and Textiles Research Journal* 7, no. 1 (1988): 23–30.

19. Marsha L. Richins, "Social Comparison and the Idealized Images of Advertising," *Journal of Consumer Research* 18 (June 1991): 71–83; Mary C. Martin and Patricia F. Kennedy, "Advertising and Social Comparison: Consequences for Female Preadolescents and Adolescents," *Psychology & Marketing* 10, no. 6 (November/December 1993): 513–530.

20. Philip N. Myers, Jr., and Frank A. Biocca, "The Elastic Body Image: The Effect of Television Advertising and Programming on Body Image Distortions in Young Women," *Journal of Communication* 42 (Summer 1992): 108–133; See also Jung-Hwan Kim and Sharron J. Lennon, "Effect of Mass Media on Self-Esteem, Body Image, and Eating Disorder Tendencies," *ITAA Proceedings* 61 (2004): 151.

21. "Boys and Their Bodies," *Time* (May 3, 2004).

22. Robin Peterson and Kent Byus, "An Analysis of the Portrayal of Female Models in Television Commercials by Degree of Slenderness," *Journal of Family and Consumer Sciences* 91, no. 3 (1999): 83–91.

23. Quoted in Marilyn Gardner, "Body by Madison Avenue Women Make 85 Percent of All Retail Purchases," *Christian Science Monitor* (November 24, 1999): 18.

24. Jeffrey F. Durgee, "Self-Esteem Advertising," *Journal of Advertising* 14, no. 4 (1986): 21.

25. Theresa Howard, "Dove Ad Gets Serious for Super Bowl," *USA Today* (January 12, 2006): B1.

26. Cited on www.adv.msu.edu (February 6, 2006).

27. Sigmund Freud, *New Introductory Lectures in Psychoanalysis* (New York: Norton, 1965).

28. Keith Gibbons and Tonya Gwynn, "A New Theory of Fashion Change: A Test of Some Predictions," *British Journal of Social and Clinical Psychology* 14 (1975): 1–9.

29. Joanne Eicher, "Influences of Changing Resources on Clothing, Textiles, and the Quality of Life: Dressing for Reality, Fun, and Fantasy," *Combined Proceedings, Eastern, Central, and Western Regional Meetings of Association of College Professors of Textiles and Clothing, Inc.* (1981): 36–41.

30. Kimberly Miller, "Dress: Private and Secret Self-Expression," *Clothing and Textiles Research Journal* 15, no. 4 (1997): 223–234.

31. Harrison G. Gough, Mario Fioravanti, and Renato Lazzari, "Some Implications of Self versus Ideal-Self Congruence on the Revised Adjective Check List," *Journal of Personality and Social Psychology* 44, no. 6 (1983): 1214–1220.

32. Steven Jay Lynn and Judith W. Rhue, "Daydream Believers," *Psychology Today* (September 1985): 14.

33. Bruce Headlam, "Ultimate Product Placement: Your Face behind the Ray-Bans," *New York Times* (June 25, 1998): E4.

34. Hope Jensen Schau and Mary Gilly, "We Are What We Post? Self-Presentation in Personal Web Space," *Journal of Consumer Research* 30 (December 2003): 385–404.

35. Tech Chronicles: MySpace Rules," *San Francisco Chronicle* (July 12, 2006): C3.

36. Gavin O'Malley, "MySpace Is Getting Older, and That's Not a Good Thing," *AdAge.com* (October 5, 2006).

37. Heather Maddan, "Virtual Wardrobe: Get Your Alter Ego All Dolled Up," *San Francisco Chronicle* (July 12, 2006): C3.

38. Reyhan Harmanci, "Get a Life and Leave the Real You at Home in Virtual Online World," *San Francisco Chronicle* (November 9, 2006): E1, E5.

39. Erving Goffman, *The Presentation of Self in Everyday Life* (Garden City, N.Y.: Doubleday, 1959); Michael R. Solomon, "The Role of Products as Social Stimuli: A Symbolic Interactionism Perspective," *Journal of Consumer Research* 10 (December 1983): 319–329.

40. A. Reed, "Activating the Self-Importance of Consumer Selves: Exploring Identity Salience Effects on Judgments," *Journal of Consumer Research* 31, no. 2 (2004): 286–295.

41. George H. Mead, *Mind, Self and Society* (Chicago: University of Chicago Press, 1934).

42. Charles H. Cooley, *Human Nature and the Social Order* (New York: Scribner's, 1902).

43. J. G. Hull and A. S. Levy, "The Organizational Functions of the Self: An Alternative to the Duval and Wicklund Model of Self-Awareness," *Journal of Personality and Social Psychology* 37 (1979): 756–768; Jay G. Hull, Ronald R. Van Treuren, Susan J. Ashford, Pamela Propsom, and Bruce W. Andrus, "Self-Consciousness and the Processing of Self-Relevant Information," *Journal of Personality and Social Psychology* 54, no. 3 (1988): 452–465.

44. Arnold W. Buss, *Self-Consciousness and Social Anxiety* (San Francisco: Freeman, 1980); Lynn Carol Miller and Cathryn Leigh Cox, "Public Self-Consciousness and Makeup Use," *Personality and Social Psychology Bulletin* 8, no. 4 (1982): 748–751; Michael R. Solomon and John Schopler, "Self-Consciousness and Clothing," *Personality and Social Psychology Bulletin* 8, no. 3 (1982): 508–514.

45. Franklin G. Miller, Leslie L. Davis, and Katherine L. Rowold, "Public Self-Consciousness, Social Anxiety, and Attitudes toward Use of Clothing," *Home Economics Research Journal* 10 no. 4 (1982): 363–368.

46. Leslie Davis, "Judgment Ambiguity, Self-Consciousness, and Conformity in Judgments of Fashionability," *Psychological Reports* 54 (1984): 671–675.

47. Yoon-Hee Kwon and Soyeon Shim, "A Structural Model for Weight Satisfaction, Self-Consciousness and Women's Use of Clothing in Mood Enhancement," *Clothing and Textiles Research Journal* 17, no. 4 (1999): 203–212.

48. Morris B. Holbrook, Michael R. Solomon, and Stephen Bell, "A Re-Examination of Self-Monitoring and Judgments of Furniture Designs," *Home Economics Research Journal* 19 (September 1990): 6–16; Mark Snyder, "Self-Monitoring Processes," in *Advances in Experimental Social Psychology,* ed. Leonard Berkowitz (New York: Academia Press, 1979), 85–128.

49. Mark Snyder and Steve Gangestad, "On the Nature of Self-Monitoring: Matters of Assessment, Matters of Validity," *Journal of Personality and Social Psychology* 51 (1986): 125–139.

50. Timothy R. Graeff, "Image Congruence Effects on Product Evaluations: The Role of Self-Monitoring and Public/Private Consumption," *Psychology & Marketing* 13, no. 5 (August 1996): 481–499.

51. Richard G. Netemeyer, Scot Burton, and Donald R. Lichtenstein, "Trait Aspects of Vanity: Measurement and Relevance to Consumer Behavior," *Journal of Consumer Research* 21 (March 1995): 612–626.

52. Leslie Davis and Sharon Lennon, "Self-Monitoring, Fashion Opinion Leadership, and Attitudes toward Clothing," in *The Psychology of Fashion,* ed. Michael R. Solomon (Lexington, Mass.: Lexington Books, 1985): 177–182; Sharon Lennon, Leslie Davis, and Ann Fairhurst, "Evaluations of Apparel Advertising as a Function of Self-Monitoring," *Perceptual Motor Skills* 66 (1988): 987–996.

53. Michael R. Solomon and Henry Assael, "The Forest or the Trees?: A Gestalt Approach to Symbolic Consumption," in *Marketing and Semiotics: New Directions in the Study of Signs for Sale,* ed. Jean Umiker-Sebeok (Berlin: Mouton de Gruyter, 1987), 189–218.

54. Jack L. Nasar, "Symbolic Meanings of House Styles," *Environment and Behavior* 21 (May 1989): 235–257; E. K. Sadalla, B. Verschure, and J. Burroughs, "Identity Symbolism in Housing," *Environment and Behavior* 19 (1987): 569–587.

55. Michael R. Solomon, "The Role of Products as Social Stimuli: A Symbolic Interactionism Perspective," *Journal of Consumer Research* 10 (December 1983): 319–328; Robert E. Kleine, III, Susan Schultz-Kleine, and Jerome B. Kernan, "Mundane Consumption and the Self: A Social-Identity Perspective," *Journal of Consumer Psychology* 2, no. 3 (1993): 209–235; Newell D. Wright, C. B. Claiborne, and M. Joseph Sirgy, "The Effects of Product Symbolism on Consumer Self-Concept," in *Advances in Consumer Research* 19, eds. John F. Sherry, Jr., and Brian Sternthal (Provo, Utah: Association for Consumer Research, 1992), 311–318; Susan Fournier, "A Person-Based Relationship Framework for Strategic Brand Management," Ph.D. dissertation, University of Florida, (1994).

56. A. Dwayne Ball and Lori H. Tasaki, "The Role and Measurement of Attachment in Consumer Behavior," *Journal of Consumer Psychology* 1, no. 2 (1992): 155–172.

57. William B. Hansen and Irwin Altman, "Decorating Personal Places: A Descriptive Analysis," *Environment and Behavior* 8 (December 1976): 491–504.

58. R. A. Wicklund and P. M. Gollwitzer, *Symbolic Self-Completion* (Hillsdale, N.J.: Lawrence Erlbaum, 1982).

59. Michael R. Solomon and Susan P. Douglas, "The Female Clotheshorse from Aesthetics to Tactics," in *The Psychology of Fashion,* ed. Michael R. Solomon (Lexington, Mass.: Lexington Books, 1985): 387–401; Nancy J. Rabolt and Mary Frances Drake, "Information Sources Used by Women for Career Dressing Decisions," in *The Psychology of Fashion,* ed. Michael R. Solomon (Lexington, Mass.: Lexington Books, 1985): 371–385.

60. Erving Goffman, *Asylums* (New York: Doubleday, 1961).

61. Quoted in Floyd Rudmin, "Property Crime Victimization Impact on Self, on Attachment, and on Territorial Dominance," *CPA Highlights,* Victims of Crime Supplement 9, no. 2 (1987): 4–7.

62. Barbara B. Brown, "House and Block as Territory," paper presented at the Conference of the Association for Consumer Research, San Francisco, 1982.

63. Quoted in Shay Sayre and David Horne, "I Shop, Therefore I Am: The Role of Possessions for Self Definition," in *Earth, Wind, and Fire and Water: Perspectives on Natural Disaster*, eds. Shay Sayre and David Horne (Pasadena, Calif.: Open Door, 1996), pp. 353–370.

64. Deborah A. Prentice, "Psychological Correspondence of Possessions, Attitudes, and Values," *Journal of Personality and Social Psychology* 53, no. 6 (1987): 993–1002.

65. Sak Onkvisit and John Shaw, "Self-Concept and Image Congruence: Some Research and Managerial Implications," *Journal of Consumer Marketing* 4 (Winter 1987): 13–24. For a related treatment of congruence between advertising appeals and self-concept, see George M. Zinkhan and Jae W. Hong, "Self-Concept and Advertising Effectiveness: A Conceptual Model of Congruency, Conspicuousness, and Response Mode," in *Advances in Consumer Research* 18, eds. Rebecca H. Holman and Michael R. Solomon (Provo, Utah: Association for Consumer Research, 1991); 348–354.

66. C. B. Claiborne and M. Joseph Sirgy, "Self-Image Congruence as a Model of Consumer Attitude Formation and Behavior: A Conceptual Review and Guide for Further Research," paper presented at the Academy of Marketing Science Conference, New Orleans, 1990.

67. Al E. Birdwell, "A Study of Influence of Image Congruence on Consumer Choice," *Journal of Business* 41 (January 1964): 76–88; Edward L. Grubb and Gregg Hupp, "Perception of Self, Generalized Stereotypes, and Brand Selection," *Journal of Marketing Research* 5 (February 1986): 58–63.

68. Ira J. Dolich, "Congruence Relationship between Self-Image and Product Brands," *Journal of Marketing Research* 6 (February 1969): 80–84; Danny N. Bellenger, Earle Steinberg, and Wilbur W. Stanton, "The Congruence of Store Image and Self Image as It Relates to Store Loyalty," *Journal of Retailing* 52, no. 1 (1976): 17–32; Ronald J. Dornoff and Ronald L. Tatham, "Congruence between Personal Image and Store Image," *Journal of the Market Research Society* 14, (1972): 45–52.

69. Naresh K. Malhotra, "A Scale to Measure Self-Concepts, Person Concepts, and Product Concepts," *Journal of Marketing Research* 18 (November 1981): 456–464.

70. Ernest Beaglehole, *Property: A Study in Social Psychology* (New York: Macmillan, 1932).

71. Russell W. Belk, "Shoes and Self," *Advances in Consumer Research* (2003): 27–33.

72. M. Csikszentmihalyi and Eugene Rochberg-Halton, *The Meaning of Things: Domestic Symbols and the Self* (Cambridge, Mass.: Cambridge University Press, 1981).

73. Russell W. Belk, "Possessions and the Extended Self," *Journal of Consumer Research* 15 (September 1988): 139–168.

74. Kaiser, The *Social Psychology of Clothing: Symbolic Appearances in Context.*

75. N. J. Chowdorow, *Femininities, Masculinities, Sexualities: Freud and Beyond* (Lexington: University Press of Kentucky, 1994).

76. Susan B. Kaiser, C. M. Freeman, and Joan L.Chandler, "Favorite Clothes and Gendered Subjectivities: Multiple Readings," in *Studies in Symbolic Interactions* 15, ed. N. K. Denzin, (Greenwich, Conn.: JAI Press, 1993), 27–50.

77. Kaiser, Freeman, and Chandler, "Favorite Clothes and Gendered Subjectivities: Multiple Readings."

78. Laura M. Holson, "A Finishing School for All, Disney Style," *New York Times on the Web* (October 4, 2004).

79. John F. Sherry Jr., Robert V. Kozinets, Adam Duhachek, Benet DeBerry-Spence, Krittinee Nuttavuthisit, and Diana Storm, "Gendered Behavior in a Male Preserve: Role Playing at ESPN Zone Chicago," *Journal of Consumer Psychology* 14, 1&2 (2004): 151–158.

80. Geoffrey A. Fowler, "Asia's Lipstick Lads," *Wall Street Journal Online* (May 27, 2005).

81. Ginny Parker, "The Little-Girl Look Is Big in Japan Now," *Wall Street Journal* (September 17, 2004): A1.

82. Joan Meyers-Levy, "The Influence of Sex Roles on Judgment," *Journal of Consumer Research* 14 (March 1988): 522-530.

83. Anne Eisenberg, "Mars and Venus, on the Net: Gender Stereotypes Prevail," *New York Times Online* (October 12, 2000).

84. Eileen Fischer and Stephen J. Arnold, "Sex, Gender Identity, Gender Role Attitudes, and Consumer Behavior," *Psychology & Marketing* 11, no. 2 (March/April 1994): 163–182.

85. Kathleen Debevec and Easwar Iyer, "Sex Roles and Consumer Perceptions of Promotions, Products, and Self: What Do We Know and Where Should We Be Headed," in *Advances in Consumer Research* 13, ed. Richard J. Lutz (Provo, Utah: Association for Consumer Research, 1986): 210–214; Joseph A. Bellizzi and Laura Milner, "Gender Positioning of a Traditionally Male-Dominant Product," *Journal of Advertising Research* (June/July 1991): 72–79.

86. Janeen Arnold Costa and Teresa M. Pavia, "Alpha-Numeric Brand Names and Gender Stereotypes," *Research in Consumer Behavior* 6 (1993): 85–112.

87. Julie Angwin, "Gamemakers Target Girls," *San Francisco Chronicle* (August 1, 1997): B1, B4.

88. Sandra L. Bem, "The Measurement of Psychological Androgyny," *Journal of Consulting and Clinical Psychology* 42 (1974): 155–162; Deborah E. S. Frable, "Sex Typing and Gender Ideology: Two Facets of the Individual's Gender Psychology That Go Together," *Journal of Personality and Social Psychology* 56, no. 1 (1989): 95–108.

89. Qimei Chen, Shelly Rodgers, and William D. Wells, "Better Than Sex: Identifying Within-Gender Differences Creates More Targeted Segmentation," *Marketing Research* (Winter 2004): 17–22.

90. Rebecca Gardyn, "Granddaughters of Feminism," *American Demographics* (April 2001): 43–47.

91. "Ads' Portrayal of Women Today Is Hardly Innovative," *Marketing News* (November 6, 1989): 12; Jill Hicks Ferguson, Peggy J. Kreshel, and Spencer F. Tinkham, "In the Pages of Ms.: Sex Role Portrayals of Women in Advertising," *Journal of Advertising* 19, no. 1 (1990): 40–51.

92. Sonia Livingstone and Gloria Greene, "Television Advertisements and the Portrayal of Gender," *British Journal of Social Psychology* 25 (1986): 149–154; for one of

the original articles on this topic, see L. Z. McArthur and B. G. Resko, "The Portrayal of Men and Women in American Television Commercials," *Journal of Social Psychology* 97 (1975): 209–220.

93. Anthony Vagnoni, "Ads from Mars, Women Are from Venus," *Print* 59 (March/April 2005): 52–55.

94. Vagnoni, "Ads from Mars, Women Are from Venus."

95. Judann Pollack, "A Few Real Women Weigh In: Dove Ads Kick Nike's Big Butt," *Advertising Age* (August 22, 2005): 18.

96. "Man-Eaters of Madison Avenue," *Business Week* online (May 15, 2005).

97. Barbara B. Stern, "Masculinism(s) and the Male Image: What Does It Mean to Be a Man?" in *Sex in Advertising: Multidisciplinary Perspectives on the Erotic Appeal,* eds. Tom Reichert and Jacqueline Lambiase (Mahwah, N.J.: Lawrence Erlbaum Associations, 2003).

98. Gordon Sumner, "Tribal Rites of the American Male," *Marketing Insights* (Summer 1989): 13.

99. Barry Janoff, "Give Me Some Men Who Are Stouthearted Men," *Brandweek* (March 6, 2006): 40.

100. Quoted in Jennifer Foote, "The Ad World's New Bimbos," *Newsweek* (January 25, 1988): 44.

101. Neal Learner, "Ad World 'Dumbs Down' American Males," *Christian Science Monitor* (June 4, 2001): 16.

102. Sally Beatty, "Cheap Fumes: Boys Have Their Reasons to Use Body Sprays; for Some Kids, It's Perfect as Deodorant; for Others, It's All About the Girls," *Wall Street Journal* (October 29, 2004): A1.

103. "Defining Metro Sexuality," *Metrosource* (September/October, November 2003).

104. www.urbandictionary.com/define.php?term=ubersexual (July 2, 2007).

105. Kala Vijayraghavan, "It's a Man's World," *The Economic Times New Delhi* (March 9, 2005): 8; Jack Neff, "Marketers Rush into Men's Care Category," *Advertising Age* (July 29, 2002): 6.

106. Cyndee Miller, "Cosmetics Makers to Men: Paint Those Nails," *Marketing News* (May 12, 1997): 14, 18.

107. Jim Carlton, "Hair-Dye Makers, Sensing a Shift, Step Up Campaigns Aimed at Men," *Wall Street Journal Interactive Edition* (January 17, 2000); Yochi Dreazen, *Wall Street Journal Interactive Edition* (June 8, 1999); Cyndee Miller, "Cosmetics Makers to Men: Paint Those Nails," *Marketing News* (May 12, 1997): 14.

108. Projections of the incidence of homosexuality in the general population often are influenced by assumptions of the researchers, as well as the methodology they employ (for example, self-report, behavioral measures, fantasy measures). For a discussion of these factors, see Edward O. Laumann, John H. Gagnon, Robert T. Michael, and Stuart Michaels, *The Social Organization of Homosexuality* (Chicago: University of Chicago Press, 1994).

109. Witeck-Combs Communications, Harris Interactive, Prime Access, Rivendell Media Co., Commercial Closet Association, cited in Carolyn Said, "Marketing Comes Out of the Closet," *San Francisco Chronicle* (June 25, 2006): F1, F4.

110. Kate Fitzgerald, "IKEA Dares to Reveal Gays Buy Tables, Too," *Advertising Age* (March 28, 1994): 3; Cyndee Miller, "Top Marketers Take Bolder Approach in Targeting Gays,"

Marketing News (July 4, 1994): 1; Valerie Seckler, "Lesbian Appeals Are Only Skin Deep," *Women's Wear Daily* (January 28, 2004): 10–11.

111. Said, "Marketing Comes Out of the Closet."

112. Valerie Seckler, "Gay Marketing's Warming Signals," *Women's Wear Daily* (February 23, 2005): 14–15; Valerie Seckler, "Gay Marketing Group Overhauls Ad Standards," *Women's Wear Daily* (May 19, 2006): 11.

113. Ronald Alsop, "Lesbians Are Often Left Out When Firms Market to Gays," *Wall Street Journal Interactive Edition* (October 11, 1999).

114. Kaiser, Freeman, and Chandler, "Favorite Clothes and Gendered Subjectivities: Multiple Readings."

115. Jaehee Jung, Sharron J. Lennon, Nancy A. Rudd, "Self-Schema or Self-Discrepancy? Which Best Explains Body Image?" *Clothing and Textiles Research Journal* 19, no. 4 (2001): 171–184.

116. Sharon J. Lennon, Nancy A. Rudd, Bridgette Sloan, and Jae Sook Kim, "Attitudes toward Gender Roles, Self-Esteem, and Body Image: Applications of a Model," *Clothing and Textiles Research Journal* 17, no. 4 (1999): 191–202.

117. Stephanie N. Mehta, "Photo Chain Ventures beyond Big Hair," *Wall Street Journal* (May 13, 1996): B1.

118. David Garner, "The 1997 Body Image Survey Results," *Psychology Today* (January/February 1997): 30–40.

119. Mary Lynn Damhorst, J. M. Littrell, and M. A. Littrell, "Adolescent Body Satisfaction," *Journal of Psychology* 121 (1987): 553–562.

120. Karen L. LaBat and Marilyn R. DeLong, "Body Cathexis and Satisfaction with Fit of Apparel," *Clothing and Textiles Research Journal* 8 (Winter 1990): 43–48.

121. Nancy J. Rabolt, Jennifer Rocha, and Myleik Teele, "Body Satisfaction of Asian, African-American, and Caucasian Students", *ITAA Proceedings* 61 (2004): 261.

122. Mary Lynn Damhorst and Jennifer P. Ogle, "A Theory-Based Approach to Assessing Body Satisfaction," *ITAA Proceedings* (2002).

123. Dennis W. Rook, "Body Cathexis and Market Segmentation," in *The Psychology of Fashion*, ed. Michael R. Solomon (Lexington, Mass.: Lexington Books, 1985), 233–241.

124. Leslie Davis, "Perceived Somatotype, Body Cathaxis, and Attitudes toward Clothing among College Females," *Perceptual and Motor Skills* 61 (1985): 1199–1205.

125. Jane E. Brody, "Notions of Beauty Transcend Culture, New Study Suggests," *New York Times* (March 21, 1994): A14.

126. "Beyond Stereotypes: Rebuilding the Foundation of Beauty Beliefs: Findings of the 2005 Dove Global Study," www.dove.us (February 2006).

127. "The U.S. National Size Survey," [TC]2, www.tc2.com (Oct. 4, 2006).

128. Eric Nagourney, "Perceptions: Everybody Except My Slender Friends and Me," *New York Times on the Web* (April 18, 2006).

129. Anne Pollak, "Limited, Catherine's Miss on Big-Size Boom: Industry Spotlight," *Bloomberg News Online* (April 4, 1998).

130. Quoted in Yumiko Ono, "For Once, Fashion Marketers Look to Sell to Heavy Teens," *Wall Street Journal Interactive Edition* (July 31, 1998).

131. Cynthia Heimel, "Full-Figured Foraging: Most American Women Wear Size 12. Where Are Their Clothes?" *San Francisco Chronicle* (June 23, 2002): E4, E5.

132. Elizabeth Bryant, "Plus-Size Models Gain New Ground," *San Francisco Chronicle* (October 15, 2006): E1, E3.

133. Geoffrey Cowley, "The Biology of Beauty," *Newsweek* (June 3, 1996): 61–66.

134. Basil G. Englis, Michael R. Solomon, and Richard D. Ashmore, "Beauty *before* the Eyes of Beholders: The Cultural Encoding of Beauty Types in Magazine Advertising and Music Television," *Journal of Advertising* 23 (June 1994): 49–64; Michael R. Solomon, Richard Ashmore, and Laura Longo, "The Beauty Match-Up Hypothesis: Congruence between Types of Beauty and Product Images in Advertising," *Journal of Advertising* 21 (December 1992), 23–34.

135. Michael Schuman, "Some Korean Women Are Taking Great Strides to Show a Little Leg," *Wall Street Journal Interactive Edition* (February 21, 2001).

136. Allison Samuels, "Smooth Operations," *Newsweek* (July 5, 2004): 48–49.

137. Seth Mydans, "Oh Blue-Eyed Thais, Flaunt Your Western Genes!" *New York Times on the Web* (August 29, 2002).

138. Ellen Knickermeyer, "Full-Figured Females Favored," *Opelika-Auburn News* (August 7, 2001).

139. Lois W. Banner, *American Beauty* (Chicago: University of Chicago Press, 1980); for a philosophical perspective, see Barry Vacker and Wayne R. Key, "Beauty *and* the Beholder: The Pursuit of Beauty through Commodities," *Psychology & Marketing* 10, no. 6 (November/December 1993): 471–494.

140. "Report Delivers Skinny on Miss America," *Montgomery Advertiser* (March 22, 2000): 5A.

141. "Study: Playboy Models Losing Hourglass Figures," *CNN.com* (December 20, 2002).

142. Stuart Elliott, "Ultrathin Models in Coca-Cola and Calvin Klein Campaigns Draw Fire and a Boycott Call," *New York Times* (April 26, 1994): D18; Cyndee Miller, "Give Them a Cheeseburger," *Marketing News* (June 6, 1994): 1.

143. Jill Neimark, "The Beefcaking of America," *Psychology Today* (November/December 1994): 32.

144. Richard H. Kolbe and Paul J. Albanese, "Man to Man: A Content Analysis of Sole-Male Images in Male-Audience Magazines," *Journal of Advertising* 25, no. 4 (Winter 1996): 1–20.

145. Hannah Karp, "Jeans Makers Launch New Styles to Flatter the Male Figure," *Wall Street Journal* (June 25, 2004): B1.

146. "Girls at 7 Think Thin, Study Finds," *New York Times* (February 11, 1988): B9.

147. David Goetzl, "Teen Girls Pan Ad Images of Women," *Advertising Age* (September 13, 1999): 32.

148. "Fat-Phobia in the Fijis: TV-thin Is In," *Newsweek* (May 31, 1999): 70.

149. Erin White and Deborah Ball, "Slim-Fast Pounds Home Tough Talk Ads Aimed at U.K. Women," *Wall Street Journal* (May 28, 2004): B3.

150. Karen Schneider, "Mission Impossible," *People* 45 (1996): 64–68.

151. Elaine L. Pedersen and Nancy L. Markee, "Fashion Dolls: Communicators of Ideals of Beauty and Fashion," paper presented at the International Conference on Marketing Meaning, Indianapolis, Ind., 1989; Dalma Heyn, "Body Hate," *Ms.* (August 1989): 34; Mary C. Martin and James W. Gentry, "Assessing the Internalization of Physical Attractiveness Norms," *Proceedings of the American Marketing Association Summer Educators' Conference* (Summer 1994): 59–65.

152. Lisa Bannon, "Barbie Is Getting Body Work, and Mattel Says She'll Be Rad," *Wall Street Journal Interactive Edition* (November 17, 1997).

153. Lisa Bannon, "Will New Clothes, Bellybutton Create 'Turn Around' Barbie," *Wall Street Journal Interactive Edition* (February 17, 2000).

154. "How Much Is Too Fat?," *USA Today* (February 1989): 8.

155. *American Demographics* (May 1987): 56.

156. Deborah Marquardt, "A Thinly Disguised Message," *Ms.* 15 (May 1987): 33.

157. Vincent Bozzi, "The Body in Question," *Psychology Today* 22 (February 1988): 10.

158. Elizabeth Fernandez, "Exercising Her Right to Work: Fitness Instructor Wins Weight-Bias Fight," *San Francisco Chronicle* (May 7, 2002): A1, A15.

159. Catherine Rutherford-Black, and Jeanne Heitmeyer, "College Students' Attitudes Toward Obesity: Fashion, Style and Garment Selection," *Journal of Fashion Marketing and Management* 4, no. 2 (2000): 132–139.

160. "Heightism: Short Guys Finish Last," *The Economist* (December 23, 1996): 19–22.

161. Elizabeth Love, "Prisoners of Perfection," *San Francisco Chronicle* (October 19, 2000): A15, A18.

162. Eric Wilson, "When Is Thin Too Thin?" *New York Times on the Web* (September 21, 2006). Also see www.webmd.com for a healthy weight chart for adults and discussion of health risk factors.

163. "Skinny Model Furor: Not All Fashion's Fault, Say Designers, Editors," *Women's Wear Daily* (January 30, 2007): 1, 8–10.

164. "Where Size 0 Doesn't Make the Cut," *New York Times on the Web* (September 22, 2006).

165. Malaika Bova, "New Guidelines Released for U.S. Models," http://abcnews.go.com/US/story?id=2791241&page=1 (April 24, 2008), www.cfda.com.

166. Debra A. Zellner, Debra F. Harner, and Robbie I. Adler, "Effects of Eating Abnormalities and Gender on Perceptions of Desirable Body Shape," *Journal of Abnormal Psychology* 98 (February 1989): 93–96.

167. Robin T. Peterson, "Bulimia and Anorexia in an Advertising Context," *Journal of Business Ethics* 6 (1987): 495–504.

168. Judy Folkenberg, "Bulimia: Not for Women Only," *Psychology Today* (March 1984): 10.

169. Stephen S. Hall, "The Bully in the Mirror," *The New York Times Magazine*, (August 22, 1999); Natalie Angier, "Drugs, Sports, Body Image and G.I. Joe," *New York Times* (December 22, 1998): D1.

170. John W. Schouten, "Selves in Transition: Symbolic Consumption in Personal Rites of Passage and Identity Reconstruction," *Journal of Consumer Research* 17 (March 1991): 412–425.

171. Emily Yoffe, "Valley of the Silicon Dolls," *Newsweek* (November 26, 1990): 72.

172. Quoted in Michelle Cottle, "Turning Boys into Girls," *The Washington Monthly* (May 1998): 32–36.

173. Jerry Adler, "New Bodies for Sale," *Newsweek* (May 27, 1985): 64.

174. Kathy H. Merrell, "Saving Faces," *Allure* (January 1994): 66.

175. "White Weight," *Psychology Today* (September/October 1994): 9.

176. Joan Ryan, "A Painful Statement of Self-Identity," *San Francisco Chronicle* (October 30, 1997): A1, A4.

177. Ruth P. Rubinstein, "Color, Circumcision, Tattos, and Scars," in *The Psychology of Fashion*, ed. Michael R. Solomon (Lexington, Mass.: Lexington Books, 1985), 243–254; Peter H. Bloch and Marsha L. Richins, "You Look 'Mahvelous': The Pursuit of Beauty and Marketing Concept," *Psychology & Marketing* 9 (January 1992): 3–16.

178. Sondra Farganis, "Lip Service: The Evolution of Pouting, Pursing, and Painting Lips Red," *Health* (November 1988): 48–51.

179. Michael Gross, "Those Lips, Those Eyebrows; New Face of 1989 (New Look of Fashion Models)," *The New York Times Magazine* (February 13, 1989): 24.

180. Quoted in "High Heels: Ecstasy's Worth the Agony," *New York Post* (December 31, 1981).

181. Elizabeth Hayt, "Over-40 Rebels with a Cause: Tattoos," *New York Times* (December 22, 2002): sec 9:2.

182. Myra L. Armstrong and Kathleen Pace Murphy, "Tattooing: Another Adolescent Risk Behavior Warranting Health Education," *Applied Nursing Research* 10, no. 4 (1997): 181–189.

183. David Whalan, "Ink Me, Stud," *American Demographics* (December 2001): 9–11.

184. http://www.pathfinder.com:80/altculture/aentries/p/piercing.html (August 22, 1997).

185. Quoted in Wendy Bounds, "Body-Piercing Gets under America's Skin," *Wall Street Journal* (April 4, 1994): B1, B4.

6
Demographic Subcultures
Age, Race, Ethnicity

It's the last week of summer vacation, and Brandon is looking forward to going back to college. It's been a tough summer. He had trouble finding a job, seemed to be out of touch with his old friends—and he and his mother weren't getting along too well. As usual, Brandon is plopped on the couch,

aimlessly flipping channels—from *Celebrity Deathmatch* on MTV, to a Sony beach volleyball tournament on ESPN, back to MTV. . . . Suddenly, Mrs. Boyd walks in, grabs the remote, and switches the channel to public television. Yet another documentary is on about Woodstock (the original one, way back in 1969). When Brandon protests, "Come on Jackie, get a life. . . ." his mom snaps back, "You might actually learn about what it was like to be in college when it really meant something. And what's with the first name stuff? In my day I would never have dreamed of calling my mom or dad by their first name!"

That's when Brandon loses it. He's tired of hearing about the "good old days" of Woodstock, Berkeley, and twenty other places he doesn't care about. Besides, most of his mom's ex-hippie friends now work for the very corporations they used to protest about—who are they to preach to him about doing something meaningful with his life? Because they've screwed up the economy so much, he'll be lucky to get any job when he finally gets his degree next year.

In disgust, Brandon storms into his room, puts an Outcast CD into his Discman, and pulls the covers up over his head. What's the difference, anyway—they'll probably all be dead from the "greenhouse effect" by the time he graduates. . . .

199

Consumer lifestyles are affected by group memberships *within* the society at large. These groups are known as **subcultures**, whose members share beliefs and common experiences that set them apart from others. While subcultural group memberships often have a significant impact on consumer behavior, some subcultural identifications are more powerful than others. In this chapter we will discuss age and ethnic and racial identity as significant components of a consumer's self-concept.

AGE AND CONSUMER IDENTITY

The era in which a consumer is born creates for that person a cultural bond with the millions of others born during the same time period. As we grow older, our needs and preferences change, often in unison with those of others who are close to our own age. For this reason, a consumer's age exerts a significant influence on his or her identity. All things being equal, we are more likely to have things in common with others of our own age than those younger or older. And, as Brandon found out, this identity may become even stronger when the actions and goals of one generation conflict with those of others—an age-old battle.

A marketer needs to communicate with members of an age-group in their own language. After years of successfully selling Dockers to baby boomers and recent declining sales of jeans, for example, Levi Strauss figured out how to reach teens: It sponsord music events to get the attention of young people. Similarly, luxury department stores are using unique merchandise mixes to attract younger-generation shoppers (teens to those in their thirties) as they become a more important part of their market. Some retailers are finding the young are more likely to spend on luxury than baby boomers. For example, Bergdorf Goodman's new fifth floor has a panini bar, a lounge music deejay, and an eclectic assortment of clothing geared toward the younger generation. Neiman Marcus introduced Cusp, a concept geared toward Gen X (those in their thirties), selling high-end designer goods, such as Chloe handbags, beside less expensive trendy items, such as J Brand jeans. As the younger generation prefers trendy style over brand loyalty, luxury retailers are having to become more creative and not just purchase the traditional lines.[1] In this section, we'll explore important characteristics of some key age-groups and consider how marketing strategies must be modified to appeal to diverse age subcultures.

Age Cohorts: "My Generation"

An **age cohort** consists of people of similar ages who have undergone similar experiences. They share many common memories about cultural heroes (John Wayne versus Brad Pitt), important historical events (World War II versus the 2001 terrorist attacks), and so on. Although there is no universally accepted way to divide people into age cohorts, each of us seems to have a pretty good idea of what we mean when we refer to "my generation." Figure 6-1 presents one reasonable scheme for defining generations.

Although many apparel companies claim they design for a certain attitude, not an age-group, fashion marketers often target products and services

The Depression & World War II Cohort

(The GI Generation)
Born before 1925
Age in 2010: Over 85
% of population: 2%, 6 million people
Money Motto: Save for a rainy day
Favorite Music: Big band, swing
Notable GIs: Ronald Reagan, Katharine Hepburn

People who were starting out in the Depression era were scarred in ways that remain with them today—especially when it comes to financial matters such as spending, saving, and debt. The Depression cohort was also the first to be truly influenced by contemporary media such as radio and especially motion pictures. "Government Issue" (GI) was a method of distributing supplies during World War II, this generation's most influential event. Their attitude is that they deserve Social Security and government benefits. Casual clothing and national brands are important; designer labels are not.

The Postwar Cohort

(The Silent Generation)
Born 1926–1945
Age in 2010: 65–84
% of population: 11%, 34 million people
Money Motto: Save a lot, spend a little
Favorite Music: Frank Sinatra
Notable Postwars: George H. Bush, Jack Nicholson

The war babies benefitted from a long period of economic growth and relative social tranquility. But global unrest and the threat of nuclear attack sparked a need to alleviate uncertainty in everyday life. The youngest subset, called the cool generation, were the first to dig folk rock. Quality for the price is important. They want clothes that will last without being overpriced.

The Baby Boomers I Cohort

(The Woodstock Generation)
Born 1946–1955
Age in 2010: 55–64
% of population: 12%, 36 million people
Money Motto: Spend, borrow, spend
Favorite Music: Rock & roll, Motown, Beatles
Notable Boomers: Bill Clinton, Harrison Ford

Vietnam is the demarcation point between leading-edge and trailing-edge boomers. The Kennedy and King assassinations signaled an end to the status quo and galvanized this vast cohort. Still, early boomers continued to experience good times and want a lifestyle at least as good as their predecessors. When young, they produced the youth culture of the 1960s. They wore Levi's in the 1960s, disco in the 1970s, and status designer labels in the 1980s. Casual Levi's Dockers and Slates were developed just for them.

The Baby Boomers II Cohort

(Zoomers)
Born 1956–1965
Age in 2010: 45–54
% of population: 15%, 45 million people
Money Motto: Spend, borrow, spend
Favorite Music: Rock & roll, Elton John, U2
Notable Boomer IIs: Tom Hanks, Caroline Kennedy

It all changed after Watergate. The idealistic fervor of youth disappeared. Instead, the later boomers exhibited a narcissistic

preoccupation that manifested itself in things such as the self-help movement. In this dawning age of downward mobility, debt as a means of maintaining a lifestyle made sense. Clothing brands matter, but their brands have a hipper attitude (Guess?, Banana Republic).

The Generation X Cohort

(The Baby Busters)
Born 1966–1975
Age in 35–44
% of population: 13%, 41 million people
Money Motto: Spend? Save?
Favorite Music: Rap, retro, Hootie and the Blowfish
Notable Xers: Madonna, Tom Cruise

Some characterize the slacker set as having nothing to hang on to; they may be the most misunderstood, complex, and self-sufficient. The latchkey kids of divorce and day care are searching for anchors with their seemingly contradictory "retro" behavior: the resurgence of proms, coming-out parties, and fraternities. Their political conservatism is motivated by a "What's in it for me?" cynicism. Brand names are not important as they rebel against the boomer generation. They make a fashion statement by antistatement.

The Generation Y Cohort

(The Wired Generation)
Born 1976–1985
Age in 2010: 25–34
% of population: 13%, 41 million
Money Philosophy: Optimistic and experimental
Favorite Music: Backstreet Boys, Britney Spears
Notable Yers: Prince William

The children of the baby boomers, this generation is being raised in an economy unlike any before them. It has been unaffected by major wars or military conflicts. These people are technologically advanced, surrounded with interactive toys, talking learning systems, video technology, cable TV, and the Internet. Generation Y already has its own credit cards and Internet accounts. They love to shop. They are knowledgeable about brands and fashion but are cynical about traditional marketing. Delia's and American Eagle Outfitters have been successful with this group.

The Generation Z Cohort

Born 1986–1995
Age in 2010: 15–24
% of population: 14%, 43 million

This group has grown up with not only the Internet but also MySpace, Facebook, and YouTube and the concept of social networking. They use iPods and cell phones to communicate, not e-mail, and are good multitaskers. They are not fans of anything "too corporate," are ad-averse, and do not appreciate offensive or insulting advertising. Marketers have to show how products are relevant to their lives.

Generation ? Cohort

Born: 1996–2010
Age in 2010: 0–14

This group doesn't have a nickname yet but will be similar to Generation Z in terms of growing up with the Internet and technology. Even children in poor, developing countries will have inexpensive computers linked to the Internet creating a still smaller, more global world.

FIGURE 6-1
Age Cohorts

Source: Adapted from "Generation Cohorts," *Fortune* (June 26, 1995): 110, updated with U.S. Census projections.

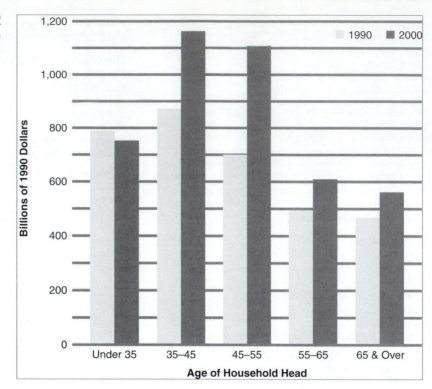

FIGURE 6-2
Household Income by Age

to one or more specific age cohorts. As shown in Figure 6-2, although middle-aged people make the most money, there's plenty of market potential attached to other age groups as well. Marketers recognize that the same offering will probably not appeal to people of different ages nor will the language and images they use to reach them. In some cases, separate campaigns are developed to attract consumers of different ages. And some companies are starting new chains to keep their aging market. For example, teen-oriented American Eagle Outfitters has recently opened Martin + Osa stores geared toward the 25–40-year-old customer with sportswear and activewear. Similarly, Gap opened its fourth brand, Forth & Towne (although it was not successful), and Abercrombie & Fitch opened Ruehl, targeting 22–30-year-olds with casual apparel, cashmere sweaters, and accessories. This demographic has been coined "Gen-Y Grad" as postcollegiate consumers search for more sophisticated but trendy items as they enter the workforce.[3]

The Appeal of Nostalgia

Because consumers within an age-group confront crucial life changes at roughly the same time, the values and symbolism used to appeal to them can evoke powerful feelings of nostalgia. Adults over thirty are particularly susceptible to this phenomenon.[2] However, young people as well as old are influenced by references to their past. In fact, research indicates that some people are more disposed to be nostalgic than others, regardless of age. A scale that has been used to measure the impact of nostalgia on individual consumers appears in Table 6-1.

Table 6-1 The Nostalgia Scale

Scale Items
• They don't make 'em like they used to.
• Things used to be better in the good old days.
• Products are getting shoddier and shoddier.
• Technological change will ensure a brighter future (reverse coded).
• History involves a steady improvement in human welfare (reverse coded).
• We are experiencing a decline in the quality of life.
• Steady growth in GNP has brought increased human happiness (reverse coded).
• Modern business constantly builds a better tomorrow (reverse coded).

Note: Items are presented on a nine-point scale ranging from strong disagreement (1) to strong agreement (9), and responses are summed.
Source: Morris B. Holbrook and Robert M. Schindler, "Age, Sex, and Attitude toward the Past as Predictors of Consumers' Aesthetic Tastes for Cultural Products," *Journal of Marketing Research* 31 (August 1994): 416. Reprinted by permission of the American Marketing Association.

Product sales can be dramatically affected by linking a brand to vivid memories and experiences, especially for items associated with childhood or adolescence. Many advertising campaigns have played upon the collective memories of consumers by resuscitating old pop classics. The old can become hip as it is discovered by a new generation. Gap ran successful campaigns using swing music of the 1940s with today's teen dancers and music from the 1960s' musical *West Side Story*. Gap also recently used classic footage of Audrey Hepburn dancing in skinny black pants, while Warner's used Marilyn Monroe and Bebe used the vamp look from the 1930s in their advertising. This attempt to appeal to more than one age-group using imagery from an older generation that also turns on young consumers is called a **multigenerational marketing strategy**.

Fossil's product designs evoke memories of earlier, classic style.

THE YOUTH MARKET

In 1956, the label "teenage" first entered the American vocabulary, as Frankie Lymon and the Teenagers became the first pop group to identify themselves with this new subculture. The concept of a teen is a fairly new cultural construction; throughout most of history a person simply made the transition from child to adult (often accompanied by some sort of ritual or ceremony). The magazine *Seventeen*, first published in 1944, was based on the revelation that young women didn't want to look just like Mom. Following World War II, the teenage drama between rebellion and conformity began to unfold, pitting Elvis Presley with his slicked hair and suggestive swivels against the wholesome Pat Boone with his white bucks. Today, this rebellion often is played out by acting detached from the adult world, as exemplified by teen idols such as hip-hop star Eminen or the confused, sullen teens appearing on daytime television talk shows.

Known as Echo Boomers, Millennials, or **Generation Y** (Gen Y), today's teens and early twenty-somethings have been born and raised in an era of technology and media with limitless access to knowledge; they are a generation with economic power unlike any before them spending over $175 billion per year on products and services. Retailers see Gen Y as one of the most attractive growth opportunities, as identified by a Montgomery Securities report entitled "The Power of the Teen Dollar: From Levi's to Lip Gloss."[4] Some have characterized them as fashion addicts; among teenage girls, the number one choice for disposing of their wealth is fashion, and marketers are scrambling to identify these fashion needs and figure out how teenage girls think, what they expect, and what they want. In fact, the "what" is very important. Jane Buckingham of Trend School uses the acronym IWWIW to describe this group, translated as "I want what I want. I want it when I want it. And I want it how I want it."[5]

This wired generation researches online, spends online, and uses the media much differently than did previous generations. Teens like the Web because of the control it gives them over their media experience. Teens now spend more time on the Internet than they do watching television, according to a survey by Harris Interactive and Teenage Research Unlimited. They multitask while online, such as doing homework or watching television and using other media such as CDs, MP3s, telephone, and radio. Only 10 percent of those surveyed did nothing else while online.[6] Teens are the prime Internet audience because they are the fastest-growing group of computer users. For many, online shopping and entertainment have replaced "old-fashioned fun" such as watching the tube or hanging out at the mall.

According to Teenage Research Unlimited, 84 percent of teenagers have a computer at home and 74 percent have access to the Internet.[7] They spend most of their online time playing games, doing research for school, downloading music, instant messaging, creating and commenting on each others' blogs, checking out things to buy, and hunting for bargains. Being active online, and especially finding really cool unique things online, is part of their identity. They like to play with customizing clothes and other virtual aids to imagination. Many teenagers have spent hours on the Nike ID site (www.nikeid.com), redesigning their own shoes, trying different styles and colors, just experimenting, even though they don't intend to buy. It's a place to express themselves. It's a game to them.[8]

Ten percent of these kids have a credit card in their own name, and another 9 percent have access to a parent's card (uh-oh!). To counteract parents' concerns about security issues, some start-ups such as RocketCash and DoughNet are creating "digital wallets" that let Mom and Dad set up an account and limit the sites at which money can be spent. Another way teens and preteens can learn about credit is a "pocket card," which is a prepaid department store card that the young person can use to make purchases and still keep spending under control. This card also comes in handy when parents are not available to shop with their children. Sending them off to the department store with a prepaid card is very appealing to working parents.

Tweens, preteens age 8–12 (or 5–12, depending on the source), have some of the same characteristics of teens, especially today as they seem to be growing up faster than in years past. (This group is actually part of Generation Z.) Some marketers feel the tween segment is slippery because it is beyond Barbie but before dating.[9] Many tweens feel toy stores are too childish, and retailers are listening. FAO Schwartz, Toys "R" Us, and K-B Toys have created departments such as electronics, sports, and videos aimed at this group. One successful tween product (and even for little kids age 6) is a cell phone like Firefly, armed with parental controls such as protected phone lists, prepaid calling minutes, and a GPS monitoring device.

One of the biggest tween successes is the meteoric rise of Mary-Kate and Ashley Olsen, who made their acting debut as little girls on the series *Full House*. They have become the most financially successful child stars in history, parlaying their star power into a reportedly billion-dollar international brand, spanning cosmetics to clothing and rugs. Hilary Duff, who shot to fame as the title character in the series *Lizzie McGuire*, is developing clothing and room decor for preteen girls. And Mattel, maker of Barbie, enlisted Hilary Duff to give her blessing to a line of Barbie clothing for flesh-and-blood girls. Thirteen-year-old Dylan and Cole Sprouse, twin actors, hope to follow in these footsteps.[10] Tween celebrities are definitely speaking to their audiences.

"Awareness of fashion is getting younger and younger," says the editor of *Cookie*, a magazine aimed at parents of children under 12.[11] This demographic group is getting more attention by junior apparel companies, which hope to get them "while they're young." Although some juniors companies such as Esprit and Rampage have carried girl's apparel for some years, we now see scaled-down versions of sophisticated looks from Juicy Couture, Calypso, Scoop, Paul & Joe (Paul & Joe Sister), True Religion, Diesel, and Sonia Rykiel. To the consternation of some adults, the conventional sugar-and-spice girls' formula is laced these days with sass—the clothes not so much sexy as candidly provocative in their mimicry of grown-up clothes.[12] Tweens just want to look like their older brothers and sisters.

Youth Values, Conflicts, and Appearance

As anyone who has been there knows, the process of puberty and adolescence can be both the best of times and the worst of times. Many exciting changes happen as individuals leave the role of child and prepare to assume the role of adult. These changes create a lot of uncertainty about the self, and the need to belong and to find one's unique identity becomes extremely important. At this age, choices of activities, friends, and "looks" often are crucial to social acceptance. Teens actively search for cues from their peers

Teen rebellion is a new phenomenon in Japan, a country known for rigid conformity and constant pressure to succeed. Now more and more teenagers are questioning the rules. The dropout rate among students in junior and senior high school increased by 20 percent in a two-year period. More than 50 percent of girls have had intercourse by their senior year of high school.[13]

Japanese youth are very style conscious, and currently there are several niches or "tribes," each with very well-defined looks and rules.[14] A popular look for Japanese girls is called the "Gals." They are easily recognized by their bleached yellow hair, salon-tanned skin, chalk-white lipstick, and seven-inch platform heels. Other groups include the Sports Clique (low-heeled Air Mocs and Gap clothing) and the Back-Harajuku Group (baggy sweatshirts, colorful jeans, sneakers, and long scarves).

To try to win the loyalty of young consumers in Japan, five big companies including Toyota, Matsushita, and Asahi Breweries formed a marketing alliance. They are introducing a range of products, from beer to refrigerators, all with the same brand name of Will (yes, Will). Critics are not sure the plan will work because these companies as of now do not have very modern images, so only time will tell if this ambitious plan Will or won't.[15]

and from advertising for the "right" way to look, what clothes to wear, and how to behave. Advertising geared to teens is typically action oriented and depicts a group of "in" teens using the product.

Teenagers in every culture grapple with fundamental developmental issues as they make the transition from childhood to adult. According to research by the Saatchi & Saatchi advertising agency, four themes of conflict are common to all teens:

1. *Autonomy versus belonging:* Teens need to acquire independence, so they try to break away from their families. On the other hand, they need to attach themselves to a support structure, such as peers, to avoid being alone. A thriving teen Internet subculture serves this purpose, and its anonymity makes it easier to talk to people of the opposite sex or of different ethnic and racial groups.[16]

2. *Rebellion versus conformity:* Teens need to rebel against social standards of appearance and behavior, yet they still need to fit in and be accepted by others. Cult products that cultivate a rebellious image are prized for this reason. Hot Topic, a retail chain based in Pomona, California, caters to this need by selling $44 million per year of such "in your face" items as nipple rings, tongue barbells, and purple hair dye.[17]

 The Columbine High School shootings in 1999 made the public more aware of the dangers of the alienation from society that some teens feel today. Some schools have outlawed the wearing of long black trench coats in high schools, as they are associated with the "Trench Coat Mafia" and were worn by the teenage gunmen who killed twelve schoolmates and a teacher in Littleton, Colorado. Shootings have continued at the University of Virginia and Northern Illinois University by alienated young individuals.

3. *Idealism versus pragmatism:* Teens tend to view adults as hypocrites, while they see themselves as being sincere. They struggle to reconcile their view of how the world should be with the realities they perceive around them.

URBAN ✴ DECAY
C O S M E T I C S

Urban Decay nail polish was one of the first cosmetics companies to introduce this concept of rebellion.

4. *Narcissism versus intimacy:* Teens often are obsessed with their own appearance and needs. On the other hand, they also feel the desire to connect with others on a meaningful level.[18]

Appealing to the Youth Market

Most teens are avid consumers of beauty products, clothing, and other appearance-related products. Much of their money goes toward "feel-good" products: cosmetics, posters, and fast food—with the occasional nose ring thrown in as well.

Because modern teens were raised on TV with more access to information than any other generation, and they tend to be much more savvy than older generations, marketers must tread lightly when they try to reach them. In particular, the messages must be seen as authentic and not condescending. As one researcher observed, "they have a B.S. alarm that goes off quick and fast. . . . They walk in and usually make up their minds very quickly about whether it's phat or not phat, and whether they want it or don't want it. They know a lot of advertising is based on lies and hype."[20]

ADOLESCENT SEXUALITY IN FASHION ADS

Calvin Klein's strategy of using adolescent sexuality to sell the company's products dates way back to 1980, when Brooke Shields proclaimed that nothing comes between "me and my Calvins." Later ads featuring singer Marky Mark in his underwear sparked a new fashion craze. In 1995, though, Klein took this approach one daring step further, when the company unveiled a very controversial advertising campaign featuring young-looking models in situations dripping with sexual innuendo. In one spot, an old man with a gravelly voice says to a scantily clad young boy, "You got a real nice look. How old are you? Are you strong? You think you could rip that shirt off of you? That's a real nice body. You work out? I can tell." The campaign ended when the chairman of Dayton Hudson asked that the stores' names be removed from the ads, and *Seventeen* refused to carry them.[19] By that time, of course, Klein had reaped invaluable volumes of free publicity as teens and adults debated the appropriateness of these images.

Authenticity and relevance to teens' lifestyles are needed to capture this market. Fashion brands have struggled with this and have made mistakes according to some analysts. For one thing, Millennials are often portrayed in advertising as naïve, and typically they are not. They also get along better with their parents than prior groups yet seldom is this used in marketing campaigns. They are the most culturally and racially diverse generation, but multicultural campaigns are rare.[21] So what are the rules of engagement when it comes to young consumers?[22]

Rule 1: Don't talk down. They want to feel they are drawing their own conclusions about products. Don't be preachy. In the words of one teen: "I don't like it when someone tells me what to do."

Rule 2: Don't try to be what you're not. Stay true to your brand image. Kids value straight talk. Firms that back up what they say impress them.

Rule 3: Entertain them. Make it interactive and keep the sell short. The hard sell is a turnoff. Participatory experience makes it more authentic. Gap asked users of its Web site to volunteer to model for an ad campaign (digital photos were submitted for an online vote). Personalizing products and avatars and evaluating products are popular with teens.

Rule 4. Show that you know what they're going through. One of Levi's promotions used a tagline, "What's True," featuring teenagers wearing Levi's they picked themselves and sharing random sidewalk philosophies, a documentary style of kids' straight talk.[23]

The publishing industry knows a hot market when it sees one and has offered teens many options. For example, www.teenpeople.com, a junior version of *People*, addresses teen readers as young adults with much more information than traditional puppy-love periodicals such as *Seventeen* and *YM*. Teen magazines are read mostly by girls; however, some boys and even moms and dads read them to keep up on their children's pop culture. In addition, catalogs are targeting Generation Y from companies including Delia's, Girlfriend, Alloy, and even retailers such as Wetseal.[24] Individualistic models

Candie's styles appeal to teenagers and young adults.
Source: www.candies.com.

WHAT IT MEANS TO BE COOL

One study asked young people in the United States and the Netherlands to write essays about what is "cool" and "uncool."[26] The researchers found that being cool has several meanings, though there are a lot of similarities between the two cultures when kids use this term. Some of the common dimensions include having charisma, being in control, and being a bit aloof. Many of the respondents agreed that being cool is a moving target: The harder you try to be cool, the more uncool you are! Some of their actual responses are listed here:

"Cool means being relaxed, to nonchalantly be the boss of every situation, and to radiate that." (Dutch female)

"Cool is the perception from others that you've got 'something' which is macho, trendy, hip, etc." (Dutch male)

"Cool has something standoffish, and at the same time, attractive." (Dutch male)

"Being different, but not too different. Doing your own thing, and standing out, without looking desperate while you're doing it." (American male)

"When you are sitting on a terrace in summer, you see those machos walk by, you know, with their mobile [phones] and their sunglasses. I always think, 'Oh please, come back to earth!' These guys only want to impress. That is just so uncool." (Dutch female)

"When a person thinks he is cool, he is absolutely uncool." (Dutch female)

"To be cool we have to make sure we measure up to it. We have to create an identity for ourselves that mirrors what we see in magazines, on TV, and with what we hear on our stereos." (American male)

with funky hairdos, edgy brands, and underground labels (small companies with no traditional showrooms) help differentiate the clothes and draw the teens to these hip new catalogs. Alternative ordering procedures on Web sites fit right into these teens' lifestyles.

Marketers view teens as "consumers in training," since brand loyalty often is developed during this age. Consider *CosmoGirl* and *Teen People*.[25] What magazines do you think their readers will buy as they get older? Advertisers

MULTICULTURAL DIMENSIONS

Throughout the world, developed countries are getting older while the developing countries are getting younger. Due to high birthrates in developing countries a large proportion of the population is very young. For example, consider that while 21 percent of U.S. residents are 14 or younger, the following corresponding percentages in some other countries are much higher:[27]

- China: 25 percent
- Argentina: 27 percent
- Brazil: 29 percent
- India: 33 percent
- Iran: 33 percent
- Malaysia: 35 percent
- Philippines: 37 percent

On the other hand, Japan has the oldest population in the world and Italy is not far behind; it has the lowest birthrate in Europe. This population trend is having an impact on consumer tastes. Dolce & Gabbana used a gray-haired model in its runway show, but still most fashion designers generally target the younger consumer, even though older women are the consumers who have the disposable income to actually afford luxury and designer items.[28]

In Japan, with 21 percent of its population over 65, retail is adjusting to its aging population. Many convenience stores, which largely serve youth, are being transformed to cater to the elderly with widened aisles, lowered shelves, enlarged price tags, automatic doors, and tables for lingering. They now stock health magazines, instant meals, and meals for singles. They have cut back on lattes and added local vegetables and sake.[29]

sometimes try to "lock in" consumers to certain brands so that in the future they will buy these brands more or less automatically. As one teen magazine ad director observed, "We . . . always say it's easier to start a habit than stop it."[30]

Big (Wo) Man on Campus: The College Market

Advertisers spend more than $100 million a year on college campuses to woo college students and with good reason: Purchases by 16.5 million U.S. college students amounted to over $41 billion, according to an Alloy College Explorer Study.[31] Many students have plenty of extra cash and free time. On a typical day the average student spends 1.7 hours in class and another 1.6 hours studying. The "average" student (or are all students above average?) has about $287 to spend on discretionary items per month (over three-quarters are employed). Students' newfound freedom and discretionary income are creating insatiable appetites and a desire for self-expression, self-indulgence, and experimentation.

As one marketing executive observed, "This is the time of life where they're willing to try new products. . . . This is the time to get them in your franchise."[32] The college market is attractive to many companies because many of these novice consumers are away from home for the first time, so they have yet to form fixed brand loyalty.

Nevertheless, college students pose a special challenge for marketers, since they are hard to reach by conventional media like newspapers. Also many are resistant to traditional promotions with their self-described distaste for celebrity marketing, which characterizes much of today's advertising. They prefer pitches by everyday people such as those appearing in the Dove and Nike campaigns.[33] Of course, online advertising is very effective: Fully 99 percent of college students go online at least a few times per week and 90 percent do so daily. In addition, enterprises like www.mtvU.com are blossoming because they reach students where they live and play.[34] And Web sites such as www.simplysearscollege.com cater specifically to this market living on and off campus. Although some large companies have found that the best way to reach students is through their college newspapers, most don't read any newspapers. One student said, "Papers are so clunky and big." He gets all his information from the Internet. So other companies are creating advertising and short videos for mobile phones and downloads to iPods and PCs.[35]

Other strategies for reaching students include the widespread distribution of sample boxes containing a variety of personal-care products and the use of posters (called *wall media*). In addition, a growing number of companies are capitalizing on the ritual of spring break to reach college students. Beach promotions used to be dominated by suntan lotion and beer companies, but now firms such as Chanel, Hershey, and Procter & Gamble are joining them. And designers such as Tommy Hilfiger are going to the beaches to stage model searches and fashion shows.[36]

BABY BUSTERS: GENERATION X

The cohort of consumers born between 1965 and 1976 consists of over 40 million Americans. This group was labeled **Generation X** following the best-selling 1991 novel by that name. They have been called "slackers" or "baby busters" because of their supposed alienation and laziness, with stereotypes pervading

popular culture in movies such as *Clueless* or in music of groups such as Marilyn Manson.[37] But as this cohort ages, these stereotypes have changed.

"The most conservative people in the U.S. are married Gen Xers with children," declared a Gen X expert.[38] As the first generation of "latchkey kids," with their baby boomer parents both working, Gen Xers tend to be much more independent and self-sufficient than Millenials. They went through their all-important formative years as one of the least-parented, least-nurtured generations in U.S. history. A fiercely independent style sensibility characterizes this group making them tricky for marketers to cater to. Xers, in their thirties, are mostly settled down, raising families, and spending money on their families in addition to paying off college loans. Fashion is a lower priority. In fact, this is the only age-group that spent less money on apparel in a recent twelve-month period than the previous year, according to the NPD Group research firm.[39]

A CNN/Time study found that 60 percent of Xers want to be their own bosses, and another study revealed that they are already responsible for 70 percent of new start-up businesses in the United States. One industry expert observed, "Today's Gen Xer is both values-oriented and value-oriented."[40] Seven out of ten regularly save some portion of their income, a rate comparable to their parents'. Xers tend to view their home as an expression of individuality rather than of material success and have values of functionality, practicality, and affordability. Their bragging points are sharing how much they saved rather than spent.

Similar to today's teens, Xers are turned off by advertising that either contains a lot of hype or takes itself too seriously. They see advertising as a form of entertainment but are turned off by overcommercialization. As the vice president of marketing for MTV put it, "You must let them know that you know who they are, that you understand their life experiences. You want them to feel you're talking directly to them."[41] Nike, for example, took a soft-sell approach to promoting its athletic shoes. Its ads show little of the product, focusing instead on encouraging readers to improve themselves through exercise. Other ads make fun of advertising: An ad created for Maybelline eye shadow depicts supermodel Christy Turlington coolly posing in a glamorous setting. She then suddenly appears on her living room couch, where she laughs and says, "Get over it."

But overall marketers have felt little urgency to speak to this generation; it's 40 percent smaller than the baby boom group, and it's not nearly as affluent. A group sandwiched between lucrative Gen Yers and lucrative baby boomers, Gen X has been somewhat ignored. Typically, they have been expected to inherit baby boomer–targeted stores, such as Banana Republic, Ann Taylor, Eddie Bauer, and J. Crew, but those stores don't always speak to them. Target and Starbucks appeal more to this group. Both market a sense of style—design at a price at Target and a lifestyle setting at Starbucks. Several new chains, however, recently have sprung from Gen Y stores to embrace Gen X. Martin & Osa (from American Eagle Outfitters) and Ruehl No 925 (from Abercrombie & Fitch), are targeting women ages 35 and older. The focus has shifted from fast fashion to high quality and from conformity to individuality.[42] Also this shopping-savvy group likes one-stop shopping, so we see Wal-Mart and Target and grocery stores adding apparel and giving these new stores a bit of competition.

BABY BOOMERS

The **baby boomers** age segment (people born between 1946 and 1964), over 78 million, is the source of many fundamental cultural and economic changes. The reason: power in numbers. As GIs returned home after World War II, they began to establish families and careers (aided by the GI Bill) at a record pace. Imagine a large python that has swallowed a mouse; the mouse moves down the length of the python, creating a moving bulge as it goes. So it is with baby boomers, as seen in Figure 6-3.

As teenagers in the 1960s and 1970s, the "Woodstock Generation" created a revolution in style, politics, and consumer attitudes. As they have aged, their collective will has been behind cultural events as diverse as the free speech movement and hippies in the 1960s to Reaganomics and yuppies in the 1980s. Now that they are older (some call them "zoomers" to reflect their increasingly active lifestyles) they continue to influence popular culture in important ways. President George W. Bush, born in 1946, turned 60 while in office, and many say he has set an excellent example for his peers, as he continues his two-hour mountain bike rides that exhaust secret service agents half his age.

Fashion, Appearance, and "Defying Age"

The CEO of Federated Department Stores pointed out that "designers and retailers need to do a better job of merchandising to people over 40."[43] Some older consumers feel that miniskirts and other inappropriate styles in nonjunior departments do not meet their needs very well. Many companies, however, are cashing in on the needs of aging boomers who are beginning to "bulge, sag, and squint their way into their 40s, 50s and 60s."[44] Lee Jeans is aiming at jeans wearers with youthful hearts and expanding behinds; Levi's

FIGURE 6-3
The Origins of the Baby Boomer Age Cohort

sells "relaxed fit." Many boomer women are looking for cool denim and willing to pay more than $100 for a good fit in jeans. Vitamina, Sergio Valente, and Red Engine are lines recently catering to this market focusing on fit and comfort through stretch denim, with many choices of premium Italian denim in a variety of washes.[45] Opticians report a rising market for blended, or lineless, bifocal glasses despite a considerably higher price tag than those with visible lines. The girdle market has been rejuvenated with products now called "thigh slimmers" or "body shapers." Even snack foods have entered the fray; for example, Nabisco has introduced the Mini Oreo, aimed at nostalgic but diet-conscious adults.

Despite the feminist movement's liberating influence on dropping age barriers in the area of personal appearance, the cosmetics industry continues to thrive on their appeal to middle-age women with slogans such as "Don't fight it, defy it" for products to cover gray hair or cover or remove wrinkles and age spots. However, instead of emphasizing the negative with "anti-aging" and "defying age" messages that many cosmetics companies use to target baby boomers, *More*, a magazine catering to the over-40 woman uses positive, upbeat, inspirational headlines and articles. *More*'s editor said she's bored with anti-aging and developed coverlines such as "Energy, Confidence, Attitude: The New Look of 40+" and "Great Style After 40." The world is still obsessed with youth, and *More* found a way to balance that with its target: Hire twenty-something media planners who shop with Mom, vacation with Mom, and can plan a magazine that relates to their cool mothers.[46] And major beauty companies are using beautiful boomer role models in their ads. Recently two have signed boomer celebrities to represent new products for this age-group, Diane Keaton for L'Oréal's Age Perfect Pro-Calcium skin care line and Susan Sarandon for Revlon's Age Defying product line.

Women in the twentieth century were socialized to value appearance throughout their lives.[47] In fact, research on older female consumers indicates that their interest in fashion does not necessarily decline with age.[48] Two-thirds of women in one study of older women exhibited a positive degree of fashion consciousness and indicated a desire to keep up with fashion. They are not especially price conscious nor do they tend to shop around; however, they do gather information from many sources.[49] These women are also less prone to social pressures and more willing to create a distinctive look that feels right to them and willing to pay more for better-quality apparel.[50]

Many designers and apparel companies feel that the maturing populace is not a big issue when it comes to marketing fashion to baby boomers. Many target this market by portraying their products as fitting a certain lifestyle or state of mind. This generation is much more active and physically fit than its predecessors; baby boomers are 6 percent more likely than the national average to be involved in some type of sporting activity.[51] Although 50 (indeed 40) used to be considered "over the hill," today it is regarded more as an age when boomers are at the peak of their professional and personal lives. We hear marketers say, "40 is the new 30," and some say "50 is the new 35." This new attitude is especially appealing to female consumers who have broken the stereotype that maturity means a woman is no longer attractive or desirable. Many fashion firms are marketing their products as part of such an aspirational goal, looking and feeling great regardless of age. The vice president of marketing at Liz Claiborne says: "It's really all about a brand, not an age. . . ."[52]

However, some apparel companies are directly marketing to this physically aging boomer rather than to the state of mind. Target developed two multifunctional brands, Linden Hill for women and Breakwater for men.[53] Chico's probably speaks to boomer women the best; they want fashion but don't have the perfect figure for it.[54] Also receiving a nod from marketing experts for catering well to boomers are Nordstrom, Eileen Fisher, Liz Claiborne, Ann Taylor, Talbots, Banana Republic, St. John Knits, Armani, Ralph Lauren, Burberry, and Coach.

Some 50+ women say "that's not me" to many fashion ads that use young models. Over 20 million of this generation are expected to possess an "age-accepting" mentality, which is anticipated to spur more realistic marketing images aimed at them. This would include gray hair and emphasis on life stages such as empty nesting, retirement, second careers, and widowhood. Boomer cohort icons such as Diane Keaton and Harrison Ford are surfacing as product spokespersons, and more multigenerational models in ads are seen including those for Eileen Fisher, Dolce & Gabbana, Nautica, and Gap.[55] Recent research has shown that overwhelmingly in-store displays are the most influential media for women 50 and older. So in addition to age-appropriate fashion ads, retailers should take special note of their in-store environments.[56]

Economic Power: He Who Pays the Piper Calls the Tune

Because of the size and buying power of the boomer group over the last twenty years, marketers focused most of their attention on this age cohort. This "mouse in the python" has moved into middle age, and this age-group is still the one that exerts the most impact on consumption patterns. Most of the growth in the market will be accounted for by people who are moving into their peak earning years. First-wave boomers are spending a total of $1 trillion in discretionary income annually.

Levi Strauss faced the challenge of the former jeans-wearing hippies getting older and losing interest in the traditional Levi product. They answered the challenge by creating a new product category, "new casuals," that would be more formal than jeans but less formal (more casual) than dress slacks and also a bit less constricting than those 501s. The target audience was men age 25–49 with higher-than-average education and income, who worked in white-collar jobs in major metropolitan areas. The workplace change from formal to casual also spurred sales. The Dockers line was born.[57] Although the Levi's image has suffered among younger consumers who prefer new names such as Diesel and 7 for all mankind, the company's role in providing clothes for casual work environments continues to thrive. Ellen Tracy also made a successful move in sync with the aging boomer, from the junior sportswear produced in the 1960s to being a major bridge (higher-end) line today.

Baby boomers are "feathering their nests"; they account for roughly 40 percent of all the money spent on household furnishings and equipment.[58] In addition, consumers age 45–54 spend the most of any age category on retirement programs (57 percent above average), apparel (38 percent above average), and food (30 percent above average). To appreciate the impact middle-aged consumers have and will have on our economy, consider this: At

current spending levels, a 1 percent increase in householders age 35–54 results in an additional $8.9 billion in consumer spending.

In addition to the direct demand for products and services created by this age-group, these consumers created a new baby boom of their own. Since fertility rates have dropped, this new boom is not as big as the one that created the baby boom generation; the new upsurge in the number of children born in comparison can best be described as a **baby boomlet**.

Many couples postponed getting married and having children because of the new emphasis on careers for women. They had babies in their thirties (and even their forties), resulting in fewer (but perhaps more-pampered) children per family. This new emphasis on children and the family created opportunities for clothing chains such as Baby Gap, GapKids, Limited Too, Gymboree, and Zutopia for kids age 6–12.[59]

Older baby boomers are now grandparents. They are a younger, more actively involved generation of grandparents and, collectively, they are showering $35 billion a year on their grandkids.[60]

THE GRAY MARKET

Apparel companies have largely neglected the elderly in their feverish pursuit of the youth market. But as our population ages and people are living longer and healthier lives, the game is rapidly changing. Many businesses are beginning to replace the old stereotype of the poor elderly recluse. The newer, more accurate image is of an elderly person who is active, is interested in appearance (generally to please themselves, not others[61]) and what life has to offer, and is an enthusiastic consumer with the means and willingness to buy many goods and services. The fashion industry, however, has not done as well in this area as other industries, such as recreation, in meeting the needs of this market. On the other hand, some companies such as Chic Jeans are attempting to cater to all ages, ethnic groups, and sizes as clearly illustrated in its ad campaign "Beautiful Idea."

ENTREPRENEURS GEAR UP FOR GRAYING OF AMERICA

There are expectations of venture capital companies that will be willing to fund products for the aging market with the huge baby boomer cohort entering the senior group soon. A contest for broad exposure of new ideas was held at a conference in Philadelphia with the following finalists:

- Green Diamond Traction Soles with industrial diamond granules injected into rubber soles to increase friction on slippery surfaces.

- A Template of Questions to help older relatives tell their life stories, the company calls assistance in "legacy creation."

- A service that helps seniors with packing and sorting, as well as emotional support, when seniors move from their family home into smaller quarters, such as assisted living.

- A stair-climbing hand truck that will carry heavy objects up and down stairs.

- PowerKnee, an orthopedic medical device, that augments the quadriceps' muscle strength to help people who have knee problems with such tasks as getting up from a chair and climbing stairs.

- A computer telephone system that reminds customers to refill prescriptions.

But if these products are to be geared to aging baby boomers, experts advise careful marketing as boomers will probably resist being branded as "seniors." Which do you think will be the most successful product?[64]

This Chic Jeans ad portrays all ages.

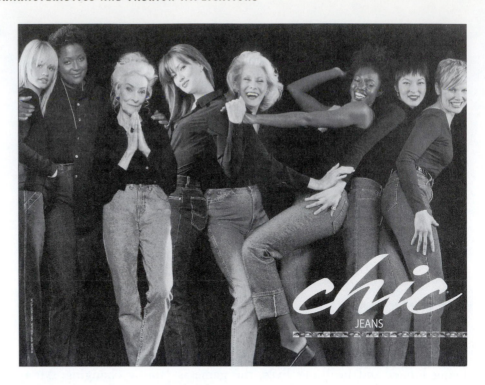

Gray Power: Seniors' Economic Clout

Think about this: By the year 2010, one of every seven Americans will be 65 or older. And by 2100 the number of Americans who are at least 100 years old will jump from 65,000 now to more than 5 million.[62] None of us may be around to see that, but we can already see the effects of the **gray market** today as seniors impact the marketplace. Older adults control more than 50 percent of discretionary income and worldwide consumers over 50 spend nearly $400 billion a year.[63] The mature market is the second fastest-growing market segment in the United States, lagging only behind the baby boomers. We can explain such dramatic growth by healthier lifestyles, improved medical diagnoses and treatment, and the resulting increase in life expectancy.

JEANS FOR ALL AGES

The idea behind the Chic Jeans ad is simple: We're all beautiful no matter what our size, age, color, or body shape! It's time to change the predominant view of female beauty in the mass media. The average real woman is not a young waif! More than 60 percent of American women are above a size 12.

The "I'm Beautiful" campaign, conceived by the Amodeo Petti agency, is a celebration of the real woman of today, in all sizes,

ages, and colors. The Chic Jeans ad is choreographed by Tony-award winner Ann Reinking. The dancers include stars from the Broadway hits *Fosse* and *Chicago* and real-life women such as 84-year-old Mimi Wedell and 18-year-old student Cameron Richardson. Move over ultrathin supermodels, the Reality . . . Chic is here!

Source: www.chicjeans.com.

Indeed, today's elderly are healthier, wealthier, and better educated than previous generations. In many cases they spend their money at an even greater rate than other age groups: Householders age 55–64 spend 15 percent more than average per capita. They spend 56 percent more than the average consumer on women's clothing, and as new grandparents they actually spend more than people age 25–44 on pets, toys, and playground equipment.[65] One study of grandmothers found that almost three-fourths preferred to select clothing items themselves rather than sending money to the child.[66] In fact, the average grandparent spends about $500 per year on gifts for grandchildren[67]—have you called your grandparents today?

Most elderly people lead more active, multidimensional lives than we assume. Nearly 60 percent engage in volunteer activities, one in four seniors age 65–72 still works, and more than 14 million are involved in daily care of a grandchild.[68] Still, outdated images of mature consumers persist. The editors of *AARP Magazine* reject about a third of the ads submitted to them because they portray older people in a negative light. In one survey, one-third of consumers over age 55 reported that they deliberately did *not* buy a product because of the way an elderly person was stereotyped in the product's advertising.[69]

It is crucial to remember that income alone does not capture the spending power of this group. Elderly consumers are finished with many of the financial obligations that siphon off the income of younger consumers. Eighty percent of consumers past age 65 own their own homes, and 80 percent of those homes are mortgage free. In addition, child-rearing costs are over. And, as evidenced by the popularity of the bumper sticker that proudly proclaims, "We're Spending Our Children's Inheritance," many seniors now are more inclined to spend money on themselves rather than skimping for the sake of children and grandchildren.

The Fashion Industry's Interest in Seniors (or Lack Thereof)

There is much potential in the fashion industry for the over-55 market, as these consumers spend more than $20 billion on apparel; however, an industry obsessed with youth is often unsure how to reach this customer. Many moderate and better retailers and apparel manufacturers have made efforts to offer trendy styles that are in keeping with the changes of aging bodies.[70] Some companies have increased their targeting of the graying customer using different strategies. Among the features added to clothing are elastic waists, adjustable waistline pants that look smooth in front, Velcro closures, easily accessible pockets, long-sleeved shirts, longer jackets, stretch fabrics, and comfortable styling. JCPenney's fashion catalog for women with arthritis, *Special Needs,* and McCall's *Perfect Fit* pattern series with fitting lines and detailed instructions on how to adjust patterns for a good fit are other examples of attempts to cater to the mature woman.

Despite older women's continued interest in fashion, there is much evidence that they have problems finding preferred clothes that fit. A Swedish study of 750 women age 65–80 indicated that about 50 percent of them did not fit into conventional sizes.[71] Several companies have begun using new ASTM (American Society for Testing and Materials) standard body measurements, which were developed from a study using sixty measurements per person from seven thousand women over age 55.[72] During the development

of this study, researchers found that two-thirds of their subjects were dissatisfied with the fit of ready-to-wear apparel.

One recent attempt at a new fit system that may be beneficial to older women is something called "Fit Logic."[73] With more than one-third of apparel returned by American women because it doesn't fit well, Cricket Lee, the developer of the system (www.fitlogic.net), feels Fit Logic will solve women's perennial fit problems. It is based on three body types: fullness at the waist, fullness primarily at mid-hip, and small waisted with fullness in the upper thighs. A decimal system denotes a size and body type (8.1 is size 8, body type 1). Jones New York was the first to use the system.

Even as apparel firms are considering the older figure when developing new lines, the problem is how to market them to this older group without being demeaning. Koret's "instafit" program featuring pants with a mechanism to increase or decrease the waistband size by three inches has been successful, but ads do not mention age when marketing the feature.

Apparel catalog shopping also has become very important for the gray set. As retail malls become larger and more confusing and congested, the elderly prefer the easier and safer method of acquiring clothing through mail order. One big drawback, that of returning unsatisfactory merchandise, is often not such a big issue with the elderly, who have more time for such activity. A study of almost one thousand AARP members found that elderly consumers considered their own experience as the most useful information source, and salespeople the least useful, for clothing selection. Perhaps this is another reason why store shopping does not hold an advantage over mail order for many in this sector.[74]

Design Criteria for Older Adults

In conjunction with the United Nations International Year of the Older Person, apparel design criteria were developed for the Active & Ageless consumer (a trademark developed by the Sporting Goods Manufacturers Association to promote healthy aging).[75] The four criteria are the following:

- *Fit:* Good fit means that a garment harmonizes with the body and that one can move without hindrances. Clothing must imperceptibly reconcile changes in the figure that occur over time and encourage comfort without looking age specific.

- *Fabrication:* The focus is on color, fiber, pattern, texture, and fabric "hand." Brighter colors enhance gray hair; lightweight, nonbulky, absorbent fabrics with "give" provide better comfort. Material components should provide a soft hand against the skin.

- *Styling:* Current, classic apparel enhances the older body, despite changes resulting from age. Styles should cover and camouflage key areas, while design details should facilitate mobility and ease of dressing and undressing. Adjustable and durable components should be included—for example, well-positioned pockets.

- *Care:* Easy-care garments and those requiring little or no ironing are preferred. Easy-to-locate, informative care labels with large, high-contrast text that is easy to read are recommended.

These criteria may be used to sanction apparel produced for active sportswear that meets the needs of the Active & Ageless market.

Perceived Age: You're Only as Old as You Feel

Market researchers who work with the elderly often comment that people think of themselves as being ten to fifteen years younger than they actually are. In fact, research confirms the popular wisdom that age is more a state of mind than of body. A person's mental outlook and activity level have a lot more to do with his or her longevity and quality of life than does *chronological age*, or the actual number of years lived.

A better yardstick to categorize the elderly is **perceived age**, or how old a person feels. One apparel study suggested that perceived age may be a more reliable prediction than chronological age of the importance of dress and other aspects of self-presentation.[76] Perceived age can be measured on several dimensions, including "feel-age" (how old a person feels) and "look-age" (how old a person looks).[77] The older consumers get, the younger they feel relative to actual age. For this reason, many marketers emphasize product benefits rather than age-appropriateness in marketing campaigns, since many consumers will not relate to products targeted to their chronological age.[78]

Understanding and Selling to Seniors

The elderly market is particularly well suited for segmentation because older consumers are easy to identify by age and stage in the family life cycle. Most receive Social Security benefits, so they can be located without much effort, and many belong to organizations such as the American Association of Retired Persons (www.aarp.org), which boasts more than 12 million dues-paying members. *AARP Magazine* (formerly known as *Modern Maturity*) segments its customers by age by printing three outwardly similar but distinct editions. They are tailored to readers in their fifties, readers in their sixties, and those 70 years old or older.[79]

Several segmentation approaches begin with the premise that a major determinant of elderly marketplace behavior is the way a person deals with being old.[80] **Social aging theories** try to understand how society assigns people to different roles across the life span. For example, when people retire they may reflect society's expectations for someone at this life stage—this is a major transition point when people exit from many relationships.[81] Some people become depressed, withdrawn, and apathetic as they age; some are angry and resist the thought of aging whereas others accept the new challenges and opportunities this period of life has to offer.

Researchers have identified a set of key values relevant to mature consumers. For marketing strategies to succeed, they should be related to one or more of these factors:[82]

- *Autonomy:* Mature consumers want to lead active lives and be self-sufficient.
- *Connectedness:* Mature consumers value the bonds they have with friends and family.
- *Altruism:* Mature consumers want to give something back to the world.

In general, the elderly have been shown to respond positively to ads that provide an abundance of information. Unlike other age-groups, these consumers usually are not amused, or persuaded, by imagery-oriented advertising.

A more successful strategy involves the construction of advertising that depicts the aged as well-integrated, contributing members of society, with emphasis on them expanding their horizons rather than clinging precariously to life. This is a market virtually untapped by mainstream apparel retailers.

RACE AND ETHNIC SUBCULTURES

An **ethnic or racial subculture** consists of a group of consumers who are held together by common cultural and/or genetic ties and is identified both by its members and by others as being a distinguishable category.[83] Ethnic and racial identites are significant components of a consumer's self-concept.

In some countries, such as Japan, ethnicity is almost synonymous with the dominant culture, since most citizens claim the same homogeneous cultural ties (although Japan has sizable minority populations, most notably people of Korean ancestry). In a heterogeneous society such as the United States, many different cultures are represented, and consumers may expend great effort to keep their subcultural identification from being submerged into the mainstream of the dominant society. Despite identification with subcultures, which we will explore in this section, a recent Maritz Marketing Research report indicates that 83 percent of U.S. residents identify their culture and traditions as uniquely "American." Ninety percent of those of European heritage embrace American ways, but also the majority of those of Latin American descent, African American descent, and Middle Eastern descent feel their traditions are quintessentially American. Those of Asian ancestry are less likely to assimilate.[84]

Why It Pays to Target Ethnic Groups

Marketers cannot ignore the stunning diversity of cultures reshaping mainstream society. Immigrants now make up 10 percent of the U.S. population and will account for 13 percent by 2050.[85] Ethnic minorities spend more than $600 billion a year on products and services, so firms must devise products and communications strategies tailored to the needs of these subcultures. Almost half of all *Fortune* 1000 companies have an ethnic marketing program up and running; however, the fashion industry has not kept pace.

Ethnicity and Marketing Strategies

Although some people may feel uncomfortable at the notion that people's racial and ethnic differences should be explicitly taken into account when formulating marketing strategies, the reality is that these subcultural memberships frequently are paramount in shaping people's needs and wants. Membership in these groups often is predictive of such consumer variables as the wearing of distinctive apparel, food preferences, political behavior, leisure activities, level and type of media exposure, and even willingness to try new products.

Furthermore, research indicates that members of minority groups are more likely to find an advertising spokesperson from their own group to be more trustworthy, which in turn translates into more positive brand attitudes.[86] In addition, the way marketing messages should be structured depends on subcultural differences in how meanings are communicated.

Sociologists make a distinction between *high-context cultures* and *low-context cultures*. In a high-context culture, group members tend to be tightly knit, and they are likely to infer meanings that go beyond the spoken word. Symbols and gestures, rather than words, carry much of the weight of the message. In contrast, people in a **low-context culture** are more literal. Compared to Anglos, many minority cultures are high context and have strong oral traditions, so perceivers will be more sensitive to nuances in advertisements that go beyond the message copy.[87]

Is Ethnicity a Moving Target?

Although ethnic marketing is in vogue with many firms, the process of actually defining and targeting members of a distinct ethnic group is not always so easy in our society. In the 2000 U.S. Census, some 7 million people identified with two or more races, refusing to describe themselves as only White, Black, Asian, Korean, Samoan, or one of the other categories listed.[88] The popularity of golfer Tiger Woods illuminates the complexity of ethnic identity in the United States. Although Woods has been lauded as an African American role model, in reality he is a model of multiracialism. His mother is Thai and he also has Caucasian and Indian ancestry. Other popular cultural figures also are multiracial, including actor Keanu Reeves (Hawaiian, Chinese, Caucasian), singer Mariah Carey (black, Venezuelan, white), and Dean Cain of *Superman* fame (Japanese, Caucasian).[89] Other celebrities "try on" different subcultural identities; Beyoncé Knowles, an African American, sometimes has blond hair; Jennifer Lopez, who is Puerto Rican, takes on the identity of a Latina-Asian princess in Louis Vuitton ads; and Christina Aguilera, who is half Ecuadorean, posed as an Indian goddess on the cover of *Allure*. This trend toward the blurring of ethnic and racial boundaries will only increase over time.

Products that are marketed with an ethnic appeal are not necessarily intended for consumption only by the ethnic subculture from which they originate. **De-ethnicitization** refers to the process where a product formerly associated with a specific ethnic group is detached from its roots and made available to other subcultures. Hairstyles and food products, two components of ethnic heritages, can be used to illustrate this phenomenon. The African American hairstyle called the "Afro" was the natural look proudly worn by black people in the 1960s and into the 1970s. Both the Afro and "cornrows" became fashionable looks for white Americans, albeit not natural for many. As we have said, fashion extends beyond clothing, and similar phenomena occur in other industries such as food. Bagels, formerly associated with the Jewish culture, are now mass-marketed with such variations as jalapeño bagels, blueberry bagels, and even a green bagel for St. Patrick's Day.[90] Another example is salsa, which is now the most popular condiment in the United States, outselling ketchup in one year by $40 million.[91]

Acculturation

One important way to distinguish among members of a subculture is to consider the extent to which they retain a sense of identification with their country of origin. **Acculturation** refers to the process of movement and adaptation to one country's cultural environment by a person from another country.[93]

MULTICULTURAL DIMENSIONS

The mass merchandising of ethnic products is widespread and growing. Aztec Indian designs appear on sweaters; gym shoes are sold trimmed in *kente* cloth from an African tribe; greeting cards bear likenesses of Native American sand paintings. However, many people are concerned about the borrowing—and in some cases, misinterpretation—of distinctive symbolism. Consider, for example, a recent storm of protest from the international Islamic community over what started as a simple dress design for the House of Chanel. In a fashion show, supermodel Claudia Schiffer wore a strapless evening gown designed by Karl Lagerfeld. The dress included Arabic letters that the designer

believed spelled out a love poem. Instead, the message was a verse from the Qur'an, the Muslim holy book. To add insult to injury, the word *God* happened to appear over the model's right breast. Both the designer and the model received death threats, and the controversy subsided only after the three versions of the dress that had been made (and priced at almost $23,000) were burned.[92] Some industry experts feel that it's acceptable to appropriate symbols from another culture even if the buyer does not know their original meaning. They argue that even in the host society there often is disagreement about these meanings. What do you think?

To understand this factor, let's apply it to the Hispanic market, since the degree to which these consumers are integrated into the American way of life varies widely. For instance, about 38 percent of all Hispanics live in *barrios*, or predominantly Hispanic neighborhoods, which tend to be somewhat insulated from mainstream society.[94] Table 6-2 describes one attempt to segment Hispanic consumers in terms of degree of acculturation.

The acculturation of Hispanic consumers may be understood in terms of the **progressive learning model**. This perspective assumes that people gradually learn a new culture as they increasingly come in contact with it. Thus, we would expect the consumer behavior of Hispanic Americans to be a mixture of practices taken from their original culture and those of the new or *host culture*.[95]

Research generally supports this pattern when factors such as shopping orientation, the importance placed on various product attributes, media preference, and brand loyalty are examined.[96] In one study, when the intensity of

Table 6-2 Segmenting the Hispanic American Subculture by Degree of Acculturation

Segment	Size	Status	Description	Characteristics
Established adapters	17%	Upwardly mobile	Older, U.S. born; assimilated into U.S. culture	Relatively low identification with Hispanic culture
Young strivers	16%	Increasingly important	Younger, born in U.S.; highly motivated to succeed; adaptable to U.S. culture	Movement to reconnect with Hispanic roots
Hopeful loyalists	40%	Largest but shrinking	Working class; attached to traditional values	Slow to adapt to U.S. culture; Spanish is dominant language
Recent seekers	27%	Growing	Newest; very conservative with high aspirations	Strongest identification with Hispanics background; little use of non-Hispanic media

Source: Adapted from a report by Yankelovich Clancy Shulman, described in "A Subculture with Very Different Needs," *Adweek* (May 11, 1992): 44. By permission of BPI Communications.

ethnic identification was taken into account, Hispanic consumers who retained a strong ethnic identification differed from their more assimilated counterparts in the following ways:[97]

- They had a more negative attitude toward business in general (probably caused by frustration due to relatively low income levels).
- They were higher users of Spanish-language media.
- They were more brand loyal.
- They were more likely to prefer brands with prestige labels.
- They were more likely to buy brands specifically advertised to their ethnic group.

The nature of the transition process is affected by many factors. Individual differences, such as whether the person speaks English, influence how rocky the adjustment will be. The person's contact with **acculturation agents**—people and institutions that teach the ways of a culture—also are crucial. Some of these agents are aligned with the *culture of origin* (in this case, Mexico). These include family, friends, the church, local businesses, and Spanish-language media that keep the consumer in touch with his or her country of origin. Other agents are associated with the *culture of immigration* (in this case, America), and help the consumer to learn how to navigate in the new environment. These include public schools and English-language media and government agencies.

As immigrants adapt to their new surroundings, several processes come into play. *Movement* refers to the factors motivating people to physically uproot themselves from one location and go to another. In this case, people leave Mexico due to the scarcity of jobs and the desire to provide a good education for their children. Upon arrival, immigrants encounter a need for *translation*. This means attempting to master a set of rules for operating in the new environment, whether learning how to decipher a different currency or figuring out the social meanings of unfamiliar clothing styles. This cultural learning leads to a process of *adaptation*, where new consumption patterns are formed. For example, some of the Mexican women interviewed had started to wear shorts and pants since settling in the United States, although this practice is frowned on in Mexico.

During the acculturation process many immigrants undergo *assimilation*, in which they adopt products that are identified with the mainstream culture. At the same time, there is an attempt at *maintenance* of practices associated with the culture of origin. Immigrants stay in touch with people in their country, and many continue to eat cultural foods and read Spanish newspapers. Their continued identification with Mexican culture may cause *resistance* as they resent the pressure to submerge their Mexican identities and take on new roles. Finally, some immigrants (voluntarily or not) tend to exhibit *segregation;* they are likely to live and shop in places that are physically separated from mainstream Anglo consumers.

These processes illustrate that ethnicity is a fluid concept, and the boundaries of a subculture are constantly being recreated. An *ethnic pluralism* perspective argues that ethnic groups differ from the mainstream in varying degrees, and that adaptation to the larger society occurs selectively. Research evidence refutes the idea that assimilation necessarily involves

losing identification with the person's original ethnic group. One study found, for example, that many French Canadians show a high level of acculturation, yet they still retain a strong ethnic affiliation. The best indicator of ethnic assimilation, these researchers argue, is the extent to which members of an ethnic group have social interactions with members of other groups in comparison to their own.[98]

Ethnic Groups

The dominant American culture always has exerted pressure on immigrants to divest themselves of their origins and become rapidly absorbed into the host culture. While the bulk of American immigrants historically came from Europe, immigration patterns shifted dramatically in the latter part of the twentieth century. New immigrants are much more likely to be Asian or Hispanic. As these new waves of immigrants settle in the United States, marketers are attempting to track their consumption patterns and adjust their strategies accordingly. These new arrivals, whether Chinese, Arab, Russian, or people of Caribbean descent, are best marketed to in their native languages. They historically have tended to cluster together geographically, which makes them easy to reach. The local community is the primary source for information and advice, so word of mouth is especially important (see Chapter 12).

The U.S. Census Bureau estimates that the population of the United States will grow from 282 million in 2000 to about 335 million in 2020. Much of this growth will be accounted for by members of ethnic groups, and a substantial portion will be due to the immigration of people from other countries as opposed to citizens who are born in the United States. The non-Hispanic white population will decrease from 69.4 to 61.3 percent in 2020.[99]

African Americans, Hispanic Americans, and Asian Americans, the "Big Three" American subcultures, account for much of America's current growth. The 2000 U.S. Census showed that the Hispanic population will become the largest ethnic subculture, with an estimate increase from 12.6 percent in 2000 to 24.4 percent in 2050. The African American population will increase from 12.7 percent to 14.6 percent. Asian Americans, though much smaller in absolute numbers with only 3.8 percent of the population, are the fastest-growing racial group and is estimated to become 8 percent of the population by 2050.[100] This growth is largely due to immigration; each year more Asians arrive in the United States as immigrants than are born in the country.

AFRICAN AMERICANS

African Americans constitute a significant racial subculture and account for almost 13 percent of the U.S. population. Although black consumers do differ in important ways from whites, the black market is hardly as homogeneous as many marketers seem to believe. Historically, blacks were separated from mainstream society. More recently, though, increasing economic success and the many cultural contributions of this group that have been absorbed by mainstream white culture have in some instances blurred the lines between American blacks and whites.

Indeed, some commentators have argued that black/white differences are largely illusory. Different consumption behaviors are more likely due to differences in income, the relatively high concentration of African Americans in urban areas, and other dimensions of social class than by racial differences. With some exceptions, the overall spending patterns of blacks and whites are roughly similar.[101]

Fashion/Clothing/Retailing Implications

Despite similarities of blacks and whites, there clearly are some differences in consumption priorities and marketplace behaviors that demand marketers' attention.[102] Sometimes differences are subtle but still can be important. African Americans constitute 30 percent of the market for hair-care products. African American women spend three times as much on their hair as Caucasian women do, and they spend on average three times more than the general market on all beauty products.[103] Major companies have realized the importance of this market. Companies such as Clairol, L'Oréal, and Alberto-Culver are buying or expanding their ethnic lines.[104] For example, L'Oréal acquired Carson Inc., billed as the world's largest manufacturer of ethnic hair and skin care products.[105] Procter & Gamble's new multicultural campaign called "My Black Is Beautiful" has the goal of making black girls and women feel beautiful and forging a closer relationship with P&G brands in the process.[106]

One study found differences between black and white consumers on four aspects of apparel purchasing: preplanning, store preferences, store patronage, and clothing selection. White women more than black women bought clothing at the beginning of each season, more blacks practiced impulse buying, and availability of accessories was more important to black women. The type of store most frequented and the importance of salespeoples' attitudes also differed. Thus, there appear to be subtle differences that merchandisers and marketers should heed.[105]

More apparel companies are designing specifically for an ethnic target. Actress-singer Diahann Carroll has her name on lines of apparel and accessories that are aimed at the African American and Hispanic communities—affordable and lots of color.[106] Lines such as Baby Phat, Rocawear, and Enyce

ETHNIC DOLLS

The proliferation of ethnic dolls in America's toy stores reflects society's growing cultural diversity. While non-Caucasian dolls used to appear only in collections of dolls from around the world, all major manufacturers have now introduced ethnic dolls to the mass market. African Americans spend well over $700 million a year on toys and games, so toy marketers are sitting up and taking notice. The American Girl Collection introduced Addy Walker, the first non-white doll in the series. Addy comes packaged with a set of books that describes her daily life and her (fictional) history as a slave: Details were provided by an advisory board of experts who ensured that Addy's experiences were told from a black perspective.

Other new entrants include Kira, the Asian fashion doll (however, the Asian American community has criticized the toy industry for having so few Asian faces on doll store shelves[111]), and Emmy, the African American baby doll. Mattel introduced a trio of dolls named Shani (which means "marvelous" in Swahili), Asha, and Nichelle that represent the range of African American facial features and skin tones (Shani also has a boyfriend named Jamal). And, while Mattel has sold a black version of Barbie for more than twenty years, it only recently began to promote the doll in television and print campaigns.[112]

are attuned to the young black woman. And the so-called urban brands of Fubu and Sean John got the attention of a few big retailers such as Macy's. But many African American middle-class women complain that the fashion industry is ignoring them despite the fact that they are generally more fashion oriented and spend more money on apparel than other Americans.[107] Mainstream designers do not consider the African American women's fit needs; they generally have larger waists and hips.[108] Designers also do not meet African American women's needs for a wider selection of sizes and styles, especially a dressier, more put-together look. Apparel has lagged behind the cosmetics, automobile, and entertainment industries that have successfully catered to this population.

African Americans and the Media

Historically, African Americans have not been well represented in mainstream advertising, but this situation is changing. Blacks now account for about one-quarter of the people depicted in ads (a rate greater than their actual proportion of the overall population), and commercials are increasingly likely to be racially integrated.[109] The more striking and important change, though, is the way African American people are portrayed on television. Unlike earlier shows that presented blacks in stereotyped roles, most television roles created for African Americans now tend to depict them as middle- to upper-class individuals who also happen to be black.

Several major magazines, such as *Jet, Ebony, Essence,* and *Black Enterprise*, target this segment exclusively and with great success. *Jet*, for example, claims to reach over 90 percent of the black male audience.

The use of African American celebrities and sports figures is also on the rise. The proliferation of black role models appears to be reducing the racial distinctions formerly made by many. For example, Queen Latifah was a spokesperson for VF Intimates Curvation line for full-figured women. But some are concerned about a caricature portrayed in the media, playing on a stereotype of heavy, black women as strong, aggressive, and controlling, which appeared recently in ads for Universal Studies and Dairy Cream.[110] Since no black writers were involved with these campaigns, there continues to be a concern about the lack of diversity in the advertising industry.

HISPANIC AMERICANS

The Hispanic subculture is a sleeping giant, a segment that was until recently largely ignored by many marketers. The growth and increasing affluence of this group have now made it impossible to overlook, and the Hispanic consumer is now diligently courted by many major corporations. Nike made history in 1993 by running the first Spanish-language commercial ever broadcast in prime time on a major American network. The spot, which ran during the baseball All-Star Game, featured boys in tattered clothes playing ball in the Dominican Republic, or *La Tierra de Mediocampistas* ("The Land of Shortstops"). This title refers to the fact that more than seventy Dominicans have played for major league ball clubs,

many of whom started at the shortstop position. This groundbreaking spot also laid bare some of the issues involved in marketing to Hispanics: Many found the commercial condescending (especially the ragged look of the actors) and felt that it promoted the idea that Hispanics don't really want to assimilate into mainstream Anglo culture.[113] If nothing else, though, this commercial by a large corporation highlights the indisputable fact that the Hispanic American market is now being taken seriously by major marketers.

Whereas concentrations and wealth of this population used to be in Miami and Texas, recent data show the following cities with the largest Hispanic populations are Los Angeles, New York, San Antonio, San Diego, and Houston. Hispanics are also moving to places like South Dakota and Indiana with affluence sure to follow.[114]

The Allure of the Hispanic Market

Demographically, two important characteristics of the Hispanic market are worth noting: First, it is a young market; median age is 24, compared to 34 overall in the United States. Many of these consumers are "young biculturals" who bounce back and forth between hip-hop and Rock en Español, blend Mexican rice with spaghetti sauce, and spread peanut butter and jelly on tortillas.[115] Latino youth are changing mainstream culture. By 2020, the U.S. Census Bureau estimates that the number of Hispanic teens will grow by 62 percent compared with 10 percent growth in teens overall. They are looking for spirituality, stronger family ties, and more color in their lives—three hallmarks of Latino culture. Music crossovers are leading the trend, including Carlos Santana, Shakira, Christina Aguilera, Marc Anthony, Enrique Iglesias, and Ricky Martin, in addition to television and movie celebrities such as Jennifer Lopez, Eva Longoria (of *Desperate Housewives*) and America Ferrera of *Ugly Betty*). In fashion, they are popularizing guayabera shirts that were once popular with old Cuban men and baseball shirts with the number 77—the former area code for Puerto Rico.[116]

Second is the sheer size of the population. There are more than 39 million Hispanic consumers in the United States. Also Hispanic families are much larger than those of the rest of the population. The average Hispanic household contains 3.5 people, compared to only 2.7 people for other U.S. households. These differences obviously affect the overall allocation of income to various product categories, such as food and clothing. A number of factors make this market segment extremely attractive:

Music crossovers like Shakira are giving mainstream music an Hispanic flavor.

- Hispanics tend to be brand loyal, especially to brands from their country of origin. In one study, about 45 percent reported that they always buy their usual brand, while only one in five said they frequently switch brands.[117] Another found that strongly identified Hispanics are more likely to seek Hispanic vendors, to be loyal to brands used by family and friends, and to be influenced by Hispanic media.[118]

- Hispanics are geographically highly concentrated in urban areas, which makes them relatively easy to reach. Hispanics make up 60 percent of Miami, 40 percent of Los Angeles, and 30 percent of New York.[119]

- Education and income levels are increasing dramatically.

Hispanic Women Trendsetters

Hispanic women have a strong interest in being fashionable. They spend more time shopping than other women, spend more money on clothes, and are more fastidious with their appearance. In a Cotton Incorporated study, Hispanic women said they preferred clothing that looked better on them over clothing that was comfortable, for an evening of dinner and dancing.[120] And more consider wearing designer clothes a "sign of success" than other Americans.[121] The fashion industry should be very interested in this market.

Fashion Companies Appealing to Hispanic Subcultures

As with other large subcultural groups, marketers have discovered that the Hispanic market is not homogeneous. *AOL Latino* segments this population by acculturation levels rather than by country of origin, finding that the Hispanic online audience is bicultural in nature.[122] They consume content in both languages (sliding seamlessly between the two) with most preferring online content in English, but nearly 40 percent also find Spanish-language content appealing, and only 15 percent prefer Spanish only. And a recent study by the Association of Hispanic Advertising Agencies found that younger, not just older, Hispanics are using Spanish-dominant media.[123] But with many companies wanting to court this lucrative market, some have found that just using the Spanish language and Hispanic models is not enough. Nuances of culture are important to understand and communicate. Lingerie companies are finding that being true to the brand is more important than trying to superficially appeal to ethnic stereotypes, which might alienate consumers.[124]

Nordstrom is about the only high-end advertiser to this market (definitely a missing category), with most attention given by Kmart, Kohl's, Sears, and JCPenney. Kmart and Kohl's have collaborated on clothing lines with Latina superstars Thalia Sodi and Daisy Fuentes, respectively. Sears has launched its 100 Multi-Cultural Aspirational Concepts (MAC) stores and Lucy Pereda line of dressy women's clothing bearing the name of the Cuban-born TV personality. On the other hand, the powerhouse J.Lo by Jennifer Lopez, is extremely popular with teen departments in many stores.[125]

The Role of the Family

The importance of the family to Hispanics cannot be overstated. A collectivist culture favors cooperation and values family needs over those of the individual. Marketers need to understand the family as a unit, including group decision making, and avoid conflict between individual and family needs. Religion and spirituality affect how this subculture sees the world, imparting both a sense of fatalism and a love of rituals and celebrations.[126] Behaviors that underscore one's ability to provide well for the family are reinforced. Clothing one's children well is regarded in particular as a matter of pride. In contrast, convenience and a product's ability to save time are not terribly important to the Hispanic homemaker, who is willing to purchase labor-intensive products if it means that her family will benefit.

Preferences to spend time with family influence the structure of many consumption activities. As one illustration, the design of Mervyns stores

included large aisles to accommodate baby strollers that larger Hispanic families have when they shop together as a family. Another example is the act of going to the movies—which has a different meaning for many Hispanics, who tend to regard this activity as a family outing. One study found that 42 percent of Hispanic moviegoers attend in groups of three or more, as compared with only 28 percent of Anglo consumers.[127]

Hispanic women have taken traditional roles within the family, with distinctive roles for men and women. Machismo is about protecting and providing for the family. Women's appearance and dress generally are highly feminine, making them a strong market for cosmetics and clothing.

ASIAN AMERICANS

Asian Americans are generally the most affluent with the fastest-growing purchasing power, best educated, and most likely to hold technology jobs of any ethnic subculture in the United States. They save more of their wages and borrow less than other Americans. On the other hand, as one Asian American advertising executive noted, "Prosperous Asians tend to be very status-conscious and will spend their money on designer clothing and premium brands, such as BMW and Mercedes-Benz."[128] This group also is a good market for technically oriented products. They spend more than the average on such products as personal computers, digital camcorders, and MP3 players.[129] According to Silicon Valley firms (in California), they are the most wired ethnic group in the United States and they spend considerably more money online than other Americans.[130] There is great potential for the companies that can harness this interest. The American advertising industry is spending between $200 million and $300 million to court these consumers.[131]

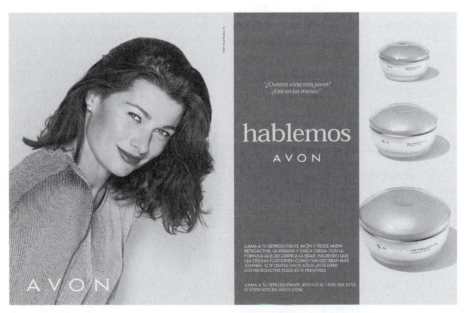

Avon targets the Hispanic American consumer.

—————————— **FENG SHUI** ——————————

Real estate marketers who do business in areas with a high concentration of Asian American buyers are learning to adapt to some unique cultural traditions. Asians are very sensitive to the design and location of a home, especially as these aspects affect the home's *chi*, an energy current that is believed to bring good or bad luck. Asian home buyers are concerned about whether a prospective house offers a good *feng shui* environment (translated literally as "the wind and the water"). One home developer in San Francisco sold up to 80 percent of its homes to Asian customers after making a few minor design changes, such as reducing the number of T intersections in the houses and adding rounded rocks to the yards—harmful *chi* travels in a straight line, while gentle *chi* travels on a curved path. It is not unusual for specialists to inspect a home or office to ensure that the *chi* is right before a purchase is transacted.[143]

Reaching the Asian American Consumer

Despite its potential, this group is hard to market to, because it is composed of subgroups that are culturally diverse and speak many different languages and dialects. The term *Asian* refers to twenty ethnic groups, with Chinese being the largest and Filipino and Japanese second and third, respectively. Asian Americans still constitute only a small proportion of the U.S. population, so mass-marketing techniques are often not viable to reach them. The problems encountered by American marketers when they first tried to reach the Hispanic market also occurred when targeting Asians and Asian Americans. Some attempts to translate advertising messages and concepts into Asian media backfired. One company attempting to wish the Chinese community a Happy New Year ran an ad with the characters upside down. Other advertisements have overlooked the differences among Asian subcultures, and some have unknowingly been insensitive to cultural practices. In one case, a footwear ad depicted Japanese women performing foot binding, a previous practice done exclusively in China.[132]

Many marketers are discouraged by the lack of media available to reach Asian Americans. Practitioners generally find that advertising in English works best for broadcast ads, whereas print ads are more effective when executed in Asian languages. Filipinos are the only Asians who predominantly speak English among themselves; most other groups prefer media in their own languages. The most frequently spoken languages among Asian Americans are Mandarin Chinese, Korean, Japanese, and Vietnamese.

Fashion/Clothing/Retailing Implications

Cotton Incorporated's *Lifestyle Monitor* reports that more Asian American women love to shop compared to all other American women.[133] They are more willing to pay full price for apparel than other groups. They could be good customers for a company to target; however, this group does not show brand loyalty—especially to Asian brands! They also tend to be fairly conservative. Popular Japanese fashion has made its way to the United States, often through Japanese American young people. In addition the popular fast-fashion Japanese store, Uniqlo, has opened its first U.S. store in Soho (New York City) bringing Japanese casual looks to the United States.

Mass-merchandised Pokémon originated in Japan.

There has been some interesting fashion and clothing research within this subculture. Some differences have been found in color preferences between Anglos and Asian Americans.[134] Color was also found to be more important to a Japanese than to an American sample. The Japanese group also indicated that they defined fashion partially by brands, where the U.S. sample did not.[135] This may be related to the fact that mass fashion in the United States is not always branded but is found at many price levels and often in private labels. Another study found that ethnic-specific clothing was worn on special holidays, and participants with a higher level of ethnic identity reported wearing and identifying with items of ethnic dress. Among Japanese American students there was a relationship between ethnic identity and the use of ethnic market sources. Similar results were not found among Chinese American students, perhaps because of the prominence of Japanese designers such as Issey Miyake and Rei Kawakubo and the lack of corresponding high-profile Chinese designers.[136] Another study found that family members and the media had stronger effects on the clothing purchase decisions of Asian Americans than of Caucasian Americans. Asian Americans also considered the quality of garments more than other groups.[137]

Fashion retailers and manufacturers are recognizing these differences and the importance of this market. Sears targeted the Asian American market by hiring an advertising agency to develop messages targeted to this segment. Sears has held one-day sales in stores in Asian communities during holidays such as the moon festival, offering discounts with ads in Asian-language newspapers.[138] JCPenney also recognized the Asian American population by handing out dragon posters in the baby apparel department during the year of the golden dragon because many Asians had planned births during that year.[139] JCPenney is seen as one of the few apparel companies that vigorously address both petite-fit needs and the Asian population. Wonderbra, also aware of the petite Asian figure, launched a special line sized for a slimmer Asian body (49 percent of Asian American women wear pants size 0–6, compared with 19 percent of the rest of the population).[140]

Many Asian American consumers become frustrated with the cosmetics industry that doesn't meet their needs by not offering products suited to yellow undertones in their skin and small eyelids. Consequently, alternative niche brands are being developed and are reshaping the industry. One example is a small company called *Thi* (Vietnamese for "lady") started by Taylor Pham, a young San Franciscan. She sells custom lashes, the perfect red lipstick, the right foundation, and the shape of brushes that all flatter and fit the needs of these customers. She created these cosmetics because she couldn't find what she needed in the marketplace.[141]

Fashion advertising generally has not targeted this market. Ads that do feature Asian celebrities have been particularly effective. When Reebok used tennis star Michael Chang in one execution, shoe sales among Asian Americans soared. The few fashion players known for using Asian models in advertising include Ellen Tracy, Kenneth Cole, Prada, J. Jill, and JCPenney. Sears and Kmart have made efforts in specialized trade areas.[142] Perhaps other companies should take note of this lucrative market.

CHAPTER SUMMARY

- Consumers identify with many groups that share common characteristics and identities such as age and ethnic groups. These large groups that exist within a society are subcultures, and membership in them often gives marketers a valuable clue about individuals' consumption decisions. Clothing is an important part of the identity of these subcultures.

- People have many things in common with others merely because they are about the same age or live in the same part of the country. Consumers who grew up at the same time share many cultural memories, so they may respond to marketers' nostalgia appeals that remind them of these experiences.

- Four important age cohorts are teens, college students, baby boomers, and the elderly. Teenagers are making a transition from childhood to adulthood, and their self-concepts tend to be unstable. They are receptive to products, especially fashion, that help them to be accepted and enable them to assert their independence. Because many teens earn money but have few financial obligations, they are a particularly important segment for many nonessential or expressive products, ranging from chewing gum to clothing fashions and music. College students are an important but hard-to-reach market. In many cases, they are living alone for the first time, so they are making important decisions about setting up a household.

- Baby boomers are the most powerful age segment because of their size and economic clout. As this group ages, its interests have changed—and marketing priorities have changed as well. The needs and desires of baby boomers affect demands for housing, child care, automobiles, clothing, and many other products.

- As the population ages, the needs of middle-aged and elderly consumers will become increasingly influential. Many marketers traditionally ignored the elderly because of the stereotype that they are too inactive and spend too little. This stereotype is no longer accurate. Women over 55 spend a considerable amount of money on clothing, but have mostly been dissatisfied with offerings. Some apparel companies are trying to design and market fashions for this age group, but are not sure how to do that. Most of the elderly are healthy, vigorous, and interested in new products and experiences—and they have the income to purchase them. Marketing appeals to this age subculture should focus on consumers' self-concepts and perceived ages, which tend to be more youthful than their chronological ages. Marketers also should emphasize concrete benefits of products, since this group tends to be skeptical of vague, image-related promotions. Personalized service is of particular importance to this segment.

- A large component of a person's identity is often determined by his or her ethnic origins and racial identity. The three largest ethnic/racial subcultures are African Americans, Hispanic Americans, and Asian Americans, but consumers with many diverse backgrounds are beginning to be considered by marketers as well. Indeed, the growing numbers of people who claim multiethnic backgrounds is beginning to blur the traditional distinctions drawn among these subcultures.

- Recently, several minority groups have caught the attention of marketers as their economic power has grown. Segmenting consumers by their ethnicity can be effective, but care must be taken not to rely on inaccurate (and sometimes offensive) ethnic stereotypes.

- African Americans are a very important market segment. Although in some respects the market expenditures of these consumers do not differ that much from whites, blacks are above-average consumers in such categories as personal-care products.

- Hispanic Americans and Asian Americans are other ethnic subcultures that are beginning to be actively courted by marketers. The size of both groups is increasing rapidly and in the coming years will dominate some major markets. Asian Americans on the whole are extremely well educated, and the socioeconomic status of Hispanics is increasing as well.

- Key issues for reaching the Hispanic market are consumers' degree of acculturation into mainstream American society.

- Both Asian Americans and Hispanic Americans tend to be extremely family oriented and are receptive to advertising that understands their heritage and reinforces traditional family values.

KEY TERMS

subcultures	Generation X	ethnic or racial subculture
age cohort	baby boomers	de-ethnicitization
multigenerational	baby boomlet	acculturation
marketing strategy	gray market	progressive learning
Generation Y	perceived age	model
tweens	social aging theories	acculturation agents

DISCUSSION QUESTIONS

1. What are some of your favorite fashion ads on TV or in magazines? Why do you like them? Are there any that you don't like or that offend you? Which ones and why?

2. What fashions do you see today that are appropriate for women older than college-aged students? Are fashions too youth oriented? Or are they suitable for anyone? If you were starting a new fashion company, what market would you target? Why? Describe the merchandise you would sell.

3. What are some of the positives and negatives of targeting college students? Identify some specific marketing strategies that you feel have been either successful or unsuccessful at appealing to this segment. What characteristics distinguish the successes from the failures?

4. Why have baby boomers had such an important impact on consumer culture in the second half of the twentieth century? How has this affected fashion over the last fifty years?

5. How has the baby boomlet changed attitudes toward child-rearing practices and created demand for different products and services?

6. "Kids these days seem content to just hang out, surf the Net, and watch mindless TV shows all day." How accurate is this statement?

7. What are some important variables to keep in mind when tailoring marketing strategies to the elderly? How do these affect clothing they purchase?

8. Find good and bad examples of advertising targeted to elderly consumers. To what degree does advertising stereotype the elderly? What elements of ads or other promotions appear to determine their effectiveness in reaching and persuading this group?

9. Can you locate any current examples of marketing stimuli that depend on an ethnic stereotype to communicate a message? How effective are these appeals?

10. To understand the power of ethnic stereotypes, conduct your own poll. For a set of ethnic groups, ask people to anonymously provide attributes (including personality traits and products) most likely to characterize each group using the technique of free association. Compare the associations for an ethnic group between actual members of that group and nonmembers.

11. Locate one or more consumers (perhaps family members) who have immigrated from another country. Interview them about how they adapted to their host culture. In particular, what changes did they make in their consumption practices, especially fashion purchases, over time?

ENDNOTES

1. Vanessa O'Connell, "Reinventing the Luxury Department Store," *Wall Street Journal* (July 15, 2006).
2. Bickley Townsend, "*Ou Sont les Reiges d'Antan?* (Where Are the Snows of Yesteryear?)," *American Demographics* (October 1988): 2.
3. Jeanine Poggi, "Growing Up Fast: Teen Retailers Develop Formats for Older Crowd," *Women's Wear Daily* (August 14, 2006): 1, 26; Pia Sarkar, "Forth & Towne Stores Bay Area-Bound," *San Francisco Chronicle* (March 23, 2006): C1, C3.
4. "The Power of the Teen Dollar: From Levi's to Lip Gloss" (Montgomery Securities, 1998), cited in "Wired to Spend," *Echo Boomers: The Power of Y* (supplement to *Women's Wear Daily*) (February 19, 1998): 4.
5. Richard Abramowitz, "Trend Guru Knows Whys and Hows of Gens X and Y," *San Francisco Chronicle* (January 6, 2008): F5.
6. Steve Fogel, "Teen Power: Understand It So You Can Harness It," Marketing Partners, Bridging the Marketing Gap, http://www.netmpapps2.com/netmp/marketing_ solutions accessed August 8, 2005. (December 8, 2004).
7. "Targeting Teen Consumers," *Newspaper Association of America* (September 2004).
8. Cate T. Corcoran, "Online, Teens Flirt, Dish and Shop," *Women's Wear Daily* (November 17, 2005): 18.
9. Anne D'Innocenzio, "Toy Retailers Retool to Attract 'Tweens,'" *San Francisco Chronicle* (October 31, 2000): C8.
10. Anne D'Innocenzio, "Olsen Twins a Tough Business Act to Follow," *San Francisco Chronicle* (July 12, 2006): C2; Khanh T. L. Tran, "Tapping Tween Market: Hilary Duff Unveiling Youth Lifestyle Brand," *Women's Wear Daily* (June 7, 2006): 1, 24, 25.
11. Ruth LaFerla, "Fashion Aims Young," *New York Times on the Web* (August 24, 2006).
12. LaFerla, "Fashion Aims Young."
13. Howard W. French, "Vocation for Dropouts Is Painting Tokyo Red," *New York Times on the Web* (March 5, 2000).
14. Yumiko Ono, "They Say that a Japanese Gal Is an Individualist: Tall, Tan, Blond," *Wall Street Journal Interactive Edition* (November 19, 1999).
15. Yumiko Ono, "Meet a Beer, a Car, a Refrigerator, and a Fabric Deodorizer, All Named Will," *Wall Street Journal Interactive Edition* (October 8, 1999).
16. Scott McCartney, "Society's Subcultures Meet by Modem," *Wall Street Journal* (December 8, 1994): B1.

17. Mary Beth Grover, "Teenage Wasteland," *Forbes* (July 28, 1997): 44–45.

18. Junu Bryan Kim, "For Savvy Teens: Real Life, Real Solutions," *Advertising Age* (August 23, 1993): S1.

19. Margaret Carlson, "Where Calvin Crossed the Line," *Time* (September 11, 1995): 64.

20. Quoted in Cyndee Miller, "Phat Is Where It's at for Today's Teen Market," *Marketing News* (August 15, 1994): 6.

21. Valerie Seckler, "Courting Gen-Y: Forget the Hype, Find Street Cred," *Women's Wear Daily* (March 5, 2003): 1, 12, 13.

22. Adapted from Gerry Khermouch, "Didja C That Kewl Ad?" *Business Week* (August 26, 2002): 158–160.

23. Carol Emert, "Big Ad-Strategy Switch for Levi's," San *Francisco Chronicle* (January 27, 1998): C1, C2; Carol Emert, "New Levi's Ads Sport Hipper Jeans for Teens," *San Francisco Chronicle* (November 17, 1998): C1, C6; Miles Socha, "Levi's New Campaign Is Ad Score," *Women's Wear Daily* (May 6, 1999): 12.

24. Karen Parr, "New Catalogs Target GenY," *Women's Wear Daily* (July 24, 1997): 12.

25. Jane Ganahl, "Consumer Agitprop Posing as Girl Power," *San Francisco Examiner* (July 11, 1999): D7.

26. Gary J. Bamossy, Michael R. Solomon, Basil G. Englis, and Trinske Antonides, "You're Not Cool If You Have to Ask: Gender in the Social Construction of Coolness," paper presented at the Association for Consumer Research Gender Conference, Chicago, June 2000.

27. Arundhati Parmar, "Global Youth United," *Marketing News* (October 28, 2002): 1–49.

28. Courtney Colavita, "The Aging Italians," *Women's Wear Daily* (February 20, 2003): 12–13.

29. Norimitsu Onishi, "In a Graying Japan, Lower Shelves and Wider Aisles," *New York Times nytimes.com* (September 4, 2006).

30. Ellen Goodman, "The Selling of Teenage Anxiety," *The Washington Post* (November 24, 1979).

31. Valerie Seckler, "Why College Students Keep Spending More," *Women's Wear Daily* (September 21, 2005): 10–11.

32. Quoted in Fannie Weinstein, "Time to Get Them in Your Franchise," *Advertising Age* (February 1, 1988): S6.

33. Seckler, "Why College Students Keep Spending More."

34. www.mtvU.com (November 14, 2006).

35. Tom Zeller, Jr., "A Generation Serves Notice: It's a Moving Target," *New York Times on the Web* (January 22, 2006).

36. Kristin Larson, "Tommy Hilfiger Heads for the Beach," *Women's Wear Daily* (March 5, 2005): 13.

37. Laura Zinn, "Move Over, Boomers," *Business Week* (December 14, 1992): 7.

38. Valerie Seckler, "Firms Ignore Stretched, Skeptical Xers," *Women's Wear Daily* (January 22, 2003): 2, 26.

39. Valerie Seckler, "Gen-X Pinches Apparel Purchasing," *Women's Wear Daily* (December 14, 2005): 15; Erin E. Clack, "Study Probes Generation Gap," *Children's Business* 19, no. 4 (May 2004): 4.

40. Robert Scally, "The Customer Connection: Gen X Grows Up, They're in Their 30s Now," *Discount Store News* 38, no. 20 (October 25, 1999).

41. Quoted in T. L. Stanley, "Age of Innocence ... Not," *PROMO* (February 1997): 30.

42. Michael Barbaro, "Leaving Behind the Torn-Jeans Look," *New York Times on the Web* (September 5, 2006); see also Jennifer Weitzman, "Retailer's Task: Regeneration X," *The WWD Business Review* supplement to *Women's Wear Daily* (August 27, 2003): 16, 17, 19.

43. "Senior Market Ripe for Action," *Women's Wear Daily* (June 15, 1994): 18.

44. Peter Kerr, "Market Turns 'Grumpy': Companies Target Aging Boomers," *San Francisco Chronicle* (September 4, 1991): B3, B4.

45. Georgia Lee, "Older Shoppers Hungry for Jeans," *Women's Wear Daily* (December 4, 2004): 8.

46. Nat Ives, "Magazine of the Year: 'More': Taps Power of 40-Plus to Draw Advertisers in Droves," *Advertising Age Online* (October 22, 2006).

47. Susan Kaiser, *The Social Psychology of Clothing: Symbolic Appearances in Context* (New York: Fairchild, 1997).

48. L. W. Banner, *American Beauty* (Chicago: University of Chicago Press, 1983): 225.

49. C. D. Martin, "A Transgenerational Comparison: The Elderly Fashion Consumer," *Advances in Consumer Research* 3 (1976): 453–456; J. R. Lumpkin and C. W. Greenberg, "Apparel Shopping Patterns of the Elderly Consumer," *Journal of Retailing* 58 (1982): 68–89.

50. "Coming of Age," *Women's Wear Daily* (February 3, 2000): 2.

51. John Fetto, "The Wild Ones," *American Demographics* (February 2000): 72.

52. Karyn Monget, "Tapping the Middle-Aged Mood," *Women's Wear Daily* (June 3, 1998): 14–15.

53. Katherine Bowers, "Target Setting Sight on Baby Boomers," *Women's Wear Daily* (November 17, 2003): 7.

54. Georgia Lee, "Making the Big Time: Once-Frumpy Chico's on Retail's Fast Track," *Women's Wear Daily* (April 22, 2001): 1, 5.

55. Valerie Seckler, "Will Boomers Come of Age in Fashion Ads?," *Women's Wear Daily* (August 11, 2004): 12.

56. Valerie Seckler, "Fickle Fiftysomethings Vote with Their Feet," *Women's Wear Daily* (February 8, 2006): 19.

57. Kevin Keller, *Strategic Marketing Management* (Upper Saddle River, N.J.: Prentice-Hall, 1998).

58. Brad Edmondson, "Do the Math," *American Demographics* (October 1999): 50–56.

59. Carol Emert, "Gymboree's Hip Kin: Spin-off Fashions Fresh Image to Sell Kids' Clothing," *San Francisco Chronicle* (March 6, 1999): D1, D2.

60. Pamela Paul, "Make Room for Granddaddy," *American Demographics* (April 2002): 40.

61. Joy M. Kozer, "Older Female Consumers' Attitudes Towards Their Clothing and Appearance," *ITAA Proceedings*, 60 (2003): 68.

62. D'Vera Cohn, "2100 Census Forecast: Minorities Expected to Account for 60% of U.S. Population," *Washington Post* (January 13, 2000): A5.

63. Catherine A. Cole and Nadine N. Castellano, "Consumer Behavior," in James E. Binnen, ed., *Encyclopedia of Gerontology*, 1 (San Diego, CA: Academic Press, 1996): 329–339.

64. Carolyn Said, "Entrepreneurs Getting Hip to the Graying of America," *San Francisco Chronicle* (March 11, 2005): C1, C3.

65. Cheryl Russell, "The Ungraying of America," *American Demographics* (July 1997): 12.

66. Tammy Kinley and Linda Sivils, "Gift-Giving Behavior of Grandmothers," *Proceedings: International Textile and Apparel Association* (1999): 97.

67. Jeff Brazil, "You Talkin' to Me?," *American Demographics* (December 1998): 55–59.

68. Rick Adler, "Stereotypes Won't Work with Seniors Anymore," *Advertising Age* (November 11, 1996): 32.

69. Melinda Beck, "Going for the Gold," *Newsweek* (April 23, 1990): 74.

70. Rusty Williamson, "Catering to the Mature Crowd," *Women's Wear Daily* (January 2, 2002): 6; Anne D'Innocenzio, "Moderate Firms Push Fashion Limit Past 55: Others Ride the Brake," *Women's Wear Daily* (June 4, 1997): 1, 14, 18.

71. E. Rosenblad-Wallen and M. Karlsson, "Clothing for the Elderly at Home and in Nursing Homes," *Journal of Consumer Studies and Home Economics* 10 (1986): 343–356.

72. Ellen Goldsberry, Soyeon Shim, and Naomi Reich. "Women 55 Year and Older: Part II, Overall Satisfaction and Dissatisfaction with the Fit of Ready-to-Wear," *Clothing and Textiles Research Journal* 14, no. 2 (1996): 121–132; Ellen Goldsberry, Soyeon Shim, and Naomi Reich. "Women 55 Years and Older: Part I. Current Body Measurements as Contrasted to the PS 42-70 Data," *Clothing and Textiles Research Journal* 14, no. 2 (1996): 108–120.

73. Valerie Seckler, "The Skinny on a New Fit System," *Women's Wear Daily* (October 5, 2005): 15.

74. Eun-Ju Lee, "Elderly Consumers' Information Search Behavior: Use of Information Sources and Perceptions of their Usefulness," *Proceedings: International Textile and Apparel Association* (1997): 96.

75. Nora McDonald, Sandra Keiser, and Kathy Mullet, "United Nations International Year of Older Persons 1999 Clothing Initiative" *Proceedings: International Textile and Apparel Association* (1998): 15–18.

76. Hilda Buckley Lakner, "Perceptions of the Importance of Dress to the Self as a Function of Perceived Age and Gender," *ITAA Proceedings* (1998): 57.

77. Benny Barak and Leon G. Schiffman, "Cognitive Age: A Nonchronological Age Variable," in *Advances in Consumer Research* 8, ed. Kent B. Monroe (Provo, Utah: Association for Consumer Research, 1981), 602–606.

78. David B. Wolfe, "An Ageless Market," *American Demographics* (July 1987): 27–55.

79. Nat Ives, "AARP Aims to Deliver Message to Marketers," *New York Times on the Web* (January 12, 2004).

80. Ellen Day, Brian Davis, Rhonda Dove, and Warren A. French, "Reaching the Senior Citizen Market(s)," *Journal of Advertising Research* (December 1987–January 1988): 23–30; Warren A. French and Richard Fox, "Segmenting the Senior Citizen Market," *Journal of Consumer Marketing* 2 (1985): 61–74; Jeffrey G. Towle and Claude R. Martin Jr., "The Elderly Consumer: One Segment or Many?" in Beverlee B. Anderson, ed., *Advances in Consumer Research* 3 (Provo, Utah: Association for Consumer Research, 1976): 463.

81. Catherine A. Cole and Nadine N. Castellano, "Consumer Behavior," *Encyclopedia of Gerontology*, 1 (1996): 329–339.

82. David B. Wolfe, "Targeting the Mature Mind," *American Demographics* (March 1994): 32–36.

83. See Frederik Barth, *Ethnic Groups and Boundaries. The Social Organization of Culture Difference* (London: Allen and Unwin, 1969); Michel Laroche, Annamma Joy, Michael Hui, and Chankon Kim, "An Examination of Ethnicity Measures: Convergent Validity and Cross-Cultural Equivalence," in *Advances in Consumer Research* 18, eds. Rebecca H. Holman and Michael R. Solomon (Provo, Utah: Association for Consumer Research, 1991), 150–157; Melanie Wallendorf and Michael Reilly, "Ethnic Migration, Assimilation, and Consumption," *Journal of Consumer Research* 10 (December 1983): 292–302; Milton J. Yinger, "Ethnicity," *Annual Review of Sociology* 11 (1985): 151–180.

84. Rebecca Gardyn, "An All-American Melting Pot," *American Demographics* (July 2001): 8–13.

85. D'Vera Cohn, "2100 Census Forecast: Minorities Expected to Account for 60% of U.S. Population," *Washington Post* (January 13, 2000): A5. For interactive demographic graphics, visit www.understandingusa.com.

86. Rohit Deshpandé and Douglas M. Stayman, "A Tale of Two Cities: Distinctiveness Theory and Advertising Effectiveness," *Journal of Marketing Research* 31 (February 1994): 57–64.

87. Steve Rabin, "How to Sell across Cultures," *American Demographics* (March 1994): 56–57.

88. J. Raymond, "The Multicultural Report," *American Demographics* (November 2001): S3, S4, S6.

89. John Leland and Gregory Beals, "In Living Colors," *Newsweek* (May 5, 1997): 58–60.

90. Eils Lotozo, "The Jalapeño Bagel and Other Artifacts," *New York Times* (June 26, 1990): C1.

91. Molly O'Neill, "New Mainstream: Hot Dogs, Apple Pie and Salsa," *New York Times* (March 11, 1992): C1.

92. Karyn D. Collins, "Culture Clash," *Asbury Park Press* (October 16, 1994): D1.

93. See Lisa Peñaloza, "*Atravesando Fronteras*/Border Crossings: A Critical Ethnographic Exploration of the Consumer Acculturation of Mexican Immigrants," *Journal of Consumer Research* 21, no. 1 (June 1994): 32–54.

94. Sigfredo A. Hernandez and Carol J. Kaufman, "Marketing Research in Hispanic Barrios: A Guide to Survey Research," *Marketing Research* (March 1990): 11–27.

95. Melanie Wallendorf and Michael D. Reilly, "Ethnic Migration, Assimilation, and Consumption," *Journal of Consumer Research* 10 (December 1983): 292–302.

96. Ronald J. Faber, Thomas C. O'Guinn, and John A. McCarty, "Ethnicity, Acculturation and the Importance of Product Attributes," *Psychology & Marketing* 4 (Summer 1987): 121–134; Humberto Valencia, "Developing an Index to Measure Hispanicness," in *Advances in Consumer Research* 12, eds. Elizabeth C. Hirschman and Morris B. Holbrook (Provo, Utah: Association for Consumer Research, 1985), 118–121.

97. Rohit Deshpandé, Wayne D. Hoyer, and Naveen Donthu, "The Intensity of Ethnic Affiliation: A Study of the Sociology of Hispanic Consumption," *Journal of Consumer Research* 13 (September 1986): 214–220.

98. Michael Laroche, Chankon Kim, Michael K. Hui, and Annamma Joy, "An Empirical Study of Multidimensional Ethnic Change: The Case of the French Canadians in Quebec," *Journal of Cross-Cultural Psychology* 27, no. 1 (January 1996): 114–131.

99. U.S. Census Bureau, "U.S. Interim Projections by Age, Sex, Race, and Hispanic Origin," www.census.gov/ipc/www/usinterimproj/ (March 18, 2004).

100. U.S. Census Bureau, "Census Bureau Projects Tripling of Hispanic and Asian Populations in 50 Years; Non-Hispanic Whites May Drop to Half of Total Population," http://www.census.gov/Press-Release/www/releases/archives/population (March 18, 2004).

101. William O'Hare, "Blacks and Whites: One Market or Two?," *American Demographics* (March 1987): 44–48.

102. For recent studies on racial differences in consumption, see Robert E. Pitts, D. Joel Whalen, Robert O'Keefe, and Vernon Murray, "Black and White Response to Culturally Targeted Television Commercials: A Values-Based Approach," *Psychology & Marketing* 6 (Winter 1989): 311–328; Melvin T. Stith and Ronald E. Goldsmith, "Race, Sex, and Fashion Innovativeness: A Replication," *Psychology & Marketing* 6 (Winter 1989): 249–262.

103. Jack Neff, "My Black Is Beautiful: P&G Wants to Connect with African-American Women," *Adage.com* (August 27, 2007).

104. Julie Naughton, "Ethnic's Increased Strength," *Women's Wear Daily* (March 24, 2000): 12.

105. Jennifer Weil, "L'Oréal to Buy Ethnic Beauty Firm," *Women's Wear Daily* (February 29, 2000): 13.

106. Neff, "My Black Is Beautiful."

107. D. Silverman, "Potential for Payoff in Inner City," *Women's Wear Daily* (January 20, 1999): 12; Georgia Lee, "African-American Women Lament Lack of Fashion Choice," *Women's Wear Daily* (August 23, 2005): 10-11.

108. Wadeeah Beyah and Shu-Hwa Lin, "African-American Female Measurements and the Standard Sizing System," *ITAA Proceedings* (2001).

109. Robert E. Wilkes and Humberto Valencia, "Hispanics and Blacks in Television Commercials," *Journal of Advertising* 18 (Winter 1989): 19.

110. Jeremy Peters, "Ad Image Popular in Films Raises Some Eyebrows in Ads," *New York Times*, www.nytimes.com (August 1, 2006).

111. Patricia Wen, "The Forgotten Face," *San Francisco Chronicle* (May 29, 2000): A3, A6.

112. Kim Foltz, "Mattel's Shift on Barbie Ads," *The New York Times* (July 19, 1990): D17; Lora Sharpe, "Dolls in All the Colors of a Child's Dream," *Boston Globe* (February 22, 1991): 42; Barbara Brotman, "Today's Dolls Have Ethnicity That's More Than Skin Deep," *Asbury Park Press* (November 14, 1993): D6.

113. Michael Janofsky, "A Commercial by Nike Raises Concerns about Hispanic Stereotypes," *The New York Times* (July 13, 1993): D19.

114. Constance Gustke, "Wider, Deeper Pockets: Top Affluent Hispanic U.S. Markets Ranked by Number of Households," *Women's Wear Daily* (August 17, 2006): 11.

115. Rick Wartzman, "When You Translate 'Got Milk' for Latinos, What Do You Get?," *The Wall Street Journal* (June 3, 1999): A1, A8; also see Rebecca Gardyn, "Habla English?" *American Demographics* (April 2001): 54–57.

116. Helene Stapinski, "Generación Latino," *American Demographics* (July 1999): 62–68; also see Joan Raymond, "Tienen Numeros?" *American Demographics* (March 2002): 22–25.

117. Joe Schwartz, "Hispanic Opportunities," *American Demographics* (May 1987): 56–59.

118. Naveen Donthu and Joseph Cherian, "Impact of Strength of Ethnic Identification on Hispanic Shopping Behavior," *Journal of Retailing* 70, no. 4 (1994): 383–393. For another study that compared shopping behavior and ethnicity influences among six ethnic groups, see Joel Herce and Siva Balasubramanian, "Ethnicity and Shopping Behavior," *Journal of Shopping Center Research* 1 (Fall 1994): 65–80.

119. Cited in "Latina Fashionistas," *Women's Wear Daily* (November 18, 1999): 2.

120. "Latina Fashion: From Vogue to K-Mart: Hispanic Heritage Month Highlights Hispanic Fashion and Consumer Trends," *Cotton Incorporated Press Release*, www.cottoninc.com (October 5, 2005). See also Rusty Williamson, "The Latin Beat Goes On," *Women's Wear Daily* (April 13, 2005): 8.

121. "Hispanics: A Hidden Opportunity," Book of Marketing/Statistics, supplement to *Women's Wear Daily* (June 30, 2004): Section II, 10–11.

122. Laurel Wentz, "Online Hispanic Audience Is Predominately Bilingual," *Advertising Age*, www.adage.com (September 18, 2006).

123. Leila Cobo, "Young Hispanics Prefer Spanish Media," *Billboard* (October 4, 2005): 8.

124. Karyn Monget, "Smashing Stereotypes: Lingerie Brands Chase Ethnic Markets," *Women's Wear Daily* (June 14, 2004): 1, 6.

125. Anne D'Innocenzio, "Retailers See Potential in Growing Latino Population," *Associated Press* (May 19, 2003); Gustke, "Wider, Deeper Pockets"; Valerie Seckler, "Hispanic Spending Falls as Profile Rises," *Women's Wear Daily* (August 9, 2006): 7.

126. Laurel Wentz, "New Data Repaints Demographic Picture of U.S. Hispanics," *Advertising Age*, www.adage.com (September 14, 2006).

127. "'Cultural Sensitivity' Required When Advertising to Hispanics."

128. Quoted in Donald Dougherty, "The Orient Express," *The Marketer* (July/August 1990): 14.

129. "Made in Japan," *American Demographics* (November 2002): 48.

130. Benny Evangelista, "Eyeing Asian American E-Shoppers," *San Francisco Chronicle* (June 19, 2000): G1, G2.

131. Greg Johnson and Edgar Sandoval, "Advertisers Court Growing Asian American Population; Marketing, Wide Range of Promotions Tied to Lunar New Year Typify Corporate Interest in Ethnic Community," *Los Angeles Times* (February 4, 2000): C1.

132. Eleanor Yu, "Asian-American Market Often Misunderstood," *Marketing News* (December 4, 1989): 11.

133. "The Asian Boom," *Women's Wear Daily* (February 17, 2000): 2.

134. Margaret Rucker, Y.-J. Kim, and H. Ho, "Evaluation of Color Preferences: A Comparison of Asian and White Consumers," in *Minority Marketing: Issues and Prospects*, vol. 3, ed. Robert L. King (Charleston, S.C.: Academy of Marketing Science, 1987): 64.

135. Hiroko Kawabata and Nancy J. Rabolt, "Comparison of Clothing Purchase Behavior between U.S. and Japanese Female University Students," *Proceedings: International Textile and Apparel Association* (1998): 60.

136. Judith C. Forney and Nancy J. Rabolt, "Ethnic Identity: Its Relationship to Ethnic and Contemporary Dress," *Clothing and Textiles Research Journal* 4, no. 2 (1986): 1–8.

137. Meng-Ching Lin and Nancy Owens, "A Comparison of Clothing Purchase Decisions of Asian American and Caucasian-American Female College Students," *ITAA Proceedings* (1997): 97.

138. Alice Z. Cuneo and Jean Halliday, "Ford, Penney's Targeting California's Asian Population; Auto Marketer Uses 3 Languages in Commercials," *Advertising Age* (January 4, 1999): 28; Jeanne Whalen, "Sears Targets Asians: Retailer Names Agency to Attract Fast-Growing Segment," *Advertising Age* (October 10, 1994): 1.

139. Johnson and Sandoval, "Advertisers Court Growing Asian-American Population."

140. Dorinda Elliott, "Objects of Desire," *Newsweek* (February 12, 1996): 41.

141. Anastasia Hendrix, "Lucky 'Lady,'" *San Francisco Chronicle* (June 4, 2006): D1, D3, D5.

142. "Asian Promise: Lost in Translation," Book of Marketing/Statistics, supplement to *Women's Wear Daily* (June 30, 2004): Section II, 12.

143. Dan Fost, "Asian Homebuyers Seek Wind and Water," *American Demographics* (June 1993): 23–25.

7

Demographic Subcultures
Income and Social Class

Finally, the big day has come! Phil is going home with Marilyn to meet her parents. Phil had been doing some contracting work at the securities firm where Marilyn works, and it was love at first sight. Even though Phil had attended the "school of hard knocks" on the streets of Brooklyn and Marilyn was fresh out of Princeton, somehow they knew they could work things out despite their vastly different backgrounds. Marilyn's been hinting that the Caldwells have money, but Phil doesn't feel intimidated. After all, he knows plenty of guys who have wheeled-and-dealed their way into six figures; he can handle one more big shot in a silk suit, flashing a roll of bills and showing off his expensive modern furniture with gadgets everywhere you look.

When they arrive at the family estate in Connecticut, Phil looks for a Rolls-Royce, but he sees only a Jeep

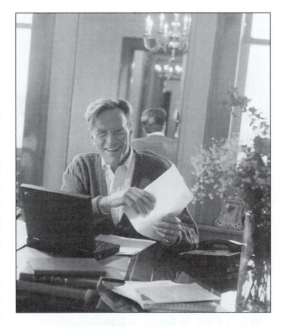

Cherokee. Once inside, Phil is surprised by how simply the house is furnished and decorated and by how shabby everything seems. The hall entryway faded Oriental rug and all of the furniture look really old—in fact, there doesn't seem to be new furniture anywhere—just a lot of antiques.

Phil is even more surprised when he meets Mr. Caldwell. He had half expected Marilyn's father to be wearing a tuxedo like the people on *Lifestyles of the Rich and Famous*. In fact, Phil had put on his best black Italian suit in anticipation, and he wore his large cubic zirconia pinky ring to show that he has some money too. When Marilyn's father emerges from his study wearing an old rumpled cardigan sweater and sneakers, Phil realizes he's definitely not in the old neighborhood . . .

CONSUMER SPENDING AND ECONOMIC BEHAVIOR

As Phil's eye-opening experience at the Caldwells' suggests, there are many ways to spend money, and a wide gulf exists between those who have it and those who don't. Perhaps an equally wide one exists between those who have had it for a long time and those who "made it the hard way—by earning it!" This chapter begins by briefly considering how general economic conditions affect the way consumers allocate their money. Then, reflecting the adage that says "The rich are different," it will explore how people who occupy different positions in society consume in very different ways.

Whether he or she is a skilled worker like Phil or a child of privilege like Marilyn, a person's social class has a profound impact on what he or she does with money and on how consumption choices, such as clothing, housing, and entertainment, reflect his or her "place" in society. And, as this chapter illustrates, these choices play another purpose as well. The specific products and services we buy are often intended to make sure *other* people know what our social standing is—or what we would like it to be. Products are frequently bought and displayed as markers of social class; they are valued as *status symbols*. This is especially true in large, modern societies where behavior and reputation can no longer be counted to convey one's position in a community.

Income Patterns

Many Americans would probably say that they don't make enough money, but in reality the average American's standard of living continues to improve. These income shifts are linked to two key factors: a shift in women's roles and increases in educational attainment.[1]

Woman's Work

One reason for this increase in income is that a larger proportion of people of working age are participating in the labor force. Mothers with preschool childeren are the fastest-growing segment of working people. Furthermore, many of these jobs are in high-paying occupations such as medicine and architecture, which used to be dominated by men. Although women are still a minority in most professional occupations, their ranks continue to swell. The steady increase in the numbers of working women is a primary cause of the rapid growth of middle- and upper-income families.[2]

Yes, It Pays to Go to School!

Another factor that determines who gets a bigger piece of the pie is education. Although paying for college often entails great sacrifice, it still pays off in the long run. College graduates earn about 50 percent more than those who have only gone through high school during the course of their lives. Women without a high school diploma earn only 40 percent as much as women who have a college degree.[3] So hang in there!

To Spend or Not to Spend, That Is the Question

Consumer demand for goods and services depends on both ability to buy and willingness to buy. Although demand for necessities tends to be stable over time, other expenditures can be postponed or eliminated if people don't feel that now is a good time to spend money.[4] For example, a person may decide to "make do" with his current wardrobe for another season rather than buying new clothes now.

Discretionary Spending

Discretionary income is the money available to a household after necessities are paid for—that is, over and above that required for a comfortable standard of living. Of course, there is wide variability in the definition of *comfortable*, and values and motivations help define what is necessary. Most clothing or fashion bought today does not fall under the heading of necessity, as we so often replace last year's clothing with new styles simply because we are bored with them or they are no longer "cutting edge." Therefore, generally clothing purchases fall under the heading of discretionary spending. Different segments of the market spend different amounts of their discretionary income on clothing or fashion. A large proportion of teens' and young singles' discretionary income is spent on clothing, whereas much less is spent later in life as spending is allocated to such things as home, children, education, and travel.

American consumers are estimated to wield about $400 billion a year in discretionary spending power. People age 35–55, whose incomes are at a peak, account for about half of this amount. With a healthy U.S. economy and booming stock market, many consumers have increased discretionary income with simple "profit taking" from their stock portfolios. Accompanying this increase are swings in the market that make newcomers to the market quite nervous and can create overnight bankruptcies. However, the rich have enough capital to ride out these swings. In fact, luxury firms such as Tiffany and Bernard Arnault report little influence of the market's ups and downs. As one CEO of a design house said, "The customers we cater to are the richest people in the world. They're rich whether the market is up or down."[5]

As the population ages and income levels rise, the typical U.S. household is changing the way it spends its money. The most noticeable change is that a much larger share of the budget is spent on shelter, transportation, entertainment, and education, while a lower proportion is being spent on apparel and food. Household expenditure changes are summarized in Figure 7-1. These shifts are due to such factors as an increase in the prevalence of home ownership (the number of homeowners rose by over 80 percent in the last three decades) and in the need for working wives to pay commuting costs. With such competition for the consumer dollar, fashion retailers are continually challenged to attract the consumer to their stores; hence, we see a constant barrage of department store sales.

Individual Attitudes Toward Money

Especially in the wake of 9/11 and a recent downturn of the economy many consumers are experiencing doubts about their individual and collective

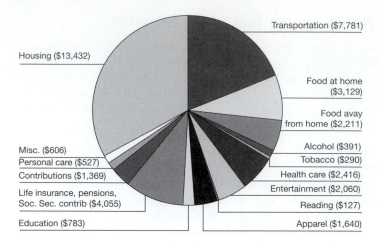

FIGURE 7-1 How the "Average" Family Spends Its Money

Source: Reprinted with permission from the February 7, 2005 issue of Advertising Age.
© Crain Communications Inc. 2005.

futures and are anxious about holding on to what they have. Whereas half of the respondents in one U.S. survey conducted by Roper Starch Worldwide say they don't believe money can buy happiness, nearly 70 percent still report that if their earnings doubled they would be happier than they are now![6]

A consumer's anxieties about money are not necessarily related to how much he or she actually has; acquiring and managing money is more a state of mind than of wallet. Money can have a variety of complex psychological meanings; it can be equated with success or failure, social acceptability, security, love, or freedom.[7] Some clinical psychologists even specialize in treating money-related disorders and report that people even feel guilty about their success and deliberately make bad investments to reduce this feeling! Some other clinical conditions include *atephobia* (fear of being ruined), *harpaxophobia* (fear of becoming a victim of robbers), *peniaphobia* (fear of poverty), and *aurophobia* (fear of gold).[8]

The Roper Starch survey found that by far, security was the attribute most closely linked to the meaning of money. Other significant associations included comfort, being able to help one's children, freedom, and pleasure. The researchers identified seven distinct types of money personalities, which are summarized in Table 7-1.

Consumer Confidence

The field of behavioral economics, or economic psychology, is concerned with the "human" side of economic decisions (including the biases in decision making discussed in Chapter 11). Beginning with the pioneering work of psychologist George Katona, this discipline studies how consumers' motives and their expectations about the future affect their current spending and how these individual decisions add up to affect a society's economic well-being.[9]

Table 7-1 Money Personalities

	Types		
	The Hunter	The Gatherer	The Protector
Percent of population	13%	19%	16%
Mean income	$44,000	$35,000	$36,000
Exemplar	Bill Gates (Microsoft)	Warren Buffett (Nebraska-based investor)	Paul Newman (actor and entrepreneur)
Profile	Takes risks to get ahead	Is better safe than sorry	Puts others first
Characteristics	Is aggressive about money, equating it with happiness and achievement; is likely to have unsettled personal life	Is a conservative investor with traditional values; tends to be thrifty and tries to minimize borrowing	Believes money is a means of protecting loved ones; tends to be predominantly women; is most likely married

Types			
The Splurger	The Striver	The Nester	The Idealist
14%	13%	14%	10%
$33,000	$29,000	$31,000	$30,000
Elizabeth Taylor (movie star)	Tonya Harding (disgraced figure skater)	Rosanne (comedienne/actress)	Allen Ginsberg (deceased poet)
Travels first class or not at all	Is controlled by money	Needs just enough to take care of self	Believe there's more to life than money
Is self-indulgent; prefers to buy luxury items rather than practical items; self-centered and not a good planner	Believes money makes the world go round; equates money with power; tends to be well educated and most likely is divorced	Is not very interested in money; is mostly concerned about meeting immediate needs	Mostly believes that money is the root of all evil; is not very interested in material things

Source: Adapted from Robert Sullivan, "Americans and Their Money," *Worth* (June 1994): 60 (8 pp.), based on a survey of approximately 2,000 American consumers conducted by Roper Starch Worldwide. © 1994 Worth Magazine. Reprinted by permission of *Worth* magazine.

A consumer's beliefs about what the future holds is an indicator of **consumer confidence**, which reflects the extent to which people are optimistic or pessimistic about the future health of the economy and how they will fare down the road. These beliefs influence how much money consumers will pump into the economy when making discretionary purchases. As this is very important to the fashion industry articles on the current confidence index regularly appear in *Women's Wear Daily*, the fashion industry trade paper.

Many businesses take forecasts about anticipated spending very seriously, and periodic surveys attempt to "take the pulse" of the American consumer to arrive at these indices. The Conference Board conducts a survey of consumer confidence, as does the Survey Research Center at the University of Michigan. The following are the types of questions posed to consumers in these surveys:[10]

- Would you say that you and your family are better off or worse off financially than a year ago?

- Will you be better off or worse off a year from now?
- Is now a good time or a bad time for people to buy major household items, such as furniture or a refrigerator?
- Do you plan to buy a car in the next year?

When people are pessimistic about their prospects and about the state of the economy, they tend to cut back their spending and take on less debt. On the other hand, when they are optimistic about the future, they tend to reduce the amount they save, take on more debt, and buy discretionary items. The overall savings rate, thus, is influenced by (1) individual consumers' pessimism or optimism about their personal circumstances, such as a sudden increase in personal wealth after cashing in a high-tech stock, (2) world events, such as the Iraq war, and (3) cultural differences in attitudes toward saving (for example, the Japanese have a much higher savings rate than do Americans).[11]

SOCIAL CLASS

Economic conditions and social status often determine the type of clothing we select. All societies can be roughly divided into the "haves" and the "have-nots" (though sometimes "having" is a question of degree). The United States is a place where "all men are created equal," but even so some people seem to be more equal than others. As Phil's encounter with the Caldwells suggests, a consumer's standing in society, or **social class**, is determined by a complex set of variables, including income, family background, education, and occupation. Kaiser describes an even broader concept of **social location,** referring to an abstract point of intersection of these and other variables, including one's sex and age, in a certain time and place with its own belief and value configuration. Through the socialization process, where individuals learn what is expected of them, most of the time people want to obey the rules or "dress the part" within one's social location.[12]

The place one occupies in the social structure is an important determinant not only of *how much* money is spent. It also influences *how* it is spent. Phil was surprised that the Caldwells, who clearly had a lot of money, did not seem to flaunt it. This understated way of living is a hallmark of so-called old money. People who have had it for a long time don't need to prove they've got it. In contrast, consumers who are relative newcomers to affluence might allocate the same amount of money very differently, especially in clothes, cars, and other outward signs of wealth.

A Universal Pecking Order

In many animal species, a social organization is developed whereby the most assertive or aggressive animals exert control over the others and have the first pick of food, living space, and even mating partners. Chickens, for example, develop a clearly defined dominance-submission hierarchy. Within this hierarchy, each hen has a position in which she is submissive to all of the hens above her and dominates all of the ones below her (hence, the origin of the term *pecking order*).[13]

People are no different. They also develop a pecking order where they are ranked in terms of their relative standing in society. This standing determines their access to such resources as education, housing, and consumer goods. And people try to improve their ranking by moving up in the social order whenever possible. This desire to improve one's lot in life, and often to let others know that one has done so, is at the core of many marketing strategies.

Social Class Affects Access to Resources

Just as marketers try to carve society into groups for segmentation purposes, sociologists have developed ways to describe meaningful divisions of society in terms of people's relative social and economic resources. Some of these divisions involve political power, whereas others revolve around purely economic distinctions. Karl Marx felt that position in a society was determined by one's relationship to the *means of production*. Some people (the "haves") control resources, and they use the labor of others to preserve their privileged positions. The "have-nots" lack control and depend on their own labor for survival, so these people have the most to gain by changing the system. Distinctions among people that entitle some people to more resources than others are perpetuated by those who will benefit by doing so.[14]

Sociologist Max Weber (1864–1920) showed that the rankings people develop are not one-dimensional. Some involve prestige or "social honor" (he called these *status groups*), some rankings focus on power (or *party*), and some revolve around wealth and property (*class*).[15]

Clothing Used to Regulate Distinction Between Classes

The power groups throughout history have been able to maintain class distinctions; clothing was one means of that control. Although hard to image today, dress was controlled by law. **Sumptuary laws** were restrictions that regulated style of dress and personal expenditures on clothing and accessories. By regulating dress, sumptuary laws functioned in Western Europe to separate the royal class from others. As the merchant or business classes gained wealth and were able to acquire opulent apparel similar to the royal courts, laws were enacted to suppress the method of expending this wealth. In Elizabethan England, laws prohibited commoners from wearing gold or silver cloth, velvet, or furs; specified colors, motif, and style were restricted to one's designated rank, class, and position within society.

Sumptuary laws have been part of the history of Korea, Japan, and China, with regulation of ornamentation of robes indicating social and political position dating back to 200 B.C. In Korea up until the 1900s, commoners were forbidden to wear long, flowing sleeves—a sign of dissociation from manual work.[16] The Japanese kimono was regulated by prescribed laws for the various classes in the late 1660s after merchants became wealthy and outshone the local leaders in terms of kimono designs, which had become bold and flowing. During the Chinese Cultural Revolution, the Mao suit, composed of a jacket with a high rounded collar that buttoned down the center and baggy pants, was worn. The *qi pao,* traditional women's dress, was outlawed as decadent, and a version of the Mao suit was prescribed for women. In this situation, dress was symbolic of one equal social class replacing earlier dress that distinguished the classes.[17]

During the nineteenth century, the constricted waists of Western dress and bound feet of Chinese women were evidence of high social standing and that the male head of the household was wealthy. Today social classes are fluid and mobile with people choosing their own lifestyles—and clothing reflects that choice. However, as discussed later in this chapter, current "status symbols" may reflect one's social standing.

Social Class Affects Taste and Lifestyles

Today the term *social class* is generally used to describe the overall rank of people in a society. People who are grouped within the same social class are approximately equal in terms of their social standing in the community. They work in roughly similar occupations, and they tend to have similar lifestyles by virtue of their income levels and common tastes. These people tend to socialize with one another and share many ideas and values regarding the way life should be lived.[18] Indeed, "birds of a feather flock together." We tend to marry people in a similar social class to ours.

Social class is as much a state of being as it is of having: As Phil saw, class also is a question of what one *does* with one's money, and how a person defines his or her role in society. Although people may not like the idea that some members of society are better off or "different" from others, most consumers do acknowledge the existence of different classes and the effect of class membership on consumption. As one wealthy woman observed when asked to define social class:

> I would suppose social class means where you went to school and how far. Your intelligence. Where you live. . . . Where you send your children to school. The hobbies you have. Skiing, for example, is higher than the snowmobile. . . . It can't be [just] money, because nobody ever knows that about you for sure.[19]

Social Stratification

In school, it always seems that some kids get all the breaks. They have access to many resources, such as special privileges, fancy cars, large allowances, or dates with other popular classmates. At work, some people are put on the fast track, are promoted to high-prestige jobs, and are given higher salaries and perhaps such perks as a parking space, a large office, or the keys to the executive washroom.

In virtually every context, some people seem to be ranked higher than others. Patterns of social arrangements evolve whereby some members get more resources than others by virtue of their relative standing, power, and/or control in the group.[20] The phenomenon of **social stratification** refers to this creation of artificial divisions in a society: "those processes in a social system by which scarce and valuable resources are distributed unequally to status positions that become more or less permanently ranked in terms of the share of valuable resources each receives."[21]

Achieved versus Ascribed Status

If you think back to groups you've belonged to, both large and small, you'll probably agree that in many instances some members seem to get more than their fair share of goodies, while other individuals are not so lucky. Some of

these resources may have gone to people who earned them through hard work or diligent study. This allocation is due to *achieved status*. Other rewards may have been obtained because the person was lucky enough to be born rich or beautiful. Such good fortune reflects *ascribed status*.

Whether rewards go to "the best and the brightest" or to someone who happens to be related to the boss, allocations are rarely equal within a social group. Most groups exhibit a structure, or **status hierarchy**, in which some members are somehow better off than others. They may have more authority or power, or they are simply better liked or respected.

The concept of **status** is actually neutral; it merely means position in a hierarchy. For example, individuals have a marital status; they are either married or single. However, when we refer to something as status oriented, we generally mean the upper end of a prestige continuum—that is, high status or a high position, rather than low position.

Class Structure in the United States

The United States supposedly does not have a rigid, objectively defined class system. Nevertheless, America has tended to maintain a stable class structure in terms of income distribution. Unlike other countries, however, what *does* change are the groups (ethnic, racial, and religious) that have occupied different positions within this structure at different times.[22] The most influential and earliest attempt to describe American class structure was proposed by W. Lloyd Warner in 1941. Warner identified six social classes:[23]

1. Upper Upper
2. Lower Upper
3. Upper Middle
4. Lower Middle
5. Upper Lower
6. Lower Lower

Note that these classifications imply (in ascending order) some judgment of desirability in terms of access to such resources as money, education, and luxury goods. Variations on this system have been proposed over the years, but these six levels summarize fairly well the way social scientists think about class. Figure 7-2 provides one view of the American status structure.

Class Structure Around the World

Every society has some type of hierarchical class structure, which determines people's access to products and services. Of course, the specific "markers" of success depend on what is valued in each culture. For the Chinese, an economic boom is rapidly creating a middle class estimated at more than 130 million people, which is projected to grow to more than 400 million in ten years. Because costs are low, a family with an annual income below the U.S. poverty threshold of about $14,000 can enjoy middle-class comforts, including stylish clothes, Chinese-made color televisions, DVD players, and cell phones. Also increased income has made many dream vacations come true. Since China put the European Union on its list of approved tourist destinations,

INCOME →

UPPER AMERICANS
Upper-Upper (0.3%): The "capital S society" world of inherited wealth
Lower-Upper (1.2%): The newer social elite, drawn from current professionals
Upper-Middle (12.5%): The rest of college graduate managers and professionals; lifestyle centers on private clubs, causes, and the arts

MIDDLE AMERICANS
Middle Class (32%): Average pay white-collar workers and their blue-collar friends; live on "the better side of town," try to "do the proper things"
Working Class (38%): Average pay blue-collar workers; lead "working class lifestyle" whatever the income, school, background, and job

LOWER AMERICANS
"A lower group of people, but not the lowest" (9%): Working, not on welfare; living standard is just above poverty; behavior judged "crude," "trashy"
"Real Lower-Lower" (7%): On welfare, visibly poverty-stricken, usually out of work (or have "the dirtiest jobs"); "common criminals"

FIGURE 7-2
A Contemporary View of the American Class Structure

Source: Richard P. Coleman, "The Continuing Significance of Social Class to Marketing," *Journal of Consumer Research* 10 (December 1983): 265–280. Reprinted with permission of The University of Chicago Press.

the volume of Chinese sightseers to Europe has surged, and France is their top choice. By 2020, the World Tourism Organization estimates that 100 million Chinese will make foreign trips each year.[24] Like Japanese tourists before them, the Chinese spend a lot of money when they get to the department stores, much of it on luxury goods that are cheaper in Europe than in China because of high import taxes. Many of France's prestigious department stores now accept China Union Pay credit cards, one of the most popular cards in China.

The rise of the Chinese middle class has been especially profitable for Nike, which consumers in a recent survey named China's coolest brand. Nike shoes have become a symbol of success, and the company is opening an average of 1.5 new stores a day there. Nike worked for a long time to attain this status; it started by outfitting top Chinese athletes and sponsored all the teams in China's new pro-basketball league in 1995. Still, becoming a fashion icon (and persuading consumers to spend twice the average monthly salary for a pair of shoes) was no mean feat in a country that wasn't exactly sports crazy. So, Nike affiliated with the National Basketball Association (which had begun televising games in China), bringing players like Michael Jordan for visits. Slowly but surely, in-the-know Chinese came to call sneakers "Nai-ke." In 2001, Nike coined a new phrase for its China marketing campaign: "Hip Hoop."[25]

Japan is a highly status-conscious society in which upscale designer labels are quite popular, and new forms of status are always being sought. To the Japanese, owning a traditional rock garden, formerly a vehicle for leisure and tranquillity, has become a sought-after item. Possession of a rock garden implies inherited wealth, since aristocrats traditionally were

patrons of the arts. In addition, considerable assets are required to afford the required land in a country where real estate is extraordinarily costly. The scarcity of land also helps explain why the Japanese are fanatic golfers: Since a golf course takes up so much space, membership in a golf club is extremely valuable.[26]

Shopping is a favorite pastime for many Arab women. In contrast to the Japanese, few of them work, so searching for the latest in Western luxury brands is a major leisure activity. Dressing rooms are large, with antechambers to accommodate friends and family members who often come along on shopping sprees. A major expansion of Western luxury brands is under way across the Middle East, home to some of the fashion industry's best customers. High-end retailers such as Saks Fifth Avenue and Giorgio Armani are building opulent stores to cater to this growing market. However, fashion retailers must take cultural and religious considerations into account. Missoni makes sure that collections include longer pants, skirts, and evening gowns with light shawls to cover heads or bare shoulders. And advertising and display options are more limited: Erotic images don't work. In the strict religious culture of Saudi Arabia, mannequins can't reveal a gender or human shape. At Saks's Riyadh store, models are headless and don't have fingers. Half of the two-level store is off-limits to men.[27]

England is an extremely class-conscious country, and at least until recently, consumption patterns were preordained in terms of one's inherited position and family background. Members of the upper class were educated at schools like Eton and Oxford and spoke like Henry Higgins in *My Fair Lady*. Remnants of this rigid class structure can still be found. "Hooray Henrys" (wealthy young men) play polo at Windsor, and hereditary peers still dominate the House of Lords.

The dominance of inherited wealth appears to be fading in Britain's traditionally aristocratic society. According to a survey, eighty-six of the two hundred wealthiest people in England made their money the old-fashioned way: They earned it. Even the sanctity of the royal family, which epitomizes the aristocracy, has been diluted through tabloid exposure and the antics of younger family members who have been transformed into celebrities more like rock stars than royalty. As one observer put it, "the royal family has gone down-market ... to the point that it sometimes resembles soap opera as much as grand opera."[28]

Now, some big marketers such as Unilever and Groupe Danone have set their sights on a previously overlooked, more lower-class group called **chavs**. The British use this term widely; it refers to young, lower-class men and women who mix flashy brands and accessories from big names like Burberry with track suits. Their style icons include soccer star David Beckham and his wife, Victoria, who was known as Posh Spice as a member of the Spice Girls pop group. Despite their (alleged) tackiness, chavs are attractive to marketers because they have a lot of disposable income to spend on fashion, food, and gadgets. France's Danone, which makes HP Sauce, a condiment the British have poured over bacon sandwiches and fries for a century, launched a series of ads playing up to the chav culture. One features a brawl over the sauce at a wedding buffet; another includes glammy soccer players' wives mingling cattily at a party.[29]

Oil and capitalism are bringing wealth to China and Russia. Just a few years into an oil boom, Moscow is becoming one of the hottest markets for luxury goods. Already it counts 25 billionaires and 88,000 million-aires.[30] And some say Moscow is home to more rich than New York. A $1.27 million cell phone? A $1.7 million Bugatti luxury car? They were available at the Millionaire Fair in Moscow, a showcase of the country's oil-driven wealth and free-spending ways of its nouveaux riches. It also seemed to be a testimony to how far it has come since the communist era. Yet the fair also served as a bleak reminder of the tremendous gap between the small group of extraordinarily wealthy and the nearly one-fifth of Russians who live below the poverty line of $410 per month.[31] The Millionaire Fair, a traveling exhibit begun in the Netherlands, has had its greatest success in Moscow. At other venues including Amsterdam, Cannes, Shanghai, and Belgium, people come to look; Russians come to buy.

No country is more obsessed with cars than China, where achieving the new middle-class dream means owning a shiny new vehicle.[32] But the car is not always enough; a license plate has become almost as much of a status symbol as the car. And mixing new-money aspirations with Old World superstitions, the number on the plate is a very important component. The unluckiest number, 4, or *si*, can also mean death in Chinese, whereas the number 8, or *ba*, which rhymes with "fa," the Chinese character for wealth, is the luckiest number. License plates are usually issued randomly, but a plate that ends in 4 is considered a very bad omen for the motorist; it might as well read DEATH. And a plate with 8s portends good fortune. An Internet ad offered one plate, A88888, for about $140,000! Like Russia, China is finding a wide gap between the rich and the poor, and a status plate can be an object of resentment. Some say it's just bragging by the new rich.

THE RISE OF MASS CLASS

Although social class still matters, it's getting more difficult to clearly link certain brands or stores with a specific class. That's because a lot of "affordable luxuries" now are within reach of many consumers who could not have managed to acquire them in the past. The driver of this global change is income distribution. In many countries, traditionally there has been a huge gulf between the rich and the poor—you were either one or the other. Today, rising incomes in many economically developing countries such as South Korea and China, coupled with decreasing prices for quality consumer goods and services, are leveling the playing field so that there are many more opportunities for people making modest incomes to get a taste of the good life. For example, look at our sophisticated cell phones, computers, and LCD and high-definition televisions that now have significantly lower prices from not too long ago.

This change is fueling demand for mass-consumed products that still offer some degree of panache or style. Think about the success of companies such as H&M, Zara, TopShop, Gap, Nike, L'Oréal, and Nokia. They cater to a consumer segment that analysts have labeled **mass class**: the hundreds of millions of global consumers who now enjoy a level of purchasing power that's sufficient to let them afford high-quality products—except for big-ticket items like college educations, housing, or luxury cars.[33]

Fashion designers are getting a bit nervous about this trend, which some call a *masstige* shift, a combination of "mass" and "prestige."[34] Mizrahi designs for Bergdorf Goodman, but he also has a very successful line at Target. Karl Lagerfeld, Stella McCartney, Viktor & Rolf, Roberto Cavalli, and Rei Kawakubo, among others have done "one off" lines for H&M (guest designers for one line), which sold out in hours, and in some cases, minutes.[35] That

Fashion may not be one of life's little luxuries anymore since everyone can afford to be stylish, be it Gap, Target, H&M, or Saks Fifth Avenue. Consumers are mixing and matching, saving money on a Costco T-shirt, and mixing it with a high-end item at Saks. Retail stores are doing it—Wal-Mart sells clothes and groceries, so consumers are doing it also.

Social Mobility

To what degree do people tend to change their social classes? In some societies, such as India with its caste system, one's social class is very difficult to change—but America is known as a country where "any man (or woman) can grow up to be president." **Social mobility** refers to the "passage of individuals from one social class to another. . . ."[36]

This passage can be upward, downward, or even horizontal. *Horizontal mobility* refers to movement from one position to another roughly equivalent in social status, such as becoming a nurse instead of an elementary school teacher. *Downward mobility* is, of course, not very desirable, but this pattern is unfortunately quite evident in recent years as farmers and other displaced workers have been forced to go on welfare rolls or have joined the ranks of the homeless. A conservative estimate is that 2 million Americans are homeless on any given day.[37]

Despite that discouraging trend, demographics in fact decree that there must be *upward mobility* in our society. The middle and upper classes reproduce less (that is, they have fewer children per family) than the lower classes (an effect known as *differential fertility*), and they tend to restrict family size below replacement level (often having only one child). Therefore, so the reasoning goes, positions of higher status over time must be filled by those of lower status.[38] Overall, though, the offspring of blue-collar consumers tend also to be blue-collar, whereas the offspring of white-collar consumers also tend to wind up as white-collar.[39] People tend to improve their positions over time, but these increases are not usually dramatic enough to catapult them from one social class to another.

Fashion has been explained as members of one class imitating those of another, who in turn are driven to ever new expressions of fashion.[40] Quentin Bell and other sociologists considered the history of fashion as inexplicable without relating it to social class; one class always is striving to reach the next level or at least to imitate the look of that level. Most fashion authorities agree that there is a direct relationship between the growth and strength of the middle class and the growth of fashion demand. The middle class is the largest and has the majority vote in the adoption of fashion. Members of the middle class tend to be followers, not leaders, of fashion, and as discussed in Chapter 1, the persistence of their imitation spurs fashion leaders to seek new and different fashions of their own to differentiate themselves from the class beneath them.[41]

Components of Social Class

When we think about a person's social class, we may consider a number of pieces of information. Two major ones are occupation and income. A third important factor is educational achievement, which is strongly related to income and occupation.

Occupational Prestige

In a system where (like it or not) a person is defined to a great extent by what he or she does for a living, *occupational prestige* is one way to evaluate the "worth" of people. Hierarchies of occupational prestige tend to be quite stable over time, and they also tend to be similar in different societies. Similarities in occupational prestige have been found in societies as diverse as Brazil, Ghana, Guam, Japan, and Turkey.[42]

A typical ranking includes a variety of professional and business occupations at the top, such as CEO of a large corporation, physician, professor at a prestigious university (one typology put Chief Justice of the Supreme Court as the most prestigious occupational position in the United States), while those jobs hovering near the bottom include shoe shiner, ditchdigger, and garbage collector. Because a person's occupation tends to be strongly linked to his or her use of leisure time, allocation of family resources, political orientation, and so on, this variable is often considered to be the single best indicator of social class.

Income

The distribution of wealth is of great interest to social scientists and to marketers, since it determines what groups have the greatest buying power and market potential. Wealth is by no means distributed evenly across the classes. The top fifth of the population controls about 75 percent of all assets.[43] As we have seen, income per se is often not a very good indicator of social class, since the way money is spent is more telling. Still, people need money to allow them to obtain the goods and services that they need to express their tastes, so obviously income is still very important. American consumers are getting both wealthier and older, and these changes will continue to influence consumption preferences.

The Relationship Between Income and Social Class

Although consumers tend to equate money with class, the precise relationship between other aspects of social class and income is not clear and has been the subject of debate among social scientists.[44] The two are by no means synonymous, which is why many people with a lot of money try to use it to upgrade their social class.

One problem is that even if a family increases household income by adding wage earners, each additional job is likely to be of lower status. For example, a spouse who gets a part-time job is not as likely to get one that is of equal or greater status compared to the primary wage earner's. In addition, the extra money earned may not be pooled toward the common good of the family. It is often used by the individual for his or her own personal spending. More money does not then result in increased status or changes in consumption patterns, since it tends to be devoted to buying more of the usual rather than upgrading to higher-status products.[45]

The following general conclusions can be made regarding the relative value of social class (place of residence, occupation, cultural interests, and so on) versus income in predicting consumer behavior:

- Social class appears to be a better predictor of purchases that have symbolic aspects but low to moderate prices (cosmetics, fashion).
- Income is a better predictor of major expenditures that do not have status or symbolic aspects (major appliances).

- Both social class and income data are needed to predict purchases of expensive, symbolic products (cars, homes).

Measurement of Social Class

Because social class is a complex concept that depends on a number of factors, not surprisingly it has proven difficult to measure. Early measures included the Index of Status Characteristics, developed in the 1940s, and the Index of Social Position, developed by Hollingshead in the 1950s.[46] These indices used various combinations of individual characteristics (such as income and type of housing) to arrive at a label of class standing. The accuracy of these composites still is a subject of debate among researchers; a study claimed that for segmentation purposes, raw education and income measures work as well as composite status measures.[47]

American consumers generally have little difficulty placing themselves in either the working class (lower middle class) or middle class. Also, the number who reject the idea that such categories exist is rather small.[48] The proportion of consumers identifying themselves as working class tended to rise until about 1960, but it has been declining since.

Blue-collar workers with relatively high-prestige jobs still tend to view themselves as working class, even though their income levels may be equivalent to those of many white-collar workers.[49] This fact reinforces the idea that the labels of "working class" or "middle class" are very subjective. Their meanings say at least as much about self-identity as they do about economic well-being.

Problems with Measures of Social Class

Market researchers were among the first to propose that people from different social classes can be distinguished from each other in important ways. While some of these dimensions still exist, others have changed.[50] Unfortunately, many of these measures are badly dated and are not as valid today for a variety of reasons.[51]

Most measures of social class were designed to accommodate the traditional nuclear family, with a male wage earner in the middle of his career and a female full-time homemaker. Such measures have trouble accounting for two-income families, young singles living alone, or households headed by women, which are so prevalent in today's society.

Another problem with measuring social class is attributable to the increasing anonymity of our society. Earlier studies relied on the *reputational method*, where extensive interviewing was done within a community to determine the reputations and backgrounds of individuals (see the discussion of sociometry in Chapter 12). This information, coupled with the tracing of interaction patterns among people, provided a very comprehensive view of social standing within a community. However, this approach is virtually impossible to implement in most communities today. One compromise is to interview individuals to obtain demographic data and to combine these data with the subjective impressions of the interviewer regarding the person's possessions and standard of living.

An example of this approach appears in Figure 7-3. Note that the accuracy of this questionnaire relies largely on the interviewer's judgment, especially regarding the quality of the respondent's neighborhood. These impressions are in danger of being biased by the interviewer's own circumstances, which may

Interviewer circles code numbers (for the computer) that in his/her judgment best fit the respondent and family. Interviewer asks for detail on occupation, then makes rating. Interviewer often asks the respondent to describe neighborhood in own words. Interviewer asks respondent to specify income—a card is presented to the respondent showing the eight brackets—and records R's response. If interviewer feels this is overstatement or understatement, a "better judgment" estimate should be given, along with an explanation.

EDUCATION

	Respondent	Respondent's Spouse
Grammar school (8 yrs or less)	−1 R's	−1 Spouse's
Some high school (9 to 11 yrs)	−2 Age	−2 Age
Graduated high school (12 yrs)	−3	−3
Some post high school (business, nursing, technical, 1 yr college)	−4	−4
Two, three years of college—possibly Associate of Arts degree	−5	−5
Graduated four-year college (B.A./B.S.)	−7	−7
Master's or five-year professional degree	−8	−8
Ph.D. or six/seven-year professional degree	−9	−9

OCCUPATION PRESTIGE LEVEL OF HOUSEHOLD HEAD: Interviewer's judgment of how head of household rates in occupational status.

(Respondent's description—asks for previous occupation if retired, or if R is widow, asks husband's: _____)

Chronically unemployed—"day" laborers, unskilled; on welfare	−0
Steadily employed but in marginal semiskilled jobs; custodians, minimum pay factory help, service workers (gas attendants, etc.)	−1
Average-skill assembly-line workers, bus and truck drivers, police and firefighters, route deliverymen, carpenters, brickmasons	−2
Skilled craftsmen (electricians), small contractors, factory foremen, low-pay salesclerks, office workers, postal employees	−3
Owners of very small firms (2–4 employees), technicians, salespeople, office workers, civil servants with average-level salaries	−4
Middle management, teachers, social workers, lesser professionals	−5
Lesser corporate officials, owners of middle-sized businesses (10–20 employees), moderate-success professionals (dentists, engineers, etc.)	−7
Top corporate executives, "big successes" in the professional world (leading doctors and lawyers), "rich" business owners	−9

AREA OF RESIDENCE: Interviewer's Impressions of the Immediate neighborhood in terms of its reputation in the eyes of the community.

Slum area: people on relief, common laborers	−1
Strictly working class; not slummy but some very poor housing	−2
Predominantly blue-collar with some office workers	−3
Predominantly white-collar with some well-paid blue-collar	−4
Better white-collar area; not many executives, but hardly any blue-collar either	−5
Excellent area; professionals and well-paid managers	−7
"Wealthy" or "society"-type neighborhood	−9

TOTAL FAMILY INCOME PER YEAR TOTAL SCORE _____

Under $5,000	−1	$20,000 to $24,999	−5
$5,000 to $9,999	−2	$25,000 to $34,999	−6
$10,000 to $14,999	−3	$35,000 to $49,999	−7
$15,000 to $19,999	−4	$50,000 and over	−8

Estimated Status _____

(Interviewer's estimate: _____ and explanation _____)

R's MARITAL STATUS: Married _____ Divorced/Separated _____ Widowed _____ Single _____ (CODE: _____)

FIGURE 7-3
Example of a Computerized Status Index

Source: Richard P. Coleman, "The Continuing Significance of Social Class to Marketing," *Journal of Consumer Research* 10 (December 1983): 265–280. Reprinted with permission of The University of Chicago Press.

affect his or her standard of comparison. Furthermore, the characteristics are described by highly subjective and relative terms: "Slummy" and "excellent" are not objective measures. These potential problems highlight the need for adequate training of interviewers, as well as for some attempt to cross-validate such data, possibly by employing multiple judges to rate the same area.

Another problem occurs when a person's social class standing creates expectations that are not met. Some people find themselves in the not unhappy position of making more money than is expected of those in their social class. This situation is known as an *overprivileged* condition and is usually defined as an income that is at least 25 percent to 30 percent over the median for one's class.[52] In contrast, *underprivileged* consumers, who earn at least 15 percent less than the median, must often devote their consumption priorities to sacrificing in order to maintain the appearance of living up to class expectations.

Lottery winners are examples of consumers who become overprivileged virtually overnight. As attractive as winning is to many people, it has its problems. Consumers with a certain standard of living and level of expectations may have trouble adapting to sudden affluence and engage in flamboyant and irresponsible displays of wealth. Ironically, it is not unusual for lottery winners to report feelings of depression in the months after cashing in. They may have trouble adjusting to an unfamiliar world, and they frequently experience pressure from friends, relatives, and businesspeople to "share the wealth."

Another "overnight" high-income group is the Silicon Valley millionaires who "struck gold" in the 1990s in their high-tech companies in California (Silicon Valley is in the San Jose/San Francisco Bay Area). It is estimated that this phenomenon applied to tens of thousands of new millionaires. One psychologist named this "Sudden Wealth Syndrome," which plagues new "dot-commers" (Internet company owners) who found themselves with money and an identity crisis. The Money, Meaning & Choices Institute could only appear in Silicon Valley! These "wealth specialists" help the rich be rich by introducing them to new schools for their children, new friends, stock options, and philanthropy. Many old friends and fellow workers have little sympathy for their guilt and difficulty of adjusting to life as a megamillionaire and their plight of not knowing how to deal with their new wealth![53] This phenomenon came to a quick halt with the dot.com busts in the early 2000s but we are seeing it again with "Web 2.0" companies.

One traditional assumption related to class and status is that husbands define a family's social class, while wives must live it. Women borrow their social status from their husbands.[54] Indeed, the evidence indicates that physically attractive women tend to "marry up" (*hierogamy*) in social class to a greater extent than attractive men. Women trade the resource of sexual appeal, which historically has been one of the few assets they were allowed to possess, for the economic resources of men.[55]

The accuracy of this assumption in today's world must be questioned. Many women now contribute equally to the family's well-being and work in positions of comparable or even greater status than their spouses. *Cosmopolitan* magazine offered this revelation:

> Women who've become liberated enough to marry any man they please, regardless of his social position, report how much more fun and spontaneous their relationships with men have become now that they no longer view men only in terms of their power symbols.[56]

Employed women tend to average both their own and their husband's respective positions when estimating their own subjective status.[57] Nevertheless, a prospective spouse's social class is often an important "product attribute" when evaluating alternatives in the interpersonal marketplace (as Phil and Marilyn were to find out).

Social class remains an important way to categorize consumers. Many marketing strategies do target different social classes. However, in summary, marketers have failed to use social class information as effectively as they could.

HOW SOCIAL CLASS AFFECTS PURCHASE DECISIONS

Different products and stores are perceived by consumers to be appropriate for certain social classes.[58] Working-class consumers tend to evaluate products in more utilitarian terms, such as sturdiness or comfort, rather than style or fashionability. They are less likely to experiment with new products or styles.[59] In contrast, more-affluent people tend to be concerned about appearance and body image. These differences mean that markets for different products such as clothing and fashion can be segmented by social class.[60]

Clothing Decisions by Social Class

The distinction in dress between blue-collar and white-collar occupations is straightforward for men by virtue of the actual terminology we used; we think of white-collar workers in higher classes. Later in this chapter we discuss Veblen, who distinguished the upper classes in one way by their "spotless white shirts," showing that they perform no manual labor. He discusses the clear distinction of dress by class in the late 1890s, but the distinction is less clear-cut today. And the distinction for women is less clear-cut than for men's occupations, as women have not really adopted a "business uniform" as men have.

Clothing research has indicated that women's employment tends to affect criteria used in clothing choices. One study found that comfort, appropriateness, quality, and attractiveness are likely to be the most important considerations for career apparel, but not necessarily for social apparel.[61] Employed women also differ from women who are not employed outside the home in terms of search patterns in selecting apparel.[62] Most of this type of research has been done with white-collar workers only. For men it is quite obvious, but for women there may be subtle and context-dependent distinctions in dress across occupation status lines.[63]

Since fashion has been *democratized* in modern times, it often crosses class lines, as discussed in Chapter 1: The "trickle-across" theory of fashion leadership states that a fashion style can become adopted by all classes almost instantaneously due to our rapid communications. Much of the fashion leadership research has found inconsistencies or has found no relationship between social class and fashion opinion leadership.[64] Ideas for and adoption of new styles comes from all levels in their own way. However, there certainly still are subtle distinctions in those fashions, such as luxurious fabrication and brand, that denote cost and, perhaps, class.

Caution must be taken in explaining consumer behavior by class, as it cannot adequately do that by itself. Lebow describes how some cultural categories of consumers seem to cut across lines of class, income, age, occupation, and so on. Nationwide marketing research identified a group as "ultraconsumers" in the late 1980s based on similarity in attitudes toward success and an insatiable desire for the new.[65] This group fell primarily in the upper-class category but also included people from the middle classes. Forty-four percent of ultraconsumers owned or used top designer clothing, but the group excluded some upper-class Americans who were less fashion oriented illustrating the inadequacies of such artificially defined market groups.

Class Differences in Worldview

A major social class difference involves the *worldview* of consumers. The world of the working class (that is, the lower-middle class) is more intimate and constricted. For example, working-class men are likely to name local sports figures as heroes and are less likely to take long vacation trips to out-of-the-way places.[66] Immediate needs, such as a new refrigerator or TV, tend to dictate buying behavior for these consumers, while the higher classes tend to focus on more long-term goals, such as saving for college tuition or retirement.[67] Working-class consumers depend heavily on relatives for emotional support and tend to orient themselves in terms of the local community rather than the world at large. They are more likely to be conservative and family oriented. Maintaining the appearance of one's home and property is a priority, regardless of the size of the house.

While they would like to have more in the way of material goods, working-class people do not necessarily envy those who rank above them in social standing.[68] The maintenance of a high-status lifestyle is sometimes not seen as worth the effort. As one blue-collar consumer commented: "Life is very hectic for those people. There are more breakdowns and alcoholism. It must be very hard to sustain the status, the clothes, the parties that are expected. I don't think I'd want to take their place."[69]

This person may be right. Although good things appear to go hand in hand with higher status and wealth, the picture is not that clear. Social scientist Emile Durkheim observed that suicide rates are much higher among the wealthy; he wrote in 1897, "the possessors of most comfort suffer most."[70] Durkheim's wisdom may still be accurate today. Many well-off consumers seem to be stressed or unhappy despite or even because of their wealth, a condition sometimes termed *affluenza*.[71] In a *New York Times*/CBS News poll, kids age 13–17 were asked to compare their lives with what their parents experienced growing up. Forty-three percent said they were having a harder time, and upper-income teenagers were the most likely to say that their lives were harder and subject to more stress. Apparently, they feel the pressure to get into elite schools and to maintain the family's status.[72]

French theorist Pierre Bourdieu reminds us of the importance of **cultural capital**. This refers to a set of distinctive and socially rare tastes and practices—knowledge of "refined" behavior that admits a person into the realm of the upper class.[73] The elites in a society collect a set of skills that enable

them to hold positions of power and authority, and they pass these on to their children—think etiquette lessons and debutante balls; however, in some U.S. cities today invitations to debutante balls are based on high grades in school, not family status. These resources gain in value because access to them is restricted. That's part of the reason why people compete so fiercely for admission to elite colleges. Much as we hate to admit it, the rich *are* different.

Targeting the Poor

About 14 percent of Americans live below the poverty line, and this segment has largely been ignored by most marketers. Still, although poor people obviously have less to spend than rich ones, they have the same basic needs as everyone else. Low-income families purchase such staples as milk, orange juice, and tea at the same rates as average-income families. Minimum-wage-level households spend a greater-than-average share on out-of-pocket health care costs, rental homes, and food eaten at home.[74] Unfortunately, these resources are harder for them to obtain, due to the reluctance of many businesses to locate in lower-income areas. On average, residents of poor neighborhoods must travel more than two miles to have the same access to supermarkets, large drugstores, and banks as do residents of affluent areas.[75]

On the other hand, some businesses have prospered by locating branches in more accessible areas for this large market. For example, Borders is locating in underserved urban neighborhoods in Detroit and Chicago. In fact, many retailers that are seeking expansion are considering underserved urban markets. One plus is the general lack of competition in many of these areas.[76] Some mail-order companies also target this group. For example, Fingerhut sells many products, but its real business is extending credit to moderate- and low-income households that allows these consumers to purchase its inventory (at high interest rates). Even a pair of $40 sneakers can be bought on credit for 13 months at $7.49 a month. The $2 billion retailer has built a

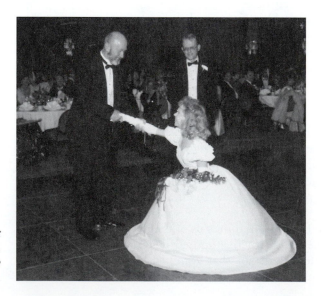

Young women "come out" at debutante or cotillion balls, traditionally a practice of the upper class.

Rodeo Drive in Beverly Hills is famous for its patrons' conspicuous consumption.

Other Forms of Conspicuous Consumption

The Modern Potlatch

Veblen was inspired by anthropological studies of the Kwakiutl people, who lived in the Pacific Northwest. At a ceremony called a *potlatch*, the host showed off his wealth and gave extravagant presents to the guests. The more one gave away, the better one looked to the others. Sometimes, the host would use an even more radical strategy to flaunt his wealth. He would publicly destroy some of his property to demonstrate how much he had.

This ritual was also used as a social weapon; since guests were expected to reciprocate, a poorer rival could be humiliated by inviting him to a lavish potlatch. The need to give away as much as the host, even though he could not afford it, would essentially force the hapless guest into bankruptcy. If this practice sounds "primitive," think for a moment about many modern weddings. Parents commonly invest huge sums of money to throw a lavish party and compete with others for the distinction of giving their daughter the "best" or most extravagant wedding, even if they have to save for twenty years to do it.

Another modern potlatch is the deluxe gift vacation. Many gift vacations are tied to celebrations such as milestone birthdays or anniversaries. In the age of "Entourage" (on HBO), many Gen Xers like to travel in groups; those with the means have been known to pay for the rest. Many wealthy Americans are indulging in lavish, exotic trips surrounded by friends and family. One gift vacation was the site of a seven-bedroom villa on Anguilla with pool, tennis court, gym, tropical gardens, and a staff of fourteen. At $33,000 per week, it was worth it for the buyer to have unstructured days with friends. One drawback to guests is the worry about reciprocation and obligation.[101]

The Leisure Class

This phenomenon of conspicuous consumption was, for Veblen, most evident among what he termed the *leisure class,* people for whom productive work is taboo. In Marxist terms, such an attitude reflects a desire to link oneself to ownership or control of the means of production, rather than to the production itself. Any evidence that one actually has to labor for a living is to be shunned, as suggested by the term the "idle rich."

Like the potlatch ritual, the desire to convince others that one has a surplus of resources creates the need for evidence of this abundance. Accordingly, priority is given to consumption activities that use up as many resources as possible in nonconstructive pursuits. This *conspicuous waste* in turn shows others that one has the assets to spare.

The Death—and Rebirth—of Status Symbols

While ostentatious products fell out of favor in the early 1990s, there has been a resurgence of interest in luxury goods. Companies such as Hermes International, LVMH (Moët Hennessy Louis Vuitton), and Baccarat have enjoyed sales gains as affluent consumers once again indulge their desires for the finer things in life. This prosperity trickles down to many middle-class workers, some of whom reap riches from company stock options they received. Maybe that's why Hermes sells out of its handbags that cost up to $14,000, or why Gulfstream reported that it has back orders for almost one hundred luxury jets.[102] Alan Millstein, publisher of *Fashion Network Report*, a New York–based retail newsletter, said, "Luxury is hot and it's portable. Brand names synonymous with status goods are selling well nationwide. If someone is committed to owning a Gucci, price is no object. These born-again needs have no intrinsic value. It's all a desire to show success."[103]

One market researcher termed this trend "the pleasure revenge"—people were just tired of buying moderately, eating low-fat foods, and so on, and as a result, sales for self-indulgent products from fur coats to premium ice creams and caviar boomed. As the chairman of LVMH put it, "The appetite for luxury is as strong as ever. The only difference is that in the 1980s, people would put a luxury trademark on anything. Today only the best sells."[104]

However, soon after the September 11 attacks, apparel sales in general were down, while the luxury market was especially hard hit. Consumers were depressed and fearful of future terrorist attacks, their confidence had fallen, and they avoided trendy and high-ticket items.[105] One result of this downturn in the luxury market was the number of bankruptcies in the "young designer" category. Industry analysts say there are too many ready-to-wear collections with too little identity chasing too few customers. Also designer RTW is a $10 billion industry worldwide, but it offers the lowest margins.[106]

Some consumers, although they can afford expensive high-status items, enjoy the challenge of finding them at bargain prices. Consignment shops have increased their market share considerably with 10 percent annual growth, much higher than other retail segments. Shops such as Michael's on New York City's Upper East Side have become very sophisticated and

choosy when selecting items to offer for sale. Some have near-cult followings with such status brands as Gucci, Prada, and Chanel. One sales official said, "You'd be surprised who shops here . . . a lot of our customers are royalty, celebrity types, and Park Avenue socialites. They do the consignment circuit and then they have lunch at Bergdorf's."[107]

While consumers appear to be displaying a renewed appetite for extravagance, many are trying to account for their lavish spending by rationalizing that these purchases merely represent good investments. The Lands' End catalog suggests that a handmade cableknit sweater for $225 "could become an heirloom." Similarly, buying a pricey Land Rover is justified because it can be used for embarking on an adventure; showrooms now feature travel trunks, telescopes, and antique maps plus an off-road test track. The company's strategy is to offer drivers the cachet of a pricey car that is built for rugged performance without the stigma that is sometimes attached to a BMW or Mercedes. One researcher terms this trend "conditional hedonism," explaining that the affluent consumer wants a rationale to have a blast.[108]

Parody Display

As the competition to accumulate status symbols escalates, sometimes the best tactic is to switch gears and go in reverse. One way to do this is to deliberately *avoid* status symbols—in fact, to seek status by mocking it. This sophisticated form of conspicuous consumption has been termed **parody display**, conspicuous counterconsumption, reverse snobbery, and conspicuous

TRADING UP AND TRADING DOWN

Have you ever bragged about how much money you saved on an item? Many do that with purchases on eBay. Other places may not be as familiar such as the wildly popular European firm Tchibo, which features "thematic worlds" that change weekly. Also Aldi, a German-based chain and worldwide leader of the rapidly growing "hard discount" category, offers even lower prices than Wal-Mart. Dollar Store, Dollar Tree, and other similar stores are expanding 10 percent annually. And higher-income consumers are the fastest-growing segment of Dollar Store customers.[110]

Michael J. Silverstein, Vice President of Boston Consulting Group, in his book, *Treasure Hunt: Inside the Mind of the New Consumer*, says today's consumers are spending their money at the high end of the spectrum but are also bargain-hunting to save money for those high-end splurges.[111] Consumers across the income spectrum are seeking out their own version of treasure—bargains at a variety of places like Target, Wal-Mart, Costco, Lowe's, and Dollar General. They are doing this because they don't want to overpay for something, but also so they can have more money to splurge on luxury brands and personal indulgences.

Forty-eight million middle-class households that earn between $50,000 and $100,000 per year control 75 percent of all discretionary income in the United States. Life is a constant balance of needs and wants, and these consumers apply a "value calculus" that helps determine the desired price when trading down and the desired level of quality when trading up.

Trading down—obtaining the best value at the best price—accounts for approximately $1 trillion of the $3.7 trillion in consumer spending in the United States. Eight broad categories are capturing the most trading-down dollars: homes, transportation, dining out, travel, food and beverage, personal items; fashion products, and home goods. In 2004, trade-down purchases of women's apparel increased 9 percent over levels of ten years earlier. Trade-ups in this category grew by 9 percent also.[112] What do you think this says for the middle-of-the-road retailer?

Consider the results of an American Affluence Research Center study of consumers with an average annual income of $359,000: 61 percent shop at Target, 54 percent shop at Costco, and 30 percent shop at Wal-Mart.[113]

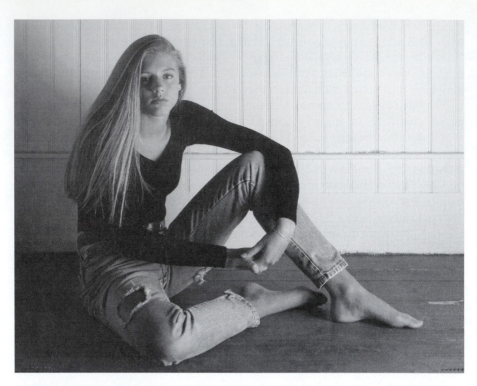

Ripped jeans (especially the pricey kind that come that way when you buy them) are an example of parody display.

outrage.[109] A Diesel ad shows this parody display by showing the life of "trailer trash." Woody Allen once wore a tuxedo to the Academy Awards, but he added his own twist by wearing tennis shoes as a way of showing his contempt for the display of wealth and lavishness at this event. This strategy is intended to show that one is so witty and "in the know" that status symbols aren't necessary. Hence, we have the popularity of old, ripped blue jeans and "utility" vehicles such as Jeeps among the upper classes (such as the Caldwells). Thus, "true" status is shown by the adoption of product symbolism that is deliberately not fashionable.

CHANGING STATUS SYMBOLS

Since the products and activities that connote high status are always changing, a significant amount of marketing effort goes into educating consumers as to what specific symbols they should be displaying and to ensuring that a product is accepted in the pantheon of status symbols.

The need to display the "right" symbols has been a boon to the publishing industry, where a variety of "how-to" books, magazines, and videos are available to school willing students of status. The concept of "dressing for success," where detailed instructions are provided to allow people to dress as if they are members of the upper middle class (at least the authors' versions of this) was one popular example.[114]

CHAPTER SUMMARY

- The field of behavioral economics considers how consumers decide what to do with their money. In particular, discretionary expenditures are made only when people are able and willing to spend money on items above and beyond their basic needs. Much of fashion is bought with this discretionary income; however, some groups treat it as a necessity of life! Consumer confidence—the state of mind consumers have about their own personal situation, as well as their feelings about their overall economic prospects—helps to determine whether they will purchase goods and services, take on debt, or save their money.

- A consumer's social class refers to his or her standing in society. It is determined by a number of factors, including education, occupation, and income.

- Virtually all groups make distinctions among members in terms of relative superiority, power, and access to valued resources. This social stratification creates a status hierarchy, where some goods are preferred over others and are used to categorize their owners' social class.

- Clothing has been used throughout history to maintain class distinctions. Sumptuary laws restricted the types of dress that could be worn by certain classes. Today social classes are more fluid, and consumers are free to choose their own lifestyles and clothing reflects that choice.

- Although income is an important indicator of social class, the relationship is far from perfect. Social class is also determined by such factors as place of residence, cultural interests, and worldview.

- Purchase decisions are sometimes influenced by the desire to "buy up" to a higher social class or to engage in the process of conspicuous consumption, where one's status is flaunted by the deliberate and nonconstructive use of valuable resources. This spending pattern is a char-acteristic of the *nouveaux riches*, whose relatively recent acquisition of income, rather than ancestry or breeding, is responsible for their increased social mobility.

- Fashion excess can occur at many levels: high price; designer labels; superfluous waste; quantity of clothes for many occasions, for every season, in every color; and a continual change in fashion styles for which consumers feel they need to replace wardrobes.

- Fashion is often used as status symbols to communicate real or desired social class. Parody display occurs when consumers seek status by deliberately avoiding fashionable products.

KEY TERMS

discretionary income	status hierarchy	status symbols
consumer confidence	status	invidious distinction
social class	chavs	conspicuous
social location	social mobility	consumption
sumptuary laws	mass class	parody display
social stratification	cultural capital	

DISCUSSION QUESTIONS

1. Sears, JCPenney, and—to a lesser degree—Kmart have made concerted efforts in recent years to upgrade their images and appeal to higher-class consumers. How successful have these efforts been? Do you believe this strategy is wise?

2. What are some of the obstacles to measuring social class in today's society? Discuss some ways to get around these obstacles.

3. What differences in clothing purchases might you expect to observe between a family characterized as underprivileged versus one whose income is average for its social class?

4. When is social class likely to be a better predictor of consumer behavior than mere knowledge of a person's income?

5. How do you assign people to social classes, or do you at all? What consumption cues do you use (clothing, speech, cars, and so on) to determine social standing?

6. Thorstein Veblen argued that women were often used as a vehicle to display their husbands' wealth. Is this argument still valid today?

7. Given present environmental conditions and dwindling resources, what is the future of "conspicuous waste"? Can the desire to impress others with affluence ever be eliminated? If not, can it take on a less dangerous form?

8. Some people argue that status symbols are dead. Do you agree? What fashion shows high status?

9. Using the status index presented in Figure 7-3, compute a social class score for people you know, including their parents if possible. Ask several friends (preferably from different places) to compile similar information for people they know. How closely do your answers compare? If you find differences, how can you explain them?

10. Compile a list of occupations and ask a sample of students in a variety of majors to rank the prestige of these jobs. Can you detect any differences in these rankings as a function of students' majors?

11. Compile a collection of ads depicting consumers of different social classes. What generalizations can you make about the reality of these ads and about the media in which they appear?

ENDNOTES

1. Data in this section adapted from Fabian Linden, *Consumer Affluence: The Next Wave* (New York: The Conference Board, 1994). For additional information about U.S. income statistics, access Occupational Employment and Wage Estimates at http://www.bls.gov/oes/oes_data.htm.
2. Sylvia Ann Hewlett, "Feminization of the Workforce," *New Perspectives Quarterly* 98 (July 1, 1998): 66–70.
3. Mary Bowler, "Women's Earnings: An Overview," *Monthly Labor Review* 122 (December 1999): 13–22.
4. Christopher D. Carroll, "How Does Future Income Affect Current Consumption?," *Quarterly Journal of Economics* 109, no. 1 (February 1994): 111–147.
5. "The Big Chill—Not," *Women's Wear Daily* (April 10, 2000): 26–27.
6. Robert Sullivan, "Americans and Their Money," *Worth* (June 1994): 60.
7. José F. Medina, Joel Saegert, and Alicia Gresham, "Comparison of Mexican-American and Anglo-American

Attitudes toward Money," *The Journal of Consumer Affairs* 30, no. 1 (1996): 124–145.

8. Kirk Johnson, "Sit Down. Breathe Deeply. This Is *Really* Scary Stuff," *New York Times* (April 16, 1995): F5.

9. Fred van Raaij, "Economic Psychology," *Journal of Economic Psychology* 1 (1981): 1–24.

10. Richard T. Curtin, "Indicators of Consumer Behavior: The University of Michigan Surveys of Consumers," *Public Opinion Quarterly* (1982): 340–352.

11. George Katona, "Consumer Saving Patterns," *Journal of Consumer Research* 1 (June 1974): 1–12.

12. Susan Kaiser, *The Social Psychology of Clothing: Symbolic Appearances in Context* (New York: Fairchild, 1997).

13. Floyd L. Ruch and Philip G. Zimbardo, *Psychology and Life*, 8th ed. (Glenview, Ill.: Scott Foresman, 1971).

14. Jonathan H. Turner, *Sociology: Studying the Human System*, 2nd ed. (Santa Monica, CA: Goodyear, 1981).

15. Turner, *Sociology: Studying the Human System.*

16. G. Sjoberg, *The Preindustrial City: Past and Present* (New York: Free Press, 1960).

17. V. M. Garrett, *Chinese Clothing: An Illustrated Guide* (Hong Kong: Oxford University Press, 1994).

18. Richard P. Coleman, "The Continuing Significance of Social Class to Marketing," *Journal of Consumer Research* 10 (December 1983): 265–280; Turner, *Sociology: Studying the Human System.*

19. Quoted in Richard P. Coleman and Lee Rainwater, *Standing in America: New Dimensions of Class* (New York: Basic Books, 1978), 89.

20. Coleman and Rainwater, *Standing in America: New Dimensions of Class.*

21. Turner, *Sociology: Studying the Human System.*

22. James Fallows, "A Talent for Disorder (Class Structure)," *U.S. News & World Report* (February 1, 1988): 83.

23. Coleman, "The Continuing Significance of Social Class to Marketing"; W. Lloyd Warner with Paul S. Lunt, *The Social Life of a Modern Community* (New Haven, Conn.: Yale University Press, 1941).

24. Craig S. Smith, "Chinese Speak the International Language of Shopping," *New York Times*, www.nytimes.com (November 7, 2006).

25. Russell Flannery, "Long Live the $25 Cigar," *Forbes* (December 27, 2004): 51; Clay Chandler, "China Deluxe," *Fortune* (July 26, 2004): 149–156; Matthew Forney, "How Nike Figured Out China," *Time* (November 2004): A10–A14; J. David Lynch, "Emerging Middle Class Reshaping China," *USA Today* (November 12, 2002): 13A.

26. James Sterngold, "How Do You Define Status? A New BMW in the Drive. An Old Rock in the Garden," *The New York Times* (December 28, 1989): C1.

27. Cecilie Rohwedder, "Design Houses Build Stores, Pamper Demanding Shoppers in Fashion-Industry Hot Spot," *Wall Street Journal on the Web* (January 23, 2004).

28. Robin Knight, "Just You Move Over, 'Enry 'Iggins; A New Regard for Profits and Talent Cracks Britain's Old Class System," *U.S. News & World Report* 106 (April 24, 1989): 40.

29. Robert Guy Matthews, "Bawdy British Ads Target Hot Youth," *Wall Street Journal* (April 20, 2005): B9.

30. Andrew E. Kramer, "New Czars of Conspicuous Consumption," *New York Times* (November 1, 2006): C1, C10.

31. Maria Danilova, "A Shopping Playground for Russia's Very Rich," *San Francisco Chronicle* (November 5, 2006): F6.

32. Jim Yardley, "First Comes the Car, Then the $10,000 License Plate," *New York Times* (July 5, 2006): C4.

33. Jennifer Steinhauer, "When the Joneses Wear Jeans," *New York Times Online* (May 29, 2005); Paul F. Nunes, Brian A. Johnson, and R. Timothy S. Breene, "Moneyed Masses," *Harvard Business Review* (July-August 2004): 94–104; *Trend Update: Massclusivity*, report from Reinier Evers and Trendwatching.com, accessed at Zyman Institute of Brand Science, Emory University, www.zibs.com (February 25, 2005).

34. Eric Wilson, "Fashion's Tectonics: Designers in a Tizzy Over Masstige Shift," *Women's Wear Daily* (September 12, 2004): 1, 34, 36.

35. "Truly Fast Fashion: H&M's Lagerfeld's Line Sells Out in Hours," *Women's Wear Daily* (September 15, 2004): 1, 28; Miles Scoha, "Viktor & Rolf Walk Down Aisle with H&M," *Women's Wear Daily* (September 28, 2006): 10.

36. Turner, *Sociology: Studying the Human System*, p. 260.

37. See Ronald Paul Hill and Mark Stamey, "The Homeless in America: An Examination of Possessions and Consumption Behaviors," *Journal of Consumer Research* 17 (December 1990): 303–321; estimate provided by Dr. Ronald Hill, personal communication (December 1997).

38. Joseph Kahl, *The American Class Structure* (New York: Holt, Rinehart and Winston, 1961).

39. Leonard Beeghley, *Social Stratification in America: A Critical Analysis of Theory and Research* (Santa Monica, CA: Goodyear, 1978).

40. Quentin Bell, *On Human Finery* (London: Hogarth, 1947), 72.

41. Elaine Stone, *The Dynamics of Fashion* (New York: Fairchild, 1999).

42. Coleman and Rainwater, *Standing in America: New Dimensions of Class*, p. 220.

43. Turner, *Sociology: Studying the Human System.*

44. See Coleman, "The Continuing Significance of Social Class to Marketing"; Charles M. Schaninger, "Social Class versus Income Revisited: An Empirical Investigation," *Journal of Marketing Research* 18 (May 1981): 192–208.

45. Coleman, "The Continuing Significance of Social Class to Marketing."

46. August B. Hollingshead and Fredrick C. Redlich, *Social Class and Mental Illness: A Community Study* (New York: Wiley, 1958).

47. John Mager and Lynn R. Kahle, "Is the Whole More Than the Sum of the Parts? Re-Evaluating Social Status in Marketing," *Journal of Business Psychology* 10 (Fall 1995): 3–18.

48. Beeghley, *Social Stratification in America.*

49. R. Vanneman and F. C. Pampel, "The American Perception of Class and Status," *American Sociological Review* 42 (June 1977): 422–437.

50. Donald W. Hendon, Emelda L. Williams, and Douglas E. Huffman, "Social Class System Revisited," *Journal of Business Research* 17 (November 1988): 259.

51. Coleman, "The Continuing Significance of Social Class to Marketing."

52. Richard P. Coleman, "The Significance of Social Stratification in Selling," in *Marketing: A Maturing Discipline, Proceedings of the American Marketing Association*

43rd National Conference, ed. Martin L. Bell (Chicago: American Marketing Association, 1960), 171–184.

53. David Lazarus, "Overcoming the New-Money Blues," *San Francisco Chronicle* (February 8, 2000): C1.

54. E. Barth and W. Watson, "Questionable Assumptions in the Theory of Social Stratification," *Pacific Sociological Review* 7 (Spring 1964): 10–16.

55. Zick Rubin, "Do American Women Marry Up?," *American Sociological Review* 33 (1968): 750–760.

56. Sue Browder, "Don't Be Afraid to Marry Down," *Cosmopolitan* (June 1987): 236.

57. K. U. Ritter and L. L. Hargens, "Occupational Positions and Class Identifications of Married Working Women: A Test of the Asymmetry Hypothesis," *American Journal of Sociology* 80 (January 1975): 934–948.

58. J. Michael Munson and W. Austin Spivey, "Product and Brand-User Stereotypes Among Social Classes: Implications for Advertising Strategy," *Journal of Advertising Research* 21 (August 1981): 37–45.

59. Stuart U. Rich and Subhash C. Jain, "Social Class and Life Cycle as Predictors of Shopping Behavior," *Journal of Marketing Research* 5 (February 1968): 41–49.

60. Thomas W. Osborn, "Analytic Techniques for Opportunity Marketing," *Marketing Communications* (September 1987): 49–63.

61. Nancy Cassill and Mary Frances Drake, "Employment Orientation's Influence on Lifestyle and Evaluative Criteria for Apparel," *Home Economics Research Journal* 16, no. 1 (1987): 23–25.

62. Soyeon Shim and Mary Frances Drake, "Apparel Selection by Employed Women: A Typology of Information Search Patterns," *Clothing and Textiles Research Journal* 6, no. 2 (1988): 1–9.

63. Kaiser, *The Social Psychology of Clothing: Symbolic Appearances in Context.*

64. Dorothy Behling, "Three and a Half Decades of Fashion Adoption Research: What Have We Learned?," *Clothing and Textiles Research Journal* 10, no. 2 (1992): 34–41.

65. J. Lebow, "Big Beauties Search Reflects Larger Outlook," *Women's Wear Daily* (August 26, 1986): 21.

66. Coleman, "The Continuing Significance of Social Class to Marketing."

67. Jeffrey F. Durgee, "How Consumer Sub-Cultures Code Reality: A Look at Some Code Types," in *Advances in Consumer Research* 13, ed. Richard J. Lutz (Provo, Utah: Association for Consumer Research, 1986), 332–337.

68. David Halle, *America's Working Man: Work, Home, and Politics among Blue-Collar Owners* (Chicago: University of Chicago Press, 1984).

69. Quoted in Coleman and Rainwater, *Standing in America: New Dimensions of Class*, p. 139.

70. Quoted in Roger Brown, *Social Psychology* (New York: Free Press, 1965): 43.

71. Kit R. Roane, "Affluenza Strikes Kids," *U.S. News & World Report* (March 20, 2000): 55.

72. Tamar Lewin, "Next to Mom and Dad: It's a Hard Life (or Not)," *New York Times on the Web* (November 7, 1999).

73. Pierre Bourdieu, *Distinction: A Social Critique of the Judgment of Taste* (Cambridge, Mass.: Cambridge University Press, 1984); see also Douglas B. Holt,

"Does Cultural Capital Structure American Consumption?," *Journal of Consumer Research* 1, no. 25 (June 1998): 1–25.

74. Paula Mergenhagen, "What Can Minimum Wage Buy?," *American Demographics* (January 1996): 32–36.

75. Linda F. Alwitt and Thomas D. Donley, "Retail Stores in Poor Urban Neighborhoods," *Journal of Consumer Affairs* 31, no. 1 (1997): 108–127.

76. Robert Sharoff, "Book Chain Taps Underserved Neighborhoods," *Wall Street Journal* (February 25, 2004).

77. Susan Chandler, "Data Is Power. Just Ask Fingerhut," *Business Week* (June 3, 1996): 69.

78. Sharon Edelson, "Missing $100B Market: Low-Income Consumers Overlooked by Retailers," *Women's Wear Daily* (October 13, 2005): 1, 18.

79. Quoted in Richard Elliott, "How Do the Unemployed Maintain Their Identity in a Culture of Consumption?," *European Advances in Consumer Research* 2 (1995): 3.

80. Cyndee Miller, "New Line of Barbie Dolls Targets Big, Rich Kids," *Marketing News* (June 17, 1996): 6.

81. Cyndee Miller, "Baubles Are Back," *Marketing News* (April 14, 1997): 1.

82. David Moin, "Rethinking the Mall: Higher-End Products, Less Square Footage," *Women's Wear Daily* (June 6, 2000): 1, 8–9.

83. "Reading the Buyer's Mind," *U.S. News & World Report* (March 16, 1987): 59.

84. Rebecca Piirto Heath, "Life on Easy Street," *American Demographics* (April 1997): 33–38.

85. Rebecca Gardyn, "Oh, the Good Life." *American Demographics* (November 2002): 34.

86. Louis Uchitelle, "Gilded Paychecks: Lure of Great Wealth Affects Career Choices," *New York Times*, www.nytimes.com (November 27, 2006).

87. Paul Fussell, *Class: A Guide through the American Status System* (New York: Summit Books, 1983), 30.

88. Elizabeth C. Hirschman, "Secular Immortality and the American Ideology of Affluence," *Journal of Consumer Research* 17 (June 1990): 31–42.

89. Coleman and Rainwater, *Standing in America: New Dimensions of Class*, p. 150.

90. Kerry A. Dolan, "The World's Working Rich," *Forbes* (July 3, 2000): 162.

91. Jason DeParle, "Spy Anxiety: The Smart Magazine That Makes Smart People Nervous about Their Standing," *Washingtonian Monthly* (February 1989): 10.

92. For a recent examination of retailing issues related to the need for status, see Jacqueline Kilsheimer Eastman, Leisa Reinecke Flynn, and Ronald E. Goldsmith, "Shopping for Status: The Retail Managerial Implications," *Association of Marketing Theory and Practice* (Spring 1994): 125–130.

93. Maritz Poll: The Rich Reap More Rewards From Loyalty Programs (February 2005), www.maritz.com.

94. Jeanette Lauer and Robert Lauer, *Fashion Power* (Upper Saddle River, N.J.: Prentice-Hall, 1981).

95. Alison Lurie, *The Language of Clothes* (New York: Vintage Books, 1981).

96. Georg Simmel, "Fashion," *American Journal of Sociology* 62 (1957): 541–558.

97. Thorstein Veblen, *Theory of the Leisure Class* (New York: Macmillan, 1899): 120.

98. John Brooks, *Showing Off in America* (Boston: Little, Brown, 1981), 13.

99. Thorstein Veblen, *Theory of the Leisure Class*, p. 121.

100. Lurie, *The Language of Clothes*.

101. Shivani Vora, "A Deluxe Vacation, Your Friends Included," *New York Times,* www.nytimes.com (October 26, 2006).

102. Michael Shnayerson, "The Champagne City," *Vanity Fair* (December 1997): 182–202.

103. Frances Hong, "If You've Got It Flaunt It," *San Francisco Examiner* (December 28, 1997): C1, C4.

104. Quoted in Miller, "Baubles Are Back"; Elaine Underwood, "Luxury's Tide Turns," *Brandweek* (March 7, 1994): 18–22.

105. "Terrorism's Trauma Casts Dark Shadow Over Luxury Sector," *Women's Wear Daily* (October 25, 2001): 1, 24, 26.

106. Miles Socha, "The Luxury Hangover: Designers Struggling with Harsher Reality," *Women's Wear Daily* (July 1, 2002): 1, 6, 7.

107. Anne D'Innocenzio, "Status Labels—the Second Time Around," *Women's Wear Daily* (March 18, 1999): 8–9.

108. Joshua Levine, "Conditional Hedonism," *Forbes* (February 10, 1997): 154.

109. Brooks, *Showing Off in America;* F. Simon-Miller, "Commentary: Signs and Cycles in the Fashion System," in *The Psychology of Fashion,* (Lexington, Mass.: Lexington Books, 1985); Lurie, *The Language of Clothes*.

110. "Today's Savvy Shoppers Think High and Low," *Pittsburgh Post-Gazette* (region edition), (August 6, 2006): C3.

111. Michael J. Silverstein and John Butman, *Treasure Hunt: Inside the Mind of the New Consumer* (Portfolio, an Imprint of Penguin Group USA, 2006); Laura Landro, "When Luxury Meets Parsimony," *The Wall Street Journal* (June 22, 2006): D7.

112. "Consumers Finding Satisfaction, for Less," *Women's Wear Daily* (April 26, 2006): 6.

113. "Lifestyles of the Super Wealthy," *Women's Wear Daily* (June 3, 2004): 12.

114. For examples, see John T. Molloy, *Dress for Success* (New York: Warner Books, 1975); Vicki Keltner and Mike Holsey, *The Success Image* (Houston, Tex.: Gulf, 1982); and William Thourlby, *You Are What You Wear* (New York: New American Library, 1978).

8
Psychographics
Personality, Attitudes, and Lifestyle

Nancy and Anna, executives in a high-powered L.A. advertising agency, are exchanging ideas about how they are going to spend the big bonus everyone in the firm has been promised for landing the Gauntlet body jewelry account. They can't help but snicker at their friend Margie in accounting, who has avidly been surfing the Net for information about a state-of-the-art home theater system she plans to put into her condo. What a couch potato! Nancy, who fancies herself a bit of a thrill seeker, plans to blow her bonus on a wild trip to Colorado where a week of outrageous bungee-jumping awaits her (assuming she lives to tell about it). Anna replies, "Been there, done that . . . I'm

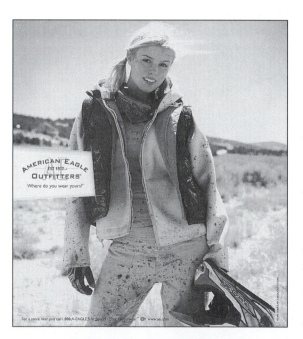

AMERICAN EAGLE OUTFITTERS®
Where do you wear yours?

For a store near you call 1.888.A-EAGLES or Shop'n Your Underwear @ www.ae.com

climbing on my new bike and going to Nevada for the next big race." Seems that Anna's been bitten by the biking bug since she started checking out www.motorcycle.com and *Woman Rider,* an enthusiast's magazine targeted to the growing number of women taking up the sport.

Nancy and Anna are sometimes amazed at how different they are from Margie, who's content to spend her downtime watching sappy old movies or reading books. All three women make about the same salary, and Anna and Margie even went to the same college together. How can their tastes be so different? Oh well, they figure, that's why they make chocolate and vanilla. . . .

PERSONALITY

Nancy and Anna are typical of many people who search for new (and even risky) ways to spend their leisure time. This desire has meant big business for the "adventure travel" industry, which specializes in providing white-knuckled experiences. Adventure travel has become a "fashionable" way to spend leisure time. Sports like bungee jumping, white-water rafting, skydiving, motorcycling, mountain biking, and other physically stimulating activities now account for about one-fifth of the U.S. leisure travel-market.[1] The U.S. Bungee Association estimates that there have been 7 million jumps since the late 1980s, while the U.S. Parachute Association continues to report an increase in membership. And although motorcycle culture used to be a man's thing, now women are fueling the sports' resurgence in popularity. The new concept of extreme sports involve high-intensity, individualistic sports, from snowboarding to Moto-X (a scary contest in which motorcyclists attempt ski jumps). Gen X and Gen Y members ar not only taking part in extreme sports, but they're also watching the X-Games on ESPN.

Just what does make Nancy and Anna so different from their more sedate friend Margie? One answer may lie in the concept of **personality**, which refers to a person's unique psychological makeup and how it consistently influences the way a person responds to his or her environment.

In recent years, the nature of the personality construct has been hotly debated. Many studies have found that people tend not to behave consistently across different situations and that they do not seem to exhibit stable personalities. In fact, some researchers argue that this is merely a convenient way to think about other people.

This argument is a bit hard to accept intuitively, possibly because we tend to see others in a limited range of situations, and so to us, most people do act consistently. On the other hand, we each know that we are not all that consistent; we may be wild and crazy at times and the model of respectability at others. While certainly not all psychologists have abandoned the idea of personality, many now recognize that a person's underlying characteristics are but one part of the puzzle and that situational factors often play a very large role in determining behavior.[2]

Still, some aspects of personality continue to be included in marketing strategies. These dimensions are usually employed in concert with a person's choices of leisure activities, political outlook, fashion and aesthetic tastes, and other individual factors to segment consumers in terms of *lifestyles,* a process we'll focus on more fully later in this chapter.

Many approaches to understanding the complex concept of personality can be traced to psychological theorists who began to develop these perspectives in the early part of the century. These perspectives were qualitative, in the sense that they were largely based on analysts' interpretations of patients' accounts of dreams, traumatic experiences, and encounters with others.

Consumer Behavior on the Couch: Freudian Theory

Sigmund Freud developed the idea that much of one's adult personality stems from a fundamental conflict between a person's desire to gratify his or her physical needs and the necessity to function as a responsible member of

society. This struggle is carried out in the mind among three systems. (*Note:* These systems do *not* refer to physical parts of the brain.)

Freudian Systems

The **id** is entirely oriented toward immediate gratification—it is the "party animal" of the mind. It operates according to the **pleasure principle**; behavior is guided by the primary desire to maximize pleasure and avoid pain. The id is selfish and illogical. It directs a person's psychic energy toward pleasurable acts without regard for any consequences.

The **superego** is the counterweight to the id. This system is essentially the person's conscience. It internalizes society's rules (especially as communicated by parents) and works to prevent the id from seeking selfish gratification.

Finally, the **ego** is the system that mediates between the id and the superego. It is in a way a referee in the fight between temptation and virtue. The ego tries to balance these two opposing forces according to the **reality principle**, whereby it finds ways to gratify the id that will be acceptable to the outside world. These conflicts occur on an unconscious level, so the person is not necessarily aware of the underlying reasons for behavior.

Some of Freud's ideas have been adapted by consumer researchers. In particular, his work highlights the potential importance of unconscious motives underlying purchases. This perspective hints at the possibility that the ego relies on the symbolism in products to compromise between the demands of the id and the prohibitions of the superego. The person channels his or her unacceptable desire into acceptable outlets by using products that signify these underlying desires. This is the connection between product symbolism and motivation: The product stands for, or represents, a consumer's true goal, which is socially unacceptable or unattainable. By acquiring the product, the person is able to vicariously experience the forbidden fruit.

Fashion Theories Based on Freud

Fashion theories based on a psychoanalytic approach focus on the sexual symbolism of fashion. According to the theory, individuals subconsciously adopt and wear sexual symbols in clothing to fulfill hidden sexual drives and communicate desires. One analysis in dress indicated that women could assess the sexual impact of their clothing on men, and those who perceived themselves as sexually attractive preferred sexually arousing styles of clothes.[3] Although the psychoanalytic approach has not been used to any great extent to explain fashion adoption, some authors have used it to examine historic ideals of beauty.[4] Such clothing accessories as umbrellas, walking sticks, neckties, and breast-pocket kerchiefs have been likened to phallic symbols throughout history.[5]

James Laver's *theory of shifting erogenous zones* also has connections to Freudian theory as used in an attempt to explain fashion change.[6] As described in Chapter 1, the theory states that changes in fashion occur concurrently with changes in perceived erogenous zones of the female body. Constant eroticism can occur when the erotic emphasis in clothing is altered. For example, in the 1920s, legs were very exciting with the onset of short skirts, as legs had previously been covered with long skirts and pantaloons.

Laver calls this phenomenon "erotic capital" that had been built up over the years. As one student put it, "it takes a long time of being covered up to get a thrill out of seeing it." Laver states it this way: "Fashion serves to maintain interest in the body by concealing parts of it long enough to build up its erotic capital." Similar to the 1920s' sexy legs, the backless dresses of the 1930s became sexy as the long covered back had built up its erotic capital. Two-piece bathing suits in the 1960s uncovered the midriff. Over the years other parts of the body have been emphasized through the use of clothing: legs with tight pants, waists with the use of belts, breasts with low-cut necklines, even feet with thin strappy sandals and heels. Generally the erogenous zones include legs, back, breasts and derrière. They are always shifting, and innovative fashion is considered daring as it exposes a new zone.

Trait Theory

One approach to personality is to focus on the quantitative measurement of **traits**, or identifiable characteristics that define a person. For example, people can be distinguished by the degree to which they are socially outgoing (the trait of *extroversion*)—Margie might be described as an introvert (quiet and reserved), while her co-worker Nancy is an extrovert.

Some specific traits that are relevant to consumer behavior include *innovativeness* (the degree to which a person likes to try new things), *materialism* (the amount of emphasis placed on acquiring and owning products), *self-consciousness* (the degree to which a person deliberately monitors and controls the image of the self that is projected to others), and *need for cognition* (the degree to which a person likes to think about things and by extension expend the necessary effort to process brand information).[7]

Since large numbers of consumers can be categorized in terms of their standing on various traits, these approaches can in theory be used for segmentation purposes. If a manufacturer, for example, could determine that individuals who fit a trait profile are more likely to prefer his product with certain features, this match could be used to great advantage. The notion that consumers buy products that are extensions of their personalities makes intuitive sense. As we'll see shortly, this idea is endorsed by many marketing managers, who try to create *brand personalities* that will appeal to different types of consumers.

Explaining Fashion Selection through Trait Theories

Researchers attempting to connect personality and fashion selection have used the *trait theory* approach. Aiken related five orientations toward dress with personality characteristics using the following profiles:[8]

- *Decoration in dress:* those scoring high on decoration tended to be conventional, conscientious, stereotyped, conforming, nonintellectual, sympathetic, sociable, and submissive.
- *Comfort in dress:* those scoring high on comfort tended to be self-controlled, socially cooperative, sociable, thorough, and deferent to authority.
- *Interest in dress:* those scoring high on interest were similar to those in the decoration profile.

- *Conformity in dress:* those scoring high on conformity in dress tended to be socially conforming, restrained, moral, traditional, and submissive.
- *Economy in dress:* those scoring high on economy tended to be responsible, alert, conscientious, efficient, precise, and controlled.

This study showed overlap in categories but was an early attempt to predict specific fashion consumer behavior from personality.

Fashion studies, similar to other marketing studies, have shown inconsistent results in relation to personality. Several have found that personality traits are generally not related to fashion innovativeness or opinion leadership (discussed more in Chapter 12). But other researchers have found the following personality traits of fashion innovators or leaders:[9]

- Higher tolerance of ambiguity, self-acceptance, and security
- Assertiveness, being likable, less depressive, and less shy
- Emotional stability, ascendancy; competitive exhibitionism, venturesomeness, self-confidence, gregariousness, assertiveness
- Conformity; impulsiveness, exhibitionism, and narcissism
- Lower levels of anxiety; higher levels of cognitive complexity (to some degree)

Brand Personality

We usually think about people with personalities. But do products have personalities? In 1886, a momentous event occurred—the Quaker Oats man first appeared on boxes of hot cereal. Quakers had a reputation in nineteenth-century America for being shrewd but fair, and peddlers sometimes dressed as Quakers for this reason. When the cereal company decided to "borrow" this imagery for its packaging, this signaled the recognition that purchasers might make the same associations with its product.[10]

A **brand personality** is the set of traits people attribute to a product as if it were a person. These inferences about a product's "personality" are an important part of **brand equity**, which refers to the extent that a consumer holds strong, favorable, and unique associations about a brand in memory.[11] Name recognition has become so valuable that some companies are completely outsourcing production to focus on nurturing the brand. Nike doesn't own any sneaker factories, and Sara Lee sold off many of its bakeries, meat-processing plants, and textile mills to become a "virtual" corporation. Its CEO commented, "Slaughtering hogs and running knitting machines are businesses of yesterday."[12]

So, how do people think about brands? Advertisers are keenly interested in this question, and several conduct extensive consumer research to help them understand how consumers connect to a brand before they roll out campaigns. DDB Worldwide does a global study of 14,000 consumers, called "Brand Capital," for this purpose; Leo Burnett's "Brand Stock" project involves 28,000 interviews. WPP Group has "BrandZ" and Young & Rubicam has its "Brand Asset Valuator." DDB's worldwide brand planning director observes, "We're not marketing just to isolated individuals. We're marketing to society. How I feel about a brand is directly related and affected by how others feel about that brand." The logic behind this bonding approach is that

Table 8-1 Brand Behaviors and Possible Personality Trait Inferences

Brand Action	Trait Inference
Brand is repositioned several times or changes its slogan repeatedly	Flighty, schizophrenic
Brand uses continuing character in its advertising	Familiar, comfortable
Brand charges a high price and uses exclusive distribution	Snobbish, sophisticated
Brand is frequently available on a deal	Cheap, uncultured
Brand offers many line extensions	Versatile, adaptable
Brand sponsors show on PBS or uses recycled materials	Helpful, supportive
Brand features easy-to-use packaging or speaks at consumer's level in advertising	Warm, approachable
Brand offers seasonal clearance sale	Planful, practical
Brand offers five-year warranty or free customer hotline	Reliable, dependable

Source: Adapted from Susan Fournier, "A Consumer-Brand Relationship Framework for Strategic Brand Management," unpublished doctoral dissertation, University of Florida (1994), Table 2.2, p. 24.

if a consumer feels a strong connection with a brand, he or she is less likely to succumb to peer pressure and switch brands.[13]

Some personality dimensions that can be used to compare and contrast the perceived characteristics of brands in various product categories include old-fashioned, wholesome, traditional, surprising, lively, with it, serious, intelligent, efficient, glamorous, romantic, sexy, rugged, outdoorsy, tough, and athletic.[14] The marketing activities undertaken on behalf of a product can influence inferences about its "personality"; some of these actions are shown in Table 8-1.

Some apparel and accessory brands are easy to visualize with personalities (this concept is not unlike that of brand image):

- Eddie Bauer and North Face—outdoors oriented
- Gap—casual
- Nike—performance
- Ralph Lauren—country chic
- Victoria's Secret—romantic, sensual, and sexy
- Rolex—expensive!

Indeed, consumers appear to have little trouble assigning personality qualities to all sorts of inanimate products, from personal-care products to more mundane, functional ones—even kitchen appliances.[15] The creation and communication of a distinctive brand personality is one of the primary ways marketers can make a product stand out from the competition and inspire years of loyalty to it. This process can be understood in terms of **animism**, the practice found in many cultures whereby inanimate objects are given qualities that make them somehow alive. Animism is in some cases a part of a religion; sacred objects, animals, or places are believed to have magical qualities or to contain the spirits of ancestors. In our society, these objects may be "worshiped" in the sense that they are believed to impart desirable qualities to the owner, or they may in a sense become so important to a person that they can be viewed as a "friend."

Two types of animism can be identified to describe the extent to which human qualities are attributed to a product:[16]

Level 1: In the highest order of animism, the object is believed to be possessed by the soul of a being—as is sometimes the case for spokespersons or even the designer of a product. This strategy allows the consumer to feel that the spirit of the celebrity or designer is available through the brand. This occurs with many high-profile designers when an item is referred to as "a Versace" or "a Donna Karan."

Level 2: Objects are *anthropomorphized*—given human characteristics. A cartoon character or mythical creation may be treated as if it were a person, and even assumed to have human feelings. Think about such familiar *spokescharacters* as Charlie the Tuna or the Keebler Elves. In this case, the product is given selected humanlike qualities, but is not treated as human. And our favorite clothing and stores are made very personal. For example, Levi's shrink-to-fit jeans in the 1970s (and again now we see this as a "new" idea) were advertised showing a young person sitting in the bathtub to allow his jeans to become a second skin, as close to a friend as possible. We may affectionately regard and may even give nicknames to our favorite department stores. We did that for Bloomie's (Bloomingdale's) and Nordie's (Nordstrom). Some of Victoria's Secret bras are given names, and Anne Fontaine, a French designer who originally only sold white and black shirts, gives each shirt a name. She says, "I design each shirt with a particular woman in mind. . . . Sometimes it takes longer to find the name than to design the shirt."[17]

ATTITUDES

The term *attitude* is widely used in popular culture. You might be asked, "What is your attitude toward building the new mall?" A parent might scold, "Young man, I don't like your attitude." Some bars even euphemistically refer to happy hour as "an attitude adjustment period." For our purposes, though, an **attitude** is a lasting, general evaluation of people (including oneself), objects, advertisements, or issues.[18] Anything toward which one has an attitude is called an **attitude object (A_o)**. Attitudes are related to psychographics (discussed later in this chapter), which, along with personality, help describe a person's lifestyle and consumption patterns. Cotton Incorporated's *Lifestyle Monitor* describes itself as "Monitoring America's Attitudes and Behavior toward Apparel and Home Furnishings," vital to the understanding of today's market. This type of analysis is done by asking simple questions about how consumers feel about their clothing and purchasing, such as, "Are you willing to sacrifice comfort for fashion?," or their agreement with the statement, "I love to shop."

Many other studies have been done using more complex statistical analysis (one model is discussed later in this chapter) to identify attitudes related to clothing and buying clothing. For example, a more favorable attitude toward domestic (U.S.-made) apparel over imported apparel has been documented.[19] Another study found that consumer socialization affected attitudes

toward clothing and shopping when mothers' and daughters' attitudes were investigated.[20] Environmental attitudes have been found to affect specific clothing environmental attitudes.[21]

An attitude is *lasting* because it tends to endure over time. It is *general* because it applies to more than a momentary event. Consumers have attitudes toward a wide range of attitude objects, from very product-specific behaviors (such as shopping at Nordstrom rather than Macy's) to more general consumption-related behaviors (such as how much you enjoy or hate shopping for clothes). Attitudes help determine what music a person listens to or whether he or she will recycle old clothes. This section will consider the contents of an attitude, how attitudes are formed, and how they can be measured and will review some of the surprisingly complex relationships between attitudes and behavior.

The ABC Model of Attitudes

Most researchers agree that an attitude has three components: affect, behavior, and cognition. **Affect** refers to the way a consumer *feels* about an attitude object. **Behavior** involves the person's intentions to *do* something with regard to an attitude object (but, as will be discussed at a later point, an intention does not always result in an actual behavior). **Cognition** refers to the *beliefs* a consumer has about an attitude object. These three components of an attitude can be remembered as the *ABC model of attitudes.*

This model emphasizes the interrelationships among knowing, feeling, and doing. Consumers' attitudes toward a product cannot be determined by simply identifying their beliefs about it. For example, a researcher may find that shoppers "know" that a particular garment is 65 percent polyester and 35 percent cotton, and made in the United States, but this does not indicate whether they feel these attributes are good, bad, or irrelevant or whether they would actually buy the item.

Although all three components of an attitude are important, their relative importance will vary depending on a consumer's level of motivation with regard to the attitude object. Attitude researchers have developed the concept of a **hierarchy of effects** to explain the relative impact of the three components. Each hierarchy specifies that a fixed sequence of steps occurs en route to an attitude. Three different hierarchies are summarized in Figure 8-1.

The Standard Learning Hierarchy

Most attitudes have been assumed to be constructed through this process. A consumer approaches a product decision as a problem-solving process. First, he or she forms beliefs about a product by accumulating knowledge regarding relevant attributes (jeans are durable). Next, the consumer evaluates these beliefs (durability is important) and then forms a feeling or affect about the product (jeans are perfect for me; I love them).[22] Finally, based on this evaluation, the consumer engages in a relevant behavior, such as buying the product. This careful choice process often results in consumer loyalty: The consumer "bonds" with the product over time and is not easily persuaded to experiment with other brands. The *standard learning hierarchy* assumes that a consumer is highly involved in making a purchase decision.[23]

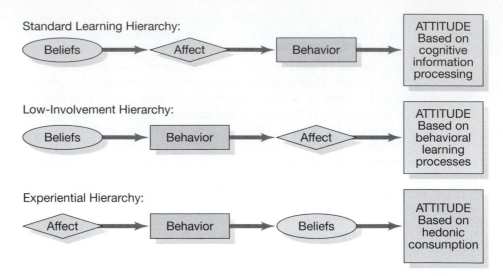

FIGURE 8-1
Three Hierarchies of Effects
Source: M. R. Solomon, *Consumer Behavior,* 8th ed., p. 259, © 2009. Reprinted by permission of Pearson Education, Inc., Upper Saddle River, NJ.

The Low-Involvement Hierarchy

A consumer can form an attitude via the *low-involvement hierarchy of effects.* In this sequence, the consumer initially does not have a strong preference for one brand over another but instead acts on the basis of limited knowledge and then forms an evaluation only after the fact.[24] The attitude is likely to come about through behavioral learning, where the consumer's choice is reinforced by good or bad experiences with the product after purchase. The possibility that consumers simply don't care much about many decisions is important, because it implies that all of the concern about influencing beliefs and carefully communicating information about product attributes may largely be wasted. Some consumers aren't necessarily going to pay attention anyway; they may be more likely to respond to simple stimulus–response connections when making purchase decisions, such as noticing that an item is on sale and making a quick decision to buy it. This results in what we might call the *involvement paradox:* The *less* important the product is to consumers, the *more* important are many of the marketing stimuli (such as point-of-purchase displays, packages, and jingles) that must be devised to sell it.

Fashion generally is a high-involvement product and, therefore, brands are vitally important to many consumers. Pantyhose or underwear, on the other hand, might be a low-involvement product for the average consumer (however, lingerie has become a fashion-oriented product and often can be quite expressive of a woman's identity).

The Experiential Hierarchy

Researchers have begun to stress the significance of emotional response as a central aspect of an attitude. According to the *experiential hierarchy of effects,* consumers act on the basis of their emotional reactions. This perspective highlights the idea that attitudes can be strongly influenced by intangible product

attributes, such as package design, and by consumers' reactions toward accompanying stimuli, such as advertising and brand names. As discussed in Chapter 4, resulting attitudes will be affected by consumers' hedonic motivations, such as how the product makes them feel or the fun its use will provide. Although fashion is a high-involvement product, it can fall under the experiential hierarchy since fashion is emotion and not necessarily rational. Fashion-oriented consumers don't necessarily follow a structured path to get to the one right item that they absolutely love and must have.

Product Attitudes Don't Tell the Whole Story

Marketers who are concerned with understanding consumers' attitudes have to contend with an even more complex issue: In decision-making situations, people form attitudes toward objects other than the product itself that can influence their ultimate selections. Additional factors to consider are attitudes toward the ad for the product (discussed below) and the act of buying in general—sometimes people simply are reluctant, embarrassed, or just plain too lazy to expend the effort to actually obtain a desired product or service.

Attitude Toward the Advertisement

Consumers' reactions to a product are influenced by their evaluations of its advertising, over and above their feelings about the product itself. Our evaluation of a product can be determined solely by our appraisal of how it's depicted in marketing communications—we don't hesitate to form attitudes toward products we've never even seen in person, much less used.

One special type of attitude object, then, is the marketing message itself. The **attitude toward the advertisement (A_{ad})** is defined as a predisposition to respond in a favorable or unfavorable manner to a particular advertising stimulus during a particular exposure occasion. For example, consumers can be influenced if they see the ad while watching a favorite TV program.[25] An ad's entertainment value can also be important.[26] Gap TV commercials with music and dancing are highly entertaining. An ad campaign for Candies shoes that targeted teens, for example, had an entertainment value for them, as people were depicted in everyday embarrassing situations.

Ads Have Feelings Too . . .

The feelings generated by an ad have the capacity to directly affect brand attitudes. Commercials can evoke a wide range of emotional responses, from disgust to happiness. These feelings can be influenced both by the way the ad is done (the specific advertising *execution*) and by the consumer's reactions to the advertiser's motives. For example, Benetton clothing ads that appealed to a social consciousness angered many consumers due to their controversial nature, and magazines even refused to run the ads so that their customers did not become alienated.

At least three emotional dimensions have been identified in commercials: pleasure, arousal, and intimidation.[27] Specific types of feelings that can be generated by an ad include the following:[28]

- *Upbeat feelings:* amused, delighted, playful
- *Warm feelings:* affectionate, contemplative, hopeful
- *Negative feelings:* critical, defiant, offended

FORMING ATTITUDES

We all have lots of attitudes, and we don't usually question how we got them. Certainly, a person isn't born with the conviction that, say, Levi's is better than Lee or that alternative music liberates the soul.

Not all attitudes are formed the same way.[29] This section will consider these differences and briefly review some theoretical perspectives that explain how attitudes form and relate to one another in the minds of consumers.

Levels of Commitment to an Attitude

Consumers vary in their *commitment* to an attitude; the degree of commitment is related to their level of involvement with the attitude object.[30] Consumers are more likely to consider brands that engender strong positive attitudes.[31]

- *Compliance:* At the lowest level of involvement, compliance, an attitude is formed because it helps in gaining rewards or avoiding punishments from others. This attitude is superficial; it is likely to change when the person's behavior is no longer monitored by others or when another option becomes available. A young woman may use a perfume because she was given a free sample as a promotion and there is no reason to buy something else.

- *Identification:* A process of identification occurs when attitudes are formed in order to be similar to another person or group. Advertising that depicts the social consequences of choosing some products over others is relying on the tendency of consumers to imitate the behavior of desirable models.

- *Internalization:* At a high level of involvement, deep-seated attitudes are internalized and become part of the person's value system. These attitudes are very difficult to change because they are so important to the individual. Brands can become intertwined with people's social identities, taking on patriotic and nostalgic properties.

The Consistency Principle

Have you ever heard someone say, "Pepsi is my favorite soft drink. It tastes terrible," or, "I love my husband. He's the biggest idiot I've ever met"? Probably not too often, because these beliefs or evaluations are not consistent with one another. According to the **principle of cognitive consistency**, consumers value harmony among their thoughts, feelings, and behaviors, and they are motivated to maintain uniformity among these elements.

Cognitive Dissonance and Harmony among Attitudes

The theory of **cognitive dissonance** states that when a person is confronted with inconsistencies among attitudes or behaviors, he or she will take some action to resolve this dissonance, perhaps by changing an attitude or modifying a behavior.[32]

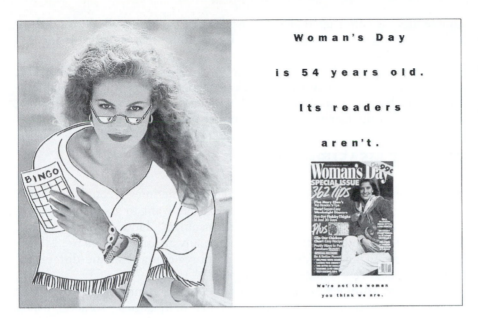

This ad for Woman's Day *attempts to counter the role that consistency plays in shaping attitudes: Consumers often distort information so that it fits with what they already know or believe.*

According to the theory, much as with hunger or thirst, people are motivated to reduce the negative feelings caused by dissonance. The theory focuses on situations in which two *cognitive elements* are inconsistent with one another. A cognitive element can be something a person believes about himself, a behavior he performs, or an observation about his surroundings. For example, the two cognitive elements "I know that smoking cigarettes causes cancer" and "I smoke cigarettes" are *dissonant* with one another. This psychological inconsistency creates a feeling of discomfort that the smoker is motivated to reduce.

Dissonance reduction can occur by either eliminating, adding, or changing elements. For example, the person could stop smoking (eliminating) or remember Great-Aunt Sophie, who smoked until the day she died at age 90 (adding). Alternatively, one might question the research that links cancer and smoking (changing), perhaps by believing industry-sponsored studies that try to refute this connection.

Dissonance theory can help explain why evaluations of a product tend to increase *after* it has been purchased. The cognitive element "I made a stupid decision buying this awful dress" is dissonant with the element "I am not a stupid person," so people tend to find even more reasons to like something after it becomes theirs. One implication of this phenomenon is that consumers actively seek support for their purchase decisions, so marketers should supply them with additional reinforcement to build positive brand attitudes.

Self-Perception Theory

Self-perception theory provides an alternative explanation of dissonance effects.[33] It assumes that people use observations of their own behavior to determine what their attitudes are, just as we assume that we know the attitudes of others by watching what they do. The theory states that we maintain

consistency by inferring that we must have a positive attitude toward an object if we have bought or consumed it (assuming that we freely made this choice).

Self-perception theory is relevant to the low-involvement hierarchy. After a purchase, the cognitive and affective components of attitude fall into line. Thus, buying a product out of habit may result in a positive attitude toward it after the fact—why would I buy it if I didn't like it?

ATTITUDE MEASUREMENT

A consumer's overall evaluation of a product sometimes accounts for much of his or her attitude. When market researchers want to assess attitudes, it can be sufficient for them to simply ask consumers, "How do you feel about Calvin Klein or Tommy Hilfiger?" In fact, many attitude studies use Likert-type scales using an agree/disagree five-point scale or a semantic-differential (bipolar) scale. See Table 8-2 for examples.

However, attitudes can be a lot more complex than that. A product or service may be composed of many *attributes,* or qualities—some of which may be more important than others. Also, a person's decision to act on his or her attitude is affected by other factors, such as whether he or she feels that buying a product would be met with approval by friends or family. As a result, *attitude models* have been developed that try to specify the different elements that influence people's evaluations of attitude objects.

Table 8-2 Examples of Measuring Clothing and Store Attitudes Using Likert-Type and Semantic Differential Scales

Likert-Type Scale

	Strongly Agree	Agree	Neutral	Disagree	Strongly Disagree
Attitudes Toward Environmental Clothing					
1. People should consider resource conservation when they buy clothes.	5	4	3	2	1
2. Clothing is a resource that is often wasted.	5	4	3	2	1
Attitudes Toward Comfort					
1. I always consider comfort and mobility more important than what is the current fashion.	5	4	3	2	1
2. I choose clothing that is as unconfining as possible.	5	4	3	2	1

Semantic Differential Scale

Attitudes Toward Store

Service is courteous	9 8 7 6 5 4 3 2 1	Service is discourteous
Location is convenient	9 8 7 6 5 4 3 2 1	Location is inconvenient
Prices are low	9 8 7 6 5 4 3 2 1	Prices are high
Environment is pleasant	9 8 7 6 5 4 3 2 1	Environment is unpleasant

Source: Adapted from Sarah M. Butler and Sally Francis, "The Effects of Environmental Attitudes on Apparel Purchasing Behavior," *Clothing and Textiles Research Journal* 15, no. 2 (1997): 76–85.

Multiattribute Attitude Models

A simple response does not always tell us everything we need to know about either *why* the consumer feels a certain way toward a product, or about what marketers can do to change the consumer's attitude. For this reason, **multiattribute attitude models** have been extremely popular among marketing researchers. This type of model assumes that a consumer's attitude of an attitude object (A_o) will depend on the beliefs he or she has about several or many attributes of the object. The use of a multiattribute model implies that an attitude toward a product or brand can be predicted by identifying these specific beliefs and combining them to derive a measure of the consumer's overall attitude. We'll describe how these work, using shoes as an example, which was the subject of an attitude study.[34]

Basic multiattribute models specify three elements:[35]

- *Attributes* are characteristics of the A_o. For example, comfort and fashion are attributes of shoes. (See Figure 8-2 for a comprehensive list of apparel attributes.[36])

- *Beliefs* are cognitions about the specific A_o. A belief measure assesses the extent to which the consumer perceives that a brand possesses a particular attribute. For example, a consumer may believe that Aerosoles are comfortable.

- *Importance weights* reflect the relative priority of an attribute to the consumer. Some attributes are likely to be more important than others (that is, they will be given greater weight) and these weights are likely to differ across consumers. In the case of shoes, for example, one consumer might stress comfort, whereas another might assign greater weight to the fashion aspect.

The Fishbein Model

The most influential multiattribute model is the *Fishbein model*, named after its primary developer.[37] The model measures three components of attitude:

1. *Salient beliefs* people have about an A_o, or the beliefs about the object that are considered during evaluation

2. *Object-attribute linkages*, or the probability that a particular object has an important attribute

3. *Evaluation* of each of the important attributes

I. Physical appearance Fabric Construction Style/fashion II. Physical performance Fabric Color Care Workmanship Comfort	III. Expressive Looks good on me Provides scope for individual creativity Appropriateness to lifestyle Comments of others IV. Extrinsic Brand Price Store/catalog Country of origin Service

FIGURE 8-2
Apparel Attributes

Source: Adapted from Liza Abraham-Murali and Mary Ann Littrell, "Consumers' Conceptualization of Apparel Attributes," *Clothing & Textiles Research Journal* 13, no. 2 (1995): 65–74. Published by permission of The International Textile & Apparel Association, Inc.

These three elements can be combined to compute a consumer's overall attitude toward an object (we'll see later how this basic equation has been modified to increase its accuracy). The basic formula is

$$A_{ijk} = \Sigma B_{ijk} I_{ik}$$

where
i = attribute
j = brand
k = consumer
I = the importance weight given attribute i by consumer k
B = consumer k's belief regarding the extent to which brand j possesses attribute i
A = a particular consumer's (k's) attitude score for brand j

The overall attitude score (A) is obtained by multiplying a consumer's rating of each attribute for all of the brands considered by the importance rating for that attribute.

To see how this basic multiattribute model works, let's suppose we want to predict which shoes a college student, Saundra, is likely to buy. Since she is deciding among several, we would first like to know which attributes she will consider in forming an attitude toward each brand. We can then ask Saundra to assign a rating regarding how well each brand performs on each attribute and also determine the relative importance of the attributes to her. An overall attitude score for each brand can then be computed by summing scores on each attribute (after weighting each by its relative importance). These hypothetical ratings are shown in Table 8-3.

Based on this analysis, it seems that Saundra has the most favorable attitude toward the Kenneth Cole brand. She is someone who would purchase a product with fashion rather than comfort, even though comfort was more important! (But fashion was rated so high for Kenneth Cole that the total score was higher than a shoe that was more comfortable—the number one attribute.)

Table 8-3 The Basic Multiattribute Model: Saundra's Shoe Decision

		Belief*			
Attribute	Importance**	Steve Madden	Kenneth Cole	Nine West	Dr. Scholl's
Comfort	4	7 (28)	6 (24)	9 (36)	3 (12)
Fashion	3	8 (24)	10 (30)	7 (21)	2 (6)
Durability	2	7 (14)	7 (14)	4 (8)	4 (8)
Leg exercise	1	3 (1)	2 (2)	2 (3)	10 (10)
Attitude Score		67	70	68	36

*Belief scores are 1–10 with higher numbers indicating "better."
**Importance ratings are 1–4 with higher numbers indicating "more important."
Note: Multiply importance ratings by belief scores and total to arrive at the Attitude Score.

Strategic Applications of the Multiattribute Model

Suppose you were the director of marketing of the other brands that Saundra was considering. How might you use the data from this analysis to improve your image?

Capitalize on Relative Advantage. If one's brand is viewed as being superior on a particular attribute, consumers like Saundra need to be convinced that this particular attribute is an important one. For example, while Saundra rates leg exercise high for Dr. Scholl's, she does not believe this attribute is a valued aspect. As Dr. Scholl's marketing director, you should emphasize the importance of leg exercise.

Strengthen Perceived Product/Attribute Linkages. A marketer may discover that consumers do not equate his or her brand with a certain attribute. This problem is commonly addressed by campaigns that stress the product's qualities to consumers (such as "new and improved"). Saundra apparently does not think much of Nine West's durability. An informational campaign might improve these perceptions.

Add a New Attribute. Product marketers frequently try to create a distinctive position from their competitors by adding a product feature. One of the companies not chosen might try to emphasize some unique aspect, such as "Made in the USA," or high quality for a lower price.

Influence Competitors' Ratings. Finally, you might try to decrease the positivity of competitors. This type of action is the rationale for a strategy of *comparative advertising*. One tactic might be to publish an ad that lists prices of a number of competitors, as well as their attributes with which one can be favorably compared, such as comfort, as the basis for emphasizing the value obtained for the money.

USING ATTITUDES TO PREDICT BEHAVIOR

Although multiattribute models have been used by consumer researchers for many years, they have been plagued by a major problem: In many cases, knowledge of a person's attitude is *not* a very good predictor of behavior. In a classic demonstration of "do as I say, not as I do," many studies have obtained a very low correlation between a person's reported attitude toward something and his or her actual behavior toward it. Research has found that the relationship between positive attitudes of "Made in USA" apparel and actual purchasing of that apparel is dismal; there appears to be no relation. People say it's important to "buy American," but when it comes to the actual purchase consumers place color, style, and price as the most important attributes.

The Extended Fishbein Model

The original Fishbein model, which focused on measuring a consumer's attitude toward a product, has been extended in several ways to improve its predictive ability and overcome this problem.[38] The newer version is called the **theory of reasoned action**.[39] Some of the modifications to this model are considered here.

Intentions versus Behavior

As the old expression goes, "The road to hell is paved with good intentions." Many factors might interfere with performance of actual behavior, even if the consumer has sincere intentions. He or she might save up with the intention of buying a new expensive Armani suit. In the interim, though, any number of things could happen: losing a job, finding one's checking account is overdrawn, or arriving at the store to find that the style you want is out of stock. It is not surprising, then, that in some instances past purchase behavior has been found to be a better predictor of future behavior than is a consumer's behavioral intention.[40] The theory of reasoned action aims to measure behavioral intentions, recognizing that certain uncontrollable factors inhibit prediction of actual behavior.

Social Pressure

The theory acknowledges the power of other people in influencing behavior. Much as we may hate to admit it, what we think others would *like* us to do may be more crucial than our own individual preferences.

In the case of Saundra's shoe choice, note that she was very positive about Kenneth Cole. However, if she felt that this choice would be unpopular (perhaps her friends would make fun of her), she might ignore or downgrade this preference when coming to a decision. A new element, the *subjective norm (SN)*, was thus added to include the effects of what we believe other people think we should do. The value of SN is arrived at by including two other factors: (1) the intensity of a *normative belief (NB)* that others believe an action should be taken or not taken, and (2) the *motivation to comply (MC)* with that belief (that is, the degree to which the consumer takes others' anticipated reactions into account when evaluating a purchase).

Knowing how someone feels about buying or using an object turns out to be more valid than merely knowing the consumer's evaluation of the object itself.[41]

The New Model

The model now measures **behavioral intention**, which includes **attitude toward the act of buying (A_{act})**, rather than only the attitude toward the product itself, and the subjective norm, which reflect the social consequences of the purchase. Therefore, the model can be presented as follows:

$$B \sim BI = (A_{act}) + SN$$

where
B = a specific behavior
BI = consumer's intention to engage in that behavior
A_{act} = consumer attitude toward engaging in that behavior
SN = subjective norm regarding whether other people want the consumer to engage in that behavior

This model may not apply to all cultures. One study using U.S. subjects found a relationship between both attitude and SN with BI; however, another study using Chinese subjects did not find a relationship with SN and BI.[42]

In 2003, Cotton Incorporated and Cotton Council International fielded the third *Global Lifestyle Monitor*™ survey covering consumer attitudes and behavior regarding their apparel and home textile purchases and usage. Fieldwork was conducted in nine countries (Brazil, China, Colombia, Germany, India, Italy, Japan, the United Kingdom, and Hong Kong). In each country, approximately 500 men and women between the ages of 15 and 54 were interviewed.

An increasing number of consumers say they enjoy wearing and want to wear denim. In just two years, the percentage of Germans who said they enjoy wearing denim rose from 68 percent to 79 percent; in Colombia, denim lovers increased from 65 percent to 75 percent. Even in China, where the survey was conducted for the first time, fully 50 percent of those interviewed said they love/enjoy wearing denim. Asked if they intended to buy more or less denim in the upcoming year (compared with the past year), 48 percent of global respondents said they intend to buy as much or more denim, with buying enthusiasm most prominent in South America and the United Kingdom. It is interesting to note that denim is highly popular in countries representing the full range of climate conditions around the globe. Denim is just as highly desirable in hot and steamy South America and Hong Kong as it is in North America and Europe where temperatures are much more moderate and, at times, frigid. Table 8-4 shows it's the young who love and enjoy denim the most; however, a large percentage of all age-groups surveyed do also.[43]

Tracking Attitudes over Time

An attitude survey is like a snapshot taken at a single point in time. It may tell us a lot about attitudes or a brand's position at that moment, but it does not permit many inferences about progress over time or any predictions about possible future changes in consumer attitudes. To accomplish that, it is necessary to develop an *attitude-tracking* program. This activity helps increase the predictability of behavior by allowing researchers to analyze attitude trends over an extended period of time. It is more like a movie than a snapshot.

Ongoing Tracking Studies

Attitude tracking involves the administration of an attitude survey at regular intervals. Preferably, the identical methodology is used each time so that results can be reliably compared. Several syndicated services, such as the Gallup Poll and the Yankelovich Monitor, track general consumer attitudes over time. Cotton Incorporated's *Lifestyle Monitor* has been tracking attitudes

Table 8-4 Attitudes Toward Denim by Age (Percentage Who Love/Enjoy Wearing)

	15–24	25–34	35–44	45–54
Asia	68%	66%	58%	45%
South America	80%	71%	66%	50%
Europe	75%	70%	67%	51%
United States*	79%	74%	77%	65%

*U.S. age-groups are 16–24 and 45–55.

Source: Cotton Incorporated and Cotton Council International, *Global Lifestyle Monitor III* (2003).

Table 8-5 Attitudes Toward Shopping for Clothes

	1994	2003	Difference
I love/like shopping for clothes			
Women	53%	57%	+4%
Men	23%	24%	+1%
I dislike shopping for clothes/I just buy what I need			
Women	28%	28%	0%
Men	64%	59%	−5%

Source: Cotton Incorporated, *Lifestyle Monitor* (Fall 2003).

about clothing, appearance, fashion, shopping, fiber selection, home furnishings, and similar topics since 1994 with a baseline study of 3,600 interviews. Each year interviews are performed using the same questions, called *barometers.* Results from a tracking study of shopping attitudes over the years are shown in Table 8-5.

Changes to Look for over Time

Some of the dimensions that can be included in attitude tracking include the following:

- *Changes in different age-groups:* Attitudes tend to change as people age (a *life-cycle effect*).
- *Scenarios about the future:* Consumers are frequently tracked in terms of their future plans, confidence in the economy, and so on.
- *Identification of change agents:* Social phenomena can change people's attitudes toward basic consumption activities over time, as when consumers' willingness to buy fur coats changes.

LIFESTYLES AND PSYCHOGRAPHICS

One's personality and attitudes—among other variables including age, education, income, social class, and so on—help determine one's lifestyle. This section explores the concept of lifestyle and how information about consumption choices can be used to tailor products and communications to individual lifestyle segments. "Niche marketing" and "branding" have been buzzwords used by marketers. In the future it is thought that companies will move more toward an integrative approach by selling across product categories under one concept to suit customer taste and style preferences.[44]

Lifestyle: Who We Are, What We Do

In traditional societies, one's consumption options are largely dictated by class, caste, village, or family. In a modern consumer society, however, people are more free to select the set of products, services, and activities that define themselves and, in turn, create a social identity that is communicated to

others. One's choice of goods and services indeed makes a statement about who one is and about the types of people with which one desires to iden- tify—and even those whom we wish to avoid.

Lifestyle refers to a pattern of consumption reflecting a person's choices of how he or she spends time and money. In an economic sense, one's lifestyle represents the way one has elected to allocate income, both in terms of rela- tive allocations to different products and services, and to specific alternatives within these categories.[45] Similar distinctions have been made to describe consumers in terms of their broad patterns of consumption, such as differen- tiating consumers in terms of those who devote a high proportion of total expenditures to food, advanced technology, or such information-intensive goods as entertainment and education.[46]

A *lifestyle marketing perspective* recognizes that people sort themselves into groups on the basis of the things they like to do, how they like to spend their leisure time, and how they choose to spend their disposable income.[47] These choices in turn create opportunities for market segmentation strate- gies that recognize the potency of a consumer's chosen lifestyle in determin- ing both the types of products purchased and the specific brands more likely to appeal to a designated lifestyle segment. Mainstream magazines such as *Reader's Digest* lost over 3 million readers and *People* lost over 2 million over the last decade,[48] while the continued popularity of finely tuned lifestyle magazines, mail-order catalogs, and Web sites is evidence of the increase of lifestyle marketing today. Fashion, home décor, fitness, sports, and culinary arts are among the industries catering to markets with specific lifestyles.

Fashion Lifestyle Marketing

Some apparel and home fashion companies have been extremely successful using the lifestyle marketing approach. Leading the ranks is Ralph Lauren, whose retail stores include not only clothing for men and women but also fur- niture and accessories for the home including wallpaper, sheets, and towels. (He has even expanded to Home Depot, which sells his designer paint for dis- criminating consumers.) Tommy Hilfiger has joined in the lifestyle concept with his new megastores in major cities. Abercrombie & Fitch captures the college student lifestyle. Even Target has developed a lifestyle orientation to merchandising, with a vice president of merchandising who has total control over the fashion program to express his or her particular point of view.[49] The company sees a significant difference between itself and Kmart, which "sells product, not lifestyle."[50] Target has put on fashion shows in Manhattan and sells housewares designed by architect Michael Graves and apparel by Mossimo and Isaac Mizrahi. *Home Textiles Today* stated that Pottery Barn epit- omizes lifestyle merchandising at its best by successfully capturing decorating trends in versatile home accessories and building brand equity with its grow- ing assortment of distinctive bed and table textiles, decorative accessories, and furniture and has been doing this for fifty years.[51] With home remodeling and decoration an important trend, many other companies such as Crate & Barrel and Restoration Hardware have gained wide popularity and are expanding across the country. Many other fashion companies fit into this genre of lifestyle merchandising, including Victoria's Secret, Neiman Marcus, and Bloomingdale's, which try to serve the many needs of a certain target customer.

Lifestyles as Group Identities

Economic approaches are useful in tracking changes in broad societal priorities, but they do not begin to embrace the symbolic nuances that separate lifestyle groups. Lifestyle is more than the allocation of discretionary income. It is a statement about who one *is* in society and who one *is not*. Group identities, whether of fashion leaders, athletes, hobbyists, or drug users, gel around forms of expressive symbolism. The self-definitions of group members are derived from the common symbol system to which the group is dedicated. Such self-definitions have been described by a number of terms, including *lifestyle, taste public, consumer group, symbolic community,* and *status culture.*[52]

A pattern of consumption often comprises many ingredients that are shared by others in similar social and economic circumstances. Still, each person also provides a unique "twist" to this pattern that allows him or her to inject some individuality into a chosen lifestyle. For example, a "typical" college student (if there is such a thing) may dress much like his or her friends, hang out in the same places, and like the same foods, yet still indulge a passion for running marathons, stamp collecting, or community activism, that makes him or her a unique person. Certainly students' wardrobes, which at first may seem identical to outsiders, are individualized even within specific trends or fads.

And lifestyles are not set in stone—unlike the deep-seated values we discussed in Chapter 4, people's tastes and preferences evolve over time, so that consumption patterns that were viewed favorably at one point in time may be laughed at (or sneered at) a few years later. If you don't believe that, simply think back to what you and your friends were wearing five or ten years ago: Where *did* you find those clothes?

Products Are the Building Blocks of Lifestyles

Consumers often choose products, services, and activities over others because they are associated with a certain lifestyle. For this reason, lifestyle marketing strategies attempt to position a product by fitting it into an existing pattern of consumption.

Because a goal of lifestyle marketing is to allow consumers to pursue their chosen ways to enjoy their lives and express their social identities, a key aspect of this strategy is to focus on product usage in desirable social settings. The goal of associating a product with a social situation is a long-standing one for advertisers, whether the product is included in a round of golf, a family barbecue, or a night at a glamorous club surrounded by "jet-setters."[53] Thus, people, products, and settings are combined to express a certain consumption style, as diagrammed in Figure 8-3.

The adoption of a lifestyle marketing perspective implies that we must look at *patterns of behavior* to understand consumers. We can get a clearer picture of how people use products to define lifestyles by examining how they make choices in a variety of product categories. As one study noted, "all goods carry meaning, but none by itself. . . . The meaning is in the relations between all the goods, just as music is in the relations marked out by the sounds and not in any one note."[54]

Indeed, many products and services do seem to "go together," usually because they tend to be selected by the same types of people. In many cases,

FIGURE 8-3
Linking Products to Lifestyles
Source: M. R. Solomon, *Consumer Behavior,* 8th ed. p. 235, © 2009. Reprinted by permission of Pearson Education, Inc., Upper Saddle River, NJ.

products do not seem to "make sense" if unaccompanied by companion products (such as a suit and tie) or are incongruous in the presence of others (such as a professional suit and a nose ring). Therefore, an important part of lifestyle marketing is to identify the set of products and services that seems to be linked in consumers' minds to a specific lifestyle. And research evidence suggests that even a relatively unattractive product becomes more appealing when evaluated with other, liked products.[55] Marketers who pursue *co-branding strategies* intuitively understand this; that's why L. L. Bean and Subaru teamed up for a co-branding deal. According to the vice president of marketing at Subaru, "L. L. Bean is a natural partner for Subaru, as both companies provide outdoor enthusiasts with products that enhance their lives."[56]

Another example of co-branding is the Nike and Apple partnership in which your Nano can become your coach. This concept is based on the idea that music and exercise go hand in hand. Your shoes talk, and your Nano listens; that is, a sensor in the sneaker talks to a receiver in your Nano. Then you can sync the data with Nike's Web site. The system tracks your distance, time, pace, and calorie expenditure for each run and compares them over time. Periodically during your run, a voice indicates your progress. Of course, this is all with the help of a couple Power Songs, which can be downloaded from iTunes to your Nano.[57]

A related concept is **product complementarity**, which occurs when the symbolic meanings of different products are related to each other.[58] These sets of products, termed **consumption constellations**, are used by consumers to define, communicate, and perform social roles.[59] For example, the American "yuppie" of the 1980s was defined by such products as a Rolex watch, an Armani suit, a BMW automobile, a Gucci briefcase and shoes, a squash racket, fresh pesto, white wine, and brie. Somewhat similar constellations could be found for "Sloane Rangers" in the United Kingdom and *"Bon Chic Bon Genres"* in France. Although people today take pains to avoid being classified as yuppies, this social role had a major influence on defining cultural values and consumption priorities in the 1980s.[60] What consumption constellation might characterize you and your friends today?

Psychographics

Consider a marketer who wishes to target a student population. The ideal consumer is identified as "a 21-year-old senior business major living on a large university campus whose parents make between $40,000 and $80,000 per year." You may know a lot of people who fit this description. Do you think they are all the same? Would they all be likely to share common interests and buy the same products? Probably not, since their lifestyles are likely to differ considerably.

As Nancy's and Anna's choices demonstrated in the opening scene of this chapter, consumers can share the same demographic characteristics and still be very different people. For this reason, marketers need a way to "breathe life" into demographic data to really identify, understand, and target consumer segments that will share a set of preferences for their products and services. This chapter earlier discussed some of the differences in

consumers' personalities that play a role in determining product choices. When personality variables are combined with knowledge of lifestyle preferences, marketers have a powerful lens with which to view consumer segments.

This tool is known as **psychographics**, which involves the "use of psychological, sociological, and anthropological factors . . . to determine how the market is segmented by the propensity of groups within the market—and their reasons—to make a particular decision about a product, person, ideology, or otherwise hold an attitude or use a medium."[61] Psychographics can help a company fine-tune its offerings to meet the needs of different segments. Demographics allow us to describe *who* buys, but psychographics allow us to understand *why* they buy.

Conducting a Psychographic Analysis: Using AIOs

Most contemporary psychographic research attempts to group consumers according to some combination of three categories of variables—activities, interests, and opinions—which are known as **AIOs**. Using data from large samples, marketers create profiles of customers who resemble each other in terms of their activities and patterns of product usage.[62] The dimensions used to assess lifestyle are listed in Table 8-6.

To group consumers into common AIO categories, respondents are given a long list of statements and are asked to indicate how much they agree with each one. Lifestyle is thus "boiled down" by discovering how people spend their time, what they find interesting and important, and how they view themselves and the world around them, as well as by gathering demographic information. By the way, the single most common use of leisure time among Americans overall is—you guessed it—watching television![63]

Typically, the first step in conducting a psychographic analysis is to determine which lifestyle segments are producing the bulk of customers for a particular product. According to a very general rule of thumb frequently used in marketing research, the **80/20 rule**, only 20 percent of a product's users account for 80 percent of the volume of product sold. Researchers

Table 8-6 Lifestyle Dimensions

Activities	Interests	Opinions	Demographics
Work	Family	Themselves	Age
Hobbies	Home	Social issues	Education
Social events	Job	Politics	Income
Vacation	Community	Business	Occupation
Entertainment	Recreation	Economics	Family size
Club membership	Fashion	Education	Dwelling
Community	Food	Products	Geography
Shopping	Media	Future	City size
Sports	Achievements	Culture	Stage in life cycle

Source: William D. Wells and Douglas J. Tigert, "Activities, Interests, and Opinions," *Journal of Advertising Research* 11 (August 1971): 27–35. © 1971 by The Advertising Research Foundation.

Girls in London have long been identified by names that define their styles including mods, dollies, Heathfields, punks, and Sloane Rangers. Today it's difficult to find one word to accurately define the look girls are after. But if there were one, it might be *TopShop Girl*. The term *topshop* may have been inspired by the Saturday mornings at the Oxford Circus store where boyfriends are lined outside the dressing rooms. Some topshop girls frequent Topshops two or three days a week. The brand director, Jane Shepherdson, nicknamed it *Topflop* to introduce the brand that English life "can't live without." Unknown models filled the sides of London buses with the tagline, "The New Major Topshop." Suddenly Topshop became a fashion authority.[65]

attempt to determine who uses the brand and try to isolate heavy, moderate, and light users. They also look for patterns of usage and attitudes toward the product. In many cases, just a few lifestyle segments account for the majority of brand users.[64] Marketers primarily target these heavy users, even though they may constitute a relatively small number of total users.

After the heavy users are identified and understood, the brand's relationship to them is considered. Heavy users may have quite different reasons for using the product; they can be further subdivided in terms of the *benefits* they derive from using the product or service. For instance, marketers at the beginning of the walking shoe craze assumed that purchasers were basically burned-out joggers. Subsequent psychographic research showed that there were actually several different groups of "walkers," ranging from those who walk to get to work to those who walk for fun. This realization resulted in shoes aimed at different segments, from FootJoy JoyWalkers to Nike Healthwalkers.

Fashion Psychographic Research

Many studies have attempted to segment fashion markets. When Levi's offered a new tailored product in the 1980s, it researched the men's apparel market and discovered a new segment, the Classic Independent, in addition to four others: Mainstream Traditionalist, Utilitarian, Trendy, and Price Shopper. Levi's designed and marketed strongly to this new segment;[66] however, due to a recessed economy and strong competition in that area at the time, it met with little success. Extensive research doesn't always guarantee success in the marketplace!

A more theoretical women's apparel study combined lifestyle segments with evaluative criteria (considerations important in choosing clothing) for both social and work apparel. Eight lifestyle segments emerged: self-confidence, attractive/fashionable, satisfaction with life, traditional, pro-American/education, price conscious/information seeking, modern traveling/spending, and mobile/impulsive. Relationships were found between these segments and important considerations for choosing clothing, supporting the notion that consumers choose apparel products that fit specific roles in their lifestyle.[67]

Using a benefit segmentation approach, other apparel researchers identified three market groups: symbolic/instrumental users of clothing (51 percent), practical/conservative users of clothing (35 percent), and apathetic

Table 8-7 Profile of Clothing Benefit Segments

	Group I Symbolic/Instrumental Users of Clothing	Group II Practical/Conservative Users of Clothing	Group III Apathetic Users of Clothing
Unique characteristics of benefits sought: Clothing . . .	Provides me with a means to enhance my self-esteem, career advancement, and reputation	Is for environmental, functional, and comfort purpose	Is of no significance to me nor provides me with any means to assist myself
Psychographics	Tends to be creative and enjoy new and different things, independent and an opinion leader	Tends to be independent and an opinion leader, tends not to enjoy spending time with friends	Less likely to be creative/innovative, or be an independent leader
Shopping orientations	Enjoys shopping, fashion-oriented shopper	Less likely to enjoy shopping, less likely to be fashion-oriented	Less likely to enjoy shopping, less likely to be fashion-oriented
Patronage behavior	Tends to shop at upscale/better department stores and specialty stores	Tends to shop at regular department stores	Tends to shop at discount stores
Demographics	Tends to have some college credits or college degree and above, has a professional career, younger	Tends to represent all education levels, professional career, older	Tends to be a high school graduate or under, homemaker, older

Source: Soyeon Shim and Marianne Bickle, "Benefit Segments of the Female Apparel Market: Psychographics, Shopping Orientations, and Demographics," *Clothing and Textiles Research Journal* 12, no. 2 (Winter 1994): 1–12. Published by permission of The International Textile & Apparel Association, Inc.

users of clothing (14 percent). Differences were found among the three groups on psychographic factors, shopping orientation factors, patronage behavior, and demographics. For example, the symbolic user group (using clothing as a means to enhance self-esteem, career advancement, reputation, social prestige, femininity, and sex appeal) was more innovative, independent, socially and exercise/health oriented, and optimistic about education, career, and finance. These women enjoyed shopping at upscale stores and were fashion-conscious and credit users. They were also younger and of higher social classes in terms of education, occupation, income, and residential area. See Table 8-7 for a profile of clothing benefit segments.[68] The fact that the symbolic user group was the largest group supports other earlier studies finding that clothing is used as a strategic tool for career women.[69] Table 8-8 gives examples of statements that measure clothing benefits.

Uses of Psychographic Segmentation

Psychographic segmentation can be used in a variety of ways.

- *To define the target market:* This information allows the marketer to go beyond simple demographic or product usage descriptions (such as middle-aged women or frequent users).

- *To create a new view of the market:* Sometimes marketers create their strategies with a "typical" customer in mind. This stereotype may not be correct because the actual customer may not match these assumptions. For example, marketers of a facial cream for women were surprised to

Table 8-8 Measuring Clothing Benefits Sought by Consumers

Benefits	Sample Statements
1. Self-improvement	My self-esteem is enhanced by the clothing I wear.
2. Social status/prestige	Wearing designer clothing gives me social status.
3. Sex appeal/femininity	Dressing to appeal to the opposite sex is important to me.
4. Fashion/image	Wearing the latest styles is important to me in order to maintain a fashionable image.
5. Functional/comfort	The main purpose of clothing is to shelter the body from the environment.
6. Role identification	The clothes that I wear identify my role.
7. Figure flaws compensation	I try to cover my figure flaws through clothing.
8. Individuality	I am more concerned with individuality of dress rather than following current fashion.
9. Mature/sophisticated look	I buy clothes that make me look sophisticated.

Source: Soyeon Shim and Marianne Bickle, "Benefit Segments of the Female Apparel Market: Psychographics, Shopping Orientations, and Demographics," *Clothing and Textiles Research Journal* 12, no. 2 (1994): 1–12. Published by permission of The International Textile & Apparel Association, Inc.

find that their key market was composed of older, widowed women rather than the younger, more sociable women to whom they were pitching their appeals.

- *To position the product:* Psychographic information can allow the marketer to emphasize features of the product that fit in with a person's lifestyle. Products targeted to people whose lifestyle profiles show a high need to be around other people might focus on the product's ability to help meet this social need.

- *To better communicate product attributes:* Psychographic information can offer very useful input to advertising creatives who must communicate something about the product. The artist or writer obtains a much richer mental image of the target consumer than that obtained through dry statistics, and this insight improves his or her ability to "talk" to that consumer.

Psychographic Segmentation Typologies

Marketers are constantly on the prowl for new insights that will allow them to identify and reach groups of consumers that are united by a common lifestyle. To meet this need, many research companies and advertising agencies have developed their own *segmentation typologies*. Respondents answer a battery of questions that allow the researchers to cluster them into a set of distinct lifestyle groups. The questions usually include a mixture of AIOs, plus other items relating to their perceptions of specific brands, favorite celebrities, media preferences, and so on. These systems are usually sold to companies that want to learn more about their customers and potential customers.

Many of these typologies are similar to one another, in that they break up the population into roughly five to eight segments. Each cluster is given

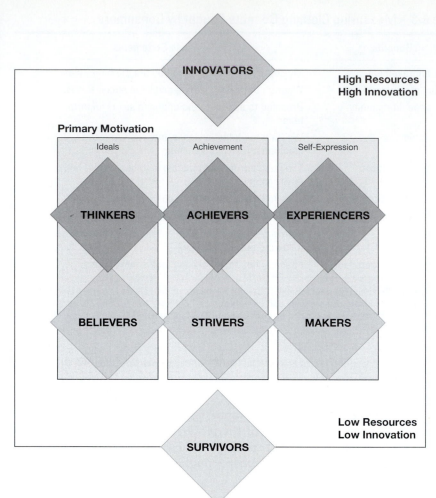

a descriptive name, and a profile of the "typical" member is provided to the client. Unfortunately, it is often difficult to compare or evaluate different typologies, since the methods and data used to devise these systems frequently are *proprietary*—the information is developed and owned by the company, and the company does not share its findings with outsiders.

VALS. One well-known segmentation system is the **Values and Lifestyles System (VALS)**, developed by SRI International in California. The current VALS2 system uses a battery of thirty-nine psychological and demographic variables to divide U.S. adults into groups, each with distinctive characteristics. As shown in Figure 8-4, groups are arranged vertically by their resources (including factors such as income, age, education, energy, self-confidence, novelty seeking, innovativeness, and leadership) and horizontally by primary motivation. An individual's primary motivation determines what about the self or the world is the meaningful core that governs one's activities, patterns that reinforce and sustain a person's identity as expressed in the marketplace.[70]

Three motivations comprise the horizontal dimension. Consumers motivated by *ideals* are grounded in knowledge and principles. They tend to make

purchase decisions guided by a belief system using criteria of quality, integrity, and tradition, and they are not concerned with the views of others. People who are motivated by *achievement* strive for a clear social position; they seek approval from a valued social group. Those motivated by *self-expression* are action oriented and buy products that emphasize individuality and personal challenge.

Innovators (formerly called *Actualizers*), the top VALS2™ group, are successful, take-charge people with high self-esteem and many resources. They are change leaders and open to new ideas and new technologies. Innovators are active consumers with cultivated tastes. Image is important as an expression of their taste and personality but not of status or power.

The next three groups also have sufficient resources but differ in their outlooks on life:

- *Thinkers* (formerly called *Fulfilled*) are motivated by ideals. They are mature, satisfied, reflective people. They tend to be practical and look for functionality and value in what they buy.
- *Achievers* are career oriented and prefer predictability to risk or self-discovery.
- *Experiencers* are impulsive, young, and enjoy offbeat or risky experiences.

The next four groups have fewer resources:

- *Believers* have strong principles, are conservative, and favor proven brands.
- *Strivers* are similar to Achievers but have fewer resources. They are concerned about the approval of others.
- *Makers* are action oriented and tend to focus their energies on self-sufficiency. They will often be found working on their cars, canning their own vegetables, or building their own houses.
- *Survivors* (formerly called *Strugglers*) are at the bottom of the economic ladder. They are most concerned with meeting needs rather than fulfilling desires. They are cautious consumers and loyal to favorite brands.

The VALS2™ system has been a useful way to understand people like Nancy and Anna. SRI estimates that 12 percent of American adults are thrill seekers, who tend to fall into the system's Experiencer category and who are likely to agree with statements such as "I like a lot of excitement in my life" and "I like to try new things." Experiencers like to break the rules and are strongly attracted to extreme sports such as sky surfing or bungee jumping. Not too surprisingly, fully one-third of consumers age 18–34 belong in this category, so it has attracted the interest of many marketers who are trying to appeal to younger people. If you want to see what VALS type you would be classified as, go to www.sric-bi.com/VALS/presurveys.shtml.

A system such as VALS2™ is useful to identify different consumer types within the United States, but in many cases multinational marketers need to reach customers who live in other countries. That's why VALS is developing similar systems to be used elsewhere—its Japan VALS identifies people there who are more or less receptive to change. In addition, though, increasingly

sophisticated efforts are being made to develop lifestyle typologies that transcend national borders.

Geodemography. Another segmentation tool is **geodemography**, which refers to analytical techniques that combine data on consumer expenditures and other socioeconomic factors with geographic information about the areas in which people live in order to identify consumers who share common consumption patterns. This approach is based on the assumption that "birds of a feather flock together"; people who have similar needs and tastes also tend to live near one another, so it should be possible to locate "pockets" of like-minded people who can then be reached more economically by direct mail and other methods. For example, a marketer who wants to reach white, single consumers who are college educated and tend to be fiscally conservative may find that it is more efficient to mail catalogs to zip codes 20770 (Greenbelt, MD) and 90277 (Redondo Beach, CA) than to adjoining areas in either Maryland or California, where there are fewer consumers who exhibit these characteristics.

One popular clustering technique is PRIZM, the system developed by Claritas, Inc. (PRIZM stands for Potential Rating Index by Zip Market). This system classifies every U.S. zip code into one of sixty-six categories, ranging from the most affluent "Blue-Blood Estates" to the least well-off "Public Assistance."[71] A resident of Southern California might be classified as "Money & Brains" if she lives in Encino (zip code 91316), whereas someone living in Sherman Oaks (zip code 91423) would be a "Young Influential." The system was updated from its original set of forty clusters to reflect the growing ethnic and economic diversity of the United States; some new clusters include "American Dreams," "Kids & Cul-de-Sacs," and "Young Literati." Clusters include demographics and lifestyle traits such as where people in this grouping eat, what TV channel they watch, what they read, and what stores they frequent. You can check out your own zip code at www.mybestsegments.com. Does this describe you?

TREND FORECASTING: PEERING INTO THE CRYSTAL BALL OF CONSUMER BEHAVIOR

Consumer lifestyles are a moving target. Society's priorities and preferences are constantly evolving, and it is essential for marketers to track these changes—and, more importantly, to try to anticipate them. Look at business headings in the Yellow Pages. The categories of livestock, records, mops, and worms have been dropped from many telephone directories. New headings include angels, body piercing, cyber cafes, feng shui, permanent makeup, and aromatherapy.[72] If a marketer could see into the future, he or she would obviously have an enormous advantage when developing products and services that would meet the needs of consumers next year, in five years, or in ten years. No one is able to do that, but a number of marketing research firms do try very hard to predict **social trends**, or broad changes in people's attitudes and behaviors. Trendwatching.com says: "Trend watching is not about the crystal ball; it is about observing and understanding what's already happening, major and minor, mainstream and fringe."[73]

Trend Analysts

Many companies conduct consumer surveys to stay on top of trends. For example, the Yankelovich Monitor, run by Yankelovich Partners, Inc. (www.yankelovich.com), interviews 2,500 American adults annually. Since 1975, the DDB Needham Worldwide advertising agency has been conducting its Lifestyle Study, an ongoing study of changes in consumer behavior consisting of a sample of 4,000 Americans' answers to a battery of 1,000 questions. Teen Research Unlimited's Trend Watch panel (www.teenresearch.com) is composed of 300 savvy teens who work with companies that pose specific questions and ideas to them. Faith Popcorn, owner of BrainReserve and author of "The Popcorn Report," has been fad-spotting for *Fortune* 500 clients for more than two decades and uses interviews with a "talent bank" of interesting people such as Calvin Klein, an Indian chief, and an executive at R.J. Reynolds Tobacco Co.[74] These services gather information and sell their knowledge.

With the advent of the Internet, there now are many more services available to companies and individuals. Much of the information from these services, mostly based on blogs, are open to anyone, readers and contributors. Consider these: www.ubercool.com, www.trendwatching.com, www.trendsetters.com, www.trendcentral.com, and www.trendhunter.com. The Amsterdam-based Web site www.trendwatching.com has more than 130,000 business and marketing professionals in more than 120 countries subscribe to the site's free monthly newsletter. A network of more than 8,000 "springspotters" from more than 70 countries reports in regularly. They spot changing ideas, concepts, and big-picture thinking from blogs of business-people. The company also actively scans MySpace, Cyworld, Habbo Hotel, Flickr, YouTube, and Second Life to keep a finger on the pulse of youth culture by reading what people are putting out there, what they do, and what they like.[75] The site http://www.trendwatching.com lists trends over the past few years. Some are ubertrends, trends that spur other trends. Note that many are brought on by today's technology explosion, and some have more direct impact on retail and fashion than others. Here are a few. How long do you think these trends will last? Check this site for the newest of the new. How would you describe the attitude about consumers of this site's authors?

- *No-frills chic:* low-cost goods and services that add design, high-quality elements, and/or exceptional customer service to create top-quality experiences at bottom prices. Think Wal-Mart, Costco, SouthWest Airlines, Trader Joe's, Zara, Target, Holland's HEMA, and Japan's Muji.
- *Uber premium:* at the opposite end of the scale is uber premium, which is everything that is truly out of reach of the vast majority of consumers. Not just financially but also by not being invited or by being too late. (This is definitely not "mass class.") It is increasingly found in the experience part of the economy, a hard-to-imitate uniqueness.
- *Transumers:* consumers in transition such as travelers and others wanting life-changing experiences with an ever-shorter satisfaction span; living for "now."
- *Minipreneurs:* those eBay sellers; everyone can be an entrepreneur.
- *Life cashing:* collecting, storing, and displaying one's entire life for private use or for friends and family, even the entire world, to peruse. The

trend owes much to bloggers ever since writing and publishing one's diary has become as easy as typing in http://www.blogger.com.

- *Countergoogling:* companies google you (instead of you googling them) to see how to individualize their market to you—if you put your blog up, companies will find you.
- *Online oxygen:* consumers don't just want online access anywhere/any-time—they absolutely crave it from airports to living rooms to roof gardens to classrooms to city parks.
- *See-hear-buy:* the capability to buy everything you see or hear, wherever you are. Amazon started allowing you to buy the niche-look you just saw discussed on TV within seconds. Go to http://www.like.com for a "likeness" search to find jewelry or boots that your favorite celebrity is wearing. An experience-and-buy service that lets you instantly buy the music you've just listened to is at http://www.launch.com.
- *Pop-up retail:* temporary retail space. Like trends that come and go, these spaces come and go. Sometimes the purpose is to sell "fast fashion," sometimes it's to start a buzz. Levi's, Swatch, Comme des Garcons, Target, and even Wal-Mart have opened pop-up shops.
- *Eco-iconic, Eco-embedded, and Eco-booster:* is a status shift; many con-sumers are eager to flaunt their green behavior and possessions because there are now millions of other consumers who are impressed by green lifestyles.
- *Status stories:* as more brands go niche and therefore tell stories that aren't known to the masses, and as experiences take over from physical status symbols, consumers will increasingly have to tell each other sto-ries to achieve a status dividend from their purchases.
- *Pink profits:* many brands now actively target the gay community, as even the most conservative executives have come to realize that there's just too much money to be made from well-to-do, happy-to-spend GLBT consumers.
- *(Still) made here:* encompasses new and enduring manufacturers and purveyors of the local. In a world seemingly ruled by globalization and mass production, a growing number of consumers are seeking out the local, the authentic, and/or the obscure.
- *Trysumers:* immune to most advertising, and enjoying full access to information, reviews, and navigation, Trysumers are trying out new serv-ices, new flavors, new authors, new destinations, new artists, new outfits, new relationships, new anything.
- *Innovation overload:* thousands of clever entrepreneurs, inventors, and marketers are coming up with so many innovative ideas that even innovation blogs have a hard time keeping track.
- *Customer made:* the phenomenon of corporations creating goods, serv-ices, and experiences in close cooperation with experienced and creative consumers, tapping into their intellectual capital and in exchange giving them a direct say in what actually gets produced.
- *Infolust:* experienced consumers are lusting after detailed information on where to get the best of the best, the cheapest of the cheapest, the first of the first, the healthiest of the healthiest, the coolest of the coolest.
- *And the list goes on.*

Fashion Forecasters

Because the fashion industry changes so fast, it is imperative that those in the industry keep on top of trends. Lifestyle forecasting gives hints to new product acceptance, but most apparel manufacturers and retailers do some type of specific *fashion forecasting*. One way is to subscribe each season to such services as Promostyl, Nigel French, Here & There (now part of Doneger), or Doneger Group Forecasting, among others. As mentioned earlier, other industry sources including fiber companies, such as DuPont, and trade associations including Cotton Incorporated produce trend books for clients or members. Employees travel the world, visit the hot spots, photograph street fashion and anything edgy, and upon returning home, put together themes for manufacturers and retailers that subscribe to their services.

In addition to these services, there are several online fashion trend sites for up-to-the-minute fashions. Style.com (www.style.com) is the Web site for *Vogue* and *W*. One can also click on fashion shows of almost 200 designers. WGSN, WorthGlobal Style Network (www.wgsn.com), lets you walk in other worlds virtually. Walk down King's Road in London, see what's happening at the Paris flea markets, take a virtual tour of practically any trade show, and see what everyone else is looking at, all with a click of the mouse.[76] These free sites give you information as opposed to analysis. That part is up to you.

Trend forecasting is a bit like reading one's horoscope in the paper. Sometimes forecasts are so general they can't help but come true (one forecasting firm said "we are never wrong!"), and only some proportion of more specific ones actually do. The problem is, we don't know until after the fact which ones will come true. Some trends are merely extensions of what we see happening around us. Can you predict what will be "hot" next?

CHAPTER SUMMARY

- The concept of personality refers to a person's unique psychological makeup and how it consistently influences the way a person responds to his or her environment. Marketing strategies and fashion studies based on personality differences have met with mixed success, partly because of the way these differences in personality traits have been measured and applied to consumption contexts. Some approaches have attempted to understand underlying differences in small samples of consumers by employing techniques based on Freudian psychology and variations of this perspective, while others have tried to assess these dimensions more objectively in large samples using sophisticated quantitative techniques.

- An attitude is a predisposition to evaluate an object or product positively or negatively.

- Attitudes are made up of three components: beliefs, affect, and behavioral intentions.

- Attitude researchers traditionally assumed that attitudes were learned in a fixed sequence, consisting first of the formation of beliefs (cognitions) regarding an attitude object, followed by some evaluation of that object (affect) and then some action (behavior). Depending on the consumer's level of involvement and the circumstances, though, attitudes can result from other hierarchies of effects as well.

- One organizing principle of attitude formation is the importance of consistency among attitudinal components—that is, some parts of an attitude may be altered to be in line with others. Such theoretical approaches to attitudes as cognitive dissonance theory and self-perception theory stress the vital role of the need for consistency.

- The complexity of attitudes is underscored by multiattribute attitude models, in which a set of beliefs and evaluations is identified and combined to predict an overall attitude. Factors such as subjective norms and the specificity of attitude scales have been integrated into attitude measures to improve predictability.

- A consumer's lifestyle refers to how he or she chooses to spend time and money and how his or her values and tastes are reflected by consumption choices. Lifestyle research is useful for tracking societal consumption preferences and also for positioning specific products and services to different segments. Marketers segment by lifestyle differences, often by grouping consumers in terms of their AIOs (activities, interests, and opinions).

- Psychographic techniques attempt to classify consumers in terms of psychological, subjective variables in addition to observable characteristics (demographics). A variety of systems, such as VALS, have been developed to identify consumer "types" and to differentiate them in terms of their brand or product preferences, media usage, leisure-time activities, and attitudes toward such broad issues as politics and religion.

- Interrelated sets of products and activities are associated with social roles to form consumption constellations. People often purchase a product or service because it is associated with a constellation that, in turn, is linked to a lifestyle they find desirable.

- Important changes occurr in consumer priorities and practices. Many trend and forecasting resources are available to retail and fashion companies. It is vital that they keep up-to-date on changing consumer lifestyles.

KEY TERMS

personality	cognition	attitude toward the act
id	hierarchy of effects	of buying (A_{act})
pleasure principle	attitude toward the	lifestyle
superego	advertisement (A_{ad})	product complementarity
ego	principle of cognitive	consumption
reality principle	consistency	constellations
traits	cognitive dissonance	psychographics
brand personality	self-perception theory	AIOs
brand equity	multi-attribute attitude	80/20 rule
animism	models	Values and Lifestyles
attitude	theory of reasoned	System (VALS)
attitude object (A_o)	action	geodemography
affect	behavioral intention	social trends
behavior		

DISCUSSION QUESTIONS

1. Construct a brand personality inventory for three different brands within a fashion product category. Ask a small number of consumers to rate each brand on about ten different personality dimensions. What differences can you locate? Do these "personalities" relate to the advertising and packaging strategies used to differentiate these products?

2. In what situations is demographic information likely to be more useful than psychographic data, and vice versa?

3. Compile a set of recent ads attempting to link consumption of a fashion product with a specific lifestyle.

4. Construct separate advertising executions for a cosmetics product targeted to the belonger, achiever, experiential, and societally conscious VALS types. How would the basic appeal differ for each group?

5. Using media targeted to the group, construct a consumption constellation for the social role of college students. What set of products, activities, and interests tend to appear in advertisements depicting "typical" college students? How realistic is this constellation?

6. List three functions played by attitudes, giving an example of how each function is employed in a fashion marketing situation.

7. Using a series of semantic differential scales, devise an attitude survey for a set of competing fashion companies. Identify areas of competitive advantage or disadvantage for each.

8. Construct a multiattribute model for a product other than shoes. Based on your findings, suggest how the brand can improve an establishment's image via the strategies described in the chapter.

9. Identify a lifestyle trend that is just surfacing in your universe. Describe this trend in detail and justify your prediction. What specific styles and/or products are part of this trend? How long do you think it will last? Why?

10. What do you predict in fashion for next season? How did you come up with these predictions?

ENDNOTES

1. For an interesting ethnographic account of skydiving as a voluntary high-risk consumption activity, see Richard L. Celsi, Randall L. Rose, and Thomas W. Leigh, "An Exploration of High-Risk Leisure Consumption through Skydiving," *Journal of Consumer Research* 20 (June 1993): 1–23. See also Jerry Adler, "Been There, Done That," *Newsweek* (July 19, 1993): 43; Joan Raymond, "Going to Extremes," *American Demographics* (June 2002): 28–30.

2. See J. Aronoff and J. P. Wilson, *Personality in the Social Process* (Hillsdale, N.J.: Lawrence Erlbaum, 1985); Walter Mischel, *Personality and Assessment* (New York: Wiley, 1968).

3. Ed Edmonds and Cahoon Delwin, "Female Clothes Preference Related to Male Sexual Interest," *Bulletin of the Psychonic Society* 22 (1984): 171–173.

4. Valerie Steel, *Fashion and Eroticism* (New York: Oxford University Press, 1985).

5. Alison Lurie, *The Language of Clothes* (New York: Random House, 1981).

6. James Laver, *Modesty in Dress* (Boston: Houghton Mifflin, 1969).

7. Linda L. Price and Nancy Ridgway, "Development of a Scale to Measure Innovativeness," in *Advances in Consumer Research* 10, eds. Richard P. Bagozzi and Alice M. Tybout (Ann Arbor, Mich.: Association for Consumer Research,

1983), 679–684; Russell W. Belk, "Three Scales to Measure Constructs Related to Materialism: Reliability, Validity, and Relationships to Measures of Happiness," in *Advances in Consumer Research* 11, ed. Thomas C. Kinnear (Ann Arbor, Mich.: Association for Consumer Research, 1984), 291; Mark Snyder, "Self-Monitoring Processes," in *Advances in Experimental Social Psychology,* ed. Leonard Berkowitz (New York: Academic Press, 1979), 85–128; Gordon R. Foxall and Ronald E. Goldsmith, "Personality and Consumer Research: Another Look," *Journal of the Market Research Society* 30, no. 2 (1988): 111–125; Ronald E. Goldsmith and Charles F. Hofacker, "Measuring Consumer Innovativeness," *Journal of the Academy of Marketing Science* 19, no. 3 (1991): 209–221; Curtis P. Haugtvedt, Richard E. Petty, and John T. Cacioppo, "Need for Cognition and Advertising: Understanding the Role of Personality Variables in Consumer Behavior," *Journal of Consumer Psychology* 1, no. 3 (1992): 239–260.

8. Lewis Aiken, "The Relationships of Dress to Selected Measures of Personality in Undergraduate Women," *Journal of Social Psychology* 59 (1963): 119–128.

9. Mary Frances Pasnak and Ruth Ayres, "Clothing Attitudes and Personality Characteristics of Fashion Innovators," *Journal of Home Economics* 61 (1969): 698–702; John Summers, "The Identity of Women's Clothing Fashion Opinion Leaders," *Journal of Marketing Research,* no. 7 (1970): 313–316; Daniel Greeno, Montrose Sommers, and Jerome Kernan, "Personality and Implicit Behavior Patterns," *Journal of Marketing Research,* no. 10 (1973): 63–69; George Sproles and Charles King, "The Consumer Fashion Change Agent: A Theoretical Conceptualization and Empirical Identification," Paper No. 433, Purdue University, Institute for Research in the Behavioral, Economic, and Management Sciences (December 1973); Holly Schrank and Lois Gilmore, "Correlates of Fashion Leadership: Implications for Fashion Process Theory," *Sociological Quarterly,* no. 14 (1973): 534–543; S. Baumgarten, "The Innovative Communicator in the Diffusion Process," *Journal of Marketing Research,* no. 12 (February 1975): 12–18; Joyce Brett and Anne Kernaleguen, "Perceptual and Personality Variables Related to Opinion Leadership in Fashion," *Perceptual and Motor Skills,* no. 40 (1975): 775–779; Sharon Lennon and Leslie Davis, "Individual Differences in Fashion Orientation and Cognitive Complexity," *Perceptual and Motor Skills,* no. 64 (1987): 327–330.

10. Thomas Hine, "Why We Buy: The Silent Persuasion of Boxes, Bottles, Cans, and Tubes," *Worth* (May 1995): 78–83.

11. Kevin L. Keller, "Conceptualization, Measuring, and Managing Customer-Based Brand Equity," *Journal of Marketing* 57 (January 1993): 1–22.

12. Rebecca Piirto Heath, "The Once and Future King," *Marketing Tools* (March 1998): 38–43.

13. Kathryn Kranhold, "Agencies Beef Up Brand Research to Identify Consumer Preferences," *The Wall Street Journal Interactive Edition* (March 9, 2000).

14. Jennifer L. Aaker, "Dimensions of Brand Personality," *Journal of Marketing Research* 34 (August 1997): 347–357.

15. Tim Triplett, "Brand Personality Must Be Managed or It Will Assume a Life of Its Own," *Marketing News* (May 9, 1994): 9.

16. Susan Fournier, "A Consumer-Brand Relationship Framework for Strategic Brand Management," unpublished doctoral dissertation, University of Florida (1994).

17. Robert Murphy, "It's All about White Shirts," *Women's Wear Daily* (July 14, 1999): 9; Rusty Williamson, "Anne Fontaine's U.S. White Wash," *Women's Wear Daily* (December 27, 2000): 11.

18. Robert A. Baron and Donn Byrne, *Social Psychology: Understanding Human Interaction,* 5th ed. (Boston: Allyn and Bacon, 1987).

19. Soyeon Shim, Nancy J. Morris, and George A. Morgan, "Attitudes toward Imported and Domestic Apparel among College Students: The Fishbein Model and External Variables," *Clothing and Textiles Research Journal* 13, no. 4 (1995): 222–226.

20. Sally Francis and Leslie Davis Burns, "Effect of Consumer Socialization on Clothing Shopping Attitudes, Clothing Acquisition, and Clothing Satisfaction," *Clothing and Textiles Research Journal* 10, no. 4 (1992): 35–39.

21. Sarah M. Butler and Sally Francis, "The Effects of Environmental Attitudes on Apparel Purchasing Behavior," *Clothing and Textiles Research Journal* 15, no. 2 (1997): 76–85.

22. For a study that found evidence of simultaneous causation of beliefs and attitudes, see Gary M. Erickson, Johny K. Johansson, and Paul Chao, "Image Variables in Multi-Attribute Product Evaluations: Country-of-Origin Effects," *Journal of Consumer Research* 11 (September 1984): 694–699.

23. Michael Ray, "Marketing Communications and the Hierarchy-of-Effects," in *New Models for Mass Communications,* ed. P. Clarke (Beverly Hills, Calif.: Sage, 1973), 147–176.

24. Herbert Krugman, "The Impact of Television Advertising: Learning without Involvement," *Public Opinion Quarterly* 29 (Fall 1965): 349–356; Robert Lavidge and Gary Steiner, "A Model for Predictive Measurements of Advertising Effectiveness," *Journal of Marketing* 25 (October 1961): 59–62.

25. John P. Murry, Jr., John L. Lastovicka, and Surendra N. Singh, "Feeling and Liking Responses to Television Programs: An Examination of Two Explanations for Media-Context Effects," *Journal of Consumer Research* 18 (March 1992): 441–451.

26. Barbara Stern and Judith Lynne Zaichkowsky, "The Impact of 'Entertaining' Advertising on Consumer Responses," *Australian Marketing Researcher* 14 (August 1991): 68–80.

27. Morris B. Holbrook and Rajeev Batra, "Assessing the Role of Emotions as Mediators of Consumer Responses to Advertising," *Journal of Consumer Research* 14 (December 1987): 404–420.

28. Marian Burke and Julie Edell, "Ad Reactions over Time: Capturing Changes in the Real World," *Journal of Consumer Research* 13 (June 1986): 114–118.

29. Herbert Kelman, "Compliance, Identification, and Internalization: Three Processes of Attitude Change," *Journal of Conflict Resolution* 2 (1958): 51–60.

30. See Sharon E. Beatty and Lynn R. Kahle, "Alternative Hierarchies of the Attitude-Behavior Relationship: The

Impact of Brand Commitment and Habit," *Journal of the Academy of Marketing Science* 16 (Summer 1988): 1–10.

31. J. R. Priester, D. Nayakankuppan, M. A. Fleming, and J. Godek, "The A(2)SC(2) Model: The Influence of Attitudes and Attitude Strength on Consideration Set Choice," *Journal of Consumer Research* 30, no. 4 (2004): 574–587.

32. Leon Festinger, *A Theory of Cognitive Dissonance* (Stanford, CA: Stanford University Press, 1957).

33. Daryl J. Bem, "Self-Perception Theory," in *Advances in Experimental Social Psychology,* ed. Leonard Berkowitz (New York: Academic Press, 1972), 1–62.

34. Brenda Sternquist Witter and Charles Noel, "Apparel Advertising: A Study in Consumer Attitude Change," *Clothing and Textiles Research Journal* 3, no. 1 (1984/1985): 34–40.

35. William L. Wilkie, *Consumer Behavior* (New York: Wiley, 1986).

36. Liza Abraham-Murrali and Mary Ann Littrell, "Consumers' Conceptualization of Apparel Attributes," *Clothing & Textiles Research Journal* 13, no. 2 (1995): 65–74.

37. M. Fishbein, "An Investigation of the Relationships between Beliefs about an Object and the Attitude toward That Object," *Human Relations* 16 (1983): 233–240.

38. Morris B. Holbrook and William J. Havlena, "Assessing the Real-to-Artificial Generalizability of Multi-Attribute Attitude Models in Tests of New Product Designs," *Journal of Marketing Research* 25 (February 1988): 25–35; Terence A. Shimp and Alican Kavas, "The Theory of Reasoned Action Applied to Coupon Usage," *Journal of Consumer Research* 11 (December 1984): 795–809.

39. Icek Ajzen and Martin Fishbein, "Attitude-Behavior Relations: A Theoretical Analysis and Review of Empirical Research," *Psychological Bulletin* 84 (September 1977): 888–918.

40. Richard P. Bagozzi, Hans Baumgartner, and Youjae Yi, "Coupon Usage and the Theory of Reasoned Action," in *Advances in Consumer Research* 18, eds. Rebecca H. Holman and Michael R. Solomon (Provo, Utah: Association for Consumer Research, 1991), 24–27; Edward F. McQuarrie, "An Alternative to Purchase Intentions: The Role of Prior Behavior in Consumer Expenditure on Computers," *Journal of the Market Research Society* 30 (October 1988): 407–437; Arch G. Woodside and William O. Bearden, "Longitudinal Analysis of Consumer Attitude, Intention, and Behavior toward Beer Brand Choice," in *Advances in Consumer Research* 4, ed. William D. Perrault, Jr. (Ann Arbor, Mich.: Association for Consumer Research, 1977), 349–356.

41. Michael J. Ryan and Edward H. Bonfield, "The Fishbein Extended Model and Consumer Behavior," *Journal of Consumer Research* 2 (1975): 118–136.

42. Youn-Kyung Kim, Eun Young Kim, and Shefali Kumar, "Testing the Behavioral Intentions Model of Online Shopping for Clothing," *Clothing and Textiles Research Journal* 21, no. 1 (2003): 32–40; Dong Shen, Marsha A. Dickson, Sharron Lennon, Catherine Montalto, and Li Zhang, "Cultural Influences on Chinese Consumers' Intentions to Purchase Apparel: Test and Extension of the Fishbein Behavioral Intentional Model," *Clothing and Textiles Research Journal* 21, no. 2 (2003): 89–99.

43. "Denim Around the World," *Cotton Incorporated Lifestyle Monitor Denim Issue* (2005): 3–5

44. Andrea Lawson Gray, "Lifestyle: The Next Big Thing," *Catalog Age* (November 1998): 105.

45. Benjamin D. Zablocki and Rosabeth Moss Kanter, "The Differentiation of Life-Styles," *Annual Review of Sociology* (1976): 269–297.

46. Mary Twe Douglas and Baron C. Isherwood, *The World of Goods* (New York: Basic Books, 1979).

47. Zablocki and Kanter, "The Differentiation of Life-Styles."

48. "The Niche's the Thing," *American Demographics* (February 2000): 22.

49. Gray, "Lifestyle: The Next Big Thing."

50. Mike Duff, "The Lifestyle Evolution Continues," *Discount Store News* (April 19, 1999): 61.

51. "Pottery Barn Captures Home Lifestyle," *Home Textiles Today* (April 6, 1998): S6.

52. Richard A. Peterson, "Revitalizing the Culture Concept," *Annual Review of Sociology* 5 (1979): 137–166.

53. William Leiss, Stephen Kline, and Sut Jhally, *Social Communication in Advertising* (Toronto: Methuen, 1986).

54. Mary Douglas and Baron Isherwood, *The World of Goods*, (New York: Basic Books, 1979): 72–73.

55. Christopher K. Hsee, and France Leclerc, "Will Products Look More Attractive When Presented Separately or Together?," *Journal of Consumer Research* 25 (September 1998): 175–186.

56. Jean Halliday, "L. L. Bean, Subaru Pair for Co-Branding," *Advertising Age* (February 21, 2000): 21.

57. www.nike.com; Edward C. Baig, "Nike + iPod So Easy to Use, It Could Get You Off Your Duff for a Workout," *USA Today* (July 20, 2006): 3B. See also Ellen Lee, "Apple, Nike Hooking Runners Up to iPods," *San Francisco Chronicle* (May 24, 2006): C1, C8.

58. Michael R. Solomon, "The Role of Products as Social Stimuli: A Symbolic Interactionism Perspective," *Journal of Consumer Research* 10 (December 1983): 319–329.

59. Michael R. Solomon and Henry Assael, "The Forest or the Trees? A Gestalt Approach to Symbolic Consumption," in *Marketing and Semiotics: New Directions in the Study of Signs for Sale,* ed. Jean Umiker-Sebeok (Berlin: Mouton de Gruyter, 1988), 189–218; Michael R. Solomon, "Mapping Product Constellations: A Social Categorization Approach to Symbolic Consumption," *Psychology & Marketing* 5, no. 3 (1988): 233–258; see also Stephen C. Cosmas, "Life Styles and Consumption Patterns," *Journal of Consumer Research* 8, no. 4 (March 1982): 453–455.

60. Russell W. Belk, "Yuppies as Arbiters of the Emerging Consumption Style," in *Advances in Consumer Research* 13, ed. Richard J. Lutz (Provo, Utah: Association for Consumer Research, 1986), 514–519.

61. See Lewis Alpert and Ronald Gatty, "Product Positioning by Behavioral Life Styles," *Journal of Marketing* 33 (April 1969): 65–69; Emanuel H. Demby, "Psychographics Revisited: The Birth of a Technique," *Marketing News* (January 2, 1989): 21; William D. Wells, "Backward Segmentation," in *Insights into Consumer Behavior,* ed. Johan Arndt (Boston: Allyn and Bacon, 1968), 85–100.

62. Alfred S. Boote, "Psychographics: Mind over Matter," *American Demographics* (April 1980): 26–29; William D. Wells, "Psychographics: A Critical Review," *Journal of Marketing Research* 12 (May 1975): 196–213.

63. "At Leisure: Americans' Use of Down Time," *The New York Times* (May 9, 1993): E2.

64. Joseph T. Plummer, "The Concept and Application of Life Style Segmentation," *Journal of Marketing* 38 (January 1974): 33–37.

65. Cathy Horyn, "She's a Topshop Girl," *New York Times* (July 11, 2004).

66. "Not by Jeans Alone," WGBH, Boston, 1981.

67. Nancy Cassill, and Mary Frances Drake, "Apparel Selection Criteria Related to Female Consumers' Lifestyle," *Clothing & Textiles Research Journal* 6, no. 1 (Fall 1987): 20–28.

68. Soyeon Shim and Marianne Bickle, "Benefit Segments of the Female Apparel Market: Psychographics, Shopping Orientations, and Demographics," *Clothing and Textiles Research Journal* 12, no. 2 (Winter 1994): 1–12.

69. Sarah P. Douglas and Michael R. Solomon, "The Power of Pinstripes," *Savvy* (March 1983): 59–62; M. K. Ericksen and M. J. Sirgy, "Achievement Motivation and Clothing Preferences of White-Collar Working Women," in *The Psychology of Fashion,* ed. Michael R. Solomon. (Lexington, Mass.: Lexington Books, 1985), pp. 357–367; E. B. Hurlock, *Motivation for Fashion* (New York: Archives of Psychology, 1929); K. E. Koch and Lois E. Dickey, "The Feminist in the Workplace: Application to a Contextual Study of Dress," *Clothing and Textiles Research Journal,* 7, no. 1 (1988): 46–54; Sarah Sweat, E. Kelley, D. Blouin, and R. Glee, "Career Appearance Perceptions of Selected University Students," *Adolescence* 16, no. 62 (1981): 359–370.

70. www.sric-bi.com/VALS/types.shtml (April 25, 2008).

71. Michael J. Weiss, *The Clustering of America* (New York: Harper & Row, 1988).

72. "Let Your Fingers Do the Trend Forecasting," *Time* (June 1, 1998): 24.

73. www.trendwatching.com, accessed November 30, 2006.

74. Julia Angwin, "Focus on Faith; Marketing Guru says 5 Trends Are in Your Future," *San Francisco Chronicle* (May 9, 1996).

75. "Cool Hunting on the Web," *The Sydney Morning Herald* (www.theage.com.au) (September 21, 2006).

76. "Target's Trendmaster Keeps Moving," *Business Week online* (June 1, 2006).

9
Consumer Perceptions

Susan has found that shopping for clothes on the Internet is great fun. There are so many virtual mall sites and companies that have Web sites now that there hardly seems a reason to fight the traffic to get to the real mall to shop. She's visited www.fashionmall.com, www. productopia.com, and many company sites including www. llbean.com, www.levi.com, www. delias.com, www.dickies. com, www.diesel.com, www. bcbg.com, www.landsend.com, www.jcpenney.com, www. bisou-bisou. com, www.gap.com, www.bluefly.com, www.bluelight.com, and www.bloomingdales.com—and the list goes on. It's great fun finding new sites all the time.

And if the item doesn't fit, just send it back. Companies are making it easier all the time to return goods that aren't quite right. But this last experience was somewhat disheartening to Susan as the bright orange sweater that looked so wonderful on her monitor, once unwrapped, was not so bright. It actually was a dull red-orange and not at all what she wanted. How did this happen? She has the perfect pants and other tops to coordinate with the sweater . . . it was going to be great. Maybe she should have bought the sweater at Macy's to get the right color. The colors look awful together and it's back to the company for credit, she figures.

INTRODUCTION

We live in a world overflowing with sensations. Wherever we turn, we are bombarded by a symphony of colors, sounds, and odors. Some of the "notes" in this symphony occur naturally, such as the loud barking of a dog, the shades of the evening sky, or the heady smell of a rosebush. Others come from people; the person sitting next to you in class might sport tinted blond hair, bright pink pants, and perhaps enough nasty perfume to make your eyes water. The fashion industry adds new colors to new lines each season to keep the fashion marketing machine continually working. Susan's orange sweater was the newest color, and buying it online might be the newest and most efficient way to shop, but her experience was less than satisfactory. Maybe if it had been black or white she would have been OK.

Marketers certainly contribute to this stimulating environment of color, sounds, and odors. Consumers are never far from advertisements, product packages, radio and television commercials, and billboards, all clamoring for our attention. Each of us copes with this bombardment by paying attention to some stimuli and tuning out others. And the messages to which we do choose to pay attention often wind up differing from what the sponsors intended, as we each put our "spin" on things by taking away meanings consistent with our own unique experiences, biases, and desires. This chapter focuses on the types and process of perception, in which sensations are absorbed by the consumer and then are used to interpret the surrounding world.

Sensation refers to the immediate response of our sensory receptors (eyes, ears, nose, mouth, fingers) to such basic stimuli as light, color, and sound. **Perception** is the process by which these sensations are selected, organized, and interpreted. The study of perception, then, focuses on what we add to or take away from these raw sensations as we choose which to notice, and then go about assigning meaning to them.

The study of perception is broken down into several ways of looking at the construct. There is some obvious overlap of these categories:

- *Object perception* is the impression or image we have of objects or products in the marketplace.
- *Person perception* refers to the impression we form of people from viewing their outward appearance. This impression is the basis of attributions that we make about their internal characteristics such as personality. Much of the perception research related to clothing and fashion relates to person perception.
- *Physical perception* occurs through the senses, such as vision, smell, sound, touch, and taste. This is related mainly to products or objects (but we do also see, smell, hear, and touch people and places). This chapter will focus mostly on physical perception.

Like computers, people undergo stages of information processing in which stimuli are input and stored. Unlike computers, though, we do not passively process whatever information happens to be present. In the first place, only a very small number of the stimuli in our environment are ever noticed. Of these, an even smaller amount are attended to. And the stimuli that do enter our consciousness might not be processed objectively. The meaning of a stimulus is interpreted by the individual, who is influenced by

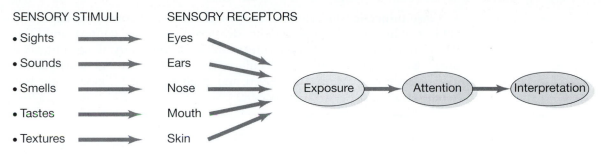

FIGURE 9-1
An Overview of the Perceptual Process

Source: M. R. Solomon, *Consumer Behavior,* 8th ed., p. 53, © 2009. Reprinted with permission of Pearson Education, Inc., Upper Saddle River, NJ.

his or her unique biases, needs, and experiences. As shown in Figure 9-1, these three stages of *exposure, attention,* and *interpretation* make up the process of perception. Before considering each of these stages, let's step back and consider the types of perception research as it relates to wearing and purchasing clothing or fashion.

OBJECT PERCEPTION

Many products have symbolic as well as utilitarian aspects.[1] The consumption of such products as clothing, cosmetics, jewelry, furniture, and automobiles may depend more on their social symbolic meanings than their functional utilities. Objects are perceived as being comfortable, status oriented, unique, or utilitarian. The perception of apparel quality has been predicted by fabric and garment construction, care, value, and style.[2] One study found that brand name affects the perception of the price of an item.[3] Also, brands are perceived in different ways and, thus, *brand image* or *brand personality* (see Chapter 8) is created in the consumer's mind. National versus private brands, type of product, and other characteristics have also been investigated relative to perceptions that we develop about products.

Cost, uniqueness, utilitarian or fashion image, and noticeability are characteristics of consumer goods that become cues in perceiver inferences about owner characteristics. Ownership of symbolic objects affects person perception as viewers attribute certain inner characteristics to a person based on this information or input. The ability to recognize the social implications of product choices differs with age but is almost fully developed by sixth grade, is the highest at college level, and then decreases with older age.[4]

Appearance in Context

Part of the understanding of the meaning of the clothing that we wear is **context**, the social circumstances or more complete framework of daily life in which clothing is worn. Appearance messages that we perceive are imbedded in context, which may be a setting, relationship, the attributes of the wearer, and the general culture in which we live and its historic meanings associated with clothing.[5]

Two principles underlie the study of clothing in a contextual approach: (1) In real life, we seldom see clothes divorced from social context, and (2) it has been demonstrated that interpretations of clothing vary along contextual lines.[6] Kaiser has set forth a model illustrating contexts through which clothing and fashion are viewed, perceived, and given meaning.[7] These are the following (from most general to specific):

culture

group association

social situation

immediate body space

person characteristics (age, gender)

kinetic interaction (sound and movement of materials)

garment/body interaction (grooming, fit)

the garment itself

The garment is subdivided by the garment pieces (skirt, pants, jacket), the treatment (gathered, draped, pleated), and the condition of the material (new, worn, faded, torn, wrinkled). We have a different perception of a garment and, therefore, the wearer if the garment is obviously new and in perfect condition versus one that has been obviously worn many times. Was the latter purchased at Goodwill? Or handed down? Or perhaps it is one of only a few clothes the person owns and, therefore, is worn often.

Finally, the perceptual elements within the design of a garment can create vastly different images and impressions about the garment and wearer. The visual images resulting from the manipulation of design elements is a study unto itself and cannot be covered in this book but are just touched on briefly here. Some are discussed more fully later in this chapter. These elements include the following:[8]

- *Line:* straight, curved; diagonal, vertical, horizontal; thick, thin; fuzzy, clear; broken, continuous
- *Space or area:* small, large; open, closed; blank, filled; overlapping, separate; convex, concave
- *Shape or form:* two-dimensional, three-dimensional; silhouette or shape of garments; shape of face and hairstyles; shape of garment elements (collars, cuffs, necklines)
- *Color:* hue (color family), value (light, dark), intensity (bright, dull); color of garment; color of skin, eyes, hair
- *Pattern:* geometric, floral, abstract
- *Texture of material:* soft, smooth, rough; shiny, dull; translucent, opaque; noisy, quiet
- *Apparent weight:* bulky
- *Fiber:* natural, synthetic
- *Odor:* smell of fabric

Principles of design, that is, the arrangement of the design elements, create harmony, unity, rhythm, balance, emphasis, and proportion. These principles apply to the design of advertisements as well as to the design of clothing to create certain images and impressions.

PERSON PERCEPTION

Clothing serves as a nonverbal form of communication that becomes the basis of judgments about people. We form first impressions about others based on limited information very quickly. Thus, we say, "You don't have a second chance to make a first impression." Clothing is probably the most symbolic of all products we own. It is one of the most eloquent and powerful products we use, as it is expressive, that is, a concrete way of revealing or communicating our ideas.[9] We communicate messages about ourselves to others through the meanings imbedded in the symbolic nature of our clothing. Hoffman identified some of these messages developed through garment elements discussed in the previous section:[10]

- *Manliness:* trousers, heavy materials
- *Femininity:* skirts, delicate materials
- *Dominance:* stiff fabrics, fur, leather, high hats or collars, dark colors, metal
- *Social power:* expensive materials, designer clothing
- *Autonomy:* casual fit, unironed clothing, rolled-up sleeves

Our clothing and accessories communicate personal and social variables, such as gender, age, occupation, marital status, economic status, self-esteem, attitudes, and values, much of which are discussed in chapters in this book. Other people perceive the stimuli offered by our clothing and make judgments about us; thus, we often use these symbols to manipulate or manage the impression we make. (See Chapter 10.)

Clothing can convey a multitude of meanings. For example, if you ask, "What do jeans mean?" there may be many answers.[11] Jeans may denote membership in groups such as agricultural laborers, civil rights, or youth subcultures; they also signify designer goods, unisexuality, comfort, earthiness, and sexiness. With so many meanings, there is much potential for ambiguity in communications through clothing symbols. Again, context becomes important to understand these meanings.

There have been many person perception studies using clothing as a variable. Generally, results indicate that the way we dress affects others' judgments about us. Clothing and cosmetics have been related to attractiveness;[12] judgments of such characteristics as personality, social status, social, political and sexual attitudes, sociability, honesty, risk taking, and managerial and teacher characteristics have been made based on clothing.[13] Even judgments of intelligence and scholastic achievement of students have been made based on dress alone.[14]

In one study college students compared the perception of owners of Calvin Klein jeans with those of generic "jeans." Owners of Calvin Klein jeans were identified as more conforming and extravagant.[15] Do you agree with these findings?

What personal characteristics come to mind when you look at this young woman? How do you perceive her?

In addition to inferences made about a person's internal characteristics, people tend to make extended inferences, such as inferences about one's family and even the type of city or place in which one works. One study found that cab drivers wearing "appropriate" dress, as opposed to "inappropriate" dress, elicited positive inferences about the city in which they worked, such as safe, not crowded, good opportunities, good shopping, and so on.[16]

PHYSICAL PERCEPTION: SENSORY SYSTEMS

External stimuli, or *sensory inputs,* provide sensations that can be received on a number of channels. We may see a billboard or a man in a formal suit, hear a jingle, feel the softness of a cashmere sweater, taste a new flavor of ice cream, or smell a leather jacket. The inputs picked up by our five senses constitute the raw data that begin the perceptual process. For example, sensory data emanating from the external environment (such as hearing a tune on the radio) can generate internal sensory experiences when the song triggers a young man's memory of his first dance and brings to mind the smell of his date's perfume. These responses are an important part of **hedonic consumption**, or the multisensory, fantasy, and emotional aspects of consumers' interactions with products.[17]

The unique sensory quality of a product can play an important role in helping it stand out from the competition, especially if the brand creates a unique association with the sensation. Owens-Corning was the first company to trademark a color, when it used a bright pink for its insulation material and adopted the Pink Panther cartoon character as its representative. Harley-Davidson actually tried to trademark the distinctive sound made by a "hog" revving up.[18] Hedonic consumption plays a central role in many marketing strategies that emphasize fantasy aspects of products—for example, Chanel's "Feel the Fantasy" ad.

Hedonic Consumption and the Design Economy

In recent years the sensory experiences we receive from products and services have become an even larger priority when we choose among competing options. As manufacturing costs go down and the amount of "stuff" that people accumulate goes up, consumers increasingly want to buy things that will give them hedonic value in addition to just doing what they're designed to do. A Dilbert comic strip poked fun at this trend when it featured a product designer who declared: "Quality is yesterday's news. Today we focus on the emotional impact of the product." Fun aside, the new focus on emotional experience is consistent with psychological research that finds that people prefer additional experiences over additional possessions as their incomes rise.[19]

In this environment, form *is* function. Two young entrepreneurs named Adam Lowry and Eric Ryan discovered that basic truth in the early days of 2000. They quit their day jobs to develop a line of house-cleaning products they called Method. Cleaning products—what a yawn, right? But think again: For years companies like Procter & Gamble have plodded along, peddling boring boxes of soap powder to generations of housewives who suffered in silence, scrubbing and buffing. Lowry and Ryan gambled that they could offer an alternative—cleaners in exotic scents like cucumber, lavender, and

ylang-ylang that come in aesthetically pleasing bottles. The bet paid off. Within two years the partners were cleaning up, taking in more than $2 million in revenue. Shortly thereafter, they hit it big when Target contracted to sell Method products in its stores.[20]

There's a method to Target's madness. Design is no longer the province of upper-crust sophisticates who never got close enough to a cleaning product to be revolted by it. The red-hot retail chain has helped to make designers like Karim Rashid, Michael Graves, Philippe Starck, Todd Oldman, and Isaac Mizrahi household names. Mass-market consumers are thirsting for great design, and they're rewarding those companies that give it to them with their enthusiastic patronage and loyalty. From T-shirts to computers like Apple, and even to the lowly trash can, design *is* substance.

Welcome to the new era of **sensory marketing**, where companies pay extra attention to the impact of sensations on our product experiences. In this section, we'll take a closer look at how some smart marketers use our sensory systems to create a competitive advantage.

Vision

Marketers rely heavily on visual elements in displays, advertising, store design, and packaging. Meanings are communicated on the visual channel through a product's color, size, and styling. In the late 1990s, Apple Computer was the first to apply color to strictly functional products with the introduction of the iMac computer in fun colors. The idea spread to phones with Nokia adding colored and patterned plates to its cell phones followed by Motorola's pink Razr while other companies offered colored cameras, CD players, USB drives, and other products.

Color Responses: Learned and Physiological

Colors may also influence our emotions more directly. Evidence suggests that some colors (particularly red) create feelings of arousal, whereas cool colors (such as blue) are more relaxing. Products presented against a backdrop of blue in advertisements are better liked than when a red background is used, and cross-cultural research indicates a consistent preference for blue whether people live in Canada or Hong Kong.[21] Colors such as green, yellow, cyan, and orange are considered the best hues to capture attention, but extensive use of these hues can overwhelm people and cause visual fatigue.[22]

Some reactions to color come from learned associations. In Western countries, black is the color associated with mourning while in some Eastern countries, white plays this role. In addition, we associate black with power and it may even have an impact on people who wear it. Teams in both the National Football League and the National Hockey League who wear black uniforms are among the most aggressive; they consistently rank near the top of their leagues in penalties during the season.[23]

A nationwide poll indicated that the demographics of age, ethnicity, and gender appear to be affecting our color preferences.[24] Color looks less bright to older people, so they gravitate to white and bright tones. As baby boomers age, this fact may have a significant effect on the fashion industry. Hispanics veer toward bright and warm colors, and African Americans are drawn to

strong, saturated colors that seem to be rooted in their African heritage. Blue continues to be the number one preference of all ethnic groups; however the second-most popular color varies, with African Americans and Hispanics leaning more toward purple, Asians toward pink, and whites toward green. Women are drawn to brighter tones and are more sensitive to subtle shadings and patterns. However, gender differences seem to be fading, especially among those under 30. One consultant said, "But it depends on context. You can't put G.I. Joe in pink. But can Diesel do pink men's clothing? Absolutely."[25]

The **hue** (the color, red versus blue) is not the only determinant in the impression we get from color. **Value** (light versus dark) and **intensity** (brightness versus dullness) are also important elements. As just mentioned, most people find that red is exciting while blue is calming, but is this always true? A dull or grayed red creates a different impression from a bright red. Similarly, a light blue and a dark blue create different feelings or perceptions.

Some studies have investigated physiological responses to color, such as heart rate, blood pressure, and galvanic skin response; others have concentrated on more subjective psychological responses. One problem that has been pointed out is the lack of control used in some early studies. The work most often cited in terms of how color affects behavior was done in 1942,[26] yet experiments were conducted on only three to five patients, all of whom had organic diseases of the central nervous system. The majority of the early color studies on which our concept of psychological responses to color is based were similarly conducted. It appears that experimental studies that utilize proper scientific controls do not find a significant difference in physiological measures. There may still be a difference in the red and blue response, but it may be that this is more aligned with learned response. If we have learned to believe red is exciting, we will find it exciting.[29]

Pantone (www.pantone.com), originally a manufacturer of color cards for print makers, is a leading developer and marketer in communicating accurate colors in a number of industries, including textiles, apparel manufacturing, graphic arts, and digital technology. Their original product, the Pantone Matching System, has become a worldwide standard language for accurate color reproduction. The Colorscopes box on the next page illustrates Pantone's conception of the meaning of colors in the United States. The meaning of colors can change over time. A Dillard's ad stated: "Pink about it. Pink. More than a color, it's a symbol of femininity, of women's health and of the fight against breast cancer, which affects all of us."[30]

MULTICULTURAL DIMENSIONS

Cultural differences in color preferences create the need for marketing strategies tailored to different countries. Procter & Gamble (P&G), for example, uses brighter colors in makeup it sells in Latin countries.[27] P&G and other cosmetics companies have found that women in Mexico and South America are willing to pay a premium for bold-colored nail polishes with names like "Orange Flip." Latina homemakers typically get dressed up in high heels tinted in tropical colors to go to the supermarket. For these women, the natural look is out. As one legal secretary in Mexico City explained, "When you don't wear makeup, men look at you like you are sick or something."[28]

COLORSCOPES

Pantone has developed color profiles that it calls *colorscopes,* showing associated meanings with certain colors. The key words associated with colors are listed here:

Red: A zest for life; winner, achiever, intense, impulsive, active, competitive, daring, aggressive, and passionate.

Pink: A softened red, so it tempers passion with purity. It is associated with romance, sweetness, delicacy, refinement, and tenderness.

Yellow: Luminous and warm because it is strongly associated with sunshine.

Orange: A combination of red and yellow, so it takes on many of the characteristics of both colors. It is vibrant and warm.

Brown: Associated with substance and stability; like Mother Earth, steady, reliable.

Beige: Similar to brown but less intense; warm, practical.

Green: Stable and balanced; like nature, fastidious and generous.

Blue: Tranquility and peace, tends to be the most preferred color universally, cool and confident.

Teal: A marriage of blue and green with many of those traits; neat, self-assured.

Purple: A combination of red and blue, aura of mystery and intrigue, enigmatic and highly creative.

Lavender: Seeking refinement.

Gray: Most neutral of all shades; secure, safe, maintain status quo.

Taupe: Also neutral but adds warmth of beige; class looks, practical.

Black: Negation of color; conventional, conservative, and serious.

White: Cleanliness and purity.

Color Forecasting

Color frequently is a key issue in product and package design. These choices used to be made casually. For example, the familiar Campbell's soup can was produced in red and white because a company executive liked the football uniforms at Cornell University! Now, however, color is a serious business, and many companies realize that their color choices can exert a big impact on consumers' assumptions about what is inside the package. This "package" includes clothing in addition to such products as automobiles and, as mentioned, even computers, telephones, and watches, where consumer preferences for colors change with the tides of fashion. That's why companies invest heavily in efforts to predict consumer tastes in colors a year, three years, and five years down the road.

For much of the 1990s black was the fashion color (or noncolor). You could walk through Barney's and see almost no color in the store, on the sales associates, or on the racks! But the pendulum seems to be swinging, as we now see color at all levels of fashion. Red has been the center of the color revival.[31] Even orange was seen everywhere one season, in women's wear and men's wear.

There are several color forecasting associations and groups whose primary purpose is to present colors to the industry that they feel will be successful in future years. In the apparel industry, early decisions in both the fiber and fabric markets are based on color, and therefore designers and retailers work closely with specialized forecasting houses. Most prominent of these groups are the International Color Authority (ICA), The Color Association of the United States, Color Marketing Group, and the Color Box.[32] Color forecasts are also included as a part of trend forecasts from forecasting services such as Promostyl (www.promostyl.com), Doneger

In Western culture the color black often is associated with sophistication whereas white connates innocence.

Creative Services, the forecasting division of the Doneger Group (www.doneger.com); and textile trade associations including Cotton Incorporated (www.cottoninc.com). And in keeping with the trend of blogs and sharing information, www.colourlovers.com is a site where people can post colors or palettes they like, vote on their favorites, and send notes to other color enthusiasts.[33]

Pantone conducts periodic research on consumer color preferences also. In its latest study it reported that blue was the country's most popular color. Second to blue was green (as discussed earlier, this varies with ethnicity). As ecology and preservation of nature has grown as a social issue, so has the popularity of green. One of the problems with fashion colors is their creative names. "Toast" in one company may be different from "toast" in another. One year "cloud" was popular . . . it was pink! Therefore, color systems such as Pantone or Munsell that have specific numeric notation systems are important to communicate precise colors to manufacturing sites.

New color trends are also introduced at trade shows and fairs throughout the world, including Interstoff Textile Fair in Frankfurt, Germany; Premiere Vision (First Look) in Paris, France; Ideacomo (Ideas from Como) in Como, Italy; and International Fashion Fabric Exhibition (IFFE) in New York City.

Color as Trade Dress

Some color combinations come to be so strongly associated with a corporation that they become known as the company's *trade dress*, similar to a trademark, and the company may even be granted exclusive use of these colors. For example, Eastman Kodak has successfully protected its trade dress of yellow, black, and red in court. As a rule, however, trade dress protection is granted only when consumers might be confused about what they are buying because of similar coloration of a competitor's packages.[36] Tommy Hilfiger attempted to secure exclusive use of red, white and blue for his label, something that may be impossible in the United States.

Translation of Color through Media

In the chapter opener we shared Susan's disappointment at the orange sweater that she bought from an Internet site and was not what she expected. One of the problems with mail order and Internet shopping is the true representation of the colors of the items for sale. About 60 percent of shoppers do not trust the colors on their monitors, according to a recent survey by CyberDialog Research. Another 30 percent decided against purchasing an

Red has become a new basic color.

COLORS FOR SPRING

Pantone is an authority on color and provider of color systems and leading technology for the selection and accurate communication of color across a variety of industries. The PANTONE® name is known worldwide as the standard language for color communication from designer to manufacturer to retailer to customer.[34] A color numbering system, rather than color names, is used to communicate the correct color. The following is one spring forecast developed by New York designers with their numbers, names, and descriptions.[35] Would you know these colors by just the names and descriptions?

- *Pantone 16-1720:* Strawberry ice—Warm, yet fresh feeling, nurturing.

- *Pantone 16-3801:* Opal gray—A variation of Fall's Frost gray, an unexpected neutral.

- *Pantone 14-4318:* Sky blue—famous for its sincerity and calming effect, this soft color has evolved over time; dependable and optimistic.

- *Pantone 16-1220:* Café crème—rich and creamy like its name; an implied earthiness.

- *Pantone 16-1220:* Tarragon—soothing and relaxing, the shade isn't acidic or bright; today it's important to appear natural, not synthetic, and tarragon is subtle with a freshness attached to it.

item due to color concerns, and 15 percent returned an item because it didn't match color expectations.[37] An "e-solution" to this problem is ColorWizzard™ software (www.colorwizzard.com), which calibrates monitors and screen-to-printer color matching. Improving images on Web sites, including accurate color, is an area for future development.

Smell

Odors can stir emotions or create a calming feeling. They can invoke memories or relieve stress. Some of our responses to scents result from early associations that call up good or bad feelings, and that explains why businesses are exploring connections among smell, memory, and mood.[38] Many new scents are turning up in unexpected places to stimulate these feelings. Dirt cologne smells like potting soil and is one of sixty-two "single-note" natural scents produced by Demeter Fragrances. Others include Carrot, Celery, and Cucumber, and single-note fragrances in development include Gasoline and Sweat (charming, right?).[39] Procter & Gamble's Physique shampoo smells like watermelon.[40] Framesi's Passion line of scented hair color includes 11 scent-coordinated shades including aromas of cinnamon, hazel, apricot, melon, strawberry, chocolate, and grape.[41]

Fragrance is processed by the limbic system, the most primitive part of the brain and the place where immediate emotions are experienced. Smell is a direct line to feelings of happiness and hunger and even memories of happy times. This explains why "plain" vanilla has of late become so widely used in scented products, from perfumes and colognes to cake frosting, coffees, and ice creams (for example, Coty sold $25 million worth of its Vanilla Fields cologne spray in a four-month period). An industry executive explains that vanilla "evokes memories of home and hearth, warmth and cuddling."[42] And wearing a certain odor can even reduce a woman's perceived weight by as much as 12 percent according to a study by the Smell and Taste Treatment and Research Foundation in Chicago![43]

The president of the Fragrance Foundation and the Olfactory Research Fund in New York says "we can improve our whole quality of life—sexwise, energywise, sleepwise with our sense of smell. The fragrance business is a $6 billion industry in the U.S. alone . . . home fragrance products reported double-digit increases over the last decade."[44] Businesses have discovered the economic clout of the ancient tenets of **aromatherapy**, by offering the public tools to "transform their environments" by creating, altering, or masking scents:

- Sea breeze for calm
- Lavender for relaxation
- Green tea for introspection
- Pine for energizing
- Jasmine for sensuality

One aromatherapy "junkie" stated: "The reason for turning to scents is simple: if bad aromas can make you sick, then it stands to reason that good aromas can make you well."[45] Although the concept has been most successful with candles and lotions, other products such as sleep therapies

are expected to become popular. In 1997, Coty introduced The Healing Garden, a line of aromatherapy products, which has brought awareness of the category to the masses. However, some companies are using the aromatherapy name without the concept; that is, they are not using essential oils, just fragrance. Most companies realize that more consumer education about how natural ingredients can help reduce stress or promote relaxation is needed.[46]

Many companies have jumped on the scent bandwagon. For example, Tony & Tina have infused traditional beauty items such as lipsticks (with names such as Empowered, Centered, and Creative) and bubble bath with the essential oils of lavender, bergamot, rosemary, and rosewater. Its lip gloss has the fragrance of geranium and tangerine.

Scented advertising, which began with perfumes, is now a $90 million business. Fragrance strips in fashion magazines have become ubiquitous. However, some people are allergic to fragrances and find these strips problematic. One county in northern California even attempted to outlaw fragrance strips coming to it in the mail. Another note of caution to advertisers: This technique adds at least 10 percent to the cost of producing an ad.

Most every department store shopper has had the experience of being waylaid by a perfume spritzer or has tried to sample several scents at the perfume counter. After a while they become a "rich stew of undistinguishable scents."[47] Barney's New York has a new approach to solve this problem by isolating one fragrance, so the customer is not smelling all the other surrounding ones. Barney's uses a French fragrance chamber whereby a fragrance

This ad for The Healing Garden combines the sensations of color and scent (there is a fragrance strip attached) and a description of extracts used to indicate the therapeutic nature of the products.

is spritzed into the chamber, the door closed for a few seconds, and then the consumer leans into the chamber to get an accurate smell. Another new wrinkle in the use of scents: fragranced clothes. The textile industry is developing New Age fabrics with "scentual" properties by embedding fragrances in microcapsules that are sewn to clothing. A French lingerie company is selling lingerie that emits scents when touched.

As we saw with color, the Internet has its shortcomings when it comes to buying scented products. Isn't part of the shopping experience missing when you merely point and click? How can you possibly buy perfumes and colognes on the Internet? Isn't there something missing like the smell of Mrs. Fields Cookies baking at the mall? Just as the catalogs and magazines solved this problem with scent strips, e-tailers have come up with a response (just as they did with the color translation problem). Just plug DigiScents Inc.'s iSmell box into your PC and sniff before you buy. Similar to a color printer mixing red, blue, and yellow to create the right shade of colors, the DigiScent software tells the iSmell how to blend up to 128 "fragrance elements" or "primary odors" to synthesize the scent of cherries, chocolate, or pine.[48]

Sound

Music and sound are also important to marketers. Consumers buy millions of dollars' worth of sound recordings each year, advertising jingles maintain brand awareness, and background music creates desired moods.[49] Many aspects of sound may affect people's feelings and behaviors. Hallmark has discovered the effect of music. It has added sound to its cards (called Sound Cards) fueling an increase in sales. These cards have also helped the company shed its staid image by resonating with teenagers and men, two difficult demographics to reach, who are now singing along to Tim McGraw, Rolling

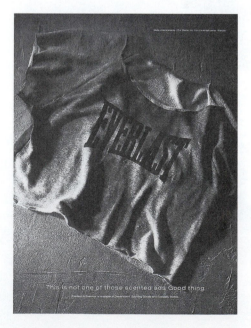

This ad for Everlast Sports Apparel pokes fun at the proliferation of scented ads.

Stones, and even the Royal Philharmonic Orchestra. A small computer chip plays music clips up to 45 seconds long for at least 200 times.[50] Two areas of research that have widespread applications in consumer contexts are the effects of background music on mood and the influence of speaking rate on attitude change and message comprehension.

Background Music

Fashion retailers often tailor their music to their market, with junior-oriented stores often playing loud popular music. In department stores, which cater to many target markets, it is common to find different music playing in each department. Informal studies have found that consumers base their judgments of the product partially on the type and loudness of music playing in the store. Some retailers have discovered that the music they play in their stores sells well. Lifestyle compilation CDs are selling at stores such as Ralph Lauren, Gap, Pottery Barn, Kolh's, Starbucks, Victoria's Secret, and Restoration Hardware. As the music industry undergoes uncertainty and major changes in distribution, compilation CDs are enjoying great success. "Leather couches are an easy way to put lifestyle in a home; music is essentially the same thing," says a Pottery Barn employee.[51] Music may be another way to distill a lifestyle.

Something quieter than fashion store music is Muzak. The Muzak Corporation estimates that its recordings are heard by 80 million people every day. This so-called functional music is played in stores, shopping malls, and offices to either relax or stimulate consumers. Research shows that workers tend to slow down during midmorning and midafternoon, so Muzak uses a system it calls "stimulus progression," in which the tempo increases during those slack times. Muzak has been linked to reductions in absenteeism among factory workers, and even the milk and egg output of cows and chickens is claimed to increase under its influence.[52] Think what it might do for your term papers!

Time Compression

Time compression is a technique used by broadcasters to manipulate perceptions of sound. It is a way to pack more information into a limited time by speeding up an announcer's voice in commercials. The speaking rate is typically accelerated to about 120 percent to 130 percent of normal. This effect is not detectable by most people; in fact, some tests indicate that consumers prefer a rate of transmission that is slightly faster than the normal speaking rate.[53]

Evidence for the effectiveness of time compression is mixed. It has been shown to increase persuasion in some situations and to reduce it in others. One explanation for a positive effect is that the listener uses a person's speaking rate to infer whether the speaker is confident; people seem to think that fast talkers must know what they are talking about.[54] Another, more plausible, explanation is that the listener is given less time to elaborate in his or her mind on the assertions made in the commercial. The acceleration disrupts normal responses to the ad and changes the cues used to form judgments about its content. This change can either hinder or facilitate attitude change, depending on other conditions.[55]

Touch

Although relatively little research has been done on the effects of tactile stimulation on consumer behavior, common observation tells us that this sensory channel is important. Of course it is most important as a criterion when buying fashion and clothing, but it's important in other aspects of our buying behavior also. Moods are stimulated or relaxed on the basis of sensations of the skin, whether from a luxurious massage or the bite of a winter wind.

Some anthropologists view touch much like a primal language, one we learn well before writing and speech. Indeed, researchers are starting to identify the important role the *haptic* (touch) sense plays in consumer behavior. We're more sure about what we perceive when we can touch it. Individuals who score high on a "Need for Touch" scale are especially influenced by this

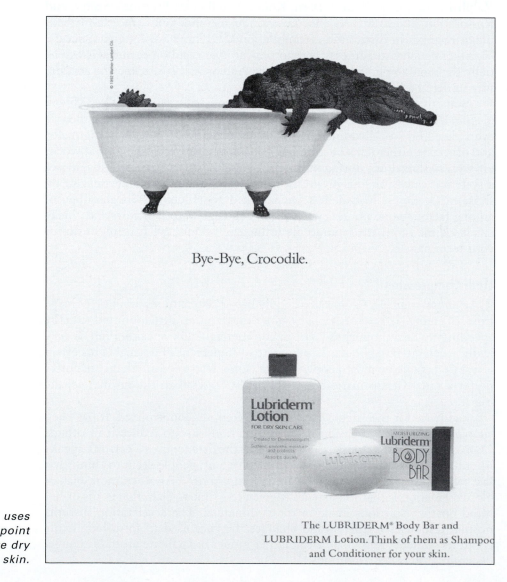

This older Lubriderm ad uses the concept of texture to point out how we can eliminate dry skin.

Bye-Bye, Crocodile.

The LUBRIDERM® Body Bar and LUBRIDERM Lotion. Think of them as Shampoo and Conditioner for your skin.

dimension (a major problem for those who sell products online). Those with a high need for touch respond positively to such statements as:

- "When walking through stores, I can't help touching all kinds of products."
- "Touching products can be fun."
- "I feel more comfortable purchasing a product after physically examining it."[56]

The perceived richness or quality of the material in clothing, bedding, or upholstery is linked to its "feel," or "hand." **Hand** is defined as an individual's reaction to the sense of touch when fabrics are held in the hand. A fabric can feel light, velvet soft, mellow, satin smooth, dry, papery, crisp, sandy, bristly, heavy, harsh, rough, scratchy, furry, waxy, fuzzy, or downy soft, as defined by an early study of aesthetic appeal of textiles.[57]

A smooth fabric such as silk is equated with luxury; denim is practical and durable. Some of these tactile/quality associations are summarized in Table 9-1. Fabrics that are composed of scarce materials or that require a high degree of processing to achieve their smoothness or fineness tend to be more expensive and, thus, are seen as being higher class. Similarly, lighter, more delicate textures are assumed to be feminine.

Taste

This sense is not normally associated with apparel fashion marketing, but flavors do enter into the cosmetics industry. Consider the fruit-flavored lip gloss and lipstick options today. And co-founder Jessica Simpson's Dessert Beauty is a unique line of "lickable, kissable products that taste as good as they look . . . serving up sweet treats like Whipped Body Creams, Lip Glosses, and Powdered Sugar Body Shimmers that let you surrender to your sweet tooth—minus the calories and carbs."[58]

Food fashions go through similar cycles to apparel fashions. Specialized companies called "flavor houses" keep busy developing new concoctions to please the changing palates of consumers. For example, consumers' greater appreciation of different ethnic dishes has contributed to increased desires for spicy foods, so the quest for the ultimate pepper sauce is a hot taste trend. More than fifty stores in the United States now specialize in supplying fiery concoctions with names like Sting and Linger, Hell in a Jar, and Religious Experience (comes in Original, Hot, and Wrath).[59] Indeed, Americans are becoming more adventurous in their eating. We want bold

Table 9-1 Tactile Oppositions in Fabrics

Perception	Male	Female	
High class	Wool	Silk	Fine
Low class	Denim	Cotton	↕
	Heavy ← → Light		Coarse

Source: M. R. Solomon, *Consumer Behavior,* 8th ed., p. 63, © 2009. Reprinted with permission of Pearson Education, Inc., Upper Saddle River, NJ.

flavors in all kinds of foods—haute cuisine, fast food, snacks, and even candy. Thus, we see Coca-Cola's Blak, a fusion beverage of Coke and coffee, and Frito-Lay's Sensations line of potato and tortilla chips seasoned with chiles and red pepper.[60]

At the other extreme of sensation, Japanese beverage companies are catching onto a new fad among younger Japanese consumers, who are becoming more health conscious and want to avoid harmful additives: bland watery drinks. Beverage manufacturers there are making fruit drinks that you can see through. Coca-Cola introduced a new cold tea with an actor who stares at a bottle and wonders: Is it tea or is it water? Stores are stacked with cartons of "near waters"—mineral waters with just a touch of flavor. Sapporo sells a watered-down iced coffee, while Asahi Breweries makes a beer that is as clear as water with a name that sums up this new trend: Beer Water.[61] Not too appealing to Americans, but perhaps good for washing down some hot sauce?

EXPOSURE

Exposure occurs when a stimulus comes within the range of someone's sensory receptors. Generally the more exposure a stimulus (or message) gets, the more consumers will become aware of it. Outdoor advertising such as billboards, ads on buses and bus shelters, blimps, and even mobile billboards are getting heavy use by the fashion industry recently. It's everywhere, and many people cannot escape the messages. The growth in outdoor advertising is attributed to more women working in urban centers, and the industry is taking advantage of the opportunities to grab their attention. Bus and car wrapping also makes the message mobile and hard to miss. It's kind of like plastic wrap for cars. A thousandth of an inch thick, the material does not hurt the finish on a vehicle and it can easily be applied and removed once the contract runs out (www.autowraps.com).[62]

Consumers concentrate on some stimuli, are unaware of some, and even go out of their way to ignore others. An experiment by a Minneapolis bank

This mobile billboard is driven around the streets of New York City. If consumers won't come to the message, the message will come to them.

illustrates consumers' tendencies to miss or ignore information in which they are not interested. After a state law was passed that required banks to explain details about money transfer in electronic banking, the Northwestern National Bank distributed a pamphlet to 120,000 of its customers at considerable cost to provide the required information, which was hardly exciting bedtime reading. In one hundred of the mailings, a section in the middle of the pamphlet offered the reader $10.00 just for finding that paragraph. Not a single person claimed the reward.[63] Before we consider what people may *choose* not to perceive, let's consider what they are capable of perceiving.

Sensory Thresholds

If you have ever blown a dog whistle and watched pets respond to a sound you cannot hear, you know that there are some stimuli that people simply are not capable of perceiving. Of course, some people are better able to pick up sensory information than are others, whose sensory channels may be impaired by disabilities or age. The science that focuses on how the physical environment is integrated into our personal, subjective world is known as **psychophysics**.

The Absolute Threshold

When we define the lowest intensity of a stimulus that can be registered on a sensory channel, we speak of a *threshold* for that receptor. The **absolute threshold** refers to the minimum amount of stimulation that can be detected on a sensory channel. The sound emitted by a dog whistle is too high to be detected by human ears, so this stimulus is beyond our auditory absolute threshold. The absolute threshold is an important consideration in designing marketing stimuli. A billboard might have the most entertaining copy ever written, but this genius is wasted if the print is too small for passing motorists to see it from the highway.

The Differential Threshold

The **differential threshold** refers to the ability of a sensory system to detect changes or differences *between* two stimuli. The mimimum difference that can be detected between two stimuli is known as the **j.n.d.** (just noticeable difference).

The issue of when and if a difference between two stimuli will be noticed by consumers is relevant to many marketing situations. Sometimes a marketer may want to ensure that a change is observed, as when merchandise is offered at a discount. In other situations, the fact that a change has been made may be downplayed, as in the case of price increases or when a product is downsized.

A consumer's ability to detect a difference between two stimuli is *relative*. A whispered conversation that might be unintelligible on a noisy street can suddenly become public and embarrassing knowledge in a quiet library. It is the relative difference between the decibel level of the conversation and its surroundings, rather than the loudness of the conversation itself, that determines whether the stimulus will register.

Subliminal Perception

Most marketers are concerned with creating messages above consumers' thresholds so they can be sure to be noticed. Ironically, a good number of consumers appear to believe that many advertising messages are, in fact, designed to be perceived unconsciously, or *below* the threshold of recognition. Another word for threshold is *limen,* and stimuli that fall below the limen are termed *subliminal.* **Subliminal perception** thus occurs when the stimulus is below the level of the consumer's awareness.

Subliminal perception is a topic that has captivated the public for more than forty years, despite the fact that there is virtually *no proof* that this process has any effect on consumer behavior. A survey of American consumers found that almost two-thirds believe in the existence of subliminal advertising, and more than one-half are convinced that this technique can get them to buy things they do not really want![64]

In fact, most examples of subliminal perception that have been "discovered" are not subliminal at all; they are quite visible. Remember, if you can see it or hear it, it is *not* subliminal, because the stimulus is above the level of conscious awareness. Nonetheless, the continuing controversy about subliminal persuasion has been important in shaping the public's beliefs about advertising and marketers' ability to manipulate consumers against their will.

Subliminal messages supposedly can be sent on both visual and aural channels. *Embeds* are tiny figures that are inserted into magazine advertising by using high-speed photography or airbrushing. These hidden figures, usually of a sexual nature, supposedly exert strong but unconscious influences on innocent readers. To date, the only real impact of this interest in hidden messages is to sell "exposés" written by a few authors, and to make some consumers (and students of consumer behavior) look a bit more closely at print ads—perhaps seeing whatever their imaginations lead them to see.

Many consumers also are fascinated by the possible effects of messages hidden on sound recordings. An attempt to capitalize on subliminal auditory perception techniques is found in the growing market for self-help cassettes. These tapes, which typically feature the sound of waves crashing or some other natural setting, supposedly contain subliminal messages to help the listener stop smoking, lose weight, gain confidence, and so on. Despite the rapid growth of this market, there is little evidence that subliminal stimuli transmitted on the auditory channel can bring about desired changes in behavior.[65]

Along with the interest in hidden self-help messages on recordings, some consumers have become concerned about rumors of satanic messages recorded backward on rock music selections. The popular press has devoted much attention to such stories, and state legislatures have considered bills requiring warning labels about these messages. These backward messages do indeed appear on some albums, including Led Zeppelin's classic song "Stairway to Heaven," which contains the lyric "there's still time to change." When played in reverse, this phrase sounds like "so here's to my sweet Satan."

The novelty of such reversals might help sell records, but the "evil" messages within have no effect.[66] Humans do not have a speech perception mechanism operating at an unconscious level that is capable of decoding a reversed signal. On the other hand, subtle acoustical messages such as "I am honest. I won't steal. Stealing is dishonest" are broadcast in more than a

thousand stores in the United States to prevent shoplifting and do appear to have some effect. Unlike subliminal perception, though, these messages are played at a (barely) audible level, using a technique known as *threshold messaging*.[67] After a nine-month test period, theft losses in one six-store chain declined almost 40 percent, saving the company $600,000. Some evidence indicates, however, that these messages are effective only on individuals who are predisposed to suggestion. For example, someone who might be thinking about taking something on a dare but who feels guilty about it might be deterred, but these soft words will not sway a professional thief.[68]

It is doubtful that these techniques would be of much use in most marketing contexts. Clearly, there are better ways to get our attention—the next section explores this.

ATTENTION

As you sit in a lecture, you might find your mind wandering (yes, even you!). One minute you are concentrating on the instructor's words, and in the next, you catch yourself daydreaming about the upcoming weekend. Suddenly, you tune back in as you hear your name being spoken. Fortunately, it's a false alarm—the professor has called on another "victim" who has the same name. But she's got your attention now. . . .

Attention refers to the extent to which processing activity is devoted to a particular stimulus. As you know from sitting through both interesting and "less interesting" lectures, this allocation can vary depending on both the characteristics of the stimulus (that is, the lecture itself) and the recipient (that is, your mental state at the time).

Although we live in an "information society," we can have too much of a good thing. Consumers often are in a state of *sensory overload,* exposed to far more information than they are capable of or willing to process. In our society, much of this bombardment comes from commercial sources, and the competition for our attention is increasing steadily. The average adult is exposed to about 3,500 pieces of advertising information every single day—up from about 560 per day 30 years ago. Many younger people in particular (80 percent, by one estimate) have developed the ability to **multitask**, or process information from more than one medium at a time as they attend to their cell phone, TV, instant messages, and so on.[69]

Still, many people (perhaps the teens' parents?) are getting fed up—in one recent survey, 54 percent of respondents said they "avoid buying products that overwhelm them with advertising and marketing"; 60 percent said their opinion of advertising "is much more negative than just a few years ago," and 69 percent said they "are interested in products and services that would help them skip or block marketing."[70] Those folks might be interested in a new product called TV-B-Gone, a plastic $14.99 keychain fob that, as the pitch goes, "turns off virtually any television!"[71]

Television networks are jamming a record number of commercials into their shows—an average of 16 minutes and 43 seconds per programming hour.[72] And to make matters worse, this onslaught is growing as we now are bombarded by *banner ads* when we surf the Web as well. These online ads can in fact increase brand awareness after only one exposure, but only if they motivate surfers to click through and see what information is awaiting them.[73]

Perceptual Selection

Because the brain's capacity to process information is limited, consumers are very selective about what they pay attention to. The process of **perceptual selection** (or *selective awareness*) means that people attend to only a small portion of stimuli to which they are exposed. Consumers practice a form of "psychic economy," picking and choosing among stimuli, to avoid being overwhelmed. How do they choose? Both personal and stimulus factors help to decide.

Personal Selection Factors

Experience, which is the result of acquiring stimulation over time, is one factor that determines how much exposure to a particular stimulus a person accepts. *Perceptual filters* based on our past experiences influence what we decide to process.

Perceptual vigilance is one such factor. Consumers are more likely to be aware of stimuli that relate to their current needs. A consumer who rarely notices clothing ads for traditional career apparel will become very much aware of them when he or she gets a job and is in the market for a new career wardrobe.

Another factor is **adaptation**, the degree to which consumers continue to notice a stimulus over time. The process of adaptation occurs when consumers no longer pay attention to a stimulus because it is so familiar. A consumer can become "habituated" and require increasingly stronger "doses" of a stimulus for it to be noticed. For example, a consumer en route to work might read a billboard message when it is first installed, but after a few days, it just becomes part of the passing scenery. Several factors can lead to adaptation:

- *Intensity:* Less-intense stimuli (such as soft sounds or dim colors) habituate because they have less of a sensory impact.
- *Duration:* Stimuli that require relatively lengthy exposure in order to be processed tend to habituate because they require a long attention span.
- *Discrimination:* Simple stimuli tend to habituate because they do not require attention to detail.
- *Exposure:* Frequently encountered stimuli tend to habituate as the rate of exposure increases.
- *Relevance:* Stimuli that are irrelevant or unimportant will habituate because they fail to attract attention.

Stimulus Selection Factors

In addition to the receiver's mind-set, characteristics of the stimulus itself play an important role in determining what gets noticed and what gets ignored. These factors need to be understood by marketers, who can apply them to their messages and packages to boost their chances of cutting through the clutter and commanding attention. In general, stimuli that differ from others around them are more likely to be noticed. This *contrast* can be created in several ways:

- *Size:* The size of the stimulus itself in contrast to the competition helps determine whether it will command attention. Readership of a magazine ad increases in proportion to the size of the ad.[74] Outside

billboards are also getting bigger. In cities, sides of whole buildings are covered with images printed on new vinyl materials. Some loom so large that complaints of visual blight may lead to regulation in some places.[75]

- *Color:* As we've seen, color is a powerful way to draw attention to a product or to give it a distinct identity. Animal prints that Nokia uses on its cell phones and Motorola's pink Razr bring attention to the product, quite different from ho-hum black phones.

- *Novelty:* Today's interactive technology, with techno gimmicks such as plasma boards and electronic billboards making city billboards come alive, grabs people's attention. Some can even talk to smart cars that are equipped with computer chips.[76] Stimuli that appear in unexpected ways or places tend to grab our attention. One solution has been to put ads in unconventional places, where there will be less competition for attention. These places include the backs of shopping carts, walls of tunnels, floors of sports stadiums, and even above public toilets.[77] Target installed a series of ads in New York City subway tunnels such that subway riders viewed them as the train sped by.

- *Position:* Not surprisingly, stimuli that are in places we're more likely to look stand a better chance of being noticed. That's why the competition is so heated among suppliers to have their products displayed in stores at eye level. Placing your ad in prominent real estate positions such as Times Square in New York City assures attention. Calvin Klein underwear ads drew much notice and comment in this location. In magazines, ads that are placed toward the front of the issue, preferably on the right-hand side, also win out in the race for readers' attention (*Hint:* The next time you read a magazine, notice which pages you're more likely to spend time looking at).[78] Cotton Incorporated's ads appear on the back page of *Women's Wear Daily* and *Daily News Record,* since they get maximum exposure when it sits on a desk or table or if someone is reading the paper while holding it up—the back of the paper is exposed. A study that tracked consumers' eye movements as they scanned telephone directories also illustrates the importance of a message's position. Consumers scanned listings in alphabetical order, and they noticed 93 percent of quarter-page display ads but only 26 percent of plain listings. Their eyes were drawn to color ads first, and these were viewed longer than black-and-white ones. In addition, subjects spent 54 percent more time viewing ads for businesses they ended up choosing, which illustrates the influence of attention on subsequent product choice.[79]

INTERPRETATION

Interpretation refers to the meaning that we assign to sensory stimuli. Just as people differ in terms of the stimuli that they perceive, the eventual assignment of meanings to these stimuli varies as well. Two people can see or hear the same event, but their interpretation of it can be like night and day depending on what they had expected the stimulus to be.

A popular British ratailer called French Connection relies on the priming process to evoke a response to its advertising by using an acronym that closely resembles another word.

Consumers assign meaning to stimuli based on the **schema**, or set of beliefs, to which the stimulus is assigned. In a process known as *priming*, certain properties of a stimulus typically will evoke a schema, which leads us to evaluate the stimulus in terms of other stimuli we have encountered that are believed to be similar. Identifying and evoking the correct schema is crucial to many marketing decisions, since this determines what criteria will be used to evaluate the product, package, or message. When Toro introduced a lightweight snow thrower, it was named the "Snow Pup." Sales were disappointing because the word *pup* called up a schema that grouped small, cuddly things together—not the desirable attributes for a snow thrower. When the product was renamed the "Snow Master," sales went up markedly.[80]

Stimulus Organization

One factor that determines how a stimulus will be interpreted is its assumed relationship with other events, sensations, or images. Our brains tend to relate incoming sensations to others already in memory based on some fundamental organizational principles. These principles are based on *Gestalt psychology*, a school of thought that maintains that people derive meaning from the *totality* of a set of stimuli, rather than from any individual stimulus. The German word **gestalt** roughly means "whole," "pattern," or "configuration,"

and this perspective is best summarized by the saying "the whole is greater than the sum of its parts." A piecemeal perspective that analyzes each component of the stimulus separately will be unable to capture the total effect.

In terms of appearance perception, the overall, or aggregate, impression that an individual makes is created through the use of fabrics, colors, and accessories all combined in a certain way. Isolating one part of an ensemble results in a loss of meaning. We think of an overall image and "what is worn with what." Think of the hippie look of the 1960s or the yuppie look of the 1980s. Retailers sell more units when items are displayed together—for example, layers and accessories. Similarly, a retail store's visual presentation creates an overall look through its merchandise, displays, lighting, and props. Consider the romantic feeling of a Victoria's Secret store. The gestalt perspective provides several principles relating to the way stimuli are organized.

- The **closure principle** states that people tend to perceive an incomplete picture as complete. That is, we tend to fill in the blanks based on our prior experience. This principle explains why most of us have no trouble reading a neon sign even if one or two of its letters are burned out or filling in the blanks in an incomplete message. The principle of closure is also at work when we hear only part of a jingle or theme. Utilization of the principle of closure in marketing strategies encourages audience participation, which increases the chance that people will attend to the message.
- The **principle of similarity** tells us that consumers tend to group together objects that share similar physical characteristics.
- The **figure-ground principle** states that one part of a stimulus will dominate (the *figure*) while other parts recede into the backdrop (the *ground*). This concept is easy to understand if one thinks literally of a photograph with a clear and sharply focused object (the figure) in the center. The figure is dominant, and the eye goes straight to it. The parts of the configuration that will be perceived as figure or ground can vary depending on the individual consumer as well as other factors. Similarly, in marketing messages that use the figure-ground principle, a stimulus can be made the focal point of the message or merely the context that surrounds the focus.

An interesting twist on the concept of figure-ground relationship is an ad for Converse, which is primarily blank except for a small image of a pair of Chuck Taylor Converse All-Stars and the tagline, "Just Rubber and a Blank Canvas." Converse placed four thousand posters in various neighborhoods in New York and Los Angeles designed to be doodled on and decorated.[81]

The Eye of the Beholder: Interpretational Biases

The stimuli we perceive often are ambiguous—it's up to us to determine the meaning based on our past experiences, expectations, and needs. We often see what we want to see. When stimuli are ambiguous, an individual will usually interpret them in a very personal way. You're all familiar with the psychologists' inkblot tests. A subject is asked to interpret an unclear picture. The description, or what meaning the individual ascribes to such a picture,

is a reflection not of the stimulus, but of the person's needs, wants, personality, or experience.

Semiotics: The Symbols Around Us

When we try to "make sense" of a marketing stimulus, whether a distinctive package, an elaborately staged television commercial, or perhaps a model on the cover of a magazine, we do so by interpreting its meaning in light of associations we have with these images. For this reason, much of the meaning we take away is influenced by what we make of the symbolism we perceive. After all, on the surface many marketing images have virtually no literal connection to actual products. What does a cowboy have to do with a bit of tobacco rolled into a paper tube? How can a celebrity such as ex-basketball star Shaquille O'Neal enhance the image of a soft drink or a fast-food restaurant? For assistance in understanding how consumers interpret the meanings of symbols, some marketers are turning to a field of study known as **semiotics**, which examines the correspondence between signs and symbols and their role in the assignment of meaning.[82] Semiotics is important to the understanding of consumer behavior because consumers use products to express their social identities. Products have learned meanings, and we rely on marketers to help us figure out what those meanings are. As one set of researchers put it, "advertising serves as a kind of culture/consumption dictionary; its entries are products, and their definitions are cultural meanings."[83]

From a semiotic perspective, every marketing message has three basic components: an object, a sign or symbol, and an interpretant. The **object** is the product that is the focus of the message (such as Marlboro cigarettes). The **sign** is the sensory imagery that represents the intended meanings of the object (such as the Marlboro cowboy). The **interpretant** is the meaning derived (such as rugged, individualistic, American). This relationship is diagrammed in Figure 9-2.

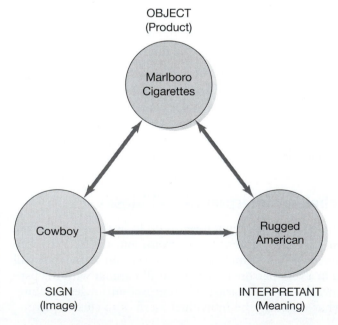

FIGURE 9-2
Relationships of Components in Semiotic Analysis of Meaning
Source: M. R. Solomon, *Consumer Behavior,* 8th ed., p. 78, © 2009. Reprinted by permission of Pearson Education, Inc., Upper Saddle River, NJ.

According to semiotician Charles Sanders Peirce, signs are related to objects in one of three ways: They can resemble objects, be connected to them, or be conventionally tied to them.[84] An *icon* is a sign that resembles the product in some way (for example, the Ford Mustang has a galloping horse on the hood.) An *index* is a sign that is connected to a product because they share some property (for example, Nike's swoosh conveys the shared property of activity). A *symbol* is a sign that is related to a product through either conventional or agreed-upon associations (for example, two horses pulling apart a pair of Levi's jeans appearing in the waistband patch and in advertising associates with the strength and functionality of the jeans). One fashion semiotic analysis looked at Gloria Vanderbilt's swan, Munsingwear's penguin, Izod Lacoste's alligator and Ralph Lauren's polo pony. Several propositions were suggested in the interpretation of the icons, indexes, and symbols: the animal icons were analyzed as representing human dominion over the natural world and the symbols are encoded with subtle status markers. Symbolic interpretation relates to the product's market positioning with Polo representing an upper-class symbol.[85] These relationships are often culturally bound; that is, they make sense only to a person who is a member of a particular culture. Marketers who forget that meanings do not automatically transfer from one cultural context to another do so at their peril.

One of the hallmarks of modern advertising is that it creates a condition that has been termed *hyperreality*. **Hyperreality** refers to the becoming real of what is initially simulation of "hype." Advertisers create new relationships between objects and interpretants by inventing new connections between products and benefits, such as equating Marlboro cigarettes with the American frontier spirit.[86]

In a hyperreal environment, over time the true relationship between the symbol and reality is no longer possible to discern. The "artificial" associations between product symbols and the real world may take on lives of their own.

Perceptual Positioning

As we've seen, a product stimulus often is interpreted in light of what we already know about a product category and the characteristics of existing brands. Perceptions of a brand are composed of both its functional attributes (its features, its price, and so on) and its symbolic attributes (its image and what we think it says about us when we use it). We'll look more closely at issues such as brand image in later chapters, but for now it's important to keep in mind that our evaluation of a product typically is the result of what it means rather than what it does. This meaning—as perceived by consumers—constitutes the product's *market position*, and it may have more to do with our expectations of product performance as communicated by its color, its packaging, its styling, or where you buy it than with the product itself.

A **positioning strategy** is a fundamental part of a company's marketing efforts, as it uses elements of the marketing mix (product design, price, distribution, and marketing communications) to influence the consumer's interpretation of its meaning. Positioning is critical in promotional strategies. Strategies can focus on the product's attributes or the competition.

Positioning Dimensions

Many dimensions can be used to establish a brand's position in the market-place:[87]

- *Lifestyle:* A Gucci purse is "high class."
- *Price leadership:* Wal-Mart sets the standard for low prices.
- *Attributes:* Rockport Concept shoe ads state: "Be comfortable, uncompromise, start with your feet."
- *Product class:* Nivea is the world's "#1 name in skin care."
- *Competitors:* An ad campaign by Levi's stated: "Calvin wore them; Tommy wore them; Ralph wore them."
- *Occasions/situation: Vogue* has a different cover for New York, Texas, and L.A.
- *Users:* Levi's Dockers are targeted primarily to men in their thirties and forties.
- *Quality:* "Sea & Ski, the name you trust in suncare: Put On the Best."

Repositioning

Repositioning occurs when a brand's original market position is modified. In some cases, a marketer may decide that a brand is competing too closely with another of its own products, so sales are being *cannibalized* (that is, the two brands are taking sales away from each other, rather than from competing companies). This was one reason for the decision by The Limited to reposition Express, a subsidiary. Its original target was a younger audience than The Limited chain, but as the two chains utilized each others' sources, one cannibalized the other with the result of an overall decrease in sales.[88]

Another reason for repositioning crops up when too many competitors are stressing the same attribute. For example, quality tends to be an attribute most apparel companies are stressing, from high- to low-end products. They certainly cannot all have the same features of quality. It's definitely a term defined differently by different consumers.

Finally, repositioning can occur when the original market evaporates or is unreceptive to the offering. *Details* magazine was initially launched as an "underground nightlife magazine" but was relaunched as a fashion and lifestyle magazine for twenty-something males. Formerly criticized for being too raw and bold, it now strives to be more sophisticated so that advertisers wishing to reach younger males will encounter a more conducive environment in which to place their advertising.[89]

Perceptual Mapping

The techniques of *perceptual mapping* help companies determine just how their products or services appear to consumers in relation to competitive brands on one or more relevant characteristics. It enables them to see gaps in the positioning of all brands in the product or service class and to identify areas in which consumer needs are not being adequately met. One technique is to ask consumers what attributes are important to them and how they feel competitors rate on these attributes. Figure 9-3 is an example of a **perceptual map** of

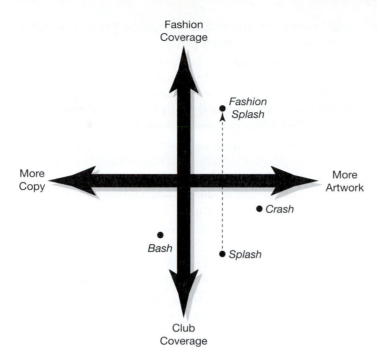

FIGURE 9-3
Perceptual Map of Competitors
Facilitates Magazine
Repositioning
Source: Leon G. Schiffman and Leslie Lazar
Kanuk, *Consumer Behavior,* 9th ed., © p. 176,
2007. Reprinted by permission of Pearson
Education, Inc., Upper Saddle River, NJ.

a new magazine targeted to Generation Y. The publisher may discover that consumers perceive its magazine (let's call it *Splash*) to be very similar in editorial content and format to its closest competitors, *Bash* and *Crash*. By changing the focus of its editorial features to appeal to a new market niche, the publisher can reposition the magazine from *Splash* to *Fashion Splash*.

CHAPTER SUMMARY

- Perception is the process by which physical sensations such as sights, sounds, and smells are selected, organized, and interpreted. We make judgments about people and objects based on stimuli presented to us. The eventual interpretation of a stimulus allows it to be assigned meaning. Thus we perceive people as having certain attributes based on their appearance; similarly, we perceive images of products based on their packaging.

- Marketing stimuli have important sensory qualities. We rely on colors, odors, sounds, tastes, and even the "feel" of products when forming evaluations of them.

- Color forecasting is an important component of fashion forecasting, as color decisions are often made years before the product is delivered to consumers.

- Not all sensations successfully make their way through the perceptual process. Many stimuli compete for our attention, and the majority are not noticed or accurately comprehended.

- People have different thresholds of perception. A stimulus must be presented at a certain level of intensity before it can be detected by sensory receptors. In addition, a consumer's ability to detect whether two stimuli are different (the differential threshold) is an important issue in many

marketing contexts, such as changing a package design, altering the size of a product, or reducing its price.

- A lot of controversy has been sparked by so-called subliminal persuasion and related techniques, by which people are exposed to visual and audio messages below the sensory threshold. Although evidence that subliminal persuasion is effective is virtually nonexistent, many consumers continue to believe that advertisers use this technique.

- Some factors that determine which stimuli (above the threshold level) do get perceived are the amount of exposure to the stimulus, how much attention it generates, and how it is interpreted. In an increasingly crowded stimulus environment, advertising clutter occurs when too many marketing-related messages compete for attention.

- A stimulus that is attended to is not perceived in isolation. It is classified and organized according to principles of perceptual organization. These principles are guided by a *gestalt,* or overall pattern. Specific grouping principles include closure, similarity, and figure-ground relationships.

- The three steps of the perceptual process are exposure, attention, and interpretation. Symbols help us make sense of the world by providing us with an interpretation of a stimulus that is often shared by others. The degree to which the symbolism is consistent with our previous experience affects the meaning we assign to related objects.

- A perceptual map is a widely used marketing tool that evaluates the relative standing of competing brands along relevant dimensions.

KEY TERMS

sensation	absolute threshold	closure principle
perception	differential threshold	principle of similarity
context	j.n.d.	figure-ground
sensory marketing	subliminal perception	principle
hedonic consumption	attention	semiotics
hue	multitask	object
value	perceptual selection	sign
intensity	perceptual vigilance	interpretant
aromatherapy	adaptation	hyperreality
hand	interpretation	positioning strategy
exposure	schema	repositioning
psychophysics	gestalt	perceptual map

DISCUSSION QUESTIONS

1. Interview three to five male and three to five female friends regarding their perceptions of both men's and women's fragrances. Construct a perceptual map for each set of products. Based on your map of perfumes, do you see any areas that are not adequately served by current offerings? What (if any) gender differences did you obtain regarding

both the relevant dimensions used by raters and the placement of specific brands along these dimensions?

2. Many studies have shown that our sensory detection abilities decline as we grow older. Discuss the implications of the absolute threshold for marketers attempting to appeal to the elderly.

3. Analyze fashion ads for figure-ground relationships. Find effective and ineffective ads based on this principle.

4. Assuming that some forms of subliminal persuasion may have the desired effect of influencing consumers, do you think the use of these techniques is ethical? Explain your answer.

5. Collect a set of current ads for one type of product (such as perfume, cosmetics, fashion jeans, or athletic shoes) from magazines, and analyze the colors employed. Describe the images conveyed by different colors, and try to identify any consistency across brands in terms of the colors used in product packaging or other aspects of the ads.

6. Do you believe in aromatherapy? Do you feel that essential oils have therapeutic benefits to the body? Survey your fellow classmates regarding their awareness and use of these products.

7. Investigate the Web sites for jeans at different price levels such as Levi Strauss, Seven for All Mankind, and so on. Analyze their positions in the marketplace relative to fashion, price, and other factors you might identify. How has Levi's repositioned itself lately?

8. Survey consumer groups regarding their color preferences for various products, including sportswear, formalwear, cars, and furniture. What's the current most fashionable color?

9. Look through a current magazine and select one ad that captures your attention over the others. Give the reasons why.

10. Find ads that utilize the techniques of contrast and novelty. Give your opinion of the effectiveness of each ad and whether the technique is likely to be appropriate for the consumers targeted by the ad.

ENDNOTES

1. Michael R. Solomon, "The Role of Products as Social Stimuli: A Symbolic Interactionist Perspective," *Journal of Consumer Research* 10 (1970): 319–329.
2. L. Abraham-Murali and Mary A. Littrell, "Consumers' Perceptions of Apparel Quality over Time: An Exploratory Study," *Clothing and Textiles Research Journal* 13, no. 3 (1995): 149–158.
3. Sandra M. Forsythe, "Effect of Private, Designer, and National Brand Names on Shoppers' Perception of Apparel Quality and Price," *Clothing and Textiles Research Journal* 9, no. 2 (1995): 1–6.
4. Russell W. Belk, Kenneth D. Bahn, and Robert N. Meyer, "Developmental Recognition of Consumption Symbolism," *Journal of Consumer Research* 9 (1982): 5–17.
5. Susan Kaiser, *The Social Psychology of Clothing: Symbolic Appearances in Context* (New York: Fairchild, 1997).
6. Mary Lou Damhorst, "Meaning of Clothing Cues in Social Context," *Clothing and Textile Research Journal* 3, no. 2 (1985): 39–48.
7. Kaiser, *The Social Psychology of Clothing: Symbolic Appearances in Context.*
8. For more information on design elements in clothing, see Marian L. Davis, *Visual Design* (Upper Saddle River, N.J.: Prentice-Hall, 1996).
9. Grant McCracken, *Culture and Consumption: New Approaches to the Symbolic Character of Consumer Goods and Activities* (Bloomington: Indiana University Press, 1988).
10. Hans-Joachim Hoffman, "How Clothes Communicate," *Media Development* 4 (1984): 7–11.
11. Nathan Joseph, *Uniforms and Nonuniforms: Communications through Clothing* (New York: Greenwood Press, 1986).

12. Paul N. Hamid, "Style of Dress as a Perceptual Cue in Impression Formation," *Perceptual and Motor Skills* 26 (1968): 904–906; Paul N. Hamid, "Changes in Person Perception as a Function of Dress," *Perceptual and Motor Skills* 29 (1969): 191–194; Jane E. Workman and Kim K. Johnson, "The Role of Cosmetics in Impression Formation," *Clothing and Textiles Research Journal* 10, no. 1 (1991): 63–67.

13. Helen H. Douty, "Influence of Clothing on Perceptions of Persons," *Journal of Home Economics* 55 (1963): 197–202; Hilda M. Buckley and Mary Ellen Roach, "Clothing as a Nonverbal Communicator of Social and Political Attitudes," *Home Economics Research Journal* 3, no. 2 (1974): 94–102; Eugene W. Mathes and Sherry B. Kempher, "Clothing as a Nonverbal Communicator of Sexual Attitudes and Behavior," *Perceptual and Motor Skills* 43 (1976): 495–498; Barbara H. Johnson, Richard H. Nagasawa, and Kathleen Peters, "Clothing Style Differences: Their Effect on the Impression of Sociability" *Home Economics Research Journal* 6 (1977): 58–63; Sandra M. Forsythe, "Dress as an Influence on the Perceptions of Managerial Characteristics in Women," *Home Economics Research Journal* 13, no. 2 (1984): 112–121; Sara Butler and Kathy Roesel, "The Influence of Dress on Students' Perceptions of Teacher Characteristics," *Clothing and Textiles Research Journal* 7, no. 3 (1989): 57–59; Jane E. Workman, Naomi E. Arseneau, and Chandra J. Ewell, "Traits and Behaviors Assigned to an Adolescent Wearing an Alcohol Promotional T-Shirt," *Family and Consumer Sciences Research Journal* 33, no. 1 (September 2004): 62–80.

14. Dorothy Behling, "Influence of Dress on Perception of Intelligence and Scholastic Achievement in Urban Schools with Minority Populations," *Clothing and Textiles Research Journal* 13, no. 1 (1995): 11–16.

15. Jane E. Workman, "Trait Inferences Based on Perceived Ownership of Designer, Brand Name, or Store Brand Jeans," *Clothing and Textiles Research Journal* 6, no. 2 (1988): 23–29.

16. Jane E. Workman and Kim P. Johnson, "The Role of Clothing in Extended Inferences," *Home Economics Research Journal* 18, no. 2 (1989): 164–169.

17. Elizabeth C. Hirschman and Morris B. Holbrook, "Hedonic Consumption: Emerging Concepts, Methods, and Propositions," *Journal of Marketing* 46 (Summer 1982): 92–101.

18. Glenn Collins, "Owens-Corning's Blurred Identity," *New York Times* (August 19, 1994): D4.

19. Virginia Postrel, "The New Trend in Spending," *New York Times on the Web* (September 9, 2004).

20. Emily Cadei, "Cleaning Up: S. F. Duo Putting a Shine on Its Product Line," *San Francisco Business Times online* (December 6, 2002).

21. Amitava Chattopadhyay, Gerald J. Gorn, and Peter R. Darke, "Roses Are Red and Violets Are Blue—Everywhere? Cultural Universals and Differences in Color Preference among Consumers and Marketing Managers," unpublished manuscript, University of British Columbia (Fall 1999); Joseph Bellizzi and Robert E. Hite, "Environmental Color, Consumer Feelings, and Purchase Likelihood," *Psychology & Marketing* 9 (1992): 347–363; Ayn E. Crowley, "The Two-Dimensional Impact of Color on Shopping," *Marketing Letters*, in press; Gerald J. Gorn, Amitava Chattopadhyay, and Tracey Yi, "Effects of Color as an Executional Cue in an Ad: It's in the Shade," unpublished manuscript, University of British Columbia (1994).

22. Mike Golding and Julie White, *Pantone Color Resource Kit* (New York: Hayden, 1997); Caroline Lego, *"Effective Web Site Design: A Marketing Strategy for Small Liberal Arts Colleges,"* unpublished honors thesis, Coe College (1998); T. Long, "Human Factors Principles for the Design of Computer Colour Graphics Display," *British Telecom Technology Journal* 2, no. 3 (July 1994): 5–14; Morton Walker, *The Power of Color* (Garden City, N.Y.: Avery, 1991).

23. Mark G. Frank and Thomas Gilovich, "The Dark Side of Self- and Social Perception: Black Uniforms and Aggression in Professional Sports," *Journal of Personality and Social Psychology* 54, no. 1 (1988): 74–85.

24. Pamela Paul, "Color By Numbers," *American Demographics* (February 2002): 30–35.

25. Paul, "Color By Numbers."

26. Kurt Goldstein, cited in Kenneth Fehrman and Cherie Fehrman, *Color: The Secret Influence* (Upper Saddle River, N.J.: Prentice-Hall, 2000), pp. 75–78.

27. Paulette Thomas, "Cosmetics Makers Offer World's Women an All-American Look with Local Twists," *Wall Street Journal* (May 8, 1995): B1.

28. Dianne Solis, "Cost No Object for Mexico's Makeup Junkies," *Wall Street Journal* (June 7, 1994): B1.

29. Fehrman and Fehrman, *Color: The Secret Influence.*

30. As seen in *Vogue* (October 2005).

31. "The Red Planet," *Women's Wear Daily* (May 10, 2000): 6–7.

32. Cited in Elaine Stone, *The Dynamics of Fashion* 2nd ed. (New York: Fairchild, 2004), p. 108.

33. "Bits & Bytes," *Women's Wear Daily* (August 10, 2005): 12.

34. www.pantone.com

35. "Cool Spring," *Women's Wear Daily* (September 7, 2006): 12.

36. Meg Rosen and Frank Alpert, "Protecting Your Business Image: The Supreme Court Rules on Trade Dress," *Journal of Consumer Marketing* 11, no. 1 (1994): 50–55.

37. Cited in Victoria Colliver, "Singing the True Blues and Greens," *San Francisco Examiner* (April 9, 2000): B1, B10.

38. Pam Scholder Ellen and Paula Fitzgerald Bone, "Does it Matter If It Smells? Olfactory Stimuli as Advertising Executional Cues," *Journal of Advertising* 27, no. 4 (Winter 1998): 29–40.

39. "That Smells Delightful! Could It Be Crème Brûlée Cologne?," *The Wall Street Journal Interactive Edition* (April 8, 1998).

40. Jack Neff, "Product Scents Hide Absence of True Innovation," *Advertising Age* (February 21, 2000): 22.

41. Michelle Devera Louie, "New Scented Dyes Make Hair Smell as Well as Look Delicious," *San Francisco Chronicle* (November 26, 2006): D1, D6.

42. Quoted in Glenn Collins, "Everything's Coming Up Vanilla," *New York Times* (June 10, 1994): D1.

43. Jane Canahl, "Does This Perfume Make Me Look Fat?" *San Francisco Chronicle* (April 6, 2003): E3; www.scienceofsmell.com.

44. Quoted in Greg Morago, "Making Scents: Saying Yes to Nose Everywhere We Go, New Aromas Induce Us and Seduce Us," *Hartford Courant* (January 25, 2000): D1.

45. Morago, p. D1.

46. Faye Brookman, "Mining Aromatherapy's Mass Appeal," *Women's Wear Daily* (June 9, 2000): 24.

47. Timothy P. Henderson, "Kiosks Bring the Science of Smell to the Shopping Experience," *Stores* (February 2000): 62.

48. Carolyn Said, "E-Roma Therapy: Oakland's DigiScents Smells Profit in Putting Aromas on the Internet," *San Francisco Chronicle* (March 27, 2000): C1, C3.

49. Gail Tom, "Marketing with Music," *Journal of Consumer Marketing* 7 (Spring 1990): 49–53; J. Vail, "Music as a Marketing Tool," *Advertising Age* (November 4, 1985): 24.

50. Dave Skretta, "Sound Cards Have Hallmark Singing a New Tune," *San Francisco Chronicle* (October 22, 2006): E6.

51. Jenny Strasbury, "Bands to Fit the Brand," *San Francisco Chronicle* (July 25, 2003): B1, B4.

52. Otto Friedrich, "Trapped in a Musical Elevator," *Time* (December 10, 1984): 3.

53. James MacLachlan and Michael H. Siegel, "Reducing the Costs of Television Commercials by Use of Time Compression," *Journal of Marketing Research* 17 (February 1980): 52–57.

54. James MacLachlan, "Listener Perception of Time Compressed Spokespersons," *Journal of Advertising Research* 2 (April/May 1982): 47–51.

55. Danny L. Moore, Douglas Hausknecht, and Kanchana Thamodaran, "Time Compression, Response Opportunity, and Persuasion," *Journal of Consumer Research* 13 (June 1986): 85–99.

56. J. Peck and T. L. Childers "Individual Differences in Haptic Information Processing: The 'Need for Touch' Scale," *Journal of Consumer Research* 30, no. 3 (2003): 430–442.

57. R. M. Hoffman, "Measuring the Aesthetic Appeal of Textiles," *Textile Research Journal* 35 No. 5 (May 1965): 428–434.

58. www.sephora.com (December 2006).

59. Becky Gaylord, "Bland Food Isn't So Bad—It Hurts Just to Think about This Stuff," *The Wall Street Journal* (April 21, 1995): B1.

60. Stacy Finz, "America's Mean Cuisine: More Like It Hot," *San Francisco Chronicle* (April 16, 2006): A1, A4.

61. Yumiko Ono, "Flat, Watery Drinks Are All the Rage as Japan Embraces New Taste Sensation," *The Wall Street Journal Interactive Edition* (August 13, 1999).

62. Carl Nolte, "Go-Go Selling," *San Francisco Chronicle* (June 12, 2000): A17, A18.

63. "$10 Sure Thing," *Time* (August 4, 1980): 51.

64. Michael Lev, "No Hidden Meaning Here: Survey Sees Subliminal Ads," *New York Times* (May 3, 1991): D7.

65. Philip M. Merikle, "Subliminal Auditory Messages: An Evaluation," *Psychology & Marketing* 5, no. 4 (1988): 355–372.

66. Timothy E. Moore, "The Case against Subliminal Manipulation," *Psychology & Marketing* 5 (Winter 1988): 297–316.

67. Sid C. Dudley, "Subliminal Advertising: What Is the Controversy About?," *Akron Business and Economic Review* 18 (Summer 1987): 6–18; "Subliminal Messages: Subtle Crime Stoppers," *Chain Store Age Executive,* no. 2 (July 1987): 85; "Mind Benders," *Money* (September 1978): 24.

68. Moore, "The Case against Subliminal Manipulation."

69. Jennifer Pendleton, "Multi Taskers," *Advertising Age* (March 29, 2004): S8.

70. Stuart Elliott, "New Survey on Ad Effectiveness," *New York Times on the Web* (April 14, 2004).

71. Seth Schiesel, "Vigilante on the TV Frontier," *New York Times on the Web* (November 4, 2004).

72. Joe Flint, "TV Networks Are 'Cluttering' Shows with a Record Number of Commercials," *Wall Street Journal Interactive Edition* (March 2, 2000).

73. Gene Koprowsky, "Eyeball to Eyeball," *Critical Mass* (Fall 1999): 32.

74. Roger Barton, *Advertising Media* (New York: McGraw-Hill, 1964).

75. Chris Reidy, "Billboards Blaring with Renewed Clout," *San Francisco Chronicle* (May 30, 2000): B1, B6; Edward Epstein, "Gallery of Ads: Sign of Times or Urban Blight," *San Francisco Chronicle* (February 5, 2000): A15, A18; Lisa Lockwood, "Outdoor Gets Heavy Traffic," *Women's Wear Daily* (March 26, 2000): 20.

76. Rosemary Feitelberg, "Billboards Come Alive," *Women's Wear Daily* (June 23, 2000): 14.

77. Michael R. Solomon and Basil G. Englis, "Reality Engineering: Blurring the Boundaries between Marketing and Popular Culture," *Journal of Current Issues and Research in Advertising* 16, no. 2 (Fall 1994): 1–18; "Toilet Ads," *Marketing* (December 5, 1996): 11; "Rare Media Well Done," *Marketing* (January 16, 1997): 31.

78. Adam Finn, "Print Ad Recognition Readership Scores: An Information Processing Perspective," *Journal of Marketing Research* 25 (May 1988): 168–177.

79. Gerald L. Lohse, "Consumer Eye Movement Patterns on Yellow Pages Advertising," *Journal of Advertising* 26, no. 1 (Spring 1997): 61–73.

80. Gail Tom, Teresa Barnett, William Lew, Jodean Selmants, "Cueing the Consumer: The Role of Salient Cues in Consumer Perception," *Journal of Consumer Marketing* 4, no. 2 (1987): 23–27.

81. Rosemary Feitelberg, "Converse Gives Outdoor Ads a Blank Slate," *Women's Wear Daily* (April 11, 2000): 23.

82. See David Mick, "Consumer Research and Semiotics: Exploring the Morphology of Signs, Symbols, and Significance," *Journal of Consumer Research* 13 (September 1986): 196–213.

83. Teresa J. Domzal and Jerome B. Kernan, "Reading Advertising: The What and How of Product Meaning," *Journal of Consumer Marketing* 9 (Summer 1992): 48–64.

84. Arthur Asa Berger, *Signs in Contemporary Culture: An Introduction to Semiotics* (New York: Longman, 1984); Mick, "Consumer Research and Semiotics: Exploring the Morphology of Signs, Symbols, and Significance"; Charles Sanders Peirce, *Collected Papers,* eds. Charles Hartshorne, Paul Weiss, and Arthur W. Burks, (Cambridge, Mass.: Harvard University Press, 1931–1958).

85. Marcia A. Morgado, "Animal Trademark Emblems on Fashion Apparel: A Semiotic Interpretation. Part I: Interpretive Strategy," *Clothing and Textiles Research Journal* 11, no. 2 (1993): 16–20; Marcia A. Morgado, "Animal Trademark Emblems on Fashion Apparel: A Semiotic

Interpretation Part II: Applied Semiotics," *Clothing and Textiles Research Journal* 11, no. 3 (1993): 31–38.

86. Jean Baudrillard, *Simulations* (New York: Semiotext(e), 1983); A. Fuat Firat and Alladi Venkatesh, "The Making of Postmodern Consumption," in *Consumption and Marketing: Macro Dimensions,* eds. Russell Belk and Nikhilesh Dholakia (Boston: PWS-Kent, 1993); A. Fuat Firat, "The Consumer in Postmodernity," in *Advances in Consumer Research* 18, eds. Rebecca H. Holman and Michael R. Solomon (Provo, Utah: Association for Consumer Research, 1991): 70–76.

87. Adapted from Michael R. Solomon and Elnora W. Stuart, *Marketing: Real People, Real Choices* (Upper Saddle River, N.J.: Prentice-Hall, 1997).

88. Evelyn Brannon, "Cannibalization in Product Development and Retailing," in *Concepts and Cases in Retail and Merchandise Management,* eds. Nancy J. Rabolt and Judy K. Miler, (New York: Fairchild, 1997): 46–47. This case is based on the Limited, Inc. See Instructor's Guide for an analysis of the case.

89. Scott Donaton, "Magazine of the Year," *Advertising Age* (March 1, 1993): S1.

FASHION COMMUNICATION AND DECISION MAKING

The chapters in this section explore how marketing messages and people around us influence our consumption decisions. Chapter 10 looks at messages and sources of the many fashion communications in the marketplace. Chapter 11 focuses on the steps we follow when making fashion and household decisions. Chapter 12 reviews group processes and the influences that groups exert on us as consumers as we conform to expectations of others. Chapter 13 looks at how particular buying situations affect our buying and satisfaction.

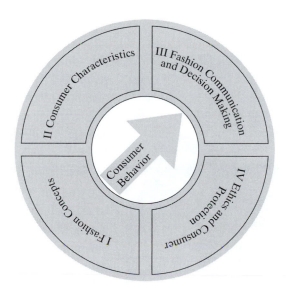

FASHION COMMUNICATION

10
Fashion Communication

Nicole is sorting through today's mail. Bill, ad, bill, fund-raising letter from a political candidate, an offer for yet another credit card.

Aha! Here it is, the envelope she's been waiting for: an invitation to a posh cocktail party at her friend Tracy's ad agency. This will be her chance to see and be seen, to mingle, to network . . . maybe even land a job offer. But, what to wear? Somehow her industrial grunge clothes don't seem to be the right look for the new life she imagines as an account executive. Nicole needs help, so she does what comes naturally. First, she IMs some of her friends to let them know about the event; then she fires up her computer to check out what the *fashionistas* roaming the blogosphere are recommending this season. Browsing through www.shoppingblog.com,

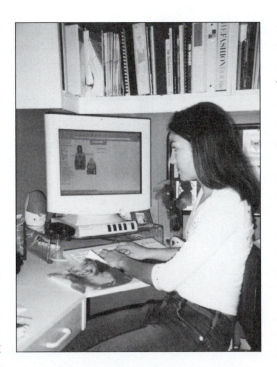

she quickly learns what new styles are hot. After reading a bunch of blogs, she's ready to go to Bloomingdale's. It also seems everyone is doing "green" today. Macy's is selling reusable tote bags with $1 of the purchase price donated to the National Park Foundation. Even Barbie has gone green. Mattel has a collection of environmentally friendly accessories for girls called Barbie BCause. She decides to order some for her young niece who is a Barbie addict. After watching a couple videos and the latest *American Idol* news, she's back to deciding what to buy for this party. Nicole quickly copies some snapshots from a few Web sites and e-mails them to her buddies to get their votes. It's fun to get input from "real people" in addition to fashion industry snobs.

BASIC COMPONENTS OF COMMUNICATION

Communication of information, which can be visual, verbal, or a combination, is directly used in consumer decision making. Much of fashion communication is visual, or nonverbal. Consumers receive this information from impersonal sources such as the media (for example, magazines and the Internet), but they also gain much information from personal sources such as people around them, including friends, family, salespeople and, sometimes more important—people on the street. This chapter will begin with a discussion of basic components of communication, including dress as a form of nonverbal communication. We will also review some of the factors that help determine the effectiveness of communication devices. The focus will be on some basic aspects of communication that specifically help determine how and if attitudes will be created or modified. This objective relates to **persuasion**, which refers to an active attempt to change attitudes. Persuasion is, of course, the central goal of many marketing communications.

In general, communication is conceived as having the following components: sender, message, channel, receiver, and feedback to sender. Marketers and advertisers have traditionally tried to understand how marketing messages can change consumers' attitudes by thinking in terms of the **communication model**, which specifies that a number of elements are necessary for communication to be achieved. In this model, a *sender* must choose and encode a message (that is, initiate the transfer of meaning by choosing appropriate symbolic images that represent that meaning).

This meaning must be put in the form of a *message*. There are many ways to say something, and the structure of the message has a big effect on how it is perceived. In the cocktail party example the visual images of well-known designers and celebrities say a thousand words about the trendiness of today's fashions.

The message must be transmitted via a *channel* or *medium*, which for companies wanting to communicate with consumers could be television, radio, magazines, billboards, Web sites, CD-ROMs, personal contact, or even matchbook covers. The message is then decoded by one or more *receivers* (such as Nicole), who interpret it in light of their own experiences. Finally, *feedback* must be received by the source, who uses the reactions of receivers to modify aspects of the message. Many Web sites collect such information from its subscribers and visitors. The traditional communication process is depicted in Figure 10-1.

In personal communication, the process is similar. The person sends a message, which can be verbal, such as a discussion about fashion trends, or nonverbal, through the medium of appearance or gestures. This information is received by another person, who then reacts to that message and consequently sends feedback to the sender. The sender may then adjust the message if the feedback dictates (for example, feedback such as, "You look tired today," in response to a nonverbal appearance message might precipitate the addition of makeup on the part of the sender). Chapter 5 discusses this process as the self establishes itself through social feedback. In addition, this process is integral to the perception of others as discussed in Chapter 9.

FIGURE 10-1
Basic Communication Model
Source: Leon C. Schiffman and Leslie Lazar Kanuk, *Consumer Behavior,* 9th ed., p. 276, © 2007. Reprinted by permission of Pearson Education, Inc., Upper Saddle River, NJ.

Much of fashion communication falls within the realm of personal communication, both verbal and nonverbal. Fashion-oriented people talk to each other about the latest trends or the best stores to shop at, just as Nicole and her friends did. An early study in this area underscores the importance of opinion leaders in fashion decisions—about two-thirds of a female sample had made a recent fashion change, and personal influence had entered into most of these decisions.[1] Much of our discussion of fashion is with people of our own age and social status.

Visual observation is equally important in the communication of fashion. We consciously or unconsciously observe other people around us when we speak with them, or just see others around us. The mass media serve not only as direct persuasion, but as nonpromotional communication through television programs, movies, and magazines by virtue of their visual content. For example, Jennifer Aniston of *Friends* was influential in the popularity of the shag hairstyle. In fact, Hollywood's leading ladies have left their mark on fashion throughout the history of movies and TV.[2] The following are just some: Greta Garbo, Marlene Dietrich, Rita Hayworth with her strapless black satin gown, Esther Williams's bathing suits, Lucille Ball's shirtdress, Katherine Hepburn's trousers, Audrey Hepburn's little black dress, Marilyn Monroe, Elizabeth Taylor, Faye Dunaway's *Bonnie and Clyde* wardrobe, Diane Keaton's "Annie Hall" androgynous look, Mia Farrow's *Great Gatsby* femininity, Madonna, Jennifer Aniston and Lisa Kudrow on *Friends*, Alicia Silverstone in *Clueless*, JLo, and on and on.

DRESS AS NONVERBAL COMMUNICATION

We express a great deal of information through our appearance, dress, accessories, and actions. We process detailed visual information in a short amount of time—that is, we make first impressions about others and things very quickly.

Dress is one form of nonverbal communication that serves as background for other forms of communication. McCracken called dress *nondiscursive behavior*, since dress is unchanging for many hours of the day, unlike other dynamically changing behavior.[3] Symbolic interactionists describe appearance as a *sign* (something that has social meaning). Kaiser discusses the concept of a *code* (or rule) that can be manipulated by an individual to produce his or her own *message* through apparel or fashion. A *signifier* is a vehicle through

which a sign conveys its message. Clothing and elements of appearance become the signifiers (or the channel). Signifiers can gain and lose meaning over time,[4] which is certainly important in the realm of fashion. It is important that marketers understand the meanings that consumers attach to such items.

An interesting analogy of layers of clothing and levels of communication has been made.[5] Each layer of clothing can be thought of as transmitting a different message by the sender to different audiences. The outermost layer of clothing is seen by the general public, whereas successive layers are directed to more intimate groups. Think about the number of layers of clothing you have on and which group of people see each layer. Perhaps you are the only one to see the last layer.

Appearance communication can be quite complex given the many variables involved with all the components of communication: sender, message, channel, and receiver. We normally think of communicating appearance through the visual channel; however, we also use the senses of hearing, touch, and smell (as discussed in Chapter 9). We hear the rustle of taffeta, we touch soft velvet, we smell someone's perfume or cigar.

Figure 10-2 outlines some of what occurs in the complex process of appearance communication. As we have discussed in other chapters, the sender can manipulate cues or signs (to manage his or her appearance) in an attempt to create a certain impression on the receiver. Often people, especially women, engage in such *impression management*. We get advice from wardrobe experts and others on how to dress or how to make a good impression; that is manipulation of cues. We often know what others are looking for and try to dress to impress or to fit in—whatever our goal might be. We can control the situation with appearance, but some people are more skilled in this area than others. So, in the attempt to discover the "real you," the receiver may come to a completely wrong conclusion. The sender had sent a particular message to the receiver and the receiver tries to understand the sender by interpreting the signs.

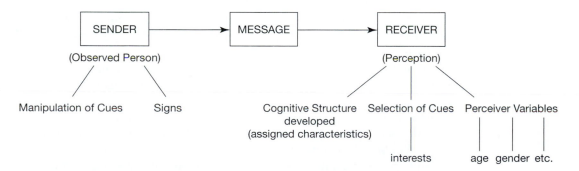

- Sender (Observed Person) may engage in impression management
- Receiver relies on appearance to understand sender; interprets signs
- Receiver develops cognitive structure assigned to person
- Receiver may concentrate on selected cues
- Receiver's unique characteristics influence perception

FIGURE 10-2
Appearance Communication

The process of person perception (integral in communication) involves the forming of an impression based on limited cues, signs, or symbols. Selected cues serve as a basis to make inferences about an individual's personal characteristics or probable behaviors. According to Asch[6] (work done in the 1940s), each characteristic has cognitive content and the perceived traits interrelate. Perceivers develop what sociologists call a *cognitive structure*, which is part of a network of thought that enables perceivers to respond to stimuli such as appearance. Cognitive structures provide a sense of order and predictability to help explain behaviors of senders. This can develop into cognitive categories such as stereotypes and halo effects, which are created when we take "cognitive leaps" by lumping stimuli into an impression of all good or all bad—that is, linking traits that come to mind based on one or a few impressions. Impressions are not merely the sum of independent traits but also the sum of all traits in relation to each other contributing to the completion of the picture.

At this point in the communication process, *perceiver variables* also "muddy the waters" when it comes to the interpretation of the message. Idiosyncrasies or unique characteristics of the receiver influence the overall reception of the message. One of the uniquenesses is *selective awareness* or selection of cues. Often what we are interested in is what we are most aware of. For example, if appearance is important to us, we may be aware of appearance details and focus on them, while those to whom appearance is not important will miss an intended message. Other variables related to the receiver, such as age and gender, can influence the message received—that is, the interpretation of the signs. For example, men see things differently than women (of course, you know that men are from Mars and women are from Venus!). Therefore, the personal message received may be different from what was intended on the part of the sender, resulting in unclear communication.

CHANGING ATTITUDES THROUGH COMMUNICATION

Marketing communication is more formalized than personal communication, and much effort, research, and expense are put into the process to ensure that clear messages are received with the result of effecting a change in behavior.

Consumers are constantly bombarded by messages inducing them to change their attitudes. These persuasion attempts can range from logical arguments to graphic pictures, and from intimidation by peers to exhortations by celebrity spokespeople. And communications flow both ways—the consumer may seek out information sources in order to learn more about these options. As Nicole's actions show, the choice to access marketing messages on our own terms is changing the way we think about persuasion attempts.

Decisions, Decisions: Tactical Communication Options

Suppose a high-profile apparel company wants to create an advertising campaign for a new fashion line targeted to young people. As it plans this campaign, it must develop a message that will create desire for the item by potential customers. To craft persuasive messages that might persuade someone to purchase

the product instead of the many other options available, we must answer several questions:

- Who will be shown wearing the fashion items in the ad? A well-known fashion model? A career woman? A rock star? The source of a message helps determine consumers' acceptance of it as well as their desire to try the product.

- How should the message be constructed? Should it emphasize the negative consequences of being left out when others are wearing it and you're still wearing last year's stuff? Should it directly compare itself with others already on the market or maybe present a fantasy in which a sexy young woman meets a dashing stranger on a romantic island?

- What media should be used to transmit the message? Should it be depicted in a print ad? On television? On a billboard? On a Web site? If a print ad is produced, should it be run in the pages of *Jane*? *Vogue*? *Cosmopolitan*? *Good Housekeeping*? Sometimes *where* something is said can be as important as *what* is said. Ideally, the attributes of the product should be matched to those of the medium. For example, magazines with high prestige are more effective at communicating messages about overall product image and quality, whereas specialized, expert magazines do a better job at conveying factual information.[7]

- What characteristics of the target market might influence the ad's acceptance? If targeted users are frustrated in their daily lives, they might be more receptive to a fantasy appeal. If they're status oriented, maybe a commercial should show bystanders swooning with admiration as a famous actress walks by wearing it.

An Updated Model: Interactive Communication

Although Nicole managed to ignore most of the "junk mail" that arrived at her door, she didn't avoid marketing messages—instead she chose which ones she wanted to see. Although the traditional communication model discussed earlier is not wrong, it also doesn't tell the whole story—especially in today's dynamic world of interactivity, where consumers have many more choices available to them and greater control over which messages they will choose to process.[8]

In fact, a popular strategy known as **permission marketing** is based on the idea that a marketer will be much more successful in persuading consumers who have agreed to let the marketer try—consumers who "opt out" of listening to the message probably weren't good prospects in the first place.[9] On the other hand, those who say they are interested in learning more are likely to be receptive to marketing communications they have chosen to see or hear. As the permission marketing concept reminds us, we don't have to just sit there and take it. We have a voice in deciding what messages we choose to see and when—and we exercise that option more and more.

The traditional model was developed to understand mass communications, where information is transferred from a producer (source) to many consumers (receivers) at one time—typically via print, television, or radio. This perspective essentially views advertising as the process of transferring information to the buyer before a sale. A message is seen as perishable—it is

repeated (perhaps frequently) for a fairly short period of time and then it "vanishes" as a new campaign eventually takes its place.

This model was strongly influenced by a group of theorists known as the *Frankfurt School*, which dominated mass communications research for most of the twentieth century. In this view, the media exert direct and powerful effects on individuals and often are used by those in power to brainwash and exploit them. The receiver is basically a passive being—a "couch potato" who simply is the receptacle for many messages—who is often duped or persuaded to act based on the information he or she is "fed" by the media.

Uses and Gratifications

Is this an accurate picture of the way we relate to marketing communications? Proponents of **uses and gratifications theory** argue instead that consumers are an active, goal-directed audience that draws on mass media as a resource to satisfy needs. Instead of asking what media do for or to people, they ask what people do *with* the media.[10]

The uses and gratifications approach emphasizes that media compete with other sources to satisfy needs and that these needs include diversion and entertainment as well as information. This also means that the line between marketing information and entertainment continues to blur—especially as companies are being forced to design more attractive retail outlets, catalogs, and Web sites in order to attract consumers.

The entertainment concept has been prevalent at the retail level for some time in such stores as Niketown, with videos and games, and the Levi's San Francisco store. The Levi's store is filled with high-tech gadgets and techno-toys such as video periscopes linked to cameras within the store, which the customer can control by zooming, panning, and tilting to see what is happening on each floor—no more two-dimensional visual concepts.

The infusion of marketing images into daily life is illustrated by the popularity of the Hello Kitty characters that have popped up on everything from tofu dishes to telephones. This craze originated in Japan and then spread across and into the United States; the Sanrio company earns over a billion dollars from Hello Kitty products annually. When a Taiwanese bank put Hello Kitty on its checkbooks and credit cards, the lines to get these items were so long many people thought there was a banking crisis.[11] Clearly, marketing ideas and products serve as sources of gratification for many—even while others scratch their heads and try to figure out why!

Research with young people in Great Britain finds that they rely on advertising for many gratifications including entertainment (some report that the "adverts" are better than the programs), escapism, play (some report singing along with jingles, while others make posters out of magazine ads), and self-affirmation (ads can reinforce their own values or provide role models). It's important to note that this perspective is not arguing that media play a uniformly positive role in our lives, only that recipients are using the information in a number of ways. For example, marketing messages have the potential to undermine self-esteem as consumers use the media to establish standards for behavior, attitudes, or even their own appearance. A comment by one study participant illustrates this negative impact. She observes that when she's watching TV with her boyfriend, "really, it makes you think 'oh

no, what must I be like?' I mean you're sitting with your boyfriend and he's saying 'oh, look at her. What a body!' "[12]

Who's in Charge of the Remote?

Whether for good or bad, though, exciting technological and social developments certainly are forcing us to rethink the picture of the passive consumer, as people increasingly are playing a proactive role in communications. In other words, they are to a greater extent becoming partners—rather than potatoes—in the communications process. Their input is helping to shape the messages that they and others like them receive, and furthermore they may seek out these messages rather than sit home and wait to see them on TV or in the paper. This updated approach to interactive communications is illustrated in Figure 10-3.

One of the early signs of this communications revolution was the humble handheld remote control device. As VCRs began to be commonplace in homes, suddenly consumers had more input into what they wanted to watch—and when. No longer were they at the mercy of the TV networks to decide when to see their favorite shows, and neither did they necessarily have to forsake a show because it conflicted with another's time slot.

Since that time, of course, our ability to control our media environment has mushroomed. Many people have access to video-on-demand or pay-per-view TV. Home shopping networks encourage us to call in and discuss our passion for cubic zirconia jewelry live on the air. Caller ID devices and answering machines allow us to decide whether we will accept a phone call during dinnertime and to know the source of the message before answering. A bit of Web surfing allows us to identify kindred spirits around the globe, to request information about products, and even to provide suggestions to product designers and market researchers.

New Message Formats

An array of new ways to transmit information in both text and picture form offers marketers exciting alternatives to traditional advertising on TV, billboards, magazines, and so on.[13] **M-commerce** (mobile commerce), in which marketers promote their goods and services via wireless devices including cell phones, PDAs, and iPods, is red-hot. In Europe and Asia, consumers already rely on their cell phones to connect them to the world in ways we are only starting to see in the United States. Worldwide revenue from

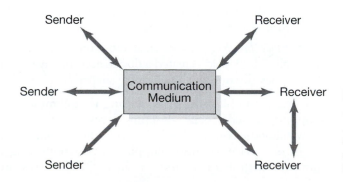

FIGURE 10-3
Interactive Communication Model
Source: M. R. Solomon, *Consumer Behavior*, 8th ed., p. 290, © 2009. Reprinted by permission of Pearson Education, Inc., Upper Saddle River, NJ.

mobile information and entertainment will reach $39 billion in 2007. In Asia, tiny cell phone screens have become electronic wallets that buy Cokes from vending machines and devices that dole out McDonald's coupons on the phone screen. Among the Chinese, cell phones have become such important status symbols that relatives at funeral rites burn paper cell phone effigies, so the dead will have their mobiles in the afterlife.

American companies are taking note of this deep attachment and they are talking to their Asian customers via cell also. In Japan, Procter & Gamble's Whisper brand of feminine-hygiene products signed up 80,000 women to receive messages about their "happy cycle." As wireless companies begin to roll out higher-capacity networks in the United States, look for similar messages on *your* phone in the fairly near future. Already, TV companies are using video-enabled cell phones to promote their prime-time lineups by sending teasers of new shows. To promote its Britney Spears cologne "Curious" to teens, Elizabeth Arden mounted a $5 million campaign that began with banner ads on teen Internet sites posing questions like "Do you dare?" Those curious enough to give their phone numbers—27,000 over seven weeks—received a voice message from Britney herself discussing the campaign's TV spot that was running on Viacom's MTV. In only five weeks Curious became the number-one-selling fragrance in the United States.

Do you blog? The other media format that's getting a lot of attention is **blogging**, in which people post messages to the Web in diary form. Blogging started as a grassroots movement in which individuals shared their thoughts on a range of topics, from the mundane to the profound. Companies are also using blogs to shape public opinion, as Wal-Mart did recently to improve its battered image regarding its low wages and health benefits, and to promote products, as Microsoft did with its Xbox game.[14] This phenomenon hasn't slowed down yet; people post about 40,000 new blogs every day. New forms of blogging itself continue to develop, such as the following:

- *Moblogging:* Posting to a blog on the go, from a camera phone or hand-held device.
- *Video blogging (vlogging):* Posting video diaries.
- *Podcasting:* Creating your own radio show that people can listen to either on their computers or iPods. Even Paris Hilton did a podcast to promote her movie *House of Wax.*
- *RSS (really simple syndication):* People sign up to have updates sent automatically to their computers. Currently about 6 million Americans use this feature, and companies such as Yahoo! are encouraging this format to keep audiences loyal.
- *Flogs (fake blogs):* Blogs created by companies to generate buzz. For example, McDonald's created a flog to accompany its Super Bowl ad about the mock discovery of a french fry shaped like President Lincoln.[15]

A twist on blogging is something that combines social networking and shopping, called "social shopping." Sites such as www.thisnext.com and www.kaboodle.com are hoping to ride the MySpace wave by gathering people in one place to swap shopping ideas connecting independent-minded shoppers with hard-to-find products.[16] The sites are designed for both

browsing and blogging. Just transfer a picture of a favorite item to your blog and share with friends.

Levels of Interactive Response

A key to understanding the dynamics of interactive marketing communications is to consider exactly what is meant by a response.[17] The early perspective on communications primarily regarded feedback in terms of behavior—did the recipient run out and buy the product after being exposed to an ad for it?

However, a variety of other responses are possible as well with the results of building awareness of the brand, informing us about product features, reminding us to buy a new package when we've run out, and—perhaps most importantly—building a long-term relationship. Therefore, a transaction is *one* type of response, but forward-thinking marketers realize that customers can interact with them in other valuable ways as well. For this reason it is helpful to distinguish between two basic types of feedback:

- *First-order response:* Direct-marketing vehicles such as catalogs, television infomercials, and Web sites are interactive—if successful, they result in an order that is most definitely a response! So a product offer that directly yields a transaction is a *first-order response.* In addition to providing revenue, sales data are a valuable source of feedback that allow marketers to gauge the effectiveness of their communications efforts.

- *Second-order response:* However, a marketing communication does not have to immediately result in a purchase to be an important component of interactive marketing. Messages can prompt useful responses from customers, even though these recipients do not necessarily place an order immediately after being exposed to the communication. Customer feedback in response to a marketing message that is not in the form of a transaction is a *second-order response.* This may take the form of a request for more information about a good, service, or organization, or perhaps receipt of a "wish list" from the customer that specifies the types of product information he or she would like to get in the future. Many Web sites have an opportunity to leave an e-mail message.

THE SOURCE

Regardless of whether a message is received by "snail mail" (Net slang for the postal service) or e-mail, common sense tells us that the same words uttered or written by different people can have very different effects. Research on *source effects* has been carried out for more than fifty years. By attributing the same message to different sources and measuring the degree of attitude change that occurs after listeners hear it, researchers can determine what aspects of a communicator will induce attitude change.[17]

Under most conditions, the source of a message can have a big impact on the likelihood that the message will be accepted. The choice of a source to maximize attitude change can tap into several dimensions. The source can be chosen because he or she is an expert, attractive, famous, or even a "typical" consumer who is both likable and trustworthy. Two particularly important source characteristics are *credibility* and *attractiveness.*[18]

Source Credibility

Source credibility refers to a source's perceived expertise, objectivity, or trustworthiness. This dimension relates to consumers' beliefs that a communicator is competent and that he or she is willing to provide the necessary information to adequately evaluate competing products. Sincerity is particularly important when a company tries to publicize its corporate social responsibility activities that benefit the community in some way. When consumers believe it is genuinely doing good things, a company's image can skyrocket. But this effort can backfire if people question the organization's motivations (e.g., if they think the firm is spending more to talk about its good deeds than actually to do them).[19] A credible source can be particularly persuasive when the consumer has not yet learned much about a product or formed an opinion of it.[20] Although

One
is a very big number
at Clinique.

Everything Clinique has to pass allergy testing. Well, what exactly does that mean? That every formula is applied 12 times to 600 people under the clinical guidelines established by our founding dermatologists. That even if one of those 7,200 applications incites an allergic reaction, we will reformulate.

To put a human face on it, the number of applications since 1990 alone is the equivalent of every man, woman and child living in Little Rock, amarillo, Tucson, San Francisco, New Haven, Fort Lauderdale, Kansas city, Boston, minneapolis, Las Vegas, Charlotte, and Buffalo. Combined.

Why do we take such extraordinary steps to get it right? You might be the one.

Clinique. Allergy Tested. 100% fragrance free.

CLINIQUE

This ad builds product credibility by explaining the extensive allergy testing the company does.

the decision to pay an expert or a celebrity to tout a product can be a very costly one, researchers have concluded that on average the investment is worth it simply because the announcement of an endorsement contract is often used by market analysts to evaluate a firm's potential profitability, thereby affecting its expected return. On average, then, the impact of endorsements on stock returns appears to be so positive that it offsets the cost of hiring the spokesperson.[21]

Building Credibility

Credibility can be enhanced if the source's qualifications are perceived as relevant to the product being endorsed. For some products, a salesperson may achieve credibility by dressing in the role of an expert. One apparel study indicated that a source appropriately dressed for the task demonstrated in an advertisement and pictured in an appropriate setting was assigned significantly higher credibility and intent-to-purchase ratings than for those not appropriately dressed.[22]

We often see sales associates wearing the clothing sold at that particular store. In fact, displaying the clothes on a live person is perhaps the best way to help customers envision the product on themselves as opposed to viewing items on a rack, especially fashion items with little *hanger appeal*. Retailers often encourage sales associates to wear their product by offering generous discounts; some actually have a garment program in which associates change into certain items set aside for them to wear during hours they are on the sales floor working with customers.

It's important to note that what is credible to one consumer segment may be a turnoff to another. Indeed, rebellious or even deviant celebrities

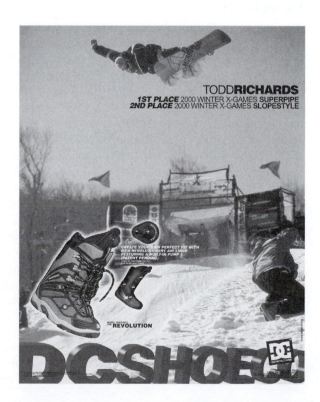

Taking first and second place in the Winter X-Games, Todd Richards is a credible source of information for this product.

may be attractive to some for just that reason. Tommy Hilfiger cultivated a rebellious, street-smart image by using rapper Snoop Doggy Dogg (who was acquitted of murder charges) to help launch his line and Coolio, a former crack addict and thief, as a runway model.[23] Parents may not be thrilled by these message sources—but isn't that the point?

Most glamorous celebrities are credible sources for selling expensive designer clothing; they may, in fact, be a large part of the limited market for such goods! Many of the celebrities attending the Academy Awards have had a gown made especially for them, and often the designers get invaluable publicity when famous people wear their clothes that night. In fact, a "best dressed" celebrity picture can run in hundreds of publications, in addition to being broadcast globally, resulting in publicity that designers say can provide media exposure equivalent to a yearlong ad campaign.[24] For example, when Uma Thurman wore Prada in 1995 it helped establish the Italian brand as more than just a maker of handbags. Similarly, Sharon Stone wore a gown made for her by Vera Wang in 1993 that broke the designer out of the bridalwear stereotype. Escada's name became instantly known after Kim Basinger wore their gown; Bob Mackie became infamous for Cher's daring gowns; Gwyneth Paltrow's pink Ralph Lauren gown was instantly knocked off for proms; and, of course, Sharon Stone's choice of a $22 Gap shirt shot sales through the roof.[25] Not only do celebrities give credibility to the designer's work and to the look, but also the designer gives credibility by virtue of his or her celebrity and reputation. (Of course, remember that a designer's reputation is as good as his or her last successful line.)

Source Biases

A consumer's beliefs about a product's attributes can be weakened if the source is perceived to be biased in presenting information.[26] *Knowledge bias* implies that a source's knowledge about a topic is not accurate. *Reporting bias* occurs when a source has the required knowledge, but his or her willingness to convey it accurately is compromised, as when a star athlete is paid by a manufacturer to use its products, such as tennis shoes, exclusively. Although his or her credentials might be appropriate, the fact that the expert is perceived as a "hired gun" compromises believability. The reputation of the retailer who sells the product has a major influence on message credibility. Products sold by respected and well-known quality stores seem to carry the added endorsement (and implicit guarantee) of the store itself: "If Neiman Marcus carries it, it must be good." The aura of credibility generated by reputable retail advertising reinforces the manufacturer's message as well. That is why so many national ads (that is, manufacturer-initiated ads) carry the line, "sold at better stores everywhere." The reputation of the *medium* that carries the communication also enhances or diminishes the credibility of the advertiser. The image of a prestige fashion magazine such as *Elle* or *Vogue* confers added status on the product being advertised.

Concerns are growing in the advertising world about the public's skepticism regarding celebrities who endorse products for money. It doesn't help matters when Britney Spears appears in lavish commercials for Pepsi-Cola but is caught on camera drinking Coca-Cola or when Tiger Woods promoted Rolex's Tudor watches for five years, but then he abruptly switched to

Swiss rival TAG Heuer. Although Tiger explained the defection simply by noting that "My tastes have changed," it's possible that the estimated $2 million he got for this new endorsement was a factor.[27] A research firm that tracks celebrities' credibility reported from its 2006 survey that more than a third of respondents who knew of home improvement guru Ty Pennington (from *Extreme Makeover: Home Edition*) said they would be more likely to buy a product he endorsed. However, only 4 percent said they trusted Paris Hilton (and this was before she got busted!).[28]

Source Attractiveness

Source attractiveness refers to the source's perceived social value. This quality can emanate from the person's physical appearance, personality, social status, or similarity to the receiver (we like to listen to people who are like us).

"What Is Beautiful Is Good"

Almost everywhere we turn, beautiful people are trying to persuade us to buy or do something. Our society places a very high premium on physical attractiveness, and we tend to assume that people who are good-looking are smarter, cooler, and happier. Such an assumption is called a *halo effect*, which occurs when people who rank high on one dimension are assumed to excel on others as well. The effect can be explained in terms of the consistency principle discussed in Chapter 8, which states that people are more comfortable when all of their judgments about a person go together. This notion has been termed the "what is beautiful is good" stereotype.[29]

A physically attractive source tends to facilitate attitude change. His or her degree of attractiveness exerts at least modest effects on consumers' purchase intentions or product evaluation.[30] How does this happen?

One explanation is that physical attractiveness functions as a cue that facilitates or modifies information processing by directing consumers' attention to relevant marketing stimuli. Some evidence indicates that consumers pay more attention to ads that contain attractive models, though not necessarily to the ad copy.[31] In other words, an ad with a beautiful person may stand a better chance of getting noticed but not necessarily read. Although we may enjoy looking at a beautiful or handsome person, these positive feelings do not necessarily affect product attitudes or purchase intentions.[32]

Beauty can also function as a source of information. The effectiveness of highly attractive spokespeople in ads appears to be largely limited to situations in which the advertised product is overtly related to attractiveness or sexuality.[33] The *social adaptation perspective* assumes that information seen to be instrumental in forming an attitude will be more heavily weighted by the perceiver. We filter out irrelevant information to minimize cognitive effort.

Under the right circumstances, an endorser's level of attractiveness constitutes a source of information instrumental to the attitude change process and thus functions as a central, task-relevant cue.[34] An attractive spokesperson, for this reason, is more likely to be an effective source when the product is relevant to attractiveness. For example, attractiveness affects attitudes toward ads about perfume or cologne, where attractiveness is relevant, but not toward coffee ads, where it is not.

Tommy Hilfiger sponsored a Britney Spears concert tour, making a connection between fashion and celebrities.

Star Power: Celebrities as Communications Sources

Celebrity endorsers don't come cheap, but many advertisers continue to believe in their effectiveness. Tiger Woods is now the richest endorser in sports history with an estimated income of $62 million per year (not counting the money he makes actually winning golf tournaments!).[35] Why do stars command this kind of money? One study found that famous faces capture attention and are processed more efficiently by the brain than are "ordinary" faces.[36] Celebrities increase awareness of a firm's advertising and enhance both company image and brand attitudes.[37] In addition, a celebrity endorsement strategy can be an effective way to differentiate among similar products.

One reason for this effectiveness is that consumers are better able to identify products that are associated with a spokesperson. Gap commercials have used celebrities including Madonna and Missy Elliott, Sarah Jessica Parker, an image of Audrey Hepburn dancing in skinny pants, and Common performing "Holiday in the Hood." Other pop stars have spokesperson or licensing deals with beauty companies such as Sean "Diddy" Combs for Estée Lauder; Beyoncé for L'Oréal; Celine Dion, Kylie Minogue, Shania Twain, and Jennifer Lopez for Coty; Mariah Carey, Hilary Duff, and Britney Spears for Elizabeth Arden; and Queen Latifah for Cover Girl.[38] And Coty added a new dimension of endorsement by using a celebrity concept rather than individual star when it signed the five *Desperate Housewives* actresses for its Forbidden Fruit fragrance.[39] How appropriate.

Also, personal appearances by designers (who often are celebrities) can be effective advertising for their company. Trunk shows, in which an entire line of merchandise is brought to a store and shown to its best customers who special order items, have become very successful for designers and retailers. These are often coupled with special appearances by the designer.

Star power works because celebrities embody *cultural meanings*—they symbolize important categories such as status and social class (a "working-class

Designers often have star power and their fashion shows serve as credible sources of fashion information.

hero," such as Kevin James of *King of Queens*), gender (a "ladies man," such as Leonardo diCaprio), age (the boyish Michael J. Fox), and even personality types (the nerdy but earnest Hiro on *Heroes*). Ideally, the advertiser decides what meanings the product should convey (that is, how it should be positioned in the marketplace) and then chooses a celebrity who has come to embody a similar meaning. The product's meaning thus moves from the manufacturer to the consumer, using the star as a vehicle.[40]

Singer/actress J-Lo or Beyoncé Knowles? Quarterback Brett Favre or Jason Campbell? With all those famous people out there, how does a firm decide who should be the source of its marketing messages? For celebrity campaigns to be effective, the endorser must have a clear and popular image. In addition, the celebrity's image and that of the product he or she endorses should be similar—researchers refer to this as the **match-up hypothesis**.[41] However, all kinds of stars are in demand, even when it seems that their "brand personality" isn't consistent with the product being advertised. For example, Victoria's Secret signed none other than the antiestablishment folk singer Bob Dylan who once wrote lyrics like "Advertising signs that con you" to pitch its "Angels" line of lingerie while models cavort in the background to a remixed version of his 1997 song "Love Sick."[42]

A market research company developed one widely used measure called the *Q Score* (*Q* stands for "quality") to decide if a celebrity will make a good endorser. This rating considers two factors: consumers' level of familiarity with a name and the number of respondents who indicate that a person, program, or character is a favorite. The company evaluates approximately 1,500 celebrities (over 400 of whom are athletes) each year.[43]

Celebrity endorsement may not always mean success for a brand or cause. In 1985, Crafted with Pride in the USA Council ran a series of TV commercials in an effort to change the American consumer's behavior from buying imported to buying domestic apparel. These ads featured well-known celebrities saying "It matters to me," as they extolled the virtues of buying American-made clothing and home furnishings. In the early 1990s the council changed its technique of using celebrities to showing out-of-work apparel employees. These ads were dark and depressing, probably something the public did not want to see. After an $80 million budget and continued years of shifting strategies,[44] we don't see these commercials today. Apparently neither the positive influence of celebrities nor the negative influence of guilt was a strong enough message to change consumer attitudes about something that hits their pocketbooks so hard (the higher price of U.S-made apparel).

Credibility versus Attractiveness

How do marketing specialists decide whether to stress credibility or attractiveness when choosing a message source? There should be a match between the needs of the recipient and potential rewards offered by the source. When this match occurs, the recipient is more motivated to process the message. People who tend to be sensitive about social acceptance and the opinions of others, for example, are more persuaded by an attractive source, while those who are more internally oriented are swayed by a credible, expert source.[45]

The choice may also depend on the type of product. Although a positive source can help reduce risk and increase message acceptance, particular types

NONHUMAN ENDORSERS

Celebrities can be effective endorsers, but there are drawbacks to using them. Their motives may be suspect if they plug products that don't fit their images or if consumers begin to see them as never having met a product they didn't like (for a fee). They may be involved in a scandal or upset customers. Martha Stewart went to jail for lying about a stock sale, which worried Kmart about its sales of Martha Stewart Everyday housewares. H&M, Burberry, Chanel, and other companies using Kate Moss in their promotions dropped her in the wake of a drug scandal.[47] Clairol decided not to use footage that it had already shot of Omarosa Manigault-Stallworth, a contestant on the NBC show *The Apprentice*, for a shampoo commercial after many fans turned against her. For these reasons some marketers seek alternatives, including cartoon characters and mascots. After all, as the marketing director for a company that manufactures costumed characters for sports teams and businesses points out, "You don't have to worry about your mascot checking into rehab."[48]

Some big companies are trying this approach. The Toronto-based clothing company Roots Canada Ltd. employs a "Buddy the Beaver" mascot to promote its outlets. Roots' director of communications observed, "A lot of our stores are in shopping malls. Malls are crowded. People don't pay attention. But it's hard to ignore a seven-foot-tall beaver."[49]

A lot of the real action these days is in the use of virtual models. An **avatar** is the manifestation of a Hindu deity in super-human or animal form. In the computing world it means a cyberspace presence represented by a character that you can move around inside a visual, graphical world. Many consumers became more aware of these cybermodels following the movie *Simone*, which starred Al Pacino as a washed-up director who creates a virtual actress that the public believes is real.[50]

Avatars like Simone originated in computer games like *The Sims*, but now they are starting to appear in online advertising and on e-commerce sites to enhance Web surfers' online experience. Rock bands, soft-drink makers, and other big-time marketers use avatars. Coca-Cola Co. recently launched an avatar-populated site for the Hong Kong market where avatars mill around and chat in a Coke-sponsored world. British Telecom also is testing such products as avatar e-mail, software that makes the sender's face appear and speak the message aloud.[51] The German firm No DNA GmbH (www.nodna.com) offers a variety of "virtualstars." These are computer-generated figures that appear as caricatures, "vuppets" (cartoon-type mascots and animals), and "replicants" that are doubles of real people. Its models receive hundreds of love letters and even a few marriage proposals.[52]

of sources are more effective at reducing different kinds of risk. Experts are effective at changing attitudes toward utilitarian products that have high *performance risk*, such as vacuum cleaners (that is, they may be complex and not work as expected). Celebrities are more effective when they focus on products such as jewelry and furniture that have high *social risk;* the user of such products is aware of their effect on the impression others have of him or her. Finally, "typical" consumers, who are appealing sources because of their similarity to the recipient, tend to be most effective when providing "man in the street" endorsements for everyday products that are low risk.[46]

THE MESSAGE

A major study of more than a 1,000 commercials identified factors that appear to determine whether a commercial message will be persuasive. The most important feature was whether the communication contained a brand-differentiating message. In other words, did the communication stress a unique attribute or benefit of the product?

Characteristics of the message itself help determine its impact on attitudes. These variables include how the message is said as well as what is said. Some of the issues facing marketers include the following:

- Should the message be conveyed in words or pictures?
- How often should the message be repeated?

- Should a conclusion be drawn, or should this be left up to the listener?
- Should both sides of an argument be presented?
- Is it effective to explicitly compare one's product to competitors?
- Should a blatant sexual appeal be used?
- Should negative emotions, such as fear, ever be aroused?
- How concrete or vivid should the arguments and imagery be?
- Should the ad be funny?

Sending the Message

The saying, "One picture is worth a thousand words," captures the idea that visual stimuli can economically deliver a big impact, especially when the communicator wants to influence receivers' emotional responses. For this reason, advertisers often place great emphasis on vivid and creative illustrations or photography.[53] Often image ads from Benetton, Nike, and Ralph Lauren have no text other than the company name; however, they appear to successfully convey powerful images.

On the other hand, a picture is not always as effective at communicating factual information. Ads that contain the same information, presented in either visual or verbal form, have been found to elicit different reactions. The verbal version affects ratings on the utilitarian aspects of a product, whereas the visual version affects aesthetic evaluations. Verbal elements are more effective when reinforced by an accompanying picture, especially if the illustration is *framed* (the message in the picture is strongly related to the copy).[54]

Because it requires more effort to process, a verbal message is most appropriate for high-involvement situations, such as in print contexts where the reader is motivated to really pay attention to the advertising. Because verbal material decays more rapidly in memory, more frequent exposures are needed to obtain the desired effect. Visual images, in contrast, allow the receiver to *chunk* information (combine small pieces of information into larger ones) at the time of encoding. Chunking results in a stronger memory trace that aids retrieval over time.[55]

Visual elements may affect brand attitudes in one of two ways. First, the consumer may form inferences about the brand and change his or her beliefs because of an illustration's imagery. Second, brand attitudes may be affected more directly; for example, a strong positive or negative reaction elicited by the visual elements will influence the consumer's attitude toward the ad (A_{ad}), which will then affect brand attitudes (A_b). This *dual-component model* of brand attitudes is illustrated in Figure 10-4.[56]

Vividness

Both pictures and words can differ in *vividness*. Powerful descriptions or graphics command attention and are more strongly embedded in memory. This may be because they tend to activate mental imagery, whereas abstract stimuli inhibit this process.[57] Of course, this effect can cut both ways: Negative information presented in a vivid manner may result in more negative evaluations at a later time.[58]

FIGURE 10-4
Effects of Visual and Verbal Components of Advertisements on Brand Attitudes
Source: M. R. Solomon, *Consumer Behavior,* 8th ed., 2009, p. 302, © 2007. Reprinted by permission of Pearson Education, Inc., Upper Saddle River, NJ.

The concrete discussion of a product attribute in ad copy also influences the importance of that attribute, because more attention is drawn to it. For example, the copy for a watch that reads, "According to industry sources, three out of every four watch breakdowns are due to water getting into the case," was more effective than this version: "According to industry sources, many watch breakdowns are due to water getting into the case."[59] The use of statistics to prove a point is more effective than a general description.

Repetition

Repetition can be a two-edged sword for marketers. Multiple exposures to a stimulus are usually required for learning (especially conditioning) to occur. Contrary to the saying, "Familiarity breeds contempt," people tend to like things that are more familiar to them, even if they were not that keen on them initially.[60] This is known as the *mere exposure* phenomenon. Fashion magazines often repeat similar ads after a few pages, sometimes on the very next page. One issue of *Vanity Fair* carried a thick supplement just for Calvin Klein ads. Positive effects for advertising repetition are found even in mature product categories—repeating product information has been shown to boost consumers' awareness of the brand, even though nothing new has been said.[61] On the other hand, too much repetition creates *habituation*, in which the consumer no longer pays attention to the stimulus because of fatigue or boredom. Excessive exposure can cause *advertising wearout*, which can result in negative reactions to an ad after seeing it too much.[62]

The **two-factor theory** (repetition increases familiarity but can also create boredom) implies that advertisers can overcome this problem by limiting the amount of exposure per repetition (such as using fifteen-second TV spots). They can also maintain familiarity but alleviate boredom by slightly varying the content of ads over time through campaigns that revolve around a common theme, although each spot may be different. Recipients who are exposed to varied ads about the product absorb more information about product attributes and experience more positive thoughts about the brand than do those exposed to the same information repeatedly. This additional information allows the person to resist attempts to change his or her attitude in the face of a counterattack by a competing brand.[63]

Constructing the Argument

Many marketing messages are similar to debates or trials, where someone presents arguments and tries to persuade the receiver to shift his or her opinion accordingly. The way the argument is presented may be as important as what is said.

One- versus Two-Sided Arguments

Most messages merely present one or more positive attributes about the product or reasons to buy it. These are known as *supportive arguments*. An alternative is to use a *two-sided message*, in which both positive and negative information is presented. Research has indicated that two-sided ads can be quite effective, yet they are not widely used.[64]

Why would a marketer want to devote advertising space to publicizing a product's negative attributes? Under the right circumstances, the use of **refutational arguments**, in which a negative issue is raised and then dismissed, can be quite effective. This approach can increase source credibility by reducing reporting bias. Also, people who are skeptical about the product may be more receptive to a balanced argument instead of a "whitewash."[65] Often the fur industry uses a two-sided approach, since there are some strong social objections to using fur for apparel.

This is not to say that the marketer should go overboard in presenting major problems with the product. In the typical refutational strategy, relatively minor attributes are discussed that may present a problem or fall short when compared with competitors. These drawbacks are then refuted by emphasizing positive, important attributes.

A two-sided strategy appears to be most effective when the audience is well educated (and is presumably more impressed by a balanced argument).[66] It is also best to use when receivers are not already loyal to the product; "preaching to the choir" about possible drawbacks may raise doubts unnecessarily.

Drawing Conclusions

A related factor is the issue of whether the argument should draw conclusions, or whether the points should merely be presented, permitting the consumer to arrive at his or her own conclusions. Should the message say only, "Our brand is superior," or should it add, "You should buy our brand"? On the one hand, consumers who make their own inferences instead of having them spoon-fed will form stronger, more accessible attitudes. On the other, leaving the conclusion ambiguous increases the chance that the desired attitude will not be formed.

The response to this issue depends on the consumers' motivation to process the ad and the complexity of the arguments. If the message is personally relevant, people will pay attention to it and spontaneously form inferences. However, if the arguments are hard to follow or consumers' motivation to follow them is lacking, it is safer for the ad to draw conclusions.[68]

Comparative Advertising

In 1971, the Federal Trade Commission issued guidelines that encouraged advertisers to name competing brands in their ads. This action was taken to

FUR—THE TWO-SIDED ARGUMENT

In one pamphlet, entitled "Fur, Your Fashion Choice,"[67] published by the Fur Information Council of America (FICA), a two-sided (albeit with a heavy dose of one-sided) argument is used to combat the negative press of furs by animal activists. It states:

> . . . It's your right to decide, in general, what to wear. Wearing a fur is a matter of individual choice. The freedom to make your own decisions is a right which we all enjoy. It's the basis on which our country was founded. The popularity of fur is no surprise, given its warmth, durability and dazzling beauty. With more designers creating artistry in fur than ever before, your most important decision is not **if** to choose, but **what** to choose.

> Animal activists don't just oppose fur, it goes much further . . . they are against the wearing of wool, leather and silk; the eating of meat and fish; the use of animals in circuses, zoos, and aquariums or for medical research.

The fur industry believes in the activists' right to express their opinions. Most importantly, we want you to have the same right to exercise your freedom of choice. We are all concerned about wildlife and our environment. The U.S. fur industry is committed to the proper treatment of all furbearing animals.

There are industry regulations ensuring that humane standards are adhered to on U.S. fur farms, and U.S. laws govern these standards for furbearers in the wild. In fact, the fur industry has pledged to have any report of irresponsibility investigated, so that remedial action is taken.

No endangered species are used in fur garments sold in the U.S.—this is guaranteed by law. Did you know that fur farms in the U.S. are part of a certification program? In fact, key American Veterinary Medical Association standards must be met to get certified. Please know that the fur industry is a responsible one, with a commitment to the environment and to you, the consumer.

improve the information available to consumers in ads, and indeed evidence indicates that at least under some conditions this type of presentation does result in more informed decision making.[69] **Comparative advertising** refers to a strategy in which a message compares two or more specifically named or recognizably presented brands and makes a comparison of them in terms of one or more specific attributes.[70] This strategy can cut both ways, especially if the sponsor depicts the competition in a nasty or negative way. Although some comparative ads result in desired attitude change or positive A_{ad}, they have also been found to be lower in believability and may result in more source derogation (that is, the consumer may doubt the credibility of a biased presentation).[71] Indeed, in some parts of the world (such as in Asia) comparative advertising is rare because some cultures find such a confrontational approach offensive.

Comparative ads do appear to be effective for new products that are trying to build a clear image by positioning themselves vis-à-vis dominant brands in the market. They work well at generating attention, awareness, favorable attitudes, and purchase intentions—but ironically, consumers may not like the ad itself because of its aggressiveness.[72] However, if the aim is to compare the new brand with the market leader in terms of specific product attributes, merely saying it is as good as or better than the leader is not sufficient.

Types of Message Appeals

The way something is said can be as significant as what is said—the same idea can be encoded in many different ways. It can tug at the heartstrings, scare you, make you laugh, make you cry, or leave you wanting to learn more.

nc2
by Nu Colour

WILD AT EMOTIONS

Many marketing messages, such as this ad for a cosmetics company in Taiwan, focus on emotions rather than cognitions.

In this section, we'll review the major alternatives available to communicators who wish to *appeal* to a message recipient.

Emotional versus Rational Appeals/Puffing versus Informative

Should the appeal be to the head or to the heart? The answer often depends on the nature of the product and the type of relationship consumers have with it. The goal of an emotional appeal is to establish a connection between the product and the consumer, a strategy known as *bonding*.[73] Emotional

appeals have the potential to increase the chance that the message will be perceived, they may be more likely to be retained in memory, and they can also increase the consumer's involvement with the product. Many fragrance ads use emotional appeals.

Some companies turned to an emotional strategy after realizing that consumers do not find many differences among brands, especially those in well-established, mature categories. The precise effects of rational versus emotional appeals are hard to gauge. Though recall of ad contents tends to be better for "thinking" ads than for "feeling" ads, conventional measures of advertising effectiveness (such as day-after recall) may not be adequate to assess cumulative effects of emotional ads. These open-ended measures are oriented toward cognitive responses, and feeling ads may be penalized because the reactions are not as easy to articulate.[74]

Although they can make a strong impression, emotional appeals also run the risk of not getting across an adequate amount of product-related information. This potential problem is reminding some advertisers that the arousal of emotions is functional only to the extent that it sells the product.

The type of product often lends itself to a rational or an emotional appeal. Products or services may be thought of as search, experience, or credence goods.[75]

- *Search goods*—These goods have properties that consumers can actually find information about, such as price, availability, and properties prior to purchase. One can easily find the price and brand name of a garment through labels or advertisements.

- *Experience goods*—Consumers cannot seek out information prior to purchase for experience goods; information comes from the experience of consuming the product. One can search for a good fit of shoes in the store by trying them on, but the only way to know that they won't cause blisters after wearing them all day at school is to experience that. Movies and restaurants are similar types of goods. Even though you can read reviews, only you know if you liked the movie or the food.

- *Credence goods*—Consumers cannot seek out information or evaluate credence goods even after the product is consumed without incurring prohibitively high information costs. As a result government intervention is common, such as licensing services that are highly technical. Consumers cannot know whether they have gotten a good college education or whether the medication they took for their illness was the best. Similarly, they don't know the chemical makeup of the fabric in their clothes unless it is labeled, and even if it is, how do we know that the labeling is correct?

Back to the concept of emotional versus rational appeals—certain types of goods lend themselves to one or the other. It is logical to use an informative ad in advertising search goods, since information can be offered and searched for. On the other hand, experience and credence goods are more difficult since information is not readily available for these goods. How do you know whether you will like the fragrance of a certain perfume after wearing it all day? You can only know once you have experienced it. You cannot know before you buy it. Therefore, promotional appeals are often emotional,

MULTICULTURAL DIMENSIONS

Nike is the master of "in your face" emotional messages about sports that barely acknowledge the shoes it is trying to sell. These appeals have played very well in the United States, but the company hit some bumps in the road as it tried to export this attitude overseas. As the company searched for new markets, it tried to conquer soccer the way it did basketball. An ad in *Soccer America* magazine announced the impending invasion: "Europe, Asia and Latin America: Barricade your stadiums. Hide your trophies. Invest in some deodorant." This message was not very well received in some soccer quarters, and similarly a successful American TV commercial featuring Satan and his demons playing soccer against Nike endorsers was banned by some European stations on the grounds that it was too scary for children to see and offensive to boot. A British TV ad featuring a French soccer player saying how his spitting at a fan and insulting his coach won him a Nike contract resulted in a scathing editorial against Nike in the sport's international federation newsletter. Nike has a tough task ahead of it: to win over European soccer fans where rival Adidas is king—in a game that traditionally doesn't have the glitz and packaging of basketball. Now a bit chastised, Nike is modifying its "question authority" approach as it tries to win over the sports organizations in countries that don't appreciate its violent messages and anti-establishment themes. Only time will tell if the athletic giant will be "red-carded" by European fans and game officials.[76]

romanticized, or *puffing*. **Puffing ads** "ballyhoo" the product or use superlatives, endorsements by celebrities, or claims of uniqueness instead of hard facts. They are fluff; they are entertaining but not very informative. That's mainly because there are no hard facts to offer, since the information comes from experience. Therefore, experience and credence goods are logical candidates for emotional ads. Consider fragrance ads: Do they discuss notes and other technical information? Not likely.

Sex Appeals

Echoing the widely held belief that "sex sells," many marketing communications for everything from perfumes to autos feature heavy doses of erotic suggestions that range from subtle hints to blatant displays of skin. Many fashion companies use a great deal of sex in their promotion. Calvin Klein, Guess?, Abercrombie & Fitch, and even Levi's use sex to sell fashion. Of course, the prevalence of sex appeals varies from country to country. For example, Shai, a high-end French clothing company, used an online campaign with porn stars frolicking, initially dressed in the company's latest styles. The campaign didn't provoke a discernible backlash in France, but nudity in advertising is hotly contested in the United States. This interactive stag film as fashion catalog illustrates how the Internet is rapidly changing the rules of advertising with no standards boards for companies to worry about. Over 2 million visitors viewed the "catalog" and brought attention to the company, but it was unclear how much clothing was sold.[77]

Many feel that gross objectification of women is degrading and inappropriate. (See Chapter 14.) But not all sex in advertising is seen as offensive; it is seen as an acceptable way to sell even by vocal women's movement leaders such as the president of the National Organization for Women: It is acceptable if the woman is "in control of the situation and her own sexuality."[78]

Perhaps not surprisingly, female nudity in print ads generates negative feelings and tension among female consumers, while men's reactions are more positive.[79] In a case of turnabout being fair play, another study found that males dislike nude males in ads, while females responded well to undressed males—but not totally nude ones.[80] Responding in part to negative consumer reactions, Abercrombie & Fitch discontinued its racy *A&F Quarterly*, a "magalog" that featured nude models in suggestive poses.[81]

So does sex work? Although erotic content does appear to draw attention to an ad, its use may actually be counterproductive to the marketer. Ironically, a provocative picture can be *too* effective; it attracts so much attention that it hinders processing and recall of the ad's contents. Sexual appeals appear to be ineffective when used merely as a "trick" to grab attention. They do, however, appear to work when the product is *itself* sexually related. Overall, though, use of a strong sexual appeal is not very well received.[82]

Humorous Appeals

The use of humor can be tricky, particularly since what is funny to one person may be offensive or incomprehensible to another. Specific cultures may have different senses of humor and also use funny material in diverse ways. For example, commercials in the United Kingdom are more likely to use puns and satire than in the United States.[83]

Does humor work? Overall, humorous advertisements do get attention. A series of Candies shoe ads depicting people in embarrassing situations is an example of a humorous ad targeting teens. Twenty years ago, Joe Boxer was founded with a simple idea: What would happen if the most basic element of men's clothing was remade to reflect humor, fashion, and popular trends? One of the things that happened is Joe Boxer achieved a 90 percent brand awareness by consumers. At www.joeboxer.com, the customer gets to play with the brand on many different levels. They can share in the various promotional events, view past television ads, and take a virtual tour of the brand's history as well as play games. The verdict is mixed as to whether humor affects recall or product attitudes in a significant way.[84] One function it may play is to provide a source of *distraction*. A funny ad inhibits the consumer from counterarguing, thereby increasing the likelihood of message acceptance.[85]

Humor is more likely to be effective when the brand is clearly identified and the funny material does not "swamp" the message. This danger is similar to that of beautiful models diverting attention from copy points. Subtle humor is usually better, as is humor that does not make fun of the potential consumer. Finally, humor should be appropriate to the product's image.

Fear Appeals

Fear appeals emphasize the negative consequences that can occur unless the consumer changes a behavior or an attitude. *Fear of deviance* may be important for adolescents as they believe that the group will apply sanctions to punish behavior that differs from the group.

A fear strategy is used in marketing communications, though more commonly in social marketing contexts when organizations are encouraging people to convert to a healthier lifestyle by quitting smoking, using contraception, relying on a designated driver, and so on.

Does fear work? Most research on this topic indicates that negative appeals are usually most effective when only a moderate threat is used and when a solution to the problem is presented (otherwise, consumers will tune out the ad since they can do nothing to solve the problem).[86] This approach also works better when source credibility is high.[87] When a weak threat is ineffective, this may be because there is insufficient elaboration of the harmful consequences of engaging in the behavior. When a strong threat doesn't work, it may be because *too much* elaboration interferes with the processing of the recommended change in behavior—the receiver is too busy thinking of reasons why the message doesn't apply to him or her to pay attention to the offered solution.[88] Some of the antifur ads may be too graphic for some people, who are merely turned off by them.

Fashion Magazine Contents

Using some of the concepts just discussed, one student project analyzed the content and types of ads in fashion magazines. There are many ways of analyzing fashion magazine contents: fashion content (editorials or articles) versus advertisements, informative versus puffing ads, sexual versus nonsexual

Table 10-1 Analysis of Advertisements of Selected Fashion Magazines

Magazine	Total Pages	Other* Ads	Informative Clothing Ads	Sexual Ads	Fragrance Ads	Makeup Ads	Hair Product Ads	Jewelry Ads
Marie Claire	152	45	37	36	7	11	9	7
Harper's Bazaar	137	27	29	24	21	23	0	10
YM	132	38	23	26	26	8	8	3
Vogue	126	37	27	23	9	9	6	15
Seventeen	126	32	24	27	22	10	10	1
Allure	126	21	26	24	25	14	10	6
Total	799	200	166	160	110	75	43	42

*Alcohol, cigarettes, feminine hygiene products.
Source: Nancy J. Rabolt and JoAnna Combs, 1997.

ads or editorials, types of products shown in ads or editorials, and so on. In a review of six different fashion magazines from *Seventeen* to *Harper's Bazaar*, results show that the largest number of pages was used for ads followed by fashion editorials displaying the newest fashions and lastly fashion articles.

Table 10-1 illustrates the ad content breakdown. Some categories overlap, and ads were counted in more than one category. The largest percentage of ads was for alcohol, cigarettes, and feminine hygiene products, followed by informative fashion ads, sexual fashion ads, fragrance ads, makeup ads, hair product ads, and jewelry ads. Try this with your favorite fashion magazines. How do they compare to this analysis? Do you find any of this exciting? Useful? Disturbing? Offensive?

The Message as Art Form: Metaphors Be with You

Marketers may be thought of as storytellers who supply visions of reality similar to those provided by authors, poets, and artists. These communications take the form of stories because the product benefits they describe are intangible and must be given tangible meaning by expressing them in a form that is concrete and visible. Advertising creatives rely (consciously or not) on various literary devices to communicate these meanings.

For example, a product or service might be personified by a character such as Mr. Goodwrench, the California Raisins, or the talking fruit in Fruit of the Loom ads. Many ads take the form of an *allegory*, in which a story is told about an abstract trait or concept that has been personified as a person, animal, or vegetable.

A **metaphor** involves the use of an explicit comparison, such as "A is B" (for example, Reebok promoted its metaphor shoes shown in a picture frame with the caption "Pretty as a Picture: Comfortable as Reebok"). Metaphors allow the marketer to activate meaningful images and apply them to everyday events. In the stock market, "white knights" battle "hostile raiders" using "poison pills," while the Merrill Lynch bull sends the message that the company is "a breed apart,"[89] and Benefit Cosmetics' superheroine Zaparella, a takeoff on Wonder Woman, is the feared foe of the Evil Blemish, as she sweeps the

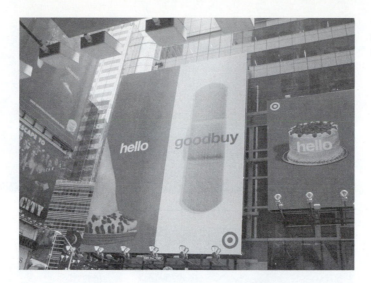

"Target uses a play on words to show their variety of merchandise."

night skies armed with her galactic duo Buh-Bye and Boo Boo Zap to fight blemishes.

Resonance is another type of literary device that advertisers frequently use. It's a form of presentation that combines a play on words with a relevant picture. Whereas a metaphor substitutes one meaning for another by connecting two things that are in some way similar, resonance uses an element that has a double meaning, such as a pun in which there is a similarity in the sound of a word but a difference in meaning. AISC athletic shoes used the line "we believe women should be running the country," in an ad with a picture of a woman jogging. Target used "goodbuy" to sound like "goodbye" in a billboard campaign.

Forms of Story Presentation

Just as a story can be told in words or pictures, the way the audience is addressed can also make a difference. Commercials are structured like other art forms, borrowing conventions from literature and art as they communicate their messages.[90]

One important distinction is between a *drama* and a *lecture*.[91] A lecture is like a speech in which the source speaks directly to the audience in an attempt to inform them about a product or persuade them to buy it. Because a lecture clearly implies an attempt at persuasion, the audience will regard it as such. Assuming that listeners are motivated to do so, the merits of the message will be weighed, along with the credibility of the source. Cognitive responses, such as counterargument, will occur. The appeal will be accepted to the extent that it overcomes objections and is congruent with a person's beliefs.

In contrast, a drama is similar to a play or movie. Whereas an argument holds the viewer at arm's length, a drama draws the viewer into the action. The characters only indirectly address the audience; they interact with each other about a product or service in an imaginary setting. Dramas attempt to be experiential—to involve the audience emotionally.

This is a portion of a sixteen-frame television storyboard for a Lee commercial, which tells a story.

CHAPTER SUMMARY

- The communication model specifies the elements needed to transmit meaning. These include a source, message, medium, receiver, and feedback. Most fashion communication falls within the realm of personal communication with both verbal and nonverbal components. Appearance can be thought of as a message from the sender to the receiver.

- Persuasion is an attempt to change consumers' attitudes.

- The traditional view of communications tends to regard the perceiver as a passive element in the process. Proponents of the uses and gratifications approach instead regard the consumer as an active participant who uses media for a variety of reasons.

- New developments in interactive communications highlight the need to consider the active roles a consumer might play in obtaining product information and building a relationship with a company. A product-related communication that directly yields a transaction is a first-order response. Customer feedback in response to a marketing message that is not in the form of a transaction is a second-order response. This may take the form of a request for more information about a good, service, or organization, or perhaps receipt of a "wish list" from the customer that specifies the types of product information he or she would like to get in the future.

- Two important characteristics that determine the effectiveness of a source are its attractiveness and credibility. Although celebrities often serve this purpose, their credibility is not always as strong as marketers hope.

- Some elements of a message that help determine its effectiveness are whether it is conveyed in words or pictures, whether an emotional or a rational appeal is employed, the frequency with which it is repeated, whether a conclusion is drawn, whether both sides of the argument are presented, and whether the message includes fear, humor, or sexual references.

- Search goods are more apt to have informative advertisements; experience goods and credence goods often are promoted through puffing advertisements. Much of cosmetics, fragrance, and fashion advertising is puffing.

- Advertising messages often incorporate such elements from art or literature as dramas, lectures, metaphors, and allegories.

KEY TERMS

persuasion	blogging	refutational argument
communication model	source credibility	comparative advertising
permission marketing	source attractiveness	puffing ads
uses and gratifications theory	match-up hypothesis	fear appeals
	avatar	metaphor
m-commerce	two-factor theory	resonance

DISCUSSION QUESTIONS

1. Review nonfashion ads on TV. Observe the dress of the actors in the commercial. What does their clothing communicate to you? What other nonverbal messages can you depict?

2. Collect ads that rely on sex appeal to sell fashion products. How often are benefits of the actual product communicated to the reader? Are these ads in good taste or are they offensive? Survey both male and female consumers. Are there different responses?

3. Discuss some conditions where it would be advisable to use a comparative advertising strategy using fashion products.

4. Why would a marketer consider saying negative things about his or her product? When is this strategy feasible? Can you find examples of it?

5. A marketer must decide whether to incorporate rational or emotional appeals in its communications strategy. Describe conditions that are more favorable to using one or the other.

6. Are infomercials ethical? Should marketers be allowed to use any format they want to present product-related information? Watch an infomercial about a new product. Evaluate its merits.

7. To observe the process of counterargument, ask a friend to respond to each point in a commercial or to write down reactions to the claims made. How much skepticism regarding the claims can you detect?

8. Make a log of all the commercials shown on one network television channel over a six-hour period. Categorize each according to product category and whether it is presented as drama or argument. Describe the types of messages used (such as two-sided arguments) and keep track of the types of spokespeople (such as television actors, famous people, or animated characters). What can you conclude about the dominant forms of persuasive tactics currently employed by marketers on TV?

9. Collect examples of ads that rely on the use of metaphors or allegories. Do you feel that these ads are effective? If you were working with the products, would you feel more comfortable with ads that use a more straightforward, "hard-sell" approach? Why or why not?

10. Create a list of current celebrities who you feel typify cultural categories (clown, mother figure, and so on). What specific brands do you feel that each could effectively endorse?

ENDNOTES

1. Elihu Katz and Paul F. Lazarsfeld, *Personal Influence* (Glencoe, Ill. Free Press, 1955).
2. Rose-Marie Turk, "The Leading Ladies," *WWDCalifornia* (supplement to *Women's Wear Daily*) (August 1999).
3. Grant McCracken, *Culture and Consumption: New Approaches to the Symbolic Character of Consumer Goods and Activities* (Bloomington: Indiana University Press, 1988).
4. Susan Kaiser, *The Social Psychology of Clothing: Symbolic Appearances in Context* (New York: Fairchild, 1997).
5. Nathan Joseph, "Layers of Signs," in *Dress and Identity*, eds. Mary Ellen Roach-Higgins, Joanne B. Eicher, and Kim K. Johnson (New York: Fairchild, 1995).
6. Solomon E. Asch, "Forming Impressions of Personality," *Journal of Abnormal Social Psychology* 41 (1946): 258–290.
7. Gert Assmus, "An Empirical Investigation into the Perception of Vehicle Source Effects," *Journal of Advertising* 7 (Winter 1978): 4–10. For a more thorough discussion of the pros and cons of different media, see Stephen Baker, *Systematic Approach to Advertising Creativity* (New York: McGraw-Hill, 1979).
8. Alladi Venkatesh, Ruby Roy Dholakia, and Nikhilesh Dholakia, "New Visions of Information Technology and Postmodernism: Implications for Advertising and Marketing Communications," in *The Information Superhighway and Private Households: Case Studies of*

Business Impacts, eds. Walter Brenner and Lutz Kolbe, (Heidelberg, Germany: Physical-Verlage 1996), 319–337; Donna L. Hoffman and Thomas P. Novak, "Marketing in Hypermedia Computer-Mediated Environments: Conceptual Foundations," *Journal of Marketing* 60, no. 3 (July 1996): 50–68. For an early theoretical discussion of interactivity in communications paradigms, see B. Aubrey Fisher, *Perspectives on Human Communication*, (New York: Macmillan, 1978).
9. Seth Godin, *Permission Marketing: Turning Strangers into Friends, and Friends into Customers* (New York: Simon & Schuster, 1999).
10. First proposed by Elihu Katz, "Mass Communication Research and the Study of Popular Culture: An Editorial Note on a Possible Future for This Journal," *Studies in Public Communication*, 2 (1959): 1–6. For a recent discussion of this approach, see Stephanie O'Donohoe, "Advertising Uses and Gratifications" *European Journal of Marketing* 28, no. 8/9 (1994): 52–75.
11. Annie Huang, "Cartoon Doll Creates Frenzy in Taiwan," *Marketing News* (September 13, 1999): 20.
12. Quoted in O'Donohoe, "Advertising Uses and Gratifications," p. 66.
13. Geoffrey A. Fowler, "Asia's Mobile Ads," *Wall Street Journal Online Edition* (April 25, 2005); Brooke Barnes, "Coming

to Your Cell: Paris Hilton," *Wall Street Journal Online Edition* (March 17, 2005); Alice Z. Cuneo, "Marketers Dial In to Messaging," *Advertising Age* (November 1, 2004): 18; Stephen Baker and Heather Green, "Blogs Will Change Your Business," *Business Week* (May 2, 2005): 56 (9).

14. Michael Barbaro, "Wal-Mart Enlists Bloggers in P.R. Campaign," *New York Times on the Web* (www.nytimes.com) (March 7, 2006).

15. Stephen Baker and Heather Green, "Blogs Will Change Your Business," *Business Week* (May 2, 2005): 56.

16. Bob Tedeschi, "Like Shopping? Social Networking? Try Social Shopping," *New York Times on the Web* (www.nytimes.com) (September 11, 2006).

17. Carl I. Hovland and W. Weiss, "The Influence of Source Credibility on Communication Effectiveness," *Public Opinion Quarterly* 15 (1952): 635–650.

18. Herbert Kelman, "Processes of Opinion Change," *Public Opinion Quarterly* 25 (Spring 1961): 57–78; Susan M. Petroshuis and Kenneth E. Crocker, "An Empirical Analysis of Spokesperson Characteristics on Advertisement and Product Evaluations," *Journal of the Academy of Marketing Science* 17 (Summer 1989): 217–226.

19. Yeosun Yoon, Zeynep Gurhan-Canil, and Norbert Schwarz, "The Effect of Corporate Social Responsibility (CSR) Activities on Companies with Bad Reputations," *Journal of Consumer Psychology* 16, no. 4 (2006): 377–390.

20. S. Ratneshwar and Shelly Chaiken, "Comprehension's Role in Persuasion: The Case of Its Moderating Effect on the Persuasive Impact of Source Cues," *Journal of Consumer Research* 18 (June 1991): 52–62.

21. Jagdish Agrawal and Wagner A. Kamakura, "The Economic Worth of Celebrity Endorsers: An Event Study Analysis," *Journal of Marketing* 59 (July 1995): 56–62.

22. Gwendolyn S. O'Neal and Mary Lapitsky, "Effects of Clothing as Nonverbal Communication on Credibility of the Message Source," *Clothing and Textiles Research Journal* 9, no. 3 (1991): 28–34.

23. Robert LaFranco, "MTV Conquers Madison Avenue," *Forbes* (June 3, 1996): 138.

24. Eric Wilson, "On with the Show Business," *Women's Wear Daily* (March 22, 1999): 28–30.

25. Eric Wilson, "On with the Show Business."

26. Alice H. Eagly, Andy Wood, and Shelly Chaiken, "Causal Inferences about Communicators and Their Effect in Opinion Change," *Journal of Personality and Social Psychology* 36, no. 4 (1978): 424–435.

27. Suzanne Vranica and Sam Walker, "Tiger Woods Switches Watches; Branding Experts Disapprove," *Wall Street Journal Interactive Edition* (October 7, 2002).

28. Alex Mindlin, "To Sell Goods, the Celebrity Face Matters," *New York Times Online* (May 8, 2006).

29. Karen K. Dion, "What Is Beautiful Is Good," *Journal of Personality and Social Psychology* 24 (December 1972): 285–290.

30. Michael J. Baker and Gilbert A. Churchill, Jr., "The Impact of Physically Attractive Models on Advertising Evaluations," *Journal of Marketing Research* 14 (November 1977): 538–555; Marjorie J. Caballero and William M. Pride, "Selected Effects of Salesperson Sex and Attractiveness in Direct Mail Advertisements," *Journal of Marketing* 48 (January 1984): 94–100; W. Benoy Joseph, "The Credibility of Physically Attractive Communicators: A Review," *Journal of Advertising* 11, no. 3 (1982): 15–24; Lynn R. Kahle and Pamela M. Homer, "Physical Attractiveness of the Celebrity Endorser: A Social Adaptation Perspective," *Journal of Consumer Research* 11 no. 4 (1985): 954–961; Judson Mills and Eliot Aronson, "Opinion Change as a Function of Communicator's Attractiveness and Desire to Influence," *Journal of Personality and Social Psychology* 1 (1965): 173–177.

31. Leonard N. Reid and Lawrence C. Soley, "Decorative Models and the Readership of Magazine Ads," *Journal of Advertising Research* 23, no. 2 (1983): 27–32.

32. Marjorie J. Caballero, James R. Lumpkin, and Charles S. Madden, "Using Physical Attractiveness as an Advertising Tool: An Empirical Test of the Attraction Phenomenon," *Journal of Advertising Research* (August/September 1989): 16–22.

33. Baker and Churchill, "The Impact of Physically Attractive Models on Advertising Evaluations"; George E. Belch, Michael A. Belch, and Angelina Villareal, "Effects of Advertising Communications: Review of Research," in *Research in Marketing,* no. 9 (Greenwich, Conn.: JAI Press, 1987), 59–117; A. E. Courtney and T. W. Whipple, *Sex Stereotyping in Advertising* (Lexington, Mass.: Lexington Books, 1983).

34. Kahle and Homer, "Physical Attractiveness of the Celebrity Endorser."

35. Vranica and Walker, "Tiger Woods Switches Watches; Branding Experts Disapprove."

36. Heather Buttle, Jane E. Raymond, and Shai Danziger, "Do Famous Faces Capture Attention?" Paper presented at Association for Consumer Research Conference Columbus, Ohio (October 1999).

37. Michael A. Kamins, "Celebrity and Noncelebrity Advertising in a Two-Sided Context," *Journal of Advertising Research* 29 (June–July 1989): 34; Joseph M. Kamen, A. C. Azhari, and J. R. Kragh, "What a Spokesman Does for a Sponsor," *Journal of Advertising Research* 15, no. 2 (1975): 17–24; Lynn Langmeyer and Mary Walker, "A First Step to Identify the Meaning in Celebrity Endorsers," in Rebecca H. Holman and Michael R. Solomon, eds., *Advances in Consumer Research* 18 (Provo, UT: Association for Consumer Research, 1991): 364–371.

38. Michelle Edgar, "Beautiful Voices," *Women's Wear Daily* (August 31, 2006, Section II): 21.

39. Julie Naughton, "Coty to Offer Consumers Forbidden Fruit," *Women's Wear Daily* (May 19, 2006): 4.

40. Grant McCracken, "Who Is the Celebrity Endorser? Cultural Foundations of the Endorsement Process," *Journal of Consumer Research* 16, no. 3 (December 1989): 310–321.

41. Michael A. Kamins, "An Investigation into the 'Match-Up' Hypothesis in Celebrity Advertising: When Beauty May Be Only Skin Deep," *Journal of Advertising* 19, no. 1 (1990): 4–13; Lynn R. Kahle and Pamola M. Homer, "Physical Attractiveness of the Celebrity Endorser: A Social Adaptation Perspective," *Journal of Consumer Research* 11 (March 1985): 954–961.

42. Brian Steinberg, "Bob Dylan Gets Tangled Up in Pink: Victoria's Secret Campaign Drafts Counterculture Hero; Just Like the Rolling Stones," *Wall Street Journal* (April 2, 2004): B3.

43. Kevin E. Kahle and Lynn R. Kahle, "Sports Celebrities' Image: A Critical Evaluation of the Utility of Q Scores," working paper, University of Oregon, 2005.

44. "Made in the U.S.A. Labels Aimed at Luring Shoppers," *San Jose Mercury News* (November 24, 1985): 10F; "Council Unveils New Made in U.S.A. Ads," *Women's Wear Daily* (November 23, 1987): 8; Dianne M. Pogoda, "Crafted With Pride Ad Drive Will Go Red, White and Blue," *Women's Wear Daily* (April 2, 1991): 15; Marvin Klapper, "Crafted With Pride Group to Air Touch New TV Spots," *Women's Wear Daily* (November 15, 1991): 13; Marvin Klapper, "Crafted Ads Trigger New Imports Rift," *Women's Wear Daily* (December 2, 1991): 4.

45. Kenneth G. DeBono and Richard J. Harnish, "Source Expertise, Source Attractiveness, and the Processing of Persuasive Information: A Functional Approach," *Journal of Personality and Social Psychology* 55, no. 4 (1988): 541–546.

46. Hershey H. Friedman and Linda Friedman, "Endorser Effectiveness by Product Type," *Journal of Advertising Research* 19, no. 5 (1979): 63–71.

47. "Backlash on Drug Use: More Brands Sever Ties with Model Kate Moss," *Women's Wear Daily* (September 22, 2005): 1, 5.

48. Nat Ives, "Marketers Run to Pull the Plug When Celebrity Endorsers Say the Darnedest Things," *New York Times on the Web* (July 16, 2004).

49. Joel Baglole, "Mascots Are Getting Bigger Role in Corporate Advertising Plans," *Wall Street Journal Interactive Edition* (April 9, 2002).

50. David Germain, "Simone Leading Lady Is Living and Breathing Model," *New York Times* (August 26, 2002): D1.

51. Tran T. L. Knanh and Regalado Antonio, "Web Sites Bet on Attracting Viewers with Humanlike Presences of Avatars," *Wall Street Journal Interactive Edition* (January 24, 2001).

52. Olaf Schirm, President, NoDNA GmbH, personal Internet communication (August 13, 2002).

53. R. C. Grass and W. H. Wallace, "Advertising Communication: Print versus TV," *Journal of Advertising Research* 14 (1974): 19–23.

54. Elizabeth C. Hirschman and Michael R. Solomon, "Utilitarian, Aesthetic, and Familiarity Responses to Verbal versus Visual Advertisements," in *Advances in Consumer Research* 11, ed. Thomas C. Kinnear (Provo, Utah: Association for Consumer Research, 1984), 426–431.

55. Terry L. Childers and Michael J. Houston, "Conditions for a Picture-Superiority Effect on Consumer Memory," *Journal of Consumer Research* 11 (September 1984): 643–654.

56. Andrew A. Mitchell, "The Effect of Verbal and Visual Components of Advertisements on Brand Attitudes and Attitude toward the Advertisement," *Journal of Consumer Research* 13 (June 1986): 12–24.

57. John R. Rossiter and Larry Percy, "Attitude Change through Visual Imagery in Advertising," *Journal of Advertising Research* 9, no. 2 (1980): 10–16.

58. Jolita Kiselius and Brian Sternthal, "Examining the Vividness Controversy: An Availability-Valence Interpretation," *Journal of Consumer Research* 12 (March 1986): 418–431.

59. Scott B. Mackenzie, "The Role of Attention in Mediating the Effect of Advertising on Attribute Importance," *Journal of Consumer Research* 13 (September 1986): 174–195.

60. Robert B. Zajonc, "Attitudinal Effects of Mere Exposure," monograph, *Journal of Personality and Social Psychology* 8 (1968): 1–29.

61. Giles D'Souza and Ram C. Rao, "Can Repeating an Advertisement More Frequently Than the Competition Affect Brand Preference in a Mature Market?," *Journal of Marketing* 59 (April 1995): 32–42.

62. George E. Belch, "The Effects of Television Commercial Repetition on Cognitive Response and Message Acceptance," *Journal of Consumer Research* 9 (June 1982): 56–65; Marian Burke and Julie Edell, "Ad Reactions over Time: Capturing Changes in the Real World," *Journal of Consumer Research* 13 (June 1986): 114–118; Herbert Krugman, "Why Three Exposures May Be Enough," *Journal of Advertising Research* 12 (December 1972): 11–14.

63. Curtis P. Haugtvedt, David W. Schumann, Wendy L. Schneier, and Wendy L. Warren, "Advertising Repetition and Variation Strategies: Implications for Understanding Attitude Strength," *Journal of Consumer Research* 21 (June 1994): 176–189.

64. Linda L. Golden and Mark I. Alpert, "Comparative Analysis of the Relative Effectiveness of One- and Two-Sided Communication for Contrasting Products," *Journal of Advertising* 16 (1987): 18–25; Kamins, "Celebrity and Noncelebrity Advertising in a Two-Sided Context"; Robert B. Settle and Linda L. Golden, "Attribution Theory and Advertiser Credibility," *Journal of Marketing Research* 11 (May 1974): 181–185.

65. See Alan G. Sawyer, "The Effects of Repetition of Refutational and Supportive Advertising Appeals," *Journal of Marketing Research* 10 (February 1973): 23–33; George J. Szybillo and Richard Heslin, "Resistance to Persuasion: Inoculation Theory in a Marketing Context," *Journal of Marketing Research* 10 (November 1973): 396–403.

66. Belch et al., "Effects of Advertising Communications."

67. "Fur, Your Fashion Choice," Fur Information Council of America, Washington, D.C., nd.

68. Frank R. Kardes, "Spontaneous Inference Processes in Advertising: The Effects of Conclusion Omission and Involvement on Persuasion," *Journal of Consumer Research* 15 (September 1988): 225–233.

69. Belch et al., "Effects of Advertising Communications"; Cornelia Pechmann and Gabriel Esteban, "Persuasion Processes Associated with Direct Comparative and Noncomparative Advertising and Implications for Advertising Effectiveness," *Journal of Consumer Psychology* 2, no. 4 (1994): 403–432.

70. Cornelia Droge and Rene Y. Darmon, "Associative Positioning Strategies through Comparative Advertising: Attribute vs. Overall Similarity Approaches," *Journal of Marketing Research* 24 (1987): 377–389; D. Muehling and N. Kangun, "The Multidimensionality of Comparative Advertising: Implications for the FTC," *Journal of Public Policy and Marketing* (1985): 112–128; Beth A. Walker and

Helen H. Anderson, "Reconceptualizing Comparative Advertising: A Framework and Theory of Effects," in *Advances in Consumer Research* 18, eds. Rebecca H. Holman and Michael R. Solomon (Provo, Utah: Association for Consumer Research, 1991), 342–347; William L. Wilkie and Paul W. Farris, "Comparison Advertising: Problems and Potential," *Journal of Marketing* 39 (October 1975): 7–15; R. G. Wyckham, "Implied Superiority Claims," *Journal of Advertising Research* (February/March 1987): 54–63.

71. Stephen A. Goodwin and Michael Etgar, "An Experimental Investigation of Comparative Advertising: Impact of Message Appeal, Information Load, and Utility of Product Class," *Journal of Marketing Research* 17 (May 1980): 187–202; Gerald J. Gorn and Charles B. Weinberg, "The Impact of Comparative Advertising on Perception and Attitude: Some Positive Findings," *Journal of Consumer Research* 11 (September 1984): 719–727; Terence A. Shimp and David C. Dyer, "The Effects of Comparative Advertising Mediated by Market Position of Sponsoring Brand," *Journal of Advertising* 3 (Summer 1978): 13–19; R. Dale Wilson, "An Empirical Evaluation of Comparative Advertising Messages: Subjects' Responses to Perceptual Dimensions," in *Advances in Consumer Research* 3, ed. B. B. Anderson (Ann Arbor, Mich.: Association for Consumer Research, 1976), 53–57.

72. Dhruv Grewal, Sukumar Kavanoor, Edward F. Fern, Carolyn Costley, and James Barnes, "Comparative versus Noncomparative Advertising: A Meta-Analysis," *Journal of Marketing* 61 (October 1997): 1–15.

73. "Connecting Consumer and Product," *New York Times* (January 18, 1990): D19.

74. H. Zielske, "Does Day-After Recall Penalize 'Feeling' Ads?," *Journal of Advertising Research* 22 (1982): 19–22.

75. Roger Swagler, *Consumers and the Marketplace* (Lexington, Mass.: Heath, 1979).

76. Roger Thurow, "As In-Your-Face Ads Backfire, Nike Finds a New Global Tack," *Wall Street Journal Interactive Edition* (May 5, 1997).

77. Claire Hoffman and Chris Gaither, "Porn Stars Shed T-shirts to Help Sell Clothes as Internet Changes the Rules," *San Francisco Chronicle* (August 16, 2006): A2.

78. Susan Sward, "Sex in Ads—Defining the Limits" *San Francisco Chronicle* (January 30, 1992): A1, A4.

79. Belch et al., "Effects of Advertising Communications"; Courtney and Whipple, *Sex Stereotyping in Advertising*; Michael S. LaTour, "Female Nudity in Print Advertising: An Analysis of Gender Differences in Arousal and Ad Response," *Psychology & Marketing* 7, no. 1 (1990): 65–81;

B. G. Yovovich, "Sex in Advertising—The Power and the Perils," *Advertising Age* (May 2, 1983): M4–M5.

80. Penny M. Simpson, Steve Horton, and Gene Brown, "Male Nudity in Advertisements: A Modified Replication and Extension of Gender and Product Effects," *Journal of the Academy of Marketing Science* 24, no. 3 (1996): 257–262.

81. Shelly Branch, "Maybe Sex Doesn't Sell, A&F Is Discovering," *Wall Street Journal on the Web* (December 12, 2003).

82. Michael S. LaTour and Tony L. Henthorne, "Ethical Judgments of Sexual Appeals in Print Advertising," *Journal of Advertising* 23, no. 3 (September 1994): 81–90.

83. Marc G. Weinberger and Harlan E. Spotts, "Humor in U.S. versus U.K. TV Commercials: A Comparison," *Journal of Advertising* 18, no. 2 (1989): 39–44.

84. Thomas J. Madden, "Humor in Advertising: An Experimental Analysis," Working Paper 83-27, University of Massachusetts (1984); Thomas J. Madden and Marc G. Weinberger, "The Effects of Humor on Attention in Magazine Advertising," *Journal of Advertising* 11, no. 3 (1982): 8–14; Weinberger and Spotts, "Humor in U.S. versus U.K. TV Commercials."

85. David Gardner, "The Distraction Hypothesis in Marketing," *Journal of Advertising Research* 10 (1970): 25–30.

86. Michael L. Ray and William L. Wilkie, "Fear: The Potential of an Appeal Neglected by Marketing," *Journal of Marketing* 34, no. 1 (1970): 54–62.

87. Brian Sternthal and C. Samuel Craig, "Fear Appeals: Revisited and Revised," *Journal of Consumer Research* 1 (December 1974): 22–34.

88. Punam Anand Keller and Lauren Goldberg Block, "Increasing the Effectiveness of Fear Appeals: The Effect of Arousal and Elaboration," *Journal of Consumer Research* 22 (March 1996): 448–459.

89. Barbara Stern, "Medieval Allegory: Roots of Advertising Strategy for the Mass Market," *Journal of Marketing* 52 (July 1988): 84–94.

90. See Linda M. Scott, "The Troupe: Celebrities as Dramatis Personae in Advertisements," in *Advances in Consumer Research* 18, eds. Rebecca H. Holman and Michael R. Solomon (Provo, Utah: Association for Consumer Research, 1991), 355–363; Barbara Stern, "Literary Criticism and Consumer Research: Overview and Illustrative Analysis," *Journal of Consumer Research* 16 (1989): 322–334; Judith Williamson, *Decoding Advertisements* (Boston: Marion Boyars, 1978).

91. John Deighton, Daniel Romer, and Josh McQueen, "Using Drama to Persuade," *Journal of Consumer Research* 16 (December 1989): 335–343.

11

Individual and Household Decision Making

Teresa has a big interview next week and she has nothing appropriate to wear, as she has spent the last four years in college with a wardrobe of jeans, T-shirts, sweatshirts, and the like. She has never purchased a real suit before, but Teresa figures she'll get a good selection and price at the department store downtown. Once in the store she passes menswear, accessories, and fragrances on the first floor and goes directly to the suit department. In minutes she's accosted by a smiling sales associate. Teresa says she's just browsing. She figures

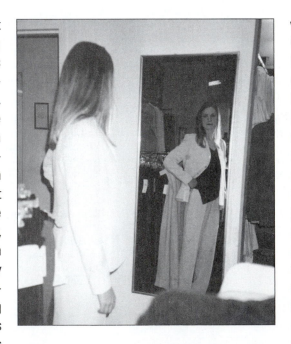

these people will say anything to make a sale and earn their commission. Teresa examines the wool suits. Her friend Carol really likes The Foxy-label suit she bought here last week, and her sister warned her about Casual B suits as they are made in sweatshops in some third-

world country. She sees that Collectibles is made in the United States, is fully lined, fits great, and has a price she can live with, but she chooses the less expensive Zany brand with a feature that is hard to resist: a matching pair of slacks and contrasting scarf, which she figures will help extend her limited professional wardrobe. After purchasing the suit, Teresa passes by the updated sportswear department and sees an outfit that would be perfect for her date this weekend. After all, she is getting a new job soon with a real income and she will

be able to afford such things. She charges both purchases (the suit and the new sportswear outfit) on her Visa card. Later that day, after coming home and trying on her new outfits, she is happy as she begins to see herself as a new professional with a great future.

CONSUMERS AS PROBLEM SOLVERS

Fashion Decision Making

A consumer purchase is a response to a problem, which in Teresa's case is the perceived need for a new suit. This decision took longer than the fashion outfit she bought and was the purpose for her trip to the department store. Her situation is similar to that encountered by consumers virtually every day of their lives. Many apparel decisions, like Teresa's suit decision, are approached rationally taking into account one's evaluative criteria (discussed later) and choosing among viable alternatives. However, much apparel that is considered fashion, such as the new sportswear outfit she treated herself to, does not lend itself to such rational consideration.

Most fashion is not a necessity in our lives. It is discretionary; that is, we can live without it. But it's fun, it's exciting, and it creates novelty and often escapism for many. We become aware of the existence of a fashion item in many ways such as store displays, magazines, or seeing our friends wearing it. If the object catches our interest, we evaluate it as something we might purchase. When Teresa saw the sportswear outfit in the store, she thought it would be perfect for her date that weekend. At this point, she considered evaluative criteria such as price, quality, color, style, fit, and country of origin. Then she might have considered alternatives as she looked at other available options in the marketplace before making a decision. But if the item is so exciting and "perfect," and perhaps time is limited, there may be no search for alternatives. Indeed, much of fashion purchasing verges on impulse buying and on the development of excitement at the point of purchase. The sequence of steps in this fashion decision is different from a major purchase decision that might entail a large amount of risk.

In the case of Teresa's suit purchase, she started her shopping trip with the purpose of buying a suit, and she went through a series of steps before making a purchase. These steps can be described as (1) problem recognition, (2) information search, (3) evaluation of alternatives, and (4) product choice. Of course, after the decision is made, the quality of that decision affects the final step in the process, (5) outcome, when learning occurs based on the good or bad outcome of the choice. Compare the stages in fashion decision making with those in other rational consumer decision making in Figure 11-1. As in the case of Teresa's sportswear fashion purchase, the fashion object, not the recognition of a problem, is at the top of the fashion decision-making model.[1]

This chapter considers various approaches that consumers and families use when faced with a purchase decision. This section focuses on three of the steps in the general decision process: how consumers recognize the problem or need for a product; their search for information about product choices; and the ways in which they evaluate alternatives to arrive at a decision. As seen with Teresa's shopping, not all apparel or fashion decisions are made in a rational or traditional manner; often fashion purchases are purely emotional.

Perspectives on Decision Making

Since some purchase decisions are more important than others, the amount of effort we put into each differs. Traditionally, consumer researchers have

FIGURE 11-1
Stages in Fashion and
Traditional Decision Making

FASHION

1. Fashion Object
(Teresa's sportswear
outfit is prominently
displayed)

2. Awareness of Object
(Teresa sees the outfit)

3. Interest
(She becomes interested
in it and looks at it)

4. Evaluation
(She tries it on and
immediately loves it)

5. Decision
(Teresa buys the outfit)

6. Outcome
(Teresa enjoys her purchase)

TRADITIONAL

1. Problem Recognition
(Teresa realizes she
needs a suit for an
interview)

2. Information Search
(Teresa talks to friends and family)

3. Evaluation of Alternatives
(Teresa compares several styles
and brands in the store in terms
of construction, country of origin,
price, and added features)

4. Product Choice
(Teresa chooses one brand
because it has appealing features)

5. Outcome
(Teresa buys the suit and
enjoys her purchase)

approached decision makers from a **rational perspective**, or traditional decision-making model. In this view, people calmly and carefully integrate as much information as possible with what they already know about a product, painstakingly weigh the pluses and minuses of each alternative, and arrive at a satisfactory decision. This process implies that steps in decision making should be carefully studied by marketing managers to understand how information is obtained, how beliefs are formed, and what product-choice criteria are specified by consumers. Products can then be developed that emphasize appropriate attributes, and promotional strategies can be tailored to deliver the types of information most likely to be desired in the most effective formats.[2]

Although the steps in decision making are followed by consumers for some high-involvement purchases, such a process is not an accurate portrayal of many purchase decisions.[3] Consumers simply do not go through this elaborate sequence for every decision. If they did, their entire lives would be spent making such decisions, leaving them very little time to enjoy the things they eventually decide to buy.

Researchers are now beginning to realize that decision makers actually possess a repertoire of strategies. A consumer evaluates the effort required to make a particular choice, and then he or she chooses a strategy best suited to

the level of effort required. This sequence of events is known as *constructive processing*. Rather than using a big club to kill an ant, consumers tailor their degree of cognitive "effort" to the task at hand.[4]

Some decisions are made under conditions of low involvement, as discussed in Chapter 4. In many of these situations, the consumer's decision is a learned response to environmental cues, as when a person decides to buy something on impulse (more on impulse later) that is promoted as a "surprise special" in a store. A concentration on these types of decisions can be described as the **behavioral influence perspective**. Under these circumstances, managers must concentrate on assessing the characteristics of the environment, such as physical surroundings and product placement, that influence members of a target market.[5] Some fashion decisions are made this way.

In other cases, consumers are highly involved in a decision, but it may not lend itself to the rational approach. For example, the traditional approach is hard-pressed to explain a person's choice of art, music, fashion, or even a spouse. In these cases, no single quality may be the determining factor. Instead, the **experiential perspective** stresses the *Gestalt*, or totality, of the product or service. This may be the case of Teresa's fashion purchase. Marketers in these areas focus on measuring consumers' affective responses to products or services and develop offerings that elicit appropriate subjective reactions.

Types of Consumer Decisions

One helpful way to characterize the decision-making process is to consider the amount of effort that goes into a decision. Consumer researchers have found it convenient to think in terms of a continuum, which is anchored on one end by **routine or habitual decision making** and at the other extreme by **extended problem solving**. Many decisions fall somewhere in the middle and are characterized by **limited problem solving**. This continuum is presented in Figure 11-2.

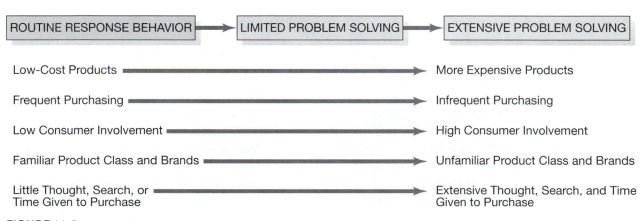

FIGURE 11-2
A Continuum of Buying Decision Behavior

Source: M. R. Solomon, *Consumer Behavior,* 8th ed., p. 326, © 2009. Reprinted by permission of Pearson Education, Inc., Upper Saddle River, NJ.

Extended Problem Solving

Decisions involving extended problem solving correspond most closely to the traditional decision-making perspective. As indicated in Table 11-1, the extended problem-solving process is usually initiated by a motive that is fairly central to the self-concept (see Chapter 5), and the eventual decision is perceived to carry a fair degree of risk. The consumer tries to collect as much information as possible, both from memory (internal search) and from outside sources (external search). Based on the importance of the decision, each product alternative is carefully evaluated. The evaluation is often done by considering the attributes of one brand at a time and seeing how each brand's attributes shape up to some set of desired characteristics.

Limited Problem Solving

Limited problem solving is usually more straightforward and simple. Buyers are not as motivated to search for information or to rigorously evaluate each alternative. People instead use simple *decision rules* to choose among alternatives. These cognitive shortcuts (more about these later) enable them to fall back on general guidelines instead of having to start from scratch every time a decision is to be made.

Habitual Decision Making

Both extended and limited problem solving modes involve some degree of information search and deliberation, varying in the degree to which these activities are undertaken. At the other end of the choice continuum, however, are decisions that are made with little to no conscious effort. Many purchase decisions are so routine that we may not realize we've made them until we look at what we've bought. Choices characterized by *automaticity* are performed with minimal effort and without conscious control.[6] Although this kind of thoughtless activity may seem dangerous or at best stupid, it is actually quite efficient in many cases. The development of habitual, repetitive behavior allows consumers to minimize the time and energy spent on mundane purchase decisions.

Table 11-1 Characteristics of Limited versus Extended Problem Solving

	Limited Problem Solving	Extended Problem Solving
Motivation	Low risk and involvement	High risk and involvement
Information Search	Little search	Extensive search
	Information processed passively	Information processed actively
	In-store decision likely	Multiple sources consulted prior to store visits
Alternative Evaluation	Weakly held beliefs	Strongly held beliefs
	Only most prominent criteria used	Many criteria used
	Alternative perceived as basically similar	Significant differences perceived among alternatives
	Noncompensatory strategy used	Compensatory strategy used
Purchase	Limited shopping time; may prefer self-service	Many outlets shopped if needed
	Choice often influenced by store displays	Communication with store personnel often desirable

Source: M. R. Solomon, *Consumer Behavior,* 8th ed., p. 327, © 2009. Reprinted by permission of Pearson Education, Inc., Upper Saddle River, NJ.

Other Decision-Making Styles

Similar to the limited to extended problem-solving styles, there are other decision-making styles. One study found that the shopping styles of adolescents fall under three types: value-maximizing recreational shopper, brand-maximizing nonutilitarian shopper, and apathetic shopper.[7]

Another study using a specific high-involvement category of apparel found six different decision style profiles.[8] Appealing to each of these groups can be challenging for retailers:

- *Shoppers:* high degree of interest in shopping and shopping trip planning
- *Loyals:* very involved with shopping, product variety, and value
- *Late bloomers:* similar to loyals but with less product involvement; convenience is important
- *Narrowers:* not interested in the shopping process
- *Apathetics:* younger, not willing or able to engage in shopping
- *Avoiders:* most process-averse, little involvement in and little time for shopping

PROBLEM RECOGNITION

Problem recognition occurs whenever the consumer sees a significant difference between his or her current state of affairs and some desired or ideal state. The consumer perceives that there is a problem to be solved, which may be small or large, simple or complex. Teresa was confronted with a need she did not have prior to getting a job interview. She now realizes that her wardrobe of four years is inadequate for her future role as a young professional.

A problem can arise in one of two ways. In the case of the need for a new wardrobe, this can be viewed as *need recognition*. On the other hand, as in the case of a person who craves a flashier or more fashion-forward wardrobe, the consumer's need can be seen as *opportunity recognition*. Either way, a gulf occurs between the actual state and the ideal state.[9] In Teresa's case, a problem was perceived as a result of need recognition; her ideal state in terms of an appropriate wardrobe was altered.

Need recognition can occur in several ways. The quality of the person's actual state can be diminished simply by running out of a product, by buying a product that turns out not to adequately satisfy needs, or by creating new needs. Opportunity recognition often occurs when a consumer is exposed to different or better-quality products. Often fashion items are adopted simply on exposure to them, as discussed earlier. This exposure often occurs because the person's circumstances have somehow changed, as when an individual goes to college or gets a new job. As the person's frame of reference shifts, a variety of purchases are made to adapt to the new environment.

Although problem recognition can and does occur naturally, this process is often spurred by marketing efforts. In some cases, marketers attempt to create *primary demand*, where consumers are encouraged to use a product or service regardless of the brand they choose. Primary demand is often encouraged through trade associations ads, such as the Cotton Incorporated ads

PRODUCTS SOLVING PROBLEMS

A common structure for advertisements has been to present a person who has a physical or social problem and then "miraculously" show how the product will resolve it. Some marketers have gone so far as to *invent* a problem and then offer a remedy for it. In the 1940s, for example, the Talon zipper was touted as a cure for "gaposis," the horrifying condition that develops when puckers appear around the buttons on a woman's shirt. Similarly, Wisk detergent drew our attention to the shame of "ring around the collar."[10]

Even when real problems are depicted in ads, the offered solutions are sometimes overly simplistic, implying that the problem will disappear if the product is used. One analysis of more than a thousand television ads found that about eight in ten suggest that the problem will be resolved within seconds or minutes after using the product. In addition, 75 percent of the ads make definite claims that the product will solve the problem, and over 75 percent imply that this solution is a one-step process—all the consumer needs to do is buy the product, and the problem will go away.[11] Consumers, however, are becoming more cynical and less susceptible to such claims. As many marketers discovered, consumers are more receptive to realistic ads that provide solid information about the product. In addition, both the government and consumer groups are now taking a more active interest in product claims, and marketers are being more cautious about the content of their ads.

with the tagline, "The Fabric of Our Lives," and "The Natural Part of Everyday Life." *Secondary demand*, in which consumers are prompted to prefer a specific brand over others, can occur only if primary demand already exists. At this point, marketers must convince consumers that a problem can best be solved by choosing their brand over others in a category.

INFORMATION SEARCH

Once a problem has been recognized, consumers need adequate information to resolve it. Futurist Alvin Toffler told retailers at a National Retail Federation convention that information is the most precious resource for today's merchants, not their stores or inventories.[12] As consumers demand more information about products they buy, retailers need to make efforts to make more product information readily available to consumers. **Information search** is the process in which the consumer surveys his or her environment for appropriate data to make a reasonable decision. This section will review some of the factors involved in this search.

Types of Search

A consumer may explicitly search the marketplace for specific information after a need has been recognized (a process called *prepurchase search*). On the other hand, many consumers, especially veteran shoppers, enjoy hunting for information and keeping track of developments just for the fun of it (*browsing*) or because they like to stay up-to-date on what's happening in the marketplace. They are engaging in *ongoing search*.[13] This applies to many fashion shoppers who are constantly in the stores updating themselves on current trends.

Internal versus External Search

Information sources can be roughly broken down into two kinds: internal and external. As a result of prior experience and simply living in a consumer culture, each of us has some degree of knowledge already in memory about

many products. When confronted with a purchase decision, we may engage in *internal search* by scanning our own memory banks to assemble information about different product alternatives. Usually, though, even the most market-savvy of us needs to supplement this knowledge with external search, by which information is obtained from advertisements, articles, stores, friends, or just plain people watching.

Deliberate versus "Accidental" Search

Our existing knowledge of a product may be the result of *directed learning*: On a previous occasion we may have already searched for relevant information or experienced some of the alternatives. A shopper who bought a pair of shoes last month, for example, probably has a good idea of the best place to go this month for another pair of shoes if needed.

Alternatively, we may have acquired information in a more passive manner. Even though a product may not be of interest, exposure to advertising, packaging, and sales promotion activities may result in *incidental learning*. Mere exposure over time results in the learning of much material that may not be needed for some time, if ever. For marketers, this result is a benefit of steady, "low-dose" advertising, as product associations are established and maintained until the time they are needed.[14] Levi's 501s, for example, are advertised in *reminder ads* even though we are very familiar with the product.

Of course, Internet search engines (especially Google) are huge players now when it comes to searching. When we search online for product information, we're a perfect target for advertisers because we're declaring our desire to make a purchase. Many companies pay search engines to show ads to users who have searched for their brand names. However, online marketing company DoubleClick found that most prepurchase searches use only generic terms, like "jeans." Then right before buying users conduct a flurry of brand-name queries.[15]

Fashion Information Sources

Since fashion changes so fast, our knowledge quickly becomes outdated. So fashion-conscious consumers use a variety of fashion sources to keep up. Which of the following sources do you use deliberately and which do you think you use incidentally?

- *Impersonal or marketer-dominated sources:* window displays, in-store displays/videos, fashion magazines, fashion catalogs, books, newspaper ads, radio/TV commercials, fashion shows, personal shoppers or wardrobe consultants, mail-order catalogs, sales associates.
- *Personal or consumer-dominated sources:* discussions with female friends, male friends; observing people at social gatherings, public places.
- *Neutral sources:* television performers, movie actresses, fashion columns, prominent people in the news.
- *Objective:* a tremendous amount of product information from many Web sites, much of which is searched before consumers head out to the stores or before clicking to buy. Two of many popular comparison sites are www.shopzilla.com and www.shopping.com.

Studies have found that different types of shoppers use different amounts of these sources. For example, convenience-oriented catalog shoppers and highly involved apparel shoppers are the most frequent users of fashion publications; apathetic apparel shoppers are the least users of all types of information sources. Fashion followers use more consumer-oriented or personal sources such as friends, whereas fashion leaders use more marketer-dominated sources such as the media.[16]

The Economics of Information: How Much Search Really Occurs?

The traditional decision-making perspective incorporates the *economics-of-information approach* to the search process; it assumes that consumers will gather as much data as needed to make an informed decision. Consumers form expectations of the value of additional information and continue to search to the extent that the rewards of doing so (that is, the *utility*) exceed the costs. This utilitarian assumption also implies that the most valuable units of information will be collected first. Additional pieces will be absorbed only to the extent that they are seen as adding to what is already known.[17]

This assumption of rational search is not always supported. The amount of external search for most products is surprisingly small, even when additional information would most likely benefit the consumer. For example, lower-income shoppers, who have more to lose by making a bad purchase, actually search less prior to buying than do more affluent people.[18] Like our friend Teresa, some consumers typically visit only one or two stores and rarely seek out unbiased information sources prior to making a purchase decision, especially when little time is available to do so.[19]

This tendency to avoid external search is less prevalent when consumers consider the purchase of symbolic items, such as clothing. In those cases, not surprisingly, people tend to do a fair amount of external search. Although the stakes may be lower financially, these self-expressive decisions may be seen as having dire social consequences if the wrong choice is made. On the other hand, one study on the use of clothing information (care label, fabric, fit, construction, manufacturer, price, salesperson's opinion, store, and style) found that subjects disregarded approximately half of this available product information before making a decision.[20] Perhaps information overload was operative in this case, and consumers used some information as a signal for other attributes (this will be discussed later in this chapter).

As a general rule, search activity is greater when the purchase is important, when there is a need to learn more about the purchase, and when the relevant information is easily obtained and utilized.[21] Consumers differ in the amount of search they tend to undertake, regardless of the product category in question. All things being equal, younger, better-educated people who enjoy the shopping/fact-finding process tend to conduct more information search.[22] Women are more inclined to search than men, as are those who place greater value on style and the image they present.

Regardless of the amount of search consumers do, they also engage in *brand switching*, even if their current brand satisfies their needs. Sometimes, it seems that people just like to try new things—they are interested in *variety seeking*. This is especially true of fashion innovators: One study found that

cathy® **by Cathy Guisewite**

Some men put less effort into search than do women.

fashion innovators had a greater need for variety (as measured by a sensation-seeking scale) than fashion followers.[23] The tendency of consumers to shift brand choices over time means that marketers can never rest assured that once they have won a customer, he or she is necessarily theirs forever.[24] This is especially prevalent in the fashion industry, where new designers and small manufacturers continually enter the market.

The Consumer's Prior Expertise

Should prior product knowledge make it more or less likely that consumers will engage in search? Product experts and novices use very different procedures during decision making. Novices who know little about a product should be the most motivated to find out more about it. However, experts are more familiar with the product category, so they should be able to better understand the meaning of any new product information they might acquire.

So, who searches more? The answer is neither: Search tends to be greatest among consumers who are *moderately* knowledgeable about the product. There is an inverted-U relationship between knowledge and external search effort, as shown in Figure 11-3. People with very limited expertise may not feel they are capable of searching extensively. In fact, they may not even know where to start. Teresa, who did not spend a lot of time researching her purchase, represents this situation. She visited one store and looked only at brands with which she was already familiar. In addition, she focused on only a small number of product features.[25]

The type of search undertaken by people with varying levels of expertise differs, as well as the amount. Because experts have a better sense of what information is relevant to the decision, they tend to engage in *selective search*, which means their efforts are more focused and efficient. In contrast, novices are more likely to rely on the opinions of others and to rely on "nonfunctional" attributes, such as brand name and price, to distinguish among alternatives.

FIGURE 11-3
The Relationship between
Amount of Information Search
and Product Knowledge
Source: M. R. Solomon, *Consumer Behavior,*
8th ed., p. 334, © 2009. Reprinted by permis-
sion of Pearson Education, Inc., Upper
Saddle River, NJ.

Perceived Risk

As a rule, purchase decisions that entail some kind of **perceived risk**, or the belief that the product has potentially negative consequences, involve extensive search. Perceived risk may be present if the product is expensive or complex. Also, if the product is visible to others, such as fashion, we can run the risk of embarrassment if we make the wrong choice.

Figure 11-4 lists five basic kinds of risk—including both objective (such as physical danger) and subjective factors (such as social embarrassment) as well as the products subject to each type. Clothing generally does not entail *physical risk* that other products, such as a motorcycle, might; however, the flammability factor should be considered. We take for granted that apparel is not dangerous; however, sometimes it is! It is illegal to sell "highly flammable" apparel in the United States, but from time to time apparel is found to be flammable and is recalled by the Consumer Product Safety Commission. See Chapter 15 for discussion on this topic.

Monetary risk may be a factor in some consumer purchases. Paying a high price for a fashion item that turns out to be a fad and is "acceptable" for only a short time may turn out to be quite a financial loss. Researchers have studied perceived risk related to apparel using word pairs to describe and measure the types of risk associated with dress style. The terms "luxury" and "necessity" were found to be related to performance or practicality in dress with an implied value judgment (wise or foolish), while "inexpensive" and "costly" refer mainly to monetary risk.[26] Monetary risk also is felt by apparel catalog and Web site shopping[27], perhaps since customers don't have the opportunity to try on the clothes before purchase and they fear that their orders may not be satisfactory.

Much of the perceived risk involved with fashion, however, relates to *social risk* or *psychological risk*. As Figure 11-4 implies, consumers with greater "risk capital" are less affected by perceived risks associated with the products. For example, a highly self-confident person would be less worried about the social risk inherent in a product, while a more vulnerable, insecure consumer might be reluctant to take a chance on a product that is new, such as a very fashion-forward item. However, one study found that fashions at different stages (introductory, current, outdated) differed in social and psychological risk with new styles seen as intermediate risk, current styles as low risk, and outdated styles as the highest in risk.[28] It appears there is nothing worse than being "out of it."

	BUYERS MOST SENSITIVE TO RISK	PURCHASES MOST SUBJECT TO RISK
MONETARY RISK	Risk capital consists of money and property. Those with relatively little income and wealth are most vulnerable.	High-ticket items that require substantial expenditures are most vulnerable.
FUNCTIONAL RISK	Risk capital consists of alternative means of performing the function or meeting the need. Practical consumers are most sensitive.	Products or services whose purchase and use require the buyer's exclusive commitment are most sensitive.
PHYSICAL RISK	Risk capital consists of physical vigor, health, and vitality. Those who are elderly, frail, or in ill health are most vulnerable.	Mechanical or electrical goods (such as vehicles or flammables), drugs and medical treatment, and food and beverages are most sensitive.
SOCIAL RISK	Risk capital consists of self-esteem and self-confidence. Those who are insecure and uncertain are most sensitive.	Socially visible or symbolic goods, such as clothes, jewelry, cars, homes, or sports equipment are most vulnerable.
PSYCHO-LOGICAL RISK	Risk capital consists of affiliations and status. Those lacking self-respect or attractiveness to peers are most sensitive.	Expensive personal luxuries that may engender guilt; durables; and services whose use demands self-discipline or sacrifice are most sensitive.

FIGURE 11-4
Five Types of Perceived Risk

Source: M. R. Solomon, *Consumer Behavior,* 8th ed., p. 336, © 2009. Reprinted by permission of Pearson Education, Inc., Upper Saddle River, NJ.

Cybermediaries

As anyone who has ever typed a phrase into a search engine like Google knows, the Web delivers enormous amounts of product and retailer information in seconds. In fact, the biggest problem Web surfers face these days is narrowing down their choices, not beefing them up. In cyberspace, simplification is key. With the tremendous number of Web sites available and the huge number of people surfing the Web each day, how can people organize information and decide where to click? One type of service that is growing to meet this demand is called a **cybermediary**. This intermediary helps to filter and organize online market information so that customers can identify and evaluate alternatives more efficiently.[29] Sites for comparison shopping include www.shopping.com, www.bizrate.com, www.mysimon.com, www.nextag.com, www.pricegrabber.com, and www.pricescan.com.[30] And if you want an item that you just saw on your favorite celebrity, sites such as www.like.com will give you similar selections just by clicking on it.

Cybermediaries take different forms:[31]

- *Directories* and *portals* such as Yahoo! or www.fashionmall.com are general services that tie together a large variety of different sites.

- *Web site evaluators* reduce the risk to consumers by reviewing sites and recommending the best ones. For example, Point Communications selects sites that it designates as Top 5 percent of the Web.
- *Forums, fan clubs,* and *user groups* offer product-related discussions to help customers sift through options. Other sites such as www.about. com help to narrow alternatives by actually connecting you with human guides who make recommendations.

IDENTIFYING ALTERNATIVES

Much of the effort that goes into a purchase decision occurs at the stage where a choice must be made from the available alternatives. After all, modern consumer society abounds with choices, as just discussed with Internet searching. In some cases, there may literally be hundreds of different brands (as in apparel) or different variations of the same brand (as in shades of lipstick), each screaming for our attention. The author of the book *The Paradox of Choice: Why Less Is More* thinks that too much choice often results in consumers buying less and being less satisfied. His suggestion to retailers is to edit down the choices for their target customers.[32]

How do we decide what criteria are important, and how do we narrow down product alternatives to an acceptable number and eventually choose one over the others? The answer varies depending on the decision-making process used. A consumer engaged in extended problem solving may carefully evaluate several brands, while someone making a habitual decision may not consider any alternatives to his or her normal brand.

The alternatives actively considered during a consumer's choice process are his or her **evoked set**. The evoked set is composed of those products already in memory (the retrieval set), plus those prominent in the retail environment. For example, recall that Teresa did not know much about tailored suits, and she had only four major brands in memory: Collectibles, Foxy, Zany, and Casual B. Of these, three were acceptable possibilities and one was not. The alternatives that the consumer is aware of but would not consider buying are his or her **inept set**, while those not entering the game at all are the **inert set**. These categories are depicted in Figure 11-5.

Consumers often consider a surprisingly small number of alternatives in their evoked set. For obvious reasons, a marketer who finds that his or her brand is not in the evoked set of many consumers in the target market has cause to worry. A new brand is more likely to be added to the evoked set than is an existing brand that was previously considered but passed over, even after additional positive information has been provided for that brand.[33] An apparel study found that at this alternative evaluation stage in the decision making process, product image affects perceived quality and performance expectations.[34] For marketers, this underscores the importance of ensuring that a product performs well and is presented well from the time it is introduced.

Product Categorization

Product categorization has many strategic implications. A product's location in a store and the way it is grouped with other similar products have very

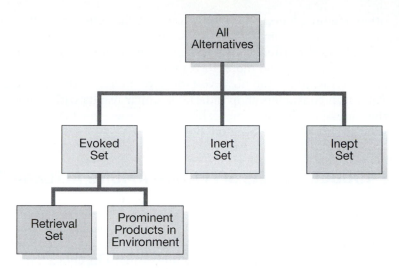

FIGURE 11-5
Identifying Alternatives:
Getting in the Game
Source: M. R. Solomon, *Consumer Behavior,*
5th ed., p. 268, © 2002. Reprinted by permis-
sion of Pearson Education, Inc., Upper
Saddle River, NJ.

important ramifications for determining both the competitors that con-
sumers consider and what criteria will be used to make a choice. In fashion
stores, if Candies and Rampage are not merchandised in the junior's depart-
ment, customers may not find them. If products do not clearly fit into cate-
gories (for example, is a tennis dress a dress; is a rug furniture?), consumers'
ability to find them or make sense of them may be affected. Do consumers
accept buying clothing at a grocery store? We see pantyhose selling well,
since it is a convenience item that isn't tried on, but normally we don't think
about buying clothing at a grocery store.

Exemplar Products

If a product is a really good example of a category, it is more familiar to con-
sumers and as a result is more easily recognized and recalled, for example,
Burberry raincoats.[35] Judgments about category attributes tend to be dispropor-
tionately influenced by the characteristics of category exemplars.[36] In a sense,
brands that are strongly associated with a category get to "call the shots" by defin-
ing the evaluative criteria that should be used to evaluate all category members.

Being a bit less than prototypical is not necessarily a bad thing. Products
that are moderately unusual within their product category may stimulate
more information processing and positive evaluations, since they are neither
so familiar that they will be taken for granted nor so discrepant that they will
be dismissed.[37] A brand that is strongly discrepant may occupy a unique
niche position, while those that are moderately discrepant remain in a dis-
tinct position within the general category.[38]

Identifying Competitors

At an abstract level, many different product forms compete. Both a fashion
show at the mall and the ballet may be considered as subcategories of "enter-
tainment" by some people, but many would not necessarily consider the
substitution of one of these activities for the other. Products and services,
however, that on the surface are quite different actually compete with each

other at a broad level, often for consumers' discretionary dollars. The results of a recent Kurt Salmon Associates study of one thousand men and women exemplifies this: More consumers are planning to spend less on apparel than are planning to spend more. Instead, they plan to spend more on eating out and on vacations and to invest or save more.[39] Another study on how American consumers shop indicated similar results with women indicating they are spending less on fashion accessories, cosmetics, fragrances, fine jewelry and watches and more on food.[40]

PRODUCT CHOICE: SELECTING AMONG ALTERNATIVES

Once the relevant options from a category have been assembled, a choice must be made among them.[41] Decision rules that guide our choices can range from very simple and quick strategies to complicated processes requiring a lot of attention and cognitive processing. The choice can be influenced by integrating information from such sources as prior experience with the product, information present at the time of purchase, and beliefs about the brands that have been created by advertising.[42]

Evaluative Criteria

When Teresa was looking at different wool suits, recall that she focused on one or two product features and completely ignored several others. She narrowed down her choices by considering only three specific brand names, and from the Collectibles, Foxy, and Zany brands she chose one that featured the value-added feature of coordinating slacks and scarf.

Evaluative criteria are the dimensions used to judge the merits of competing options. In comparing alternative products, Teresa could have chosen from among any number of criteria, ranging from very functional attributes (does it have pockets?) to purely fashion considerations (is it designed by a hot new designer?). The specific evaluative criteria used often vary among people and also across cultures, but not always. Some criteria may be universal. One study of Taiwanese and U.S. consumers found very little difference and both groups identified size/fit as the most important criteria when buying clothes.[43]

Another important point is that criteria on which products *differ* from one another carry more weight in the decision process than do those where the alternatives are *similar*. If all brands being considered rate equally well on one attribute (for example, if all suits had pockets), consumers will have to find other reasons to choose one over another. The attributes actually used to differentiate among choices are called **determinant attributes**. Marketers can play a role in educating consumers about which criteria should be used as determinant attributes. For example, research has indicated that many consumers view the concept of "natural" as a determinant attribute.[44] In apparel, natural fibers such as cotton, wool, and silk are often seen as better quality than synthetic fibers.

Evaluative Criteria Used in Apparel/Fashion Decisions

Many studies have looked at criteria that consumers use when making apparel and fashion decisions. Some have viewed criteria in terms of *extrinsic*

factors (such as price, brand name, and store image) and *intrinsic factors* (such as comfort, style, color, fabric, care, fit, and quality). Others studies have developed different typologies. The following fashion criteria used by consumers have been researched:[45]

1. *Appropriateness/personal style:* suitability to individual, good fit, appropriate for occasion, comfort, fabric type and quality, wardrobe coordination, suits my personality
2. *Economy/usefulness:* price, good buy, ease of care, durability, versatility, matching, utility
3. *Attractiveness/aesthetics:* beautiful, fashionable, color/pattern, styling, good fit, pleasing to others
4. *Quality:* quality of construction, fabric type, fiber, durability
5. *Other-people-directed/image:* prestige, sexy, brand and store name, label, fashionable
6. *Country of origin:* Made in United States or imported
7. *Fiber/fabric:* natural or synthetic; knits or wovens

Although there are some cross-cultural differences as to the importance of evaluative criteria used in clothing decisions, generally there has been little substantive difference found with fit, style, quality, and price having top priority and brand and country of origin being less important.[46]

Decision Rules

Consumers consider sets of product attributes by using different rules, depending on the complexity and importance of the decision. In some cases these rules are quite simple: *if* (an attribute is important), *then* (choose this product). One way to differentiate among decision rules is to divide them into those that are *compensatory* and those that are *noncompensatory*. To aid the discussion of some of these rules, the attributes of wool suits considered by Teresa are summarized in Table 11-2.

Noncompensatory Decision Rules

Simple decision rules are **noncompensatory rules**, and a product with a low standing on one attribute cannot make up for this position by being better on another attribute. In other words, people simply eliminate all options that

Table 11-2 Hypothetical Alternatives for a Suit

Attribute	Importance Ranking	Brand		
		Collectibles	Foxy	Zany
Professional looking	1	Excellent	Excellent	Excellent
Value-added features	2	Poor	Good	Excellent
Lined/good construction	3	Excellent	Poor	Poor
Made in United States	4	Excellent	Excellent	Good

do not meet some basic standards. A consumer like Teresa who uses the decision rule "Only buy well-known brand names" would not consider a new brand, even if it is equal or superior to existing ones. When people are less familiar with a product category or not very motivated to process complex information, they tend to use simple, noncompensatory rules.[47]

Normally, the brand that is the best on the most important attribute is selected. However, if two or more brands are seen as being equally good on that attribute (for Teresa, the attribute was "professional looking"), the consumer then compares them on the second most important attribute. This selection process goes on until the tie is broken. Teresa chose Zany because of its rating on the second most important attribute—value-added features. In some case, though, specific cutoffs are imposed. For example, if Teresa had been more interested in having a lining in her suit (that is, if it had a higher importance ranking), she might have stipulated that her choice "must have a lining." Since Collectibles had one, and Foxy and Zany did not, the Collectibles would have been chosen.

Compensatory Decision Rules

Unlike noncompensatory decision rules, **compensatory rules** give a product a chance to make up for its shortcomings. Consumers who employ these rules tend to be more involved in the purchase and thus are willing to exert the effort to consider the entire picture in a more exacting way. The willingness to let good and bad product qualities balance out can result in quite different choices. For example, if Teresa were not concerned about having the value-added features, she might have chosen Collectibles. But because this brand did not feature this highly ranked attribute, it doesn't stand a chance when she uses a noncompensatory rule. With the compensatory decision rule, Collectibles would have been chosen.

Heuristics: Mental Shortcuts

Do we actually perform complex mental calculations every time we make a purchase decision? Get a life! To simplify decisions, consumers often employ decision rules that allow them to use some dimensions as substitutes for others. Especially when limited problem solving occurs prior to making a choice, consumers often fall back on **heuristics**, or mental rules of thumb that lead to a speedy decision. These rules are used with both fashion decisions and other general consumer product decisions. They range from the very general ("Higher-priced products are higher-quality products" or "Buy the same brand I bought last time") to the very specific ("Buy Jockey, the brand of underwear my mother always bought").[48] Teresa relied on certain assumptions as substitutes for prolonged information search. Sometimes these shortcuts may not be in consumers' best interests.

Relying on a Product Signal

One frequently used shortcut is the tendency to infer hidden dimensions of products from observable attributes, discussed as "object perception" in Chapter 9. The aspect of the product that is visible acts as a *signal* of some underlying quality. When product information is incomplete, judgments

are often derived from beliefs about *covariation*, or associations among events.[49] For example, a consumer may form an association between product quality and the length of time a manufacturer has been in business.

Unfortunately, consumers tend to be poor estimators of covariation. Their beliefs persist despite evidence to the contrary. Similar to the consistency principle discussed in Chapter 8, people tend to see what they are looking for. They will look for product information that confirms their guesses, thus creating a sort of self-fulfilling prophecy.

Market Beliefs as Heuristics

Consumers often form assumptions about companies, products, and stores. These beliefs then become the shortcuts that guide their decisions—whether or not they are accurate.[50] Our friend Teresa's decisions were influenced by her **market beliefs**. Recall, for instance, that she chose to shop at a large department store because she assumed the selection would be better. A large number of market beliefs have been identified. Some of these are listed in Table 11-3. How many do you share?

Price as a Heuristic

Do higher prices mean higher quality? The assumption of a *price–quality relationship* is one of the most pervasive market beliefs.[51] Novice consumers may in fact consider price the only relevant product attribute. For the most part, this belief is justified. You do tend to get what you pay for; a Cotton Incorporated study found 68 percent of consumers agree.[52] Several apparel studies have found this relationship.[53] However, let the buyer beware: The price-quality relationship is not always justified.[54] Often designer names carry high price tags, and not always high quality. On the other hand, designers and manufacturers can offer similar merchandise at lower prices through their outlets than at department stores.[55] Apparel quality is a complex concept. One study found fabric to be the underlying determinant of apparel quality by consumers.[56] Another study found that perceived apparel quality before and after purchase changed;[57] this could make it rather difficult for manufacturers to anticipate consumer needs.

The term *value* is often used when referring to the price–quality relationship. We generally expect low quality for a low price and high quality for a high price. On the other hand, high-quality items offered at a low price are thought of as an excellent value or a "bargain," while low-quality goods with a high price tag are thought of as a poor value or "overpriced." See Figure 11-6.

Brand Names as a Heuristic

Branding is a marketing strategy that often functions as a heuristic. People form preferences for a favorite brand and then may literally never change their minds in the course of a lifetime. A brand that exhibits that kind of staying power is treasured by marketers, and for good reason. Brands that dominate their markets are as much as 50 percent more profitable than their nearest competitors.[58]

A *Women's Wear Daily*–commissioned study found that jeans and casual clothes is the category where a brand name is the most important, with suits/dresses a close second.[59] But the importance of knowing the designer

Table 11-3 Common Market Beliefs

Brand	All brands are basically the same. Generic products are just name brands sold under a different label at a lower price. The best brands are the ones that are purchased the most. When in doubt, a national brand is always a safe bet.
Store	Specialty stores are great places to familiarize yourself with the best brands, but once you figure out what you want, it's cheaper to buy it at a discount outlet. A store's character is reflected in its window displays. Salespeople in specialty stores are more knowledgable than other sales personnel. Larger stores offer better prices than small stores. Locally owned stores give the best service. A store that offers a good value on one of its products probably offers good values on all of its items. Credit and return policies are most lenient at large department stores. Stores that have just opened usually charge attractive prices.
Prices/Discounts/Sales	Sales are typically run to get rid of slow-moving merchandise. Stores that are constantly having sales don't really save you money. Within a given store, higher prices generally indicate higher quality.
Advertising and Sales Promotion	"Hard-sell" advertising is associated with low-quality products. Items tied to "giveaways" are not a good value (even with the freebie). Coupons represent real savings for customers because they are not offered by the store. When you buy heavily advertised products, you are paying for the label, not for higher quality.
Product/Packaging	Largest-sized containers are almost always cheaper per unit than smaller sizes. New products are more expensive when they're first introduced; prices tend to settle down as time goes by. When you are not sure what you need in a product, it's a good idea to invest in the extra features, because you'll probably wish you had them later. In general, synthetic goods are lower in quality than goods made of natural materials. It's advisable to stay away from products when they are new to the market; it usually takes the manufacturer a little time to work the bugs out.

Source: Adapted from Calvin P. Duncan, "Consumer Market Beliefs: A Review of the Literature and an Agenda for Future Research," in *Advances in Consumer Research*, eds. Marvin E. Golberg, Gerald Gorn, and Richard W. Pollay, 17 (Provo, Utah: Association for 1990): 729–735.

or manufacturer of an apparel item continues to rank lower than fiber content and even care instructions.[60]

Some people tend to buy the same brand all the time. This consistent pattern is often due to **inertia**, where a brand is bought out of habit merely because less effort is required. If another product comes along that is cheaper or for some reason easier to buy (for example, the original product

FIGURE 11-6
Price/Quality Relationship

Source: Adapted from Nancy J. Rabolt and Judy K. Miler, *Concepts and Cases in Retail and Merchandise Management* (New York: Fairchild, 1997).

is out of stock), the consumer will not hesitate to do so. A competitor who is trying to change a buying pattern based on inertia often can do so rather easily with such promotional tools as point-of-purchase displays or noticeable price reductions. This kind of fickleness will not occur if true **brand loyalty** exists. In contrast to inertia, brand loyalty is a form of repeat purchasing behavior reflecting a conscious decision to continue buying the same brand.

Marketers increasingly are struggling with the problem of **brand parity,** which refers to consumers' beliefs that there are no significant differences among brands. Some analysts even proclaimed that brand names are dead, killed off by private-label or generic products that offer the same value for less money. However, the reports of this death appear to be premature—many major brands are making a comeback. This renaissance may be attributed to information overload—with too many alternatives (many of them unfamiliar names) to choose from, people are looking for a few clear signals of quality.

However, this can vary across product categories. Apparel brand loyalty is reported to have declined recently as measured in a Kurt Salmon Associates survey.[61] Commodity products such as underwear and jeans inspire the highest brand loyalty in apparel. That may be since these companies have more stability than fashion companies. This erosion of brand loyalty may be due to an increase in the volume of promotions. Also, there is too much competition and too many stores (in addition to the increasing number of Internet sites) selling fashion and apparel. This situation leads to smarter consumer selection, deflated prices, and less loyalty.

Country of Origin as a Heuristic

Modern consumers choose among products made in many countries. Americans may buy Brazilian shoes, Japanese cars, clothing imported from Vietnam, or microwave ovens built in South Korea. Consumers' reactions to

these imports are mixed. In some cases, people have come to assume that a product made overseas is of better quality (cars or apparel from Europe), while in other cases the knowledge that a product has been imported tends to lower perceptions of product quality[62] (apparel from third-world countries). In general, people tend to rate products from industrialized countries better than those from developing countries. A study on the quality of imported apparel from eighteen countries found that only France, Italy, and the United States received favorable ratings, while third-world (for example, India and Thailand) and newly industrialized countries (for example, Hong Kong, Taiwan, South Korea) received mostly neutral ratings.[63] Other studies have shown that there is no apparent relationship between perception of quality and country of origin of apparel.[64]

Generally research has shown that American consumers do not care about where their clothing is made, and that price, color, quality, and style or fashion, among other evaluative criteria, are more important.[65] In some instances, demographic characteristics of the consumer affect the evaluation of products from different countries and the importance of country of origin. For example, those with lower education have rated imports from low-wage countries higher than have those with more education;[66] older consumers seem to care about country of origin more than do younger consumers.[67] A recent International Associated Press/lpsos-Public Affairs survey indicated that 76 percent of U.S. respondents would rather buy an American product—assuming the quality and price were the same as imports. However, most felt U.S. goods were not bargains and over a third felt they were more expensive.[68] Studies have shown mixed results, but in many cases it appears that American consumers are unaware of the country of origin of their apparel purchases.

Learning of a product's country of origin can have the effect of stimulating the consumer's interest in the product to a greater degree. The purchaser thinks more extensively about the product and evaluates it more carefully.[69] Recently more and more consumers have become aware of labor conditions involved with the production of clothing both in the United States and in third-world countries. Many have consciously decided not to buy clothing from China and certain third-world countries, for example, due to work conditions there considered inappropriate by Western standards, and often illegal in the United States. (See Chapter 14.)

As we have discussed, there are often individual personality differences in how people evaluate products and services. One such difference is **ethnocentrism**, which is the tendency to prefer products or people of one's own culture over those from other countries. One study found that a U.S. sample preferred U.S.-made apparel over that produced in other countries, primarily because they felt imported apparel was of lower quality.[70] Similarly, another study found ethnocentric attitudes with a Japanese sample preferring Japanese-made over American-made apparel and an American sample preferring American-made over Japanese-made apparel.[71] Consumers may feel it is wrong to buy products from other countries, because of the negative effect this may have on the domestic economy. Marketing campaigns, such as "Crafted with Pride in the U.S.A.," stressing the desirability of "buying American" are more likely to appeal to this consumer segment. The trait of ethnocentrism has been measured on the

Consumer Ethnocentrism Scale (CETSCALE) that was devised for this purpose. The scale identifies ethnocentric consumers by their extent of agreement with such statements as the following:

- Purchasing foreign-made products is un-American.
- Curbs should be put on all imports.
- American consumers who purchase products made in other countries are responsible for putting their fellow Americans out of work.[72]

THE FAMILY AS A DECISION-MAKING UNIT

The preceding section focused on individual decision making; however, for many in today's society the family is the unit making decisions. Although it is true that the proportion of people living in a traditional family structure consisting of a married couple with children living at home continues to decline, many other types of families are growing rapidly. Indeed, some experts have argued that as traditional family living arrangements have waned, people are placing even greater emphasis on siblings, close friends, and other relatives in providing companionship and social support.[73]

Defining the Modern Family

The **extended family** was once the most common family unit. It consisted of three generations living together and often included not only the grandparents but also aunts, uncles, and cousins. As evidenced by the Cleavers of *Leave It to Beaver* and other television families of the 1950s, the **nuclear family**—a mother and a father and one or more children (perhaps with a sheepdog thrown in for good measure)—became the model American family unit over time. However, many changes have occurred; demographic data show that this ideal image of the family is no longer a realistic picture.

Just What Is a Household?

When it conducts the national census every ten years, the U.S. Census Bureau regards any occupied housing unit as a **household**, regardless of the relationships among people living there. A **family household**, as defined by the Census Bureau, contains at least two people who are related by blood or marriage. The Census Bureau and other survey firms compile a massive amount of data on family households, but certain categories are of particular interest to marketers.

Age of the Family

People are waiting longer to get married: According to the U.S. Census Bureau, the average age of marriage is now 24 for women and 26 for men. This trend has implications for businesses ranging from wedding dresses to catering. For example, since couples tend to be married later and many already have acquired basic household items, the trend is toward giving nontraditional items like home electronics and PCs as wedding gifts.[74] Retailers such as Target and Home Depot now offer bridal registry service for practical gifts.

Family Size

Worldwide, surveys show that almost all women want smaller families than they did a decade ago. In 1960, the average American household contained 3.3 people, but that number is projected to decline to about 2.5 people by the year 2010.[75]

Family size is dependent on such factors as educational level, the availability of birth control, and religion.[76] The **fertility rate** is determined by the number of births per year per one thousand women of childbearing age. The U.S. fertility rate increased dramatically in the late 1950s and early 1960s, the period of the so-called baby boomers. It declined in the 1970s and began to climb again in the 1980s as baby boomers began to have their own children in a "baby boomlet" as discussed in Chapter 6.

This boomlet has led many apparel companies to develop children's lines and stores, such as The Children's Place, babyGap, GapKids, and Limited Too. Infant wear and other items for toddlers have become big business. Dual-career couples are waiting longer to have kids and thus are able to spend more on them. As a result, children's designer clothing is booming—Versace sells a $250 black motorcycle jacket for that junior James Dean, and Nicole Miller offers a $150 cocktail dress for that petite *femme fatale*.[77] Infants are not being left out: Ralph Lauren sells a cashmere receiving blanket for $350 and Nike is marketing a line of toddler athletic wear.[78] Pottery Barn has even started Pottery Barn Kids to show new parents (with discretionary income) how to furnish their kids' rooms.

Who's Living at Home?

Although traditional families are shrinking, ironically in other cases the traditional extended family is very much a reality. Many adults are being forced to care for parents as well as children. In fact, Americans on average spend seventeen years caring for children, but eighteen years assisting aged parents.[79] Middle-aged people have been termed "*the sandwich generation*," because they must attend to those above and below them in age.

In addition to dealing with live-in parents, many adults are surprised to find that their children are living with them longer or are moving back in, well after their "lease" has expired.[80] These returnees have been termed **boomerang kids** by demographers (they keep coming back!). The number of children between 18 and 34 living at home is growing dramatically, and today more than one-fifth of 25-year-old Americans still live with their parents. If this trend continues, it will affect a variety of markets as boomerang kids spend less on housing and staples and more on discretionary purchases such as fashion and entertainment.

Nontraditional Family Structures

As noted earlier, the U.S. Census Bureau regards any occupied housing unit as a household, regardless of the relationships among people living there. Thus, persons living alone, three roommates, or two lovers (whether straight or gay) constitute households. Indeed, same-sex households are increasingly common and as a result more marketers are targeting them as a family unit. The Web sites www.gayweddings.com and www.twobrides.com offer wedding decorations and gifts. Conventional companies that make products like baby food

WOMEN JUGGLING LIFESTYLES

Many women who work outside the home are victims of what has been termed the "juggling lifestyle," a frenzied, guilt-ridden compromise between conflicting cultural ideals of motherhood and professionalism.[85] Some marketers are picking up on one response to this conflict—they are beginning to target what they are calling "work-pausals," or women who are taking time off from careers to stay home with their children. As one advertising executive observed, "Women have stopped apologizing for stay-ing home. Now it's a badge." Advertisers are seeking neutral territory when they design their messages, trying to avoid traditional home settings or office settings so their campaigns can be targeted both to women who work inside and outside of the home. For example, a Levi's Jeans for Women commercial depicts an animated figure trading in her dress for jeans and breaking out of the "prison" that held her.[86]

and children's clothing are even starting to advertise in *And Baby*, a gay parenting magazine.[81] Many people share a living arrangement the government calls *POSSLQ*, which stands for Persons of Opposite Sex Sharing Living Quarters. This situation is increasingly common. Nearly half of Americans aged 25 to 40 have at some point lived with a person of the opposite sex.[82] These changes are part of a broader shift toward nonfamily and childless households.

Families consisting of breadwinner dads and stay-at-home moms now account for just one-tenth of all households. The U.S. Census Bureau reports that married couples with kids, which made up nearly every residence a century ago, now total just 25 percent, with the number projected to drop to 20 percent by 2010. By then, nearly 30 percent of homes will be inhabited by someone who lives alone. Manhattan is the "singles capital," with 48 percent of households occupied by singles. Perhaps privacy is valued when surrounded by so many people all day.[83] A large number of these singles appear to have two things in common: financial success and the willingness to spend to satisfy their desires,[84] something that bodes well for the fashion industry targeting this population.

Animals Are People Too! Nonhuman Family Members

Consumers often treat companion animals as family members. Many people assume pets share our emotions—perhaps that helps to explain why more than three-quarters of domestic cats and dogs receive presents on holidays and birthdays.[87] More than half of all U.S. households (62 percent) have at least one pet—92 percent of pet owners consider their furry friends to be members of the family—and 83 percent call themselves "Mommy" or "Daddy" when talking to their animals.[88]

Spending on pets has doubled in the last decade, and today the pet industry pulls in more revenue than either the toy or candy industries. Here are some recent examples of pet-smart marketing strategies:

- Many Web sites such as www.doggiedesigner.com and www.pet-shop.net give sophisticated owners lots of choices.
- Companies traditionally known for human products, such as Gucci, Burberry, Juicy Couture, Harley-Davidson, IKEA, Lands' End, Paul Mitchell, and Ralph Lauren, have begun selling products for pets—from shampoos to nail polish to gold-plated bowls. Customers can buy denim and leather jackets for their pets, as well as riding goggles, bandanas,

Pets are important family members that even dress up for Halloween.

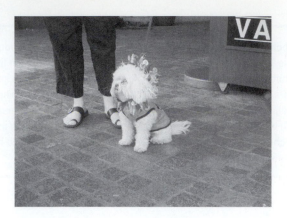

spiked leather collars, and even squeaky toys shaped like oil cans.[89] And how about Ralph Lauren's $18,000 crocodile-clad dog carrier?[90]

• The Los Angeles Kennel Club pampers pets in a theme-decorated cottage with a bed, a TV, and a VCR stocked with doggie videos. Exercise classes and massage are also available. And what should the well-turned-out pet wear to the kennel? At the Petigree shop operated by Macy's department store you can buy pink satin party dresses and black dinner jackets for the proper pooch.

The Family Life Cycle

A family's needs and expenditures are affected by factors such as the number of people (children and adults) in the family; their ages; and whether one, two, or more adults are employed outside of the home. Recognizing that family needs and expenditures change over time, marketers apply the **family life cycle (FLC)** concept to segment households. The FLC combines trends in income and family composition with the changes in demands placed upon this income. As we age, our preferences for products and activities tend to change.

A life-cycle approach to the study of the family assumes that pivotal events trigger new stages of life. These events include couples who move in together, marriage, the birth of a first child, the departure of the last child from the house, the death of a spouse, retirement of the principal wage earner, and divorce.[91] Movement through these life stages is indeed accompanied by significant changes in expenditures in leisure, food, clothing, durables, and services, even after the figures have been adjusted to reflect changes in income.[92]

Researchers divide consumers into groups based on age, adults present, and children in the home. For example, a distinction is made between the consumption needs of people in the Full Nest I category (where the youngest child is less than six), the Full Nest II category (where the youngest child is older than six), the Full Nest III category (where the youngest child is older than six and the parents are middle-aged), and the Delayed Full Nest (where the parents are middle-aged but the youngest child is younger than six).

As might be expected, consumers classified into these categories show marked differences in consumption patterns. Young bachelors and newlyweds

are the most likely to engage in exercise; to go dancing and out to clubs, concerts, movies, and restaurants; and to buy more fashion apparel. Young professionals without children spend more on professional wardrobes. Families with young children are likely to spend more on shoes as they grow fast, whereas those made up of single parents and older children buy more fashion apparel. Recently divorced individuals have been known to leave behind their old wardrobe and buy a completely new one for their new life.

FAMILY DECISION MAKING

The decision process within a household unit in some ways resembles a business conference. Certain matters are put on the table for discussion, different members may have different priorities and agendas, and there may be power struggles to rival any tale of corporate intrigue.

Household Decisions

Two basic types of decisions are made by families.[93] In a **consensual purchase decision**, members agree on the desired purchase, differing only in terms of how it will be achieved. In these circumstances, the family will most likely engage in problem solving and consider alternatives until the means for satisfying the group's goal is found.

Unfortunately, life is not always so easy. In an **accommodative purchase decision**, group members have different preferences or priorities and cannot agree on a purchase that will satisfy the minimum expectations of all involved. It is here that bargaining, coercion, compromise, and the wielding of power are all likely to be used to achieve agreement on what to buy or who gets to use it. Family decisions often are characterized by an accommodative rather than a consensual decision.

Conflict occurs when there is not complete correspondence in family members' needs and preferences. Although money is the most common source of conflict between marriage partners, television choices come in a close second![94] Some specific factors determining the degree of family decision conflict include the following:[95]

- *Interpersonal need* (a person's level of investment in the group). A teenager may care more about what his or her family buys for the house than will a college student who is temporarily living in a dorm.

- *Product involvement and utility* (the degree to which the product in question will be used or will satisfy a need). A family member who is a fashion victim will obviously be more interested in buying new clothes than a new lawnmower.

- *Responsibility* (for procurement, maintenance, payment, and so on). People are more likely to have disagreements about a decision if it entails long-term consequences and commitments.

- *Power* (the degree to which one family member exerts influence over the others in making decisions). In traditional families, the husband

tends to have more power than the wife, who in turn has more than the oldest child, and so on.

Sex Roles and Decision-Making Responsibilities

Who "wears the pants" in the family? Sometimes it's not obvious which spouse makes the decisions. Indeed, although many men still wear the pants, it's women who buy them. When Haggar's research showed that nearly half of married women bought pants for their husbands without them being present, the firm started advertising its menswear products in women's magazines.[96] When one family member chooses a product, this is called an **autonomic decision**. In traditional households, for example, men often have sole responsibility for selecting a car, whereas decorating choices fall to women. **Syncretic decisions**, such as choosing a vacation destination, are made jointly.

Figuring out who makes buying decisions is an important issue for marketers, so that they know whom to target and whether they need to reach both spouses to influence a choice. Researchers have paid special attention to which spouse plays the role of what has been called the **family financial officer (FFO)**, who keeps track of the family's bills and decides how any surplus funds will be spent. Among newlyweds, this role tends to be played jointly, and then over time one spouse or the other tends to take over these responsibilities.[97]

In traditional families (and especially those with low educational levels), women are primarily responsible for family financial management—the man makes it, and the woman spends it.[98] Each spouse "specializes" in certain activities.[99] Often clothing for the whole family, including the husband, is bought by the wife. This is not always the case, of course. Focus group research conducted by Levi Strauss on segmenting the men's clothing market found a segment that they labeled *Classic Independent*, who shopped by himself and never with a spouse or girlfriend.

Four factors appear to determine the degree to which decisions will be made jointly or by one or the other spouse.[100]

1. *Sex-role stereotypes:* Couples who believe in traditional sex-role stereotypes tend to make individual decisions for sex-typed products (those considered to be "masculine" or "feminine").

2. *Spousal resources:* The spouse who contributes more resources to the family has the greater influence.

3. *Experience:* Individual decisions are made more frequently when the couple has gained experience as a decision-making unit.

4. *Socioeconomic status:* Joint decisions are made more by middle-class families than in either higher- or lower-class families.

With many women now working outside of the home, men are participating more in housekeeping activities—in one-fifth of American homes, men do most of the shopping.[101] Still, women continue to do the lion's share of household chores. Overall, the degree to which a couple adheres to traditional sex-role norms determines how much their allocation of responsibilities will fall along familiar lines and how their consumer decision-making responsibilities will be allocated.

CHILDREN AS DECISION MAKERS: CONSUMERS-IN-TRAINING

Anyone who has had the "delightful" experience of grocery shopping with one or more children in tow knows that kids often have a say in what their parents buy. Children make up three distinct markets:[102]

- *Primary market:* Kids spend a lot on their own wants and needs. In 1991 the typical allowance of a 10-year-old was $4.20 a week; by 1997 this weekly stipend had risen to $6.13. On average, an allowance is only 45 percent of a kid's income, with the rest coming from money earned for doing household chores and gifts from relatives. About two-thirds of this goes to toys, apparel, movies, and games.

- *Influence market:* **Parental yielding** occurs when a parental decision maker is influenced by a child's request and "surrenders."[103] This is a key driver of product selections, with about 90 percent of requests by brand name. Researchers estimate that children directly influence about $453 billion worth of family purchases in a year. They report that on average children weigh in with a purchase request every two minutes when they shop with parents.[104] Most children simply ask for things, but some other tactics include saying they saw it on TV, saying that a sibling or friend has it, or offering to do chores in return. Other actions are less innocuous, such as directly placing an object in the cart and continuous pleading—often a "persuasive" behavior![105] The amount of influence children have over consumption is culturally determined. Children who live in individualistic cultures such as the United States have more direct influence, while kids in collective cultures such as Japan get their way more indirectly.[106] Table 11-4 documents kids' influence in ten different product categories.

- *Future market:* Kids have a way of growing up to be adults (eventually), and savvy marketers try to lock in brand loyalty at an early age.

Table 11-4 Kids' Influence on Household Purchases

Top 10 Selected Products	Industry Sales ($ Billions)	Influence Factor (%)	Sales Influence ($ Billions)
Fruit snacks	$0.30	80%	$0.24
Frozen novelties	1.40	75	1.05
Kids' beauty aids	1.20	70	0.84
Kids' fragrances	0.30	70	0.21
Toys	13.40	70	9.38
Canned pasta	0.57	60	0.34
Kids' clothing	18.40	60	11.04
Video games	3.50	60	2.10
Hot cereals	0.74	50	0.37
Kids' shoes	2.00	50	1.00

Source: "Charting the Children's Market," *Adweek* (February 10, 1992): 42. Reprinted with permission of James J. McNeal, Texas A&M University, College Station, Texas.

MULTICULTURAL DIMENSIONS

Bratz has knocked Barbie off the top spot as the United Kingdom's favorite doll and the fact that fashion is intrinsic to the Bratz brand has been cited as a major reason for its success. British children are becoming increasingly brand-conscious with huge spending power. The National Consumer Council (NCC) studies children's views on shopping, brands, and advertising and indicates children aged 10 to 19 are avid shoppers and have more pocket money and more influence over family spending than ever before.[107] But this trend is fueling dissatisfaction. The stronger the desire for labels, such as Bratz, combined with the reality of lower family income, tends to generate higher levels of discontent. And two-thirds of brand-aware children feel dissatisfied compared to just under half of the less brand-aware children.

Children are enthusiastic about shopping but say they feel exposed to a persistent stream of advertising, believing brands are trying to sell to them almost constantly. A group of young people have come up with solutions in their own four-point Children's Agenda on Consumer Life. They ask marketers to be honest and up-front about products and services; to treat them with respect and take them seriously; to curb the use of inappropriate advertising aimed at younger people; and to put tighter controls on advertising for products that are bad for young people.

Consumer Socialization

Children do not spring from the womb with consumer skills already in memory. **Consumer socialization** has been defined as the process "by which young people acquire skills, knowledge, and attitudes relevant to their functioning in the marketplace."[108] Where does this knowledge come from? Friends and teachers certainly participate in this process. Especially for young children, though, the two primary socialization sources are the family and the media.

Influence of Parents

Parents' influences in consumer socialization are both direct and indirect. They deliberately try to instill their own values about consumption in their children ("You're going to learn the value of a dollar"). Parents also determine the degree to which their children will be exposed to other information sources, such as television, salespeople, and peers.[109] And grown-ups serve as significant models for observational learning. Children learn about consumption by watching their parents' behavior and imitating it. This modeling is facilitated by marketers that package adult products in child versions. Storybook Heirlooms (www.storybook.com), a children's apparel company, offers mother-daughter dresses and outfits for all types of occasions.

The process of consumer socialization begins with infants, who accompany their parents to stores where they are initially exposed to marketing stimuli. Within the first two years, children begin to make requests for desired objects. As kids learn to walk, they also begin to make their own selections when they are in stores. By around the age of five, most kids are making purchases with the help of parents and grandparents, and by eight most are making independent purchases and have become full-fledged consumers.[110] The sequence of steps involved in turning kids into consumers is summarized in Figure 11-7.

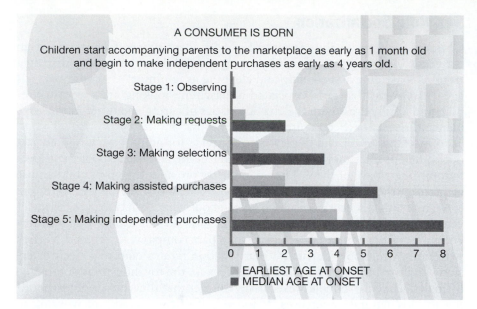

FIGURE 11-7
Five Stages of Consumer
Development by Earliest Age at
Onset and Median Age at Onset
Source: Adapted from James U. McNeal
and Chyon-Hwa Yeh, "Born to Shop,"
American Demographics (June 1993): 36.
Reprinted by permission of American
Demographics, Inc.

Influence of Television: "The Electric Babysitter"

It's no secret that kids watch a lot of television. As a result, they are constantly bombarded with messages about consumption, both in commercials and in the shows themselves. The more a child is exposed to television, whether the show is MTV's *Laguna Beach* or *Sponge Bob Square Pants*, the more he or she will accept the images depicted there as real.[111] The TV show *Teletubbies* from the United Kingdom targets viewers from three months to two years old. The show has become a national obsession, attracting more than 2 million viewers every weekday morning.[112] BabyFirstTV is a new channel designed for babies as young as 6 months touted as a learning experience for babies with developmental benefits. A study found that many parents believe television is beneficial for their children despite the recommendation by the American Academy of Pediatrics of no television at all for children under age 2.[113]

In addition to the large volume of programming targeted directly to children, kids also are exposed to idealized images of what it is like to be an adult. Since children over age 6 do about a quarter of their television viewing during prime time, they are affected by programs and commercials targeted to adults. For example, young girls exposed to adult lipstick commercials learn to associate lipstick with beauty.[114]

Channel One has been controversial since the early 1990s, as it is shown to children at schools throughout the country. Schools receive free TV monitors and satellite dishes in return for broadcasting the Channel One program, which is broken up into ten minutes of educational news briefs and two minutes of flashy MTV-style ads for companies such as Reebok and Pepsi. Many feel that there is a problem with advertising in school. When students see a product advertised in school they think it is endorsed by the school and their teachers. Some parents and teachers feel that they are selling out to advertisers, but today many school districts feel they cannot afford to say no to corporate gifts to schools even if they come with some type of advertising.[115] Hence, we have kids watching TV ads at school in addition to home.

Sex-Role Socialization

Children pick up on the concept of gender identity (see Chapter 5) at an early age. One study found that by age 3, most children categorize driving a truck as masculine and cooking and cleaning as feminine.[116] A study of girls age 2–10 found that girls associated a masculine-looking attire with a fireman and a frilly dress with the characteristics of caring about her looks, popular, and sweet.[117] (See Figure 11-8.)

One function of child's play is to rehearse for adulthood. Children "act out" different roles they might assume later in life and learn about the expectations others have of them. The toy industry provides the props children use to perform these roles.[118] Depending on which side of the debate you're on, these toys either reflect or teach children about what society expects of males versus females. While preschool boys and girls do not exhibit many differences in toy preferences, after age 5 they part company: Girls tend to stick with dolls, while boys gravitate toward "action figures" and high-tech diversions. Industry critics charge that this is because the toy industry is dominated by males, while toy company executives counter that they are simply responding to kids' natural preferences.[119] Indeed, after two decades of working to avoid boy-versus-girl stereotypes, many companies seem to have decided that differences are inevitable. Toys "R" Us unveiled a new store design after interviewing ten thousand customers, and the chain now has separate sections called Girls World and Boys World. According to the president of Fox Family Channel, "Boys and girls are different, and it's great to celebrate what's special about each."[120] However, on their shopping Web site (through www. amazon.com) there is a gender-neutral section labeled Shop By Age, but there are also categories called Gifts for Boys and Gifts for Girls.

Critics also point out that the video-game industry is dominated by men, and video gaming appears to still be a "boys' club." A recent Electronic Entertainment Expo in Los Angeles showed two role models for girls: Barbie and Lara Croft. The Barbie-type software is called "pink" titles such as makeovers or dating games. Lara Croft, an Indiana Jones–style hero, symbolizes the type of females who populate many male-designed computer games: namely "a buxom babe who wears tight shorts."[121]

And there is always Barbie. Barbie's continual rebirth illustrates how concerns about socialization can be taken to heart by a firm. One of the latest Barbies is the Jeff Gordon NASCAR Barbie doll. And then there are Bratz. While Barbie generally emphasizes fairies and princesses to capture younger girls, the sexy Bratz underscore what sociologists call "age compression" and what toy marketers recognize as "KGOY," or Kids Growing Older Younger. The progression from Barbie to Bratz mirrors society's blurred lines between children and adults.[122] Kids love Bratz with their heavily made-up faces and puffy lips. Even though parents see them as trampy, kids don't; they see them as pretty as personified by MTV videos.

Cognitive Development

The ability of children to make mature, "adult" consumer decisions obviously increases with age (not that grown-ups always make mature decisions). Kids can be segmented by age in terms of their stage of **cognitive development**, or ability to comprehend concepts of increasing complexity.

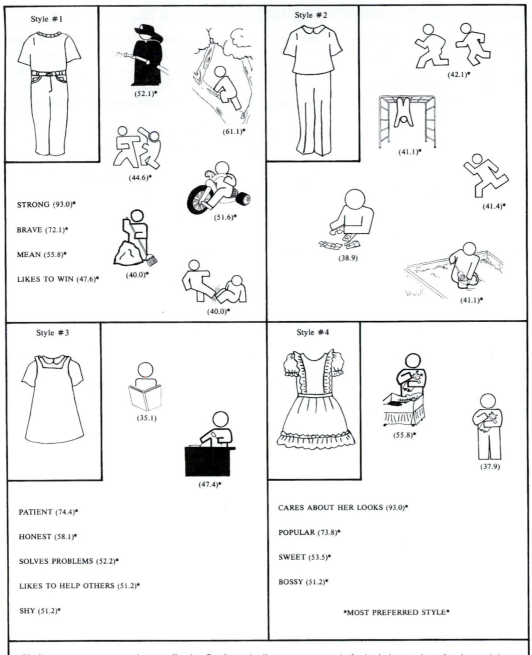

FIGURE 11-8
Symbolic-Associative Networks: Clothing, Behaviors,[a] and Traits[b]

Source: Susan B. Kaiser, "Clothing and Social Organization of Gender Perception: A Developmental Approach," *Clothing and Textiles Research Journal* 7, no. 2 (1989): 46–56. Reprinted by permission of the International Textile & Apparel Associations, Inc.

--- **KIDS GROWING UP QUICKLY** ---

Are marketers robbing kids of their childhood? Young children have become the target of grownup designers. As a spokesperson for Donna Karan observed, "These 7-year-olds are going on 30. A lot of them have their own sense of style."[123] Maybe so, but perhaps one of the consequences is that they are forced to adopt adult values earlier than they should. One author of a book about kids complains, "We are seeing the deliberate teening of childhood. Parents are giving their kids a lot more choices on what to wear at ever younger ages. The advertisers know this, and they are exploiting the kids' longing to seem sophisticated and grown-up. One of the great things about childhood in the United States used to be that kids were protected by the market and allowed to develop their own ideas.

Now there is no time to be a kid separate from those pressures. You may have always had kids who are little princesses, but now there are 8-year-old boys who are extremely uptight if they don't get the right Abercrombie & Fitch sweatshirt.[124] Maybe that explains why preteens now account for $200 million of the $3 billion mass-market sales of makeup; a survey of 8- to 12-year-old girls found that two-thirds regularly used cosmetics. Townley Inc. offers fruit-flavored lip gloss for young girls, including the Hello Kitty brand for 5- to 8-year-olds. Bath & Body Works sells a line of sparkling cosmetics that includes Coco Crush lipstick and Berry-Go-Round roll-on glitter makeup.[125] So much for the age of innocence . . .

The foremost proponent of the idea that children pass through distinct stages of cognitive development was Swiss psychologist Jean Piaget, who believed that each stage is characterized by a certain cognitive structure the child uses to handle information.[126] Many developmental specialists no longer believe that children necessarily pass through fixed stages at the same time. An alternative approach regards children as differing in information-processing capability, or ability to store and retrieve information from memory. The following three segments have been identified by this approach:[127]

1. *Limited:* Below age 6, children do not employ storage and retrieval strategies.
2. *Cued:* Children between ages 6 and 12 employ these strategies, but only when prompted.
3. *Strategic:* Children age 12 and older spontaneously employ storage and retrieval strategies.

This sequence of development underscores the notion that children do not think like adults, and they cannot be expected to use information the same way. It also reminds us that they do not necessarily form the same conclusions as adults do when presented with product information. For example, kids are not as likely to realize that something they see on television is not "real," and as a result they are more vulnerable to persuasive messages.

CHAPTER SUMMARY

- Consumers are faced with the need to make decisions about products all of the time. Some of these decisions are very important and entail great effort, while others are made on a virtually automatic basis.

- Fashion decisions often don't follow a rational decision-making model, but start with the awareness of a fashion object rather than recognition of a problem. Point-of-purchase displays can be very important in this awareness. These decisions often result in little or no information search.

- Perspectives on decision making range from a focus on habits that people develop over time to novel situations involving a great deal of risk, in which consumers must carefully collect and analyze information prior to making a choice.

- A typical decision process involves several steps. The first is problem recognition, in which the consumer first realizes that some action must be taken. This realization may be prompted in a variety of ways, ranging from the actual malfunction of a current purchase to a desire for new things based on exposure to different circumstances or advertising that provides a glimpse into what is needed to "live the good life."

- Once a problem has been recognized and is seen as sufficiently important to warrant some action, information search begins. This search may range from simply scanning memory to determine what has been done to resolve the problem in the past to extensive fieldwork in which the consumer consults a variety of sources to amass as much information as possible. In many cases, people engage in surprisingly little search. Instead, they rely upon various mental shortcuts, such as brand names or price, or they may simply imitate others.

- Fashion leaders and followers use different sources to search for information, with leaders using more impersonal sources and followers using more personal sources such as friends.

- In the evaluation-of-alternatives stage, the product alternatives that are considered make up the individual's evoked set. The way products are mentally grouped influences which alternatives will be considered, and some brands are more strongly associated with these categories than are others (that is, they are more prototypical).

- Evaluative criteria are the dimensions used to compare products when making a choice. Apparel and fashion studies have used a series of different criteria; however, style, fit, and quality have consistently been given high priority by consumers.

- Very often, heuristics, or mental rules of thumb, are used to simplify decision making. In particular, people develop many market beliefs over time. One of the most common beliefs is that price is positively related to quality. Other heuristics rely on well-known brand names or a product's country of origin as signals of product quality. When a brand is consistently purchased over time, this pattern may be due to true brand loyalty, or simply to inertia because it's the easiest thing to do.

- When the consumer eventually makes a product choice from among alternatives, a number of decision rules may be used. Noncompensatory rules eliminate alternatives that are deficient on any of the criteria the consumer has chosen to use. Compensatory rules, which are more likely to be applied in high-involvement situations, allow the decision maker to consider each alternative's good and bad points more carefully to arrive at the overall best choice.

- Many purchasing decisions are made by more than one person. Collective decision making occurs whenever two or more people are involved in evaluating, selecting, or using a product or service.

- A household is an occupied housing unit. The number and type of U.S. households is changing in many ways, including delays in getting married and having children, and in the composition of family households, which increasingly are headed by a single parent. New perspectives on the family life cycle, which focuses on how people's needs change as they move through different stages in their lives, are forcing marketers to consider such consumer segments as divorced people and childless couples when they develop targeting strategies.

- Families must be understood in terms of their decision-making dynamics. Spouses in particular have different priorities and exert varying amounts of influence in terms of effort and power. Children are also increasingly influential during a widening range of purchase decisions.

- Children undergo a process of socialization, whereby they learn how to be consumers. Some of this knowledge is instilled by parents and friends, but a lot of it comes from exposure to mass media and advertising. Since children are in some cases so easily persuaded, the ethical aspects of marketing to them are hotly debated among consumers, academics, and marketing practitioners.

KEY TERMS

rational perspective
behavioral influence
 perspective
experiential perspective
habitual decision
 making
extended problem
 solving
limited problem
 solving
problem recognition
information search
perceived risk
cybermediary
evoked set

inept set
inert set
evaluative criteria
determinant attributes
noncompensatory rule
compensatory rule
heuristics
market beliefs
inertia
brand loyalty
brand parity
ethnocentrism
extended family
nuclear family
household

family household
fertility rate
boomerang kids
family life cycle (FLC)
consensual purchase
 decision
accommodative purchase
 decision
autocratic decisions
syncratic decisions
family financial officer
 (FFO)
parental yielding
consumer socialization
cognitive development

DISCUSSION QUESTIONS

1. Are fashion purchasers rational decision makers?

2. If people are not always rational decision makers, is it worth the effort to study how these decisions are made? What techniques might be employed to understand experiential consumption and to translate this knowledge into marketing strategy?

3. List three product attributes that can be used as quality signals and provide an example of each.

4. Why is it difficult to place a product in a consumer's evoked set after it has already been rejected? What strategies might a marketer use in an attempt to accomplish this goal?

5. Discuss two different noncompensatory decision rules and highlight the difference(s) between them. How might the use of one rule versus another result in a different product choice?

6. Choose a friend who shops for fashion on a regular basis and keep a log of his or her purchases over the semester. Can you detect any evidence of brand loyalty in any categories based upon consistency of purchases? If so, talk to your friend about these purchases. Try to determine whether his or her choices are based on true brand loyalty or inertia. What techniques might you use to differentiate between the two?

7. Form a group of three. Pick a product and develop a marketing plan based on each of the three approaches to consumer decision making: rational, experiential, and behavioral influence. What are the major differences in emphasis among the three perspectives? Which is the most likely type of problem-solving activity for the product you have selected? What characteristics of the product make this so?

8. Locate a person who is about to make a major purchase. Ask that person to make a chronological list of all the information sources he or she consulted prior to making a decision. How would you characterize the types of sources used? Which sources appeared to have the most impact on the person's decision?

9. Perform a survey of country-of-origin stereotypes. Compile a list of five countries and ask people what products they associate with each. What are their evaluations of the products and likely attributes of these different products? The power of a country stereotype can also be demonstrated in another way. Prepare a brief description of a product, including a list of features, and ask people to rate it in terms of quality, likelihood of purchase, and so on. Make several versions of the description, varying only the country from which it comes. Do ratings change as a function of the country of origin?

10. Ask a friend to "talk through" the process he or she used to choose one brand over others during a recent purchase. Based on this description, can you identify the decision rule that was most likely employed?

11. For each of the following product categories—clothing, cosmetics, and furniture—describe the ways in which you believe a married couple's choices would be affected if they had children.

12. Collect ads for three different product categories in which the family is targeted. Find another set of ads for different brands of the same items in which the family is not featured. Prepare a report on the effectiveness of the approaches.

13. Select a product category, and using the life-cycle stages given in the chapter, list the variables that will affect a purchase decision for the product by consumers in each stage of the cycle.

14. Consider three important changes in modern family structure. For each, find an example of a marketer who has attempted to be conscious of this change as reflected in product communications, retailing innovations, or other aspects of the marketing mix. If possible, also try to find examples of marketers who have failed to keep up with these developments.

15. Marketers have been criticized for donating products and services to educational institutions in exchange for free promotion. Is this a fair exchange, in your opinion, or should corporations be prohibited from attempting to influence youngsters in school?

ENDNOTES

1. George Sproles, *Fashion: Consumer Behavior toward Dress* (Minneapolis, Minn.: Burgess, 1979).
2. John C. Mowen, "Beyond Consumer Decision Making," *Journal of Consumer Marketing* 5, no. 1 (1988): 15–25.
3. Richard W. Olshavsky and Donald H. Granbois, "Consumer Decision Making—Fact or Fiction," *Journal of Consumer Research* 6 (September 1989): 93–100.
4. James R. Bettman, "The Decision Maker Who Came in from the Cold," presidential address, in *Advances in Consumer Research* 20, eds. Leigh McAllister and Michael Rothschild (Provo, Utah: Association for Consumer Research, in press); John W. Payne, James R. Bettman, and Eric J. Johnson, "Behavioral Decision Research: A Constructive Processing Perspective," *Annual Review of Psychology* 4 (1992): 87–131. For an overview of individual choice models, see Robert J. Meyer and Barbara E. Kahn, "Probabilistic Models of Consumer Choice Behavior," in *Handbook of Consumer Behavior*, eds. Thomas S. Robertson and Harold H. Kassarjian (Upper Saddle River, N.J.: Prentice-Hall, 1991), 85–123.
5. Mowen, "Beyond Consumer Decision Making."
6. Joseph W. Alba and J. Wesley Hutchinson, "Dimensions of Consumer Expertise," *Journal of Consumer Research* 13 (March 1988): 411–454.
7. Soyeon Shim and Aeran Koh, "Profiling Adolescent Consumer Decision-Making Styles: Effects of Socialization Agents and Social-Structural Variables," *Clothing and Textiles Research Journal* 15, no. 1 (1997): 50–59.
8. Janice L. Haynes, Alison L. Pipkin, William C. Black, and Rinn M. Cloud, "Application of a Choice Sets Model to Assess Patronage Decision Styles of High Involvement Consumers," *Clothing and Textiles Research Journal* 12 (Spring 1994): 22–32.
9. Gordon C. Bruner III and Richard J. Pomazal, "Problem Recognition: The Crucial First Stage of the Consumer Decision Process," *Journal of Consumer Marketing* 5, no. 1 (1988): 53–63.
10. Ross K. Baker, "Textually Transmitted Diseases," *American Demographics* (December 1987): 64.
11. Julia Marlowe, Gary Selnow, and Lois Blosser, "A Content Analysis of Problem-Resolution Appeals in Television Commercials," *Journal of Consumer Affairs* 23, no. 1 (1989): 175–194.

12. Valerie Seckler, "Futurist Alvin Toffler: Information Explosion to Shock Retail World," *Women's Wear Daily* (January 16, 1997): 1, 29.
13. Peter H. Bloch, Daniel L. Sherrell, and Nancy M. Ridgway, "Consumer Search: An Extended Framework," *Journal of Consumer Research* 13 (June 1986): 119–126.
14. Girish Punj, "Presearch Decision Making in Consumer Durable Purchases," *Journal of Consumer Marketing* 4 (Winter 1987): 71–82.
15. Alex Mindlin, "Buyers Search Online, but Not by Brand," *New York Times Online* (March 13, 2006).
16. Rosemary Polegato and Marjorie Wall, "Information Seeking by Fashion Opinion Leaders and Followers," *Home Economics Research Journal* 8 (May 1980): 327–338; Soyeon Shim and Antigone Kotsiopulos, "A Typology of Apparel Shopping Orientation Segments among Female Consumers," *Clothing and Textiles Research Journal* 12 (Fall 1993): 73–85.
17. Itamar Simonson, Joel Huber, and John Payne, "The Relationship between Prior Brand Knowledge and Information Acquisition Order," *Journal of Consumer Research* 14 (March 1988): 566–578.
18. Cathy J. Cobb and Wayne D. Hoyer, "Direct Observation of Search Behavior," *Psychology & Marketing* 2 (Fall 1985): 161–179.
19. Sharon E. Beatty and Scott M. Smith, "External Search Effort: An Investigation across Several Product Categories," *Journal of Consumer Research* 14 (June 1987): 83–95; William L. Moore and Donald R. Lehmann, "Individual Differences in Search Behavior for a Nondurable," *Journal of Consumer Research* 7 (December 1980): 296–307.
20. Leslie L. Davis, "Consumer Use of Label Information in Ratings of Clothing Quality and Clothing Fashionability," *Clothing and Textiles Research Journal* 6 (Fall 1987): 9–14.
21. Girish N. Punj and Richard Staelin, "A Model of Consumer Search Behavior for New Automobiles," *Journal of Consumer Research* 9 (March 1983): 366–380.
22. Cobb and Hoyer, "Direct Observation of Search Behavior"; Moore and Lehmann, "Individual Differences in Search Behavior for a Nondurable"; Punj and Staelin, "A Model of Consumer Search Behavior for New Automobiles."

23. Jane E. Workman and Kim K. P. Johnson, "Fashion Opinion Leadership, Fashion Innovativeness, and Need for Variety," *Clothing and Textiles Research Journal* 11, no. 3 (Spring 1993): 60–64.

24. Barbara E. Kahn, "Understanding Variety-Seeking Behavior From a Marketing Perspective," unpublished manuscript, University of Pennsylvania, University Park (1991); Leigh McAlister and Edgar A. Pessemier, "Variety-Seeking Behavior: An Interdisciplinary Review," *Journal of Consumer Research* 9 (December 1982): 311–322; Fred M. Feinberg, Barbara E. Kahn, and Leigh McAlister, "Market Share Response When Consumers Seek Variety," *Journal of Marketing Research* 29 (May 1992): 228–237; Barbara E. Kahn and Alice M. Isen, "The Influence of Positive Affect on Variety Seeking among Safe, Enjoyable Products," *Journal of Consumer Research* 20, (September 1993): 257–270.

25. James R. Bettman and C. Whan Park, "Effects of Prior Knowledge and Experience and Phase of the Choice Process on Consumer Decision Processes: A Protocol Analysis," *Journal of Consumer Research* 7 (December 1980): 234–248.

26. Geitel Winakor and Jacqueline Lubner-Rupert, "Dress Style Variation Related to Perceived Economic Risk," *Home Economics Research Journal* 11, no. 4 (June 1983): 343–351.

27. Linda Simpson and Hilda Buckley Lakner, "Perceived Risk and Mail Order Shopping for Apparel," *Journal of Consumer Studies and Home Economics* 17 (1993): 377–389.

28. Bettie Minshall, Geitel Winakor, and Jane L. Swinney, "Fashion Preferences of Males and Females, Risks Perceived and Temporal Quality of Styles," *Home Economics Research Journal* 10, no. 4 (June 1982): 369–379.

29. Michael Porter, *Competitive Advantage* (New York: Free Press, 1985).

30. Linda Stern, "Wanna Deal? Click Here," *Newsweek* (March 22, 2004): 65.

31. Material in this section adapted from Michael R. Solomon and Elnora W. Stuart, *Welcome to Marketing.com: The Brave New World of E-Commerce* (Upper Saddle River, N.J.: Prentice Hall, 2001).

32. Vicki M. Young, "Author: Too Many Choices Can Overwhelm Shoppers," *Women's Wear Daily* (October 16, 2005): 15; Barry Schwartz, *The Paradox of Choice: Why Less Is More* (New York: Harper Collins, 2005).

33. Robert J. Sutton, "Using Empirical Data to Investigate the Likelihood of Brands Being Admitted or Readmitted into an Established Evoked Set," *Journal of the Academy of Marketing Science* 15 (Fall 1987): 82.

34. H. Jessie Chen-Yu and Doris H. Kincade, "Effects of Product Image at Three Stages of the Consumer Decision Process for Apparel Products: Alternative Evaluation, Purchase and Post-Purchase," *Journal of Fashion Marketing and Management* 5, No. 1 (2001): 29–43.

35. Mita Sujan, "Consumer Knowledge: Effects on Evaluation Strategies Mediating Consumer Judgments," *Journal of Consumer Research* 12 (June 1985): 31–46.

36. Eleaner Rosch, "Principles of Categorization," in *Recognition and Categorizations*, ed. E. Rosch and B. B. Lloyd (Hillsdale, N.J.: Laurence Erlbaum, 1978).

37. Joan Meyers-Levy and Alice M. Tybout, "Schema Congruity as a Basis for Product Evaluation," *Journal of Consumer Research* 16 (June 1989): 39–55.

38. Mita Sujan and James R. Bettman, "The Effects of Brand Positioning Strategies on Consumers' Brand and Category Perceptions: Some Insights from Schema Research," *Journal of Marketing Research* 26 (November 1989): 454–467.

39. "Consumer Outlook 99," Kurt Salmon Associates (1999).

40. Valerie Seckler, "Is the Thrill Gone? Stressed Consumer in Shopping Slump," *Women's Wear Daily* (July 17, 2002): 1, 10, 15.

41. Cf. William P. Putsis, Jr., and Narasimhan Srinivasan, "Buying or Just Browsing? The Duration of Purchase Deliberation," *Journal of Marketing Research* 31 (August 1994): 393–402.

42. Robert E. Smith, "Integrating Information from Advertising and Trial: Processes and Effects on Consumer Response to Product Information," *Journal of Marketing Research* 30 (May 1993): 204–219.

43. Hsiu-Jun Hsu and Leslie Davis Burns, "Clothing Evaluative Criteria: A Cross-National Comparison of Taiwanese and United States Consumers," *Clothing and Textiles Research Journal*, 20, no. 4 (2002): 246–252.

44. Jack Trout, "Marketing in Tough Times," *Boardroom Reports*, no. 2 (October 1992): 8.

45. Nancy L. Cassill and Mary Frances Drake, "Apparel Selection Criteria Related to Female Consumers' Lifestyle," *Clothing and Textiles Research Journal* 6 (Fall 1987): 21–28; Soyeon Shim and Mary Frances Drake, "Influence of Lifestyle and Evaluative Criteria for Apparel on Information Search among Non-Employed Female Consumers," *Home Economics Research Journal* 13 (1989): 381–395; Molly Eckman, Mary Lynn Damhorst, and Sara J. Kadolph, "Toward a Model of the In-Store Purchase Decision Process: Consumer Use of Criteria for Evaluating Women's Apparel," *Clothing and Textiles Research Journal* 8 (Winter 1990): 13–22; Patricia Huddleston and Nancy L. Cassill, "Female Consumers' Brand Orientation: The Influence of Quality and Demographics," *Home Economics Research Journal* 18 (March 1990): 255–262; Patricia Huddleston, Nancy L. Cassill, and Lucy K. Hamilton, "Apparel Selection Criteria as Predictors of Brand Orientation," *Clothing and Textiles Research Journal* 12 (Fall 1993): 51–56; Judith C. Forney, William Pelton, Susan Turnbull Caton, and Nancy J. Rabolt, "Country of Origin and Evaluative Criteria: Influences on Women's Apparel Purchase Decisions," *Journal of Family and Consumer Sciences* 91, no. 4 (1999); 57–62.

46. Hiroko Kawabata and Nancy J. Rabolt, "Comparison of Clothing Purchase Behaviour between U.S. and Japanese Female University Students," *Journal of Consumer Studies and Home Economics* 23, no. 4 (December 1999): 213–223; Lorraine A. Friend, Judith C. Forney, and Nancy J. Rabolt, "Clothing Shoping Behaviour of New Zealand and United States Consumers: A Cross-Cultural Comparison," *Australasian Textiles* 9 (September/October 1989): 58–62; Forney, Pelton, Turnbull-Caton, and Rabolt, "Evaluative Criteria and Country of Origin in U.S. and Canadian University Women's Apparel Purchase Decisions"; Chin-Fen Hsiao and Kitty Dickerson, "Evaluative Criteria for

Purchasing Leisurewear: Taiwanese and U.S. Students in a U.S. University," *Journal of Consumer Studies and Home Economics* 19 (1995): 145–153.

47. C. Whan Park, "The Effect of Individual and Situation-Related Factors on Consumer Selection of Judgmental Models," *Journal of Marketing Research* 13 (May 1976): 144–151.

48. Wayne D. Hoyer, "An Examination of Consumer Decision Making for a Common Repeat Purchase Product," *Journal of Consumer Research* 11 (December 1984): 822–829; Calvin P. Duncan, "Consumer Market Beliefs: A Review of the Literature and an Agenda for Future Research," in *Advances in Consumer Research* 17, eds. Marvin E. Goldberg, Gerald Gorn, and Richard W. Pollay (Provo, Utah: Association for Consumer Research, 1990), 729–735; Frank Alpert, "Consumer Market Beliefs and Their Managerial Implications: An Empirical Examination," *Journal of Consumer Marketing* 10, no. 2 (1993): 56–70.

49. Gary T. Ford and Ruth Ann Smith, "Inferential Beliefs in Consumer Evaluations: An Assessment of Alternative Processing Strategies," *Journal of Consumer Research* 14 (December 1987): 363–371; Deborah Roedder John, Carol A. Scott, and James R. Bettman, "Sampling Data for Covariation Assessment: The Effects of Prior Beliefs on Search Patterns," *Journal of Consumer Research* 13 (June 1986): 38–47; Gary L. Sullivan and Kenneth J. Berger, "An Investigation of the Determinants of Cue Utilization," *Psychology & Marketing* 4 (Spring 1987): 63–74.

50. Duncan, "Consumer Market Beliefs."

51. Christian Hjorth-Andersen, "Price as a Risk Indicator," *Journal of Consumer Policy* 10 (1987): 267–281.

52. "Paralysis Sets in," *Lifestyle Monitor* (Spring/Summer 2008): 18.

53. Pamela S. Norum and Lee Ann Clark, "A Comparison of Quality and Retail Price of Domestically Produced and Imported Blazers," *Clothing and Textiles Research Journal* 7 (Spring 1989): 1–9; Francesann L. Heisey, "Perceived Quality and Predicted Price: Use of the Minimum Information Environment in Evaluating Apparel," *Clothing and Textiles Research Journal* 8 (Summer 1990): 23–28.

54. David M. Gardner, "Is There a Generalized Price-Quality Relationship?," *Journal of Marketing Research* 8 (May 1971): 241–243; Kent B. Monroe, "Buyers' Subjective Perceptions of Price," *Journal of Marketing Research* 10 (1973): 70–80.

55. Deborah Fowler and Richard Clodfelter, "A Comparison of Apparel Quality: Outlet Stores Versus Department Stores," *Journal of Fashion Marketing and Management* 5, No. 1 (2001): 57–66.

56. Jean D. Hines and Gwendolyn S. O'Neal, "Underlying Determinants of Clothing Quality: The Consumers' Perspective," *Clothing and Textiles Research Journal* 13, no. 4 (1995): 227–233.

57. Liza Abraham-Murali and Mary Ann Littrell, "Consumers' Perception of Apparel Quality over Time: An Exploratory Study," *Clothing and Textiles Research Journal* 13, no. 3 (1995): 149–158.

58. Ronald Alsop, "Enduring Brands Hold Their Allure by Sticking Close to Their Roots," *Wall Street Journal*, centennial ed. (June 23, 1989): B4.

59. Ira P. Schneiderman, "The Consumer Psyche Twenty Questions: Where Will the Money Go?," *Women's Wear Daily,* Section II (November 18, 1998): 1–19.

60. "Remaining Nameless," *Women's Wear Daily* (May 25, 2000): 2.

61. Jennifer Owens, "Survey Says Loyalty to Brands Is Fleeting," *Women's Wear Daily* (August 25, 1998): 14.

62. Durairaj Maheswaran, "Country of Origin as a Stereotype: Effects of Consumer Expertise and Attribute Strength on Product Evaluations," *Journal of Consumer Research* 21 (September 1994): 354–365; Ingrid M. Martin and Sevgin Eroglu, "Measuring a Multi-Dimensional Construct: Country Image," *Journal of Business Research* 28 (1993): 191–210; Richard Ettenson, Janet Wagner, and Gary Gaeth, "Evaluating the Effect of Country of Origin and the 'Made in the U.S.A.' Campaign: A Conjoint Approach," *Journal of Retailing* 64 (Spring 1988): 85–100; C. Min Han and Vern Terpstra, "Country-of-Origin Effects for Uni-National & Bi-National Products," *Journal of International Business* 19 (Summer 1988): 235–255; Michelle A. Morganosky and Michelle M. Lazarde, "Foreign-Made Apparel: Influences on Consumers' Perceptions of Brand and Store Quality," *International Journal of Advertising* 6 (Fall 1987): 339–348.

63. D. Bergeron and M. Carver. "Student Preferences for Domestic-Made or Imported Apparel as Influenced by Shopping Habits," *Journal of Consumer Studies and Home Economics* 12 (1988): 87–94.

64. Brenda Sternquist and B. Davis, "Store Status and Country of Origin as Information Cues: Consumer's Perception of Sweater Price and Quality," *Home Economics Research Journal* 15 (1986): 124–131; Norum and Clark, "A Comparison of Quality and Retail Price of Domestically Produced and Imported Blazers"; Francesann L. Heisey, "Perceived Quality and Predicted Price: Use of the Minimum Information Environment in Evaluating Apparel."

65. K. Gipson and Sally Francis, "The Effect of Country of Origin on Purchase Behaviour: An Intercept Study," *Journal of Consumer Studies and Home Economics* 15 (1991): 33–44.

66. Marjorie Wall and Louise Heslop, "Consumer Attitudes towards the Quality of Domestic and Imported Apparel and Footwear," *Journal of Consumer Studies and Home Economics,* 13, no. 4 (1989): 337–358.

67. Gipson and Francis, "The Effect of Country of Origin on Purchase Behaviour: An Intercept Study."

68. Mark Dolliver, "Americans Think Highly of U.S.-Made Products," *Adweek* (February 28, 2005): 57.

69. Sung-Tai Hong and Robert S. Wyer, Jr., "Effects of Country-of-Origin and Product–Attribute Information on Product Evaluation: An Information Processing Perspective," *Journal of Consumer Research* 16 (September 1989): 175–187; Marjorie Wall, John Liefeld, and Louise A. Heslop, "Impact of Country-of-Origin Cues on Consumer Judgments in Multi-Cue Situations: A Covariance Analysis," *Journal of the Academy of Marketing Science* 19, no. 2 (1991): 105–113.

70. Kitty Dickerson, "Imported versus U.S.-Produced Apparel: Consumer Views and Buying Patterns," *Home Economics Research Journal* 10, no. 3 (1982): 241–252.

71. Nancy J. Rabolt and Judith C. Forney, "Japanese and California Students' Fashion Purchase Behavior and Perception of Country of Origin" (Atlanta, Ga.: Association of College Professors of Textiles and Clothing Proceedings, 1989): 109.

72. Items excerpted from Terence A. Shimp and Subhash Sharma, "Consumer Ethnocentrism: Construction and Validation of the CETSCALE," *Journal of Marketing Research* 24 (August 1987): 282.

73. Robert Boutilier, "Diversity in Family Structures," *American Demographics Marketing Tools* (1993): 4–6; W. Bradford Fay, "Families in the 1990s: Universal Values, Uncommon Experiences," *Marketing Research: A Magazine of Management & Applications* 5, no. 1 (Winter 1993): 47.

74. Cyndee Miller, "'Til Death Do They Part," *Marketing News* (March 27, 1995): 1–2.

75. Diane Crispell, "Family Futures," *American Demographics* (August 1996): 13–14.

76. Karen Hardee-Cleaveland, "Is Eight Enough?," *American Demographics* (June 1989): 60.

77. Robert Berner, "Toddlers Dress to the Nines and Designers Rake It In," *Wall Street Journal Interactive Edition* (May 27, 1997).

78. Quoted in Lisa Gubernick and Marla Matzer, "Babies as Dolls," *Forbes* (February 27, 1995): 79.

79. "Mothers Bearing a Second Burden," *New York Times* (May 14, 1989): 26.

80. Thomas Exter, "Disappearing Act," *American Demographics* (January 1989): 78. See also Keren Ami Johnson and Scott D. Roberts, "Incompletely-Launched and Returning Young Adults: Social Change, Consumption, and Family Environment," in *Enhancing Knowledge Development in Marketing*, eds. Robert P. Leone and V. Kumar, (Chicago: American Marketing Association Educator's Proceedings, vol. 3, 1992), 249–254; John Burnett and Denise Smart, "Returning Young Adults: Implications for Marketers," *Psychology & Marketing* 11, no. 3 (May/June 1994): 253–269.

81. Ronald Alsop, "Businesses Market to Gay Couples as Same Sex Households Increase," *Wall Street Journal Interactive Edition* (August 8, 2002).

82. Brad Edmondson, "Inside the New Household Projections," *The Number News* (July 1996).

83. David Caruso, "New York-Singles Capital," *San Francisco Chronicle* (September 3, 2005): A2.

84. James Morrow, "A Place for One," *American Demographics* (November 2003): 25–30; Michelle Conlin, "Unmarried America," *BusinessWeek* (October 20, 2003): 106–116.

85. Craig J. Thompson, "Caring Consumers: Gendered Consumption Meanings and the Juggling Lifestyle," *Journal of Consumer Research* 22 (March 1996): 388–407.

86. Quoted in Bernice Kanner, "Advertisers Take Aim at Women at Home," *New York Times* (January 2, 1995): 42.

87. For a review, see Russell W. Belk, "Metaphoric Relationships with Pets," *Society and Animals* 4, no. 2 (1996): 121–146.

88. Rebecca Gardyn, "Animal Magnetism," *American Demographics* (May 2002): 31–37.

89. Maryann Mott, "Catering to the Consumers with Animal Appetites," *New York Times on the Web* (November 14, 2004).

90. Stephanie Thompson, "What's Next, Pup Tents in Bryant Park?" *Advertising Age*, www.adage.com (January 29, 2007).

91. Mary C. Gilly and Ben M. Enis, "Recycling the Family Life Cycle: A Proposal for Redefinition," in *Advances in Consumer Research* 9, ed. Andrew A. Mitchell (Ann Arbor, Mich.: Association for Consumer Research, 1982), 271–276.

92. Charles M. Schaninger and William D. Danko, "A Conceptual and Empirical Comparison of Alternative Household Life Cycle Models," *Journal of Consumer Research* 19 (March 1993): 580-594; Robert E. Wilkes, "Household Life-Cycle Stages, Transitions, and Product Expenditures," *Journal of Consumer Research* 22, no. 1 (June 1995): 27–42.

93. Harry L. Davis, "Decision Making within the Household," *Journal of Consumer Research* 2 (March 1972): 241–260; Michael B. Menasco and David J. Curry, "Utility and Choice: An Empirical Study of Wife/Husband Decision Making," *Journal of Consumer Research* 16 (June 1989): 87–97. For a recent review, see Conway Lackman and John M. Lanasa, "Family Decision-Making Theory: An Overview and Assessment," *Psychology & Marketing* 10, no. 2 (March/April 1993): 81–94.

94. Shannon Dortch, "Money and Marital Discord," *American Demographics* (October 1994): 11.

95. Daniel Seymour and Greg Lessne, "Spousal Conflict Arousal: Scale Development," *Journal of Consumer Research* 11 (December 1984): 810–821.

96. Robert Lohrer, "Haggar Targets Women with $8M Media Campaign," *Daily News Record* (January 8, 1997): 1.

97. Robert Boutilier, *Targeting Families: Marketing to and through the New Family* (Ithaca, N. Y.: American Demographics, 1993).

98. Dennis L. Rosen and Donald H. Granbois, "Determinants of Role Structure in Family Financial Management," *Journal of Consumer Research* 10 (September 1983): 253–258.

99. Robert F. Bales, *Interaction Process Analysis: A Method for the Study of Small Groups* (Reading, Mass.: Addison-Wesley, 1950). For a cross-gender comparison of food shopping strategies, see Rosemary Polegato and Judith L. Zaichkowsky, "Family Food Shopping: Strategies Used by Husbands and Wives," *Journal of Consumer Affairs* 28, no. 2 (1994): 278–299.

100. Gary L. Sullivan and P. J. O'Connor, "The Family Purchase Decision Process: A Cross-Cultural Review and Framework for Research," *Southwest Journal of Business & Economics* (Fall 1988): 43; Marilyn Lavin, "Husband-Dominant, Wife-Dominant, Joint," *Journal of Consumer Marketing* 10, no. 3 (1993): 33–42.

101. Diane Crispell, "Mr. Mom Goes Mainstream," *American Demographics* (March 1994): 59; Gabrielle Sándor, "Attention Advertisers: Real Men Do Laundry," *American Demographics* (March 1994): 13.

102. James U. McNeal, "Tapping the Three Kids' Markets," *American Demographics* (April 1998): 37–41.

103. Kay L. Palan and Robert E. Wilkes, "Adolescent-Parent Interaction in Family Decision Making," *Journal of Consumer Research* 24 (September 1997): 159–169.

104. Russell N. Laczniak and Kay M. Palan, "Under the Influence," *Marketing Research* (Spring 2004): 34–39.

105. Leslie Isler, Edward T. Popper, and Scott Ward, "Children's Purchase Requests and Parental Responses: Results from a Diary Study," *Journal of Advertising Research* 27 (October/November 1987): 28–39.

106. Gregory M. Rose, "Consumer Socialization, Parental Style, and Development Timetables in the United States and Japan,"*Journal of Marketing* 63, no. 3 (1999): 105–119.

107. "Insight—Child Consumerism: First of the Little Big Spenders," *Marketing Week, London* (July 21, 2005): 32.

108. Scott Ward, "Consumer Socialization," in *Perspectives in Consumer Behavior*, eds. Harold H. Kassarjian and Thomas S. Robertson (Glenville, Ill.: Scott Foresman, 1980), 380.

109. George P. Moschis, "The Role of Family Communication in Consumer Socialization of Children and Adolescents," *Journal of Consumer Research* 11 (March 1985): 898–913.

110. James U. McNeal and Chyon-Hwa Yeh, "Born to Shop," *American Demographics* (June 1993): 34–39.

111. See Patricia M. Greenfield et al. "The Program-Length Commercial: A Study of the Effects of Television/Toy Tie-Ins on Imaginative Play," *Psychology & Marketing* 7 (Winter 1990): 237–256 for a study on the effects of commercial programming on creative play.

112. Jill Goldsmith, "Ga, Ga, Goo, Goo, Where's the Remote? TV Show Targets Tots," *Dow Jones Business News* (February 5, 1997); Robert Frank, "Toddler Set Loves Teletubbies, but Parents Question Value," *The Wall Street Journal Interactive Edition* (August 21, 1997); Marina Baker, "Teletubbies Say 'Eh Oh . . . It's War!'" *The Independent* (March 6, 2000): 7; "A Trojan Horse for Advertisers," *Business Week* (April 3, 2000): 10.

113. Janine DeFao, "TV Channel for Babies? Pediatricians Say Turn It Off," *San Francisco Chronicle* (September 11, 2006): A1, A8.

114. Gerald J. Gorn and Renee Florsheim, "The Effects of Commercials for Adult Products on Children," *Journal of Consumer Research* 11 (March 1985): 962–967. For a study that assessed the impact of violent commercials on children, see V. Kanti Prasad and Lois J. Smith, "Television Commercials in Violent Programming: An Experimental Evaluation of Their Effects on Children," *Journal of the Academy of Marketing Science* 22, no. 4 (1994): 340–351.

115. Julian Guthrie, "Pitching to Pupils," *San Francisco Examiner* (January 18, 1998): A1, A9.

116. Glenn Collins, "New Studies on 'Girl Toys' and 'Boy Toys,'" *The New York Times* (February 13, 1984): D1.

117. Susan B. Kaiser, "Clothing and Social Organization of Gender Perception: A Developmental Approach," *Clothing and Textiles Research Journal* 7, no. 2 (1989): 46–56.

118. Lori Schwartz and William Markham, "Sex Stereotyping in Children's Toy Advertisements," *Sex Roles* 12 (January 1985): 157–170.

119. Joseph Pereira, "Oh Boy! In Toyland, You Get More If You're Male," *Wall Street Journal* (September 23, 1994): B1; Joseph Pereira, "Girls' Favorite Playthings: Dolls, Dolls, and Dolls," *Wall Street Journal* (September 23, 1994): B1.

120. Quoted in Lisa Bannon, "More Kids' Marketers Pitch Number of Single-Sex Products," *Wall Street Journal Interactive Edition* (February 14, 2000).

121. Kelly Zito, "Still a Boys' Club: Video-Game Industry Offers Slim Pickings for Girls," *San Francisco Chronicle* (May 13, 2000): B1, B2.

122. Reyhan Harmanci, "Cultural Shift: Little Girls, Sexy Dolls—Toy Industry Markets to 'Kids Growing Older Younger,'" *San Francisco Chronicle* (December 17, 2006): A1, A4.

123. Kay Hymovitz, quoted in Leslie Kaufman, "New Style Maven: 6 Years Old and Picky," *New York Times on the Web* (September 7, 1999).

124. Ibid.

125. Tara Parker-Pope, "Cosmetics Industry Takes Look at the Growing Preteen Market," *The Wall Street Journal Interactive Edition* (December 4, 1998).

126. Jean Piaget, "The Child and Modern Physics," *Scientific American* 196, no. 3 (1957): 46–51. See also Kenneth D. Bahn, "How and When Do Brand Perceptions and Preferences First Form? A Cognitive Developmental Investigation," *Journal of Consumer Research* 13 (December 1986): 382–393.

127. Deborah L. Roedder, "Age Differences in Children's Responses to Television Advertising: An Information-Processing Approach," *Journal of Consumer Research* 8 (September 1981): 144–253. See also Deborah Roedder John and Ramnath Lakshmi-Ratan, "Age Differences in Children's Choice Behavior: The Impact of Available Alternatives," *Journal of Marketing Research* 29 (May 1992): 216–226; Jennifer Gregan-Paxton and Deborah Roedder John, "Are Young Children Adaptive Decision Makers? A Study of Age Differences in Information Search Behavior," *Journal of Consumer Research* 21, no. 4 (1995): 567–580.

12
Group Influence and Fashion Opinion Leadership

Zachary leads a secret life. During the week, he is a straightlaced stock analyst. The weekend is another story. Come Friday evening, it's off with the Brooks Brothers suit and on with the black leather, as he trades in his BMW for his treasured Harley-Davidson motorcycle. A dedicated member of HOG (Harley Owners Group), Zachary belongs to the faction of Harley riders known as "RUBs" (rich urban bikers). Everyone in his group wears expensive leather vests with Harley insignias. Just this week, Zack finally got his new Harley belt buckle when he logged on to the Genuine Harley-Davidson Roadstore at www.harley-davidson.com. As he surfed around the site, he realized the lengths some of his fellow enthusiasts go to make sure others know they are Hog riders. As one of the Harley Web pages observed, "It's one thing to have people buy your prod-

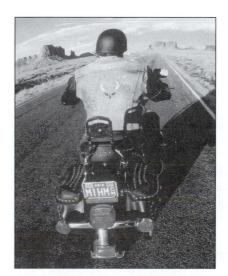

ucts. It's another thing to have them tattoo your name on their bodies." Zack had to restrain himself from buying more Harley stuff; there were jackets, vests, eyewear, belts, buckles, jewelry, even housewares ("home is the road") for sale.

Zack has spent a lot of money on his bike and on outfitting himself to be like the rest of the group. But it's worth it. Zachary feels a real sense of brotherhood with his fellow RUBs. The group rides together in two-column formation to rallies that sometimes attract up to 300,000 biker enthusiasts. What a sense of power he feels when they're all cruising together!

Of course, an added benefit is the business networking with his fellow professionals who also wait for the weekend to "ride on the wild side."[1] Sometimes sharing a secret can pay off in more ways than one.

REFERENCE GROUPS

Humans are social animals. We all belong to groups, try to please others, and take cues about how to behave by observing the actions of those around us. In fact, our desire to "fit in" or to identify with desirable individuals or groups is the primary motivation for many of our purchases and activities. We will often go to great lengths to please the members of a group whose acceptance we covet.[2]

Zachary's biker group is an important part of his identity, and this membership influences many of his buying decisions. He has spent many thousands of dollars on parts and accessories for his Harley, in addition to clothing, since acquiring his identity as a RUB. His fellow riders are united by their consumption choices, so that total strangers feel an immediate bond with each other when they meet. The publisher of *American Iron*, an industry magazine, observed, "You don't buy a Harley because it's a superior bike, you buy a Harley to be a part of a family."[3]

Zachary doesn't model himself after just *any* biker—only the people with whom he really identifies can exert that kind of influence on him. For example, Zachary's group doesn't have much to do with outlaw clubs, which are primarily composed of blue-collar riders sporting Harley tattoos. The members of his group also have only polite contact with "Ma and Pa" bikers, whose bikes are the epitome of comfort, featuring such niceties as radios, heated handgrips, and floorboards. Essentially, only the RUBs constitute Zachary's *reference group*.

A **reference group** is "an actual or imaginary individual or group conceived of having significant relevance upon an individual's evaluations, aspirations, or behavior."[4] Reference groups influence our fashion and clothing choices in three ways. These influences—*informational*, *utilitarian*, and *value-expressive*—are described in Table 12-1. This chapter focuses on how other people, whether fellow bikers, co-workers, friends and family, or just casual acquaintances, influence our purchase decisions. It considers how our preferences are shaped by our group memberships, by our desire to please or be accepted by others, or even by the actions of famous people whom we've never even met. Finally, it explores why some people are more influential than others in affecting fashion and other product preferences, and how marketers go about finding those people and enlisting their support in the persuasion process.

Types of Reference Groups

Although two or more people are normally required to form a group, the term *reference group* often is used a bit more loosely to describe *any* external influence that provides social cues.[5] The referent may be a well-known figure who has an impact on many people or a person or group whose influence is confined to the consumer's immediate environment (such as Zachary's biker club). Reference groups that affect consumption can include parents, co-workers, sororities or fraternities, fellow motorcycle enthusiasts, or simply casual acquaintances.

Obviously, some groups and individuals exert a greater influence than others, and affect a broader range of consumption decisions. For example,

Table 12-1 Three Forms of Reference Group Influence

Informational influence	• The— individual seeks information about various brands from an association of professionals or independent group of experts. • The individual seeks information from those who work with the product as a profession. • The individual seeks brand-related knowledge and experience (such as how Brand A's performance compares to Brand B's) from friends, neighbors, relatives, or work associates who have reliable information about the brands. • The brand the individual selects is influenced by observing a seal of approval of an independent testing agency (such as *Good Housekeeping*). • The individual's observation of what experts do (such as observing the type of car that police drive or the brand of television that repairmen buy) influences his or her choice of a brand.
Utilitarian influence	• So that he or she satisfies the expectations of fellow work associates, the individual's decision to purchase a particular brand is influenced by their preferences. • The individual's decision to purchase a particular brand is influenced by the preferences of people with whom he or she has social interaction. • The individual's decision to purchase a particular brand is influenced by the preference of family members. • The desire to satisfy the expectations that others have of him or her has an impact on the individual's brand choice.
Value-expressive influence	• The individual feels that the purchase or use of a particular brand will enhance the image others have of him or her. • The individual feels that those who purchase or use a particular brand possess the characteristics that he or she would like to have. • The individual sometimes feels that it would be nice to be like the type of person that advertisements show using a particular brand. • The individual feels that the people who purchase a particular brand are admired and respected by others. • The individual feels that the purchase of a particular brand would help show others what he or she is or would like to be (such as an athlete, successful businessperson, good parent, and so on).

Source: Adapted from C. Whan Park and V. Parker Lessig, "Students and Housewives: Differences in Susceptibility to Reference Group Influence," *Journal of Consumer Research* 4 (September 1977): 102. Reprinted with permission by The University of Chicago Press.

our parents may play a pivotal role in forming our values toward many important issues, such as attitudes about marriage or where to go to college. This type of influence is **normative influence**—that is, the reference group helps set and enforce fundamental standards of conduct as it gives reinforcement and criticism to the individual. Normative influence may result in conformity to the fashion norms of a particular group as individuals attempt to gain acceptance by group members. Many studies have found that fashion conformity is related to peer acceptance.[6] In contrast, a Harley-Davidson club might exert **comparative influence**, where decisions about specific brands or activities are affected as individuals compare themselves to group members.[7]

Formal versus Informal Groups

A reference group can take the form of a large, formal organization that has a recognized structure, complete with a charter, regular meeting times, and officers. Or it can be small and informal, such as a group of friends or students living in a dormitory. Marketers tend to be more successful at influencing formal groups because they are more easily identifiable and accessible.

However, as a rule, small, informal groups exert a more powerful influence on individual consumers. For example, in a recent Roper Starch Worldwide survey, 34 percent of teens said that their friends' ideas had the greatest influence on how they spend their money, while only 25 percent said that advertising had the same impact.[8] These groups tend to be more involved in our day-to-day lives and to be more important to us, because they are high in normative influence. Larger, formal groups tend to be more product- or activity-specific and, thus, are high in comparative influence.

Membership versus Aspirational Reference Groups

Although some reference groups consist of people the consumer actually knows (**membership reference groups**) others are composed of people the consumer can identify with or admire (**aspirational reference groups**). Not surprisingly, many marketing efforts that specifically adopt a reference group appeal concentrate on highly visible, widely admired figures (such as well-known athletes or celebrities).

Although the consumer may have no direct contact with reference groups, they can have powerful influences on his or her tastes and preferences, because they provide guidance as to the types of products used by admired people.[9] For example, one study that included business students who aspired to the "executive" role found a strong relationship between products they associated with their *ideal selves* (see Chapter 5) and those they assumed would be owned or used by executives.[10]

Since people tend to compare themselves to others who are similar, they often are swayed by knowing how people like them conduct their lives. For this reason, many promotional strategies include "ordinary" people whose consumption activities provide informational (or comparative) social influence. Some fashion ads targeting a certain group—for example, Levi's ad campaigns—have used everyday people.

The likelihood that people will become part of a consumer's membership reference group is affected by several factors, including the following:

- *Propinquity:* As physical distance between people decreases and opportunities for interaction increase, relationships are more likely to form. Physical nearness is called *propinquity*. An early study on friendship patterns in a housing complex showed this factor's strong effects: Residents were much more likely to be friends with the people next door than with those who lived only two doors away. And people who lived next to a staircase had more friends than those at the ends of a hall (presumably, they were more likely to "bump into" people using the stairs).[11] Physical structure has a lot to do with whom we get to know and how popular we are.

- *Mere exposure:* We come to like people or things simply as a result of seeing them more often, which is known as the *mere exposure phenomenon.*[12] Greater frequency of contact, even if unintentional, may help determine one's set of local referents. The same effect holds when evaluating a fashion item. As it becomes more and more widespread and accepted, we see it everywhere, it becomes familiar, and then we begin to like it.

- *Group cohesiveness: Cohesiveness* refers to the degree to which members of a group are attracted to each other and value their group membership. As the value of the group to the individual increases, so too does the likelihood that the group will guide consumption decisions. Smaller groups tend to be more cohesive, because it is more difficult to relate to larger groups of people. Members of small groups interact frequently and tend to define one another as members. Through appearance, group members express their interests and identities. The group rewards the individual, which in turn promotes a sense of cohesiveness. Clothing and appearance provide a visible basis for assigning and receiving rewards in the form of compliments and group recognition.[13] One study of teenage girls found that the movement from an individual's social isolation to social acceptance in a group was facilitated by a higher degree of group cohesiveness and the display of dress and appearance shared by the group.[14] By the same token, groups often try to restrict membership to a select few, such as sororities and fraternities, which increases the value of membership to those who are admitted.

Positive versus Negative Reference Groups

Reference groups may exert *either* a positive or a negative influence on consumption behaviors. In most cases, consumers model their behavior to be consistent with what they think the group expects of them. One study found high agreement among adolescents in the identification of peers who were "best dressed" and "not dressed right,"[15] indicating high awareness of

AN AMERICAN PRINCESS LOST

Carolyn Bessette Kennedy was killed as she went down in a small private plane on July 16, 1999, with her husband, John F. Kennedy Jr., and her sister. "Fashion appears to have lost its newest and brightest fashion icon—the only real successor to her mother-in-law, Jacqueline Onassis," stated a news report. The news focused largely on John's fate—the latest in a long history of Kennedy family tragedies—but in the eyes of the fashion industry it was Carolyn's loss that was felt. Some felt that Carolyn Bessette Kennedy was a designer's dream that comes along once in a lifetime: a striking woman of easy style who commanded attention. She was a natural beauty whose style went beyond clothes, beyond the aid of fashiony adornment. She was as glamorous and gorgeous dressed in T-shirt and jeans as in the

intense Yohji Yamamoto suits that became her trademark for high-profile events.

Carolyn was a woman who epitomized that grail of fashion: "She wears the clothes, the clothes don't wear her." Once the paparazzi got wise to her as JFK Jr.'s girlfriend and her pictures started appearing everywhere, her influence soared; everyone wanted her look. She could catapult designers' names just by wearing their creations. These designers included Calvin Klein, for whom she once served as public relations director; Narciso Rodriguez, who designed her wedding dress; and Yamamoto. Although a powerful influence, Carolyn was fiercely protective of her private life and, as with her mother-in-law, this created only more intense public interest.[16]

Carolyn Bessette Kennedy had referent power, as consumers looked upon her as an aspirational referent. Photo: Steve Eichner Women's Wear Daily.

fashion expectations. In some cases, though, a consumer may try to distance himself or herself from other people or groups that function as *avoidance groups*. He or she may carefully study the dress or mannerisms of a disliked group (such as "nerds," "druggies," or "preppies") and scrupulously avoid buying anything that might identify him or her with that group. Maybe that's why the television show *What Not to Buy* on TLC (http://tlc.discovery.com/fansites/whatnottowear/whatnottowear.html) is popular with fashionistas who wouldn't be caught dead in the "wrong" outfit.

Virtual Communities

In ancient times (that is, before the Internet was widely accessible), most membership reference groups consisted of people who had face-to-face contact. Now, it's possible to share interests with people whom you've never met—and probably never will. A **virtual community of consumption** is a collection of people whose online interactions are based on shared enthusiasm for and knowledge of a specific consumption activity. These anonymous groups grow up around quite a diverse set of interests; everything from Barbie dolls to fine wine. Virtual communities come in many different forms:[17]

- *Multi-User Dungeons (MUDs):* Originally, these were environments in which players of fantasy games met. Now they refer to any computer-generated environment in which people socially interact through the structured format of role and game playing. Online gaming is catching on in a big way: Sony Online Entertainment's gaming Web site, The Station (www.station.com), has more than 12 million registered users, while Microsoft's Gaming Zone (www.zone.com) boasts a membership of 29 million.[18]

- *Rooms, Rings, and Lists:* These include Internet Relay Chat (IRC), otherwise known as *chat rooms*. *Rings* are organizations of related home pages, and *lists* are groups of people on a single mailing list who share information.

- *Boards:* Online communities organize around interest-specific electronic bulletin boards. Active members read and post messages sorted by date and subject. There are boards devoted to musical groups, movies, cigars, cars, comic strips, and other pop cultural icons.

- *Blogs:* The newest and fastest-growing form of online community is the **weblog**, or *blog*. Bloggers can fire off thoughts on a whim, click a button, and quickly have them appear on a site. Weblogs frequently look like online diaries, with brief musings about the days' events, and perhaps a link or two of interest. Although these sites are similar to Web pages offered by Geocities and other free services, they employ a different technology that lets people upload a few sentences without going through the process of updating a Web site built with conventional home page software. This burgeoning **blogosphere** (the name given to the universe of active weblogs) is definitely a force to be reckoned with. A recent survey found that blog readership is increasing dramatically—despite the fact that 62 percent of adult American Internet users still don't know what a blog is, researchers estimate that over 32 million Americans are blog readers.[19]

Many products, especially those targeted to young people, are often touted as a way to take the inside track to popularity. This Brazilian shoe ad proclaims, "Anyone who doesn't like them is a nerd."

Virtual communities are still a new phenomenon, but their impact on individuals' product preferences promises to be huge. These loyal consumers essentially are working together to form their tastes, evaluate product quality, and even negotiate for better deals with producers. They place great weight on the judgments of their fellow members.

Although consumption communities are largely a grassroots phenomenon founded by consumers for other consumers, these community members can be reached by marketers—if they are careful not to alienate members by being too aggressive or "commercial." Using newsgroup archives, companies can create a detailed profile of any individual consumer who has posted information.

In addition, some online start-ups are profiting by creating Web sites that give people a forum for their opinions about products likes and dislikes. The Web site www.eopinions.com both rewards and rates product reviewers, in hope of giving them enough incentive to provide useful opinions. Anyone can sign up to give advice on products that fit into the site's categories, and shoppers can rate the reviews on a scale from not useful to very useful. It mimics the way word of mouth works in the real world. When a recommendation results in a sale, the company earns a referral fee from merchants.[20]

How do people get drawn into consumption communities? Internet users tend to progress from asocial information gathering ("lurkers" are surfers who like to watch but don't participate) to increasing social activities. At first they will merely browse the site but later they may well be drawn into active participation. The intensity of identification with a virtual community depends on two factors. The first is that the more central the activity to a person's self-concept, the more likely he or she will be to pursue an active membership in a community. The second is that the intensity of the social relationships the person forms with other members of the virtual community helps determine his or her extent of involvement. Combining these two factors creates four distinct member types:

1. *Tourists* lack strong social ties to the group and maintain only a passing interest in the activity.
2. *Minglers* maintain strong social ties but are not very interested in the central consumption activity.

3. *Devotees* express strong interest in the activity but have few social attachments to the group.

4. *Insiders* exhibit both strong social ties and strong interest in the activity.

Devotees and insiders are the most important targets for marketers who wish to leverage communities for promotional purposes. They are the heavy users of virtual communities. And, by reinforcing usage, the community may upgrade tourists and minglers to insiders and devotees.[21] Marketers have only scratched the surface of this intriguing new virtual world.

When Reference Groups Are Important

Reference group influences are not equally powerful for all types of products and consumption activities. For example, generally products that are not very complex, that are low in perceived risk, and that can be tried prior to purchase are less susceptible to personal influence.[22] Clothing generally is not seen as very complex and, of course, it can be tried on before purchase; thus, it would have lower susceptibility to influence. But a fashion item may be high in perceived risk if the item is not well tested by others and, therefore, may be high in susceptibility to influence.

In addition, the specific impact of reference groups may vary. At times they may determine the use of certain products rather than others (such as owning or not owning a computer, or eating junk food versus health food), while at other times they may have specific effects on brand decisions within a product category (such as wearing Levi's versus Diesel jeans).

Two dimensions that influence the degree to which reference groups are important are whether the purchase is to be consumed publicly or privately and whether it is a luxury or a necessity. As a rule, reference group effects are more robust for purchases that are

1. *Luxuries* (such as diamonds) rather than necessities, since products that are purchased with discretionary income are subject to individual tastes and preferences, whereas necessities do not offer this range of choices.

2. *Socially conspicuous or visible to others* (such as fashion apparel or living room furniture), since consumers tend to be swayed more by the opinions of others if their purchases will be observed by others.[24]

The relative effects of reference group influences on some specific product classes are shown in Figure 12-1.

The Power of Reference Groups

Why are reference groups so persuasive? The answer lies in the potential power they wield over us.

Social power refers to "the capacity to alter the actions of others."[25] To the degree that you are able to make someone else do something, whether they do it willingly or not, you have power over that person. The following classification of *power bases* can help us distinguish among the reasons a person can exert power over another, the degree to which the influence is allowed voluntarily, and whether this influence will continue to have an effect in the absence of the power source.[26]

FIGURE 12-1
Relative Reference Group Influence on Purchase Decisions

Source: Adapted from William O. Bearden and Michael J. Etzel. "Reference Group Influence on Product and Brand Purchase Decisions." *Journal of Consumer Research* (September 1982): 185. Reprinted with permission by The University of Chicago Press.

Referent Power

If a person admires the qualities of a person or a group, he or she will try to imitate those qualities by copying the referent's behaviors (such as choice of clothing, cars, or leisure activities) as a guide to forming consumption preferences, just as Zack's preferences were affected by his fellow bikers. Prominent people in all walks of life can affect people's consumption behaviors by virtue of product endorsements (such as Michael Jordan for Air Nike), distinctive fashion statements (such as Fergie's displays of high-end designer clothing), or championing causes (such as Elizabeth Taylor's work for AIDS). **Referent**

THE LEADING LADIES

From Clara Bow to Lisa Kudrow, Hollywood's leading ladies have left their mark on fashion. Clara Bow's look of flapper dresses, flaming red hair, rolled stockings, and sparkling Charleston shoes were imitated across America. *Women's Wear Daily* lists the most influential Hollywood figures over the years for clothing, shoes, and hairstyles:[23]

Clara Bow, Greta Garbo, Claudette Colbert, Hedy Lamarr, Rita Hayworth, Jean Harlow, Greer Garson, Loretta Young, Joan Blondell, Betty Grable, Lana Turner, Marlene Dietrich, Esther Williams, Elizabeth Taylor, Ginger Rogers, Barbara Stanwyck, Bette Davis, Rosalind Russell, Joan Crawford, Rita Hayworth, Veronica Lake, Grace Kelly, Audrey Hepburn, Kathryn Hepburn, Sophia Lauren, Marilyn Monroe, Lauren Bacall, Sandra Dee, Annette Funicello, Debbie Reynolds, Doris Day, Lucille Ball, Faye Dunaway, Diane Keaton, Mia Farrow, Jane Fonda, Farrah Fawcett, Bo Derek, Joan Collins, Linda Evans, Jennifer Beals, Madonna, Uma Thurman, Gwyneth Paltrow, Lisa Kudrow, Jennifer Aniston, and the list goes on.

power is important to many marketing strategies because consumers voluntarily change behaviors to please or identify with a referent.

Information Power

A person can have power simply because he or she knows something others would like to know. Editors of trade publications in the fashion industry such as *Women's Wear Daily* often possess power due to their ability to compile and disseminate information that can make or break individual designers or companies. People with **information power** are able to influence consumer opinion by virtue of their (assumed) access to the "truth."

Legitimate Power

Sometimes people are granted power by virtue of social agreements, such as the power given to policemen and professors. The **legitimate power** conferred by a uniform is recognized in many consumer contexts, including teaching hospitals, where medical students don white coats to enhance their aura of authority with patients, and banks, where tellers' uniforms communicate trustworthiness.[27] This form of power may be "borrowed" by marketers to influence consumers. For example, an ad featuring a model wearing a white doctor's coat can add an aura of legitimacy or authority to the presentation of the product.

Expert Power

Fashion designers are seen as possessing expert power since they are the makers of fashion and they have the skill to develop new apparel lines each season. Some designers are *hot* one season, and *not* the next. Thus, their influence

The famous image of Audrey Hepburn still provides referent power.

is as good as their last success (not unlike movie makers and actors). **Expert power** is derived from possessing a specific knowledge or skill.

Reward Power

When a person or group has the means to provide positive reinforcement, that entity will have **reward power** over an individual to the extent that this reinforcement is valued or desired. The reward may be tangible, as occurs when an employee is given a raise. Or the reward may be intangible: Social approval or acceptance is exchanged in return for molding one's behavior to a group or buying the products that are expected of group members. Often fashion items fall into this category.

Coercive Power

Although a threat often is effective in the short term, it does not tend to produce permanent attitudinal or behavioral change. **Coercive power** refers to influencing a person by social or physical intimidation. Fortunately, coercive power is rarely employed in marketing situations. However, elements of this power base are evident in fear appeals, intimidation in personal selling, and some campaigns that emphasize the negative consequences that might occur if people do not use a product.

FASHION CONFORMITY AND INDIVIDUALITY

We all have had a dilemma related to dress and appearance: How can I fit in with others and still be an individual? How can I look similar to my friends or the gang and still stand out? There is a tension between dressing to fit in and dressing to be unique, which escalates when an individual wants to follow fashion—a conforming behavior—while also wanting to appear as an original person.[28] Certainly sales associates face the challenge of helping customers find apparel and accessories that meet their individual needs within a framework of conforming fashion. Sorority/fraternity members' appearance, school uniforms, and formal and informal workplace dress codes are all areas where the forces of conformity and individuality function.

Conformity refers to a change in beliefs or actions as a reaction to real or imagined group pressure. In order for a society to function, its members develop **norms,** or informal rules that govern behavior. Conformity in dress can be thought of as acceptance of or adherence to a clothing norm, which represents the typical or accepted manner of dressing shown by a specified group.[29] We use the term **mode** to mean the most common form of clothing worn among a given group of people, or the greatest frequency of a **style** (a characteristic or distinctive form of dress). **Fashion** represents the popular, accepted, prevailing style at any given time. **Individuality** in dress refers to a desire to set one's self apart from the norm.

Information from reference groups can lead to conformity with group norms. This is especially prevalent when groups such as high school cliques adhere to strictly defined fashion norms. School uniforms also is an example of conformity in dress, albeit imposed upon students by the institution. Former President Clinton made school uniforms a national topic when he

proposed uniforms in public schools as a way to reduce violence (discussed in his State of the Union address, January 23, 1996). The connection between reducing violence and wearing school uniforms has not been fully supported, and a cause-and-effect relationship is difficult to prove. Although school uniforms are thought of as a way to de-emphasize differences, students always seem to use their creativity to find a way to individualize their conforming uniform.[30]

Similarly, dress codes in the workplace act to create or maintain a unified look or image. They are sometimes explicit—that is, clearly explained to the employee (perhaps written)—but more often they are implicit, where clothing norms are "understood" and followed. Fellow employees thus serve as a comparative reference group that provides information on how to appropriately conform.

Factors Influencing the Likelihood of Conformity

Conformity is not an automatic process, and many factors contribute to the likelihood that consumers will pattern their behavior after others.[31] Among the factors that affect the likelihood of conformity are the following:

- *Cultural pressures:* Different cultures encourage conformity to a greater or lesser degree. The American slogan "Do your own thing" in the 1960s reflected a movement away from conformity and toward individualism. In contrast, Japanese society is characterized by the dominance of collective well-being and group loyalty over individuals' needs.

- *Fear of deviance:* The individual may have reason to believe that the group will apply *sanctions* to punish behavior that differs from the group's. It is not unusual to observe adolescents shunning a peer who is "different" or a corporation passing over a person for promotion because he or she is not a "team player."

- *Commitment:* The more a person is dedicated to a group and values membership in it, the more motivated he or she will be to follow the dictates of the group. Rock groupies and followers of television evangelists may do anything their idols ask of them.

- *Group unanimity, size, and expertise:* As groups gain in power, compliance increases. It is often harder to resist the demands of a large number of people than just a few. Resistance to conformity is compounded when the group members are perceived to know what they are talking about.

- *Susceptibility to interpersonal influence:* This trait refers to an individual's need to identify or enhance his or her image in the opinion of significant others. This enhancement process often is accompanied by the acquisition of products the person believes will impress his or her audience, and by the tendency to learn about products by observing how others use them.[32] Consumers who are low on this trait have been called *role relaxed* and they tend to be older and affluent and to have high self-confidence. Young people, it has always been believed, are susceptible to influence. One study found that, as preadolescents age, social conformity increases.[33] Research with career women found that

those who were younger and new at their job (as opposed to older and veterans in their jobs) were more susceptible to influence from both personal and market sources regarding their dress.[34]

Social Comparison: "How'm I Doing?"

Sometimes we look to the behavior of others to provide a yardstick about reality. **Social comparison theory**, as discussed in Chapter 5, asserts that this process occurs as a way to increase the stability of one's self-evaluation.[35] Social comparison even applies to choices for which there is no objectively correct answer. Stylistic decisions as tastes in fashion, art, and music are assumed to be a matter of individual choice, yet people often assume that some types are "better" or more "correct" than others.[36]

Although people often like to compare their judgments and actions to those of others, they tend to be selective about precisely whom they will use as benchmarks. Similarity between the consumer and others used for social comparison boosts confidence that the information is accurate.[37] In general people tend to choose a *co-oriented peer,* or a person of equivalent standing, when undergoing social comparison. For example, a study of adult cosmetics users found that women were more likely to seek information about product choices from similar friends to reduce uncertainty and to trust the judgments of similar others.[38] The same effects have been found for evaluations of products as diverse as men's suits and coffee.[39] Also, it is not surprising that adolescent peer influence on clothing purchases increases with age while parental influence decreases.[40]

Compliance to Norms

The discussion of persuasive communications in Chapter 10 indicated that source and message characteristics have a big impact on the likelihood of influence. Influencers have been found to be more successful at gaining compliance if they are perceived to be confident or expert.[41] Actually, compliance to clothing norms may be a religious or a legal issue.

Group Effects on Individual Behavior

With more people in a group, it becomes less likely that any one member will be singled out for attention. People in larger groups or those in situations where they are likely to be unidentified tend to focus less attention on themselves, so normal restraints on behavior are reduced. You may have observed that people sometimes behave more wildly at costume parties or on Halloween night than they do normally. This phenomenon is known as **deindividuation**, in which individual identities get submerged within a group.

Social loafing refers to the fact that people do not devote as much to a task when their contribution is part of a larger group effort.[42] Students often complain that one grade for group projects is not fair since some students do much of the work while others "loaf." Has that ever happened to you?

There is some evidence that decisions made by groups differ from those that would be made by each individual. In many cases, group members show a greater willingness to consider riskier alternatives following group discussion

than they would if each member made his or her own decision with no discussion. This change is known as the *risky shift*.[43] Several explanations have been advanced to explain this increased riskiness. One possibility is that something similar to social loafing occurs. As more people are involved in a decision, each individual is less accountable for the outcome, so *diffusion of responsibility* occurs.[44]

Even shopping behavior changes when people shop in groups. For example, people who shop with at least one other person tend to make more unplanned purchases, buy more, and cover more areas of a store than those who go alone.[45] These effects are due to both normative and informational social influence. Group members may be convinced to buy a fashion item to gain the approval of the others, or they may simply be exposed to more products and stores by pooling information with the group. Teens have been found to enjoy shopping with friends as opposed to shopping alone. And they tend to spend more when shopping with friends than when shopping alone.[46] For these reasons, retailers are well-advised to encourage group shopping activities.

Home shopping parties, as epitomized by the Tupperware party[47] and similarly organized lingerie or toy parties (and even recent Botox parties), capitalize on group pressures to boost sales. A company representative makes a sales presentation to a group of people who have gathered in the home of a friend or acquaintance. This format is effective because of the rep's information power base resulting in influence. Participants model the behavior of others who can provide them with information about how to use or wear certain products, especially since the home party is likely to be attended by a relatively homogeneous group (such as neighbors) that serves as a valuable benchmark. Normative social influence also operates because actions are publicly observed. Pressures to conform may be particularly intense and may escalate as more and more group members begin to "cave in" (this process is sometimes termed the *bandwagon effect*). In addition, deindividuation and/or the risky shift may be activated: As consumers get caught up in the group, they may find themselves willing to try new products they would not normally consider.

Clothing Conformity and Group Membership

Fashion or clothing conformity can serve to identify group members, with clothing visually distinguishing group members from nonmembers.[48] Sororities and fraternities on college campuses are examples of group conformity in many ways, especially when wearing a group "uniform" or signifying pins. It is generally thought that members give up part of their individual identity to assume a collective one when they join a sorority or fraternity. However, one qualitative study concluded that today members do not necessarily demand a certain appearance.[49]

Some cultural and religious groups, such as the Amish, have strict rules for dress style, skirt length, and head coverings. Members gain personal identity from group membership. Purposeful violation of the rules can mean excommunication from the group, as breaking the rules would signify a questioning and abandoning of the rules that are rooted in the religious identity of the group.[50] Individuals in more loosely formed groups also can gain identity from the group by virtue of their appearance. A group look can emerge from

Sororities act as a reference group for college women.

close friendship groups. One look at high school cliques can clearly illustrate this. One study found college women who considered conforming dress important placed a low value on aesthetics and creativity. The most important thing to them was that it was acceptable to others around them.[51] Another study of high school students indicated a relationship between conformity to the clothing mode and peer acceptance.[52]

The Legal View of Clothing

Conformity in dress is often mandated by law. Complete freedom in dress does not exist in the United States. It is not guaranteed by law but is derived from legal principles that do not specifically mention dress, such as the First Amendment that guarantees the right to free speech, including symbolic communication. When an individual believes that his or her dress choices are too restricted, a challenge to the court can be made. Judicial decisions are based on societal definitions of norms, which not only change overtime but also differ based on location; therefore, decisions may appear to be inconsistent from case to case. They often consider such things as employer authority, freedom of religion, public safety, and the definition of symbolic conduct. One study reviewed 110 court cases dealing with dress and appearance in the workplace and in social situations:[53]

- *Teachers:* Can school boards institute dress and grooming codes restricting personal appearance of teachers? Judges generally ruled in favor of teachers' facial hair preferences, thus limiting school authority. Twelve cases dealt with clothing such as wearing a jacket and tie or miniskirts. Judges generally held that school boards were allowed to use their discretionary power to issue and enforce teachers' dress codes.

- *Public service:* The court ruled that facial hair on firemen could interfere with equipment use and long hair could be a fire hazard. Dress codes (and hair length) were also upheld for police officers and driver's license examiners.
- *Private business:* Employees felt that dress codes were unfair and resulted in sex role stereotyping. In the majority of the grooming-related cases, judges held that restricting hair/facial hair in the workplace did not constitute sex discrimination. In some cases employers were prohibited from using different policies for men and women. Employers generally have the right to project a particular image in their workplace.
- *Attorneys:* Judges regulated the dress of attorneys appearing before them in court. Failure to comply with judicial stipulations can result in sanctions. Several cases involved wearing miniskirts.
- *Wearing government symbols:* State and national flag laws prohibit mutilating, defacing, or defiling the flag. Cases have been heard related to wearing the flag; decisions have not been consistent, but generally the right to make the national flag into clothing has been denied. (The debate on this issue continues in Congress.)
- *Wearing group symbols:* Wearing group symbols such as Ku Klux Klan and Nazi symbols has been denied and perceived to infringe upon the rights of others. Decisions have been uneven, but most symbols are protected by free speech.
- *Dress for recreational activities:* Hippie dress in the 1970s restricted from a public park was declared unconstitutional because it labeled a group solely based on lifestyle. One case banning bathing suit attire as streetwear was not upheld. Nudity on public property has had uneven decisions; some states held that nudity offended public morals and standards of decency. On public beaches, judges have stated that individuals are free to demonstrate their clothing preferences provided that some clothing was worn.
- *Dress for public performances:* The First Amendment does guarantee symbolic conduct and communication but does not protect obscenity. Some nudity in plays has not been protected if there was no redeeming social merit. At times topless and nude dancing has been considered symbolic conduct and at other times has not. (Decency standards change over time.)

Fashion Independence: Resistance to Conformity

Many people pride themselves on their independence, unique style, or ability to resist the best efforts of salespeople and advertisers to buy products.[54] Indeed, individuality is encouraged by the marketing system (as long as you stay within the law!): Innovation creates change and demand for new products and styles. This is especially true in the field of fashion.

Individuality

Individuality in dress, as mentioned earlier, refers to an awareness of the norm and a desire to set one's self apart from it.[55] It is thought of as the

personification of characteristics that make each of us distinctive. This uniqueness is what sets us apart from others and makes each of us what we are: individual.[56] Signs of a person's individuality may be expressed through clothing choices in the following ways:[57]

- Rejecting styles that are in fashion because they are unflattering.
- Refraining from wearing the same style garments, hairstyle, and so on that everyone else is wearing.
- Choosing to wear a favorite color.
- Having a signature "look."
- Being known as the first to try new styles.

Anticonformity versus Independence

Researchers often view conformity and nonconformity as a unidimensional phenomenon. However, it can be pointed out that there are several ways in which to *not* conform, hence the confusing proliferation of terms such as *nonconformity, independence, anticonformity,* and *freedom.* One study identified freedom in dress as a separate dimension, not the polar opposite of conformity in dress.[58]

It is important to distinguish between these concepts as best we can. *Anticonformity* may be considered as defiance of the group as the actual object of behavior.[59] Some people will go out of their way *not* to buy whatever happens to be *in* at the moment. Indeed, they may spend a lot of time and effort to ensure that they will not be caught in fashion. This behavior is a bit of a paradox, since in order to be vigilant about not doing what is expected, one must always be aware of what is expected. In contrast, truly **independent** people are oblivious to what is expected; they "march to their own drummers."

Reactance and Need for Uniqueness

People have a deep-seated need to preserve freedom of choice. When they are threatened with a loss of this freedom, they try to overcome this loss. This negative emotional state is termed **reactance**.[60] For example, efforts to censor books, television shows, or rock music because some people find the content objectionable may result in an *increased* desire for these products by the public.[61] Our clothing choices are not generally censored, but there are some situations where this occurs. Many schools and some occupations today require uniforms. Students often subtly rebel against restrictions and, as mentioned earlier, find clever ways to include some form of individuality or uniqueness into their uniform such as a special way of wearing the collar or other part of their uniform. However, uniforms by their nature repress individuality and personal statements. In fact, adding personal or political statements to the uniform is not allowed for police or other government workers.

Similarly, extremely overbearing promotions that tell consumers they must or should use a product may create reactance and wind up losing more customers in the long run, even those who were already loyal to the advertised brand! Reactance is more likely to occur when the perceived threat to one's freedom increases and as the threatened behavior's importance to the consumer also increases.

If you have ever shown up at a party wearing the same outfit as someone else, you know how upsetting the discovery can be. Some psychologists believe that this reaction is a result of a *need for uniqueness*.[62] Because of its visual nature and its link to self-concept, clothing is one means of presenting our uniqueness to others. Consumers who have been led to believe that they are not unique are more likely to try to compensate by increasing their creativity or even to engage in unusual experiences. In fact, this need could be one explanation for the purchase of relatively obscure brands. People may try to establish a unique identity by deliberately *not* buying market leaders. We've heard students say lately, "I'm not a Gap person." This sentiment may be one reason for the increase in specialty boutiques as fashion-forward consumers do not want to wear mass fashion seen in so many chain, department, and discount stores today. Not surprisingly, one study found that fashion innovators portray a greater need for variety than fashion followers.[63]

WORD-OF-MOUTH COMMUNICATION

Despite the abundance of formal means of communication (such as newspapers, magazines, and television), much information about the world and consumer products actually is conveyed by individuals on an informal basis. If you think carefully about the content of your own conversations in the course of a normal day, you will probably find that much of what you discuss with friends, family members, or co-workers is product related: Whether you compliment a friend on her dress and ask her where she bought it, recommend a new restaurant to a friend, or complain to your neighbor about the shoddy treatment you got at the bank, you are engaging in **word-of-mouth communication (WOM)**.

WOM is important product information transmitted by individuals to individuals. Because we get the word from people we know, WOM tends to be more reliable and trustworthy than recommendations we get through more formal marketing channels. And unlike advertising, WOM often is backed up by social pressure to conform with these recommendations.[64] Recall, for example, that many of Zachary's biker purchases were directly initiated by comments and suggestions from his fellow RUBs. The power of this process was recognized by M.A.C. cosmetic company. This company is an anomaly in the $6 billion cosmetics industry because it doesn't advertise. Instead, the firm built WOM by offering discounts to professional makeup artists to encourage them to use the line.[65] By cultivating an image as the choice of beauty professionals, this company has become a huge success.

The importance of personal, informal product communication to marketers is underscored by one advertising executive who stated, "Today, 80 percent of all buying decisions are influenced by someone's direct recommendations."[66] Recall our discussion of virtual communities and Epinions.com. Sometimes these recommendations are obtained by giving out samples of the product and hoping people will talk about it.

The Dominance of WOM

As far back as the Stone Age (well, the 1950s, anyway), communications theorists began to challenge the assumption that advertising is the pri-

mary determinant of purchases. It is now generally accepted that advertising is more effective at reinforcing existing product preferences than at creating new ones.[67] There is even a word-of-mouth marketing association with a goal of teaching marketers to use alternatives to traditional advertising.[68] Studies in both industrial and consumer purchase settings underscore the idea that while information from impersonal sources is important for creating brand awareness, personal sources and word of mouth are relied on in the later stages of evaluation and adoption.[69] The more positive information a consumer gets about a product from peers, the more likely he or she will adopt the product.[70] The influence of others' opinions is at times even more powerful than one's own perceptions. In one study of furniture choices, consumers' estimates of how much their friends would like the furniture was a better predictor of purchase than their *own* evaluations.[71]

As marketers increasingly recognize the power of WOM to make or break a new product, they are coming up with new ways to get consumers to help them sell. In these cases, a "buzz" is intentionally created. Let's review two successful strategies.

Guerrilla Marketing and Seeding

Lyor Cohen, a partner in the Def Jam hip-hop label, built his business using street marketing tactics. To promote hip-hop albums, Def Jam and other labels start building a buzz months before a release, leaking advance copies to deejays who put together "mix tapes" to sell on the street. If the kids seem to like a song, *street teams* then push it to club deejays. As the official release date nears, these groups of fans start slapping up posters around the inner city. They plaster telephone poles, sides of buildings, and car windshields with promotions announcing the release of new albums.[72]

These streetwise strategies started in the mid 1970s, when pioneering deejays such as Kool DJ Herc and Afrika Bambaataa promoted their parties through graffiti-style flyers. This type of grassroots effort epitomizes **guerrilla marketing**, promotional strategies that use unconventional locations and intensive word-of-mouth campaigns to push products. As Ice Cube observed, "Even though I'm an established artist, I still like to leak my music to a kid on the street and let him duplicate it for his homies before it hits radio."[73]

Today, big companies are buying into guerrilla marketing strategies bigtime. Nike did it to build interest in a new shoe model.[74] When RCA Records wanted to create a buzz around teen pop singer Christina Aguilera, it hired a team of young people to swarm the Web and chat about her on popular teen sites like www.alloy.com, and www.gurl.com. Guerrilla marketing delivers: The album quickly went to No. 1 on the charts.

Similar to guerrilla marketing is **seeding** in which fashion firms quietly sneak next season's designs onto influential types—editors, stylists, artists, and deejays, people who have the power to influence others by word of mouth and "subtle osmosis."[75] *The New York Times* ran a major photo essay on Prada, invaluable publicity, as a result of the company's giveaway of expensive bags. However, product seeding can work only if the influentials like the product and decide to use it. Levi's, Ralph Lauren, and Tommy Hilfiger have been

seeding for years sending advance product to editors, musicians, and artists, giving them a chance to use the product and of course tell a friend or two. Levi's sent out hundreds of wide-legged K-1 khakis to editors, artists, Internet entrepreneurs, writers, and other creative types months in advance of shipments to stores. Sightings of the pants on hipsters in New York's East Village was proof enough that the method worked. However, there's no formal measurement tool for seeding; how do you measure buzz?

Viral Marketing

Many students are big fans of Hotmail, a free e-mail service. But there's no such thing as a free lunch: Hotmail inserts a small ad on every message sent, making each user a salesperson. Hotmail had 5 million subscribers in its first year and continues to grow exponentially.[76] **Viral marketing** refers to the strategy of getting customers to sell a product on behalf of the company that creates it. This approach is particularly well-suited to the Web, since e-mails circulate so easily. According to a study by Jupiter Communications, only 24 percent of consumers say they learn about new Web sites in magazine or newspaper ads. Instead, they rely on friends and family for new site recommendations, so viral marketing is their main source of information about new sites.[77]

As an advertising concept, viral ads should add value to the consumer's experience, such as something entertaining, educational, or rewarding (such as a discount coupon). Viral ads also have the objective of brand building. Jockey's "Make a Flake" campaign, one holiday season, recorded close to 2 million "snowflakes." As the sponsor of this successful campaign, it positioned its logo on the site and offered special offers on its products.[78]

A similar example of viral advertising is a 2005 Gap ad where viewers created an image of themselves by adjusting the physical traits of an animated model including weight, skin tone, and even jawline and then picked out outfits for the model who began gyrating to club music. The Gap logo flashed at the beginning of the ad and appeared in the corner of the computer screen as a reminder. The ad did not prompt viewers to buy Gap clothing—at least not directly.[79] The ad depended on the viewer to spread the word about the Web site allowing the ad to take on a life of its own rather than the company making a direct sales pitch. Similar to guerilla advertising, no one knows how effective the ads are, but they certainly are good at generating buzz.

Social Networking

Social networking is the newest form of word of mouth. Web sites like Facebook and MySpace let members post information about themselves and make contact with others who share similar interests and opinions or who want to make business contacts. People who register on sites can set up a home page with photos, a profile, and links to others in their social networks. Users can browse for friends, dates, or contacts of all kinds and invite them to join the users' personal networks as "friends." Probably every one of you spends time on one of these sites. They range from the fun to the serious:

- Facebook (www.facebook.com) was started by five Harvard students and is now the most popular way to either network or waste time for millions

of young people. In addition to listing their favorite movies, books, music, and so on, they can also submit lists of friends as they form groups based on common interests. These groups cover the waterfront; they include such pressing issues as People against Popped Collars (the preppy look of rolling up the collar of your knit shirt), Future Trophy Wives of America, and even a group called People against Groups.[80]

- MySpace (www.myspace.com) similarly is a site offering an interactive, user-submitted network of friends, personal profiles ("about me" and "who I'd like to meet"), a comment section, blogs, groups, photos, music, and videos. The User's Friends Space contains a count of a user's friends, a "Top Friends" area, and a link to view all of the user's friends. A Fashion Fix brings you to the Instyle.com site. With a million registered users around the world, marketers are taking advantage of this hugely popular site including a group of young designers.[81]

- At Ryze (www.ryze.com), registrants set up personal Web pages to communicate with current and prospective business contacts. A typical page might include photos and graphics, along with a résumé-like description of business and academic achievements, before going into personal hobbies and other nonbusiness topics.[82]

Factors Encouraging WOM

Most WOM campaigns happen spontaneously, as a product begins to develop a regional following. As we've seen, a "buzz" can be intentionally created. Lee Jeans did that by creating a "phantom campaign" based on the retro hero Buddy Lee as illustrated in Chapter 10. The company quietly put up posters of Buddy Lee in cities such as New York and Los Angeles and waited for momentum to build before launching TV commercials that were shown during shows such as *Dawson's Creek*.[83] Product-related conversations can be motivated by a number of factors:[84]

- A person might be highly involved with a type of product or activity and get pleasure in talking about it. Fashion enthusiasts, computer hackers, and avid birdwatchers seem to share the ability to steer a conversation toward their particular interest.

- A person might be knowledgeable about fashion and use conversations as a way to let others know it. Thus, word-of-mouth communication sometimes enhances the ego of the individual who wants to impress others with his or her expertise.

WOM STAGED

A thirty-second commercial on the *Today* show costs more than $25,000. To avoid paying this fee, several companies have tried to drum up word of mouth by getting free exposure on *Today's* live cameras, which periodically pan over the crowd gathered outside the studio window at Rockefeller Center in Manhattan. Companies including the Gap, General Mills, Avon, Oscar Mayer, and BMW all have tried to entice the cameras by dressing employees in outlandish costumes or performing attention-grabbing stunts. The Gap's Old Navy division dressed five people as Old Navy candy bars to mingle with tourists and pass out samples.[85] Other companies have done similar things. The *Today* show staff was not amused.

- A person might initiate such a discussion out of a genuine concern for someone else. We often are motivated to ensure that people we care about buy what is good for them, do not waste their money, and so on.
- One way to reduce uncertainty about the wisdom of a purchase is to talk about it. Talking gives the consumer an opportunity to generate more supporting arguments for the purchase and to garner support for this decision from others.

Negative WOM

Word of mouth is a two-edged sword that can cut both ways for marketers. Informal discussions among consumers can make or break a product or store. Furthermore, negative word of mouth is weighted *more* heavily by consumers than are positive comments. According to a study by the White House Office of Consumer Affairs, 90 percent of unhappy customers will not do business with a company again. Each of these people is likely to share their grievance with at least nine other people, and 13 percent of these disgruntled customers will go on to tell more than *thirty people* of their negative experience.[86] Especially when making a decision about trying a product innovation, the consumer is more likely to pay attention to negative information than positive information and to relate news of this experience to others.[87] Negative WOM has been shown to reduce the credibility of a firm's advertising, and to influence consumers' attitudes toward a product as well as their intention to buy it.[88]

Negative WOM is even easier to spread online. Many dissatisfied customers and disgruntled former employees have been "inspired" to create Web sites just to share their tales of woe with others. For protest sites, visit www.protest.net and prepare to be outraged. Check out what protests are going on in your city.

Rumors: Distortion in the Word-of-Mouth Process

In the 1930s, "professional rumormongers" were hired to organize word-of-mouth campaigns to promote clients' products and criticize those of competitors.[89] A rumor, even if it has no basis in fact, can be a very dangerous thing. As information is transmitted among consumers, it tends to change. The resulting message usually does not at all resemble the original.

Social scientists who study rumors have examined the process by which information gets distorted. British psychologist Frederic Bartlett used the method of *serial reproduction* to examine this phenomenon. As in the game of "telephone" that you probably played as a child, a subject is asked to reproduce a stimulus, such as a drawing or a story. Another subject is given this reproduction and asked to copy that, and so on. This technique is shown in Figure 12-2. Bartlett found that distortions almost inevitably follow a pattern: They tend to change from ambiguous forms to more conventional ones as subjects try to make them consistent with preexisting schemas. This process, known as *assimilation,* is characterized by *leveling*, where details are omitted to simplify the structure, or *sharpening*, where prominent details are accentuated.

The Web is a perfect medium for spreading rumors and hoaxes, some of which involve major corporations. A popular one resulted in Nike receiving several hundred pairs of old sneakers a day after the rumor spread that if you send

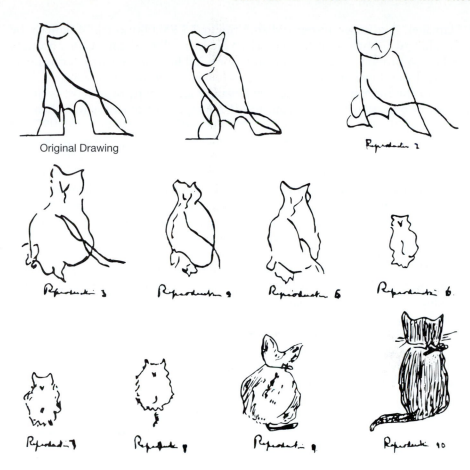

FIGURE 12-2
The Transmission of
Misinformation
These drawings provide a classic example of the distortions that can occur as information is transmitted from person to person. As each participant reproduces the figure, it gradually changes from an owl to a cat.
Source: Kenneth J. Gergen and Mary Gergen, *Social Psychology* (New York: Harcourt Brace Jovanovioch, 1981): 365, Fig. 10-3; adapted from F. C. Bartlett, *Remembering* (Cambridge, England: Cambridge University Press, 1932).

your old, smelly shoes you would get a free pair of new shoes in exchange (pity the delivery people who had to cart these packages to the company). There are Web sites dedicated to tracking hoaxes such as www.hoaxkill.com and www.hoaxbusters.ciac.org. The moral: Don't believe everything you click on.

In general, people have been shown to prefer transmitting good news rather than bad, perhaps because they like to avoid unpleasantness or dislike arousing hostility.[90] However, this reluctance does not appear to occur when companies are the topic of conversation. Corporations such as Tommy Hilfiger and Liz Claiborne have been the subjects of rumors about their products, sometimes with noticeable effects on sales. One study found that a Tommy Hilfiger rumor had gained some level of credence among students, many of whom had consciously chosen not to purchase Tommy gear as a result.[91]

Consumer Boycotts

Sometimes a negative experience can trigger an organized and devastating response, as when a consumer group organizes a *boycott* of a company's products. These can include threats to boycott if a company does not change some policy or actual protests and boycotts. One ongoing protest is against the use of furs for fashion. The day after Thanksgiving has traditionally seen protests from animal activists in upscale shopping areas; however, protests are seen at any time of the year. They can be peaceful or they can inflict costly

damages. Antifur protesters did an estimated $200,000 worth of damage by breaking windows in the San Francisco Neiman Marcus store. Other protests relate to products from a politically undesirable country (many consumers individually boycott apparel and other consumer products made in China due to the human rights issue), while still another type of boycott is in the form of objections to an organization's management practices (as when the Southern Baptist Convention voted to boycott Disney products in 1997 due to its conviction that the company's policies were inappropriately pro-gay and lesbian).

Boycotts are not always effective—studies show that only 18 percent of Americans participate in them. However, those who do are disproportionately upscale and well educated, so they are a group that companies especially don't want to alienate. One increasingly popular solution used by marketers is setting up a joint task force with the boycotting organization to try to iron out the problem.

Although many consumer boycotts are not effective, some are. Calvin Klein's controversial ads featuring teenage models in provocative poses were criticized as "kiddy porn." They were pulled by the company after a call for a consumer boycott by groups such as the Catholic League and Morality in Media. In addition, some retailers declined to have their name listed in the ads.[92]

OPINION LEADERSHIP

Although consumers get information from personal sources, they do not tend to ask just *anyone* for advice about purchases. If you decide to buy a new fashion item, you will most likely seek advise from a friend who has a reputation for being stylish and who spends his or her free time reading *Vogue, Elle,* or *Gentlemen's Quarterly* and shopping at trendy boutiques. On the other hand, if you decide to buy a new stereo, you will seek advice from friends who know a lot about sound systems. These friends may own sophisticated systems, or they may subscribe to specialized magazines such as *Stereo Review* and spend free time browsing through electronics stores. While you might not bring up your fashion interest with your stereo friends, you may take them to the stereo store with you.

The Nature of Opinion Leadership

Everyone knows people who are knowledgeable about products and whose advice is taken seriously by others. These individuals are **opinion leaders** or sometimes called **influentials**. An opinion leader is a person who is frequently able to influence others' attitudes or behaviors.[93] A fashion influential's adoption of a new style gives it prestige among a group.[94] Opinion leaders are extremely valuable information sources for a number of reasons:

1. They are technically competent and thus are convincing because they possess expert power.[95]
2. They have prescreened, evaluated, and synthesized product information in an unbiased way, so they possess knowledge power.[96] Unlike commercial endorsers, opinion leaders do not actually represent the

interests of one company. They are more credible because they have no "axe to grind."

3. They tend to be socially active and highly interconnected in their community.[97] They are likely to hold office in community groups and clubs and to be active outside of the home. As a result, opinion leaders often have legitimate power by virtue of their social standing.

4. They tend to be similar to the consumer in terms of their values and beliefs, so they possess referent power. Note that while opinion leaders are set apart by their interest or expertise in a product category, they are more convincing to the extent that they are *homophilous* rather than *heterophilous. Homophily* refers to the degree that a pair of individuals is similar in terms of education, social status, and beliefs.[98] Effective opinion leaders tend to be slightly higher than those they influence in terms of status and educational attainment, but not so high as to be in a different social class.

5. Opinion leaders often are among the first to buy new products, so they absorb much of the risk. This experience reduces uncertainty for others who are not as courageous. And while company-sponsored communications tend to focus exclusively on the positive aspects of a product, this hands-on experience makes opinion leaders more likely to impart *both* positive and negative information about product performance.

Fashion Opinion Leadership

Fashion opinion leaders are thought of as those who buy fashions early in the fashion season. Like other opinion leaders, they take the risk and others then follow that lead. Opinion leaders in some fields may or may not be purchasers of the products they recommend. As we saw in Chapter 1, those who are the first to use a new product are known as *innovators*. (A caveat as we delve into terminology usage: Unfortunately terms are not used consistently throughout the literature.) Opinion leaders who also are early purchasers have been termed *innovative communicators*. Fashion theorists use the term *fashion leader*, which may be similar to a fashion opinion leader. One early theorist stated this of fashion leaders: "The leader of fashion does not come into existence until the fashion is itself created . . . a king or person of great eminence may indeed lead the fashion, but he leads only in the general direction which it has already adopted."[99] Thus, the leader may "head the parade" or further the trend toward a new fashion. True fashion leaders constantly seek distinction and, therefore, are likely to launch a succession of fashions rather than just one, as perhaps a celebrity might do at the height of his or her popularity. Table 12-2 lists items that have been used to measure fashion opinion leadership.[100]

A review of twenty fashion adoption research studies spanning thirty-five years indicated no clear distinction between such labels as *fashion innovator, fashion leader, innovative communicator, early adopter*, and other similar terms. However, the term *early adopter* seems to be generic enough to encompass those terms, and may be a better label. That person exhibits the following demographic profile:[101]

- Relatively young
- Not married; has no children

Table 12-2 Fashion Opinion Leadership Scale

Others consult me for information about the latest fashion trends.

My friends ask for my opinion about new clothing styles.

My friends think of me as a knowledgeable source of information about fashion trends.

I generally pass along fashion information to others.

I like to help others make decisions about fashion.

It is important to share one's opinion about new styles with others.

I recently convinced someone to change an aspect of his or her appearance to something more fashionable.

Source: Patricia Huddleston, Imogene Ford, and Marianne C. Bickle, "Demographic and Lifestyle Characteristics as Predictors of Fashion Opinion Leadership among Mature Consumers," *Clothing and Textiles Research Journal* 11, no. 4 (1993): 26–31.

- Relatively high income and occupational level
- Female
- Reads fashion magazines
- Mobile
- Gregarious, social, conforming, and competitive
- Likes or does not object to change
- Tends to be an exhibitionist or narcissistic

How Influential Is an Opinion Leader?

When marketers and social scientists initially developed the concept of the opinion leader, it was assumed that certain influential people in a community would exert an overall impact on group members' attitudes. Later work, however, began to question the assumption that there is such a thing as a *generalized opinion leader*, somebody whose recommendations are sought for all types of purchases. Very few people are capable of being expert in a number of fields. Sociologists distinguish between those who are *monomorphic*, or experts in a limited field, and those who are *polymorphic*, or experts in several fields.[102] Even opinion leaders who are polymorphic, however, tend to concentrate on one broad domain, such as fashion or electronics.

Research on opinion leadership generally indicates that while opinion leaders do exist for multiple product categories, expertise tends to overlap across similar categories. It is rare to find a generalized opinion leader. An opinion leader for home appliances is likely to serve a similar function for home cleaners, but not for cosmetics. In contrast, a fashion opinion leader whose primary influence is on clothing choices may also be consulted for recommendations on cosmetics purchases, but not necessarily on microwave ovens.[103]

Opinion Leaders versus Other Consumer Types

Early conceptions of the opinion leader role also assumed a static process: The opinion leader absorbs information from the mass media and in turn transmits these data to opinion receivers. This view has turned out to be overly simplified; it confuses the functions of several different types of consumers.

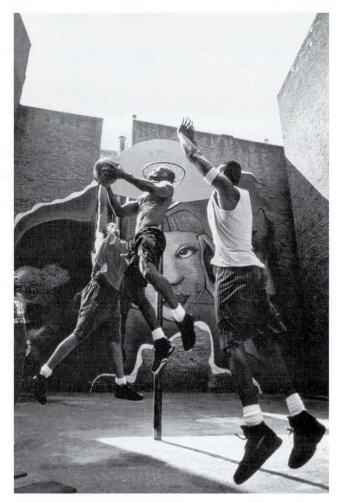

Opinion leadership is heavily emphasized in athletic shoe marketing. Athletic shoes are very much a fashion statement and a phenomenon largely fueled by inner-city kids, despite sky-high price tags. Many styles originate in the inner city and then spread by word of mouth.

THE PROSUMER

Futurist Alvin Toffler coined the word *prosumer* in his book *The Third Wave* to illustrate the equalization of consumer and producer giving rise to prosumer economics in an age of information. Prosumers are influentials who love to talk about the latest thing, passing along opinions to an average of nine people each. Retailers should take note: They will tell everyone if they don't like the way they are treated. They are inclined toward experimentation and innovation and like to discover trends on their own. Thus, they don't like to be dictated to by marketers. Mariam Salzman, executive vice president of Euro PRCG Worldwide, advises companies to give prosumers something to talk about; give them something truly unique. They are far more likely than typical consumers to be consulted for their opinions on companies and brands. They are gatekeepers to the consumer masses; starting buzz among prosumers is essential.[104]

A recent study by this agency profiles the prosumer: A higher percentage of the prosumer than the nonprosumer agrees with the following:

- I take pride in my appearance.
- I am physically fit.
- I consider shopping a recreational activity.
- It is fun to browse and shop in shopping malls.
- I like to experiment with grooming products.
- I am distrustful of advertising and the claims it makes.
- I am less trustful of a product or company I can't find on the Internet.
- I have made twenty or more purchases online in the past year.

FIGURE 12-3
Perspectives on the
Communications Process
Source: M. R. Solomon, *Consumer Behavior,*
8th ed., p. 302, © 2009. Reprinted by permission of Pearson Education, Inc., Upper
Saddle River, NJ.

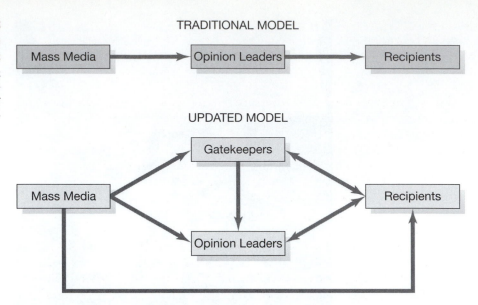

Opinion leaders are also likely to be *opinion seekers*. They are generally more involved in a product category and actively search for information. As a result, they are more likely to talk about products with others and to solicit others' opinions as well.[105] Contrary to the static view of opinion leadership, most product-related conversation does not take place in a "lecture" format, where one person does all of the talking. A lot of product-related conversation is prompted by the situation and occurs in the context of a casual interaction rather than as formal instruction.[106] People gain product information from opinion leaders in nonverbal ways also. This updated view of interpersonal product communication is contrasted with the traditional view in Figure 12-3.

Consumers who are expert in a product category may not actively communicate with others, while other consumers may have a more general interest in being involved in product discussions. A consumer category called the **market maven** has been proposed to describe people who are actively involved in transmitting marketplace information of all types. Market mavens are not necessarily interested in certain products and may not necessarily be early purchasers of products. They come closer to the function of a generalized opinion leader because they tend to have a solid overall knowledge of how and where to procure products. The following scale items, where respondents indicate how much they agree or disagree, have been used to identify market mavens:[107]

1. I like introducing new brands and products to my friends.
2. I like helping people by providing them with information about many kinds of products.
3. People ask me for information about products, places to shop, or sales.
4. If someone asked me where to get the best buy on several types of products, I could tell him or her where to shop.
5. My friends think of me as a good source of information when it comes to new products or sales.

Think about a person who has information about a variety of products and likes to share this information with others. This person knows about new products, sales, stores, and so on, but does not necessarily feel he or she is an expert on one particular product. How well would you say this description fits you?

In addition to everyday consumers who influence others' purchase decisions, a class of marketing intermediary called the **surrogate consumer** is an active player in many categories. A surrogate consumer is a person who is hired to provide input into purchase decisions. Unlike the opinion leader or market maven, the surrogate is usually compensated for this involvement.

Professional shoppers, interior designers, stockbrokers, and other types of consultants can all be thought of as surrogate consumers. Whether or not they actually make the purchase on behalf of the consumer, surrogates' recommendations can be enormously influential. The consumer in essence relinquishes control over several or all decision-making functions, such as information search, evaluation of alternatives, or the actual purchase. For example, a client may commission an interior designer to redo her house, or a fashion shopper may make decisions on behalf of his or her clients. Many retail stores have their own **personal shoppers**, sometimes called **client specialists**, whose service customers can utilize. These super salespeople keep a client book with individual customers' preferences, measurements, and other pertinent information. They may do the majority of the "shopping" for clients before calling them to come into the store to try on items and sometimes they even go to the client's home with possible choices. The involvement of surrogates in a wide range of purchase decisions tends to be overlooked by many marketers, who may be mistargeting their communications to end consumers instead of to the surrogates who are actually sifting through product information.[108]

Identifying Opinion Leaders

Because opinion leaders are so central to consumer decision making, marketers are quite interested in identifying influential people for a product category. In fact, many ads are intended to reach these influentials rather than the average consumer, especially if the ads contain a lot of technical information.

Unfortunately, since most opinion leaders are everyday consumers and are not formally included in marketing efforts, they are harder to find. A celebrity or an influential industry executive is by definition easy to locate. He or she has national or at least regional visibility or may be listed in published directories. In contrast, opinion leaders tend to operate at the local level and may influence five to ten consumers rather than an entire market segment. In some cases, companies have been known to identify influentials and involve them directly in their marketing efforts, hoping to create a "ripple effect" as these consumers sing the company's praises to their friends. Many department stores, for example, have fashion "panels," usually composed of adolescent girls, who provide input into fashion trends, participate in fashion shows, and so on.

Because of the difficulties involved in identifying specific opinion leaders in a large market, most attempts to do so instead focus on exploratory studies where the characteristics of representative opinion leaders can be identified

and then generalized to the larger market. This knowledge helps marketers target their product-related information to appropriate settings and media.

The Self-Designating Method

The most commonly used technique to identify opinion leaders is simply to ask individual consumers whether they consider themselves opinion leaders. While respondents who report a greater degree of interest in a product category are more likely to be opinion leaders, the results of surveys intended to identify self-designated opinion leaders must be viewed with some skepticism. Some people have a tendency to inflate their own importance and influence, whereas others who really are influential might not admit to this quality or be conscious of it.[109] Just because we transmit advice about products does not mean other people *take* that advice. For someone to be considered a bona fide opinion leader, his or her advice must actually be heard and heeded by opinion seekers. An alternative is to select certain group members (*key informants*) who in turn are asked to identify opinion leaders. The success of this approach hinges on locating those who have accurate knowledge of the group and on minimizing their response biases (such as the tendency to inflate one's own influence on the choices of others).

The self-designating method is not as reliable as a more systematic analysis (where individual claims of influence can be verified by asking others whether the person is really influential), but it does have the advantage of being easy to apply to a large group of potential opinion leaders. In some cases not all members of a community are surveyed. One of the measurement scales developed for self-designation of opinion leaders is shown in Figure 12-4.

Please rate yourself on the following scales relating to your interactions with friends and neighbors regarding _____.

1. In general, do you talk to your friends and neighbors about _____:

very often				never
5	4	3	2	1

2. When you talk to your friends and neighbors about _____ do you:

give a great deal of information				give very little information
5	4	3	2	1

3. During the past six months, how many people have you told about a new _____?

told a number of people				told no one
5	4	3	2	1

4. Compared with your circle of friends, how likely are you to be asked about new _____?

very likely to be asked				not at all likely to be asked
5	4	3	2	1

5. In discussion of new _____, which of the following happens most?

you tell your friends about _____				your friends tell you about _____
5	4	3	2	1

6. Overall in all of your discussions with friends and neighbors are you:

often used as a source of advice				not used as a source of advice
5	4	3	2	1

FIGURE 12-4
A Revised and Updated Version of the Opinion Leadership Scale

Source: Adapted from Terry L. Childers, "Assessment of the Psychometric Properties of an Opinion Leadership Scale," *Journal of Marketing Research* 23 (May 1986): 184–188, with permission of American Marketing Association; and Leisa Reinecke Flynn, Donald E. Goldsmith, and Jacqueline K. Eastman, "The King and Summers Opinion Leadership Scale: Revision and Refinement," *Journal of Business Research* 31 (1994): 55–64, with permission from Elsevier Science.

Sociometry

The popular play *Six Degrees of Separation* is based on the premise that everyone on the planet indirectly knows everyone else—or at least knows people who know them. Indeed, social scientists estimate that the average person has 1,500 acquaintances and that five to six intermediaries could connect any two people in the United States.[110] A popular game challenges players to link the actor Kevin Bacon with other actors in much the same way.

Sociometric methods are used to trace communication patterns among members of a group. These techniques allow researchers to systematically map out the interactions that take place among group members. By interviewing participants and asking them to whom they go for product information, researchers can identify those who tend to be sources of product-related information. This method is the most precise, but it is very hard and expensive to implement because it involves very close study of interaction patterns in small groups. For this reason, sociometric techniques are best applied in a closed, self-contained social setting, where members are largely isolated from other social networks.

Sociometry has long been used to study group membership and friendship groups. Reciprocal friendship structures (dyads, triads, and so on) evolve from sociometric methodology that asks respondents questions pertaining to interpersonal relationships such as awareness of shared norms and behaviors, and who is most popular or best dressed. One high school sociometric study found that members of reciprocal friendship structures dress more like one another than like other members of their high school class and thus serve as a reference group for its members.[111] Another longitudinal study of high school students found that clothing and appearance is an important factor in friendship choices, but were not sufficient *alone* for group acceptance or exclusion. Isolation was sometimes by choice; the well-dressed isolate was by choice, but the poorly dressed isolate was the result of group exclusion.[112] Opinion leaders can be identified through this methodology; however, it is a lengthy, time-consuming process.

Sociometric analyses can be used to better understand *referral behavior* and to locate strengths and weaknesses in terms of how one's reputation is communicated through a community.[113] One study using this method examined similarities in brand choice among members of a college sorority. The researchers found evidence that subgroups, or *cliques*, within the sorority were likely to share preferences for various products. In some cases, even choices of "private" (socially inconspicuous) products were shared, possibly because of structural variables such as sharing bathrooms in the sorority house.[114]

CHAPTER SUMMARY

- Consumers belong to or admire many different groups and are often influenced in their purchase decisions by a desire to be accepted by others.

- Individuals have influence in a group to the extent that they possess social power; types of social power include information power, referent power, legitimate power, expert power, reward power, and coercive power.

- We conform to the desires of others for one of two basic reasons. People who model their behavior after others because they take others' behavior as evidence of the correct way to act are conforming because of informational social influence. Those who conform to satisfy the expectations of others and/or to be accepted by the group are affected by normative social influence. Clothing and fashion choices may be affected by both types of influence.

- Individuals or groups whose opinions or behavior are particularly important to consumers are reference groups. Both formal and informal groups influence the individual's purchase decisions.

- Our fashion choices may be influenced by reference groups because fashion is socially conspicuous and visible and because it may be a luxury that is often influenced by others.

- The Internet has greatly amplified consumers' abilities to be exposed to numerous reference groups; virtual consumption communities are composed of people who are united by a common bond—enthusiasm about and/or knowledge of a specific product or service.

- Conformity refers to a change in belief or behavior as a reaction to pressure. Fashion represents the popular, accepted, prevailing style. Acceptance of a fashion is a form of conformity.

- Group members often do things they would not do as individuals because their identities become merged with the group; they become deindividuated. Shopping in groups affects one's behavior as consumers buy more and make more unplanned purchases in a group than alone.

- We do not have complete freedom in dress, as laws affect what is acceptable. Generally school boards and private businesses are allowed to enforce dress codes, and decency standards related to dress are enforced.

- Some people react to too much conformity by creating their own uniqueness and individuality in dress.

- Opinion leaders who are knowledgeable about a product and whose opinions are highly regarded tend to influence others' choices. Specific opinion leaders are somewhat hard to identify, but marketers who know their general characteristics can try to target them in their media and promotional strategies. Fashion opinion leaders have been found to be young, female, single, and mobile; have a high income; read fashion magazines; and be gregarious and social.

- Other influencers include market mavens, who have a general interest in marketplace activities, and surrogate consumers, such as personal shoppers and fashion consultants, who are compensated for their advice about purchases.

- Much of what we know about products comes about through word-of-mouth communication (WOM) rather than formal advertising. Product-related information tends to be exchanged in casual conversations.

- Although word of mouth often is helpful for making consumers aware of products, it can also hurt companies when damaging product rumors or negative word of mouth occurs.

- Sociometric methods are used to trace friendship and referral patterns. This information can be used to identify opinion leaders and other influential consumers.

KEY TERMS

reference group	legitimate power	reactance
normative influence	expert power	word-of-mouth commu-
comparative influence	reward power	nication (WOM)
membership reference	coercive power	guerrilla marketing
group	conformity	seeding
aspirational reference	norms	viral marketing
group	mode	social networking
virtual community of	style	opinion leaders
consumption	fashion	influentials
weblog	individuality	market maven
blogosphere	social comparison	surrogate consumer
social power	theory	personal shoppers
referent power	deindividuation	client specialists
information power	independent	sociometric methods

DISCUSSION QUESTIONS

1. Compare and contrast the types of power described in the text. Which are most likely to be relevant for fashion marketing efforts?

2. Why is referent power an especially potent force for marketing appeals? What are factors that help to predict whether reference groups will or will not be a powerful influence on a person's purchase decisions?

3. Discuss some factors that determine the amount of conformity likely to be observed among consumers. Which age-groups do you think most conform in terms of fashion? Do you conform to fashion or are you a pure individualist?

4. Under what conditions are we more likely to engage in social comparison with dissimilar others versus similar others? How might this dimension be used in the design of marketing appeals?

5. Discuss some reasons for the effectiveness of home shopping parties as a selling tool. What other products might potentially be sold this way?

6. Discuss some factors that influence whether membership groups will have a significant influence on a person's behavior. What groups do you belong to? Do they have an effect on what you buy?

7. Why is word-of-mouth communication often more persuasive than advertising?

8. Is there such a thing as a generalized opinion leader? What is likely to determine whether an opinion leader will be influential with regard to a specific product category?

9. The adoption of a certain brand of shoe or apparel by athletes can be a powerful influence on students and other fans. Should high school and college coaches be paid to determine what brand of athletic equipment their players will wear?

10. Are you aware of any legal issues in the news lately relating to clothing?

11. What are your attitudes about school uniforms required in schools? Have you ever worn a uniform?

12. Identify a set of avoidance groups for your peers. Can you identify any consumption decisions that are made with these groups in mind?

13. Identify fashion opinion leaders on your campus. Do they fit the profile discussed in the chapter?

14. Conduct a sociometric analysis within your dormitory or neighborhood. For a product category such as fashion, music, or cosmetics, ask each individual to identify other individuals with whom they share information. Systematically trace all of these avenues of communication, and identify opinion leaders by locating individuals who are repeatedly named as providing helpful information.

ENDNOTES

1. Details adapted from John W. Schouten and James H. McAlexander, "Market Impact of a Consumption Subculture: The Harley-Davidson Mystique," in *Proceedings of the 1992 European Conference of the Association for Consumer Research*, eds. Fred van Raaij and Gary Bamossy (Amsterdam, 1992); John W. Schouten and James H. McAlexander, "Subcultures of Consumption: An Ethnography of the New Bikers," *Journal of Consumer Research* 22 (June 1995): 43–61.

2. Joel B. Cohen and Ellen Golden, "Informational Social Influence and Product Evaluation," *Journal of Applied Psychology* 56 (February 1972): 54–59; Robert E. Burnkrant and Alain Cousineau, "Informational and Normative Social Influence in Buyer Behavior," *Journal of Consumer Research* 2 (December 1975): 206–215; Peter H. Reingen, "Test of a List Procedure for Inducing Compliance with a Request to Donate Money," *Journal of Applied Psychology* 67 (1982): 110–118.

3. Quoted in Dyan Machan, "Is the Hog Going Soft?," *Forbes* (March 10, 1997): 114–119.

4. C. Whan Park and V. Parker Lessig, "Students and Housewives: Differences in Susceptibility to Reference Group Influence," *Journal of Consumer Research* 4 (September 1977): 102–110.

5. Kenneth J. Gergen and Mary Gergen, *Social Psychology* (New York: Harcourt Brace Jovanovich, 1981).

6. Betty Smucker and Anna M. Creekmore, "Adolescents' Clothing Conformity, Awareness and Peer Acceptance," *Home Economics Research Journal* 1 (1972): 92–97; Suzanne H. Hendricks, Eleanor A. Kelly, and JoAnne B. Eicher, "Senior Girls' Appearance and Social Participation," *Journal of Home Economics* 60 (1968): 167–172; Mary B. Littrell and JoAnne B. Eicher, "Clothing Opinions and the Social Acceptance Process among Adolescents," *Adolescents* 8 (1973): 197–212; Madeline C. Williams and JoAnne B. Eicher, "Teenagers' Appearance and Social Acceptance," *Journal of Home Economics* 58 (1966): 457–461.

7. Harold H. Kelley, "Two Functions of Reference Groups," in *Basic Studies in Social Psychology*, eds. Harold Proshansky and Bernard Siedenberg (New York: Holt, Rinehart and Winston, 1965), 210–214.

8. Carol Krol, "Survey: Friends Lead Pack in Kids' Spending Decisions," *Advertising Age* (March 10, 1997): 16.

9. A. Benton Cocanougher and Grady D. Bruce, "Socially Distant Reference Groups and Consumer Aspirations," *Journal of Marketing Research* 8 (August 1971): 79–81; James E. Stafford, "Effects of Group Influences on Consumer Brand Preferences," *Journal of Marketing Research* 3 (February 1966): 68–75.

10. Cocanougher and Bruce, "Socially Distant Reference Groups and Consumer Aspirations."

11. L. Festinger, S. Schachter, and K. Back, *Social Pressures in Informal Groups: A Study of Human Factors in Housing* (New York: Harper, 1950).

12. R. B. Zajonc, H. M. Markus, and W. Wilson, "Exposure Effects and Associative Learning," *Journal of Experimental Social Psychology* 10 (1974): 248–263.

13. Susan Kaiser, *The Social Psychology of Clothing: Symbolic Appearances in Context* (New York: Fairchild, 1997).

14. Littrell and Eicher, "Clothing Opinions and the Social Acceptance Process among Adolescents."

15. Eleanor A. Kelly and Joanne B. Eicher, "Popularity, Group Membership, and Dress," *Journal of Home Economics* 62 (1970): 246–250.

16. "An American Princess," *Women's Wear Daily* (July 19, 1999): 1, 6–9.

17. This typology is adapted from material presented in Robert V. Kozinets, "E-Tribalized Marketing: The Strategic Implications of Virtual Communities of Consumption," *European Management Journal* 17, no. 3 (June 1999): 252–264.

18. Hassan Fattah and Pamela Paul, "Gaming Gets Serious," *American Demographics* (May 2002): 39–43.

19. Rob McGann, "Blog Readership Surged 58 Percent in 2004," ClickZ Network (January 5, 2005), http://www.

clickz.com/stats/sectors/traffic_patterns/article.php/3453431#table (June 10, 2005).

20. Bob Tedeschi, "Product Reviews from Anyone with an Opinion," *New York Times on the Web* (October 25, 1999).

21. Kozinets, "E-Tribalized Marketing: The Strategic Implications of Virtual Communities of Consumption."

22. Jeffrey D. Ford and Elwood A. Ellis, "A Re-Examination of Group Influence on Member Brand Preference," *Journal of Marketing Research* 17 (February 1980): 125–132; Thomas S. Robertson, *Innovative Behavior and Communication* (New York: Holt, Rinehart and Winston, 1980), Chapter 8.

23. Rose-Marie Turk, "The Leading Ladies," *WWWCalifornia* (supplement to *Women's Wear Daily*) (August 1999): 14–18, 56.

24. William O. Bearden and Michael J. Etzel, "Reference Group Influence on Product and Brand Purchase Decisions," *Journal of Consumer Research* 9, no. 2 (1982): 183–194.

25. Gergen and Gergen, *Social Psychology*, p. 312.

26. J. R. P. French, Jr., and B. Raven, "The Bases of Social Power," in *Studies in Social Power*, ed. D. Cartwright (Ann Arbor, Mich.: Institute for Social Research, 1959), 150–167.

27. Michael R. Solomon, "Packaging the Service Provider," *The Service Industries Journal* 5 (March 1985): 64–72.

28. Kimberly A. Miller, "Standing Out from the Crowd," in *The Meanings of Dress,* eds. Mary Lynn Damhorst, Kimberly A. Miller, and Susan O. Michelman (New York: Fairchild, 1999), 206-214.

29. Marilyn Horn, *The Second Skin* (Boston: Houghton Mifflin, 1981).

30. William L. Hamilton, "The School Uniform as Fashion Statement: How Students Crack the Dress Code" in *The Meanings of Dress,* eds. Mary Lynn Damhorst, Kimberly A. Miller, and Susan O. Michelman (New York: Fairchild, 1999), 232–235.

31. For an attempt to measure individual differences in proclivity to conformity, see William O. Bearden, Richard G. Netemeyer, and Jesse E. Teel, "Measurement of Consumer Susceptibility to Interpersonal Influence," *Journal of Consumer Research* 15 (March 1989): 473–481.

32. William O. Bearden, Richard G. Netemeyer, and Jesse E. Teel, "Measurement of Consumer Susceptibility to Interpersonal Influence," *Journal of Consumer Research* 9, no. 3 (1989): 183–194; Lynn R. Kahle, "Observations: Role-Relaxed Consumers: A Trend of the Nineties," *Journal of Advertising Research* (March/April 1995): 66–71; Lynn R. Kahle and Aviv Shoham, "Observations: Role-Relaxed Consumers: Empirical Evidence," *Journal of Advertising Research* 35, no. 3 (May/June 1995): 59–62.

33. Heather Anderson and Deborah Meyer, "Pre-Adolescent Consumer Conformity: A Study of Motivation for Purchasing Apparel," *Journal of Fashion Marketing and Management* 4, no. 2 (2000): 173–181.

34. Nancy J. Rabolt and Mary Frances Drake, "Information Sources Used by Women for Career Dressing Decisions," in *The Psychology of Dress*, ed. Michael R. Solomon (Lexington, Mass.: Lexington Books, 1985), 371–385.

35. Leon Festinger, "A Theory of Social Comparison Processes," *Human Relations* 7 (May 1954): 117–140.

36. Chester A. Insko, Sarah Drenan, Michael R. Solomon, Richard Smith, and Terry J. Wade, "Conformity as a Function of the Consistency of Positive Self-Evaluation with Being Liked and Being Right," *Journal of Experimental Social Psychology* 19 (1983): 341–358.

37. Abraham Tesser, Murray Millar, and Janet Moore, "Some Affective Consequences of Social Comparison and Reflection Processes: The Pain and Pleasure of Being Close," *Journal of Personality and Social Psychology* 54, no. 1 (1988): 49–61.

38. George P. Moschis, "Social Comparison and Informal Group Influence," *Journal of Marketing Research* 13 (August 1976): 237–244.

39. Burnkrant and Cousineau, "Informational and Normative Social Influence in Buyer Behavior"; M. Venkatesan, "Experimental Study of Consumer Behavior Conformity and Independence," *Journal of Marketing Research* 3 (November 1966): 384–387.

40. Janet K. May and Ardis W. Koester, "Clothing Purchase Practices of Adolescents" *Home Economics Research Journal* 9, no. 4 (1981): 356–362.

41. Harvey London, *Psychology of the Persuader* (Morristown, N.J.: Silver Burdett/General Learning Press, 1973); William J. McGuire, "The Nature of Attitudes and Attitude Change," in *The Handbook of Social Psychology*, eds. G. Lindzey and E. Aronson (Reading, Mass.: Addison-Wesley, 1968), 3; N. Miller, G. Naruyama, R. J. Baebert, and K. Valone, "Speed of Speech and Persuasion," *Journal of Personality and Social Psychology* 34 (1976): 615–624.

42. B. Latane, K. Williams, and S. Harkings, "Many Hands Make Light the Work: The Causes and Consequences of Social Loafing," *Journal of Personality and Social Psychology* 37 (1979): 822–832.

43. Nathan Kogan and Michael A. Wallach, "Risky Shift Phenomenon in Small Decision-Making Groups: A Test of the Information Exchange Hypothesis," *Journal of Experimental Social Psychology* 3 (January 1967): 75–84; Nathan Kogan and Michael A. Wallach, *Risk Taking* (New York: Holt, Rinehart and Winston, 1964); Arch G. Woodside and M. Wayne DeLozier, "Effects of Word-of-Mouth Advertising on Consumer Risk Taking," *Journal of Advertising* (Fall 1976): 12–19.

44. Kogan and Wallach, *Risk Taking*.

45. Donald H. Granbois, "Improving the Study of Customer In-Store Behavior," *Journal of Marketing* 32 (October 1968): 28–32.

46. Tamara F. Mangelburg, Patricia M. Doney, and Terry Bristol, "Shopping with Friends and Teens' Susceptibility to Peer Influence," *Journal of Retailing* 80 (2004): 101–116.

47. Len Strazewski, "Tupperware Locks in New Strategy," *Advertising Age* (February 8, 1988): 30.

48. George B. Sproles and Leslie Davis Burns, *Changing Appearances: Understanding Dress in Contemporary Culture* (New York: Fairchild, 1994).

49. Kimberly A. Miller and Scott A. Hunt, "It's All Greek to Me: Sorority Members and Identity Talk," in *The*

Meanings of Dress eds. Mary Lynn Damhorst, Kimberly A. Miller, and Susan O. Michelman (New York: Fairchild, 1999): 224–228.

50. Mary Lynn Damhorst, Kimberly A. Miller, and Susan O. Michelman, eds., *The Meanings of Dress* (New York: Fairchild, 1999).

51. Lucy C. Taylor and Norma H. Compton, "Personality Correlates of Dress Conformity," *Journal of Home Economics* 60 (October 1968): 653–656.

52. Anna M. Creekmore, "Clothing and Personal Attractiveness of Adolescents Related to Conformity, to Clothing Mode, Peer Acceptance, and Leadership Potential, *Home Economics Research Journal* 8 (January 1980): 203–215.

53. Pat Marie Maher and Ann C. Slocum, "Freedom in Dress: The Legal View," *Home Economics Research Journal* 14, no. 4 (June 1986): 371–379; Pat Marie Maher and Ann C. Slocum, "Freedom in Dress: Legal Sanctions," *Clothing and Textiles Research Journal* 5, no. 4 (Summer 1987): 14–22.

54. Gergen and Gergen, *Social Psychology.*

55. Horn, *The Second Skin.*

56. Mary Kefgen and Phyllis Touchie-Specht, *Individuality in Clothing Selection and Personal Appearance: A Guide for the Consumer* (New York: Macmillan, 1981). See updated edition by Suzanne B. Marshall, Hazel O. Jackson, M. Sue Stanley, Mary Kefgen, and Phyllis Touchie-Specht (Upper Saddle River, N.J.: Prentice Hall, 2000).

57. Marshall et al. *Individuality in Clothing Selection and Personal Appearance.*

58. Elizabeth D. Lowe and Hilda M. Buckley, "Freedom and Conformity in Dress: A Two-Dimensional Approach," *Home Economics Research Journal* 11 (December 1992): 197–204.

59. L. J. Strickland, S. Messick, and D. N. Jackson, "Conformity, Anticonformity and Independence: Their Dimensionality and Generality," *Journal of Personality and Social Psychology* 16 (1970): 494–507.

60. Jack W. Brehm, *A Theory of Psychological Reactance* (New York: Academic Press, 1966).

61. R. D. Ashmore, V. Ramchandra, and R. Jones, "Censorship as an Attitude Change Induction," paper presented at meetings of Eastern Psychological Association, New York, 1971; R. A. Wicklund and J. Brehm, *Perspectives on Cognitive Dissonance* (Hillsdale, N.J.: Lawrence Erlbaum, 1976).

62. C. R. Snyder and H. L. Fromkin, *Uniqueness: The Human Pursuit of Difference* (New York: Plenum Press, 1980).

63. Jane E. Workman and Kim K. P. Johnson. "Fashion Opinion Leadership, Fashion Innovativeness, and Need for Variety," *Clothing and Textiles Research Journal* 11, no. 3 (1993): 60–64.

64. Johan Arndt, "Role of Product-Related Conversations in the Diffusion of a New Product," *Journal of Marketing Research* 4 (August 1967): 291–295.

65. Yumiko Ono, "Earth Tones and Attitude Make a Tiny Cosmetics Company Hot," *Wall Street Journal* (February 23, 1995): B1.

66. Quoted in Barbara B. Stern and Stephen J. Gould, "The Consumer as Financial Opinion Leader," *Journal of Retail Banking* 10 (Summer 1988): 43–52.

67. Elihu Katz and Paul F. Lazarsfeld, *Personal Influence* (Glencoe, Ill.: Free Press, 1955).

68. Julie Bosnan, "Advertising Is Obsolete. Everyone Says So," *New York Times* (nytimes.com) (January 23, 2006).

69. John A. Martilla, "Word-of-Mouth Communication in the Industrial Adoption Process," *Journal of Marketing Research* 8 (March 1971): 173–178. See also Marsha L. Richins, "Negative Word-of-Mouth by Dissatisfied Consumers: A Pilot Study," *Journal of Marketing* 47 (Winter 1983): 68–78.

70. Arndt, "Role of Product-Related Conversations in the Diffusion of a New Product."

71. James H. Myers and Thomas S. Robertson, "Dimensions of Opinion Leadership," *Journal of Marketing Research* 9 (February 1972): 41–46.

72. Sonia Murray, "Street Marketing Does the Trick," *Advertising Age* (March 20, 2000): S12.

73. Quoted in "Taking to the Streets," *Newsweek* (November 2, 1998): 70–73.

74. Constance L. Hays, "Guerrilla Marketing Is Going Mainstream," *New York Times on the Web* (October 7, 1999).

75. Miles Socha and Janet Ozzard, "Building Buzz, One by One," *Women's Wear Daily* (April 14, 2000): 14, 16.

76. Jared Sandberg, "The Friendly Virus," *Newsweek* (April 12, 1999): 65–66.

77. Karen J. Bannan, "Marketers Try Infecting the Internet," *New York Times on the Web* (March 22, 2000).

78. Abram Sauer, "Are You Sick of Viral Marketing?," www.brandchannel.com (April 5, 2004).

79. Pia Sarkar, "A Different Way of Selling Clothes," *San Francisco Chronicle* (August 27, 2005): C1–C2.

80. Peter Applebome, "On Campus, Hanging Out by Logging On," *New York Times on the Web* (December 1, 2004).

81. Mengly Taing, "Young Designers Build Business Networks on MySpace," *Women's Wear Daily* (September 5, 2006): 12.

82. Bob Tedeschi, "Social Networks: Will Users Pay to Get Friends?" *New York Times on the Web* (February 9, 2004).

83. Jennifer Lach, "Intelligence Agents," *American Demographics* (March 1999): 52–60.

84. James F. Engel, Robert J. Kegerreis, and Roger D. Blackwell, "Word of Mouth Communication by the Innovator," *Journal of Marketing* 33 (July 1969): 15–19.

85. David Kirkpatrick, "Advertisers Crash Crowd Outside 'Today,'" *Wall Street Journal* (April 24, 1996): B1.

86. Chip Walker, "Word of Mouth," *American Demographics* (July 1995): 38–44.

87. Richard J. Lutz, "Changing Brand Attitudes through Modification of Cognitive Structure," *Journal of Consumer Research* 1 (March 1975): 49–59. For some suggested remedies to bad publicity, see Mitch Griffin, Barry J. Babin, and Jill S. Attaway, "An Empirical Investigation of the Impact of Negative Public Publicity on Consumer Attitudes and Intentions," in *Advances in Consumer Research* 18, eds. Rebecca H. Holman and Michael R. Solomon (Provo, Utah: Association for Consumer Research, 1991), 334–341; Alice M. Tybout, Bobby J. Calder, and Brian Sternthal, "Using Information Processing Theory to Design Marketing Strategies," *Journal of Marketing Research* 18 (1981): 73–79.

88. Robert E. Smith and Christine A. Vogt, "The Effects of Integrating Advertising and Negative Word-of-Mouth Communications on Message Processing and Response," *Journal of Consumer Psychology* 4, no. 2 (1995): 133–151; Paula Fitzgerald Bone, "Word-of-Mouth Effects on Short-Term and Long-Term Product Judgments," *Journal of Business Research* 32 (1995): 213–223.

89. Charles W. King and John O. Summers, "Overlap of Opinion Leadership across Consumer Product Categories," *Journal of Marketing Research* 7 (February 1970): 43–50.

90. A. Tesser and S. Rosen, "The Reluctance to Transmit Bad News," in *Advances in Experimental Social Psychology,* ed. L. Berkowitz (New York: Academic Press, 1975), 8.

91. Kimberly R. McNeil, Olenda E. Johnson, and Ann Y. Johnson, "'Did You Hear What Tommy Hilfiger Said?' Urban Legend, Urban Fashion and African-American Generation Xers," *Journal of Fashion Marketing and Management* 3, no. 5 (2001): 234–240.

92. Judie Glave, "Calvin Klein Axes Controversial Campaign," *Denver Post* (August 29, 1996): C9.

93. Everett M. Rogers, *Diffusion of Innovations*, 3rd ed. (New York: Free Press, 1983): See also Ed Keller and Jon Berry, *The Influentials* (New York: The Free Press/Simon and Schuster, 2003).

94. Elaine Stone, *The Dynamics of Fashion* (New York: Fairchild, 1999).

95. Dorothy Leonard-Barton, "Experts as Negative Opinion Leaders in the Diffusion of a Technological Innovation," *Journal of Consumer Research* 11 (March 1985): 914–926; Rogers, *Diffusion of Innovations*.

96. Herbert Menzel, "Interpersonal and Unplanned Communications: Indispensable or Obsolete?," in *Biomedical Innovation* (Cambridge, Mass.: MIT Press, 1981), 155–163.

97. Meera P. Venkatraman, "Opinion Leaders, Adopters, and Communicative Adopters: A Role Analysis," *Psychology & Marketing* 6 (Spring 1989): 51–68.

98. Rogers, *Diffusion of Innovations*.

99. Quentin Bell, *On Human Finery* (London: Hogarth Press), 46.

100. Patricia Huddleston, Imogene Ford, and Marianne C. Bickle, "Demographic and Lifestyle Characteristics as Predictors of Fashion Opinion Leadership, among Mature Consumers," *Clothing and Textiles Research Journal* 11, no. 4 (1993): 26–31.

101. Dorothy U. Behling, "Three and a Half Decades of Fashion Adoption Research: What Have We Learned?" *Clothing and Textiles Research Journal* 10, no. 2 (1992): 34–41.

102. Robert Merton, *Social Theory and Social Structure* (Glencoe, Ill.: Free Press, 1957).

103. King and Summers, "Overlap of Opinion Leadership across Consumer Product Categories." See also Ronald E. Goldsmith, Jeanne R. Heitmeyer, and Jon B. Freiden, "Social Values and Fashion Leadership," *Clothing and Textiles Research Journal* 10 (Fall 1991): 37–45; J. O. Summers, "Identity of Women's Clothing Fashion Opinion Leaders," *Journal of Marketing Research* 7 (1970): 178–185.

104. Valerie Seckler, "Prosumers: Give Them Something to Talk About," *Women's Wear Daily* (July 28, 2004): 10.

105. Laura J. Yale and Mary C. Gilly, "Dyadic Perceptions in Personal Source Information Search," *Journal of Business Research* 32 (1995): 225–237.

106. Russell W. Belk, "Occurrence of Word-of-Mouth Buyer Behavior as a Function of Situation and Advertising Stimuli," in *Combined Proceedings of the American Marketing Association*, Series No. 33, ed. Fred C. Allvine (Chicago: American Marketing Association, 1971), 419–422.

107. For discussion of the market maven construct, see Lawrence F. Feick and Linda L. Price, "The Market Maven," *Managing* (July 1985): 10. Scale items adapted from Lawrence Feick and Linda Price, "The Market Maven: A Diffuser of Marketplace Information," *Journal of Marketing* 51 (January 1987): 83–87.

108. Michael R. Solomon, "The Missing Link: Surrogate Consumers in the Marketing Chain," *Journal of Marketing* 50 (October 1986): 208–218.

109. William R. Darden and Fred D. Reynolds, "Predicting Opinion Leadership for Men's Apparel Fashions," *Journal of Marketing Research* 1 (August 1972): 324–328. A modified version of the opinion leadership scale with improved reliability and validity can be found in Terry L. Childers, "Assessment of the Psychometric Properties of an Opinion Leadership Scale," *Journal of Marketing Research* 23 (May 1986): 184–188.

110. Dan Seligman, "Me and Monica," *Forbes* (March 23, 1998): 76.

111. Terry L. Clum and Joanne B. Eicher, "Teenagers' Conformity in Dress and Peer Friendship Groups," Research Report #152 (East Lansing, Mich.: Michigan State University Agricultural Experiment Station, March 1972).

112. Kelly and Eicher, "Popularity, Group Membership, and Dress."

113. Peter H. Reingen and Jerome B. Kernan, "Analysis of Referral Networks in Marketing: Methods and Illustration," *Journal of Marketing Research* 23 (November 1986): 370–378.

114. Peter H. Reingen, Brian L. Foster, Jacqueline Johnson Brown, and Stephen B. Seidman, "Brand Congruence in Interpersonal Relations: A Social Network Analysis," *Journal of Consumer Research* 11 (December 1984): 771–783; see also James C. Ward and Peter H. Reingen, "Sociocognitive Analysis of Group Decision Making among Consumers," *Journal of Consumer Research* 17 (December 1990): 245–262.

13
Buying and Disposing

Sharon is really psyched. She is finally going to be able to grab some extra time out of her busy schedule to go downtown to the huge metro flea market. She knows that this flea market is well known for jewelry, including jade and other semi-precious stones, which she has been saving up for. Sharon figures she can probably get what she wants for considerably less than the asking price—this is just the kind of place where sellers are hungry. Sharon dreads the prospect of haggling over the price, but she hopes to persuade the seller to take her offer, especially since she is ready to buy.

Big signs on the booths proclaim that today is a special day for good prices! Maybe she can get jade for even less than she had planned. She heads for one

of the jewelry booths and is a bit surprised when a seller introduces herself as Melanie. She had expected to be dealing with a middle-aged man with a lot of knowledge, albeit games to play, but this is more good luck. She figures the dealing might not be so bad with a young woman who looks to be about her age.

Melanie laughs when Sharon offers her $100 for the perfect jade necklace. Melanie's enthusiasm for the piece convinces Sharon all the more that she has to have it. When she finally writes a check for $250, she's exhausted from all the haggling. Sharon figures she did well, getting the necklace for less than the original asking price.

Actually, she's pleased with her purchase, and with herself—she's a tougher negotiator than she thought. . . .

INTRODUCTION

Many consumers dread the act of buying items that require haggling over the price, such as automobiles or items at yard sales and flea markets, while others love the challenge of the "deal." In the United States, unlike other parts of the world, most retail prices, especially on apparel bought at department and specialty stores, are nonnegotiable. It is interesting to observe international travelers attempting to bargain with sales associates at Macy's. We have established expectations and methods of purchasing at retailers such as department stores, and others for flea markets and used car lots. However, change is in the wind in consumer purchasing methods; shoppers are trying alternatives such as logging on to Internet buying services (some where the prices decrease as more people buy), calling brokers who negotiate major purchases for them, and buying at warehouse clubs, among other methods. And today people are using the Web to arm themselves with product and price information before they even enter a store, which puts added pressure on retailers to deliver the value they expect.

A Cotton Incorporated *Lifestyle Monitor* survey indicates that 60 percent of female shoppers either love or like shopping. When the economy is good, shoppers are upbeat. The loosening of dress codes has set women free to be more fashionable in the office and have fun with clothing. But the statistics mean that 40 percent don't enjoy shopping.[1] Retailers are working hard to find ways to make shopping a more pleasurable experience, which they hope might turn around those 40 percent. Many apparel retailers have guidelines for sales associates on how to treat shoppers, which include such directions as "customers courteously acknowledged within two minutes of arrival" and "relationship established by knowledgeable sales consultant who listens to customers, identifies needs and ensures needs are met."[2] These efforts highlight the importance of the purchase situation for marketers: You can have the best product in the world, but people have to be willing to do what it takes to obtain it.

Sharon's experience in buying the necklace illustrates some of the concepts to be discussed in this chapter. Making a purchase is often not a simple, routine matter of going to a store and quickly picking out something. As illustrated in Figure 13-1, a consumer's choices are affected by many personal factors, such as his or her mood, whether there is time pressure to make the purchase, and the particular situation or context for which the product is needed. In some situations the salesperson plays a pivotal role in the final selection.

The store environment also exerts a big influence. Involved are salespeople, other shoppers, the image of a particular store and the "feeling" it imparts to the shopper, and store decorations and promotional materials that try to influence the shopper's decisions. In addition, a lot of important consumer activity occurs *after* a product has been purchased and brought home. After using a product, the consumer decides whether he or she is satisfied with it. The satisfaction process is especially important to savvy marketers, who realize that the key to success is not selling a product one time, but rather forging a relationship with the consumer so that he or she will continue to buy one's products in the future. This chapter considers many issues related to purchase and postpurchase phenomena.

FIGURE 13-1
Issues Related to Purchase and Postpurchase Activities
Source: M. R. Solomon, *Consumer Behavior,* 8th ed., p. 364, © 2009. Reprinted by permission of Pearson Education, Inc., Upper Saddle River, NJ.

SITUATIONAL EFFECTS ON CONSUMER BUYING

A *consumption situation* is defined by factors over and above characteristics of the person and of the product that influence the buying and/or using of products and services. Situational effects can be behavioral (entertaining friends) or perceptual (being depressed or feeling pressed for time).[3] Common sense tells us that people tailor their purchases to specific occasions, and that the way we feel at a specific point in time affects what we feel like buying or doing.

Smart marketers understand these patterns and tailor their efforts to coincide with situations and timeframes when people are most prone to buy. This is obvious in the apparel business, as there are distinct clothing "seasons." Men's apparel seasons generally are thought of as fall and spring, while women's wear may have five or more seasons. Merchandise generally appears in the stores in the following months:

- Resort—January
- Spring—February, March, and April
- Summer—May and June
- Transition/early fall—July
- Fall—August and September
- Holiday—October, November, and December

Some designers and manufacturers time their market offerings to coincide with specific holidays and events such as back-to-school or Easter (similar to fall and spring). However, more and more designers and manufacturers are offering lines every month, rather than five times a year, so that stores have a continual flow of new goods to entice customers.

In addition to the functional relationships between products and usage situation, another reason to take environmental circumstances seriously is that the role a person plays at any time is partly determined by his or her *situational self-image,* where he or she basically asks: "Who am I *right now*?" (see Chapter 5).[4] A young man trying to impress his date by playing the role of

Situational Exogenous Influence

I want to choose appropriate clothes for the occasion.

When the garment (dress, suit, and so on) that I have in mind is at the cleaners, I choose the next best.

I think about the kind(s) of role I will play that day before I choose my clothes (student, teacher, and so on).

I think about whom I am going to see that day before I choose clothes for each day.

I look outside to check the weather before I choose my clothes.

I want to choose clothes that are fashionable (or currently in style).

When I feel enthusiastic, I wear my brightest clothes.

When I have to be on my feet a lot, I wear comfortable shoes.

I choose bright clothes for a sunny day.

I get up late sometimes, and I put on anything that is available.

Situational Endogenous Influence

When I feel depressed, I perk up myself with my brightest outfit.

When I feel tired, I wear cheerful clothes.

When I feel insecure, I wear the outfit I like best.

FIGURE 13-2
Situational Effects on Clothing Selection

Source: Yoon-Hee Kwon, "Effects of Situational and Individual Influences on the Selection of Daily Clothing," *Clothing and Textiles Research Journal*, 6 (1988): 6–12.

"man-about-town" may wear cool clothes and spend more lavishly, ordering champagne instead of beer and buying flowers—purchases he would never consider when he is hanging out with his friends, slurping beer, and playing the role of "one of the boys." As this example demonstrates, knowledge of what consumers are doing at the time a product is consumed, and the role they are playing at that time, can improve predictions of product and brand choice.[5]

Another way of viewing situational factors affecting purchasing behavior is the typology of *endogenous* (inside the body) versus *exongenous* (outside the body). One apparel study found that situational factors affecting clothing selection are mostly exogenous in nature, such as weather environment, social activity, and time, while there are fewer endogenous factors such as mood or perception of self.[6] Figure 13-2 illustrates some of the survey items measuring these influences.

Situational Segmentation

By systematically identifying important usage situations, researchers can develop market segmentation strategies to position products that will meet the specific needs arising from these situations. Many product categories are

COACH'S SITUATIONAL SEGMENTATION

Coach, the maker of luxury leather goods, decided to overhaul its marketing strategy in order to convince women that they need more than just one bag for everyday use and one for dressy occasions. Now, Coach is helping women to update their wardrobes by offering them weekend bags, evening bags, backpacks, satchels, clutches, totes, briefcases, diaper bags, coin purses, duffels, and a mini-handbag that doubles as a bag-within-a-bag called a wristlet. The company even makes new bags to fill what it calls "usage voids," activities that range from weekend getaways to trips to the grocery store. Coach introduced its Hamptons Weekend collection by displaying bags stuffed with beach towels and colorful flip-flops. Have bag, will travel.[7]

FIGURE 13-3
Women's and Men's Apparel
Classifications

Women's

Sportswear: tops (T-shirts, shirts, blouses, blazers), bottoms (pants, skirts)

Activewear: fitness (leotards, dancewear, exercisewear, jogging suits) and sports (tennis, golf, biking, etc.)

Swimwear/beachwear

Dresses: casual, dressy

Evening and bridal

Outerwear: coats, jackets, capes, rainwear

Suits: with pants, skirts

Intimate apparel

 Foundation (bras, garter belts, girdles, shapewear)

 Lingerie (daywear—slips, panties, camisoles; sleepwear—pajamas, nightgowns, negligees)

Maternity

Accessories

Misc.: uniforms, aprons, etc.

Men's

Tailored clothing: suits, overcoats, topcoats, sportscoats, dress trousers, formal wear

Furnishings: dress shirts, neckwear (ties, scarves), underwear, hats, socks, sleepwear, robes

Sportswear: sport shirts, knit shirts, sweaters, shorts, slacks, exercisewear, swim trunks

Work clothing: work shirts and pants, overalls, jeans

Misc.: raincoats, uniforms, caps

amenable to this form of segmentation. Certainly fashion apparel is segmented to different situations: everyday casual, professional career dress, prom dresses, and so on. Figure 13-3 illustrates women's and men's apparel classifications offered at retail, showing specific clothing for many types of situations and occasions. Some product categories, such as footwear, have become increasingly complex. We used to buy sneakers; now we buy different sport shoes for every conceivable sport. Nike's Web site (www.nike.com) shows many styles for each of the following sports/activities: baseball/softball, basketball, cross-training, football, golf, outdoor (all conditions gear), rugby, running, soccer, tennis, and women's fitness. How's that for selection?

Social and Physical Surroundings

A consumer's physical and social environment can make a big difference in motives for product usage and also affect how the product is evaluated. Important cues include the person's physical surroundings, as well as the amount and type of other consumers also present in that situation. Dimensions of the physical environment, such as decor, smells, and even temperature, can significantly influence consumption. We'll take a closer look at some of these factors a bit later in the chapter.

In addition to physical cues, though, many of a consumer's purchase decisions are significantly affected by groups or social settings. In some cases, the sheer presence or absence of other patrons ("co-consumers") in a setting actually can function as a product attribute, as when an exclusive boutique

promises to provide privacy to privileged customers. At other times, the presence of others can have positive value. An empty boutique or restaurant can send a powerful message.

The presence of large numbers of people in a consumer environment increases arousal levels, so a consumer's subjective experience of a setting tends to be more intense. This however, can be both positive and negative. While the presence of other people creates a state of arousal, the consumer's actual experience depends upon his or her *interpretation* of this arousal. It is important to distinguish between *density* and *crowding* for this reason. *Density* refers to the actual number of people occupying a space, while the psychological state of *crowding* exists only if a negative affective state occurs as a result of this density.[8] For example, a large number of people in a small store may signify a very successful sale and be positive for the owner, but perhaps not for the shoppers.

In addition, the *type* of consumers who patronize a store or service or who use a product can influence evaluations. We often infer something about a store by examining its customers. Elegantly dressed women shopping an exclusive boutique add cachet. For this reason, some restaurants require men to wear a jacket for dinner (and supply a rather tacky one if they don't), and bouncers at some "hot" clubs and openings of exclusive boutique openings hand-pick people waiting in line based on whether they have the right "look." To paraphrase the comedian Groucho Marx, "I would never join a club that would have me for a member!"

Temporal Factors

Time is one of consumers' most precious resources. We talk about "making time" or "spending time," and we frequently are reminded that "time is money." Common sense tells us that more careful information search and deliberation occurs when we have the luxury of taking our time.

Economic Time

Time is an economic variable; it is a resource that must be divided among activities.[9] Consumers try to maximize satisfaction by allocating time to the appropriate combination of tasks. An individual's priorities determine his or her *timestyle*.[10]

Analysts say that consumers are increasingly time-starved and shopping for the latest flirty skirt could be becoming less of a priority. One study found the average person is stuck in traffic for forty-seven hours a year compared to sixteen hours in 1982. And out of women's five leisure hours per day, they are spending three of them watching television.[11] There are plenty of other leisure activities, including socializing and sports, for those other two hours, which worries retailers.

Many consumers believe they are more pressed for time than ever before, a feeling called **time poverty**. This feeling may, however, be due more to perception than to fact. People may just have more options for spending their time and feel pressured by the weight of all of these choices. The average working day at the beginning of the twentieth century was ten hours (six days per week), and women did twenty-seven hours of housework per week,

compared to less than five hours weekly now at the beginning of the twenty-first century. In addition to laborsaving devices, one reason for this difference is that men are sharing these burdens more, and in some families maintaining a spotless home may not be as important as it used to be.[12] Still, about a third of Americans report always feeling rushed—up from 25 percent of the population in 1964.[13]

This sense of time poverty has made consumers very responsive to marketing innovations that allow them to save time. This priority has created new opportunities for services as diverse as dry cleaning and online photo sharing, where speed of delivery has become an important attribute.[14] There are also implications for store layout and clear signage in stores for busy consumers wanting to get in and out of stores fast. And some feel that brand loyalty should be aggressively cultivated in a time-starved era. If consumers have favorite apparel brands that are known to fit well, there is less reason to spend time in the stores shopping for the perfect item.

According to *Lifestyle Monitor*, women spend an average of one hour and forty-one minutes shopping for clothes per shopping trip, while men spend less than ninety minutes. The time in the stores has increased recently.[15] This may be due to better merchandise selection, which takes time to peruse, keeping consumers in the store. At the same time, visits to retail Web sites, often used to become familiar with new merchandise available at the store, may tend to cut down the time women spend in the stores.

Psychological Time

Some products and services are believed to be appropriate for certain times and not for others. Also, we may be more receptive to advertising messages at certain times. Who wants to hear a beer commercial at seven in the morning? An ad for a sale at JCPenney or Target might be received better in the morning. However, there is some evidence that consumers' arousal levels are lower in the morning than in the evening, which affects their style and quality of information processing.[16]

The psychological dimension of time, or how it is experienced, is an important factor in *queuing theory*, the mathematical study of waiting lines. A consumer's experience of waiting can radically influence his or her perceptions of service quality. Although we assume that something must be pretty good if we have to wait for it, the negative feelings aroused by long waits can quickly turn off customers.[17] According to a survey, 83 percent of women and 91 percent of men say long lines made them stop going to a particular store. Retailers are testing technologies to reduce or eliminate lines. Customer self-checkout is one way that is working in some stores.

Antecedent States: If It Feels Good, Buy It

A person's mood or physiological condition at the time of purchase can have a big impact on what is bought and can also affect how products are evaluated.[18] For example, stress can impair information-processing and problem-solving abilities.[19] Two dimensions, *pleasure* and *arousal*, determine whether a shopper will react positively or negatively to a consumption environment. A person can enjoy or not enjoy a situation, and he or she can feel stimulated or

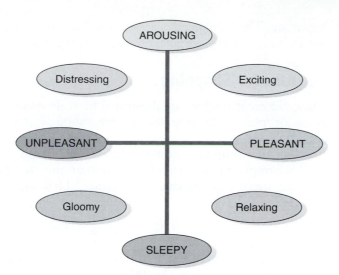

FIGURE 13-4
Dimensions of Emotional States
Source: James Russell and Geraldine Pratt, "A Description of the Affective Quality Attributed to Environment," *Journal of Personality and Social Psychology,* 38 (August 1980): 311–322. © Copyright 1980 by the American Psychological Association. Adapted by permission.

not. As Figure 13-4 indicates, different combinations of pleasure and arousal levels result in a variety of emotional states. For example, an arousing situation can be either distressing or exciting, depending on whether the context is positive or negative (for example, a street riot versus a street festival). Maintaining an "up" feeling is one factor behind the success of theme parks such as Disney World, which try to provide consistent doses of stimulation to patrons,[20] and many new retail formats catering to young people—for example, Niketown, which supplies lively displays and music in a very upbeat tone.

A specific mood is some combination of pleasure and arousal. For example, the state of happiness is high in pleasantness and moderate in arousal, while elation is high on both dimensions.[21] In general, a mood state (either positive or negative) biases judgments of products and service in that direction.[22] Put simply, consumers like things better when they are in a good mood. And vice versa: Some purchases put consumers in a good mood. A *Women's Wear Daily* study that explored attitudes toward color in the wardrobe revealed that a majority of women say they wear colors to reflect their moods and that bright colors make them feel good or happy (this is especially true of the senior set).[23]

Moods can be affected by store design, the weather, or other factors specific to the consumer. In addition, music and television programming can affect mood, which has important consequences for commercials.[24] When consumers hear happy music or watch happy programs, they have more positive reactions to commercials and products, especially when the marketing appeals are aimed at arousing emotional reactions.[25] When in positive moods, consumers process ads with less elaboration. They pay less attention to specifics of the message and rely more on heuristic processing (see Chapter 11).[26]

SHOPPING: A JOB OR AN ADVENTURE?

Some people shop even though they do not necessarily intend to buy anything at all, while others have to be dragged to a mall. Shopping is a way to acquire needed products and services, but social motives for shopping also are

important. Thus, shopping is an activity that can be performed for either utilitarian (functional or tangible) or hedonic (pleasurable or intangible) reasons.[27]

Reasons for Shopping

These different motives are illustrated by scale items used by researchers to assess people's underlying reasons for shopping. One item that measures hedonic value is "During the trip, I felt the excitement of the hunt." When that type of sentiment is compared to a functionally related statement, such as, "I accomplished just what I wanted to on this shopping trip," the contrast between these two dimensions is clear.[28] Hedonic shopping motives can include the following.[29]

- *Social experiences:* The shopping center or department store has replaced the traditional town square or county fair as a community gathering place. Many people (especially in suburban or rural areas) may have no place else to go to spend their leisure time. One study

WHY DO YOU SHOP?

Women's Wear Daily surveyed women around the world. Here are a few responses to the question "Why do you shop?"[30]

New York

- I get the fashion magazines. I'm in New York to hit Saks, Bergdorf's, and Barney's.
- I shop when I'm depressed, but sometimes I see something that I really like and that inspires me to shop.

Los Angeles

- Boredom.
- Just about anything.
- My favorite time to shop is when I want to go to parties.

Chicago

- I shop where they totally put me together from soup to nuts.
- Keeping up with the styles, new things; I love clothes.
- Whatever strikes my eye. I look all the time. It's never seasonal, I just shop.

Madrid

- I live to shop, mainly for quality and basics.
- I like to shop because it makes me feel good.
- I'm not interested in brands, except Levi's. That's all I know about American labels.

London

- I'm an impulsive and constant shopper. I'm always looking at labels.

- I shop for brands. I see something I like, I buy it, and I get out.

Milan

- I love to buy shoes and cosmetics.
- I have absolutely no time to shop, it's only when I desperately need something.
- I don't follow the trends, I follow my feelings. Good quality lasts a lifetime.

Toronto

- You always want something different and try to keep up with fashion.
- It's a gene you've got! I like to shop, what can I say?
- I love to have nice things for my home and like nice clothes.

Moscow

- I like shopping. I prefer being beautiful to being trendy.
- I don't buy things because I need them but because they suit my image.
- Because it's fun. I want cool clothes.

Paris

- I buy because of the beauty of the clothes and not because of the label.
- I love to wear jeans and no makeup, but I also love to dress up.
- I buy what I like. Dior and Chanel are beautiful but for older people.

The mall has become a gathering place for young people, something that can be problematic at times—for example, when the elderly do not feel safe.

found a correlation between teenage loneliness and going to the mall for entertainment and socializing.[31] Another interesting example of loneliness is an elderly man who goes to a Madison Avenue boutique every Saturday, reads the paper, and accepts coffee and danish as provided to customers in the luxurious setting. He has never bought anything in the six years he has been doing this, but the store offers this high-end service to everyone.

- *Sharing of common interests:* Stores frequently offer specialized goods that allow people with shared interests to communicate.
- *Interpersonal attraction:* Shopping centers are a natural place to congregate. The shopping mall has become a central "hangout" for teenagers. It also represents a controlled, secure environment for the elderly, and many malls now feature "mall walkers' clubs" for early-morning workouts.
- *Instant status:* As every salesperson knows, some people savor the experience of being waited on, even though they may not necessarily buy anything. One men's clothing salesman offered this advice: "Remember their size, remember what you sold them last time. Make them feel important! If you can make people feel important, they are going to come back. Everybody likes to feel important!"[32]
- *"The thrill of the hunt":* Some people pride themselves on their knowledge of the marketplace. Unlike Sharon, they may relish the process of haggling and bargaining, viewing it almost as a sport.

Apparel Shopping: Love It or Hate It?

Which way is it? Do people hate to shop or love it? It depends. According to research by *Lifestyle Monitor*, the number of female consumers who love to shop for clothes is decreasing.[33] Out of a possible score of 100, their

Early hours before stores open at many malls is a time when older adults take to "mall walking" for exercise in a safe and temperate environment.

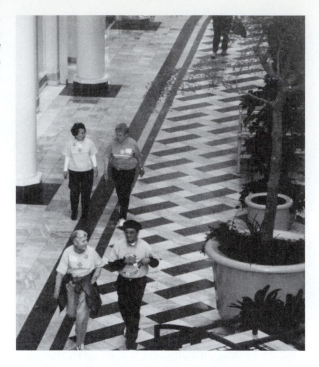

"shopping barometer" registers 56 (just above a neutral rating) for all females. (Of course, fashion innovators score the highest at 72.)

The largest reasons for not "loving to shop for clothes" and evidence that consumers are focusing their energies on other things in life than clothes shopping include the following:

- Rather spend money on other things
- Not as interested in clothes as I used to be
- Current styles don't flatter my shape
- I don't have time to shop for clothes

Research indicates that the important 25–34 age-group is becoming disenchanted with fashion apparel selections, with comments such as, "The stuff in the stores today is either not very well made or too expensive for my budget. There's nothing in the middle," and "Everything in the department and chain stores looks the same. In order to find really unusual clothes, you have to spend a lot of money, which I am not willing to do for every purchase." Apparel companies, beware of the disenchanted consumer!

Shopping Orientation

Consumers can be segmented in terms of their **shopping orientation**, or general attitudes about shopping. These orientations may vary depending on the particular product categories and store types considered. Sharon loves to shop for jewelry, but she may hate to go to shoe stores or hardware stores. Industry experts also claim that men and women tend to

Who loves to shop the most? In a survey of women around the world, more than 60 percent of women said they enjoy shopping for clothes in every country except Hong Kong, where only 39 percent responded so positively. The "Born to Shop" prize goes to Latin Americans; more than 80 percent of women in countries such as Brazil and Colombia agree that clothes shopping is a favorite activity. Other high-scoring countries include France, Italy, and Japan. In comparison, only 61 percent of American women said they like or love to go clothes shopping. Almost everywhere in the world, women agreed that store displays are the most important source of information about clothing. Two exceptions are German women, who ranked fashion magazines highest, and Mexican women, who reported that their families are the best source to learn about what to wear.[34]

differ in their shopping styles. Several shopping types have been identified.[35] Which one are you?

- *The economic consumer:* a rational, goal-oriented shopper who is primarily interested in maximizing the value of his or her money.
- *The personalized consumer:* a shopper who tends to form strong attachments to store personnel ("I shop where they know my name").
- *The ethical consumer:* a shopper who likes to help out the underdog and will support locally owned stores against big chains.
- *The apathetic consumer:* a person who does not like to shop and sees it as a necessary but unpleasant chore.
- *The recreational shopper:* a person who views shopping as a fun, social activity—a preferred way to spend leisure time.

E-Commerce: Clicks versus Bricks

As more and more Web sites pop up to sell everything from T-shirts to refrigerator magnets, marketers are hotly debating how the online world affects their business.[36] Some consumer types more than others may be more inclined to use e-commerce (a good research project!). Many are losing sleep wondering whether e-commerce is destined to replace traditional retailing, work in concert with it, or perhaps even fade away to become another fad your kids will laugh about someday.

For marketers, the growth of online commerce is a sword that cuts both ways: On the one hand, they can reach customers around the world even if they're physically located a hundred miles from nowhere. On the other hand, their competition now comes not only from the store across the street, but from thousands of Web sites spanning the globe. A second problem is that offering products directly to consumers has the potential to cut out the middleman—the loyal store-based retailers who carry the firm's products and who sell them at a marked-up price.[37] The "clicks versus bricks" dilemma is raging in the marketing world.

So, what makes e-commerce sites successful? According to a survey by NPD Online, 75 percent of online shoppers surveyed said that good customer service would make them shop at the site again.[38] A recent Internet

E-commerce sites such as Bluefly.com give shoppers the option of shopping without leaving home.

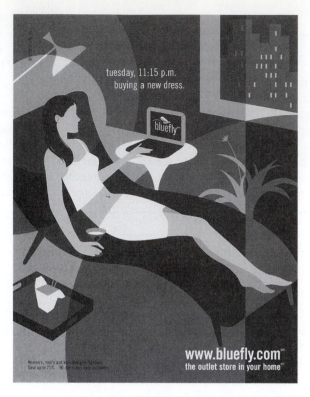

fashion study conducted online found high satisfaction with many aspects of Web shopping. However, older customers and women were less satisfied. Lack of customer service contacts was the greatest concern.[39] Many successful e-tailers are learning that using technology to provide extra value for customers is attracting and keeping customers. For example, Lands' End (www.landsend.com) offers men and women a Virtual Model™ that lets them design a model matching their own body type so they can then "try on" the clothing they're looking at on the Web site. The Cover Girl makeup site (www.covergirl.com) allows women to find colors that match their skin and hair types or to design a total look that's right for their lifestyle.

E-commerce does have its limitations. Security is one important concern. We hear horror stories of consumers whose credit cards and other identity information have been stolen. Although an individual's financial liability in most theft cases is limited to $50, the damage to one's credit rating can last for years. Some shady companies are making money by prying and then selling personal information to others—one company promotes itself as "an amazing new tool that allows you to find out EVERYTHING you ever wanted to know about your friends, family, neighbors, employees, and even your boss!"[40] Pretty scary. Almost daily we hear of hackers getting into a business or even a government Web site and causing havoc. Businesses risk the loss of trade secrets and other proprietary information. Many must spend significant amounts to maintain security and conduct regular audits to ensure the integrity of their sites.

Another limitation of e-commerce relates to the actual shopping experience. While it may be satisfactory to buy a computer or a book on the

Table 13-1 Pros and Cons of E-Commerce

Benefits of E-Commerce	Limitations of E-Commerce
For the Consumer	
Shop 24 hours a day	Lack of security
Less traveling	Fraud
Can receive relevant information in seconds from any location	Can't touch items
More choices of products	Exact colors may not reproduce on computer monitors
More products available to less-developed countries	Expensive to order and then return
Greater price information	Potential breakdown of human relationships
Lower prices so that less affluent can purchase	
Participate in virtual auctions	
Fast delivery	
Electronic communities	
For the Marketer	
The world is the marketplace	Lack of security
Decreases costs of doing business	Must maintain site to reap benefits
Very specialized businesses can be successful	Fierce price competition
Real-time pricing	Conflicts with conventional retailers
	Legal issues not resolved

Source: Adapted from Michael R. Solomon and Elnora W. Stuart, *Welcome to Marketing.com: The Brave New World of E-Commerce* (Upper Saddle River, N.J.: Prentice-Hall, 2001).

Internet, buying clothing and other items where touching the item or trying it on is essential, may be less attractive. Even though most companies have very liberal return policies, consumers can still get stuck with large delivery and return shipping charges for items that don't fit or simply aren't the right color. Timing and delivery can also be a problem for companies that haven't figured out the formula yet. Many promises for quick Christmas deliveries have been broken, and actually large fines have been levied by the Federal Trade Commission on some dot-com companies that broke their delivery promises or never delivered at all.[41] Some of the pros and cons of e-commerce are summarized in Table 13-1. It's clear that traditional shopping isn't quite dead yet—but bricks-and-mortar retailers do need to work harder to give shoppers something they can't get (yet, anyway) in the virtual world—a stimulating or pleasant environment in which to browse. Now let's consider how they're doing that.

Retailing as Theater

The competition for shoppers is becoming intense as nonstore alternatives, from Web sites and print catalogs to TV shopping networks and home shopping parties, continue to multiply.

RUSH-HOUR PARTIES

Some marketers are choosing to follow people to work in order to boost sales. After realizing that many of its female customers are no longer home during the day, even Avon has expanded its distribution network to the office, where representatives make presentations during lunch and coffee breaks. Similarly, Tupperware features "rush-hour parties" at the end of the work-day and now finds that about 20 percent of its sales are made outside homes. An employee of Mary Kay cosmetics, another company adapting this strategy, offered another explanation for its success: "Working women buy more in the office because they are not looking at the wallpaper that needs replacing. They feel richer away from home."[42]

With all of these shopping alternatives available, how can a traditional store compete? Shopping malls have tried to gain the loyalty of shoppers by appealing to their social motives as well as providing access to desired goods. The mall is often a focal point in a community. In the United States, 94 percent of adults visit a mall at least once a month. More than half of all retail purchases (excluding autos and gasoline) are made in a mall.[43]

Malls are becoming giant entertainment centers, almost to the point where their traditional retail occupants seem like an afterthought. As one retailing executive put it, "Malls are becoming the new mini-amusement parks."[44] It is now typical to find such features as carousels, miniature golf, and even batting cages in a suburban mall. The goal is to provide an experience that will draw people to the mall, and this motivates innovative marketers to blur the line between shopping and theater.[45]

Individual stores strive to add excitement, entertainment, and something new to keep customers intrigued. The Prada SoHo store in New York City features high-tech dressing rooms, plasma screen monitors with constant entertainment throughout the store, and the first ever circular glass elevator, keeping both customers and tourists amused.[46] Issey Miyake's latest New York store, designed by Frank Gehry (architect for Guggenheim museums), also adds a bit of intrigue for shoppers in a museum environment that is interactive and always surprising.[47]

Levi's store in its hometown San Francisco and Niketown throughout the country offer specialized product services in addition to constant visual stimulation and activities such as huge video screens and game simulations. The concept and development director of Levi's Global Retailing, discussing its first San Francisco store known for its multisensory shopping experience, said, "The store is more than a retail space, it's an engaging environment where kids can hang out. We've taken our retail experience beyond a place you shop to create an atmosphere that spawns energy and encourages creativity."[48]

There is a downside to the high foot traffic in entertainment/mall combos. It is a concern that these high-tech options are attracting primarily the group that mall operators want least: packs of teenage boys that intimidate shoppers.[49] Despite Levi's apparent goal to create an environment for young people to hang out, teenage gatherings in many malls are causing concerns. The Mall of America near Minneapolis, for example, encountered problems

Expo-Xplore, part of a new shopping complex near Durban, South Africa, is the next wave in retail and entertainment design. The courtyard, lined with retailers selling clothes and gear for a variety of outdoor adventure sports, leads to Planet Blue, the ocean-themed heart of the project, with stores oriented around scuba diving, boating, surfing, and other water sports.

with too much teenage congregation and developed strict hours that young people can be in the mall without an adult.

At the chain of malls run by the Mills Corporation, there is an emphasis on providing interactive experiences. The company is trying to give its ten malls around the country a single national brand image using the total-experience theme. They feature theme restaurants such as The Rainforest Cafe and virtual-reality game centers.[50] Other retailers are seeking to combine two favorite consumer activities, shopping and eating, by developing other *themed environments*. According to a recent Roper Starch survey, eating out is the top form of out-of-home entertainment, and innovative firms are offering customers a chance to eat, buy, and be entertained all at once. The Hard Rock Café (www.hardrock.com), first established in London in 1971, now has over 130 restaurants in 40 countries. Likewise, Planet Hollywood (www.planethollywood.com) is crammed full of costumes and props and the chain has locations worldwide and is building a vacation timeshare in

MULTICULTURAL DIMENSIONS

American retailers, including Original Levi's stores, Foot Locker, Toys "R" Us, and Gap, are exporting their version of dynamic retail environments to Europe—with some adaptations. These overseas "invasions" often begin in Britain, since bureaucratic hurdles tend to be lower, and weaker unions yield reduced personnel costs. Malls still are rare in most of the European Union, so these chains must usually bid for high-rent sites on city streets. Gap found that it needed to stock smaller sizes than in the United States and that many of its European customers prefer darker colors. Also, some retailers have done away with "greeters" who now stand at the entrance in many American stores—Europeans tend to find them intimidating.[51]

Las Vegas. With profit margins on the merchandise sold at these restaurants as high as 60 percent, it's not surprising that as much as 50 percent of a theme chain's revenues come from T-shirts and goods other than T-bones and other foods![52] On the other hand, not all themes work with food. The Fashion Café in New York, with part ownership by supermodels Elle Macpherson, Claudia Schiffer, and Naomi Campbell, closed after several years.

Store Image

With so many stores competing for customers, how do consumers pick one over another? Like products (see Chapter 8), stores may be thought of as having "personalities." Some stores have very clearly defined images (either good or bad). Others tend to blend into the crowd. They may not have anything distinctive about them and may be overlooked for this reason. This personality, or **store image**, is composed of many different factors. Store features, coupled with such consumer characteristics as shopping orientation, help predict which shopping outlets people will prefer.[53] Some of the important dimensions of a store's profile are location, merchandise suitability, and the knowledge and congeniality of the sales staff.[54]

These features typically work together to create an overall impression. When shoppers think about stores, they may not say, "Well, that place is fairly good in terms of convenience, the salespeople are acceptable, and services are good." They are more likely to say, "That place gives me the creeps," or "I always enjoy shopping there." Consumers often evaluate stores using a general evaluation, and this overall feeling may have more to do with things such as interior design and the types of people one finds in the store than with aspects such as return policies or credit availability. A typical shopper may wander in and out of different stores, making quick value judgments. As a result, some stores are likely to consistently be in consumers' evoked sets (see Chapter 11), while others will never be considered.[55]

Atmospherics

Because a store's image now is recognized as a very important aspect of the retailing mix, attention is increasingly paid to **atmospherics**, or the "conscious designing of space and its various dimensions to evoke certain effects in buyers."[56] These dimensions include colors, scents, and sounds. For example, stores done in red tend to make people tense, while a blue decor imparts a calmer feeling.[57] Color can account for the majority of one's acceptance of a product.[58] As was noted in Chapter 9, some preliminary evidence indicates that smells (olfactory cues) also can influence evaluations of a store's environment.[59] A store's atmosphere in turn affects purchasing behavior—one study reported that the extent of pleasure reported by shoppers five minutes after entering a store was predictive of the amount of time spent in the store as well as the level of spending there.[60]

Many elements of store design can be cleverly controlled to attract customers and produce desired effects on consumers. Light colors can impart a feeling of spaciousness and serenity. The Color Marketing Group forecasts that blue, the color most closely linked with water (a symbol of tranquillity), will be the most dominant color for the next decade; neutral colors and a new

SHOP THE STORE, BUY THE SOUND TRACK

Do you like the music playing in your favorite store? Growing recognition of the important role played by a store's audio environment has created a new niche: compilation CDs. Victoria's Secret led the way in the field when it released a CD of classical music played in the store. Customers were soon buying Beethoven with their lingerie. Over 2 million *Classics by Request* CDs have been sold. Rock River Communications creates music strategies for retailers such as Pottery Barn, Polo/Ralph Lauren, Gap, Williams-Sonoma, Kohl's, and Restoration Hardware to name a few. Although marketers have long known that ambient music helps put shoppers in the mood to buy, they only recently have thought to package background music as a product itself.[65] Stores use music to match their marketing and image. For example, when Eddie Bauer decided to try to attract a younger customer, it ditched its big band CD for a hipper recording of Latin music. One year Restoration Hardware matched its fun rum glasses with drink stirrers, coasters, and songs like "Papa Loves Mambo" by Perry Como and "Cocoanut Woman" by Harry Belafonte. To top it off, high-margin compilation CDs make a great at-the-register impulse buy.

wave of soft pales such as aqua and lavender will also be evident as consumers seek out soothing and spiritual environments in today's fast-paced digital age.[61] On the other hand, bright colors create excitement and bring attention to point-of-purchase (POP) displays and signage in the store. In one subtle but effective application of color in the retail environment, fashion designer Norma Kamali replaced fluorescent lights with pink ones in department store dressing rooms. The light had the effect of flattering the face and banishing wrinkles, making female customers more willing to try on (and buy) the company's bathing suits.[62] Wal-Mart found that sales were higher in areas of a prototype store lit in natural daylight compared to the more typical artificial light.[63] One study found that brighter in-store lighting influenced people to examine and handle more merchandise.[64]

In-Store Decision Making

Despite all their efforts to "presell" consumers through advertising, marketers increasingly are recognizing the significant degree to which many purchases are influenced by the store environments. Women tell researchers, for example, that store displays are one of the major information sources they use to decide what clothing to buy.[66] It is estimated that almost 70 percent of cosmetics purchases are unplanned.[67]

Spontaneous and Impulse Buying

When a shopper is prompted to buy something while in the store, one of two different processes may be at work: *Unplanned buying* may occur when a person is unfamiliar with a store's layout or perhaps when under some time pressure. Or a person may be reminded to buy something by seeing it on a store shelf. About one-third of unplanned buying has been attributed to the recognition of new needs while within the store.[68]

In contrast, **impulse buying** occurs when the person experiences a sudden urge that he or she cannot resist. The tendency to buy spontaneously is most likely to result in a purchase when the consumer believes that acting on impulse is appropriate, such as purchasing a gift for a sick friend.[69] To cater to these urges, so-called *impulse items* such as small accessories at retail stores are conveniently placed near the checkout.

Researchers are not consistent in identifying categories of impulse buying; however, there is some agreement that there are several dimensions to impulse buys. One fashion study used the following categories of impulse buying:[70]

- *Planned impulse buying:* the purchase is dependent on sale conditions. Consumers wait to see what is available and the purchase decision is made in the store.
- *Reminder impulse buying:* the purchaser remembers a previous decision, which causes an on-the-spot purchase.
- *Fashion-oriented buying* (the term *suggestion impulse* is used in other typologies[71]): the customer sees the product in a new style, is motivated by the suggestion, and decides to buy it. This refers to a person's awareness of the newness or fashionability of an innovative design or style.
- *Pure impulse buying:* the purchase occurs without any previous thought or plan to buy; it can be "escape buying" resulting from a sudden urge to buy something.

As we can see, impulse buying is not all purely irrational. Often "impulse" buys turn out to be the ones that best meet our needs. How many times have you resisted the impulse to buy something and later said "I wished I'd bought that [item], it would have been perfect"? On the other hand, fashion students have been found to engage in more impulse buying (of all types) when compared with nonfashion students and nonstudent consumers.[72]

Point-of-Purchase Stimuli

Because so much decision making apparently occurs while the shopper is in the purchasing environment, retailers pay attention to the amount of information in their stores, as well as to the way it is presented. It has been estimated that impulse purchases increase by 10 percent when appropriate displays are used. Each year, U.S. companies spend more than $13 billion on **point-of-purchase (POP) stimuli**, ranging from elaborate product displays and demonstrations to someone giving free samples of a new fragrance in a department store.

In-store advertising is becoming very sophisticated, as marketers come to appreciate the influence of the shopping environment in steering consumers toward promoted items. Kmart's famous blue-light specials have highlighted sale items for years (it is using this same concept with "featured products for

COUPONED FASHION

Cents-off coupons are widely used by manufacturers and retailers to induce consumers to switch brands. They also recently have been used in some department stores such as Macy's. While coupons are an important form of sales promotion, evidence regarding their effectiveness at luring *new* customers is mixed. Households that already use the couponed brand are more likely to redeem the coupon, and most customers revert to their original brand after the promotion has expired. As a result,

the company that hopes to attract brand switchers by luring them with coupon offers may instead find itself "preaching to the converted."[73] Thanks to technology, retailers are able to slice and dice their databases to find valuable customers. "Bounce-back" or "targeted" coupons sent in the mail to these good customers, rather than mass coupons printed in newspapers, cultivate repeat visitors.[74] Those who return too much merchandise probably don't receive these mailings.

the day" on its Web site, www.bluelight.com). *In-store displays* are a commonly used device to attract attention in the store environment. Some of the more dramatic POP displays have included the following:[75]

- *Timex:* A still-ticking watch sits in the bottom of a filled aquarium.
- *Elizabeth Arden:* "Elizabeth," a computer and video makeover system, allows customers to test out their images with different shades of makeup without having to actually apply the products first.
- *Trifari:* This company offered paper punch-out versions of its jewelry so that customers can "try on" the pieces at home.
- *REI:* This retailer of outdoor apparel and gear introduced experiential retailing to its customers. One of its most famous hands-on activities is its climbing wall, called the Pinnacle, on which customers can test out various pieces of equipment.[76]

Much of the growth in point-of-purchase activity has been in new electronic technologies.[77] Some stores feature talking posters that contain a human-body sensor that speaks up when a shopper approaches. In-store video displays allow advertisers to reinforce major media campaigns at the point of purchase.[78] Kiosks give product information and opportunities to purchase products not in the store.

Some of the most interesting innovations can be found in state-of-the-art vending machines, which now dispense everything from software to clothing. Kiosks are now dispensing smells—that is, samples of perfume—one molecule at a time so that it is not intrusive to other customers around you.[79] French consumers can purchase Levi's jeans from a machine called "Libre Service," which offers the pants in ten different sizes. Due to their frenetic lifestyles, the Japanese are particularly avid users of vending machines. These machines dispense virtually all of life's necessities, plus many luxuries people in other countries would not consider obtaining from a machine. The

EXPERIENTIAL RETAILING

More consumers today are wanting experience rather than product. Experiential retailing makes connections with consumers and products through interactive stores. Companies selling dolls to sports gear have created experiences that teach the customer how to use a product in addition to selling a pure experience.

Club Libby Lu is a business that offers 5- to 13-year-old girls the chance to live out a fantasy during an hour-and-a-half-long party in a shopping mall. For $22 to $35 per child, a birthday girl and a dozen of her closest friends can get a makeover and accessories to complete the look of Rock Star, Pop Princess, Celebrity DJ, or Hannah Montana. Hairstyling, glittery cosmetics, and create your own spa are all coordinated by "club counselors."[84] Even little girls want to be glamorous.

American Girl Place, with locations in New York, Los Angeles, and Chicago, has a museum-like display of upscale dolls, includes a café with booster seats for eighteen-inch dolls and a styling salon for their hair, and lets little girls dress like their dolls. A visit to American Girl Place is like a pilgrimage for American Girl Place fans.

The concept of experiences that help sell product is used in Apple stores where customers can try out new products and get hands-on, real-time solutions to Apple-related technical problems at its "Genius Bar." Cabela's, which sells outdoor apparel and gear, has destination stores to educate and entertain customers with wildlife dioramas and archery ranges. And REI's climbing wall gives customers opportunities to try out products before buying. One analyst said, "It (experiential retailing) reflects a U.S. economy where consumers generally have what they need but will shop for nonessentials if given a reason."[85]

list includes jewelry, fresh flowers, frozen beef, pornography, business cards, underwear, and even the names of possible dates.[80]

The Salesperson

One of the most important in-store factors is the salesperson, who attempts to influence the buying behavior of the customer.[81] This influence can be understood in terms of **exchange theory**, which stresses that every interaction involves an exchange of value. Each participant gives something to the other and hopes to receive something in return.[82]

What "value" does the customer look for in a sales interaction? There are a variety of resources a salesperson might offer. For example, he or she, might offer expertise about the product to make the shopper's choice easier. Alternatively, the customer may be reassured because the salesperson is a likable person whose tastes are similar and is seen as someone who can be trusted.[83] Sharon's jewelry purchase, for example, was strongly influenced by the age and sex of Melanie, the seller with whom she negotiated. In fact, a long stream of research attests to the impact of a salesperson's appearance on sales effectiveness. In sales, as in much of life, attractive people appear to hold the upper hand.[86] In addition, it's not unusual for service personnel and customers to form fairly warm personal relationships; these have been termed *commercial friendships* (think of all those patient bartenders who double as therapists for many people!). Researchers have found that commercial friendships are similar to other friendships in that they can involve affection, intimacy, social support, loyalty, and reciprocal gift giving. They also work to support marketing objectives such as satisfaction, loyalty, and positive word of mouth.[87]

Little girls can have their doll's hair done at the doll salon at the American Girl store on Fifth Avenue in New York City. For an extra charge a pampering package includes a thorough facial scrub and a set of nail decals to take home. American Girl is billed as "a place for magical experiences and memories she'll cherish forever."

Web sites are even using salespersons, but they are under the heading of "chat." Internet retailers are increasingly adding online chat specialists to help customers who need a nudge to buy. This is the equivalent of a store's clerk's "Hi, may I help you?" Retailers that approach a customer on chat are more likely to generate a sale than those that rely on customers to find the chat button and click on it.[88]

A buyer/seller situation is like many other dyadic encounters (two-person groups). It is a relationship in which some agreement must be reached about the roles of each participant: A process of *identity negotiation* occurs.[89] For example, if Melanie immediately establishes herself as an expert (and Sharon accepts this position), she is likely to have more influence over her through the course of the relationship. Some of the factors that help determine a salesperson's role (and relative effectiveness) are his or her age, appearance, educational level, and motivation to sell.[90]

In addition, more effective salespeople usually know their customers' traits and preferences better than do ineffective salespeople, because this knowledge allows them to adapt their approach to meet the needs of the specific customer.[91] The ability to be adaptable is especially vital when customers and salespeople differ in terms of their *interaction styles*.[92] Consumers, for example, vary in the degree of assertiveness they bring to interactions. At one extreme, nonassertive people believe that complaining is not socially acceptable and may be intimidated in sales situations. Assertive people are more likely to stand up for themselves in a firm but nonthreatening way. Aggressives may resort to rudeness and threats if they do not get their way.[93]

POSTPURCHASE SATISFACTION

Consumer satisfaction/dissatisfaction is determined by the overall feelings, or attitude, a person has about a product after it has been purchased. A recent study by Sears found a correlation between high sales and high customer satisfaction. This was considered so important that the company reengineered its executive compensation package to reflect results of customer satisfaction surveys.[94]

Consumers are engaged in a constant process of evaluating the things they buy as these products are integrated into their daily consumption activities.[95] Consumers define apparel quality differently before and after purchase,[96] thereby making more complex the study of apparel purchase satisfaction. Customer satisfaction has a real impact on the bottom line: A recent study conducted among a large sample of Swedish consumers found that product quality affects customer satisfaction, which in turn results in increased profitability among firms that provide quality products.[97] Quality is more than a marketing "buzzword."

Perceptions of Product Quality

Just what do consumers look for in products? That's easy: They want quality and value. Especially because of foreign competition, claims of product quality have become strategically crucial to maintaining a competitive

SATISFIED CUSTOMERS

Customer satisfaction is a must for successful retailers. The National Retail Federation in conjunction with American Express developed a survey to identify retailers that deliver the best customer service. Respondents were asked, "Which retailer delivers the best customer service?" The following are the best:[98]

1. *Nordstrom:* hires enthusiastic sales associates who love fashion. It listens for feedback from customers and sales associates.

2. *Coldwater Creek:* started as an eighteen-page catalog, it has over 160 stores and active catalog and Internet sales with an attitude of covering service by every angle.

3. *Marshall Field's:* now under the Macy's name. According to the company, Marshall Field's coined the phrase: "Give the lady what she wants."

4. *Kohl's:* its core customer is a busy mom shopping for herself and her family.

5. *Boscov's:* built on the policy that "the customer is always right."

6. *REI (Recreation Equipment):* the largest consumer cooperative with more than 200 million members enjoying special benefits.

7. *JCPenney:* with over a thousand stores, it has excellent customer satisfaction.

8. *Lane Bryant:* most recognized name in large-sized clothing with emphasis on fashion.

9. *Best Buy:* the number-one specialty retailer of consumer electronics.

10. *Eddie Bauer:* a guarantee to deliver sincere service and complete satisfaction.

advantage.[99] Consumers use a number of cues to infer quality, including brand name, price, and even their own estimates of how much money has been put into a new product's advertising campaign.[100] These cues often are used by consumers to relieve perceived risk and assure themselves that they have made smart purchase decisions.

Apparel Quality

While everyone wants quality, no one is sure exactly what it means. Certainly, many manufacturers claim to provide it. The meaning of apparel quality from an industry perspective, illustrated in Figure 13-5, includes structural integrity (such as even stitching and matching plaids), aesthetic presence (such as perfect finishing and overall appearance), and power of appeal (such as pizzazz).[101] Consumers may define it differently; pizzazz may not be a requirement for a quality garment. One consumer study found that attributes of consumer-defined apparel quality fell into the four categories of construction, fabric, fiber, and garment features, while another study found fabric considerations to be the most important and underlying dimension of garment quality.[102]

Quality Is What We Expect It to Be

One apparel study found that consumers transfer an image or perception of the overall quality of a country's products to their perception of apparel quality from that country. For Mexico, a neutral country image correlated with neutral apparel image, while for France, a high country image correlated to a high apparel image. It appears that consumers expect similar quality of products from a country. In this study, however, purchase intent was not correlated with perception of quality.[103] Quality may not be the most important thing to consumers; price and style are often what become the deciding factors when we buy apparel and fashion.

Structural Integrity	Aesthetic Presence	Power of Appeal
Clean seams	Feels right	It just grabs the eye
Consistent gore seams	Overall appearance	Pops out at you
Consistent collar notches	The look	Collar expression
Consistent lapel notches	Cleanness of coat	Shoulder expression
Measurements have to be right	Aesthetically comforting	Coat jumps out at you
Pocket bag inside should be flat	Nice looking	The overall expression
Everything matches well	Whole look of the shoulder	It just looks rich
Pockets are even	Soft finished	It appeals to you
The peaks (lapel) are both pointed	In the eyes of the beholder	Swept out
It has to be sewn right	It has to fit, feel good	It stands out
Overall balance	Beyond measuring and fitting	Finesse
The proper fullness	Look good	Hanger appeal
It has to be sewn natural	A different look	Pizzazz
Thing you build in a garment	Symmetry	
It has to be cut right	The drape	
Bottom of coat should be straight	Smooth	
Good fit on the form	Overall balance	
A coat that matches the buttons	Lining cleanliness	
Constructed properly and accurately	The proper look	
Sleeve hang is consistent	It is crisp	
Plaids have to match	Coat has to be finished perfectly	

FIGURE 13-5
Constructs of Apparel Quality from an Industry Perspective

Note: Listed are portions of raw data in the form of statements representing diverse notions of quality from operators, supervisors, plant managers, and senior managers of large producers of men's tailored clothing.

Source: Heidi P. Scheller and Grace I. Kunz, "Toward a Grounded Theory of Apparel Product Quality," *Clothing and Textiles Research Journal* 16, no. 2 (1998): 57–67.

Marketers appear to use the word *quality* as a catch-all term for "good." Because of its wide and imprecise usage, the attribute of "quality" threatens to become a meaningless claim. If everyone has it, what good is it?

To muddy the waters a bit more, satisfaction or dissatisfaction is more than a reaction to the actual performance quality of a product or service. It is influenced by prior expectations regarding the level of quality. According to the **expectancy disconfirmation model**, consumers form beliefs about product performance based on prior experience with the product and/or communications about the product that imply a certain level of quality.[104] When something performs the way we thought it would—good or bad—we may not think much about it (*confirmation*). If, on the other hand, it fails to live up to our expectations (*disconfirmation*), negative affect may result (*negative disconfirmation*). Furthermore, if performance happens to exceed our expectations, we are satisfied and pleased (*positive disconfirmation*).

To understand this perspective, think about different types of apparel retail stores. People expect to be provided with high-quality, well-made garments at upscale stores, and they might become upset if they discover a fabric flaw or seam coming apart in a dress. On the other hand, we may not be surprised to find *seconds* at a manufacturer's outlet with actual holes in them; we may even shrug it off because it contributes to the fun of finding a "deal." An important lesson emerges for marketers from this perspective: Don't overpromise.[105]

Legend:
- ■ Firm's performance level
- ▨ Realistic expectations
- ▨ Unrealistic expectations
- ▨ Extremely discrepant expectations

Zone of accommodation Zone of accommodation

Zone of alteration Zone of alteration

Zone of abandonment Zone of abandonment

FIGURE 13-6
Zones

Source: Adapted from Jagdish N. Sheth and Banwari Mittal, "A Framework for Managing Customer Expectations," *Journal of Market Focused Management* 1 (1996): 137–158. Fig. 2, p. 140.

This perspective underscores the importance of *managing expectations*—customer dissatisfaction usually is due to expectations exceeding the company's ability to deliver. Figure 13-6 illustrates the alternative strategies a firm can choose in these situations. When confronted with unrealistic expectations about what it can do, the firm can either accommodate these demands by improving the range or quality of products it offers, alter the expectations, or perhaps even choose to abandon the customer if it is not feasible to meet his or her needs.[106] Expectations are altered, for example, when sales associates tell customers in advance that a style runs small or large. A firm also can *underpromise*, as when a company inflates the time it will take for a special order to arrive.

Acting on Dissatisfaction

If a person is not happy with a product or service, what can be done? A consumer has at least three different courses of action (more than one can be taken):[107]

1. *Voice response:* The consumer can appeal directly to the retailer for redress (such as a refund or exchange) by either speaking to or writing the store manager. In a letter it is advisable to be straightforward with a description of the problem and to include a clear indication of what you require to fix the problem and gain satisfaction.

2. *Private response:* The consumer can express dissatisfaction about the store or product to friends and/or boycott the store. As discussed in Chapter 12, negative word of mouth (WOM) can be very damaging to a store's reputation.

3. *Third-party response:* The consumer can take legal action against the merchant, register a complaint with the Better Business Bureau, or write a letter to a newspaper or call a radio station's consumer hotline.

In one study, business majors wrote complaint letters to companies. Those who were sent a free sample in response indicated that their image of the company significantly improved, but those who received only a letter of apology did not change their evaluations of the company. However, students

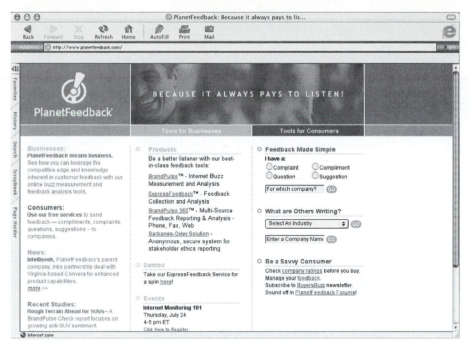

Some entrepreneurs have been inspired to turn lemons into lemonade by compiling consumer complaints and providing feedback to companies so they can clean up their acts and improve satisfaction. Planetfeedback.com has forwarded over 750,000 consumer feedback letters (including compliments, complaints, suggestions, and questions) to companies, brands, and corporations to help them find consumer trends, problem areas, marketing opportunities, and product.

who got no response reported an even more negative image than before, indicating that some form of response is better than none.[108]

A number of factors influence which response to dissatisfaction is eventually taken. The consumer may in general be an assertive or a meek person. Action is more likely to be taken for expensive products such as household durables, cars, and clothing than for inexpensive products.[109] In addition, consumers who are satisfied with a store are *more* likely to complain; they take the time to complain because they feel connected to the store. Older people are more likely to complain, and are much more likely to believe that the store will actually resolve the problem. Shoppers who get their problems resolved feel even *better* about the store than if nothing had gone wrong.[110] On the other hand, if the consumer does not believe that the store will respond well to a complaint, the person will be more likely to simply switch than fight.[111] Ironically, marketers should actually *encourage* consumers to complain to them: People are more likely to spread the word about unresolved negative experiences to their friends than they are to boast about positive occurrences.[112] (See Chapter 15 for an example of a standard complaint letter.)

PRODUCT DISPOSAL

Traditionally, marketers have been interested only in selling products. They have not been concerned with what happens to the merchandise after it goes home with the consumer (and *stays* home). But the mounting fashion that we buy and eventually dispose of has an impact on landfills. It is not easy in many parts of the country to "get rid" of things. We can't just put all unwanted products at curbside for garbage pickup.

We have lots of reasons why we cannot dispose of clothing we don't wear.

Because people often do form strong attachments to products, the decision to dispose of something may be a painful one. One function performed by possessions is to serve as anchors for our identities: Our past lives on in our things.[113] This attachment to some types of apparel can often be very strong for some people. Such items as baptismal gowns, first prom dresses, and wedding dresses are saved for generations.

Although some people have more trouble than others with discarding things, even a "pack rat" does not keep everything. Consumers must often dispose of things, either because they have fulfilled their designated functions, or possibly because they no longer fit with consumers' view of themselves. Concern about the environment coupled with a need for convenience has made ease of product disposal a key attribute in many product categories, including apparel.

A study by *Women's Wear Daily* regarding disposition of fashion apparel, to the chagrin of the apparel industry, indicated that 60 percent of those surveyed said they never "cast off perfectly good clothes just because they are considered to be 'out of style.'" Only 9 percent said they often did. Of those who did, the largest proportion were young (age 18–34), and of the highest income level (over $75,000).[114]

Disposal Options

When a consumer decides that a product is no longer of use, several choices are available. The person can either (1) keep the item, (2) temporarily dispose of it, or (3) permanently dispose of it. In many cases, a new product is acquired even though the old one still functions. Some reasons for this replacement include a desire for new styles (especially important in fashion) or features (such as a DVD to replace an old VHS recording system), a change in the person's environment (such as a new job that necessitates an addition of a career wardrobe), or a change in the person's role or self-image.[115] Figure 13-7 provides an overview of consumers' disposal options.

The issue of product disposition is doubly vital because of its enormous public policy implications. We live in a throwaway society, which creates problems for the environment and also results in a great deal of unfortunate waste. In one study, 15 percent of adults admitted that they are pack rats and another 64 percent said they are selective savers. In contrast, 20 percent said they throw out as much garbage as they can. The consumers most likely to save things are older people and single households.[116]

Training consumers to recycle has become a priority in many countries. Japan recycles about 40 percent of its garbage, and this relatively high rate of compliance is partly due to the social value the Japanese place on recycling: Citizens are encouraged by garbage trucks that periodically rumble through

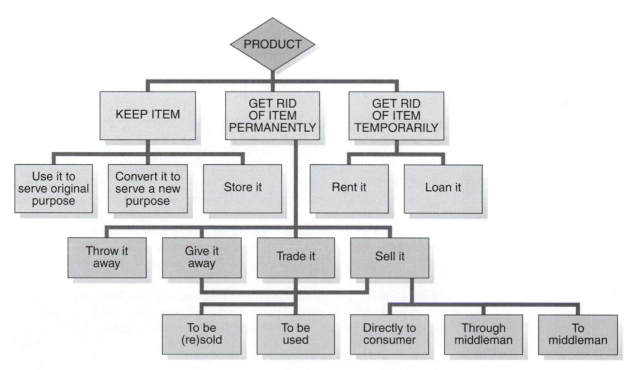

FIGURE 13-7
Consumers Disposal Options

Source: Jacob Jacoby, Carol K. Berning, and Thomas F. Dietvorst, "What about Disposition," *Journal of Marketing* 41 (April 1977): 23. By permission of American Marketing Association.

the streets playing classical music or children's songs.[117] Companies continue to search for ways to use resources more efficiently, often at the prompting of activist consumer groups. One rather extreme example is a group of teachers, engineers, and executives in northern California who vowed for one year not to buy anything new—except food, health, and safety items. They feel consumer culture has led to a global environmental crisis. Members of this "compact" agreed to buy only from thrift stores, flea markets (as long as the items were secondhand), and online auctions such as eBay. Their aims are to go beyond recycling, to reduce clutter and waste in their homes, and to simplify their lives.[118] Many joined their cause, but there was also a backlash of ridicule and criticism.[119] During economically depressed times and in many parts of the world today, recycling is not an option but a necessity.

One study examined the relevant goals consumers have for recycling. It identified how specific instrumental goals are linked to more abstract terminal values. The most important lower-order goals identified were "avoid filling up landfills," "reduce waste," "reuse materials," and "save the environment." These were linked to the terminal values of "promote health/avoid sickness," "achieve life-sustaining ends," and "provide for future generations."

Perceived effort has been found to be the best predictor of whether people will go to the trouble to recycle—this pragmatic dimension appears to outweigh general attitudes toward recycling and the environment in predicting intention to recycle.[120] An apparel study looked at the gender differences in patterns of apparel disposition. Females were more likely to choose environmentally friendly disposal patterns than were males.[121] This may be linked to perceived effort.

By applying such techniques to study recycling and other product disposal behaviors, social marketers will find it easier to design advertising copy and other messages that tap into the underlying values that will motivate people to increase environmentally responsible behavior.[122]

Lateral Cycling: Junk versus "Junque"

Interesting consumer processes occur during **lateral cycling**, where already purchased objects are sold to others or exchanged for still other things. Many purchases are made secondhand rather than new. Reusing other people's things is especially important in our throwaway society because, as one researcher put it, "there is no longer an 'away' to throw things to."[123] Selling one's clothing (often "outdated" fashion) is a good way to recoup some of the cost of the items. One study of clothing disposal patterns indicated that resale of apparel was more driven by monetary or economic reasons than by environmental reasons.[124]

Flea markets, garage sales, classified advertisements, bartering for services, hand-me-downs, and the black market all represent alternative marketing systems that operate in addition to the formal marketplace. For example, the number of used-merchandise retail establishments has grown at about ten times the rate of other stores.[125]

The Internet has revolutionized the lateral cycling process, as millions of people flock to eBay (www.ebay.com) to buy and sell their "treasures." This phenomenally successful online auction site with revenue of over $4.5 billion started as a trading post for Beanie Babies and other collectibles. Now two-

SELLING FASHION ONLINE

Flea markets are online, and in a big way. People have swapped used items on bulletin boards and newsgroups for years, but now a number of sites have been set up to transact such swaps in a more sophisticated way. On the tremendously popular auction site www.eBay.com apparel and accessories is one of the fastest-growing categories. The number-one designer searched is Gucci, with about 1.5 million searches in one month, followed by Prada and Kate Spade. One of the reasons for eBay's success is the customer service component and—interestingly—the human element, which is not lost because buyers who want to chat with their sellers can do so.[131]

Other sites include www.bidfind.com, which combs the Web to list and sell used goods from Aerosmith memorabilia to wedding dresses with veil, ring pillow, and money bag (used only once!).[132] Still other sites are springing up to meet the needs of businesses that need to liquidate inventory, such as www.liquidation.com. (eBay also does a lively business by hosting many small to midsize retailers and apparel liquidators.) Looking for an elegant cashmere coat? Gold cuff links? A home hair cutting kit? All of these items have been left at airline baggage claims, and an online store called www.unclaimedbaggage.com specializes in the lateral cycling of goodies that people never bothered to claim.[133]

Searching for garage sales will never be the same.

thirds of the site's sales are for practical goods. Despite its success, there's sometimes a bittersweet quality to eBay. Some of the sellers are listing computers, fancy cars, jewelry, and other luxury items because they desperately need the money. As one vendor explained when he described the classic convertible he wanted to sell, "I am out of money and need to pay my rent, so my toys have to be sold."[126]

Although traditional marketers have not paid much attention to used-product sellers, factors such as concern about the environment, demands for quality, cost, and fashion consciousness are conspiring to make these "secondary" markets more important.[127] In the United States alone, there are more than 3,500 flea markets that operate nationwide to produce upwards of $10 billion in gross sales.[128] Other growth areas include student markets for used computers and textbooks, as well as ski swaps, at which consumers exchange millions of dollars worth of used ski equipment. Many are nonprofit ventures started with government funding. A trade association called the Reuse Development Organization (www.redo.org) encourages them. These efforts remind us that recycling is actually the last step in the familiar mantra of the environmental movement: Reduce, reuse, and recycle.[129]

Many vintage apparel shops are popping up in chic parts of cities such as New York, Los Angeles, and San Francisco. Stores including Wasteland, Buffalo Exchange, and Resurrection are very popular with celebrities, designers looking for inspiration, and customers wanting to create a different look. Stores are combining old and new merchandise to create a unique effect. Picking up on the habits of young people who find treasures in thrift shops, these new venues are highly successful. Stores such as ABC Carpet and Fishes Eddy in SoHo (lower Manhattan) combine fashionable new home furnishings with antique treasures. Apparel stores are following suit. Interest in antiques, period accessories, and specialty magazines catering to this niche is also increasing.

Donating Clothes: Spring Cleaning or Socially Responsible Behavior?

One recent study interviewed consumers on their motivations for donating clothing. Not unexpectedly, "to get rid of stuff" was an important reason for

FIGURE 13-8
The Process of Consumer Clothing Donation Behavior
Source: Jung-Eun Ha and Nancy J. Nelson Hodges, "Exploring Motivations, Intentions, and Behavior of Socially Responsible Consumption in a Clothing Disposal Setting," *ITAA Proceedings* (November 2006).

donation. A self-orientation rather than social orientation seemed to be the dominate motivation. As shown in Figure 13-8, participants classified their "spring-cleaning" used clothes by condition (good and bad shape) and further by level of sentimentality. Those with high sentimental value were kept, mainly due to strong guilt of giving away something of value. Those having low sentimental value, accompanied by low guilt, were donated.[130] Do you have high guilt, high sentimental–value clothing in your closet that you don't wear?

CHAPTER SUMMARY

• The act of purchase can be affected by many factors. These include the consumer's antecedent state (for example, his or her mood, time pressure, or disposition toward shopping). Time is an important resource that often determines how much effort and search will go into a decision. Mood can be affected by the degree of pleasure and arousal present in a store environment.

• Consumers look for different product attributes depending upon the use to which they intend to put their purchase. The presence or absence of other people—and the types of people they are—can also affect a consumer's decisions.

• A consumer's shopping orientation can affect decisions. Some people love and some hate shopping for clothes. Fashion innovators score the highest on *Lifestyle Monitor*'s Shopping Barometer on "love to shop."

- The shopping experience is a pivotal part of the purchase decision. In many cases, retailing is like theater—the consumer's evaluation of stores and products may depend on the type of "performance" he or she witnesses. This evaluation can be influenced by the actors (salespeople), the setting (the store environment), and props (store displays). A store image, like a brand personality, is determined by a number of factors, such as perceived convenience, sophistication, and knowledgeability of salespeople. With increasing competition from nonstore alternatives, the creation of a positive shopping experience has never been more important.

- Since many purchase decisions are not made until the consumer is actually in the store, point-of-purchase (POP) stimuli are very important sales tools. These include product samples, elaborate package displays, place-based media, and in-store promotional materials. POP stimuli are particularly useful in stimulating impulse buying, in which a consumer yields to a sudden urge for a product. High-tech kiosks offer consumers more choices through special ordering in the store.

- The consumer's encounter with a salesperson is a complex and important process. The outcome can be affected by such factors as the salesperson's similarity to the customer and his or her perceived credibility.

- Consumer satisfaction is determined by the person's overall feeling toward the product after purchase. Many factors influence perceptions of product quality, including price, brand name, and product performance. Satisfaction is often determined by the degree to which a product's performance is consistent with the consumer's prior expectations of how well it will function.

- Apparel satisfaction is linked to the concept of quality. Industry-defined constructs of quality include structural integrity, aesthetic presence, and power of appeal, which may be different from consumer definitions.

- Product disposal is an increasingly important problem. Recycling is one option that will continue to be stressed as consumers' environmental awareness grows. Products may also be introduced by consumers into secondary markets during a process of lateral cycling, which occurs when objects are bought and sold secondhand, fenced, or bartered.

KEY TERMS

time poverty
shopping orientation
store image
atmospherics
impulse buying

point-of-purchase
 (POP) stimuli
exchange theory
consumer satisfaction/
 dissatisfaction

expectancy disconfirma-
 tion model
lateral cycling

DISCUSSION QUESTIONS

1. Discuss some of the motivations for shopping as described in the chapter. How might a retailer adjust his or her strategy to accommodate these motivations?

2. Analyze the shopping that you do. Are you seeing more entertainment components as discussed in this chapter as part of your shoping experience? Do you think entertainment is effective in selling fashion?

3. A number of court cases in recent years have attempted to prohibit special-interest groups from distributing literature in shopping malls. Mall management claims that these centers are private property. On the other hand, these groups argue that the mall is the modern-day version of the town square and as such is a public forum. Find some recent court cases involving this free-speech issue, and examine the arguments pro and con. What is the current status of the mall as a public forum? Do you agree with this concept?

4. What are some positive and negative aspects of requiring employees who interact with customers to wear some kind of uniform or to mandate a dress code in the office?

5. Think about exceptionally good and bad salespeople you have encountered in the past. What qualities seem to differentiate them?

6. Discuss the concept of "timestyle." Based on your own experiences, how might consumers be segmented in terms of their timestyles? How does this relate to selling fashion?

7. Compare and contrast different cultures' conceptions of time. What are some implications for marketing strategy within each of these frameworks?

8. The movement away from a "disposable consumer society" toward one that emphasizes creative recycling creates many opportunities for marketers. Can you identify some?

9. Conduct naturalistic observation at a local mall. Sit in a central location and observe the activities of mall employees and patrons. Keep a log of the nonretailing activity you observe (special performances, exhibits, socializing, and so on). Does this activity enhance or detract from business conducted at the mall? As malls become more like high-tech game rooms, how valid is the criticism raised in the chapter that shopping areas are only encouraging more loitering by teenage boys, who don't spend a lot in stores and simply scare away other customers?

10. Select three competing clothing stores in your area and conduct a store image study for them. Ask a group of consumers to rate each store on a set of attributes and plot these ratings on the same graph. Based on your findings, are there any areas of competitive advantage or disadvantage you could bring to the attention of store management?

11. The store environment is heating up as more and more companies put their promotional dollars into point-of-purchase efforts. Shoppers are now confronted by videos at the checkout counter, computer monitors attached to their shopping carts, and so on. Place-based media even expose us to ads in nonshopping environments. Do you feel that these innovations are overly intrusive? At what point might shoppers "rebel" and demand some peace and quiet while shopping? Do you see any market potential in the future for stores that "countermarket" by promising a "hands-off" shopping environment?

ENDNOTES

1. "It's Buying Time Again," *Women's Wear Daily* (March 2, 2000): 2.
2. Paul Gray, "Nice Guys Finish First?," *Time* (July 25, 1994): 48–49.
3. Pradeep Kakkar and Richard J. Lutz, "Situational Influence on Consumer Behavior: A Review," in *Perspectives in Consumer Behavior*, 3rd ed., eds. Harold H. Kassarjian and Thomas S. Robertson (Glenview, Ill.: Scott Foresman, 1981), 204–214.
4. Carolyn Turner Schenk and Rebecca H. Holman, "A Sociological Approach to Brand Choice: The Concept of Situational Self-Image," in *Advances in Consumer Research* 7, ed. Jerry C. Olson (Ann Arbor, Mich.: Association for Consumer Research, 1980), 610–614.
5. Russell W. Belk, "An Exploratory Assessment of Situational Effects in Buyer Behavior," *Journal of Marketing Research* 11 (May 1974): 156–163; U. N. Umesh and Joseph A. Cote, "Influence of Situational Variables on Brand-Choice Models," *Journal of Business Research* 16, no. 2 (1988): 91–99. See also J. Wesley Hutchinson and Joseph W. Alba, "Ignoring Irrelevant Information: Situational Determinants of Consumer Learning," *Journal of Consumer Research* 18 (December 1991): 325–345.
6. Yoon–Hee Kwon, "Effects of Situational and Individual Influences on the Selection of Daily Clothing," *Clothing and Textiles Research Journal* 6 (Summer 1988): 6–12.
7. Ellen Byron, "How Coach Won a Rich Purse by Inventing New Uses for Bags: What Was a Semiannual Buy Is Now a Regular Ritual; Wristlets, Clutches, Totes, Fresh Competition from Gap," *Wall Street Journal on the Web* (November 17, 2004): A1.
8. Daniel Stokols, "On the Distinction between Density and Crowding: Some Implications for Future Research," *Psychological Review* 79 (1972): 275–277.
9. Carol Felker Kaufman, Paul M. Lane, and Jay D. Lindquist, "Exploring More Than 24 Hours a Day: A Preliminary Investigation of Polychronic Time Use," *Journal of Consumer Research* 18 (December 1991): 392–401.
10. Laurence P. Feldman and Jacob Hornik, "The Use of Time: An Integrated Conceptual Model," *Journal of Consumer Research* 7 (March 1981): 407–419. See also Michelle M. Bergadaa, "The Role of Time in the Action of the Consumer," *Journal of Consumer Research* 17 (December 1990): 289–302.
11. Joanna Ramy, "No Time to Shop?" *Women's Wear Daily*, Section II (June 20, 2005): 6.
12. Robert J. Samuelson, "Rediscovering the Rat Race," *Newsweek* (May 15, 1989): 57.
13. John P. Robinson, "Time Squeeze," *Advertising Age* (February 1990): 30–33.
14. Leonard L. Berry, "Market to the Perception," *American Demographics* (February 1990): 32.
15. "Shopping on the Clock," *Women's Wear Daily* (September 16, 1999): 2.
16. Jacob Hornik, "Diurnal Variation in Consumer Response," *Journal of Consumer Research* 14 (March 1988): 588–591.
17. See Shirley Taylor, "Waiting for Service: The Relationship between Delays and Evaluations of Service," *Journal of Marketing* 58 (April 1994): 56–69.
18. Laurette Dube and Bernd H. Schmitt, "The Processing of Emotional and Cognitive Aspects of Product Usage in Satisfaction Judgments," in *Advances in Consumer Research* 18, eds. Rebecca H. Holman and Michael R. Solomon (Provo, Utah: Association for Consumer Research, 1991), 52–56; Lalita A. Manrai and Meryl P. Gardner, "The Influence of Affect on Attributions for Product Failure," in *Advances in Consumer Research* 18, eds. Rebecca H. Holman and Michael R. Solomon (Provo, Utah: Association for Consumer Research, 1991), 249–254.
19. Kevin G. Celuch and Linda S. Showers, "It's Time to Stress Stress: The Stress-Purchase/Consumption Relationship," in *Advances in Consumer Research* 18, eds. Rebecca H. Holman and Michael R. Solomon (Provo, Utah: Association for Consumer Research, 1991), 284–289; Lawrence R. Lepisto, J. Kathleen Stuenkel, and Linda K. Anglin, "Stress: An Ignored Situational Influence," in *Advances in Consumer Research* 18, eds. Rebecca H. Holman and Michael R. Solomon (Provo, Utah: Association for Consumer Research, 1991), 296–302.
20. See Eben Shapiro, "Need a Little Fantasy? A Bevy of New Companies Can Help," *New York Times* (March 10, 1991): F4.
21. John D. Mayer and Yvonne N. Gaschke, "The Experience and Meta-Experience of Mood," *Journal of Personality and Social Psychology* 55 (July 1988): 102–111.
22. Meryl Paula Gardner, "Mood States and Consumer Behavior: A Critical Review," *Journal of Consumer Research* 12 (December 1985): 281–300; Scott Dawson, Peter H. Bloch, and Nancy M. Ridgway, "Shopping Motives, Emotional States, and Retail Outcomes," *Journal of Retailing* 66 (Winter 1990): 408–427; Patricia A. Knowles, Stephen J. Grove, and W. Jeffrey Burroughs (1993), "An Experimental Examination of Mood States on Retrieval and Evaluation of Advertisement and Brand Information," *Journal of the Academy of Marketing Science* 21 (April 1993); Paul W. Miniard, Sunil Bhatla, and Deepak Sirdeskmuhk, "Mood as a Determinant of Postconsumption Product Evaluations: Mood Effects and Their Dependency on the Affective Intensity of the Consumption Experience," *Journal of Consumer Psychology* 1, no. 2 (1992): 173–195; Mary T. Curren and Katrin R. Harich, "Consumers' Mood States: The Mitigating Influence of Personal Relevance on Product Evaluations," *Psychology & Marketing* 11, no. 2 (March/April 1994): 91–107; Gerald J. Gorn, Marvin E. Rosenberg, and Kunal Basu, "Mood, Awareness, and Product Evaluation," *Journal of Consumer Psychology* 2, no. 3 (1993): 237–256.
23. Ira P. Schneiderman, "Color My World," *Women's Wear Daily,"* (November 19, 1999): 17.
24. Gordon C. Bruner, "Music, Mood, and Marketing," *Journal of Marketing* 54 (October 1990): 94–104; Basil G. Englis, "Music Television and Its Influences on Consumers, Consumer Culture, and the Transmission of Consumption Messages," in *Advances in Consumer Research*

18, eds. Rebecca H. Holman and Michael R. Solomon (Provo, Utah: Association for Consumer Research, 1991).

25. Marvin E. Goldberg and Gerald J. Gorn, "Happy and Sad TV Programs: How They Affect Reactions to Commercials," *Journal of Consumer Research* 14 (December 1987): 387–403; Gerald J. Gorn, Marvin E. Goldberg, and Kunal Basu, "Mood, Awareness, and Product Evaluation," *Journal of Consumer Psychology* 2, no. 3 (1993): 237–256; Mary T. Curren and Katrin R. Harich, "Consumers' Mood States: The Mitigating Influence of Personal Relevance on Product Evaluations," *Psychology & Marketing* 11, no. 2 (March/April 1994): 91–107.

26. Rajeev Batra and Douglas M. Stayman, "The Role of Mood in Advertising Effectiveness," *Journal of Consumer Research* 17 (September 1990): 203; John P. Murry, Jr., and Peter A. Dacin, "Cognitive Moderators of Negative-Emotion Effects: Implications for Understanding Media Context," *Journal of Consumer Research* 22 (March 1996): 439–447. See also Mary T. Curren and Harich, "Consumers' Mood States: The Mitigating Influence of Personal Relevance on Product Evaluations"; Gorn, Goldberg, and Basu, "Mood, Awareness, and Product Evaluation."

27. For a scale that was devised to assess these dimensions of the shopping experience, see Barry J. Babin, William R. Darden, and Mitch Griffin, "Work and/or Fun: Measuring Hedonic and Utilitarian Shopping Value," *Journal of Consumer Research* 20 (March 1994): 644–656.

28. Babin, Darden, and Griffin, "Work and/or Fun: Measuring Hedonic and Utilitarian Shopping Value."

29. Edward M. Tauber, "Why Do People Shop?," *Journal of Marketing* 36 (October 1972): 47–48; see also Diana L. Haytko and Julie Baker, "It's All at the Mall: Exploring Adolescent Girls' Experiences," *Journal of Retailing* 80 (2004): 67–83; see also Eun Young Kim and Youn-Kyung Kim, "The Effects of Ethnicity and Gender on Teens' Mall Shopping Motivations," *Clothing & Textiles Research Journal* 23, no. 2 (2005): 65–77.

30. "Why Do You Shop?" *Women's Wear Daily* (July 1997): 44, 46.

31. Youn-Kyung Kim, Shefali Kumar, and Jikyeong Kang, "Teenagers' Shopping Motivations and Loneliness," *Proceedings of the International Textile and Apparel Association,* (1999): 67.

32. Quoted in Robert C. Prus, *Making Sales: Influence as Interpersonal Accomplishment* (Newbury Park, Calif.: Sage, 1989), 225.

33. "Is the Thrill Gone?," *Women's Wear Daily* (March 26, 1998): 2.

34. "A Global Perspective . . . on Women & Women's Wear," Cotton Inc. *Lifestyle Monitor* 14 (Winter 1999/2000): 8–11.

35. Gregory P. Stone, "City Shoppers and Urban Identification: Observations on the Social Psychology of City Life," *American Journal of Sociology* 60 (1954): 36–45; Danny Bellenger and Pradeep K. Korgaonkar, "Profiling the Recreational Shopper," *Journal of Retailing* 56, no. 3 (1980): 77–92.

36. Some material in this section was adapted from Michael R. Solomon and Elnora W. Stuart, *Welcome to Marketing.Com: The Brave New World of E-Commerce.* Upper Saddle River N.J.: Prentice-Hall, 2001.

37. Rebecca K. Ratner, Barbara E. Kahn, and Daniel Kahneman, "Choosing Less-Preferred Experiences for the Sake of Variety," *Journal of Consumer Research* 26 (June 1999): 1–15.

38. Jennifer Gilbert, "Customer Service Crucial to Online Buyers," *Advertising Age* (September 13, 1999): 52.

39. Cora Yuen and Nancy J. Rabolt, "Consumer Satisfaction with Fashion Internet Purchases: Using a Website Gathering Technique." *Proceedings of the International Textile and Apparel Association, 2002,* available at www.itaaonline.org.

40. Timothy L. O'Brien, "Aided by Internet, Identity Theft Soars," *New York Times on the Web* (April 3, 2000).

41. Carol Emert, "E-Tailers Fined for Broken Promises," *San Francisco Chronicle* (July 27, 2000): B1, B5.

42. Quoted in Kate Ballen, "Get Ready for Shopping at Work," *Fortune* (February 15, 1988): 95.

43. For a recent study of consumer shopping patterns in a mall that views the mall as an ecological habitat, see Peter N. Bloch, Nancy M. Ridgway, and Scott A. Dawson, "The Shopping Mall as Consumer Habitat," *Journal of Retailing* 70, no. 1 (1994): 23–42.

44. Quoted in Jacquelyn Bivins, "Fun and Mall Games," *Stores* (August 1989): 35.

45. Sallie Hook, "All the Retail World's a Stage: Consumers Conditioned to Entertainment in Shopping Environment," *Marketing News* 21 (July 31, 1987): 16.

46. Eric Wilson, "Adventures in Design: Prada's Vision of Techno Chic Comes to SoHo," *Women's Wear Daily* (January 23, 2002): 1, 10–11.

47. Anamaria Wilson, "Miyake's Mix of Design Extremes," *Women's Wear Daily* (October 30, 2001): 7.

48. "Levi's Brand Delivers Global Product Line-Up and Multi-Sensory Shopping Experience at First San Francisco Store," *Business Wire* (August 16, 1999): 1.

49. Quoted in Mitchell Pacelle, "Malls Add Fun and Games to Attract Shoppers," *Wall Street Journal* (January 23, 1996): B1.

50. Patricia Winters Lauro, "Developer Promotes Its Malls as Destinations for Fun," *New York Times on the Web* (October 21, 1999).

51. John Tagliabue, "Enticing Europe's Shoppers: U.S. Way of Dressing and of Retailing Spreading Fast," *New York Times* (April 24, 1996): D1.

52. Joshua Levine, "Hamburgers and Tennis Socks," *Forbes* (November 20, 1995): 184–185; Iris Cohen Selinger, "Lights! Camera! But Can We Get a Table?" *Advertising Age* (April 17, 1995): 48.

53. Susan Spiggle and Murphy A. Sewall, "A Choice Sets Model of Retail Selection," *Journal of Marketing* 51 (April 1987): 97–111; William R. Darden and Barry J. Babin, "The Role of Emotions in Expanding the Concept of Retail Personality," *Stores* 76, no. 4 (April 1994): RR7–RR8.

54. Most measures of store image are quite similar to other attitude measures, as discussed in Chapter 8. For an excellent bibliography of store image studies, see Mary R. Zimmer and Linda L. Golden, "Impressions of Retail Stores: A Content Analysis of Consumer Images," *Journal of Retailing* 64 (Fall 1988): 265–293.

55. Spiggle and Sewall, "A Choice Sets Model of Retail Selection."

56. Philip Kotler, "Atmospherics as a Marketing Tool," *Journal of Retailing* (Winter 1973–1974): 10–43, 48–64, 50. For a review of more research, see J. Duncan Herrington, "An Integrative Path Model of the Effects of Retail Environments on Shopper Behavior," ed. Robert L. King, *Marketing: Toward the Twenty-First Century* (Richmond, VA Southern Marketing Association, 1991), 58–62.

57. Joseph A. Bellizzi and Robert E. Hite, "Environmental Color, Consumer Feelings, and Purchase Likelihood," *Psychology & Marketing* 9, no. 5 (September/October 1992): 347–363.

58. Quoted in Cherie Fehrman and Kenneth Fehrman, *Color the Secret Influence* (Upper Saddle River, N. J.: Prentice-Hall, 2000), pp. 141–142.

59. See Eric R. Spangenberg, Ayn E. Crowley, and Pamela W. Henderson, "Improving the Store Environment: Do Olfactory Cues Affect Evaluations and Behaviors?," *Journal of Marketing* 60 (April 1996): 67–80, for a study that assessed olfaction in a controlled, simulated store environment.

60. Robert J. Donovan, John R. Rossiter, Gilian Marcoolyn, and Andrew Nesdale, "Store Atmosphere and Purchasing Behavior," *Journal of Retailing* 70, no. 3 (1994): 283–294.

61. "2001 Colors Reflect Desire for Serenity in a Fast Paced World," *PR Newswire*, New York (August 20, 1999): 1.

62. Deborah Blumenthal, "Scenic Design for In-Store Try-Ons," *The New York Times* (April 9, 1988): 56.

63. John Pierson, "If Sun Shines In, Workers Work Better, Buyers Buy More," *Wall Street Journal* (November 20, 1995): B1.

64. Charles S. Areni and David Kim, "The Influence of In-Store Lighting on Consumers' Examination of Merchandise in a Wine Store," *International Journal of Research in Marketing* 11, no. 2 (March 1994): 117–125.

65. Julie Flaherty, "Music to a Retailer's Ear," *New York Times*, www.nytimes.com (July 4, 2001).

66. Marianne Meyer, "Attention Shoppers!," *Marketing and Media Decisions* 23 (May 1988): 67.

67. "Through the Looking Glass," *Lifestyle Monitor* 16 (Fall–Winter 2002).

68. Easwar S. Iyer, "Unplanned Purchasing: Knowledge of Shopping Environment and Time Pressure," *Journal of Retailing* 65 (Spring 1989): 40–57; C. Whan Park, Easwar S. Iyer, and Daniel C. Smith, "The Effects of Situational Factors on In-Store Grocery Shopping," *Journal of Consumer Research* 15 (March 1989): 422–433.

69. Dennis W. Rook and Robert J. Fisher, "Normative Influences on Impulsive Buying Behavior," *Journal of Consumer Research* 22 (December 1995): 305–313; Francis Piron, "Defining Impulse Purchasing," in *Advances in Consumer Research* 18, eds. Rebecca H. Holman and Michael R. Solomon (Provo, Utah: Association for Consumer Research, 1991), 509–514; Dennis W. Rook, "The Buying Impulse," *Journal of Consumer Research* 14 (September 1987): 189–199.

70. Yu K. Han, George A. Morgan, Antigone Kotsiopulos, and Jikyeong Kang-Park, "Impulse Buying Behavior of Apparel Purchasers," *Clothing and Textiles Research Journal* 9 (Spring 1991): 15–21.

71. H. Stern, "The Significance of Impulse Buying Today," *Journal of Marketing* 26 (1962): 59–62.

72. Han, Morgan, Kotsiopulos and Kang-Park, "Impulse Buying Behavior of Apparel Purchasers."

73. See Aradhna Krishna, Imran S. Currim, and Robert W. Shoemaker, "Consumer Perceptions of Promotional Activity," *Journal of Marketing* 55 (April 1991): 4–16. See also H. Bruce Lammers, "The Effect of Free Samples on Immediate Consumer Purchase," *Journal of Consumer Marketing* 8 (Spring 1991): 31–37; Kapil Bawa and Robert W. Shoemaker, "The Effects of a Direct Mail Coupon on Brand Choice Behavior," *Journal of Marketing Research* 24 (November 1987): 370–376.

74. Dina ElBoghdady, "Giving Discounts Where It Counts," *Washington Post* (December 19, 2003): E1.

75. Bernice Kanner, "Trolling in the Aisles," *New York* (January 16, 1989): 12; Michael Janofsky, "Using Crowing Roosters and Ringing Business Cards to Tap a Boom in Point-of-Purchase Displays," *New York Times* (March 21, 1994): D9.

76. Dale Buss, "REI Working Out," *Brandchannel.com* (November 7, 2005).

77. William Keenan, Jr., "Point-of-Purchase: From Clutter to Technoclutter," *Sales and Marketing Management* 141 (April 1989): 96.

78. Paco Underhill, "In-Store Video Ads Can Reinforce Media Campaigns," *Marketing News* (May 1989): 5.

79. Timothy P. Henderson, "Kiosks Bring the Science of Smell to the Shopping Experience," *Stores* (February 2000): 62, 64.

80. James Sterngold, "Why Japanese Adore Vending Machines," *New York Times* (January 5, 1992): A1.

81. See Robert B. Cialdini, *Influence: Science and Practice*, 2nd ed. (Glenview, Ill.: Scott Foresman, 1988).

82. Richard P. Bagozzi, "Marketing as Exchange," *Journal of Marketing* 39 (October 1975): 32–39; Peter M. Blau, *Exchange and Power in Social Life* (New York: Wiley, 1964); Marjorie Caballero and Alan J. Resnik, "The Attraction Paradigm in Dyadic Exchange," *Psychology & Marketing* 3, no. 1 (1986): 17–34; George C. Homans, "Social Behavior as Exchange," *American Journal of Sociology* 63 (1958): 597–606; Paul H. Schurr and Julie L. Ozanne, "Influences on Exchange Processes: Buyers' Preconceptions of a Seller's Trustworthiness and Bargaining Toughness," *Journal of Consumer Research* 11 (March 1985): 939–953; Arch G. Woodside and J. W. Davenport, "The Effect of Salesman Similarity and Expertise on Consumer Purchasing Behavior," *Journal of Marketing Research* 8 (1974): 433–436.

83. Paul Busch and David T. Wilson, "An Experimental Analysis of a Salesman's Expert and Referent Bases of Social Power in the Buyer-Seller Dyad," *Journal of Marketing Research* 13 (February 1976): 3–11; John E. Swan, Fred Trawick, Jr., David R. Rink, and Jenny J. Roberts, "Measuring Dimensions of Purchaser Trust of Industrial Salespeople," *Journal of Personal Selling and Sales Management* 8 (May 1988): 1.

84. Rob Walker, "Girls Just Want to Belong," *New York Times* (August 21, 2005); www.clublibbylu.com.

85. Ann Meyer, "Are You Experiential?" www.multichannel.com (August 1, 2006).

86. For a study in this area, see Peter H. Reingen and Jerome B. Kernan, "Social Perception and Interpersonal Influence: Some Consequences of the Physical Attractiveness Stereotype in a Personal Selling Setting," *Journal of Consumer Psychology* 2, no. 1 (1993): 25–38.

87. Linda L. Price and Eric J. Arnould, "Commercial Friendships: Service Provider–Client Relationships in Context," *Journal of Marketing* 63 (October 1999): 38–56.

88. Bob Tedeschi, "Salesmanship Comes to the Online Stores, but Please Call It a Chat," *New York Times*, www.nytimes.com (August 7, 2006).

89. Mary Jo Bitner, Bernard H. Booms, and Mary Stansfield Tetreault, "The Service Encounter: Diagnosing Favorable and Unfavorable Incidents," *Journal of Marketing* 54 (January 1990): 7–84; Robert C. Prus, *Making Sales* (Newbury Park, Calif.: Sage, 1989); Arch G. Woodside and James L. Taylor, "Identity Negotiations in Buyer-Seller Interactions," in *Advances in Consumer Research* 12, eds. Elizabeth C. Hirschman and Morris B. Holbrook (Provo, Utah: Association for Consumer Research, 1985), 443–449.

90. Barry J. Babin, James S. Boles, and William R. Darden, "Salesperson Stereotypes, Consumer Emotions, and Their Impact on Information Processing," *Journal of the Academy of Marketing Science* 23, no. 2 (1995): 94–105; Gilbert A. Churchill, Jr., Neil M. Ford, Steven W. Hartley, and Orville C. Walker, Jr., "The Determinants of Salesperson Performance: A Meta-Analysis," *Journal of Marketing Research* 22 (May 1985): 103–118.

91. Siew Meng Leong, Paul S. Busch, and Deborah Roedder John, "Knowledge Bases and Salesperson Effectiveness: A Script-Theoretic Analysis," *Journal of Marketing Research* 26 (May 1989): 164; Harish Sujan, Mita Sujan, and James R. Bettman, "Knowledge Structure Differences between More Effective and Less Effective Salespeople," *Journal of Marketing Research* 25 (February 1988): 81–86; Robert Saxe and Barton Weitz, "The SOCCO Scale: A Measure of the Customer Orientation of Salespeople," *Journal of Marketing Research* 19 (August 1982): 343–351; David M. Szymanski, "Determinants of Selling Effectiveness: The Importance of Declarative Knowledge to the Personal Selling Concept," *Journal of Marketing* 52 (January 1988): 64–77; Barton A. Weitz, "Effectiveness in Sales Interactions: A Contingency Framework," *Journal of Marketing* 45 (Winter 1981): 85–103.

92. Jagdish M. Sheth, "Buyer-Seller Interaction: A Conceptual Framework," in *Advances in Consumer Research* (Cincinnati, Ohio: Association for Consumer Research, 1976): 382–386; Kaylene C. Williams and Rosann L. Spiro, "Communication Style in the Salesperson-Customer Dyad," *Journal of Marketing Research* 22 (November 1985): 434–442.

93. .Marsha L. Richins, "An Analysis of Consumer Interaction Styles in the Marketplace," *Journal of Consumer Research* 10 (June 1983): 73–82.

94. Teena Hammond, "Sears' Survey: Stores That Satisfy Customers Glean Higher Sales," *Women's Wear Daily* (July 7, 1997): 12.

95. Rama Jayanti and Anita Jackson, "Service Satisfaction: Investigation of Three Models," in *Advances in Consumer Research* 18, eds. Rebecca H. Holman and Michael R. Solomon (Provo, Utah: Association for Consumer

Research, 1991), 603–610; David K. Tse, Franco M. Nicosia, and Peter C. Wilton, "Consumer Satisfaction as a Process," *Psychology & Marketing* 7 (Fall 1990): 177–193.

96. Liza Abraham-Murali and Mary Ann Littrell, "Consumers' Perception of Apparel Quality over Time: An Exploratory Study," *Clothing and Textiles Research Journal* 13, no. 3 (1995): 149–158.

97. Eugene W. Anderson, Claes Fornell, and Donald R. Lehmann, "Customer Satisfaction, Market Share, and Profitability: Findings from Sweden," *Journal of Marketing* 58, no. 3 (July 1994): 53–66.

98. Cecily Hall and Emily Kaiser, "Satisfied Shoppers: The Top Retailers Ranked by Customer Satisfaction," *Women's Wear Daily* (December 15, 2005): 16.

99. Robert Jacobson and David A. Aaker, "The Strategic Role of Product Quality," *Journal of Marketing* 51 (October 1987): 31–44. For a review of issues regarding the measurement of service quality, see J. Joseph Cronin, Jr. and Steven A. Taylor, "Measuring Service Quality: A Reexamination and Extension," *Journal of Marketing* 56 (July 1992): 55–68.

100. Anna Kirmani and Peter Wright, "Money Talks: Perceived Advertising Expense and Expected Product Quality," *Journal of Consumer Research* 16 (December 1989): 344–353; Donald R. Lichtenstein and Scot Burton, "The Relationship between Perceived and Objective Price-Quality," *Journal of Marketing Research* 26 (November 1989): 429–443; Akshay R. Rao and Kent B. Monroe, "The Effect of Price, Brand Name, and Store Name on Buyers' Perceptions of Product Quality: An Integrative Review," *Journal of Marketing Research* 26 (August 1989): 351–357.

101. Heidi P. Scheller and Grace I. Kunz, "Toward a Grounded Theory of Apparel Product Quality," *Clothing and Textiles Research Journal* 16, no. 2 (1998): 57–67.

102. Ronda Chaney and Nancy J. Rabolt, "Perceptions of Apparel Quality," *FIT Review* (Fall 1990): 38–44; Jean D. Hines and Gwendolyn S. O'Neal, "Underlying Determinants of Clothing Quality: The Consumers' Perspective," *Clothing and Textiles Research Journal* 13, no. 4 (1995): 227–233.

103. Lynn Barnes, "Country Image: Relationship between Perceived Garment Quality and Purchase Intent," master's thesis, San Francisco State University (1999).

104. Gilbert A. Churchill, Jr., and Carol F. Surprenant, "An Investigation into the Determinants of Customer Satisfaction," *Journal of Marketing Research* 19 (November 1983): 491–504; John E. Swan and I. Frederick Trawick, "Disconfirmation of Expectations and Satisfaction with a Retail Service," *Journal of Retailing* 57 (Fall 1981): 49–67; Peter C. Wilton and David K. Tse, "Models of Consumer Satisfaction Formation: An Extension," *Journal of Marketing Research* 25 (May 1988): 204–212. For a discussion of what may occur when customers evaluate a new service for which comparison standards do not yet exist, see Ann L. McGill and Dawn Iacobucci, "The Role of Post-Experience Comparison Standards in the Evaluation of Unfamiliar Services," in *Advances in Consumer Research* 19, eds. John F. Sherry, Jr., and Brian Sternthal, (Provo, Utah: Association for Consumer Research, 1992), 570–578; William Boulding, Ajay Kalra, Richard Staelin, and Valarie A. Zeithaml, "A Dynamic Process Model of

Service Quality: From Expectations to Behavioral Intentions," *Journal of Marketing Research* 30 (February 1993): 7–27.

105. John W. Gamble, "The Expectations Paradox: The More You Offer Customer, Closer You Are to Failure," *Marketing News* (March 14, 1988): 38.

106. Jagdish N. Sheth and Banwari Mittal, "A Framework for Managing Customer Expectations," *Journal of Market Focused Management* 1 (1996): 137–158.

107. Mary C. Gilly and Betsy D. Gelb, "Post-Purchase Consumer Processes and the Complaining Consumer," *Journal of Consumer Research* 9 (December 1982): 323–328; Diane Halstead and Cornelia Droge, "Consumer Attitudes toward Complaining and the Prediction of Multiple Complaint Responses," in *Advances in Consumer Research* 18, eds. Rebecca H. Holman and Michael R. Solomon (Provo, Utah: Association for Consumer Research, 1991), 210–216; Jagdip Singh, "Consumer Complaint Intentions and Behavior: Definitional and Taxonomical Issues," *Journal of Marketing* 52 (January 1988): 93–107.

108. Gary L. Clark, Peter F. Kaminski, and David R. Rink, "Consumer Complaints: Advice on How Companies Should Respond Based on an Empirical Study," *Journal of Services Marketing* 6, no. 1 (Winter 1992): 41–50.

109. Alan Andreasen and Arthur Best, "Consumers Complain—Does Business Respond?," *Harvard Business Review* 55 (July–August 1977): 93–101.

110. Tibbett L. Speer, "They Complain Because They Care," *American Demographics* (May 1996): 13–14.

111. Ingrid Martin, "Expert-Novice Differences in Complaint Scripts," in *Advances in Consumer Research* 18, eds. Rebecca H. Holman and Michael R. Solomon (Provo, Utah: Association for Consumer Research, 1991), 225–231; Marsha L. Richins, "A Multivariate Analysis of Responses to Dissatisfaction," *Journal of the Academy of Marketing Science* 15 (Fall 1987): 24–31.

112. John A. Schibrowsky and Richard S. Lapidus, "Gaining a Competitive Advantage by Analyzing Aggregate Complaints," *Journal of Consumer Marketing* 11, no. 1 (1994): 15–26.

113. Russell W. Belk, "The Role of Possessions in Constructing and Maintaining a Sense of Past," in *Advances in Consumer Research* 17, eds. Marvin E. Goldberg, Gerald Gorn, and Richard W. Pollay (Provo, Utah: Association for Consumer Research, 1989), 669–676.

114. Ira P. Schneiderman, "Keeping Clothes beyond Fashion," *Women's Wear Daily* (April 22, 1997): 8.

115. Jacob Jacoby, Carol K. Berning, and Thomas F. Dietvorst, "What about Disposition?," *Journal of Marketing* 41 (April 1977): 22–28.

116. Jennifer Lach, "Welcome to the Hoard Fest," *American Demographics* (April 2000): 8–9.

117. Mike Tharp, "Tchaikovsky and Toilet Paper," *U.S. News & World Report* (December 1987): 62; B. Van Voorst, "The Recycling Bottleneck," *Time* (September 14, 1992): 52–54; Richard P. Bagozzi and Pratibha A. Dabholkar, "Consumer Recycling Goals and Their Effect on Decisions to Recycle:

A Means-End Chain Analysis," *Psychology & Marketing* 11, no. 4 (July/August 1994): 313–340.

118. http://groups.yahoo.com/group/thecompact (December 29, 2006.)

119. Carolyn Jones, "Out of the Retail Rat Race," *San Francisco Chronicle* (February 13, 2006): B1, B6; Carolyn Jones, "Passionate Response to Want-Not-Waste-Not Group," *San Francisco Chronicle* (February 17, 2006): B8.

120. Debra J. Dahab, James W. Gentry, and Wanru Su, "New Ways to Reach Non-Recyclers: An Extension of the Model of Reasoned Action to Recycling Behaviors," in eds. Frank Kardes and Mita Sujan *Advances in Consumer Research,* (Provo, Utah: Association for Consumer Research, 1994), 251–256.

121. Soyeon Shim, "Environmentalism and Consumers' Clothing Disposal Patterns: An Exploratory Study," *Clothing and Textiles Research Journal* 13, no. 1 (1995): 38–48.

122. Richard P. Bagozzi and Pratibha A. Dabholkar, "Consumer Recycling Goals and Their Effect on Decisions to Recycle: A Means-End Chain Analysis," *Psychology & Marketing* 11, no. 4 (July/August 1994): 313–340. See also L. J. Shrum, Tina M. Lowrey, and John A. McCarty, "Recycling as a Marketing Problem: A Framework for Strategy Development," *Psychology & Marketing* 11, no. 4 (July/August 1994): 393–416; Dahab, Gentry, and Su, "New Ways to Reach Non-Recyclers: An Extension of the Model of Reasoned Action to Recycling Behaviors."

123. John F. Sherry, Jr., "A Sociocultural Analysis of a Midwestern American Flea Market," *Journal of Consumer Research* 17 (June 1990): 13–30.

124. Shim, "Environmentalism and Consumers' Clothing Disposal Patterns: An Exploratory Study."

125. Diane Crispell, "Collecting Memories," *American Demographics* (November 1988): 38–42.

126. Stephanie Stoughton, "Unemployed Americans Turn to E-Bay to Make Money," *The Boston Globe* (October 16, 2001).

127. Allan J. Magrath, "If Used Product Sellers Ever Get Organized, Watch Out," *Marketing News* (June 25, 1990): 9; Kevin McCrohan and James D. Smith, "Consumer Participation in the Informal Economy," *Journal of the Academy of Marketing Science* 15 (Winter 1990): 62.

128. John F. Sherry Jr., "Dealers and Dealing in a Periodic Market: Informal Retailing in Ethnographic Perspective," *Journal of Retailing* 66 (Summer 1990): 174.

129. "New Kind of Store Getting More Use Out of Used Goods," *Montgomery Advertiser* (December 12, 1996): 7A.

130. Jung-Eun Ha and Nancy J. Nelson Hodges, "Exploring Motivations, Intentions, and Behavior of Socially Responsible Consumption in a Clothing Disposal Setting," *ITAA Proceedings* (November 2006).

131. Anamaria Wilson, "A Dot-Com Success: eBay Apparel Volume Heads for the $1B Mark," *Women's Wear Daily* (July 2, 2002): 1, 6, 15.

132. Yumiko Ono, "The 'Pizza Queen' of Japan Becomes a Web Auctioneer," *The Wall Street Journal Interactive Edition* (March 6, 2000).

133. Jessie Hartland, "Lost and Found and Sold," *Travel & Leisure* (February 2000): 102–103.

ETHICS AND CONSUMER PROTECTION

The two chapters in this last section focus on our responsibility as consumers in the marketplace, business's responsibility to consumers, and the protection that government and business agencies afford us. Chapter 14 focuses on business and personal ethics, including environmental issues related to fashion consumption. Chapter 15 outlines the many protections in the form of laws and government agencies that oversee our consumption.

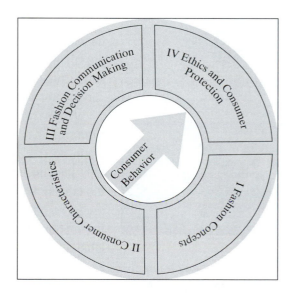

14

Ethics, Social Responsibility, and Environmental Issues

Travis was shopping at his favorite sporting goods store and was finding great buys on activewear when he overheard the conversations of other customers who came into the store. As they looked at and read the labels (Travis never looks at labels!), they kept commenting on where the garments were made. *What difference does that make?* he said to himself. *The only thing that matters is whether its comfortable (it's 100% cotton, so that's good), and, of course, how it looks on me, and whether my friends like it. And I did see these styles in the latest issue of GQ.*

After trying on several items, Travis encountered these same customers as they continued to talk in a loud manner about the clothes made in third-world countries. They said the clothes had probably been made with child labor, maybe even prison labor. They also commented on the "shoddy sewing" in the sport-shirts, the same ones that Travis had just tried on. He hesitated, but that shirt looked great on, and why should he worry about what those people think anyway? He didn't know them. Travis paid for his "finds" and happily left the store.

When he got home and tried on his new purchases again he read the labels carefully (maybe he *should* look at the labels). It sparked his memory as he had seen the name of the manufacturer listed on the label before. He then realized that he had been given a handbill outside a department store last week. He vaguely remembered it saying something about sweatshop labor, but he just tossed it; it was a bother since he was in quite a hurry to get to work. *Maybe this is something to think about,* Travis thought. *I wonder who did make this shirt? But what can I do about it? I'm halfway around the world from where this shirt was made. It must be OK if it's for sale in the best stores in town.* Travis decided not to worry about it and proudly wore his new shirt to school the next day.

CONSUMER AND BUSINESS ETHICS

In business, conflicts often arise between the goal to succeed in the marketplace and the desire to maximize the well-being of consumers by providing them with safe and effective products and services that meet their needs and at the same time are beneficial (or at least not harmful) to society. Where is the social or moral line when producing, promoting, and selling products? Sometimes personal ethics clash with business ethics which can be problematic for employees who feel that their company is not being ethical. Some consumers also don't show very ethical and responsible consumer behavior.

Do you think Travis should be concerned about who made the shirt he just bought? Or how much they got paid to make it? Or how much profit the company made from it? Do you think he is even aware of these issues? Some students across the country are very aware and are demonstrating against their university's role in selling sweatshop-made apparel in their campus stores. In this chapter we will explore the ethics and social responsibility of both businesses and consumers.

Business and Personal Ethics

Business ethics essentially are rules of conduct that guide actions in the marketplace—the standards against which most people in a culture judge what is right and what is wrong, good or bad, socially acceptable or unacceptable.[1] **Personal ethics** are similar codes of conduct that guide our daily living as individuals. These universal standards or values include honesty, trustworthiness, fairness, respect, justice, integrity, concern for others, accountability, loyalty, and responsible citizenship. Industry is increasingly coming to realize that ethical behavior is also good business in the long run, since the trust and satisfaction of consumers translate into years of loyalty from customers whose needs have been met. Consumers think better of products made by firms they feel are behaving ethically.[2] A Conference Board survey of U.S. consumers found that the most important criterion when forming opinions about corporations is social responsibility in such areas as labor practices, business ethics, and environmental issues.[3] Consumers think better of products made by firms they feel are behaving ethically.[4]

Sometimes, ethical decisions can be costly for businesses in the short term when they result in lost revenue. For example, a store in Indianapolis removed from its shelves T-shirts with the message "Destroy All Girls" after complaints from consumers.[5] And despite robust sales of a video game called Night Trap made by Sega, executives at Toys "R" Us decided to pull the product from store shelves after receiving complaints from parents. In the game, players defend a group of barely dressed sorority sisters against zombies, who suck out the students' blood with a giant syringe if they win.[6]

Whether intentionally or not, some marketers do violate their bond of trust with consumers. Table 14-1 illustrates examples of what some people feel are unethical business behaviors. In some cases, these actions are illegal, as when a manufacturer deliberately mislabels the contents of a package or a retailer adopts a "bait-and-switch" selling strategy, whereby consumers are lured into the store with promises of inexpensive products with the sole intent of getting them to switch to higher-priced goods (see Chapter 15).

Table 14-1 Unethical Business Behavior

Product	Example
Safety	Manufacture of flammable clothing or toys
Shoddy goods	Products that cannot withstand ordinary wear and tear
Environmental pollution	Using polluting dyes and chemicals in apparel and fabric manufacture
Mislabeled products	Identifying the wrong fiber content or country of origin on apparel
Brand counterfeits	Counterfeit goods labeled and sold as the genuine brand
Price	
Excessive markups	High prices used by retailers to connote quality
Price comparisons	False original price for sale price to appear as a bargain
Promotion	
Exaggerated claims	Cosmetic ads claiming to change skin structure
Tasteless advertising	Sexual innuendos and gender disparagement
Deceptive advertising	Lose pounds with no diet or exercise
Captive audiences	Mandatory view to TV commercials by schools subscribing to closed channel newscasts

Source: Adapted from Leon G. Schiffman and Leslie Lazar Kanuk, *Consumer Behavior* (Upper Saddle River, N.J.: Prentice-Hall, 2000).

Do you think you will make an ethical professional in your future career? One study in the 1980s indicated that students were "less ethically minded" than students from previous decades.[7] Do you think this is true of your peers? A later study conducted with apparel merchandising students found that students did not appear to be as ethical as retail managers or executives.[8] Another study found students who were female, employed, practiced their primary faith, and had completed an ethics course were less accepting of unethical consumer behavior. Student-centered studies recommend that ethics be taught in the curriculum and that company policies be clearly explained to employees.[9]

Use of Fur for Fashion

Some consumers feel strongly that the use of fur from animals to make consumers look more beautiful is not ethical or moral. The antifur movement has been the most visible arm of the animal rights movement. Related issues include the use of animal testing in cosmetics and drugs. The use of furs for fashion has been controversial for years, and many feel it is unethical consumer behavior. It is, however, typical of other fashion cycles. After many years of activists protesting the use of animal fur to decorate consumers in the form of fashion (and the protests still continue today),[10] there is a concurrent resurgence in the interest of using furs. The early 1990s saw a low point for the fur industry; many consumers felt it was politically incorrect to wear fur, and fur salons in upper-end department stores closed. Then a turnaround began in the mid-1990s, with more designers showing fur in their

Donna Karan used shearling wool, which is the pelt of a yearling sheep, in her collection.

lines.[11] We now see a mixture of good-quality faux furs, as in Oleg Cassini's hundred-piece fake fur line unveiled at a benefit for the Humane Society of the United States,[12] and the use of traditional furs by top designers and companies such as Michael Kors, Arnold Scaasi, Jerry Sorbara, Zandra Rhodes, Randolph Duke, Halston, Hennessy International, Revillon, and others.[13] And "croc" is popular, whether real or fake.[14]

Many agree that attitudes about furs have changed over the years,[15] but despite efforts of PETA and other animal activists (discussed later), we see a resurgence in the use of fur. Some consumers are wearing furs as an expression of independence, in effect saying "No one is going to tell me what not to wear."[16] The Fur Information Council of America (FICA) invited American designers—including Donna Karan, Oscar de la Renta, Marc Jacobs, Mary McFadden, and others—to visit fur farms and Scandinavian showrooms to inspire their creative use of fur. Saga Furs of Scandinavia also has offered free fur to new young designers to use in their collections. In addition designers are doing more fun, fashion-oriented pieces geared toward younger consumers rather than just the traditional long mink coat. Younger consumers don't look at mink or sable as luxury but as fashion.[17]

LEVI STRAUSS ETHICS

Levi Strauss has always been a company with strong ethical values. A spokesperson said, "For Levi Strauss, doing business based on ethics is not just good PR, it's the bottom line." The company stands on principles, not just the bottom line: "Companies are going to be judged on their practices as well as their products. And if we lose money by doing the right thing, we lose money."[18] When Levi Strauss founded the company in 1853, he was progressive with his employees and generous to his community. During the Depression in the 1930s with few orders to fill, the company kept employees on the payroll refinishing the hardwood floors in the San Francisco plant. Levi's did not go into Mississippi and Alabama in the 1950s and 1960s because of the racial conditions and for the same reason did not go into South Africa. In the 1990s Levi's stopped contributions to the Boy Scouts due to their discrimination policy against gays, despite right-wing groups burning Levi jeans, attacking the company as peddling anti-Christian values, and boycotting the product.

Other criticisms of the company came from the decision of going private in the 1980s, which led to scaled-back production, plant closures, and layoffs and closing plants in San Antonio to open plants overseas. Company response to criticisms was the retraining support of displaced San Antonio employees, and as a free-trader, Levi's felt that the customer is best served by having a complete range of options and striving for the best value and quality possible.

Levi's has set apparel industry standards for global business partners. Its "Terms of Engagement," or code of conduct, includes provisions for clearly defined conditions for hiring contractors: ethical standards, legal requirements, environmental requirements, community betterment, and employee standards that address wages, benefits, working hours, child labor, prison labor, health and safety, discrimination, and disciplinary practices.

Levi's withdrew from the Chinese market in 1993 when many Western companies were entering to take advantage of the huge potential there. Upon investigations of working conditions and human rights violations, Levi's ceased business with current contractors. But in 1998 the company reentered the country, citing seven years of workplace monitoring programs in sixty countries and assurances that it could do ethical business in China by contracting with companies that agree to follow its Terms of Engagement.[19] In 1999, Levi's joined the Fair Labor Association, established as a result of the Apparel Industry Partnership, a White House task force to combat sweatshops globally. Many feel that Levi's membership in this alliance added clout to the movement.[20]

Levi Strauss is not without criticism, as mentioned, but many feel it is one of the model companies of the apparel industry.

A recall of fur coats by Burlington Coat Factory added fuel to the fur-for-fashion controversy. The company pulled hundreds of parkas from stores after a vendor admitted that they were trimmed with fur from slaughtered dogs in China. FICA immediately condemned the use of cat or dog fur in garments; however, U.S. federal law does not prohibit the practice. Of course, the mislabeling of fur is illegal.

Offensive Fashion Advertising and Products

Some companies behave in ways that bring moral indignation from the public. Even former President Clinton criticized the fashion industry for glorifying heroin addiction using strung-out-looking models on runways and in fashion magazines, blaming them in part for the rise of heroin as the "drug of choice" among college students. The author of a book on the modeling business said, "Fashion is amoral . . . fashion doesn't care what messages it is sending out as long as the message sells frocks . . . their point is not to addict them to heroin, their point is to addict them to clothing."[21]

Advertising some products, such as personal hygiene products and contraceptives, are inherently offensive to some people. And the fashion industry has often pushed the limits of acceptability. Up through the early 1960s, fashion magazines did not give advertising or editorial space to underwear because the items were too personal in nature and made consumers uncomfortable.[22] Today we see provocative Victoria's Secret ads and fashion shows. A Cannes fashion show aired on www.victoriassecret.com showing "postage stamp bikini" lingerie; the site received 15 million hits from 140 countries one year![23] These fashion shows airing during prime time have generated many complaints regarding decency standards. The Federal Communications Commission, however, decided that the scantily clad lingerie models were not "indecent."[24] Other products can be offensive to consumers. T-shirts with offensive sayings glorifying drunkenness or mocking minorities have prompted many complaints of companies such as Abercrombie & Fitch and Urban Outfitters, among others.[25] And some video games, such as Grand Theft Auto with a simulated cop killing, are offensive to many people prompting complaints from parents and teachers with good reason: In 2005, a *60 Minutes* segment showed a young person on trial for a murder similar to one on the video.

Some consumers are offended by overly sexual ads. Those that demean women, such as many beer ads, have been criticized as unethical. Fashion examples include Guess? Diesel and many Calvin Klein ads over the years, beginning in the 1980s with Brooke Shields saying, "Nothing comes between me and my Calvins." A CK ad campaign featuring young boys in their underwear was pulled soon after initial runs in magazines and Times Square (in New York City) upon complaints from consumer watchdog groups and the Mayor and even FBI involvement.[26] Another controversial explicit men's underwear ad featured model Joel West, an ad even nixed by Klein's own manufacturer. The ad appeared only in *Esquire* and *Playboy*, but the conservative American Family Association was so enraged about the ad it had plans to threaten major retail chains with a national boycott and picketing campaign if they didn't drop Calvin Klein products.[27] Perhaps to quiet some of the criticism of such highly sexual ads, the following year Calvin

sponsored an antiviolence ad campaign with the theme "Unlock the Silence," which ran in *Spin, Rolling Stone, Village Voice, New York Times*, and other media.[28]

Abercrombie & Fitch (A&F) has found itself in a similar controversy, with a racy and sexually charged "magalog" (cross between magazine and catalog)—one was called "Naughty or Nice." Its most loyal demographics are between ages 18 and 22. However, underage customers tried to buy the magalog, which included nudity and an interview with a porn star. This is similar to Calvin Klein's strategy; analysts say, "sex is one of the prime marketing tools for fashion companies. As indicated in Chapter 13, A&F has rethought the magalog, and discontinued it. A few years ago A&F's back-to-school catalog also was controversial due to its "Drinking 101" feature with its cutout spinner chart for drinking games, which some saw as encouraging students to drink. The company was accused of connecting alcohol abuse with sex, fun, and fashion; was the target of protests by Mothers Against Drunk Driving (MADD); and even drew complaints from government officials, who called for a consumer boycott.[29] Despite consumer uproar, A&F continues the controversy with sexy thongs for 10- to 14-year-old girls, generating editorials and consumer criticism, as well as a misguided attempt at humor on T-shirts with graphics portraying caricatured Asian faces, leading to cries of racism. (The offending shirts were quickly pulled from store shelves.)[30]

Some feel that such companies enter into sexual advertising to develop an image the company wants for its brand and in an attempt to capture consumer attention. Although it can be successful in the short term, it may damage the brand in the long term by alienating consumers.

Benetton has been known for its controversial ads for almost two decades, using subjects from AIDS to religion and prisons. The images are well known: photos of dying AIDS patients, a nun and priest kissing, a black woman nursing a white baby, oil-slick-damaged birds, and death row inmates. These campaigns were often criticized for their sensational nature and banned by publications around the world. They drew attention to the company, but analysts never knew if it helped sell fashion. Sears had entered into an agreement to sell Benetton apparel in its stores, a departure from Benetton strategy of licensed stores. With the latest consciousness-raising ad with photography by Oliviero Toscani, Sears canceled the agreement,

EDGY FASHION ADS

Fashion companies have spent millions of dollars chasing after edgy advertising to freshen their image and sales. One ad executive says these companies should chill out and get their own identity. Ads attempting to be edgy for edgy's sake just become vulgar. One analyst said, "The last time it worked was with CK One fragrance in terms of sales" (the ads featured a lineup of skanky, tattooed youth). Among other "edgy" ads that were criticized are Emanuel Ungaro's dogs-in-bondage images, footwear firm Cesare Paciotti's vixens in a graveyard, and A/X Armani's Barbara Kruger–esque portraits of quirky-looking youths. Other stereotypically edgy ads have explored themes including heroin chic, homosexuality, S&M chic, and the drained-of-life boredom attitude. Edgy ads that have no substance to back it up can fail. "The true avant-garde is the stuff that predicts what is going to happen, it's the stuff that is going to change the world."[31] What fashion ads do you think are edgy without being vulgar?

--- **WAL-MART'S GIFT AND GRATUITY POLICY** ---

No gifts or gratuities that have monetary value are to be given, offered, or encouraged in any way to any Wal-Mart Associate or potential Wal-Mart Associate. Suppliers may donate gifts for the purpose of raising funds for charities or nonprofit organizations or for resale at Wal-Mart's Associate Store. Gifts or gratuities include but are not limited to free goods, tickets to sporting or entertainment events, kickbacks in the form of money or merchandise, special discounts to any Wal-Mart Associate, discontinued or no-longer-used samples, supplier-paid trips, liquor, food products, meals, or personal services. When practical, any such item received must be returned to the sender with an explanation of this policy. Any item not returned shall be considered the property of Wal-Mart.

Source: www.walmart.com

perhaps because its "warm and fuzzy" image clashed with such an avant-garde approach to advertising.[32] Later Luciano Benetton apologized for causing pain to families of victims as criticized by some, but defended his company's stance on its controversial advertising, indicating that the intention of the campaign was to contribute to the debate about capital punishment.[33] Soon after, Toscani left Benetton.

Cultural Differences

Notions of right and wrong differ among people, organizations, and cultures. Some businesses, for example, believe it is all right for salespeople to persuade customers to buy, even if it means giving them false information, while other firms feel that anything less than total honesty with customers is terribly wrong. Because each culture has its own set of values, beliefs, and customs, ethical business behaviors are defined quite differently around the world. Giving "gifts" in exchange for getting business from suppliers or customers is a way of life in many countries, for example, even though this may be considered bribery or extortion in others. TJX and Wal-Mart are two retailers that clearly state to their suppliers their policy of prohibiting employees from accepting any gifts, without exception. One consumer study found that there are differences among students of different cultures in the United States regarding acceptance of unethical clothing consumption activities (such as changing price tags on clothing items).[34]

Needs and Wants: Do Marketers Manipulate Consumers?

One of the most common and stinging criticisms of marketing is that companies convince consumers that they "need" many material things (some say this happens with fashion every season!) and that they will be unhappy and somehow inferior people if they do not have these "necessities." The issue is a complex one and is certainly worth considering: Do marketers give people what they want, or do they tell people what they *should* want?

Do Marketers Create Artificial Needs?

The marketing system has come under fire from both ends of the political spectrum. The religious right believes that marketers contribute to the moral breakdown of society by presenting images of hedonistic pleasure, thus

encouraging the pursuit of secular humanism. On the other hand, some left-ists argue that the same deceitful promises of material pleasure function to buy off people who would otherwise be revolutionaries working to change the system.[35] They claim that the marketing system creates demand that only its products can satisfy. Marketers respond that they simply recommend ways to satisfy needs. A basic objective of marketing is to create awareness that these needs exist, not to create the needs themselves.

Are Advertising and Marketing Necessary?

As social critic Vance Packard wrote more than forty years ago, "Large-scale efforts are being made, often with impressive success, to channel our unthinking habits, our purchasing decisions, and our thought processes by the use of insights gleaned from psychiatry and the social sciences."[36] Economist John Kenneth Galbraith charged that radio and television are important tools to accomplish this manipulation of the masses. Many feel that marketers arbitrarily link products to desirable social attributes, foster-ing a materialistic society in which we are measured by what we own. Marketers respond to this criticism by saying that products are designed to meet existing needs, and advertising only helps to communicate their avail-ability.[37] According to the *economics of information* perspective, advertising is an important source of consumer information.[38] This view emphasizes the economic cost of the time spent searching for products. Accordingly, adver-tising is a service for which consumers are willing to pay, since the informa-tion it provides reduces search time.

Do Marketers Promise Miracles?

Consumers are led to believe through advertising that products have magical properties and will do special and mysterious things for them that will trans-form their lives. They will be beautiful, have power over others' feelings, be suc-cessful, be relieved of all ills, and so on. Marketers respond to this criticism by indicating that advertisers simply do not know enough about people to manip-ulate them. Consider that the failure rate for new products ranges from 40 per-cent to 80 percent. In testimony before the Federal Trade Commission, one advertising executive observed that while people think that advertisers have an endless source of magical tricks and/or scientific techniques to manipulate people, in reality the industry is successful when it tries to sell good products and unsuccessful when selling poor ones.[39]

SOCIAL RESPONSIBILITY

Some companies feel that the best way to serve their communities is through *cause marketing*, in which marketing efforts are linked to a charitable cause. Companies recognize that socially responsible activities can improve their image among consumers and stockholders and consequently influence pur-chasing decisions. The converse is also true: Perceptions of a company's lack of social responsibility can negatively affect consumer purchase decisions.[40] **Social responsibility** is going beyond what is legal and doing what can ben-efit society.

According to a Cone/Roper survey of two thousand American adults, 80 percent form more positive images of a company that they know supports causes of importance to them. In addition, two-thirds say they would switch brands or retailers and would pay more for the product and indicate that they have a greater trust in companies linked to good causes. They would like to see corporate involvement in such issues as education, the environment, poverty, child care, drug abuse, and homelessness, and this should be standard business practice. This study also found that deep involvement in social issues is important to college graduates, white-collar workers, working women, and affluent consumers—demographics that many apparel companies are interested in.[41] Another Cone survey of a thousand U.S. consumers found that more than half intended to buy a holiday gift associated with a cause or buy from a retailer that supports a cause.[42] That's good enough reason for retailers to support causes!

Some companies create special products to sell in support of a designated charity, such as Kenneth Cole's World AIDS Day T-shirt, Nordstrom's ONE T-shirt (made by Edun), Gap's (Product) Red merchandise, and even Scoop's ballet slipper with the CFDA (Council of Fashion Designers of America) motif for their breast cancer program.[43] Others offer to donate a portion of their sales to the charity. Large-scale disasters such as Hurricane Katrina and the Indian Ocean tsunami, leaving many in need, were causes that some retailers took up. Wal-Mart's early response to Katrina victims bringing millions of dollars of merchandise and in-kind donations into New Orleans is an example.

Companies promote causes because it is good for business—but they also promote causes because they truly believe in them and because the problem or disease directly affects them. A case in point is breast cancer. As one in nine women today have the disease, and women are the main customers of fashion, the industry has rallied to support this cause. Many apparel companies, manufacturers, and retailers have become well known for their work in many social causes:[44]

- Liz Claiborne has become a recognized leader in fighting domestic violence. Since 1991, the company has supported local shelters and donates profits from sales of special items to the Family Violence Prevention Fund.

- Levi Strauss has a grant program in forty countries. The Global Giving Program is carried out through the Levi Strauss Foundation, established in 1952. Its grassroots nature has a mission to improve lives in communities where Levi's has employees. It gives grants of more than $20 million annually in charitable gifts to organizations that address key social or community issues (www.levistrauss.com).

- Macy's in California produces Passport, its annual fashion show fund-raiser for AIDS causes. Macy's also sponsors "For the Love of Her Life," a fund-raiser for breast cancer research, and the American Heart Association's "Go Red for Women" education campaign that raises women's awareness of the threat of heart disease.[45]

- Gap, Converse, and Emporio Armani participate in the (Product) RED campaign, along with Apple, Dell, Hallmark, Motorola, American Express, and others by offering limited-edition red-colored products to benefit the charity fighting AIDS in Africa.

- Ralph Lauren opened a cancer center in East Harlem in New York City[46] and also works with Habitat for Humanity.
- Kenneth Cole is involved with many causes including AMFAR (AIDS research), Help USA (to help the homeless), Mentoring USA (early intervention for young people), Rock the Vote, Riverkeeper, and more.
- Eddie Bauer's Global ReLeaf tree project is a partnership with American Forests to reforest areas that have been devastated by natural disasters and plant trees in and around urban areas.
- Timberland is a supporter of City Year, a program encouraging young people to devote service to their communities.
- Patagonia donates to more than 350 organizations and contributes clothing and in-kind services to environmental groups.
- Lee Jeans founded Lee National Denim Day, the largest single-day fund raiser for breast cancer.
- The Council of Fashion Designers of America Foundation formed "Fashion Targets Breast Cancer," a campaign that galvanized many U.S. fashion companies.

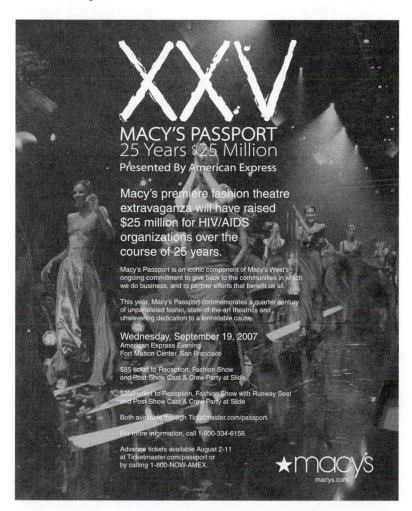

Macy's Passport fashion show proceeds support HIV/AIDS victims.

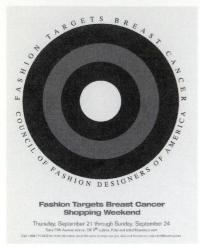

The Council of Fashion Designers of America recognized Saks Fifth Avenue, which led the charge with the most ambitious campaign among retailers for the Breast Cancer Awareness month.

- Bloomingdale's is a corporate partner of the National Colorectal Cancer Research Alliance. It also sponsors the Susan G. Komen foundation to fight breast cancer, as many retailers do.

- Benetton has been raising social consciousness with its unusual and provocative ads since 1982 and has made contributions to the AIDS cause and to other programs connected with its ads.

- There are also nonprofit companies with similar missions; for example, Edun launched in spring 2005 by Bono and wife, Ali Hewson. The company fosters sustainable employment in developing areas of the world, particularly Africa. It is founded on the premise of trade, not aid, as a means of building sustainable communities helping to build skill sets of factories where the clothes are produced. Edun is currently produced in India, Peru, Tunisia, Kenya, Uganda, Lesotho, Mauritius, and Madagascar (www.edunonline.com).

Why Do Consumers Buy from Socially Responsible Companies?

In addition to cause marketing being popular with consumers as discussed, one study analyzed motivations for consumers buying from a "socially responsible business" (SRB), which was defined in this case as a clothing business that has strict labor guidelines for its vendors with whom they work. Four motivational themes were identified:[47]

- *Principles for the workplace:* It is important to consumers that businesses treat their workers with respect and dignity by providing a safe and fair workplace.

- *The role of business and government:* Business and government should take actions to ensure business responsibility, including establishing more laws. They should set and follow sourcing guidelines, follow laws, be ethical, and not be greedy.

- *The consumer's role:* Consumers send a message to businesses through their purchases; businesses feel a form of punishment as a result of consumer boycotts.

- *Consumer needs:* There are difficulties when trying to support socially responsible companies. Price constrains their shopping from SRBs. For many, style and other product attributes were more highly prioritized than social responsibility.

The Apparel Labor Issue

Global sourcing, or manufacturing in countries around the world, has stimulated much interest and concern among the public for humanitarian rights. Consumers and critics are showing their displeasure over what is perceived as a lack of ethics, social responsibility, and conscience of large fashion companies and those who produce their product in third-world countries for wages as low as 25 cents an hour. As we saw in the opening scene of this chapter, many consumers are aware of this and will not purchase fashion

The Pink Pony Fund for Cancer Care and Prevention is a Polo Ralph Lauren initiative in the fight against cancer and supports programs for early diagnosis, education, treatment, and research. Ten percent of proceeds from Pink Pony products benefits the fund. The Pink Pony Web site includes the following quote from Ralph Lauren: "Breast cancer is not just a women's issue—it affects all of us: the brothers, fathers, children, friends. Pink Pony is our effort in the fight against cancer."

made in these countries. Many others, like Travis, are unaware of the controversy and feel that if retailers are selling merchandise, everything must be OK. But people are picketing new store openings and publishing newspaper editorial titles such as "Shopping Can Make a Statement," and "Informed Consumers Can Improve Sweatshops," encouraging consumers to do a little strategic shopping to nudge the economic justice agenda along. One message stated, "Think about the pennies paid to assembly workers producing the clothes and shoes you buy."[48] Enough consumers and companies are thinking this way that we are hearing the terms *fair trade fashion* and *ethical fashion* being used, which will be discussed later.

Issues of Exploitation

The fashion industry has received a great deal of unflattering publicity. One recent example is the incident of child labor in India where children as young as 10 were found sewing sequins on Gap shirts next door to children working

on saris worn by Indian women.[49] India's garment export industry is a $10 billion a year business and some of the biggest names in retailing produce in India. The Gap case involved a subcontractor hired in violation of Gap's policy and without Gap's knowledge. An earlier case in the United States was the 1995 El Monte, California, sweatshop discovery where seventy-two Thai apparel workers were kept in prisonlike conditions. Also, sweatshop conditions discovered in New York City and El Salvador, where Kathie Lee Gifford–licensed goods were being manufactured, produced another wave of attention on the industry. Kathie Lee subsequently became a crusader for the antisweatshop movement. Holding licensees (manufacturers) accountable for contractor abuses affects not only them but also celebrities who financially gain from sales of fashion on which their name appears. This is controversial because small manufacturers say that the expense of regulating their contractors would bankrupt them. Similarly, large manufacturers do not feel they should be held accountable for the business dealings of their contractors, which are separate, independent companies. However, legislatures may change that; California has passed bills to force retailers and manufacturers to pay back wages of contractors producing their products.[50]

The National Labor Committee, an independent human rights organization, publishes scathing reports of the apparel industry, such as its report entitled "Wal-Mart Shirts of Misery" outlining sweatshop conditions of Wal-Mart contractors in Bangladesh.[51]

One problem with analyzing compliance with labor laws in overseas apparel production is the lack of a standard, recognized evaluation model.[52] However, more independent inspection with resulting improvements are occurring in the industry. This was precipitated by the high-profile attention given to the situation in Saipan (in the Northern Mariana Islands, a U.S. commonwealth), where companies such as Gap, Nordstrom, J. Crew, Ralph Lauren, Donna Karan, and Tommy Hilfiger used sweatshop contractors for apparel assembly. As the public became aware of the deplorable conditions in such factories and that "Made in USA" labels appeared on garments made there, social pressure was put on the industry to clean up its act. One pressure comes from Global Exchange, a labor advocacy organization. It engages in such activities as handing out flyers at company stockholder meetings and picketing stores across the country.[53] Other pressure to get companies to take responsibility for their supply chain comes from grassroots activism, shareholder activism, and media controversy. For at least the past decade both Nike and Gap have been criticized for their use of sweatshops. Due to such social pressure, both have recently taken the important step toward taking responsibility for suppliers by releasing detailed supplier and audit information.[54]

The apparel industry is attempting to address the perceived public notion of it as the bad guy. For example, the Saipan Garment Manufacturers Association has countered its image with new regulations. It has adopted a code of conduct based on the Levi Strauss model that prohibits forced labor and other abuses and has developed promotional materials to show that abuses and poor conditions do not exist anymore.[55] This was an attempt to stop the flight of business from the country, such as Tommy Hilfiger, who pulled orders after the publicity. Some critics feel that this "abandonment" may help divorce companies from potential scandal, but it does not help solve the problem. Similar cases occurred in El Salvador and Honduras in the

Women in Haiti are paid wages of 28 cents an hour sewing Disney garments. Photo courtesy of National Labor Committee.

mid-1990s when the Gap and Liz Claiborne pulled production from abusive, noncompliant factories. The message sent, some felt, was that speaking up about abuses can jeopardize your job.[58] Both companies ultimately returned to help improve conditions. But dropping suppliers that violate labor laws is a normal reaction to a bad compliance report. Wal-Mart recently terminated 1,200 facilities with repeated violations.

College students have organized as United Students Against Sweatshops and have pressured university officials to take a tougher stand against sweatshop labor by joining the Fair Labor Association (FLA). The FLA was formed as part of the Apparel Industry Partnership, a White House task force set up in 1996 to combat sweatshop conditions internationally. Student protests appear to have had an effect. For example, the University of California (UC) added provisions to its code-of-conduct policy requiring a living wage and disclosure of names and addresses of its manufacturing plants, and added protection for female employees working for contractors producing university-logo products.[59] However, in 2006 students at UC continued to protest with arrests made.[60] And the controversy continues. . . .

AMERICAN APPAREL: A SOCIALLY RESPONSIBLE COMPANY

A million T-shirts a week are produced by American Apparel just outside the Los Angeles garment district. Dov Charney, the founder, has pledged his loyalty to homegrown apparel, above-average wages, and worker-friendly factory conditions.[56] The company has become well known for its "sweatshop-free," good-quality U.S. production. With so many apparel companies going overseas for low-cost production, American Apparel is an exception. With an edgy, out-front image and in-your-face marketing, the founder of American Apparel is confident his company will be able to compete in the industry. He says of another local sweatshop-free company that went out of business: "It was all about the social premise, and the only thing that works in this business is the product."

The company is as much a capitalist success as it is a social success.[57] American Apparel combines the right product with the social element, which includes not only good wages and many benefits for its employees but also environmentally friendly practices. These include the use of organic cotton and recycling over a million pounds of fabric scraps each year. And an in-house vertical business model keeps costs down. The company continues production in Los Angeles and is opening retail stores worldwide. Check out the store closest to you.

Cultural Definitions of Exploitation

One of the reasons for controversies in the apparel industry is that it is a global industry. As discussed earlier, each country in the world has its own mix of customs, laws, values, and ways of doing business; however, U.S. companies generally use an American perspective in formulating their code of conduct, imposing foreign value systems to offshore sourcing companies. Some governments, especially in Asian countries, argue that human rights should be interpreted culturally and that U.S. companies should not impose American standards and culture arbitrarily onto developing countries. "For example, workers in China typically arrive in cities from rural areas, then work very hard for one or two years to earn money to take back to their home province."[61] Imposing a minimum workweek and overtime limitations on this situation is not seen as effective by Chinese standards.

What is regarded as exploitative in one country is standard practice in another. For example, many countries have laws governing child labor. However, in some countries children's work is an important part of a family's method of survival. And countries define child labor differently. One study of thirty-seven of the largest apparel manufacturers and retailers found that all included child labor in their codes of conduct, some defining it and some not.[62] Child labor remains prevalent and controversial around the world.

Retelling History: Between a Rock and a Hard Place

A controversial Smithsonian exhibit entitled "Between a Rock and a Hard Place: American Sweatshops, 1820–Present" opened in 1998 in Washington, D.C., and later moved to Los Angeles amid mixed reviews from the industry and the public. Early criticism of the exhibit surfaced during preparation, with industry concerns of laying blame for poor working conditions and hurting corporate images. The American Apparel Manufacturers Association believed the "program unfairly tars the reputation of law-abiding U.S. companies with the same brush as El Monte and other illegal operations."[63] Moving the exhibit to Los Angeles was no small feat, as the city was not seen in a positive light; one major part of the exhibit depicted the El Monte sweatshop discovery. (El Monte is on the outskirts of Los Angeles.)

An explanatory text at the beginning of the show stated that the mission of a history museum is to "interpret difficult, unpleasant, or controversial episodes, not out of any desire to embarrass, be unpatriotic, or cause

SOCIALLY RESPONSIBLE DOLLS

The Popsi doll is a tool for teaching kids the benefits of recycling. The doll matches the Popsi's storybook, *Popsi, the Daughter of Mother Nature*. The clothes and stuffing are made from recycled PET plastic fabric and is one of the first products introduced into the marketplace that truly demonstrates the concept of recycling.

Popsi is not only made from five recycled plastic bottles, but also it is packaged in the same material from which she is made—a large three-liter plastic soda bottle. In the Popsi School Program, children are encouraged to recycle the packaging so that they can contribute to the manufacturing of additional Popsi dolls.[65]

pain, but out of a responsibility to convey a fuller, more inclusive history." Another statement signed by the curators, Peter Liebhold and Harry Rubenstein, stressed that "there are no simple answers to the quandary of sweatshops."[64] One of the exhibit's main premises is that sweatshops flourish because of low prices paid by manufacturers and retailers. Consumers have not been left out of this debate, as the pressure on retailers is seen as coming directly from consumers; it is passed on by retailers to manufacturers, which compete with each other by reducing costs through low wages to their employees. One of the museum's themes is of personal responsibilities, which the curators hoped was exemplified through the exhibit.[66] Whose responsibility do you think the state of the apparel industry is: manufacturers, retailers, or consumers?[67]

Fair Trade Fashion

There is a buzz of new companies and mainstream companies, such as Nike and Tommy Hilfiger, interested in apparel production that guarantees workers' rights called "fair trade apparel" or "ethical fashion."[68] Until recently fair trade companies were located on the fringes of the fashion world. Now more companies are posting codes of conduct for their suppliers, barring child labor, and mandating legal minimum wages and adherence to other labor laws. For example, American Apparel, based in Los Angeles, is recognized as a fair trade business; its brand is best known for T-shirts aimed at young urban buyers. New companies have entered the fair trade arena also. For example, Bono, the U2 lead singer and activist, started Edun, a fair trade fashion brand offering high-priced goods through Saks and Nordstrom. Fair Indigo (www.fairindigo.com), aiming at a mass market, is a new online store. The company searched for suppliers that paid more than the minimum wage and offered other benefits such as medical treatment. For suppliers it found twenty-three locally run plants in Peru and China that ran cooperatives where workers and management share profits.

Several other efforts have begun to promote fair trade apparel. For example, fair trade companies are showcased in a new venue called the Ethical Fashion Show in Paris. The Ethical Fashion Forum, a network of designers and businesses in the United Kingdom, focuses on social and environmental sustainability in the fashion industry.[69]

One study on consumer purchase intentions from fair trade companies found that consumers who supported the fair trade mission, were active in politics, and considered quality, value, and aesthetic uniqueness were more inclined to purchase goods from these companies.[70] Fair trade consumers want to make a difference but require independent verification of fair trade claims. Fair trade certification is a system designed to allow consumers to identify products that meet agreed environmental, labor, and developmental standards. Overseen by a standards-setting body, Fairtrade Labelling Organizations International (FLO), and a certification body, FLO-CERT, the system involves independent auditing of producers to ensure the agreed standards are met. Certification has begun in the coffee, sugar, and ice cream industries, among others, but not the apparel industry yet. Concerned consumers should call for such certification. Transfair, a U.S. certifying member of FLO, hopes to do just that.[71]

ENVIRONMENTAL ISSUES AND THE FASHION INDUSTRY

Former Vice President Al Gore's documentary "An Inconvenient Truth" drew much attention to the threat of climate change in 2006 and sparked a new wave of environmentalism in the United States. Since then many retailers and manufacturers have rushed to make environmental claims of their products.[72]

But is it possible to be both fashionable and environmentally friendly? Many feel the textile and fashion industries pose a serious threat to the environment from the chemicals and finishes used in fabric production; the pollutants in detergent consumers use to launder their clothing; and, most important, the underlying principle of the fashion industry—buying new clothes each year.[73] It is reported that 80 percent of all garbage generated in the United States is buried in landfills, and approximately 5 percent of waste materials (more than 8 billion pounds annually) is contributed by postconsumer textiles.[74] Consumers can keep clothing and textile products from the landfill by alternative disposal options discussed in Chapter 13. In fact, 2 million pounds of clothes are kept from landfills every year by donations to the Salvation Army alone.

Packaging of consumer products accounts for 32 percent of the waste that ends up in landfills, according to a 2003 report by the Environmental Protection Agency. Recently Target and Wal-Mart have made important efforts to reduce this waste by eliminating oversized and overwrapped packaging for their private-label products. Wal-Mart has set a goal of producing "zero waste" by 2025; through recycling and packaging reduction, the company states that it will eliminate all waste flowing through its stores.[75]

Concern for the environment, or the *green movement*, is thought to be a priority for many consumers today. (**Green consumers** are considered those who exhibit environmental concerns through purchase behavior.) Young people are often thought as being the most eco-concerned. One example is Chicago teens who showed their environmental awareness in an eco-fashion show modeling clothes made from recycled soda pop bottles.[76] On the other hand, a British study found that young people are becoming apathetic about green and ethical issues, whereas previously, teenagers led the way in this concern.[77]

However, there appears to be a new trend of vegan-chic, not only in diet but also in fashion with college students at the forefront. Boutiques and online stores are offering "cruelty-free wardrobes" that reject shoes and clothing made from hides, even those made with animal-based glues and dyes.[78]

Consumer Concern for the Environment

A *Wall Street Journal* poll indicated that eight out of ten consumers considered themselves environmentalists, and more than half said fundamental changes in lifestyle were necessary.[79] Despite the vegan-chic trend just discussed, this sentiment does not appear to translate well to behavior toward apparel. One study found that although subjects felt that the environment *should be* considered when buying clothing, they did not consider it in actual purchasing situations. This may be because other factors such as price and style, which were not investigated in this study, were more important than the environmental factor.[80] A later study had a similar conclusion by *not* finding definitive relationships between environmental concern and

responsible apparel consumption,[81] but there was a link between this concern and positive response to green apparel advertising.[82] Some relationships have been found between general socially responsible consumption attitudes and attitudes about clothing acquisition and discard; however, awareness of green apparel behavior appears less pervasive than for other consumer products.[83] An educational video had an impact on consumer interest in green apparel, green retailers, and alternative dry cleaning methods.[84] Other new measurement tools may need to be developed to further investigate green apparel behavior. Often studies use college students who may not be representative of the average consumer. Studies often conclude by stating that "there appears to be a need for businesses to educate consumers further about the environmental benefits of some apparel products."

Recycling a soda bottle apparently is a different type of behavior from recycling an outdated fashion item. This is not a behavior we are used to or one that is made convenient for us. One study found that consumers with curbside collection were more likely to recycle traditional materials than those who did not have collection. Also, the frequency of recycling nontraditional materials such as textiles was lower than that for traditional materials.[85] Do you think consumers would recycle their old clothes more routinely if there were a clothing bin alongside the containers for paper, glass, and plastic?

Being fashionable and being environmentally concerned appear to be in direct conflict. Fashion leadership implies a desire to maintain newness and practice a form of fashion obsolescence, the opposite of an environmentalist value. Attempts to demographically define the ecologically concerned consumer have been less than successful,[86] with inconsistent findings in the literature. However, the pro-environmental consumer appears to be more educated, has a higher income than those not concerned with the environment, and is more often female.[87]

Table 14-2 shows the relatively neutral attitudes toward environmental clothing concerns. The strongest agreement was that clothing as a resource is wasted. Do you think these attitudes have changed?

Table 14-2 Clothing Environmental Attitudes

Clothing Attitude	Mean Score*
Clothing is a resource that is often wasted.	3.65
People should consider resource conservation when they buy clothes.	3.57
I try to purchase clothing from manufacturers who I know are concerned about the environment.	3.33
There isn't much of a relationship between conservation of resources and clothing consumption.	2.64
People should not be asked to conserve in clothing consumption because they are already expected to conserve in so many other ways.	2.43
It doesn't matter if people buy more clothing than they need because eventually it will be passed on to others.	2.61

*Scoring is from 1 to 5, with 5 meaning "strongly agrees."
Source: Sara M. Butler and Sally Francis, "The Effects of Environmental Attitudes on Apparel Purchasing Behavior," *Clothing and Textiles Research Journal* 15, no. 2 (1997): 76–85.

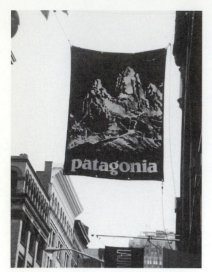

Patagonia is one of the best-known environmentally conscious apparel companies.

Green Retailers and Manufacturers

Although the green and socially responsible consumer is hard to define, many retailers and manufacturers are attempting to meet the needs of these consumers and at the same time stay true to their values of adhering to strict green practices in the production of their product. It is not always easy being "green," as some companies and consumers have discovered. It's a balancing act for many companies, between profit and green policies. Esprit, one of the early green apparel manufacturers, experimented with its *e-collection* incorporating only "environmentally friendly" processes and materials in its production. It was not profitable; however, the company claimed that its ultimate goal was to incorporate the concepts into its mainstream lines, which it did. Patagonia found it could not produce satisfactory waterproof coatings without using Gore-Tex, which contains chemical toxins. Other industries have found similar problems: Ben & Jerry's ice cream has not been able to find a satisfactory solution for its high-fat dairy waste.[88]

Many apparel, fashion, and catalog companies have attempted to offer consumers green alternatives. Following are just a few:

- *Patagonia*, a California active sportswear company started in the 1960s, is one of the best-known environmentally conscious companies selling products of organic cotton and its Syncilla line made from recycled plastic soda bottles. Each issue of its catalog includes an appeal for support of at least one environmental cause. Its newest initiative is ECO CIRCLE, a closed-loop fiber-to-fiber recycling system developed in Japan where used fabric is returned to the fiber state and reused. Consumers voluntarily

CONCEPTS FROM E-COLLECTION

Esprit's *e-collection* probably is the closest the apparel industry has come to true "environmentally friendly" production. However, it is no longer produced. The following were the objectives of the Esprit e-collection as published by the company, which can serve as a model for others:

- *Maximize product life* (use durable construction; emphasize style, not fashion)

- *Eliminate or minimize use of man-made fibers* (use cotton, wool, and linen; investigate alternative fabrics; use natural alternatives to plastic buttons; use cellulose shoulder pads and interfacings)

- *Eliminate harmful processes on fabric* (eliminate stonewashing and acid washing, use biodegradable enzymes, eliminate bleaching, eliminate resin and formaldehyde in finishing process)

- *Minimize load on landfills—use recycled and biodegradable materials* (use recycled wool and cotton fabric and sweater yarn, use postconsumer recycled paper, use postconsumer recycled L.D.P.E. plastic bags)

- *Support sustainable agriculture and farming* (use organically grown cotton, use sustainable tree farming and low-impact processing for rayon, use organically grown wool)

- *Support endangered areas and cultures and promote small-scale local economies* (use co-ops for handcraft projects, set up "trade, not aid" projects and training)

- *Support proactive businesses* (that have good working conditions for employees; recycle; minimize waste, energy, and water use; share similar ecological goals; provide documentation for all claims; use sustainable resources)

- *Educate the customer* (informative hangtags, catalogs/brochures, PR, information areas in stores and shops)

- *Influence the industry* (be involved in government criteria for eco-labeling globally, give college lectures, publish information, support and host industry conferences on ecologically responsible business)

return worn-out Capilene garments to the company to be returned to the fiber state in its Common Threads Recycling program.[89]

- *Body Shop* is a London-based cosmetics specialty chain that sells natural cosmetics and promotes saving the rain forest, protecting whales, and warning against the dangers of acid rain. None of the company's products are tested on animals and are labeled as such. It encourages customers to return empty containers for a refill at a reduced cost. The Body Shop is considered by many to be a pioneer in environmentally conscious retailing. Introducing aromatherapy products three decades ago, the Body Shop continues its tradition of taking alternative beauty and health regimes and demystifying them for the consumer. The company introduced a new Eastern ayurvedic line of natural products inspired from ayurvedic medicine—a five thousand-year-old holistic Indian science that teaches the balancing of the mind, body, and spirit. It uses the concepts of Vata, or air, for those who want to beat stress; Pitta, or fire, for those who want to change their mood; and Kapha, or earth, for those who want to be energized.[90]

- *Greenpeace* opened a retail store to help raise funds. It stocks only environmentally friendly products such as those made from organic cotton; tree-free paper; and products made from kenaf, a renewable fiber plant.

- *Deju Shoe* produces shoes using a natural treetap rubber.

- *Birkenstock* uses low-impact dyes, sustainable cork, and natural latex.

- *Levi Strauss* has a new line of jeans called Levi's Eco, made of 100 percent organic cotton.

- The *Seventh Generation* catalog offers organic cotton clothing in addition to nontoxic household products. Every potential product is analyzed for chemical content, the manufacturing process evaluated, and environmental benefits weighed before it is accepted into the catalog.

- *National Green Pages* provides a listing of nearly three thousand green businesses throughout the United States including mail-order catalogs and retail stores (www.coopamerica.org).

- Discount stores such as *Wal-Mart, Target*, and *Kmart* are making efforts to identify with green products with shelf labels and hang tags.

- *Origins*, a line of cosmetics by Estée Lauder, was the first major U.S. beauty brand to bring natural, non-animal-tested products in recyclable containers into department stores.[91]

- *Organics Collection* offers body care products formulated with certified organic ingredients in Coty's Healing Garden line.

Many consumers are not familiar with the concept of green apparel, green fashion, or even organic cotton, as there has been very little promotion, and most consumers who frequent mainstream retailers would not think there were many, if any, companies selling such products. The Internet is a good venue for these companies, as markets tend to be limited. Many online companies from CoolNotCruel to Bossy Baby, indicate that they sell organic cotton clothing and other soft goods of organic cotton, hemp, and recycled fibers and/or provide information.

Use of tagua nut buttons supports a sustainable industry from the trees, reducing the need for cutting timber in rain forests.

_____ **FASHION FROM THE RECYCLING CENTER** _____

Some enterprising entrepreneurs have found profitable ways to encourage recycling by creating fashion items out of recycled materials. Two young jewelry designers in New York created a fad by making necklaces out of old bottle caps. A Pittsburgh-based company called Little Earth Productions makes all of its products from recycled materials. It sells backpacks decorated with old license plates, a shoulder bag made from rubber and hubcaps, and even purses crafted from discarded tuna cans.[92]

Estelle Akamine is a former artist-in-residence at the Norcal Waste Systems San Francisco Transfer and Recycling Center. In a six-month residency she created apparel such as a dress made from foam sheeting and computer printer ribbon and "formals" made from reclaimed typewriter and computer printer ribbon, which were worn by recycling station employees at the San Francisco Black and White Ball.

Textile Industry Contributions to a Cleaner Environment

Although consumers are not generally aware of this, the textile industry has developed cleaner, safer methods of fiber and fabric production over the years and, despite criticisms of being a "dirty industry," has made contributions to a cleaner environment. Trade associations play an important role in implementation of environmentally safe processes. Encouraging Environmental Excellence, also known as the E3 program, was created by the American Textile Manufacturers Institute (ATMI) in 1992 to advance the U.S. industry's environmental record. The program's main purpose was to challenge textile companies to strengthen their commitment to the environment by going beyond simple compliance with environmental laws.[93] Unfortunately, the program was eliminated when ATMI was dismantled in 2004. However, two national textile industry groups, National Textiles Association (NTA) and National Council of Textile Organization (NCTO), have revived the old E3 program. Some of the benefits to textile firms that were certified by the E3 program are the following:[94]

- Establishing a voluntary minimum standard for process and performance

Want To Help Save Our Beautiful Planet?

Organically grown cotton is a beneficial, caring choice- for you AND our planet.

Every organic cotton tee you purchase prevents 4 oz. of concentrated, hazardous chemicals from polluting our earth.

Our style and quality means you can delight everybody, even while making an environmental choice.

It's As Easy...

...As Changing Your Tee-Shirt.

Hae Now is a company offering organic cotton clothing stressing "the beneficial, caring choice for you and our planet."

- Developing promotional materials responding to the impact that environmental concerns have on consumer purchases
- Generating environmental investment opportunities
- Improving air, water, and land quality

E3 is seen as a model for other industries in helping companies promote the importance of environmental preservation.

The cotton industry has made progress toward a cleaner environment with thousands of acres of organic cotton grown in the United States, although this is still a fraction of the total. Conventional cotton growing practices burden the environment—some feel as much as oil-based nylon and polyester—as they require heavy use of toxic chemicals to control weeds and insects as well as stripping the leaves for mechanical harvesting. (It is estimated that 35 million pounds of pesticides—25 percent of the total pesticides used in agriculture—are applied to cotton crops in the United States.) Recall that Travis in the opening section knew that 100 percent cotton was good; it would be comfortable and he may have heard people saying that polyester and other synthetics are not good for the environment. Most consumers certainly are not aware of the pesticide factor behind that comfortable cotton shirt.

Organic cotton uses minimal or no chemical fertilizers and no pesticides; instead, natural fertilizers and organic techniques are used. The government's Organic Fiber processing certification is available for cotton grown under these conditions and is used in advertising the end-use product to consumers. Although better for the environment, organic cotton is expensive to grow primarily due to increased labor costs. Some apparel companies, such as Patagonia, and to some extent Levi's and Gap, are using organic cotton.

Foxfibre, developed by Sally Fox, is the first naturally colored cotton fiber (it grows in shades of greens and browns) that can be processed with modern textile equipment. This innovation eliminates the need for textile dyes, which are toxic to the environment. As with many new ideas, there were objections. California cotton growers were not happy to have Sally growing her colored cotton so near their pure white cotton. She consequently relocated to Arizona, where conditions were more conducive to her experimentation and production of this unconventional product.[95]

Some textile manufacturers are attempting to use other natural and green processes. Natural dyes instead of chemical dyes, which can be polluting, are used by some companies; however, costs are higher and the muted colors are not always acceptable to consumers. *Tencel* is a relatively new cellulosic fiber made from harvested wood pulp, which is viewed as a method of recycling. It has a fine texture and is popular in higher-end apparel, as the costs are somewhat higher than other fibers.

Some companies are making fabric from recycled soda bottles, which are cleaned, sorted by color, chopped into pieces, heated, purified, formed into pellets, melted, and extruded as fine fibers that can be spun into thread or yarn. It takes an average of twenty-five plastic soda bottles to make one garment.[96] Wellman's fiber division produces Fortrel *EcoSpun*, recycled polyester containing 100 percent recycled fiber. It is estimated that 2.4 billion bottles are kept out of landfills each year through the manufacture of EcoSpun fibers.

EcoSpun fibers are made out of recycled plastic soda bottles.

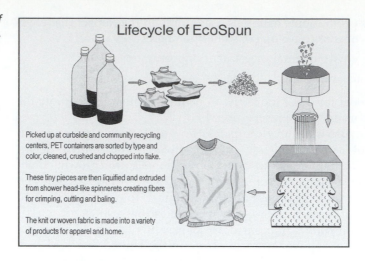

Hemp is a natural fiber popular with environmentalists and used by many eco-companies. However, there are several problems, not the least of which is that it is illegal to grow hemp in the United States; government officials have not approved the fiber, a cousin to marijuana, for U.S. production. Thus, it is imported from Canada and overseas. Some feel there is an educational problem. Hemp is a prolific plant with many applications, including fiber products (such as paper and clothing); building materials; rope; and oils containing essential fatty acids, proteins, and other nutrients that can serve as a base for skin and hair care products. In 1999, Hawaii was given permission to test the hemp plant for production, but the United States remains the only industrialized country in the world where growing hemp is illegal, and many are pushing for the legalization of the product.[97] Hemp fiber is stiff, making it hard on sewing machines, with needles breaking and machine mechanisms needing frequent replacement. Sewing is slower and, consequently, more expensive. Styles are often simple.

As mentioned several times throughout this section, the costs of producing environmentally friendly fashions and textiles are higher than those of conventional methods. Companies ask, "How much can we afford to do this and still stay competitive?" It appears to be up to consumers to decide how important environmentalism is to them. It may be that a small niche of environmentally aware consumers will support such industry efforts.

Green Advertising

With many consumers interested in green products, some marketers have been known to abuse the claim of "environmentally friendly" or "eco-friendly," which consequently has led some consumers to discount these claims. In fact, with the increased number of ad campaigns declaring products to be eco-friendly, there appear to be ever larger numbers of consumers who don't believe them. With rising eco-cynicism, marketers need to look for ways to make more authentic brand statements about their green intentions.[98] TerraChoice Environmental Marketing company analyzed over 1,700 environmental statements of consumer products finding very few made outright

lies about environmental benefits, but nearly all the products committed subtle forms of what TerraChoice calls "greenwashing." Some claims were based on only one attribute without addressing such things as toxic ingredients. Other claims were so vague as to be meaningless. Words like "natural" and "sustainable" are marketing buzzwords that have many meanings.[99]

There are no enforced standards on environmental claims of products. (There are, however, voluntary standards discussed later.) A pamphlet published by the Environmental Protection Agency informs consumers on how to analyze green advertising claims:[100]

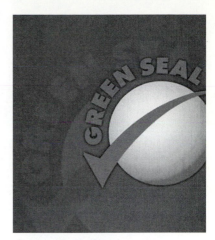

Green Seal's logo.

- *Look for environmental claims that are specific.* If an ad says "recycled," check for how much of the product is recycled. Check where the recycled material comes from: "Postconsumer" waste means previously used business or consumer waste; "preconsumer" waste means manufacturing waste. Labels with "recyclable" claims indicate that these products can be collected and made into useful products; this is meaningful only if the consumer recycles the product.

- *Be wary of overly broad or vague environmental claims.* Labels with unqualified claims that a product is "environmentally friendly" or "eco-safe" have little meaning.

- *Degradable materials will not help save landfill space.* Biodegradable materials such as food and leaves break down and decompose when exposed to air, moisture, and bacteria or other organisms. Degradation occurs very slowly in landfills, where most garbage is sent, because modern landfills are designed, according to law, to minimize the entry of sunlight, air, and moisture. This slows decomposition, and even organic materials such as paper and food may take decades to decompose in a landfill. Imagine how long a polyester shirt will last!

Certifications

With the increased interest in green products there has been a proliferation in product certifications and seals. Some address single issues such as animal welfare and biodegradability. The problem for the consumer is figuring out what they mean and if they can be trusted. The following are three established systems.

EcoLogo (www.ecologo.org) is North America's oldest environmental standard and certification organization. Launched by the Canadian federal government in 1988, it sets standards and certifies products in more than 120 categories. It is the only North American standard accredited by the Global Ecolabeling Network as meeting the international ISO 14024 standard for environmental labels.

Green Seal (www.greenseal.org) is a nonprofit environmental labeling organization that awards the "Green Seal of Approval" to products that cause less harm to the environment than other similar products. Before a product gets the Green Seal, it must pass rigorous tests and meet stringent environmental standards.

Scientific Certification Systems (www.scs1.com) certifies environmental claims made by manufacturers regarding qualities such as biodegradability, recycled content, water efficiency, and no-smog-producing ingredients. The staff also conducts life-cycle assessments of companies' use of natural resources and develops environmental workplace analyses.

THE DARK SIDE OF CONSUMER BEHAVIOR

Despite the best efforts of researchers, government regulators, and concerned industry people, sometimes consumers' worst enemies are themselves. Individuals often are depicted as rational decision makers, calmly doing their best to obtain products and services that will maximize the health and well-being of themselves, their families, and society. In reality, however, consumer desires, choices, and actions often result in negative consequences to the individual and/or the society. Some consumer activities stem from social pressures, and the cultural value placed on money can encourage such activities as shoplifting or fraud. Exposure to unattainable media ideals of beauty and success can create dissatisfaction with the self. Table 14-3 illustrates some unethical consumer practices. Let's review some dimensions of what has been called "the dark side" of consumer behavior.

Addictive Consumption

Consumer addiction is a physiological and/or psychological dependency on products or services. While most people equate addiction with drugs, virtually any product or service can be seen as relieving some problem or satisfying some need to the point where reliance on it becomes extreme. Indeed, some psychologists are even raising concerns about "Internet addiction," in which people (particularly college students) become obsessed by online chat rooms to the point that their "virtual" lives take priority over their real ones.[101]

Table 14-3 Unethical Consumer Practices

Shoplifting

Shoplifting and attempting to return merchandise for a refund

Switching price tags

Returning clothing that has been worn

Returning partially used products, such as cosmetics, for store credit

Abusing products and returning them as damaged goods

Returning products bought at sale and demanding full-price refund

Stealing accessories, such as belts or pins, from clothing

Cutting buttons off merchandise

Damaging merchandise in the store and demanding a sales discount

Filing for personal bankruptcy when debt could be repaid

Source: Adapted from Leon G. Schiffman and Leslie Lazar Kanuk, *Consumer Behavior* (Upper Saddle River, N.J.: Prentice-Hall, 2000).

Compulsive Consumption

For some consumers, the expression "born to shop" is taken quite literally. These consumers shop because they are compelled to do so rather than because shopping is a pleasurable or functional task. **Compulsive consumption** refers to repetitive shopping, often excessive, as an antidote to tension, anxiety, depression, or boredom. "Shopaholics" turn to shopping much the way addicted people turn to drugs or alcohol.[102] It has been suggested that different types of compulsive behavior can co-occur, such as compulsive buying and binge eating. One study found that compulsive buying was positively related to television shopping exposure. Results imply that television shopping might become the "drug of choice" for compulsive shoppers, as it provides an easy method of shopping through credit card use, is convenient, and can be indulged in through the privacy of one's own home away from the judgments of others.[103]

Compulsive consumption is distinctly different from impulse buying, discussed in Chapter 13. The impulse to buy a specific item is temporary, and it centers on a specific product at a particular moment. In contrast, compulsive buying is an enduring behavior that centers on the process of buying, not the purchases themselves. As one woman who spent $20,000 per year on clothing confessed, "I was possessed when I went into a store. I bought clothes that didn't fit, that I didn't like, and that I certainly didn't need."[104]

In some cases, it is fairly safe to say that the consumer, not unlike a drug addict, has little to no control over consumption. The products control the consumer, whether alcohol, cigarettes, fashion, chocolate, or diet colas. Even the act of shopping itself is an addicting experience for some consumers. Much negative or destructive consumer behavior can be characterized by three common elements:[105]

1. The behavior is not done by choice.
2. The gratification derived from the behavior is short-lived.
3. The person experiences strong feelings of regret or guilt afterward.

Such out-of-control spending can result in a pile of debt the consumer cannot pay and often results in consumer bankruptcy. More than 1 million consumers file for bankruptcy in the United States each year. With bankruptcy laws "loose" (as perceived by retailers), more consumers are taking this avenue rather than repaying their debt. Analysis has indicated that many who file for bankruptcy could have paid back part or all the debt.[106] Retailers tread lightly as they attempt to collect past debt, however, as they do not want to alienate consumers who should be repeat customers after the debt is repaid or forgiven. Bankruptcy indicators include a recent major purchase such as a car, a high level of outstanding revolving debt, and being over credit limits. The easy way out taken by many consumers places a heavy burden on businesses, which must pass on this cost to other consumers.

Many consumer behaviors not only are self-destructive or socially damaging, but they are illegal as well. Crimes committed by consumers against businesses, including shoplifting, employee pilferage, arson, and insurance fraud, have been estimated at more than $40 billion per year.

Consumer Theft

A retail theft is committed every five seconds. **Shrinkage** is the industry term for inventory and cash losses due to shoplifting and employee theft (about 40 percent of the losses can be attributed to employees rather than shoppers). This is a massive problem for businesses that is passed on to consumers in the form of higher prices. A comprehensive retail study found that shoplifting costs U.S. retailers $9 billion annually.[107]

Most shoplifting is *not* done by professional thieves or by people who genuinely need the stolen items.[108] About 2 million Americans are charged with shoplifting each year, but it's estimated that for every arrest, eighteen unreported incidents occur.[109] About three-quarters of those caught are middle- or high-income people who shoplift for the thrill of it or as a substitute for affection. And shoplifting is common among adolescents. Research evidence indicates that teen shoplifting is influenced by factors such as having friends who also shoplift. It is also more likely to occur if the adolescent does not believe that this behavior is morally wrong.[110] Athletic shoes, logo and brand-name apparel, designer jeans, and undergarments are among the most frequently stolen products.[111] Cosmetics may be added to that list, with the trend toward open-selling merchandise formats led by Sephora, a French cosmetics company with stores worldwide.

Retailers have taken measures to help fight shoplifting, but some stores do not want to use heavy sensor tags that make it hard for customers to try on clothing and give the impression that the store does not trust the consumer. Good customer service is the best defense against shoplifting; a sales associate who acknowledges customers and is aware of their moves deters such illegal behavior. Stores with a self-service style, however, cannot accommodate such a philosophy. Mervyn's adopted a three-in-one source tagging system that eliminates the bulky sensor tag but guards against shoplifting. The system incorporates graphic labels, price code tags, and electronic article surveillance antitheft devices into one tag, resulting in what they call less "tag pollution." Potential shoplifters cannot tell if somewhere embedded within the tag is also the antitheft device.[112]

Anticonsumption

Some types of destructive consumer behavior can be thought of as **anticonsumption**, whereby products and services are deliberately defaced or destroyed. This type of behavior can range from product tampering, by which innocent consumers are hurt or killed, to graffiti on buildings and subways. In some cases acts of anticonsumption are a form of cultural resistance, whereby consumers who are alienated from mainstream society (such as juvenile delinquents) single out objects that represent the values of the larger group and modify them as an act of rebellion or self-expression.[113] In the hippie culture of the 1960s and 1970s, for example, many antiwar protestors began wearing cast-off military apparel, often replacing insignias of rank with peace signs and other symbols of "revolution."

Anticonsumption can also take the form of social protest, in which activists alter or destroy billboards and other advertisements that promote what they feel to be unhealthy or unethical acts—a practice that has been termed **culture jamming**.

An example of culture jamming is the *eco-terrorism* attacks by animal liberation groups, which include the firebombing of breeding companies and the plethora of antifur protests. Protesters often are seen during the holiday season, a time when many shoppers can be exposed to their cause. They have been known to throw red paint on women's fur coats, which defaces them while depicting the blood of the animal—one reason for leaving your fur coat home! People for the Ethical Treatment of Animals (PETA) and the Coalition to Abolish the Fur Trade have waged war against the use of fur for fashion for years by demonstrating in front of stores such as Macy's and Neiman Marcus. Antifur activists smashed twenty-nine windows at the Neiman Marcus store in San Francisco causing $250,000 worth of damage.[114] One year more than a thousand people marched down Seventh Avenue in New York, where many furriers are located. Such demonstrations in Europe are often more violent and graphic than in the United States. Despite arrests and protests, sales of fur continue on a regular basis.

Animal activists even attempted to pass a local ordinance in Beverly Hills (which sells many luxury furs) that would require labels to include a statement of how the animal was killed such as: "Consumer notice: This product is made with fur from animals that may have been killed by electrocution, gassing, neck breaking, poisoning, clubbing, stomping or drowning and may have been trapped in steel-jaw, leg-hold traps."[115] PETA has also targeted kids whose mothers wear furs. One year flyers were given to children attending *The Nutcracker* in cities across the United States with statements such as "Ask your mommy how many animals she killed to make her fur coat."[116]

The Fur Information Council of America and Saga Furs of Scandinavia have fought what they feel is the animal activists' "one-sided" publicity with such things as videos and literature describing principles of animal management and fur farming, and fur as a natural resource. Problems of overpopulation of some wild animals and analogies to animal farming for food are

PETA protests the use of furs for fashion.

discussed. Responsible companies do not use endangered species in their products. Making or selling clothing and fashion from animals and plants that are endangered is a legal issue; this topic is covered in Chapter 15.

CHAPTER SUMMARY

- Business ethics are rules of conduct that guide actions in the marketplace. Universal standards or values include honesty, trustworthiness, fairness, respect, justice, integrity, concern for others, accountability, loyalty, and responsible citizenship. Cultural differences exist in how ethics are defined.
- Both consumers and companies engage in unethical behavior.
- Levi Strauss has set the standard for ethics in apparel contracting overseas.
- Socially responsible companies go beyond what is legal to do what benefits society. Many apparel and textile companies engage in cause marketing, in which marketing efforts are linked to charitable causes.
- Many consumers today are aware of and concerned about exploitation issues related to labor in the global production of apparel. Awareness was brought about by high-profile abusive situations in Los Angeles, New York City, and Saipan, a U.S. commonwealth.
- Many consumers are also concerned about the environmental abuses of the fashion industry, but factors other than environmental have been found to be more important to consumers when it comes to apparel purchases. Apparel environmental behavior has not been linked with other types of environmental attitudes and behavior. Nevertheless, consumers say they are interested in the environment, and many apparel and textile companies have made strong efforts to produce products that are environmentally friendly. They are called green companies.
- Although textbooks often paint a picture of the consumer as a rational, informed decision maker, in reality many consumer activities are harmful to individuals or to society. The dark side of consumer behavior includes addictive and compulsive consumption and theft or vandalism (anticonsumption).

KEY TERMS

business ethics	green consumers	shrinkage
personal ethics	consumer addiction	anticonsumption
social responsibility	compulsive consumption	culture jamming

DISCUSSION QUESTIONS

1. Discuss ethical situations in your workplace. Does your company incorporate an ethical stand in its mission statement?
2. Some people feel that companies should be able to advertise their product in any way, especially in ways that consumers respond to.

Industry folks say sexual content in advertising is acceptable, while parents and family agencies have boycotted some companies. What are your views regarding this issue?

3. How do you feel about child labor and sweatshops in the apparel industry? Consider families in third-world countries that depend on their children's income and where prostitution is an alternative to sweatshop labor.

4. Do you check the label to see where clothes were made before buying them? Compare yourself to Travis in the opening scene in this chapter. Survey your fellow classmates as to the importance they put on where their clothes are made.

5. Do marketers have the ability to control our desires or the power to create needs?

6. Are you a *green* consumer? Describe ways you help the environment. What do you do with your unwanted fashion items?

7. Search the Internet for environmentally responsible apparel companies. What are they doing to help (or at least be friendly to) the environment?

8. Search the Internet for consumer boycotts of apparel companies. Why are they boycotting?

9. "College students' concerns about the environment and vegetarianism are just a passing fad, a way to look cool." Do you agree?

10. How do you feel about wearing fur for fashion? About antifur protests? Have any of your favorite stores been picketed for selling fur?

11. Do you know anyone who shoplifts? Why do they do it? What measures can retailers take to guard against shoplifting?

ENDNOTES

1. For ethics and business discussion, see Gene R. Laczniak and Patrick E. Murphy, *Marketing Ethics: Guidelines for Managers* (Lexington, Mass.: Lexington Books, 1985), 117–123; Donald P. Robin and Eric Reidenbach, "Social Responsibility, Ethics, and Marketing Strategy: Closing the Gap between Concept and Application," *Journal of Marketing* 51 (January 1987): 44–58; Rob Harrison, Terry Newholm, and Deirdre Shaw, eds., *The Ethical Consumer* (London: Sage, 2005).

2. Valerie S. Folkes and Michael A. Kamins, "Effects of Information About Firms' Ethical and Unethical Actions on Consumers' Attitudes," *Journal of Consumer Psychology* 8, no. 3 (1999): 243–259.

3. Jennifer Lach, *American Demographics* (December 1999): 18.

4. Valerie S. Folkes and Michael A. Kamins, "Effects of Information About Firms' Ethical and Unethical Actions on Consumers' Attitudes," *Journal of Consumer Psychology* 8 (1999): 243–259.

5. Quoted in Mary Lynn Damhorst, Kimberly A. Miller, and Susan O. Michelman, *The Meanings of Dress* (New York: Fairchild, 1999), 418.

6. Joseph Pereira, "Toys 'R' Us Says It Decided to Pull Sega's Night Trap from Store Shelves," *Wall Street Journal* (December 17, 1993): B5F.

7. Lantos, cited in Ann E. Fairhurst, "Ethics and Home Economics: Perceptions of Apparel Merchandising Students," *Home Economics Forum* (Spring 1991): 20–23.

8. Ann E. Fairhurst, "Ethics and Home Economics: Perceptions of Apparel Merchandising Students." See also Kelly J. Mize, Nancy Stanforth, and Christine Johnson, "Perceptions of Retail Supervisors' Ethical Behavior and Front-Line Managers' Organizational Commitment," *Clothing and Textiles Research Journal* 18, no. 2 (2000): 100–110.

9. Karen S. Callen and Shiretta F. Ownbey, "Associations between Demographics and Perceptions of Unethical Consumer Behavior," *International Journal of Consumer Studies* 27, no. 2 (2003): 99–110; Hyeon Cho, Jeong-Ju Yoo, and Kim K. P. Johnson, "Ethical Ideologies: Do They Affect Shopping Behaviors and Perceptions of Morality?" *Journal of Family & Consumer Sciences* 97, no. 3 (2005): 48–55; V. Ann Paulins and Lisa Lombardy, "Ethical

Dilemmas in Retail Merchandising: Student Perceptions," *Journal of Family & Consumer Sciences* 97, no. 3 (2005): 55–62.

10. Trish Donnally, "An Outpouring of Fur, Anger on the Runways," *San Francisco Chronicle* (February 11, 2000): C1, C5.

11. Rosemary Feitelberg, "The Sizzle Is Back," *Women's Wear Daily* (March 12, 1996): 12.

12. Alison Maxwell, "Oleg Cassini Launches Fake-Fur Line," *Women's Wear Daily* (November 9, 1999): 12.

13. Eric Wilson, "Furs Fare Well, Despite a Warm Winter," *Women's Wear Daily* (February 1, 2000): 8.

14. "Croc On," *Women's Wear Daily* (April 5, 2000): 4.

15. Scott Malone, "PETA Power," *Women's Wear Daily*, Section II (April 1, 2003): 10.

16. Rosemary Feitelberg, "Is PETA Defanged? Fur Looks Are Back On and Off Runways," *Women Wear Daily* (February 14, 2007): 1, 12.

17. Eric Wilson, "The Long Reach of Fur," *Women's Wear Daily* (April 13, 2004): 14.

18. David Sheff, "Mr. Blue Jeans," *San Francisco Focus* (October 1993): 65–66, 127–133.

19. Joanna Ramey, "Levi's Will Resume Production in China after 5-Year Absence," *Women's Wear Daily* (April 9, 1998): 1, 11.

20. Alison Maxwell, "Levi's Joins Fair Labor Association," *Women's Wear Daily* (July 21, 1999): 2.

21. "Clinton Pans Fashion Trade for Hyping Heroin," *San Francisco Chronicle* (May 22, 1997): A3.

22. Kristin K. Swanson and Judith C. Everett, *Promotion in the Merchandising Environment* (New York: Fairchild, 2000), 527.

23. Susan Reda, "Technology Team Brings Victoria's Secret Webcast to Huge Audience," *Stores* (July 2000): 54–57.

24. "FCC Ruling Sates Victoria's Secret Wasn't Indecent," *Women's Wear Daily* (March 26, 2002): 2; Karyn Monget, "Victoria's Secret Keeps the Heat On," *Women's Wear Daily* (December 5, 2005): 21.

25. Joan Ryan, "T-shirts Glorify Teen Drunkenness," *San Francisco Chronicle* (May 5, 2005): B1; Deborah Yao, "Urban Outfitters Stay Focused on Youth," *Forbes* (February 17, 2006).

26. "Calvin Klein Dumps Ad Campaign Displaying Scantily Clad Kids," *San Francisco Chronicle* (February 19, 2000): B10.

27. Karyn Monget and Lisa Lockwood, "Warnaco's Wachner Stands by Calvin—but Not by That Ad," *Women's Wear Daily* (November 3, 1995): 1, 14.

28. "Calvin, Amos Anti-Violence Ad Campaign," *Women's Wear Daily* (December 4, 1996): 13.

29. Lisa Lockwood and Vicki M.Young, "A&F's Blue Language Has Some Seeing Red, but Results Are Green," *Women's Wear Daily* (November 23, 1999): 1, 12; Mark Williams, "Abercrombie Catalog a Guide to Drinking 101," *San Francisco Chronicle* (July 25, 1998): D1, D2; Vicki M. Young, "A&F Posts Its 30th Record Net, but Stock Is Hit," *Women's Wear Daily* (February 16, 2000): 2, 21.

30. Dave Ford, "Abercrombie's Lolita Line of Thongs Goes Beyond Bad Taste," *San Francisco Chronicle* (May 26, 2002): E2; Joshua Greene and Lisa Lockwood, "A&F's Bad Fortune," *Women's Wear Daily* (April 19, 2002): 11; "Join Lieutenant Governor Corinne Wood in Her Boycott Against Abercrombie & Fitch," (www.state.il.us/ltgov/stopAandF.htm), accessed on June 28, 2001.

31. Janet Ozzard and Miles Socha, "Losing the Edge," *Women's Wear Daily* (April 5, 2000): 18, 20.

32. Anne D'Innocenzio, "Behind the Sears-Benetton Split," *Women's Wear Daily* (February 18, 2000): 14; "Benetton Split: The Aftershocks," *Women's Wear Daily* (May 5, 2000): 10, 17.

33. Anne D'Innocenzio, "Benetton Maps Growth on Net and in the U.S.," *Women's Wear Daily* (April 19, 2000): 10.

34. Doug Shen and Marsha Dickson, "Consumers' Acceptance of Unethical Clothing Consumption Activities: Influence of Cultural Identification, Ethnicity, and Machiavellism," *Clothing and Textiles Research Journal* 19, no. 2 (2001): 76–87.

35. William Leiss, Stephen Kline, and Sut Jhally, *Social Communication in Advertising: Persons, Products, and Images of Well-Being* (Toronto: Methuen, 1986); Jerry Mander, *Four Arguments for the Elimination of Television* (New York: Morrow, 1977).

36. Vance Packard, quoted in Leiss, Kline, and Jhally, *Social Communication in Advertising*, p. 11.

37. Leiss, Kline, and Jhally, *Social Communication in Advertising*.

38. George Stigler, "The Economics of Information," *Journal of Political Economy* (1961): 69.

39. Quoted in Leiss, Kline, and Jhally, *Social Communications in Advertising*; p. 11.

40. Leon G. Schiffman and Leslie Lazar Kanuk, *Consumer Behavior* (Upper Saddle River, N.J.: Prentice-Hall, 2000).

41. Dick Silverman, "Corporate Charity: Cause and Effect," *Women's Wear Daily* (August 10, 1999): 23; Nancy Arnott, "Marketing with a Passion," *Sales & Marketing Management* (January 1994): 64–71.

42. Allie Shah, "Suddenly, You Can Do Good and Look Good," *San Francisco Chronicle* (January 1, 2006): D4.

43. For other examples, see Michael Barbaro, "Candles, Jeans, Lipsticks: Products with Ulterior Motives," *New York Times*, Special Section: Giving (November 13, 2006): 33; Denise Power, "WWD Honors Charitable Retailers," *Women's Wear Daily* (January 11, 2006): 12, 14.

44. Dick Silverman, "Corporate Charity: Cause and Effect"; "Fashion Targets Breast Cancer," available online at www.joeboxer.com; "Battling Breast Cancer: Retail's Fall Offensive," *Women's Wear Daily* (September 21, 1999): 15–23; Diane Dorrans Saeks, "Extreme Passport," *Women's Wear Daily* (September 22, 1999): 26–27; "Bloomingdale's Benefit Aids Cancer Research," *Women's Wear Daily* (September 22, 1999): 30; George Raine, "Clothing with a Conscience," *San Francisco Examiner* (November 29, 1998): D1, D7.

45. David Moin, "Macy's Institutes National Drive Against Women's Heart Disease," *Women's Wear Daily* (February 3, 2004): 2, 12; www.macy.com (January 15, 2007).

46. Eric Wilson, "Ralph Lauren Cancer Center Opens," *Women's Wear Daily* (May 5, 2003): 2.

47. Marsha A. Dickson, "Consumer Motivations for Purchasing Apparel from Socially Responsible Businesses," *Proceedings of the International Textiles and Apparel*

Association, (1999): 70; see also Marsha A. Dickson, "Personal Values, Beliefs, Knowledge, and Attitudes Relating to Intentions to Purchase Apparel from Socially Responsible Businesses," *Clothing and Textiles Research Journal* 18, no. 1 (2000): 19–30.

48. Julianne Malveaux, "Shopping Can Make a Statement," *San Francisco Examiner* (November 30, 1997): B2; Conrad MacKerron, "Informed Consumers Can Improve Sweatshops," *San Francisco Chronicle* (July 15, 2005): 89.

49. Matthew Rosenberg, "New Delhi Raids Highlight Indian Child Labor Problem," *San Francisco Chronicle* (October 30, 2007): C1, C6; Heidi J. Shrager, "Struggle to End Child Labor: India Fights Practice Some Parents Favor," *San Francisco Chronicle* (December 23, 2007): A1, A10.

50. Robert Collier, "Legislature Passes 2 Sweatshop Bills," *San Francisco Chronicle* (September 11, 1999): A7.

51. "Wal-Mart's Shirts of Misery," a report by the National Labor Committee (July 1999).

52. Eddie Wong and Gail Taylor, "An Investigation of Ethical Sourcing Practices: Levi Strauss & Co.," *Journal of Fashion Marketing and Management* 4, no. 1 (2000): 71–79.

53. Carol Emert, "Holders Grill Gap on Labor Practices," *San Francisco Chronicle* (May 5, 1999): B2.

54. MacKerron, "Informed Consumers Can Improve Sweatshops"; Melanie Kletter, "Labor Cites Nike Study as Model," *Women's Wear Daily* (April 15, 2005): 14.

55. Eric Wilson and Joanna Ramey, "Saipan Factories Counter Sweatshop Stigma," *Women's Wear Daily Global* (July 1999): 10, 20.

56. Jenny Strasburg, "Made in the USA," *San Francisco Chronicle* (July 4, 2004): J1, J4.

57. www.americanapparel.net (January 19, 2007).

58. Mark Tosh, "N.Y. Gap Unit Picketed over El Salvador Pullout," *Women's Wear Daily* (December 4, 1995): 24; Joanna Ramey, "Apparel's Ethics Dilemma," *Women's Wear Daily* (March 19, 1996): 10–12.

59. Tanya Schevitz, "UC Strengthens Code against Sweatshops," *San Francisco Chronicle* (January 8, 2000): A13, A17.

60. Charles Burress, "18 Arrested at 'Sweatshops' Sit In," *San Francisco Chronicle* (April 12, 2006): 87.

61. Eddie Wong and Gail Taylor, "Practitioner Papers an Investigation of Ethical Sourcing Practices: Levi Strauss & Co.," *Journal of Fashion Marketing and Management* 4, no. 1 (2000): 71–79.

62. Jennifer H. Wolfe and Marsha A. Dickson, "Apparel Manufacturer and Retailer Efforts to Reduce Child Labor: An Ethics of Virtue Perspective on Codes of Conduct," *Clothing and Textiles Research Journal* 20, no. 1 (2002): 183–195; see also Wanda K. Cheek and Cynthia Easterling Moore, "Apparel Sweatshops at Home and Abroad: Global and Ethical Issues," *Journal of Family and Consumer Sciences* 95, no. 1 (2003): 9–19.

63. Jacqueline Trescott, "In 'Sweatshops,' Smithsonian Holds Back the Outrage," *The Washington Post* (August 22, 1999): D1, D8.

64. Trescott, "In 'Sweatshops,' Smithsonian Holds Back the Outrage."

65. www.gopopsi.com (January 12, 2007).

66. Joanna Ramey, "Smithsonian Readies Sweatshop Exhibit," *Women's Wear Daily* (July 7, 1997): 4; Joanna Ramey, "An Industry Divided as Sweatshop Exhibit Opens at Smithsonian," *Women's Wear Daily* (April 22, 1998): 1, 14–15; Joanna Ramey, "Smithsonian Finds Space in L.A. to Show Exhibit on Sweatshops," *Women's Wear Daily* (August 27, 1999): 17.

67. See also Daniel E. Bender and Richard A. Greenwald, eds., *Sweatshop USA: The American Sweatshop in Historical and Global Perspective* (New York: Taylor & Frances Group, Routledge, 2003).

68. B. Geffrey MacDonald, "Stopping the Outcry Before It Starts," *The Christian Science Monitor* (August 28, 2006); Ellen Groves, "Ethical Fashion Goes Mainstream," *Women's Wear Daily* (October 31, 2006): 12.

69. www.ethicalfashionforum.com (January 14, 2007).

70. Yoon Jin Ma and Mary Littrell, "Prediction of Fair Trade Customers' Purchase Intentions," *International Textile and Apparel Association Proceedings*, 62 (2005): 422.

71. Terence Chea, "Coffee Ice Cream Wins Fair Trade Certification," *San Francisco Chronicle* (April 30, 2005): C3.

72. Illana DeBare, "What Does Green Really Mean?" *San Francisco Chronicle* (April 19, 2008): A1, A8.

73. Hannah Hunter, "Fashion Eco-Centrics," *The Independent* (January 6, 1999): 9.

74. "Don't Overlook Textiles," Council for Textile Recycling (March 3, 1999). Available online at www.textilerecycle.org.

75. Chris Serres, "Retail Starting to Turn Green," *San Francisco Chronicle* (August 19, 2007): F1–F2.

76. "Teens Hit Runway to Show Off Their Environmental Awareness," [Arlington Heights, Ill.] *(Daily Herald)* (November 23, 1999): 1.

77. Roger Cowe, "Caring Attitudes out of Fashion," *The* [Manchester, England] *Guardian* (March 12, 1999): 22.

78. Ruth LaFerla, "Uncruel Beauty," *New York Times* (January 11, 2007): E1, E5.

79. R. Gutfield, "Eight of 10 Americans Are Environmentalists, at Least So They Say," *Wall Street Journal* (August 2, 1991): 1.

80. Sara M. Butler and Sally Francis, "The Effects of Environmental Attitudes on Apparel Purchasing Behavior," *Clothing and Textiles Research Journal* 15, no. 2 (1997): 76–85.

81. Hye-Shin Kim and Mary Lynn Damhurst, "Environmental Concern and Apparel Consumption," *Clothing and Textiles Research Journal* 16, no. 3 (1998): 126–133.

82. Youn-Kyung Kim, Judith Forney, and Elizabeth Arnold, "Environmental Messages in Fashion Advertisements: Impact on Consumer Responses," *Clothing and Textiles Research Journal* 15, no. 3 (1997): 147–154.

83. S. H. Stephens, cited in Butler and Francis, "The Effects of Environmental Attitudes on Apparel Purchasing Behavior," p. 77.

84. Kathryn Osgood and Nancy J. Rabolt, "The Impact of Education on Consumer Interest in Green Apparel and Retailers," *Proceedings, International Textile and Apparel Association* (November 1997): 99.

85. Tanya Domina and Kathryn Koch, "Frequency of Recycling: Implications for Including Textiles in Curbside Recycling," paper presented at *International Textiles and Apparel Association,* Santa Fe, N.M., (November 1999).

86. Cited in Butler and Francis, "The Effects of Environmental Attitudes on Apparel Purchasing Behavior," p. 77.

87. Cited in Soyeon Shim, "Environmentalism and Consumers' Clothing Disposal Patterns: An Exploratory Study," *Clothing and Textiles Research Journal* 13, no. 1 (1995): 38–48.

88. Paul C. Judge, "It's Not Easy Being Green," *Business Week* (November 24, 1998): 180–182.

89. See Suzanne Loker, "A Technology-Enabled Sustainable Fashion System: Fashion's Future," in *Sustainable Fashion Why Now?* eds. Janet Hethorn and Connie Ulasewic, (New York: Fairchild, 2008), 95–126.

90. James Fallon, "Body Shop Looks East for a Dose of Success," *Women's Wear Daily* (February 4, 2000): 12.

91. Pat Sloan, "Cosmetics: Color It Green," *Advertising Age* (July 23, 1990): 1.

92. Timothy Aeppel, "From License Plates to Fashion Plates," *Wall Street Journal* (September 21, 1994): B1.

93. "Encouraging Environmental Excellence Report," American Textile Manufacturers Institute, 1996.

94. Belinda Orzada and Mary Ann Moore, "Environmental Impact of Textile Production," in *Sustainable Fashion Why Now?* eds. Janet Hethorn and Connie Ulasewicz (New York: Fairchild, 2008), 299–325.

95. Sally Fox, "Socially Critical Issues in Business: Social Responsibility, Ecology, and Ethics," paper presented at *Finding Your Niche: Business Options in the Textile Industry, Fashion, Interiors, and the Textile Arts Conference*, Surface Design Association, San Francisco, June 1993.

96. Burns and Bryant, *The Business Fashion*, 95.

97. Bruce Dunford, "Hawaii High on Hemp," *San Francisco Chronicle* (December 17, 1999): B2; Deward Epstein, "Hemp-Growing Gardens Proposed for S.F.," *San Francisco Chronicle* (June 8, 1999): A15, A17; Leslie Guttman, "Hemp—It's Rope, Not Dope," *San Francisco Chronicle* (May 28, 1999): A1, A17; Kathleen Seligman, "Hemp's Backers Try for a Comeback," *San Francisco Chronicle* (May 9, 1999): C1, C4; Michael Dougan, "Hemp Fest: A Sobering Show of Potential," *San Francisco Chronicle* (November 15, 1998): D1, D8; Michael Pulley, "High on Hemp," *San Francisco Chronicle* (August 24, 1997): B1, B4.

98. "Making a Brand Statement with an Eco-Friendly Building," *Adage.com* (March 10, 2008).

99. DeBare, "What Does Green Really Mean?"

100. "Green Advertising Claims," Environmental Protection Agency, 1992.

101. "Psychologist Warns of Internet Addiction," *Montgomery Advertiser* (August 18, 1997): 2D.

102. Thomas C. O'Guinn and Ronald J. Faber, "Compulsive Buying: A Phenomenological Explanation," *Journal of Consumer Research* 16 (September 1989): 154.

103. Suenghee Lee, Sharon Lennon, and Nancy Rudd, "Compulsive Consumption Tendencies among Television Shoppers," *Proceedings of the International Textile and Apparel Association*, (1999): 95.

104. Quoted in Anastasia Toufexis, "365 Shopping Days till Christmas," *Time* (December 26, 1988): 82; See also Ronald J. Faber and Thomas C. O'Guinn, "Compulsive Consumption and Credit Abuse," *Journal of Consumer Policy* 11 (1988): 109–121; Mary S. Butler, "Compulsive Buying—It's No Joke," *Consumer's Digest* (September 1986): 55; Derek N. Hassay and Malcolm C. Smith, "Compulsive Buying: An Examination of the Consumption Motive," *Psychology & Marketing* 13 (December 1996): 741–752.

105. Georgia Witkin, "The Shopping Fix," *Health* (May 1988): 73. See also Arch G. Woodside and Randolph J. Trappey III, "Compulsive Consumption of a Consumer Service: An Exploratory Study of Chronic Horse Race Track Gambling Behavior," working paper #90-MKTG-04, A. B. Freeman School of Business, Tulane University, 1990; Rajan Nataraajan and Brent G. Goff, "Manifestations of Compulsiveness in the Consumer-Marketplace Domain," *Psychology & Marketing* 9 (January 1992): 31–44; Joann Ellison Rodgers, "Addiction: A Whole New View," *Psychology Today* (September/October 1994): 32.

106. Susan Reda, "Consumer Bankruptcy," *Stores* (September 1997): 20–24.

107. "New Survey Shows Shoplifting Is a Year-Round Problem," *Business Wire* (April 4, 1998).

108. Catherine A. Cole, "Deterrence and Consumer Fraud," *Journal of Retailing* 65 (Spring 1989): 107–120; Stephen J. Grove, Scott J. Vitell, and David Strutton, "Non-Normative Consumer Behavior and the Techniques of Neutralization," in *Marketing Theory and Practice*, eds. Terry Childers et al. (Chicago: American Marketing Association, 1989), 131–135.

109. Mark Curnutte, "The Scope of the Shoplifting Problems," Gannett News Service, (November 29, 1997).

110. Anthony D. Cox, Dena Cox, Ronald D. Anderson, and George P. Moschis, "Social Influences on Adolescent Shoplifting—Theory, Evidence, and Implications for the Retail Industry," *Journal of Retailing* 69, no. 2 (Summer 1993): 234–246.

111. "New Survey Shows Shoplifting Is a Year-Round Problem."

112. Brad Barth, "Mervyn's Adopts Three-in-One Source-Tagging," *Women's Wear Daily* (February 2, 2000): 16.

113. Julie L. Ozanne, Ronald Paul Hill, and Newell D. Wright, "Culture as Contested Terrain: The Juvenile Delinquents' Use of Consumption as Cultural Resistance," Unpublished manuscript, Virginia Polytechnic Institute and State University (1994).

114. Pamela J. Podger, "Animal-Rights Group Claims 6 Past Attacks," *San Francisco Chronicle* (March 17, 2000): A19, A24; Janet Wells, "Animal Activists Raise the Stakes In Co-Attacks," *San Francisco Chronicle* (April 21, 2000): A1, A19.

115. "Beverly Hills Considers Warning Tag for Fur Coats," *San Francisco Chronicle* (February 4, 1999): A6.

116. "PETA Targets Kids with Fur-Wearing Mothers," *San Francisco Chronicle* (December 21, 2003): A2.

15

The Role of Government and Business in Consumer Protection

Ivy is very shocked that after one washing of an expensive dress she just purchased, it looks awful—it lost its shape and faded from the great bright red it once was! How can that be? "How can this dress I bought at the best store in town last through only one wearing?" That indeed is an expensive garment! Ivy has some knowledge of textiles from her Beginning Textiles class and lab experiences. She knows that cotton and polyester should be able to be washed in a washing machine, even though the dress manufacturer labeled the item "dry-clean only." She also learned that some manufacturers use *low labeling*—that is, they sometimes recommend a

safe method in order to protect themselves, even though others could be used. There may be, however, one component of this dress that cannot be home laundered. Ivy forgot that it is the consumer's responsibility to follow care recommendations, and if consumers don't, any damage to the garment is their responsibility. She did learn this quickly, however, upon returning the dress to the store. When the sales associate asked her if she followed the care directions, she couldn't lie, and said she had washed it, not dry-cleaned it as recommended on the care label. Unfortunately at that point she had no recourse. Chalk it up to experience.

THE COMPLEX MARKETPLACE

The marketplace can be a confusing arena, with complex regulations related to credit cards; your credit rating; return policies; copyright and trademark law; interpretation of labels and warranties; advertising pitches (are they real?); buying expensive items such as cars and houses; the communications system, which seems to expand daily with cell phones and the Internet; and on and on. With such complexity in much of our everyday purchasing and decision making, it is more and more important that consumers be "consumer literate." Many laws and programs are in place to protect the consumer from fraudulent business practices and to provide information that consumers would not necessarily be able to seek out on their own. For example, Ivy didn't really know the correct way to care for that expensive dress. As a consumer you should have certain basic skills and knowledge of the marketplace. And as a professional in the field of fashion and business, you must know the law to protect your own business.

Background of Public Policy and Consumerism

Concern for the welfare of consumers has been an issue since at least the beginning of the twentieth century. Partly as a result of consumers' efforts, many federal agencies have been established to oversee consumer-related activities.

After Upton Sinclair's 1905 book *The Jungle* exposed the awful conditions in the Chicago meat-packing industry, Congress was prompted to pass important pieces of legislation—the Pure Food and Drug Act in 1906, among others—to protect consumers. A summary of some important consumer legislation that especially relates to retailing and manufacturing of fashion goods appears in Table 15-1. Most of this legislation was enacted in the 1950s, 1960s, and 1970s.

President John F. Kennedy ushered in the modern era of consumerism with his *Declaration of Consumer Rights* in 1962. These include the right to safety, the right to be informed, the right to redress, and the right to choice. The 1960s and 1970s were a time of consumer activism as consumers began to organize to demand better-quality products (and to boycott companies that did not provide them). These movements were prompted by the publication of such books as Rachel Carson's *Silent Spring* in 1962, which attacked the irresponsible use of pesticides, and Ralph Nader's *Unsafe at Any Speed* in 1965, which exposed safety defects in General Motors' Corvair automobile. Consumers themselves continue to have a vigorous interest in issues ranging from environmental concerns—such as pollution caused by oil spills and toxic waste—to excessive violence and sex on television or in the lyrics of popular rock and rap songs.

The field of consumer behavior can play an important role in improving our lives as consumers.[1] Many researchers play a role in formulating or evaluating public policies, such as ensuring that products are labeled accurately, that people can comprehend important information presented in advertising, or that children are not exploited by program-length toy commercials masquerading as television shows. This chapter will look at the role of government agencies in protecting consumers in addition to consumer protection agencies supported by business and other independent groups.

Table 15-1 Federal Legislation Affecting the Fashion Industry

1936	Robinson-Patman Act	Designed to equalize competition between large and small retailers (that is, to reduce the advantages that big retailers have over small retailers).
		Examples of provisions of law: 1. Outlawed price discrimination if both small and large retailers buy the same amount of goods. 2. Outlawed inequitable and unjustified quantity discounts (for example, discounts allowable if available to all types of retailers). 3. Outlawed "phony" advertising allowance monies (that is, advertising money must be used for advertising). 4. Outlawed discrimination in promotional allowances (monies for advertising, promotional displays, and so on)—equal allowances must be given under same conditions to small and large retailers alike.
1939	Wool Products Labeling Act	Protects consumers from unrevealed presence of substitutes or mixtures. FTC responsible for enforcing law.
1951	Fur Products Labeling Act	Regulates the branding, advertising, and shipment of fur products.
1953	Flammable Fabrics Act	Prohibits the transportation of flammable fabrics across state lines.
1960	Textile Fiber Product Identification Act	Protects producers and consumers against false identification of fiber content.
1966	Child Protection Act	Prohibits the sale of dangerous toys and other items.
1968	Truth-in-Lending Act	Requires lenders to divulge the true costs of a credit transaction.
1969	National Environmental Policy Act	Established a national environmental policy and created the Council on Environmental Quality to monitor the effects of products of the environment.
1972	Care Labeling of Textile Wearing Apparel Ruling	Requires that all apparel have permanent labels attached that clearly inform consumers about care and maintenance of the article.
1972	Consumer Product Safety Act	Established the Consumer Product Safety Commission, which identifies unsafe products, establishes safety standards, recalls defective products, and bans dangerous items.
1975	Consumer Goods Pricing Act	Bans the use of price maintenance agreements among manufacturers and resellers.
1975	Magnuson-Moss Warranty-Improvement Act	Creates disclosure standards for consumer product warranties and allows the Federal Trade Commission to set policy regarding unfair or deceptive practices.
1984	Counterfeiting Act	Criminalized trademark counterfeiting with a sentence of up to five years in prison and five of up to $ 250,000; goods can be seized from store shelves.

Source: Michael R. Solomon, *Consumer Behavior,* 8e, p. 26, © 2009. Reprinted by permission of Prentice Hall, Inc., Upper Saddle River, NJ.

GOVERNMENT PROTECTION

Government regulates business in the context of competition, safety, and providing information to consumers. Under the U.S. federal government, independent regulatory agencies were developed to regulate certain aspects of economic activity where market forces would be inadequate to ensure

competition, and thereby protect the consumer. Commissioners on these agencies are appointed by the president and approved by the U.S. Senate and serve from five to seven years, theoretically outside political influence. One type of agency limits monopolies, such as the Interstate Commerce Commission; the second type operates in the private sector, overseeing general business practices in key industries, such as the apparel and cosmetics industries. This second type is more closely associated with consumer protection and includes the Federal Trade Commission (FTC), the Consumer Product Safety Commission (CPSC), and the Food and Drug Administration (FDA).[2]

The three basic types of federal legislation that affect the fashion consumer and fashion industry relate to laws that regulate competition (such as antitrust legislation), labeling laws designed to protect consumers and give them information about items they purchase, and safety regulations. In addition to protection through specific legislation, many federal and state agencies, such as the Office of Consumer Affairs, provide information to the consuming public. The next section reviews agencies and regulations that address consumer protection.

Federal Trade Commission

The **Federal Trade Commission (FTC)** was created in 1914 to protect consumers against unfair, deceptive, and anticompetitive business practices. It deals with abuses in advertising, credit, and many other aspects of business that directly affect consumers. A recent FTC report indicates that, of more than 200,000 consumer complaints in one year, the largest category (42%) involved identity theft, with victims losing tens of millions of dollars.[3] It publishes trade regulation rules and industry guides that define the law, sues for penalties, and issues *cease and desist* orders to halt fraudulent business practices. Its broad investigative powers are stronger than those of any other government agency. The FTC requires several types of apparel labeling, which is discussed next. This provides the consumer with information to help make wise choices in the marketplace.

Apparel Content Identification

Textile apparel and fur products that you buy must be identified by the correct content. Three pieces of legislation give consumers this information: the Wool Products Labeling Act, the Fur Products Labeling Act, and the Textile Fiber Products Identification Act.

Since 1939 the **Wool Products Labeling Act**, called the Wool Act, has required wool products to indicate the type of wool used. The terms *wool* and *pure wool* refer to wool fibers that have not previously been made into fabric. *New wool* and *virgin wool* refer to fibers that have not previously been processed in any way. *Lamb's wool* comes from animals younger than seven months old; *recycled wool* refers to wool previously fabricated, possibly used, and reclaimed into fiber form.[4] Recycled wool is often used in interlinings (a warm layer between the lining and outer fabric) and sometimes in the outer fabrics of lower-price coats. Since the yarns are short, abrasion from normal wear often quickly results in pilling. So consumers, beware!

The **Fur Products Labeling Act** states that furs must be labeled and advertised as to whether the fur is natural, dyed, bleached, or otherwise artificially colored; they must include the name of the animal from which the skin came and the country of origin of imported furs. If the fur is used, rather than new, this must be noted. Recall from Chapter 14 that animal rights advocates want the method of killing the animal included.

The **Textile Fiber Products Identification Act** states that apparel items must be labeled with the percentage of fiber content by weight (or percentage). For example, a label may not say "35% cotton, 65% polyester"; this might be considered misleading, since the smallest amount of fiber is the fiber seen first by the consumer. It must state, "65% polyester, 35% cotton." Fibers of less than 5 percent may not be listed (it must state "5% other")—with the exception of spandex, which is unique in that it lends a significant quality to the fabric with that small amount. True generic fiber names, not brand or trademarked names, must be listed. For example, consumers will not see the term *Dacron* by itself, as this is a trademark for polyester; however, it can be used in conjunction with the generic fiber. Correct identification would be "Dacron polyester." Some of the generic fibers, including natural, cellulosics, and synthetics are listed here:

cotton	rubber	triacetate
silk	polyester	olefin
wool	spandex	azlon
flax	rayon	metallic
acrylic	vinyl	nytril
nylon	acetate	glass
modacrylic	vinyon	saran

There are also guides for feather and down products that establish definitions to be used in labeling. **Down** is the undercoating of waterfowl. **Feathers** are the outer covering of fowl. Products made with crushed, damaged, or used feathers or down must be so labeled. A recent labeling infringement relates to cashmere, with more rigorous enforcement possible in the future. Some 100-percent-cashmere-labeled sweaters have been found to contain 50 percent wool that has been treated to feel extra soft.[5]

Manufacturer's Identification

In addition to fiber content, the name or RN (registered identification number) of the manufacturer or WPL (wool product labeling number) must be provided so that consumers can communicate with the manufacturer of a garment. These can be obtained from the Federal Trade Commission, Washington, D.C., 20580 (www.ftc.gov).

Country of Origin

When you buy a garment, the **country of origin** will appear on the label. Mail-order catalogs must state whether an apparel item is imported or made

The "Crafted with Pride in U.S.A." label is used to appeal to the patriotic nature of American consumers. Some, however, do not particularly care where their apparel is made.
Source: Crafted with Pride in U.S.A. Council.

Table 15-2 Examples of RN and WPL Identification Numbers

Liz Claiborne Inc.	RN052002
Guess? Activewear	RN091437
Hanes Corporation	RN015763
Tommy Hilfiger Co., Inc.	RN076922
Calvin Klein Jeanswear Company	RN036009
Ralph Lauren Womenswear Company, LP	RN094306
Mast Industries (The Limited)	RN054867
Miss Erika Inc.	RN040299
Imports by Andrew St. John Inc.	RN030842
Take I Sportswear Inc.	RN051735
Fowles & Company	WPL009511

Note: RN = Registered Number
WPL = Wool Product Labeling Number

in the United States. This is vital information for U.S. Customs and Border Protection, which tracks imports into this country, since country of origin is used as the basis for quota and tariff calculations. However, consumers are often unaware of the origin, many don't care where the garment is made, and they certainly don't care how much tariff was paid on a dress. On the other hand, many consumers today are keenly aware of the controversy of labor abuses in third-world countries, as discussed in Chapter 14, and make a point of checking labels and boycotting products from certain countries. Some consumers today want to purchase clothing that is made in the United States. *Crafted with Pride in U.S.A.* is one label that companies use to appeal to the patriotic nature of American consumers. Consumer perception of quality and value often is made based on the country of origin. The Crafted with Pride in U.S.A. certification mark may be used solely to identify U.S.-produced fiber, yarn, textiles, and apparel and home furnishings (www.craftedwithpride.org).

To make things more complex (it seems nothing is easy when it comes to importing apparel), country of origin is designated by where the garment was sewn. However, if it is made from U.S. fabric and assembled in Mexico or a Caribbean country under a special trade agreement (Chapter 98 of the Harmonized Tariff Schedule, also known as Item 807 from the old U.S. Tariff Schedule), the designation would be *Made in Mexico* (or country where assembled) *of U.S. materials.* Garments made in the United States of imported fabric will state *Made in U.S.A. of imported fabric.*

Care Labels

Manufacturers are required to attach to textile garments a permanent care label that provides directions for their care. The 1972 **Care Label Rule** was amended in 1984, and there has been talk recently to amend the current rule. Presently when you buy a garment the label includes one method of safe care. It does not have to include *all* safe methods, just one; it also does not have to indicate methods that are harmful to the garment. It must specify washing, bleaching, drying, ironing, and/or dry-cleaning procedures and warn against any part of the prescribed care procedure that would be harmful to any part

of the garment or others being cleaned with it. Care labels cannot be promotional in nature, such as "never needs ironing." It also must warn when there is no method for cleaning a garment without damaging it. (We hope you don't buy too many of these types of fashion items!)

Manufacturers assume that the consumer will follow the recommended procedure. It must, in fact, have a reasonable basis for the claim, not just the whim of the company. If a care label says "washable," it may or may not be dry-cleanable; therefore, your dry cleaner may ask you to sign a consent form if you request a cleaning method different from the recommendation on the label. Care labels also are required to be easily found, must not separate from the garment, and must remain legible during the garment's useful life.

Care label regulations apply only to textile clothing, not leather, suede, and fur garments, footwear, gloves, and hats. Accessories such as ties and belts are also exempt. Exceptions to the permanent provision of the rule include items where a label would detract from its appearance, such as in some sheer items or if the item can withstand any care procedure. Instructions, however, must accompany the product on a hangtag or packaging for these items.

International symbols also may appear on the care label to supplement the written instructions; the ruling had required that instructions must be in English (if sold in the United States).[6] However, in 1997 manufacturers were able to use certain care symbols in place of words on labels with accompanying explanations of the symbol on handtags or elsewhere on the garments through 1999.[7] Apparently, you're now on your own. Refer to Figure 15-1; how many of the symbols' meanings would you know without the words? Probably you would guess the ironing instructions; what about the squares, circles, and triangles?

As mentioned earlier, there is a movement by the Federal Trade Commission to modify the existing Care Label Rule. However, several years from the beginning of discussions there does not seem to be substantial progress in that direction. In 2000, a change was made to define "hot," "warm," and "cold" water and to specify when a water temperature must be stated on the label. A second change involves the "reliable evidence" provision for determining what cleaning technique should be used. A manufacturer has to know how the garment as a whole should be washed, in addition to its components.[8] Other changes advocated by the FTC included optional care methods on labels rather than only one. For example, if indeed Ivy's dress could have been home-laundered rather than only dry-cleaned, as she suspected, the label would state both options. (But in Ivy's case, she was wrong!) One impetus for this change is to reduce the use of perchloroethylene, a solvent used in dry cleaning that is damaging to the environment. Also, washing items that could safely be cared for this way would save consumers many dry-cleaning dollars.[9]

The FTC has settled several recent cases with Jessica McClintock, Tommy Hilfiger, and Jones Apparel for incorrect cleaning directions.[10] The agency charged that the care labels were not specific enough to keep garments from being damaged at the dry cleaners.[11] The FTC claims that in numerous instances the care procedures recommended on the care label resulted in damage to sequins, beads, or other trim and other damage to the garment. Although the FTC does not investigate every consumer complaint,

CONSUMER GUIDE TO CARE SYMBOLS

Wash

Machine wash cycles

| normal | permanent press | delicate / gentle | | hand wash |

Water temperatures (maximum)

	(140F)	(120F)	(105F)	(65F-85F)
symbol(s)	60C	50C	40C	30C

Warning symbols for laundering

- do not wash
- do not bleach
- do not dry (used with do not wash)
- do not iron

Bleach

- any bleach when needed
- only non-chlorine bleach when needed

Dry

Tumble dry cycles

| normal | permanent press | delicate / gentle |

- line dry / hang to dry
- drip dry
- dry flat

Tumble dry heat setting

| any heat | high | medium | low | no heat / air |

Additional instructions (in symbols or words)

- do not wring
- do not tumble dry
- in the shade (added to line dry, drip dry, or dry flat)
- no steam (added to iron)

Iron

Iron--dry or steam

| maximum temperature | 200 C (390 F) high | 150 C (300F) medium | 110 C (230 F) low |

Dryclean

Dryclean

(A) normal cycle any solvent

Professionally dryclean

- reduce moisture
- short cycle
- no steam finishing
- low heat

--requires modified drycleaning

(P) any solvent except trichloroethylene

(F) petroleum solvent only

Warning symbol

- do not dryclean

Note: This Figure illustrates the symbols used for laundering and drycleaning instructions. As a minimum, laundering instructions include, in order, four symbols: washing, bleaching, drying, and ironing; and, drycleaning instructions include one symbol. Additional symbols or words may be used to clarify the instruction

FIGURE 15-1
Consumer Guide to Care Symbols

Source: Copyright 1996. American Society for Testing and Materials, 100 Barr Harbor Drive, West Conshohocken, PA 19428. ASTM Designation: D 5489 PCN: 12-454890-18.

if there is a preponderance of evidence against one company, it will investigate. Therefore, it is your responsibility as a consumer to notify companies whose products are not to the quality that you expected. Often that is the only way manufacturers know there is a problem.

Consumer Responsibilities

As in Ivy's case, many consumers do not read or follow care labels but use their experience or best judgment. Normally cotton/polyester can be machine-washed, as Ivy figured, but there might have been a certain piece of trim or buttons that could not withstand home-laundering techniques; thus, the "dry-clean only" care recommendation on her dress. Some cotton fabrics that normally are washable have dyes that may bleed when washed in hot water; therefore, dry-clean only care might be recommended. The bottom line is that the recommended care procedures are there for a purpose; when consumers ignore them, they do so at their own risk.

The structure of the Care Label Rule also protects manufacturers from consumers who return garments damaged from not following care procedures as instructed. On the other hand, if you did exactly what the label indicated and you were not satisfied with the results, such as a damaged garment, you should first return it to the retailer. If you get no resolution, then write the manufacturer; tell them what happened and how you would like them to resolve the problem. You may want them to replace the item or reimburse you. For example, if you followed the care instructions, and a garment fell apart, the manufacturer should take responsibility for this product. Normally the retailer will refund your money and then try to return it to the manufacturer. See the sample complaint letter as a guide.

Deceptive Business Practices

Over the years the FTC has attacked thousands of devious business schemes in such areas as false advertising involving interstate commerce; fictitious pricing, in which goods are falsely advertised as bargains; bait-and-switch advertising, by which consumers are lured by a spectacular bargain not intended to be sold, and "switched" to a higher-priced purchase; exaggerated claims for the efficacy of drugs and cosmetics; failure to disclose limitations of guarantees; misrepresentations of the quality of products; fair packaging and labeling; truth in lending; and fair credit reporting.[12]

Use of personal data is another area the FTC recently has become involved in, especially with the advent of the Internet. FTC has filed suit against companies regarding how they collect and use Net surfers' personal data.[13] It would seem that new dot-com companies may have no idea what potential trouble they can get into with a "good idea" to increase business. As a consumer, you should ask a company how they are using the personal data they require you to provide. The Direct Marketing Association has guidelines for use of personal data, discussed further in this chapter.

Pricing

The laws on pricing branded merchandise are about to change based on a 2007 Supreme Court decision to strike down a 96-year-old ban on minimum

SAMPLE COMPLAINT LETTER FOR DAMAGED GARMENT

(Your address)
(Your city, state, zip code)

(Date)

(Name of contact person)
(Title)
(Company name)
(Street address)
(City, state, zip code)

Dear (contact person):

On (date), I purchased (describe the garment) from (retailer's name and address). The care label indicated that (list information from the labels and tags). Unfortunately, my garment has been damaged because (explain the problem). Therefore, to resolve the problem, I would like you to (state the specific action you want). Enclosed are copies (copies, NOT originals) of my records (receipts, canceled checks, and any other documents).

I look forward to your reply and a resolution to my problem by (set a time limit). Please contact me at the above address or by phone (home or office numbers with area codes).

Sincerely,

(Your name)

pricing agreements. Previously manufacturers could recommend but not set retail prices. The practice known as **price maintenance** has long been a violation of the **Sherman Antitrust Act**. Even so, some manufacturers have dictated prices to retailers, often in setting which styles could be discounted, in violation of antitrust laws. Laws stated that retailers, not manufacturers, decide what prices consumers pay and which styles to discount. Europe has similar laws. Recently fines were levied on beauty brands owned by LVMH Moet Hennessy, L'Oréal, and Chanel and to retailers Sephora and Nocibe for agreements to eliminate competition.[14] However, the new U. S. Supreme Court decision will give brands the potential to enforce the lowest price at which their products could be sold.[15] Actually the decision gives lower courts the leeway to determine, on a case-by-case basis, whether minimum pricing agreements are anticompetitive. So changes, if any, will be gradual rather than revolutionary. Most agree that this decision will raise prices of goods at retail and also create more business for the court system.

Fair trade laws, or price maintenance laws, were in effect until 1975, with the passage of the **Consumer Goods Pricing Act**. Larger retailers were not allowed to receive a discount for quantity purchases; thus, fair trade laws had protected the small retailer from larger retailers, as they both sold the same

goods at the same price. With the repeal of this regulation, retailers were able to sell products below manufacturers' suggested retail prices. This ended protection for small retailers but gave the consumer the opportunity for lower prices from discounters. From time to time sentiments change against discounters relative to the manufacturer's right to establish an image (and not to sell to discounters) as seen most recently with the 2007 decision.[16] Some consumers and small towns get frustrated when big-box discounters such as Wal-Mart and Home Depot put small local specialty stores out of business.

Companies in some small towns have sued Wal-Mart for **predatory pricing**. This occurs when a retailer prices a product below cost with the intent of driving out competition—which is illegal. Discounters that have been sued for predatory pricing justify their lower-than-cost pricing by saying that their main objective is not to hurt competition but to provide low prices for their customers.

As a consumer, if you suspect a company of price-fixing you can report it to the Antitrust Division of the Department of Justice at many locations (www.pueblo.gsa.gov).[17] Generally if sellers of similar products have agreed to price their products a certain way, to sell only a certain amount of their product, or to sell only in certain areas and to certain customers, there may be trustlike behavior. Some representatives of apparel companies clearly have policies of selling only to certain companies to maintain their image. At times the courts have approved this. A rep does not like to place his or her product in two small stores on the same street, since competition hurts his commission. And customers don't like to see the same merchandise in many stores; they like the perception of exclusivity. Therefore, reps often will sell only to retailers that are not competing in the same area. Since legally they cannot refuse to sell to a retailer, often informal practices are used, such as running out of merchandise in this particular instance.

How to Protect Yourself

How can you protect yourself from unscrupulous businesspeople? We don't think well-known companies are unscrupulous; more than likely when a company gets in trouble an employee misinterpreted a complex law. On the other hand, some companies will engage in a practice until they "get caught." The FTC outlines basic warning signals that should put consumers on their toes:

- You are getting something for nothing.
- You have been specially selected.
- You will be receiving free goods.
- You have to decide on the spot, with no time to think about an offer.

Furthermore, you can protect yourself by following guidelines such as these:

- Shop for the best buy from several sources.
- Don't buy when being pressured.
- Do not sign contracts without reading them or contracts that have blank spaces.
- Read contracts carefully; if you do not understand terms, see an attorney.

- Be sure you know the total cost of the item (including delivery and finance charges).
- Deal with companies with a reputation for fair dealings.

FTC Mail Order Rule

Consumers order millions of items from mail-order companies each year; with the increase in Internet shopping, much of what we buy is delivered through the mail. The Mail Order Rule was issued by the FTC to correct growing problems with late or undelivered mail-order merchandise after receiving thousands of consumer complaints.

The following constitutes the rule. Mail-order companies must ship your order within the time promised, or, if no time is stated, within thirty days of receipt of your properly completed order and payment. The thirty days begins when you are charged, if using credit. In case of delay, the seller must notify you when your order will be shipped. If the new shipment date is more than thirty days past the original date promised, you can accept the new date or cancel for a full refund. Either way, you must do so in writing. The seller must refund your money within seven working days after receiving your cancel order.[18]

If your package arrives damaged, you can refuse acceptance by writing "refused" on the package and return it unopened to the seller. No new postage is required.

One of the continuing controversies is whether sales tax should be applied to all mail order and Internet sales. Billions of dollars are at stake. Bills are being debated in Congress that would place a 5 percent national sales tax on Internet sales and other mail order and catalog sales that are not now subject to sales taxes.[19] For years there has been a curb on sales tax collections from out-of-state companies. In 1967 the Supreme Court banned states from imposing tax-collection obligations on businesses that have no physical presence or retail outlets in the state. For example, a consumer would pay sales tax on a mail order from Williams-Sonoma if there is a store in the state, but if there is no store, no sales tax is charged. That is the contention of Web sites where there is no brick and mortar. The argument is, why should they pay for sidewalk repair if they don't use the sidewalk?

As we all know, there are risks involved in ordering from an Internet or mail-order business. These can be minimized:[20]

- Deal with reliable firms. Check with the Better Business Bureau (www.bbb.org) if you question a firm.
- Read advertisements and promotions carefully.
- Pay by check, money order, or credit card so you have a record of each transaction. Never send cash in the mail.
- Keep a copy of the ad or catalog you ordered from and a copy of the order form.
- For Internet sites, use a secure site and a secure browser (128-bit encryption); as with mail-order catalogs, deal with reputable firms that you trust. Check for the BBBOnLine seal discussed later in this chapter.

Mail-Order Disputes. If you pay by credit card, the law says you can stop payment on the amount in dispute by notifying the company that issued the card. You must get the problem settled within two billing cycles (ninety days).

Unordered Merchandise. You have no legal obligation to pay for unordered merchandise that you receive in the mail. It is, in fact, illegal for companies to pressure you to return it or pay for it. Some companies play the guilt game by sending you merchandise and then making you feel sorry for an underprivileged group or otherwise make you feel some obligation to send a donation. This is very successful in many instances. Remember the exchange principle discussed in Chapter 13. When we receive something, we feel obligated to give something of equal value in return.

Consumer Product Safety Commission

The **Consumer Product Safety Commission (CPSC)**, like the FTC, is an independent federal regulatory agency—in this case, established by the Consumer Product Safety Act in 1972. It protects the public against unreasonable risks of injury (from clothing to toasters), assists consumers in evaluating products' comparative safety, develops uniform safety standards, and promotes investigation into the causes and prevention of product-related deaths, illnesses, and injuries. It has responsibility for implementing provisions of the Flammable Fabrics Act. It also publishes industry guides such as "Regulations for Toys and Children's Articles" (safety of toys) and "Guidelines for Drawstrings on Children's Outerwear" (to help prevent children from strangling or getting entangled in drawstrings at the neck, waist, or bottom of clothing).[21]

The agency has begun a new outreach program whereby officials visit thrift shops to seek out recalled products. One effort in informing the public of dangerous products is to post color pictures of recalled products in thousands of post offices across the country. The CPSC commissioner said, "We can get dangerous products off store shelves, but the real challenge is to get them out of families' homes. Since 7 million people go to post offices to mail letters and packages, they will have an opportunity to view the recalled products—along with the FBI's 'Most Wanted' criminals!"[22]

Flammable Fabrics

When consumers buy clothing, they assume it is safe. The regulation that ensures this is the **Flammable Fabrics Act**, which was passed in 1953 and amended in 1988 and 1998. The regulations apply to clothing, plastics, carpets, rugs, mattresses, and mattress pads. The law prohibits the sale of apparel made from dangerously flammable fabrics.

There are stringent regulations for infants' and children's sizes 0–14 sleepwear, including nightgowns, pajamas, robes, and other sleep-related accessories. These items must pass a standards test after fifty washings: The finish, if used to maintain flame resistance, should remain effective over the lifetime of the garment. Although manufacturers must retain records on each piece of children's sleepwear, there is no requirement that this information appear on a label that the consumer will see. Some companies, however, voluntarily indicate compliance with the law as a service to the consumer and to promote the garment. In 1998 an amendment to this law allowed the sale of

tight-fitting children's sleepwear even if the garments do not meet the minimum standards for flame resistance ordinarily applicable to such sleepwear. The CPSC allowed the exemption since there have been no reported injuries from tight-fitting sleepwear, and parents were circumventing the law by buying loose-fitting cotton T-shirts as sleepwear (this is even higher in risk). The tight fit appears to be more important than the flame-resistant nature of the fabric when the item comes into contact with an ignition source.[23]

From time to time some items reach the retail floor, consumers purchase them, and later they are found to be highly flammable. In these cases the retailer, manufacturer, or the CPSC recalls the items. The CPSC Web site (www.cpsc.gov) lists 26 adult clothing recalls since 1994 and over 100 children's clothing recals. These include such items as bathrobes, scarves, fleece jackets, sweaters, and chiffon skirts. Many of the children's recalls relate to the strangulation hazard of drawstrings on hooded sweatshirts. Many items involved with adult clothing recalls were made from sheer or brushed fabric. One well-publicized example of a recall is the rayon/cotton-blend chiffon skirts from India. The skirts were found to burn faster than newspaper. They were long, full summer- and fall-line skirts made with two layers: a sheer chiffon layer over a gauze lining. The CPSC worked with importers and retailers to recall more than a quarter million of these skirts. Consumers were urged to stop wearing the skirts and to bring them back to the retailer for a refund.

Since the Indian skirt recall, CPSC figures indicate that more than 1.2 million garments were recalled. Some recent recalls include 120,000 Halloween costumes from Family Dollar, children's bathrobes from Ross, True Religion hooded sweatshirts, and Zutopia girl's lounge-wear among others.[24] The CPSC is working with large retailers to head off recalls such as these. To fight a rise in highly flammable fabrics, the CPSC is encouraging more testing by organizing retailers and industry associations to establish a voluntary pledge program. Retailers would commit to complying with the Flammable Fabrics Act, educating their buyers and suppliers about the act, and randomly testing their products, while the CPSC would eliminate some civil penalties.[25]

Toy Safety

Toy safety is a concern of the CPSC especially after the 2007 incident with Mattel's recall of over 10 million toys made in China which did not meet U.S. safety standards. Generally before Christmas, articles in newspapers are run warning parents of potential dangers from toys.[26] The CPSC is vigilant in monitoring toys for children's safety. Other groups are also concerned: Greenpeace claimed that Tweety Bird hats and 101 Dalmatians backpacks containing high levels of lead or cadmium could pose dangers to children. The CPSC and toy manufacturers disputed the findings.[27]

Shopping tips for different ages are published by the CPSC. For example:

Under Age 3:
- Avoid buying toys intended for older children, which may have small parts that pose a choking danger.
- Avoid marbles, balls, and games with balls that have a diameter of 1.75 inches or less.
- Avoid toys that have sharp edges and points.

Age 3–5:

- Avoid toys constructed with thin, brittle plastic that might break into small pieces or leave jagged edges.
- Look for household art materials, including crayons and paint sets, marked with designation ASTM D-4236. This means the product has been reviewed by a toxicologist and, if necessary, labeled with cautionary information.

Age 6–12:

- Be sure, when you purchase a toy gun, it is brightly colored so that it's not mistaken for a real gun.
- Along with a bicycle, buy a helmet and make sure the child wears it.

The CPSC requires toy manufacturers to meet stringent safety standards and to label certain toys that could be a hazard for younger children. Look for labels that give age recommendations and use that information as a guide. Labels on toys that state "not recommended for children under age 3 . . . contains small parts" are labeled that way because they may pose a choking hazard to children under 3.[28]

Food and Drug Administration

In addition to food and drugs, the **Food and Drug Administration (FDA)** regulates the cosmetics industry. But there has been confusion between the definitions of cosmetics and drugs, resulting in a continued battle between FDA and the cosmetics industry. The FDA tests drugs for safety and effectiveness. But what about cosmetics?

Cosmetics Regulation

The **Federal Food, Drug and Cosmetic Act** defines cosmetics as "articles other than soap which are applied to the human body for cleansing, beautifying, promoting attractiveness, or altering the appearance without affecting the body's structure or functions."[29] This definition includes skin-care creams, lotions, perfumes, lipsticks, fingernail polish, eye and facial makeup, permanent waves, hair colors, deodorants, bath oils, and mouthwashes. The **Fair Packaging and Labeling Act** requires an ingredient declaration on every cosmetics product offered for sale to consumers. Ingredients must be listed in descending order of quantity (see Figure 15-2).

Active ingredients: Aluminum zirconium Trichlorohydrex gly (anhydrous) Other ingredients: Cyclopentasiloxane Octyldodecanol Hydroxy-stearic acid	Dibutyl lauroyl glutamide C20-40 pareth-10 C20-40 pareth-40 Fragrance C20-40 alcohols Disodium edta

FIGURE 15-2
Ingredients in One Women's Deodorant. What Does This List of Ingredients Say to You?

Products that intend to treat or prevent disease, or otherwise affect the structure of function of the human body, are considered drugs. Cosmetics that make therapeutic claims are regulated as drugs and cosmetics, and must meet labeling requirements for both. For these products, the regulations require that active ingredients be listed first on these products, followed by the list of cosmetic ingredients in order of decreasing predominance. "Active ingredients" are the chemicals that make the product effective, and the manufacturer must have proof that it's safe for its intended use. Examples are sunblock/tanning preparations including foundations that contain sunscreens. Before a drug can be marketed, it must be scientifically proven safe and effective for its therapeutic claims. If it is not, FDA considers it misbranded and can take regulatory action.

Indeed, consumers are confused about the multitude of cosmetics products on the market, all claiming to perform so many functions (some close to miracles!). Some of these claims have been attacked by the government as false and misleading, as no testing is evident to substantiate their claims. The FDA surveyed more than 1,600 consumers age 14 and older about their use of cosmetics. Many said they expect a product to prevent or slow the formation of wrinkles if it makes such a claim, and nearly half felt that a product claiming to be "natural" should contain all natural ingredients.[30] Sometimes these claims are true and sometimes not.

In the late 1980s the FDA charged the cosmetics industry with making unsubstantiated drug claims to sell skin-care products. Claims that their products will reverse the aging process, renew skin cells, remove wrinkles, or affect the skin below the epidermis were seen by the FDA as affecting the body in a physiological way, making it a drug. At that time many firms agreed to delete such claims from their advertising and labeling.[31]

Cosmetics are not required to undergo approval before they are sold to the public and the FDA does not require companies to submit safety data before marketing cosmetic products.[32] However, the safety of several types of chemicals used in cosmetics continues to be a consumer issue. These chemicals include alpha hydroxyl acids (AHAs), which are used in facial creams to prevent wrinkles, parabens (alkyl-p-hydroxybenzoates), which are used as a preservative in more than 13,000 cosmetic products, and phthalates, which are chemical additives used in fragrances, hair spray, nail polishes, and deodorants and which are not required to be listed on the label. Independent groups, such as the Campaign for Safe Cosmetics, are bringing awareness about cancer-causing chemicals in cosmetics to the public.[33] The European Union has banned the use of certain chemicals in cosmetics, and two major cosmetic companies, L'Oréal and Revlon, have agreed to abide by these new antitoxics rules.[34] Some companies voluntarily register their cosmetics with the FDA by forwarding data to the FDA about their ingredients. According to the Office of Cosmetics and Colors, however, only about 35 to 40 percent of cosmetics manufacturers currently participate in the program.[35]

Cosmetics Terms

Some of the terms used on cosmetics, such as *natural* and *hypoallergenic,* have little medical meaning and companies can use them on cosmetics labels to mean just about anything. Most of these terms, however, have considerable

market value in promoting products to consumers. Some common terms that consumers should be aware of include the following:[36]

- *Natural:* Implies that ingredients are extracted directly from plants or animal products as opposed to being produced synthetically. There is no basis to the notion that products containing natural ingredients are good for the skin.

- *Hypoallergenic:* Implies that products are less likely to cause allergic reactions. No scientific studies are required to substantiate this claim. Likewise, the terms *dermatologist-tested, sensitivity tested,* and *nonirritating* carry no guarantee that they won't cause skin reactions.

- *Alcohol free:* These products do not contain ethyl alcohol, but they may contain other alcohols, such as cetyl, stearyl, cetearyl, or lanolin (known as fatty alcohols).

- *Fragrance free:* Implies that the product has no perceptible odor. However, fragrance ingredients may be added to a fragrance-free cosmetic to mask any offensive odor originating from the raw materials used.

- *Cruelty free:* Implies that the product has not been tested on animals. Most ingredients used in cosmetics have at some point been tested on animals, so consumers may want to look for "no new animal testing" to get a more accurate indication.

Shelf Life of Cosmetics

The shelf life of cosmetics products is from one to three years under normal storage conditions, depending on the product's composition, packaging, preservation, and other factors. There are no regulations or requirements under current law that require cosmetics manufacturers to print expiration dates on the labels of cosmetics. Consumers should be aware that expiration dates are simply "rules of thumb" anyway and that a product's safety may expire long before the date if the product has not been properly stored.[37] One of the problems with cosmetics sold at some large discount or warehouse stores is the question of age of the product. *Gray goods* cosmetics may also be old. These are imports that are unauthorized for sale by the license holder. This is discussed later.

Intellectual Property: Trademarks, Copyrights, and Patents

Trademarks, copyrights, and patents are considered a company's **intellectual property**, infringement of which is illegal. Of the three, trademarks are most used in fashion and most counterfeited, or illegally copied. **Counterfeit goods** are fakes or copies of popular branded merchandise illegally using the trademark or brand name of the rightful owner. Counterfeits are a multibillion-dollar industry encompassing fake Levi jeans, Gucci handbags, Cartier watches, and sports apparel and accessories in addition to computer software, videos, audiotapes, and a multitude of products. Some companies such as Levi's and Nike have spent considerable sums to protect their trademarks. One method to fight illegal copies is *fingerprinted* labels, which can be detected by a laser, enabling authorities to detect counterfeit goods.

Counterfeiters don't worry about the quality of the merchandise or a store or company's reputation. They're not after repeat business, so they make their product as cheap as possible. Hundreds of thousands of American jobs are lost due to imported counterfeits.

If consumers cannot separate a specific trademarked product (such as Levi's) from a generic product (such as jeans), the company may be in danger of losing the exclusive rights to their trademarked terminology. Therefore, companies use a generic name with their trademark to remind consumers that theirs is a special type of that product. Therefore, even though it seems redundant, we see the terminology Levi's jeans, rather than just Levi's.[38]

Trademarks

A **trademark** is any word, name, or symbol that has been adopted and used by the owner to identify a product and distinguish it from others. In 1984, the **Counterfeiting Act** became law, which for the first time criminalized trademark counterfeiting. A person intentionally trafficking in goods and services that are known to bear a counterfeit mark could be sentenced to up to five years in prison and required to pay a fine of up to $250,000 for the first offense, and goods can be seized from store shelves. It is illegal to sell counterfeited goods, but it is not illegal for consumers to buy them. Thus, we see people buying cheap copies of branded goods at flea markets; in cities such as New York, they buy them on the street.

The International AntiCounterfeiting Coalition (IACC) was formed in 1978 by Levi Strauss and fifteen other companies to combat counterfeits. Membership has grown to more than three hundred corporations, and it is the largest multinational organization devoted solely to combating product counterfeiting and piracy. Comprising a cross section of businesses—from apparel, luxury goods, autos, and pharmaceuticals, to food, book publishing, software, and entertainment—the IACC is devoted to combating product counterfeiting and piracy (www.iacc.org). The IACC offers tips on how to avoid fakes:[39]

- *Pick a store you can trust.* Reputable retailers don't knowingly deal in counterfeits. Flea markets and street vendors may be questionable.

- *Price too good to be true? You can bet it is.* When you find a $100 item for $10, it's probably a fake. Know the usual price range for your intended purchase.

- *Look at the label closely.* Compare trademarks with ones you know are real. Fakes are sometimes fuzzy, indistinct, off-color, or even misspelled! (However, some counterfeits can be almost indistinguishable from the real thing.)

- *Check the special tags and marks.* Check authentic products to see if other tags are sewn in or attached in certain ways. Carelessly attached tags can be a strong clue to a fake.

- *The real stuff is quality.* Look over the piece carefully for cheap materials and shoddy construction.

- *Check the packaging.* Quality merchandise means quality packaging. Check for smeared printing or uneven wrappings.

In addition to these points, the place of manufacture can identify merchandise as counterfeit. For example, Seven for All Mankind jeans are only made in the United States, so it's easy for U.S. Customs agents to locate counterfeits: anything that is imported.[40]

People buy counterfeits for different reasons. Low price and having a popular look are obvious ones. And for some it's fun to own a "Rolex" for awhile (how long does a $30 Rolex last?).

Five Reasons You Should Never Fake It

IACC lists reasons why consumers should not buy fakes.[41]

1. Counterfeiting is illegal and purchasing counterfeit products supports illegal activity.
2. Counterfeiters do not pay taxes, meaning less money for your city's schools, hospitals, parks, and other social programs.
3. Counterfeiters do not pay their employees fair wages or benefits, have poor working conditions, and often use forced child labor.
4. The profits from counterfeiting have been linked to funding organized crime, drug trafficking, and terrorist activity.
5. When you purchase a fake, you become part of the cycle of counterfeiting and your money directly supports things you would never want to support.

Many legitimate companies have recently filed suit against companies selling look-a-like counterfeits of their products, including Diesel, LVMH, Bauman, Burberry, Aeropostale, Seven for All Mankind, Gucci, Polo, Montblanc, Lucky brand, and Liz Claiborne, among others.[42] Companies also try to protect trademarked words or phrases used to promote their products. For example, Victoria's Secret has been involved with lawsuits over the use of "sexy little things" and Victor's Secret.[43]

Many counterfeited watches are sold on the streets of large cities (left).
A judge determined that this perfume bottle design for Ralph Lauren (right) was not close enough to Calvin Klein's to be confusing to consumers. Designers are fighting to maintain exclusive rights to their designs.

As we said, it is illegal to copy a trademark. However, some companies copy the idea, not exactly, but so closely that it could be confused by the consumer. Courts generally do not allow such behavior. There are many examples of these lawsuits. Escada sued the Limited's Victoria's Secret division for copying the registered design of its signature heart-shaped fragrance bottle. It was "confusingly similar."[44] Calvin Klein sued Ralph Lauren for knocking off his trademarked Eternity perfume bottle for Lauren's fragrance, Romance. Even though the bottles were strikingly similar, the courts did not see that consumers would be confused by the two bottles since there are enough differences.[45] Sara Lee Corp., owner of the Wonderbra trademark, sued Ce Soir, owner of the Water Bra trademark, again based on the similar argument of consumer confusion. And Tommy Hilfiger sued Goody's Family Clothing with trademark infringement of his flag design logo on patches, labels, embroidery, and tags that "imitate" his look used on Goody's private labels.[46]

The Internet marketplace has made it easy to start small mom-and-pop companies, but it's also easy to search for names of these companies that might infringe on another's trademark. One such case involved 52 small Internet retailers, including one California young mother who used her daughter's pet name, "sweet pea." Turns out that a Florida company, Sweet Pea Limited, filed a federal lawsuit against all 52 for using its registered name. The 52 companies got together to form www.sourpeas.com to fight this David and Goliath legal battle.[48]

Trade dress, or the "look" of the product, is a category of trademarks that has received considerable attention lately. In a high-profile case, Sephora, a French cosmetics company, filed a trade dress infringement suit against Federated, the owner of Macy's, charging Macy's West with copying Sephora's store layout and shopping experience. The charges concerned Macy's Souson freestanding, open-sell fragrance and cosmetics stores, as well as its renovated beauty departments in Macy's stores in California. Surprising some, the courts granted Sephora the right to bar Macy's from opening more similar cosmetics departments allegedly copying the Sephora concept.

But Abercrombie & Fitch lost a case against American Eagle Outfitters over American Eagle's alleged copying of the A&F brand and business practices, due to the generic nature of those practices. Forbidding other retailers from adopting similar methods would be anticompetitive.[49] Also, the courts ruled in favor of Wal-Mart in its right to interpret (or knock off) the look of a children's popular playsuit by Samara, a New York children's manufacturer.[50] This makes it harder for brand-name designs to qualify for trade dress protection. The courts reaffirmed that trade dress law can be invoked only when a design is readily recognized as belonging to a particular brand, or in legal parlance, carries secondary meaning. But secondary meaning takes time to

IACC MEMBER SPOTLIGHT

Cyberspace has become the epicenter of the counterfeit product industry. Since 1995, Rob Holmes of IPCyberCrime has been investigating counterfeiters in cyberspace, hunting them down, and exposing their operations. His investigations have led to the seizure of over $1 billion in counterfeit goods worldwide and $100 million in judgments. The world's first Internet IP enforcement program, IPCyberCrime has played an integral part in many cases that led to eBay's VeRO program and the Anti-Cybersquatting Act.[47]

develop, often longer than fashion items have. As these suits show, companies are becoming increasingly protective of their creativity as the battle for market share gets more intense. The knockoff industry, however, appears to be alive and well.

Copyrights

A **copyright** is protection for original creative writings, photos, music, or works of art. From time to time an apparel designer will procure a copyright on a design. Fashion is not normally copyrighted because it is not seen as "original" but as some type of reinterpretation of a previous design. Fabric designs, however, are copyrighted as original art and designers are becoming more protective of their work by going after copycats. Recently Diane von Furstenberg sued Forever 21 over infringement of her print design called "small dentelle" and "flower lace border," designs seen at Forever 21 soon after the runway appearance.[51] This is not the first time this retailer has found itself in court over copyright infringement.

The fashion industry thrives on inspiration, reinterpretation, and reinvention, and companies like Forever 21, H&M, Zara, ABS by Allen B. Schwartz, Target, and other private labels bring reinterpretation of higher-priced designs to the masses at affordable prices. This has long been the backbone of the multibillion-dollar fashion industry. But designers who put much creativity, energy, and resources into their runway collections are tired of such instant copycat knockoffs. A recent bill, HR 1055, would provide copyright protection for fashion designs for three years, something that has caused much controversy within the industry.[52] Some feel cases would clog the courts and stifle competition. What do you think?

The Copyright Term Extension Act (commonly known as the Sonny Bono Act of 1998), extends copyright protection to seventy years (from fifty) after the creator dies and ninety-five (from seventy-five) years after creation by a corporate author. Mickey Mouse, for example, has until 2019 before he enters the public domain. So it'll be a while before we see more of Mickey; presently Disney receives royalties through licensing agreements.[53] This new law harmonizes U.S. law with Europe's copyright laws.

Patents

A **patent** granted to an inventor is the right for twenty years to exclude others from making, using, or selling that invention. Few patents are granted to developers of fashion, since fashion isn't seen as an invention; however, patents are granted if a unique process or material is developed in textiles or special purposes in apparel. A small maternity manufacturer in San Francisco, Japanese Weekend, received a patent for products called the OK belt and pant, a new concept for maternity wear. This apparel uses a belt under the unborn baby for support and leaves the mother's stomach exposed rather than covering it with a large expanse of fabric, as in other maternity pants.[54] In 1997 Wayne Rogers, a better sportswear firm, marketed a new stretch fabric it developed and patented. Called RecoveRib, the easy-care fabric is made up of 78 percent silk and 22 percent Lycra spandex. It claims that this fabric keeps its form whatever you do to it.[55] Other patents have been granted for wrinkle-resistant finishes, pucker-free technologies, and methods of manufacturing parts of garments, among others related to fabric and garment construction.

One category of patent is the *design patent*, which the cosmetics company MAC has on its lipstick tube. In 1999 MAC sued the New Age Canadian company Tony & Tina for patent infringement. MAC's lipstick is packaged in gunmetal-gray tubes with one end curved like a bullet. Tony & Tina's lipstick is packaged in a shiny silver container with a bulletlike tip with oval designs around the middle of the case and the company's name printed in black along the bottom.[56]

Gray Goods

One category of goods that is a gray area for businesses and consumers is called **parallel imports**, or **gray goods**. These are goods that may be trademarked but are imported by companies who are not authorized to sell them. They are the same product (so they aren't imitations, like counterfeits), but they are sold in another country by someone other than the licensee. Normally foreign companies establish a U.S.-based subsidiary to obtain U.S. trademarks and control distribution and service. But gray goods are purchased legally in the country of manufacture and then brought to the United States for sale (but not by the subsidiary). For now they are legal, but new bills continue to come before Congress to outlaw them.

Gray goods don't come with warranties (products such as expensive watches). They also may be old or past their shelf life (such as fragrances). Some discounters cannot get some types of goods, particularly fragrances, unless they buy gray market goods. Prices generally run 40 percent off manufacturers' suggested retail prices, so they are seen as good for the consumer. Levi Strauss has been plagued by gray goods whereby international "tourists" buy up all the stock in one store and take it home to sell on the gray market. The problem again is that Levi's sells its product overseas through its dealers at higher prices. In addition, U.S. customers find empty shelves and leave the store dissatisfied. Gray luxury goods sold at discount stores hurt the brand's equity. They undercut the cachet the brand has developed and, therefore, this becomes a problem similar to the counterfeit problem for the company.[57]

U.S. Fish and Wildlife Service

The **Endangered Species Act of 1973** recognized that endangered species of fish, wildlife, and plants "are of esthetic, ecological, educational, historical, recreational, and scientific value to the nation and its people."[58] Humans are exterminating entire species at an ever-increasing rate due to habitat degradation, environmental pollution, introduction of nonnative organisms, and exploitation. More than a thousand species of animals and plants are officially listed under U.S. law as endangered or threatened. With limited exceptions, such as certain antiques, selling or importing products made from endangered species is illegal. The *Federal Register*, a daily government publication, lists endangered or threatened species. Some states, such as California, can be more restrictive than the federal government. For example, the python is not protected under federal law, but it is one of several animals protected under the California Penal Code (www.leginfo.ca.gov). In early 2000 python was a hot new trend shown in fashion catalogs selling nationwide, but it cannot be shipped to California.[59]

American consumers traveling abroad should be aware of the items banned from sale and importation to their state. Tourists may lawfully buy souvenirs in a number of foreign countries, but it may be illegal to bring them home. If on the endangered species list, they will be seized by U.S. Customs or wildlife inspectors and the buyer also might be subject to fines.[60] Purchasing such items adds to the demand for these products and supports a market for which more animals will be killed. Items in the endangered category (and thus prohibited entry into the United States) that are commonly sold abroad include the following:

- Whole shells and "tortoise" shell jewelry made from the shells of sea turtles
- Sea turtle soup and facial cremes
- Rugs, pelts, and a wide variety of manufactured articles (such as handbags, coats, and wallets) made from the skins and/or fur of endangered or threatened animals including the cheetah, jaguar, margay, ocelot, vicuna, and tiger
- Asian elephant ivory and whale teeth decorated with etchings (scrimshaw) or made into figurines or jewelry
- African elephant ivory
- Crocodile and sea turtle leather shoes, handbags, belts, wallets, luggage, and similar articles

Under the Convention on International Trade in Endangered Species of Wild Fauna and Flora (CITES), more than 120 nations are now regulating international trade to prevent the decline of species threatened or potentially threatened with extinction.

One example of a fashion item made from an endangered species is the shatoosh shawl, which costs upward of $2,000. Shatoosh is derived from the woolly fur around the throat of the threatened Tibetan antelope, or chiru. Trade in shatoosh has been illegal since 1979 under CITES, and China is calling for more stringent measures against poaching and illegal sale of shatoosh, often called "the king of wools." The animal's number is estimated to have dwindled from at least 1 million in the early 1990s to fewer than 75,000 in 1995 due to poaching. A New Jersey grand jury subpoenaed socialites who possessed shatoosh shawls to testify about how they came to possess them. Building on this publicity, the World Wildlife Fund initiated a "Don't Buy Shatoosh" campaign. In Japan local newspapers ran articles on an underground market for shatoosh in Japan.[61]

On the other hand, the alligator is an example of confusion of what is and what is not illegal to sell and buy. The alligator was removed from the endangered list more than a decade ago, but apparently American consumers are still squeamish about the skin. Many buyers at a fabric trade show in New York, upon seeing a fourteen-foot American alligator skin, asked, "Is this really all legal?" Most American alligator skins that are harvested from breeding farms are exported to France. John Galliano showed a full-length alligator dress in one Fall line.[62]

After a ten-year ban on ivory sales, in 1999 CITES agreed to allow three African countries to sell stockpiled elephant ivory to Japan. In 1989 selling ivory became illegal. At its peak in the mid-1980s, there was a $100 million-a-year

market in raw elephant tusks, carved ivory, and skin for boots, golf bags, and luggage. As much as two-thirds of the ivory was poached, reducing the elephant herds in some African countries by 80 percent. The lifting of the ban allows culling of herds but is controversial, as many fear that the elephant numbers will again be dangerously reduced.[63] In Asia, approximately thirty thousand elephants remain. Thailand finds itself balancing growth and development with maintaining the species, as hungry elephants trample pineapple fields. Think of it—an average elephant weighs 7,700 pounds and in a day consumes five hundred pounds of vegetation, drinks fifty gallons of water, and spends eighteen to twenty hours feeding.[64]

Americans with Disabilities Act

Another legal issue that affects selling fashion is the **Americans with Disabilities Act (ADA),** which is a federal civil rights law that prohibits the exclusion of people with disabilities from everyday activities, such as buying clothing at department stores, watching a movie in a theater, enjoying a meal in a restaurant, or taking classes at the local state university. Requirements went into effect in 1992. Retail stores are included in the ADA under the public accommodations clause. A new structure built after 1993 must comply with ADA requirements, but all businesses must make reasonable accommodations for people with disabilities.

The ADA is vague, resulting in cases landing in courts for judges to decide whether retailers are complying. Macy's resolved a long-standing lawsuit over such issues as aisle widths and where to place brochures about services, as the disabled struggle with these in addition to heavy doors, high counters, and steep ramps.[64] Physical barriers in buildings that serve the public must be removed from existing buildings if *readily achievable* (this is the concept most often contested). Aisles in retail stores that are too narrow for wheelchairs must be corrected. Door openings should be at least thirty-six inches wide. *ADA Standards for Accessible Design* is a guide for businesses.

Retailers must consider how people with disabilities get access to displayed merchandise. In general, a thirty-six-inch-wide accessible route is needed. If cutting down floor space for merchandise display substantially affects profitability, alternative services can be provided, such as sales associates available to assist customers in retrieving items. Sale merchandise should not be placed in narrow aisles. Counters with a cash register must have a section at least thirty-six inches long and no more than thirty-six inches above the floor so that money can be exchanged. More information is available at www.pueblo.gsa.gov.

Generally consumers with disabilities are aware of the law and will remind stores if they are not in compliance. Do you think the space between sale rounders at your favorite department store complies?

Federal, State, and Local Government Consumer Protection Offices

The U.S. Office of Consumer Affairs, a federal office, advises the White House on consumer-related policies and assists consumers in securing their basic rights. From time to time, these rights are disregarded by retailers, and

uninformed consumers find themselves the owners of poor-quality goods or the recipients of less than adequate services. The *Consumer's Resource Handbook*, published by the Office of Consumer Affairs, can answer many consumer questions. It gives advice on how to be a smart consumer in addition to a consumer assistance directory of agencies. This directory consists of thousands of names, addresses, telephone numbers, and Web site and e-mail addresses for national consumer organizations, Better Business Bureaus, corporations, trade associations, state and local consumer protection offices, state agencies, military consumer offices, and federal agencies. It can be found at www.consumer.gov/productsafety.htm.

State, county, and city consumer protection offices provide consumers with important services. These offices mediate complaints, conduct investigations, prosecute offenders of consumer laws, license and regulate a variety of professionals, promote strong consumer protection legislation, provide educational materials, and advocate in the consumer interest. City and county consumer offices are familiar with local businesses and local ordinances. State offices, whether in the attorney general's or governor's office or in a separate department of consumer affairs, are familiar with state laws and look for statewide patterns of problems.

Consumer Information Center

The U.S. government is the largest publisher in the country. A great deal of information, much of it of interest to consumers, is available from the U.S. Government Printing Office. Selected titles related to retail and fashion consumers that are available in hard copy and on the Internet (www.pueblo.gsa. gov) are listed here.

- *Consumer Action Handbook.* Use this updated guide to get help with consumer problems and complaints. Find consumer contacts at hundreds of companies and trade associations, local, state, and federal government agencies, and national consumer organizations. 172 pp. (2007)

- *Teens and Money* (August 2006). Help your teens prepare for the real world of saving, investing, and buying insurance, CD-ROMs.

- *Americans with Disabilities Act: Questions and Answers.* Explains how the civil rights of persons with disabilities are protected at work and in public places. 31 pp. (2002)

- *Copyright Basics.* Covers what can be copyrighted, who can apply, registration procedures, filing fees, and what forms to use. 12 pp. (2002)

- *Clearing Up Cosmetic Confusion.* Gives you the facts on cosmetic terms as well as advice on how to protect yourself from makeup misuse. 5 pp. (1998)

- *Cosmetic Laser Surgery: A High-Tech Weapon in the Fight Against Aging Skin.* Explains how laser surgery can help remove facial wrinkles and lines, how to tell if it's right for you, and the risks. 4 pp. (2000)

- *Cosmetics.* Basic fact sheet about using cosmetics safely. 2 pp. (2005)

- *Hair Dye and Hair Relaxers—Fact Sheet.* Hair dye is used to color your hair. Hair relaxers are used to make your hair straight. Both hair dye and hair relaxers can hurt your skin, hair, and eyes, especially if you are not careful. 2 pp. (2006)

- *Tattoos and Permanent Makeup.* Describes the types of tattoos, risks involved in getting them, and ways to remove them. 2 pp. (2004)
- *Eating Disorders.* Recognize the symptoms of different eating disorders, who is most likely to be affected, and various treatment options. 8 pp.
- *ID Theft: What It's All About.* Thieves can steal your personal information and use it to commit fraud for long periods without your knowledge. Here's how to protect yourself and what to do if you are a victim. 18 pp.
- *Building a Better Credit Report.* Learn how to legally improve your credit report, how to deal with debt, how to spot credit-related scams. 16 pp.
- *Credit Matters.* How to qualify for credit, keep a good credit history, and protect your credit once you have it. 2 pp. (2000)

CONSUMER PROTECTION FROM BUSINESS AGENCIES

Several trade associations and services that help consumers solve problems with businesses, including Better Business Bureaus, The International Fabricare Institute, and others, are discussed in this section. If you have a bad experience with a retailer, as we mentioned earlier, go back to the company first to try to resolve the problem. But if you can't, don't panic; there is much help out there.

Better Business Bureau

Better Business Bureaus (BBBs) are nonprofit organizations supported primarily by local business members in a community. The focus of BBB activities is to promote an ethical marketplace by encouraging honest advertising and selling practices, and by providing alternative dispute resolution. BBBs offer a variety of consumer services. For example, they provide consumer education materials; answer consumer questions; provide information about a business, particularly whether there are unanswered or unsettled complaints or other marketplace problems; help resolve buyer/seller complaints against a business, including mediation and arbitration services; and provide information about charities and other organizations that are seeking public donations.

BBBs usually request that a complaint be submitted in writing so that an accurate record exists of the dispute. The BBB will then take up the complaint with the company involved. If the complaint cannot be satisfactorily resolved through communication with the business, the BBB may offer an alternative dispute settlement process, such as mediation or arbitration. BBBs do not judge or rate individual products or brands, handle employer/employee wage disputes, or give legal advice.

If you need help with a consumer question or complaint, call your local BBB to ask about its services. Bureaus that provide information via 1-900 telephone numbers charge a nominal fee. Some numbers require a major credit card to access information and charge a flat fee. Or you can contact the BBB online (www.bbb.org) for consumer fraud and scam alerts and

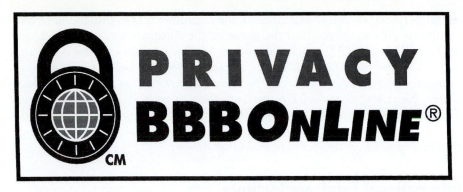

The Council of Better Business Bureaus (CBBB) created BBBOnline to extend what it has done for over 95 years in the brick-and-mortar world to the Internet and to promote trust and confidence. The BBBOnline Reliability Web site seal allows Web sites to demonstrate they have met the program requirements, which include local BBB membership, truth in advertising, and dispute resolution. The BBBOnline Privacy Seal specifically addresses online shoppers' privacy concerns. Web sites displaying this seal have met BBBOnline privacy requirements, which encompass FTC and European Union requirements. For more information about these programs and to find Web sites participating in these programs, go to www.bbbonline.org.

information about BBB programs, services, and locations. BBBOnLine provides Internet users an easy way to verify the legitimacy of online businesses. Companies carrying the BBBOnLine seal have been checked out by the BBB, and agree to resolve customer concerns regarding goods or services promoted online.

The Council of Better Business Bureaus, the umbrella organization for the BBBs, can assist with complaints about the truthfulness and accuracy of national advertising claims, including children's advertising; provide reports on national soliciting charities; and help settle disputes with manufacturers.

Corporate Consumer Contacts

The corporate consumer contacts section on the BBB Web site will help you resolve a complaint about a service or product. In some instances it may be best to go back to the place where you bought the product or service. In other cases, it may be better to write or call the consumer affairs department at the company's headquarters. Even if you decide to go directly back to the seller, let the consumer affairs department of the company know about your complaint. These offices are set up within companies because they want to hear from you.

Many of the companies listed in the BBB are members of the Society of Consumer Affairs Professionals in Business (SOCAP). An international professional organization established in 1973, SOCAP provides training, conferences, and publications to encourage and maintain the integrity of business in transactions with consumers; to encourage and promote effective communication and understanding among business, government, and

consumers; and to define and advance the consumer affairs profession (www. socap.org). If you do not find the name of the company you are looking for at the BBB or SOCAP, check the product label or warranty for the name and address of the manufacturer. Public libraries also have helpful information. *Standard & Poor's Register of Corporations, Directors, and Executives; Trade Names Directory; Standard Directory of Advertisers;* and *Dun & Bradstreet Directory* are four sources that list information about most firms. If you do not know the name of the manufacturer, consult *Brands and Their Companies*, or *The Thomas Register of American Manufacturers.*

International Fabricare Institute

The **International Fabricare Institute (IFI)** is a trade association of professional dry cleaners and launderers. If you take your best suit to the cleaners and it comes back to you in shambles, there is a procedure consumers can go through for redress (if you and your dry cleaner followed the recommended care instructions). The IFI recommends that you take it back to the store you bought it from; if the store will not resolve the problem, ask for the manufacturer's name and address and write the company. If the dry cleaner takes responsibility for the mistake, it should replace the garment. If neither the manufacturer nor the dry cleaner admits fault, the garment can be sent to the IFI for analysis and a decision as to responsibility.

Direct Marketing Association

The **Direct Marketing Association (DMA)** is a business trade association founded in 1917 that serves the direct marketing field. It offers consumer information through its Web site (www.the-dma.org), including shopping tips and your rights as a consumer, especially with regard to your privacy and the selling of your names to mail-order companies.

The Direct Marketing Association takes a proactive stance in response to consumer problems related to mail order and other direct marketing. It is the oldest and largest national trade association serving the direct marketing field. The purpose of its consumer guide is to help make consumers aware of their rights and rights to privacy.

> The *Mail Preference Service* (MPS) is designed to help consumers decrease the amount of national nonprofit or commercial mail that they receive at home (some call it "junk mail"—but not the DMA!).
>
> The *Telephone Preference Service* (TPS), a do-not-call service, helps consumers decrease the number of national commercial calls received at home. (These are the calls that interrupt dinner.)
>
> The *e-Mail Preference Service* (e-MPS) helps consumers decrease the amount of national unsolicited commercial e-mail they receive.

The DMA's Web site (www.the-dma.org/consumers/consumerassistance. html) also offers easy-to-use tips for shopping by phone and lists federal laws and regulations that protect your consumer rights and/or combat fraud that can be committed by phone. You can also write to Direct

Marketing Association, 1111 19th Street NW, Suite 1100, Washington, D.C. 20036.

Other Independent Services

Action Lines

Local newspapers and radio stations often have *action lines* or *hotline* services. Many of these services try to resolve all of the consumer complaints they receive. Others handle only the most serious cases, or cases that represent their community's most frequently occurring problems. To find these services, check with your local newspapers, radio and television stations, or local library.

Call for Action, Inc. (www.callforaction.org), is a forty-five-year-old international nonprofit network of consumer hotlines that operates in conjunction with broadcast partners to educate and assist consumers and small businesses with consumer problems. Many major markets have a Call for Action chapter staffed with trained volunteers who offer advice and mediate complaints at no cost to consumers. For example, WABC is the Call for Action station in New York City; in Philadelphia it's WPVI-TV; and it's WTVI-TV in St. Louis. The Web site listed earlier will give you the closest station to where you live.

The National Consumers League

The National Consumers League (NCL) (www.natlconsumersleague.org) is a private, nonprofit advocacy group representing consumers on marketplace and workplace issues. NCL is the nation's oldest consumer organization. Its mission is to identify, protect, represent, and advance the economic and social interests of consumers and workers. NCL provides government, businesses, and other organizations with the consumer's perspective on concerns including child labor and privacy information among other topics.

The National Fraud Information Center & Internet Fraud Watch (NFIC) (www.fraud.org/info/aboutnfic.htm) was originally established in 1992 by the National Consumers League to fight the growing menace of telemarketing fraud by improving prevention and enforcement. The NFIC provides a nationwide toll-free hotline for consumers to get advice about telephone solicitations and report possible telemarketing fraud to law enforcement agencies. In 1996, the Internet Fraud Watch was created, enabling the NFIC to offer consumers advice about promotions in cyberspace and route reports of suspected online and Internet fraud to the appropriate government agencies. Consumers can call the NFIC hotline toll-free at 1-800-876-7060 or send their questions to the NFIC via the Web site.

National Consumer Agencies

Many organizations define their missions as consumer assistance, protection, and/or advocacy. Most develop and distribute consumer education and information materials and advocate in the interest of consumers before government and in the news media. The U.S. government offers the

Consumer Assistance Directory online (www.pueblo.gsa.gov). Selected organizations are listed here:

- *American Council on Consumer Interests* (ACCI): Serves consumer educators, researchers, and policy makers.
- *Congress Watch:* Works for consumer-related legislation, regulation, and policies on trade, health, and safety.
- *Consumer Action:* Assists consumers with marketplace problems.
- *Consumer Federation of America* (CFA): 240 organizations representing 50 million consumers.
- *Public Citizen:* Represents consumer interests through lobbying, litigation, research, and publications.
- *U.S. Public Interest Research Group* (PIRG): National lobbying office for state public interest research groups; they are consumer environmental advocacy groups active in many states.

CHAPTER SUMMARY

- Many government, business, and private agencies have consumer protection as their main purpose. Consumers do, however, have to educate themselves on their rights, a complex task in today's competitive marketplace.
- The Federal Trade Commission, the Consumer Product Safety Commission, and the Food and Drug Administration are government independent regulatory agencies that monitor the marketplace for unfair competition and protection in the form of safe products and accurate information available to consumers.
- Fiber identification, care labels, manufacturer information, and country of origin are provided on apparel as consumer information.
- Mail-order and Internet sales are monitored, but as in other areas, consumers must be cautious about with whom they do business.
- Trademarks, copyrights, and patents are a company's intellectual property and there are penalties for infringement. Consumers must beware of fakes in the marketplace. Counterfeits are cheap copies of branded, trademarked goods.
- The Endangered Species Act protects threatened and endangered plants and animals, and it is illegal to use any parts of such in apparel or fashion goods.
- The Americans with Disabilities Act prohibits exclusion of people with disabilities from everyday activities. Retail stores must comply with access provisions of the act.
- The U.S. government is the largest publisher in the country and offers consumers an array of information pamphlets and Internet sites to access information on purchasing products and protecting oneself from deceptive business practices.
- Call for Action lines and other business services are available for consumers in trouble.

KEY TERMS

Federal Trade
 Commission (FTC)
Wool Products
 Labeling Act
Fur Products
 Labeling Act
Textile Fiber Products
 Identification Act
down
feathers
country of origin
Care Label Rule
price maintenance
Sherman Antitrust
 Act
Fair Trade Laws

Consumer Goods
 Pricing Act
predatory pricing
Consumer Product
 Safety Commission
Flammable Fabrics Act
Food and Drug
 Administration
 (FDA)
Federal Food, Drug
 and Cosmetic Act
Fair Packaging and
 Labeling Act
intellectual property
counterfeit goods
trademark

Counterfeiting Act
trade dress
copyright
patent
parallel imports
gray goods
Endangered Species
 Act of 1973
Americans with
 Disabilities Act (ADA)
Better Business Bureau
 (BBB)
International Fabricare
 Institute (IMI)
Direct Marketing
 Association (DMA)

DISCUSSION QUESTIONS

1. Discuss problems you have had with a dry cleaner. Have you ever ignored care instructions on a fashion item and ruined an item? Have you ever ignored care instructions on a fashion item and *not* ruined an item? Survey consumers as to their experience with care labeling.

2. Collect labels from garments and analyze them for required information as outlined in this chapter. How many international labels do you find? Do you understand them?

3. Do you feel that the government interferes too much with businesses producing and selling apparel or not enough for the sake of the consumer?

4. Write a complaint letter, using the format recommended by this chapter, to a manufacturer of a product that you were dissatisfied with. Report the findings to your class.

5. Contact government, business, and independent consumer protection agencies/services with a consumer problem and compare their responsiveness and effectiveness.

6. Analyze sales in discount stores and compare them with other stores. Do you think there is any predatory pricing?

7. Have you ever received unordered merchandise in the mail? What did you do with it?

8. Compare ingredients on expensive and discount store cosmetics. Why do you think the upper-end brand-name skin-care products are so expensive?

9. Gather trademarks (names, logos, and symbols) of fashion items and survey consumers to see how many can recognize the company that owns the trademark.

10. Have you ever bought a known counterfeited product? If so, discuss your experience with it regarding quality and service life of the product.

11. Measure the distance between store racks and aisle widths in relation to ADA requirements. You can do this discreetly by pacing out the distance; your footlength is roughly one foot. (If you have small feet, add a few inches of space when you pace out the distance.) Compare results in several types of stores.

12. Order some free or low-cost information pamphlets from the U.S. Government Printing Office. Report on their effectiveness.

ENDNOTES

1. For consumer research and discussions related to public policy issues, see Paul N. Bloom and Stephen A. Greyser, "The Maturing of Consumerism," *Harvard Business Review* (November–December 1981): 130–139; George S. Day, "Assessing the Effect of Information Disclosure Requirements," *Journal of Marketing* (April 1976): 42–52; Michael Houston and Michael Rothschild, "Policy-Related Experiments on Information Provision: A Normative Model and Explication," *Journal of Marketing Research* 17 (November 1980): 432–449; Jacob Jacoby, Wayne D. Hoyer, and David A. Sheluga, Misperception of Televised Communications (New York: American Association of Advertising Agencies, 1980); Lynn Phillips and Bobby Calder, "Evaluating Consumer Protection Laws: Promising Methods," *Journal of Consumer Affairs* 14 (Summer 1980): 9–36; Howard Schutz and Marianne Casey, "Consumer Perceptions of Advertising as Misleading," *Journal of Consumer Affairs* 15 (Winter 1981): 340–357; Darlene Brannigan Smith and Paul N. Bloom, "Is Consumerism Dead or Alive? Some New Evidence," in *Advances in Consumer Research* 11, ed. Thomas C. Kinnear (Provo, Utah: Association for Consumer Research, 1984), 369–373.

2. Roger M. Swagler, *Consumers and the Market* (Lexington, Mass: Heath, 1979).

3. Larry Hatfield, "Identity Theft Tops FTC Fraud Complaints," *San Francisco Chronicle* (January 24, 2002): A2.

4. Patty Brown and Janette Rice, *Ready-to-Wear Apparel Analysis* (Upper Saddle River, N.J.: Prentice-Hall, 1998), 20.

5. Joanna Ramey, "FTC's Crackdown on Cashmere," *Women's Wear Daily* (May 7, 2001): 7.

6. "Care Labels—Professional Cleaners Care," International Fabricare Instititute (Silver Spring, Md., 1994); "What's New about Care Labels," Federal Trade Commission (Washington, D.C., April 1984); "Writing a Care Label: How to Comply with the Amended Care Labeling Rule," Federal Trade Commission (Washington, D.C., March 1984).

7. "Closed Cues: Care Labels and Your Clothes," Federal Trade Commission (July 1997).

8. Joanna Ramey, "FTC Alters Care Label," *Women's Wear Daily/Global* (August 2000): 15.

9. "FTC Aims to Update Rules for Care Labels on Apparel," *Women's Wear Daily* (January 3, 1996): 11; Sheryl Harris, "Care Labels May Soon Get Altered," *The* [Contra Costa, CA.] *Times* (July 8, 1998): C1, C5.

10. Joanna Ramey, "Jones Hit with FTC Sanction," *Women's Wear Daily* (April 3, 2002): 2.

11. Joanna Ramey, "McClintock to Pay $66,000 to Settle FTC Charges," *Women's Wear Daily* (January 27, 1995): 12.

12. "Background Material for Consumer Protection and the FTC," Federal Trade Commission.

13. Alison Maxwell, "Amazon.com Hit by Suits, FTC Probe," *Women's Wear Daily* (February 9, 2000): 18.

14. Ellen Groves, "Prestige Brands Fined for Price Fixing," *Women's Wear Daily* (March 15, 2006): 2.

15. Evan Clark and Kristi Ellis, "Power to Set Prices: Supreme Court Backs Brands Over Retailers," *Women's Wear Daily* (June 29, 2007): 1, 14.

16. Nancy J. Rabolt and Judy K. Miler, *Concepts and Cases in Retail and Merchandise Management* (New York: Fairchild, 1997).

17. "Antitrust Enforcement and the Consumer," U.S. Department of Justice, Washington, D.C., 20530 (http://www.pueblo.gsa.gov).

18. "A Business Guide to the Federal Trade Commission's Mail Order Rule," Federal Trade Commission Bureau of Consumer Protection, Washington, D.C.

19. Janet Attard, "National Internet Sales Tax Bill Introduced," http://www. businessknowhow.com, March 25, 2000.

20. "Mail Order Rights," American Express.

21. http://www.cpsc.gov/.

22. "'Wanted' Posters in Post Offices to Share Space with Product Recalls," *San Francisco Chronicle* (April 19, 2000): A2.

23. Brown and Rice, *Ready-to-Wear Apparel Analysis*.

24. www.cpsc.gov (January 27, 2007).

25. Jennifer Owens, "Big Stores Endorse CPSC's Call for Team to Battle Flammability," *Women's Wear Daily* (June 5, 1997): 22.

26. Debra Levi Holtz, "Hazardous Toy Alert Issued as Parents Begin Holiday Shopping," *San Francisco Chronicle* (November 24, 1999): A3.

27. Louis Freedberg, "Greenpeace Issues Warning on Toys," *San Francisco Chronicle* (October 19, 1997): A3.

28. "Are You Buying the Right Toy for the Right Age Child?," Consumer Product Safety Commission.

29. http://www.fda.gov.

30. Carol Lewis, "Cleaning Up Cosmetic Confusion," *FDA Consumer* (U.S. Food and Drug Administration, May–June 1998).

31. Betsy Stanton, "FDA Nixes Beauty Label Compromise," *Women's Wear Daily* (November 23, 1987): 1, 11.

32. "Alpha Hydroxy Acids in Cosmetics," (www.fda.gov) (January 3, 2007).

33. Beth Greer, "Looking Good Could Be Hazardous," *San Francisco Chronicle* (September 27, 2006): G6.

34. Jane Kay, "L'Oréal, Revlon Bow to Bay Area Pressure," *San Francisco Chronicle* (January 15, 2005): B1, B2.

35. Lewis, "Cleaning Up Cosmetic Confusion."

36. Lewis, "Cleaning Up Cosmetic Confusion."

37. "Shelf Life-Expiration Date" (May 8, 1996). Available online at http://vm.cfsan.fda.gov.

38. Rabolt and Miler, *Concepts and Cases in Retail and Merchandise Management.*

39. "How to Spot a Fake and Save a Buck," International AntiCounterfeiting Coalition.

40. Liza Casabona, "What Makes a Fake," *Women's Wear Daily* (May 25, 2006): 14.

41. www.iacc.org (January 27, 2007); see also video "Illicit: The Dark Trade," National Geographic Specials.

42. Examples of articles on counterfeits seizures and lawsuits in *Women's Wear Daily:* Ross Tucker, "Attacking Counterfeits: Major Ring Broken up by Polo and North Face," *Women's Wear Daily* (March 1, 2006): 1, 13; Liza Casabona, "Luxe Brands Fight Online Counterfeits," *Women's Wear Daily* (November 14, 2006): 5; Bambina Wise, "Polo Battles Copies on Mauritius Island," *Women's Wear Daily* (April 10, 2003): 3, 14.

43. Ross Tucker, "Victoria's Secret Hit with 'Sexy Suit,'" *Women's Wear Daily* (January 20, 2005): 16; Joanna Ramey, "Court Upholds Victor's Secret," *Women's Wear Daily* (March 5, 2003): 2, 19.

44. "Escada Sues Limited over Fragrance," *Women's Wear Daily* (October 16, 1992): 14.

45. Vicki M. Young, "Calvin vs. Ralph: The Bronx Bombers Slug It Out," *Women's Wear Daily* (June 26, 1998): 1, 8; Vicki M. Young, "Ralph Beats Calvin in Bottle Battle," *Women's Wear Daily* (May 11, 1999): 1, 13.

46. Vicki M. Young, "Hilfiger Unit Sues Goody's," *Women's Wear Daily* (August 1, 2000): 11.

47. www.iacc.org/membership/spotlight (January 27, 2007).

48. Peter Fimrite, "Internet Makes Sweet Pea Get Tough," *San Francisco Chronicle* (March 14, 2006): B1.

49. Vicki M. Young, "Sephora's Challenge to Federated, Macy's Seen as Uphill Fight," *Women's Wear Daily* (April 13, 1999): 1, 7; Vicki M. Young and David Moin, "Injunction Granted: Sephora Wins Round in Federated Battle," *Women's Wear Daily* (February 2, 2000): 1, 17.

50. Joanna Ramey, "Top Court Favors Wal-Mart in Trade-Dress Case," *Women's Wear Daily* (March 23, 2000): 14.

51. Liza Casabona, "Diane von Furstenberg Sues Forever 21 Over Copyright," *Women's Wear Daily* (March 28, 2007): 3.

52. Kristi Ellis, "Copyrighting a Dress: Congress Mulling Bill to Protect Designers," *Women's Wear Daily* (April 26, 2007): 1, 13.

53. Daren Fonda, "Copyright Crusader," *Boston Globe Magazine* (August 29, 1999). Available online at http://www.boston.com/globe.

54. Rabolt and Miler, *Concepts and Cases in Retail and Merchandise Management.*

55. Anne D'Innocenzio, "Wayne Rogers Sets Ad Campaign for Its Patented Stretch Silk Fabric," *Women's Wear Daily* (June 25, 1997): 31.

56. Vicki M. Young, "MAC Sues Tony & Tina," *Women's Wear Daily* (April 16, 1999): 4.

57. Z Casabona, "Gray Market Presents Legal Challenge for Brands," *Women's Wear Daily* (October 30, 2006): 26.

58. "Why Save Endangered Species?" (March 2000). Available online at http://www.pueblo.gsa.gov/cic_text/misc/endangered/species.txt; "Endangered Species," U.S. Fish and Wildlife Service.

59. Jeannine Stein, "State Puts the Squeeze on Purveyors of Python," *Los Angeles Times* (March 19, 2000): 1.

60. "Wildlife Laws: U.S. Fish and Wild life Service Facts about Federal Wildlife Laws." U.S. Fish and Wildlife Service; "Ban on Ivory Trade Eased for 3 African Countries," *San Francisco Chronicle* (June 20, 1997): A20.

61. "Animal Group Wants Ban on Shatoosh Shawls," *Mainichi* [Tokyo] *Daily News* [English edition] December 19, 1999: 1; Ginia Bellafante, "Shatoosh and Alligator: Fashions That Come with a Stigma Attached," *Houston Chronicle* (November 11, 1999): 7.

62. Bellafante, "Shatoosh and Alligator: Fashions that Come with a Stigma Attached."

63. "Ban on Ivory Trade Eased for 3 African Countries,"; Katy Payne, "Permitting Ivory Trade Puts Elephants on Shaky Ground," *San Francisco Chronicle* (June 11, 1999): A21; Kevin Leary, "Hunt Elephants to Save Them, Author Argues," *San Francisco Chronicle* (May 7, 1993): B3, B4.

64. John Cramer, "Thailand's Wild Elephants Dying Out," *San Francisco Chronicle* (July 9, 1997): A7.

65. Bob Egelko, "Macy's Settles Lawsuit," *San Francisco Chronicle* (December 19, 2001): B3.

Photo Credits

Index